D0842944

15=°

The Divine Comedy of
PAVEL TCHELITCHEW

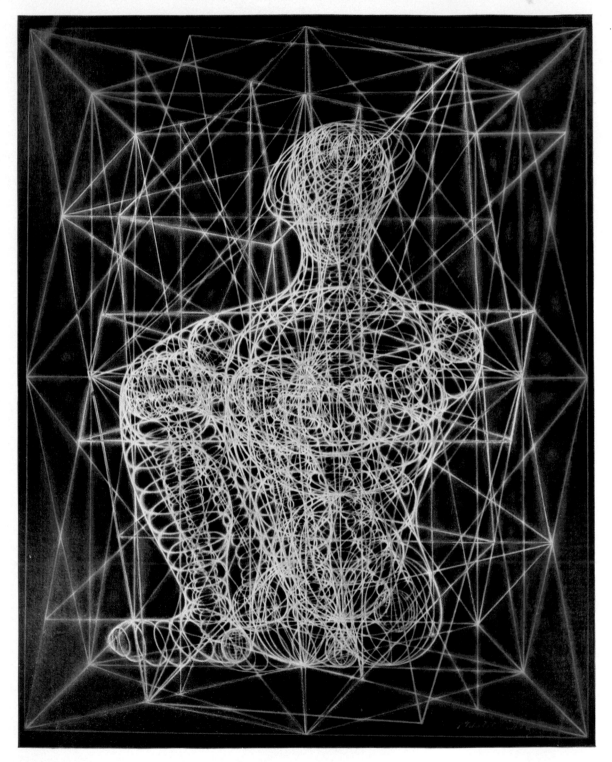

TCHELITCHEW: *Mercure*, 1956, oil on canvas, 31¼ by 25¼ inches.
Collection Mrs. L. B. Wescott.
Photo: Michael Ciavolino, Jr., Flemington, N. J.

The Divine Comedy of
PAVEL TCHELITCHEW
A Biography by Parker Tyler

Fleet Publishing Corporation, New York

Copyright © 1967 by Parker Tyler
All rights reserved.
Five stanzas from "Seven Poems,"
Rainer Maria Rilke, *Poems 1906–1926*,
Copyright © 1957 by New Directions,
reprinted by permission of New Directions

Quotation from *The I Ching* or *Book of Changes*,
The Richard Wilhelm Translation, Rendered into
English by Cary F. Baines, Foreword by C. G.
Jung, by permission of Bollinger Foundation

Quotation from The Divine Comedy of Dante
Alighieri, Translated by Lawrence Grant White,
by permission of Random House, Inc.

Library of Congress Catalog Card Number: 66–25989
Printed in the United States of America

PETER CZIFFRA

ACKNOWLEDGMENTS

A biographer is indebted to information in all its varieties and to all its human agents. He is especially fortunate if he has had immediate personal contact with those who knew his living subject. In the great majority of cases among Pavel Tchelitchew's friends and colleagues, I had the advantage of knowing them personally, and on starting this biography, usually obtained special interviews with them; the circumstances attending certain interviews are built into the following narrative.

My deepest thanks for coöperation and help must go to the three people who knew Tchelitchew most intimately: his sister, Mme. Alexandra Zaoussailoff, Mr. Charles Henri Ford and Mr. Allen Tanner; all three showed me an unblemished confidence in unreservedly placing at my disposal their ample, invaluable memories of the artist; references to actual documents with which respectively they supplied me will be found in subsequent pages.

To the following—all of them personally acquainted with Tchelitchew, some of them close friends—I must express my gratitude for kindly recalling him, for showing me his works and/or for recollecting the milieux they shared; in some cases, I had the advantage of reading Tchelitchew's letters to them: Mr. and Mrs. R. Kirk Askew, Jr., Mr. Cecil Beaton, Mr. Eugene Berman, Mr. and Mrs. Norman Borisoff, Mr. Charles Boultenhouse, Miss Erica Brausen, Mrs. Philip Claflin, Sir Kenneth Clark, Mrs. Louise Dahl-Wolfe, Miss Alice De Lamar, Mr. Anthony Denney, Mlle. Léonor Fini, Mr. and Mrs. James W. Fosburgh, Dr. A. L. Garbat, Mr. Geoffrey Gorer, Mr. Robert H. Holmes, Mr. and Mrs. Oliver B. Jennings, Mr. Lincoln Kirstein, Mr. Nicholas Kopeikine, Mr. Léonid (Berman), Mr. Julien Levy, M. Pierre Loeb, Mr. Joseph Lubitch, Mr. Fred Melton, Mr. Ben Morris, Mr. Edouard Roditi, Mrs. Zachary Scott, Sir Osbert Sitwell, Mr. James T. Soby, M. Pierre Souvtchinsky, Mr. Walter Stein, the Hon. Stephen Tennant, Mr. Virgil

Thomson, Miss Alice B. Toklas, Mr. John A. Torson, Mr. Wallace Tyler, Miss Catherine Viviano, Mr. Glenway Wescott, Mrs. L. B. Wescott, and Mr. Monroe Wheeler. In the above group, but passed away since I talked to them, also belong Alfred Frankfurter, Zossia Kochansky, Vera Koshkin, Henry McBride, Kurt Seligmann and Edith Sitwell.

My gratitude to Mr. Kirstein is very great for having originally sponsored the project of this biography and for having placed in my hands a large group of important documents. I add my gratitude to others who sponsored this book for the various grants that enabled me to undertake and complete it: Dr. Marius Bewley, Mr. Thomas B. Hess, the late Henry McBride, Dr. Meyer Schapiro, Mr. James T. Soby, Mr. Glenway Wescott and Dr. Edgar Wind. Those institutions to which I owe thanks for grants, hereby very warmly acknowledged, are the Chapelbrook Foundation, the Ford Foundation, the John Simon Guggenheim Memorial Foundation and the Ingram-Merrill Foundation.

I am in special debt to the Beinecke Library at Yale University for affording me ideal conditions for consulting the Tchelitchew correspondence (made available to me by personal consent from Dame Edith Sitwell) and for permission to quote from it at length.

For help in viewing Tchelitchew works and/or for supplying me with photographic copies of them, I extend thanks to the Museum of Modern Art, New York, the Wadsworth Atheneum, Hartford, Conn., the Museum of Fine Arts, Boston, the Santa Barbara Museum of Art, Santa Barbara, Calif., Durlacher Bros., New York, Arthur Jeffress, London, and the editors of *Art News*. Special thanks are due Miss Jean Volkmer, Conservationist at the Museum of Modern Art, for enlightening me regarding the restoration of *Hide and Seek*.

For permission to quote stanzas from the Rilke poem, my thanks also go to Mr. James Laughlin of New Directions; in equal measure, of course, I am grateful to all those individuals granting me permission to reproduce photographs of Tchelitchew works in their possession (their names duly appear next to the illustrations) and to Mr. J. Russell Lynes for allowing me to use numerous photographs taken by the late George Platt Lynes.

For help of an incidental kind, I am indebted to the thoughtfulness of Miss Patricia Blake.

P.T.

One

PARADISE

It was the night of March 17th, 1964, the occasion of one of the gala previews of the Pavel Tchelitchew* exhibition that in a few days was to inaugurate the Gallery of Modern Art in New York City. Black mourning for the artist who had died in 1957, without till now having received proper public memorial, had turned into the solemn gladness of black tie. The choice of Tchelitchew as the artist to open the institution owned by Huntington Hartford, known to the art world for his moralistic attacks on modern abstraction, was a surprisingly fortunate start and in particular a master stroke by the Gallery's then director, Carl J. Weinhardt, Jr. An artist had been found to reconcile Hartford's unmodern, uninteresting orthodoxy with modern, interesting unorthodoxy. Tchelitchew's adherence to the figure's classic anatomy and, till 1942, to the surface representation of nature had made his modernism rare, ambiguous and uniquely controversial. Since his arrival in the United States in November, 1934, he had steadily won enough fame, friends and admiration to become a notable figure.

Most American admirers were his collectors and friends; a few were museum and gallery directors; a minority was found among the critics and a minority, equally unimposing, among fellow artists and art students. One wondered who besides visitors to the Museum of Modern Art, where he was known as "that man who painted *Hide and Seek*," his admirers might be. If his name had been easy to pronounce, it might have had more currency. Was he, as they say, an "artist's artist"? In a sense, yes, and yet he had, as not his least asset, that peculiar theatrical appeal that earns popularity. With his style constantly evolving, Tchelitchew's reputation had begun a decline after he started making Italy his home in 1952. As a naturalized American of Russian birth, he was supposed to have returned to the United States the year that he died. At his death—shockingly premature according to his age, scarcely fifty-nine—no sudden rise in esteem had sent his prices up while to the dismay of

* Normally pronounced chel'ly-cheff with a light accent on the first syllable. However, at least in the United States, the artist himself developed the habit of shifting the accent, again lightly, to the second syllable so that one heard something very close to chell-ee'(t)cheff.

his close adherents he had seemed, immediately, to drift into obscurity. Pavel Tchelitchew had a coterie full of undiminished faith, but as soon as Abstract Expressionism began to dominate the international art scene, he was put in the shade and became "dated." It is bad form to date an artist of Tchelitchew's calibre. But it is the contemporary milieu that must apologize.

On this preview night of the memorial exhibition, a glow of human warmth, answered and amplified by the splendor on the walls, suffused the air inside and drew together in contagious smiles the cream of New York's Tchelitchevians. They had never been much of a conscious clique; now they were just amateurs, mostly, finding themselves together on the basis of defined taste like members of some far-flung family, some of whom did not even know others to speak to.* Tonight the gathering was reserved chiefly for lenders to the exhibition and these were more numerous than one might have anticipated. The façade of Edward Stone's pale, curved, tasteful, undistinguished building, topped with its token Renaissance arcade, was flooded with giant spotlights; approaching, one detected the atmosphere of a Broadway first night with garnishing celebrities. Champagne was flowing on the top floor and underground. Almost precisely between, in one of the high ceilinged rooms off the main exhibition halls, Mr. Hartford, Edward Stone, Salvador Dali, Carl Weinhardt and their wives formed a receiving line. This room held two huge paintings and some drawings by Dali and dominated the Permanent Collection that was also opening to the public. Dali, venerated by Hartford as an exceptional modern genius, had been an arch public rival of Tchelitchew's so that, tonight, he shared the spotlight with an incongruity that must have annoyed Tchelitchew's ghost.

For Tchelitchew's admirers, however, it was enough that public justice (if this term is not too outrageously romantic) was being done their idol; a politely hot elation seemed to spread from hand to hand, mouth to mouth. Old acquaintance were reminded of a communal pleasure of which, perhaps, the artist himself had been the immediate dynamic nexus. Nostalgia, teamed with placid satisfaction, was rampant; no one thought of reining it in. I was not surprised to see Lincoln Kirstein's nobly naked head, slightly bowed with the weight of shyness, manoeuvring above the man-level of the crowd. Of course I had expected an encounter with the man who had been personally instrumental in promoting the existence of the present biography, but with whom at that moment I had somewhat unstable relations of amity. Alas, I should add, we have too little faith in the shape of the heart, which (despite all) is beautiful and steadfast.

Kirstein shrinks modestly within his bulk as if aware of sustaining the hoarded, harnessed power of a football player. In a triple portrait, Tcheli-

* John Canaday, while granting the importance of the exhibition, felt the peculiar intimacy of the occasion.

tchew once conceived him, without ineptitude, as a prizefighter. His head has the shaven look of an athlete's and a monk's. The mobile decided bow of his mouth carries iridescent subtleties of mood; the firm thrust of the jaw and the aggressively arched nose are the distinguished vanguard of his rather weak but level glance, sheltering as it were the brimming well of their owner's extreme sensibility. Tonight, Kirstein was both jubilant and nervous (a frequent complex of his nature) and was necessarily conspicuous as a leading Tchelitchevian and author of the biographic piece in the catalog. He had worked long and consistently to bring about this posthumous tribute to the artist he had revered most among those living. Beams of fun or gloom habitually shoot from his brow and cover the retreat and advance of his notably mercurial impulses. His mood seemed rather high in tension as figuratively he grabbed me by the arm and led me to a work which hung with the very last Tchelitchew had accomplished before he died.

Dated 1957, it apparently received some touches even after the heart attack that originally sent the artist from his Frascati penthouse on Christmas Eve, 1956, to Salvator Mundi Hospital in nearby Rome. He lay there struggling with death for about ten weeks, only to arise in March for a false convalescence and to return in May to the hospital, where he died on July 31st. That evening of another March, I was speeded (with an acquiescence that shelters my own sensibilities) to a work which I could have told Kirstein I had already viewed some minutes before; again, I saw the distinction of the work's refinement, so to speak, without perceiving either its subject or a grain of its true significance. The truth was: it was astonishingly abstract for Tchelitchew. As the artist's very last work, it had been entitled *Inachevé* by his surviving sister, Mme. Alexandra Zaoussailoff. This lady, one of the most concerned over the delay of paying her brother this posthumous tribute, was currently too ill in her home in Paris to be present.

If only as "unfinished," presumably, the painting before which I stood did not seem to me "full." But perhaps its lack of dimension, or at least *solid* dimension, was, I thought, due to its being more positively abstract than anything of the artist's last period. That rich, unique, rarefied fusion of geometry and calligraphy which Tchelitchew matured as his final style usually holds the presence of an object, animal or human figure, remorselessly deprived of mass and all outer semblance, but pulsing as with some brilliant and precise organization of the stars, caught unmoving, simultaneously, in their paths through space. It had been only myself among Tchelitchew's critics who had insisted on the Zodiacal status of these taut, frail, ordered figurations, plotted as if in infinity and displayed two-dimensionally as if in a cube of invisible glass.

I could not forget that Tchelitchew's imagination was dominated by Astrology and that the Earthly and Celestial Globes of antiquity had proven,

throughout his career, the two indispensable emblems of his plastic vision. He set great store by the Tarot pack, and the fact that in his maturity he discovered, on one card, a globe painted with flowers restimulated his reverence for the globe as an archetype with decisive meaning for him. He was not merely an intuitive cosmic spirit, but a large and devout one. His last style has the transparency of endless night and that still luminosity of the cosmos which distance can do nothing to kill.

Kirstein, beside me, produced a remark: "Flashy, isn't it?"

The word came in one of those bursts of freighted emotion that lift the speaker's voice to its highest register: a sort of ecstatically gulped contralto. Obediently, and more inquiringly, I looked at the picture again. Kirstein is very earnest in his formal criticism, so I was struck by the colloquial "flashy." Horizontal in emphasis, *Inachevé's* inner image is lightly cased in what Tchelitchew termed his "dancing boxes," frameworks eloquent of the geometric arrangements called configurations of the planets in the casting of horoscopes, a magical office the artist constantly had done for him. Spread out within the set of dancing boxes is a flat design like a variety of dried seaweed, porous, meticulously drawn; as if interpenetrating this seaweed appears a self-overlapped, central unity of free linear spirals which are relatively simple for the artist's late density of skein, and void (so I thought then) of any identity referent to nature.

I was giving half my attention to the work and half to speculating what Kirstein could mean by "flashy." About us, the museum was becoming more clamorous with people. The neatly looped spirals at the center of *Inachevé* looked vaguely like a graph of an atom's structure, but intuitively I felt sure, if only because of a subtle deviance, they meant nothing of the sort. On the whole, the picture seemed to me the ultimate crystallization of Tchelitchew's yantras and mandalas: his own versions of the chaste, semi-abstract designs of the East whose contemplation supposedly absorbs one into a world beyond this one, a world of absolute peace and unity. Ritually, besides, yantras have the architectural connotation of the labyrinth. Tchelitchew's absorption with mystic and occult things in every way sanctioned this interpretation. The assumed zodiac status of such works, far from disqualifying them as yantras, reinforced that function. I may have told Kirstein that I thought *Inachevé* a yantra; in any case on that night of fever, glitter and art fog, I refrained from bringing up the point as perhaps not really keyed to the occasion.

Maybe, I reflected later, my hesitation was due to my sense of the radical contradiction of character which Tchelitchew somehow relentlessly communicated to his art. His intent struggle for the highest place in the art world, for popular success on the worldliest level, had tended to make him the opposite of a serene mystic. He belonged to none of the fashionable oriental cults that have arisen in this century among intellectuals of the West. Hence I

saw him, as a man, the scene of a fierce duel of motives which his professional drive shaped finally into the inner/outer Hell he painted in 1938: *Phenomena*. The analogy with *The Divine Comedy*, as he explained, was originally suggested by Charles Henri Ford while he was painting his next large work, *Hide and Seek*. He readily adopted the scheme that identified the latter as Purgatory. Then, over a lengthy period of evolution and development, he had aimed at the third member of the trilogy, Paradise.

It was with a genuine start of surprise that I learned, following the night of the preview, that *Inachevé* was alleged to be the long-projected Paradise. *Was it?* It seemed as much a conundrum as Kirstein's casual epithet, which had been followed by the whir of flight that always means, with him, an urgent call elsewhere. Was Kirstein making a wry, purely funning comment on the fact that *Inachevé* might be taken for Tchelitchew's farewell concession to the absolute abstractionism which his art persistently and violently had opposed?—but that, really, it was not such at all—it was something "hermetic" which only the most enlightened Tchelitchevians (such as he and myself) could divine and share? Or did he mean, after all, that it was *just that:* a capitulation betraying Tchelitchew's tragic weakness as he neared the end, the kind of secret which a biographer may choose to conceal in order to preserve his subject's credit?

The late Dame Edith Sitwell gave me some advice relevant to this point when I asked her, soon after beginning work on this biography, whether in her opinion a biographer ought to guess, or seek to learn, his subject's inmost secrets. It was a deliberately leading question and her evasion of it assumed a significant form. "Don't," she said in her distant bell-like tones, "hand him over to the wolves." The word, wolves, given the full vowel treatment, reverberated like a warning. I had the odd feeling, that night of preview nights, that Kirstein might be using a kind of magic with me and perhaps with others—he seemed behaving informally like a Master of Ceremonies—by seeming flippantly to dismiss, with a light word, a work whose very title might be thought to confess its lack of validity. As to people—of whatever school of taste—admiring it for its flashy qualities, this was implausible because *Inachevé* seemed not nearly so vivid in presence as other works of the same style that hung with it. No. Kirstein was being entirely lucid and serious: his adjective was a casual "in" joke.

I myself, that momentous evening, was not a perfectly responsible judge of what I saw—or thought I saw. I was in a state of hangover from the shock of the fire in my apartment that had threatened to destroy all my Tchelitchew documents and all the work I had done so far on this biography. By the miracle that sometimes accompanies the most fatal of accidents, virtually 95 per cent of my Tchelitcheviana was saved; if not in perfect condition, in readable and usable condition. This accident had come as a shocking anti-

climax to the physical distemper that had put me out of working commission for more than half the man-hours of the four years I had already devoted to this book.

It had happened the day after New Year's, 1964; I was dining in a restaurant in the same block as my apartment and heard a fire engine roar past. In a few minutes, stunned, I stood outside my building amid Medusa-like fire hoses and excited tenants. Flames had mysteriously burst, apparently, from the very walls of my studio den and would have succeeded in making an inferno of it had not the fire engines arrived so quickly. The fire's origin was quite enigmatic: there had not even been any smoking in the apartment that day. As an event preceding the Tchelitchew exhibition by two months or so—in other words when at its prime heat of being organized—the fire meant a crisis for my already chronic personal distress. I had agreed to act as consultant for the memorial show and would not dream of backing out.

But this resolve to hew to the line was, of course, an afterthought. The same night, I had to leave my devastated apartment and drag myself to an alien bed. Before getting to sleep with the aid of multiple sedatives, I recalled what an uncanny feeling I had had more than five years before when, in the April of 1958, I heard over the radio that a fire had broken out in the Museum of Modern Art and threatened the destruction of numerous paintings, among them Tchelitchew's masterpiece, *Hide and Seek*. It was hours before I could get conclusive details, and when I did, I learned that *Hide and Seek* had sustained some damage but could probably be restored.

As is well known of a painting among the most popular in the Museum, it contains a passage of fire as if the sun had ignited, in one place, the august tree which presides, symbolically and plastically, over its cosmic space. As more than one friend of Tchelitchew's must have said of this volatile, superstition-laden man—one certainly did say it—"Imagine what Pavlik* would have made of that!" Magically, fire attracts fire, and according to Tchelitchew's egoism and melodramatic anxiety, incendiarism would have been within the realm of possibility. The whole surface of the work was covered with a layer of hot soot which later was removed with consummate craft, insofar as the original image remained technically intact. However, the oil paint was literally cooked by the heat so that, today, to the inquiring eye, especially visible in the areas of light yellow, a faint orange-brown freckling is to be seen extending over the whole painting. As some critics of *Hide and Seek* thought its brilliance too sharp, even a little vulgar, the resultant toning down might be construed as an improvement; basically, its color now has the same dazzling rainbow-saturation as before.

It is easy for an intimate friend of the artist to guess what he "would have made" of this extremely close shave; more, assuredly, than *one* issue. At the

* Diminutive for Pavel.

moment that a workman's discarded cigarette, during lunch hour, started the fire that leapt straight up through an air-conditioning shaft being installed, *Hide and Seek*, with other works, stood in temporary storage nearby. One can hear Tchelitchew flare up with correspondingly sudden flame, using an Americanism from the medley of slang he had soon acquired in this country: "Oh, *yeah?*" There would be visible constriction of his livid, excited face as he went on, and equal constriction of his histrionic gestures.

"What was my painting doing so exposed as that?—and in fact, if you stop to ask, why wasn't it hanging? They know how the public complains when it is not there. Simply everybody comes to see it and stares and stares so long, fahs-cinated, that it is wonder any paint at all is left: my paint there, you know, is put on *thin* as onion skin! I'm going to speak to Monroe [Wheeler]* and find out *why* such care-lessness is permitted round about where *Cache-Cache* [*Hide and Seek*] is. Do they treat Mr. Picasso and Mr. Matisse like that? Hah?? What did they run to save first? *My* painting? My bet is not!! We know who's favorites with whom in that establishment. How, anyhow, do they know who started that fire? When méchant, impossible thoughts and persons are around they act like flints, striking upon each other. You think I'm *kidding?*" Imagine nostrils flaring, invisible steam coming from them, and the mouth—so used to smiling—drawn tight as a bowstring.

The obvious argument that *Hide and Seek's* relatively vulnerable position, when the fire broke out, was as accidental as the fire itself, would have borne little or no weight with Tchelitchew in the access of his alarm. All his life, paranoia remained a loving nurse of his inmost amour-propre. A man of warm blood and the most ingratiating manners (when he chose), he could be a true gallant and a true friend. But he was not modest, one might even say he was immodest, and this blind Olympian superiority could carry him away with the speed of a hurricane, once he thought himself slighted or conspired against. No, indeed! No good acquaintance, or even a strange bystander, would have thought from his tirade that he was kidding. Imagining him in the fury which I used to observe, I felt how feeble was any pretense of mine, however conscientious, that my own troubles could be traced to a hyper-sensitivity, a paranoia, so sublime as his. The thought made me humble. Yet it did not lessen the seriousness of the blow I received on that January 2nd.

The salvaging of my Tchelitchew material, frigid and hideous as the scene was, began in earnest the morning after the fire. Hose water and general violence had done about as much damage as the flames themselves. I had no thoughts of enemies acting in secret and with equal candor I felt innocent of any personal irresponsibility or negligence; I realized I had not been in a stupor induced by either despair or sedatives. I *would* have had paranoid sensations had the fire insurance company, with which I had two policies,

* At this time, of course, Wheeler would have been a personal friend of very long standing.

found reason to question the accidental nature of the fire; on the contrary, the nominal sums were duly paid. My only luck was that batches of more personal documents had been saved by being tossed out the window, by firemen, into a courtyard next door.

More immediate, more tangible, was a superstitious thought that began insidiously to plague me. Had I somehow "deserved" this ordeal or punishment by fire because I had not found the strength to prevail over my miseries and thus could be accused of dilatoriness? I began imagining colloquies with Tchelitchew's ghost in which I justified myself on every ground conceivable, including my intense scruples about the method of this biography. These tactics came to little in dealing, even imaginarily, with a superstitious positivist of Tchelitchew's calibre. Steel filing cabinets had failed to be quite waterproof and fireproof. But in perfect common sense, had the book been completed, the fatality of a fire would not have had the same consequences, psychological and otherwise. Documents such as the artist's correspondence would already have been returned to their owners, valuable photographs already utilized, and so on. Tchelitchew's ghost was the first to bring this merely sensible, unsuperstitious point to my attention.

My enigmatic and fluctuating illness had had its psychological elements, but as frequently true in such cases, it was impossible, medically or otherwise, to separate cause from effect in the revolving states of semi-exhaustion and semi-fright from which I had suffered since the Fall of 1960. At last, a technically medical solution of the puzzle had come to my rescue but the cure had proved only partial. My worst spell over, I had managed to accomplish a great deal of research as well as over two hundred pages of manuscript. A stalemate, despite this, had been reached by the end of 1963. All the vitality I possessed that year had been poured into reading Charles Henri Ford's million-word diary, covering his domestic life with Tchelitchew from 1948 (a turning point in their relations) to 1957. Ford, continuing to live abroad after his friend's death, had made a visit to this country especially to put in my hands the heavy folios in which he had written his diaries. The data in them represented a profound dimension of Tchelitchew's private life and personality, so that I had made, as I read, over a hundred packed pages of notes.

When the evening of January 2nd, 1964, arrived, I had only one thing on my mind: girding myself for the rigors of helping the Gallery of Modern Art prepare its catalog for the Tchelitchew exhibition. By then I had accused myself of being in a false position. Since Tchelitchew's ghost had not materialized to me, really, I had nothing to defend and was arguing in a vacuum. As I had speculated from the beginning, it was possible to map out Tchelitchew's Hell, Purgatory and travels toward Paradise as crystallized in the shifting psycho-physical illness of which he had been the chronic victim

since 1938, when he had contracted an elusive but pertinaceous diarrhea while summering in Yugoslavia. Thereafter, a supposed sufferer from colitis, he had conducted a kind of guerrilla warfare with discomfort, anxiety and fatigue, including many complications, till the end of his life.

Figuring out the etiology of Tchelitchew's colitis and a theory of the relation of his previous illness to the heart attack and pneumonia, which simultaneously laid the basis for his death, was one of the main problems of my biography. I believe in the psychic powers of magic which can be identified with poetry. With neither quibble nor subterfuge, then, I wondered if, by occult suggestion, I had not empathetically produced in myself a state to correspond with Tchelitchew's. For six months in the winter of 1960–61, I reflected, I had lived through the same terrors of imminent death as he had in the first six months of 1957. I had not been hit nearly so hard, nor, in terms of human extinction, had I died; this was a fact made plain to me each morning when I awoke. Yet I died dozens and dozens of imaginary deaths, deaths that were symbolic, when I felt guilty of hating, not loving, Tchelitchew, of having tricked myself speciously into writing a book I really did not wish to write; of deserving, therefore, any supernatural vengeance that Tchelitchew's surviving spirit was capable of inflicting on me; of having allowed, in short, my perverse self-indulgence, perhaps my vanity, to deflect me from the straight course of composing this biography. It has been hard to rid myself of the idea of this persecution by guilt.

At this moment, I ponder the wisdom of having introduced the sort of narrative that might be taken for an objectionable, inept *mea culpa*. But I must make every sacrifice to the form that was peremptorily dictated to me a few weeks before: I had to reconstruct this entire book or abandon it forever; and suggested to me was a very extraordinary form of reconstruction. My literary problems, exactly those of composition, were always very real—and not altogether owed, I feel sure, to lack of physical energy and intellectual tone; on the contrary, it was reviving energy and tone that imposed the present alteration. Tchelitchew's closest friend, Charles Henri Ford, and his most prominent adherent, Lincoln Kirstein, automatically (in my view) fell into place as my principal advisers. But they belong to the school of psychological plain sailing, the literary school of canonic simplicity: a coincidence all the more impressive as they have tastes so diverse, minds so different, from each other's; Kirstein is an intellectual, Ford an anti-intellectual.

Both these men I have to thank for a very great deal regarding this book; my enormous debt to each, diverse in kind, can never be erased. Yet I was taken aback by Ford's advice, for which I applied, that I should write the book "as if I were Pavlik," and Kirstein's advice, also solicited, that all I had to do was "write a book worthy of Pavlik and we [my original sponsors] will

be satisfied." Kirstein had already approved the summary of my original idea for the biography, which had been submitted to the Foundation awarding me my first grant. He had also written me, in patient reassuringness, "You are a poet, you knew and loved Pavlik," and so on . . . Then it was still 1960 and the worst was brewing ahead of me.

Three ambiguous years later, my personal history was one thing; my acquired total knowledge of Tchelitchew (I had been his personal friend for the last twenty-two years of his life) another. I could do nothing about it: the trouble had all placed itself somehow *between* me and my book. I had to traverse it to get to my book, if only because literature, like painting, is not ecstasy but work. Practically speaking, on March 17th, 1964, I could not believe that the painting, *Inachevé,* however "flashy," was the statutory Paradise that would logically have flowed from Tchelitchew's Hell and Purgatory, that is to say, from his *Phenomena* and *Hide and Seek,* which I knew so well. Yantra or no yantra, I saw Tchelitchew's ideal Paradise as a painting probably twice the area of *Phenomena* or *Hide and Seek* and bearing miniature versions of the exquisite suite of figures he had one by one nominated, from 1950 on, as eternal inhabitants of his dancing boxes. This last period of Tchelitchew's I call his Celestial Physiognomy. He had somehow read in the fluid features of infinity a new Zodiac capable of fitting into a new, more refined Astrology: an Astrology perhaps susceptible to a more poetic as well as a more scientific method. Yet there were questions to be answered: Had he had the intellect to work out any sort of system for this before he died? And had he had the *energy* to do it?

This I knew beyond question: Profound philosophic intuitions had always moved Tchelitchew's hand, carnal apprehensions of spiritual essence that spoke equally of being submitted to the fire within the earth and to the fire beyond it: to the furnace of the Cosmos. One can talk neither rewardingly nor coherently about Tchelitchew and be afraid of trespassing on the grounds of established scientific skepticism. Tchelitchew was a solid exponent of the old poetic magic: this is to be regarded as his *modernism.* I was completely in agreement with his premise (we used to discuss the point) that human knowledge as an accumulative body of doctrine could be just as beneficial to poetry and painting, to all the arts, as it could be to science. I conclude that his work was a subdividing alembic in an alchemic search for the Philosopher's Stone: specifically an applied psychological and aesthetic concept.

Tchelitchew's art, traced from beginning to end, forms an investigation of man's physical composition as if interpreted through special X-ray lenses, ranged in stages implicitly between microscopy and telescopy, and meanwhile obeying a scale of absolute relativity having nothing to do with mathematical extent or the mass and volume of matter. This, eventually,

made man's soul, no more and no less, the same as his body. Scale, as a faculty of overlap and transparence, has something to do with this. There is a sense in which all painting is *re*production, never the actual scale of nature even when representational *and* life-sized. The scale of art, essentially, is *no* scale to begin with; art must originate its scale, but this is an aesthetic, not a scientific, matter. No-scale is perhaps the attribute of all material bodies in the context which we call infinity and eternity. This relativity-function of the aesthetic plastique comes into most significant play when the artist intends cosmic effects. Steadily Tchelitchew ceased to paint anything which did not directly suggest a pan-eclectic or cosmic effect.

One can apply these principles to common experience. In looking at some actual star, the actual Moon, one sees simultaneously a picture in the most elementary sense and a cosmic effect of which great elasticity of dimension is the home. Unless we feel outside the cosmos (and implicitly outside nature) the beauty of the Moon is very warm and, as psychologically tangible, quite near. Science has done a great deal to break everybody but classical scholars of the habit of associating planetary bodies with the divine and semi-divine persons of myth, but it has increased our awareness of the cosmic dimension as a vast system of prodigious and dizzying extents. The curious thing is that while, scientifically, it is possible to experience *space* and impossible to experience *infinity*, one seems to get quite close to the latter as a non-terrestrial sensation. The chief emotion flowing from the modern aspect of the superterrestrial is an exciting challenge to penetrate space indefinitely—to effect conscious passage through it—so that the airplane has been replaced by the space capsule as a symbol of the infinite in the indefinite. The more man identifies himself with "infinitely" traversible space, the more transparent, if not non-existent, he becomes; the more outer space-clothes he has to wear, the more inner overlap he has with the void. Tchelitchew grasped this with one of the timeless instruments of poetry: painting.

Looking at the naked Moon the other night, I thought at once how much closer a concrete aspect of science, space travel, made it seem. And then I reflected that to the first astronomers, the Chaldeans and Babylonians, the denizens of the sky were conceived as much closer than, scientifically speaking, they are. Historically, astronomy corrected its own error by mathematical calculation. But at first the planetary bodies were "dressed" in a neighborly and even cozy availability, one just as psychological as (supposedly) physical. In an anthropomorphic universe, the stars were and are the familiars of astronomer and astrologer alike. It is this emotionalism that controls the spatial modes of art regardless of the literal distance implied between the spectator and the scene, the objects, he beholds. This is true, at least, in a world where emotions retain their statutory rights as passions.

I decided to inhabit this world with Tchelitchew for he never lived

anywhere else. It is a world in which the material and the immaterial are in a constant state of transposition. At first, there seemed not only no human but no cosmic identity in *Inachevé* to bring it close, to render it attractive and lucid, "available." In front of this last painting by Tchelitchew, I felt the characteristic sensation derived from works with which I am dissatisfied. Satisfying art can easily do without a precise referent scale. *Inachevé* seemed to call for a particular scale which was not present. It seemed indeed the least cosmic of all Tchelitchew's Celestial Physiognomy examples of style. By chance, I dropped short of its meaning then. Months later, when I was studying its reproduction in the Gallery of Modern Art catalog, I perceived the truth and identified the spiral network occupying the central part as an incarnation of the head of La Dame Blanche, the Jungian *anima* which, as a boy and long before he knew what an anima was, Tchelitchew had seen on Doubrovka, his family's former estate in Russia.

Before this person of vague yet very real features, the boy Pavel had the awe one feels for a familiar spirit at once terrible and endearing, eternal and passing, vaporous and tangible. He saw La Dame Blanche throughout his life and said that from the first he believed the apparition would announce his death some day. It seemed he had been right. As usual in an artist's private melodrama of fate, a climactic apparition has been prepared for, unevenly sensed, suspected, feared; in other words, unwillingly previewed before its final and decisive entrance. Though the lurking Dame Blanche, for me, had been preceded by an explicit identification which I should have remembered, my mind (filled with a hundred hauntings of its own on the night of the Tchelitchew opening) was momentarily blind to her.

Yet there she was, suggesting the scale of deep space where it is the absence of environment for both spectator and object that makes vision, all sense of relative position, mysterious and mercurial. During Tchelitchew's childhood, La Dame Blanche was a mirage at the end of an alley of trees; when one went to meet it, it tended to disappear and vanished altogether as one reached the alley's midpoint; only when one arrived at the end, and turned around, would the mirage reappear at the opposite end, as before. This effort to "capture" an impalpable turned into the artist's search among the Celestial Physiognomies for that point *at the center* where one could see the limits of the cosmos, and accounts, in his later styles, for the simultaneous "coming and going" that he proposed as his plastic ideal: absolute space, absolute transparency.

In the Celestial Physiognomies, Tchelitchew was systematically translating the commonest objects into their scaleless as well as their timeless aspects. When he came to the subject of *Inachevé* (perhaps the Sun as center of our immediate universe), his long education in anthropomorphic magic gave him the image of La Dame Blanche—the contrary of the center of life, or death itself, so that in this work we find a ghostliness, as of the Moon in

relation to the Sun. That he associated the Moon with death may be verified by turning to his *Phenomena*, where it is represented as a skull—as if a cloud, obscuring the Moon's face, wrought the illusion of a skull.

With *Inachevé* came Tchelitchew's most radical attempt to dispense with the very idea of pictorial space (a limited ground on which an image exists) by simultaneously abstracting and geometrizing the face of the amorphous *anima* that haunted his life. The fear of death is due not only to the prospect of losing human identity and the ego but of abandoning oneself, or one's vestige, to the "mercies" of the abyss: that bottomless immensity that seems to make nothing of the merely human. Modern science promotes this type of fear by adding its supposed rule of measure to space, which only italicizes the awesome mythological dimensions of the afterlife, as seen in a work such as Dante's.

Of course, as an interpretation of universal conditions, *The Divine Comedy* is Western in spirit insofar as it expands familiar mystic ritual into cosmic scale. Pavel Tchelitchew's young sensibility was trained in this school of myth and fairy tale through vulgarized versions of the old ritual ordeal. He had a mystic instinct to penetrate past these trappings to the spiritual and philosophic essence yet his worldly temperament was such that the story of Dante's epic journey tended to furnish his life with the same profane and frightening obstacles, the same temptations to "worldly sin." This was an aesthetic, never a moral, problem. He was susceptible to every worldly, material temptation at the same moment that he had a spiritual revulsion from it. This made him peculiarly sensitive (especially since he was a painter) to the physical mould of Dante's epic poem, whose planetary vistas and natural metaphors are foreign to the metaphysics of the true hermetic that Tchelitchew had an impulse to be.

In *The Divine Comedy*, Dante is often so frightened by visions of dark heights and depths, as well as the human miseries that emerge from them, that he faints away. This is one of Tchelitchew's firmest links with the work whose illustrator so much impressed him: Doré. He too can faint away. The tragic vista, which lurks throughout Tchelitchew's multiform suite of life-works, came directly from his experiences. During World War II, when his career and work were in crisis, he had many reasons for anguish and fear. The whole world seemed a Dantean nightmare. And he could not divorce the formal problem of the painter's space from what was happening in the world. Like all men with the mystic voice, he sought to escape from common material things: what the mystic adept calls *appearances*.

Significantly, proving the inadequacy of the mystical attainment that was already a goal for him, the artist assumed (as shown by his wartime correspondence with Edith Sitwell) a psychological stance toward the problem of space. Being the genius he was, he could not do this without an inspiration

that bespoke plastic, if not philosophic, originality. Except for the final revelatory metaphor (a poet's own) he could be quoting, in the following passage from a letter, some contemporary text: "The Eternity the endless instant beginning is the incapacity of our brain to grasp the colossal size of time-space proportions. Our brains can function to certain limits. After that, there is no possibility of imagination—because of lack of appropriate experience and all imagination being based on experience and combinations of it. Those giagantic [sic] proportions crush our resistance. As result of our limitation we will now be able to see the universe as it is—because it had changed 125,000,000 years ago—what we see is partly there and partly gone—so if it looks like it looked 125,000,000 years before, it means that there is a permanent illusion in time like in a reproduction of a photo of a dead person."*

The role of time in creating spatial illusion had long been a theme of Tchelitchew's painting, and of twentieth century painting, when these ideas (however original or speculative) took root in his mind. The only urgent question here is their peculiar portent for Tchelitchew and his work. They help define the calculated vagueness and impersonality of the human element of *Inachevé*—that element which I think is indicated in the work as "partly there and partly gone" as if the artist's familiar female apparition were seen through "time-space proportions" so great that her original identity is submerged, transformed. Tchelitchew painted it in the death-phase of his life—as will become clear—so that it has the status of a "photograph of a dead person"—or rather, a dead portrait. It is the moonlike ghost of an art.

* In this book, all direct quotations from documents written by Tchelitchew have been left in their original idiom.

First Manifestation

Just how "religious," to begin with, was the nature of Tchelitchew's goal? His relation to official religion, though sincere, was determined by his boyhood education as a Russian Orthodox Christian. Was his personal search for Paradise, when a mature man, much the same as that less official search for the spirit's permanent haven, that moment of bliss over which the soul, in the case of religious adepts, supposedly has, or had, an absolute control while still in this world? In the Orient it is still a tradition but, in general, only saints and mystic adepts of the highest class have ever regarded this search as man's supreme occupation.

One is struck by the *dedication* apparent in Tchelitchew's obsessive concern with his Celestial Physiognomies. Here the religious issue of ecstasy comes into question. Ecstasy means literally a displacement, a being "beside oneself" with emotion, and religiously signifies an overcoming of the feeling of existing in the ordinary world, the very act of magically transcending it and reaching a world beyond. Intense contemplation of divine things is the traditional means to this end. In the West, it may be contemplation of an image of Christ or the Virgin. Among Oriental religions, a picture (for instance, a yantra) is the immediate object of contemplation, indeed the specific agent of the transcendent power as if magically wielded. Bliss, rapture, ecstasy—these supernal states are conceivably the gravitational fields of Paradise. I do not annex the terminology of modern science to make Tchelitchew appear modish. His whole life and work suggest a qualification of orthodox and traditional religions because he reoriented everything to painting.

All Tchelitchew's close friends knew that he imagined himself in the occult tradition of the magus, the ancient wise man of magic faculties; there was not the slightest affectation in this stance; the worst that one might think of Tchelitchew as a magus was that he was impossibly naive; the fact is that through painting and otherwise he imbued life with a serious supernatural tinge. What at first I could not see in *Inachevé*, however, was the very type

of holding power, the necessary "hypnotism" to suggest it had the inherent faculty of a yantra or mandala: a truly divine image. The mandala is a painting of some pantheon of the East containing geometric elements so that literally it corresponds to the pagan Zodiac with its arrangement of ruling planets and mythic constellations enwebbed in the geometry of the Celestial Globe. Tchelitchew followed the astrological belief that man's body, being made of elements compounded from earth and heaven, is ruled by the myriad conjunctions and characteristic humors attributed to the heavenly bodies as these transmit themselves to earthly things.

Hence it was as if, in providing *Inachevé* as the technical climax of his last series of works, Tchelitchew had taken the unusual step of exchanging a representation of Paradise in the mandala sense (an abode of the gods) for an incarnation of Paradise in the yantra-functioning sense of the almost abstract, almost completed *Inachevé*. The Tchelitchew Paradise of my imagination, a super-incarnation of a new Zodiac, based on modern sensibility and following a Western Astrology, may have been implicit in Tchelitchew's work since 1950, when his primitive experiments in Celestial Physiognomy began. But either he had not lived to realize the supreme synthesis of his last style (in a work to rank with his Hell and his Purgatory) or he may have, at some late point, consciously discarded the synthesis. And if he had discarded it, why had he done so? Had he suddenly realized a fatal gap between art and religion, religion and magic? In taking magic more seriously than did the Surrealists, did he propound a formula encroaching on religion without becoming himself truly religious? His case provokes the old issue—or is it still young?—of art *as* a religion.

There is no doubt of this: Tchelitchew's last style is a transfiguration of matter in the orthodox sense of extreme spiritualization: a new extreme in spiritualization. It is what distinguishes him from any other painter of his stature in the twentieth century except perhaps Rouault. As again and yet again, I stood in the Gallery of Modern Art absorbing the diaphanous quality of *Inachevé*, now identified with La Dame Blanche, the artist's *anima* (a fatal person of the opposite sex, according to Jung, seen in dreams and hallucinations), I had to pause over the vagueness of this insistent, positive identification. I was still working off the toxic effects of the stupefaction that had gripped me, mind and body, as a result of the fire in my apartment and its various associations with Tchelitchew's work and the cremation of his corpse. Even four months after January 2nd, 1964, I had some of the curious detached awareness felt by the very ill or dying. Yet instead of being transfigured with perfect revelation, I was still clogged with psycho-physical sensations and inchoate fantasies. As Kirstein had steered me toward *Inachevé*, I knew quite well the dramatic form in which La Dame Blanche had revealed herself to Tchelitchew when he was near his death.

Tchelitchew's *anima* had first made herself known to me visually as the nucleus of meaning in a little set of variations that Charles Henri Ford found on the last sketchbook page on which the artist worked. Yet its importance had been quite submerged by the urgency and variety of my tasks as a biographer. For some reason as unclear to me as to Kirstein, who nevertheless gloomily resented the fact, Tchelitchew's biography had been virtually static for two years, bogged down in an ominous impasse. It had missed the ideal opportunity of being issued at the time of the memorial exhibition and certain Tchelitchew partisans, it was not hard to sense, were keenly aware of the yawning gap. The emergent technical trouble had been that the book simply would not, despite all my strategies, obey the chronological line—*proceed peacefully, smoothly from my subject's birth to his death*. No doubt, poetic tendencies in my own work (including a previous biography) prejudiced me against bare chronology. Thereupon, as if for penance, a Tchelitchew Chronology was precisely the main task that I was asked to perform for the Gallery of Modern Art catalog. I knew from the first that the contrariness of the present book was rooted in one of Tchelitchew's basic plastic formulas, the cycle. This had issued from his plastic apprehension of the line: a line is never straight but invariably curves spherically in comformance with the shape of our earthly globe. He declared that his belief in this well-known postulate originated when he was in Kiev in 1919. Perhaps Tchelitchew's plastic dogma was inspired indirectly by the example of Nikolai I. Lobachevsky, who had investigated in the early nineteenth century the possibility that if parallel lines were extended far enough, they might curve and meet. Of course the uses of geometry were part of the "new art." In any case Tchelitchew's art proceeded to develop a formidable array of personal means to explore and confirm the postulate of the curved line, which soon showed signs of universal application to his vision. As if at the dictate of some supreme dialectic, his last period utilized the straight line—which he came to draw with a ruler—but only in order to qualify it with contradictory straightness. But what was the image at the heart of the cycle?

Pavel Tchelitchew had intuited himself as a sort of aesthetic sacrifice to modern art. This may seem, along with other revelations of his character, paradoxical; it is. Divining by profoundest instinct that the destiny of the human image was the anguishing issue to be decided by today's art, Tchelitchew registered the fact not only in his hand, that painted his pictures, but also (my point is) in his vitals. This region is the very crucible of human integrity and the animal humors; it is the locus of physical conjugation and propagation, hunger that notifies the body of its means of preservation, and nervous center of every man's commerce with the material world outside him. An ancient maxim has it that the solar plexus is the seat of the soul. As the anatomic term indicates, the center of man is as the Sun, the center of the

Universe. There the body's largest organ, the liver, greatist in life-main-tenance, is situated. It is the supreme domain of fear, throne of all erotic splendor and (as put elegantly by the vocabulary of the eighteenth century) the "bowels" that also breed courage and righteous anger; therefore, a lion (the heart) is its upper astrologic emblem.

I could not but agree with Kirstein when he repeatedly would say, in a gush of *humeur noire*, that Tchelitchew had "died of rage." I felt it as difficultly true: no mere metaphor. Kirstein did not say this in the chastened, equable prose of his 1964 catalog piece. There he confined his notice of Tchelitchew's capacity for moral anger to the "rage and outrage" evident in the epic satire, *Phenomena*, where (Kirstein said) the artist had shown a rage "domesticated, not heroic . . . serpentine, not elephantine." The emotions of *Phenomena*, like the sources of its inspiration, are various and complicated; above all, *Phenomena* (whose ostensible theme is the moral monsterdom of man) is the statement of a very private turbulence that had decided to publicize its tantrums on their most far-reaching—that is to say, Hellish—level; these tantrums wished to free themselves as much as Tchelitchew wished to free himself of them. *Phenomena* is itself a book. It is an autobio-graphic instalment, Hell, on whose double-spread lies the infancy of the emotion that might summarily be called the rage-that-kills.

"*Raa-ge*": I can hear the very intonation of the word in Kirstein's mouth, its harsh monosyllable giving a drawn-out, high-low wail of frustration that at the same instant is a whiplash across the face of an imagined enemy. Tchelitchew, of course, had impotent rage; rage that had the bowels to respond but not to wreak itself, in a wide practical way, on his antagonists. From the personal angle of the biography I am writing, rage is the exact ultimate product of that desperate access of courage whose first symptom was like a religious revelation to the youth Tchelitchew, who had not yet reached twenty when Russia's 1917 revolution was in triumphant motion. At that moment, he became engaged to modern art in a very spontaneous, almost tacit, actually adventitious way—the way, in fact, a boy calmly, suddenly realizes in the midst of ordinary devotions in church that he will end up in a monastery. Maybe it is wise to remind the reader that to this day such things do happen, however much their contemporary significance be qualified. Only a few months before his death, Tchelitchew wrote a friend how he and Ford, in Frascati, lived together like "two mad monks." The basic biographic fact was that Tchelitchew's monastery was essentially the plastic physique of twentieth-century art, whose solar plexus, man's image, had been violated by art (as he gradually persuaded himself) even as Jesus' body was violated by nails and a spear.

Biography is an official account of step-by-step; hence as a standard form it proceeds in supposed accordance with the growth of the organism and its

conscious absorption, or perhaps nonabsorption, into the adult community where it was born. The hero tale, whatever its sophisticated adumbrations throughout the ages, is meant essentially for childish organisms: youngsters who are learning to be law-abiding and preferably active members of the tribal nucleus. This may well sound absurd and is intentionally so. Life itself proceeds this way only on those personal information charts supposed to be exemplary and edifying; in short, merely biographical. Merely? Yes. Nothing is mere about Tchelitchew. Hence his biography should not resemble other biographies but proceed with those devious and melodramatic movements that governed his art and his life, his mind and especially his body.

The unexpected cablegram which I received in New York from Charles Henri Ford in Frascati, Italy, on the afternoon of August 1st, 1957, said: PAVLIK'S GREAT HEART CEASED BEATING LAST NIGHT AT TEN TO EIGHT. Tchelitchew's death seemed cruelly sudden and un-sudden. At that time, even though some people had had word of the artist's relapse in May, his friends knew that he had made a miraculous if drawn-out recovery from the devastating twin attack on his life that had taken place the previous Christmas Eve: a heart attack and double pneumonia. I was at my apartment on West Sixteenth St., the scene of my own future trials, when I opened Ford's message and read this bitterest of news about modern art. I felt a sharp villainous blow and a desolate emptying.

The light in the room was subdued. The pale sunlight did not fall directly on the northern exposure of my great skylight, whose long, hard-to-reach panes, anyway, were grimy as with the moral texture of the world. At dusk a light of beautiful mercurial shades was filtered through it in reds and blues reminding me of muffled tones in Tchelitchew's early painting when he had turned to "earthy" colors. It was upon a strange weathermark in a pane of this skylight that I was religiously to fix my eyes during the period of long daily rests prescribed by my doctor. This was years later, when I could not work on the biography and was advised not to try for a few weeks.

But all this external reality, at that past moment, suddenly emptied. Things quivered in a drastic withdrawal of vital warmth: phenomenal to me because inanimate objects seemed to doff the rich robes of the pathetic fallacy. Uppermost in my consciousness was the simple obligation of having to respond to Ford's cablegram. My personal consolation to him, an old and intimate friend, would go soon by letter. My cablegram should express, and at once, a proper salute to the dead man and my own peculiar sense of loss. Not that I thought it could be very accurately defined just then. Only a day or so later did my friend Charles Boultenhouse and myself, reminiscing of Tchelitchew, lean our heads together, without warning, and sob.

I had begun composing the cablegram almost from the instant the consciousness of the news sank in. I scribbled in a hand I could hardly read two

minutes later. I got up to pace the winding little promenade of my hopelessly crowded living space. I was to repeat this trek endlessly, day in day out, during years to come in an anguish entirely my own. Now I merely behaved as I often did, puzzling over an idea, a fact, an entrance into language. I tossed myself unthinkingly into a sling chair and cast my eyes into the light beyond the skylight, failing to pierce it just as the daylight failed from the other side. Then I had it: the concise formula needed for an economic cablegram. And the right formula! Had I not thought it perfectly right I could not have gone to the telegraph office—that tame, stupid, anonymous August afternoon—and dispatched it to Ford: CRUSHED AND YET SOMEHOW THE PHOENIX.

A couple of weeks later, when I had gone back to the country to round out my summer vacation, Thomas B. Hess of *Art News* phoned me to ask for an obituary on Tchelitchew. I had rather expected the request since I was, I believe, the only declared Tchelitchevian connected with *Art News*, although the late Alfred Frankfurter, its then editor, liked Tchelitchew and admired *Hide and Seek*. Hess irked me by gently suggesting that my obituary should refrain from being a eulogy. I knew quite well that Hess, though liberal-minded, was an arch committed modern who believed Tchelitchew was not of the first rank. Fleetingly I was tempted to refuse the commission; still, I deemed it an honor, and if I declined, the function would pass to a hand which most probably would reflect *Art News'* central policy; therefore, I accepted. Hess told me that the magazine, for the purpose of illustrating the obituary, was having rushed to them from Rome a recent photograph of Tchelitchew and a photograph of the last sketchbook page on which he had worked.

This page contained in express, vivid, analytical form the withdrawn identity, the mysterious filmed-over, spectacular "anonymity" that was La Dame Blanche of *Inachevé:* much more articulate than in her celestialized form! Foremost, and casting a gooseflesh on my soul, I perceived the hybrid presence of a phoenix—two of them, rather, flanked and fringed by other sketches: one a more or less featureless dummy-head baldly rounded off— such was my first, straightoff impression—a couple of small, vaselike figures, transparent forms, one with a single handle like a wine jug, sketchy and abstract: and smaller still, more rapid, three separate units of dancing boxes. That was all. I knew the birds were phoenixes because they were so indicated by a title. The following I merely took in intuitively at the moment. About seven years, and a double-take of *Inachevé*, were needed to make this rather elementary riddle perfectly clear. Meanwhile, I had been thinking about so many other things.

At first I took for granted the funerary character of the two juglike forms. That one of them was scored with regularly spaced vertical and horizontal

lines, I accepted as a sign for the latitude and longitude of the earthly globe. Yet puzzling to me was the fact that only one form possessed the interrupting "V" of a pitcher's mouth. The craters and amphoras have double handles while on only one of these images was a single handle visible.* What ancient jar had a continuous round mouth and but one handle? The answer was the hydria, used only for carrying water; the crater and amphora were reserved for mixing wine and water and storing wine. Tchelitchew's preference made sense in several ways; chiefly that in the Zodiac, ever-present in his subconscious, Aquarius the Water Carrier was important to him as the sign under which his closest friend, Charles Henri Ford, was born.

Seeing the title, *Metamorphosis of La Dame Blanche (Death) into a Phoenix*, I could detect a woman's face, skyward turned, spread flat on the crown of the mushroomlike dummy-head. One cannot dispense with the assumption that Tchelitchew was playing here on the mushroom cloud of the atomic explosion: a photograph of the first atomic explosion shows the cloud in the form of a Janus-faced head on a single neck.** Since I did not, at the Gallery of Modern Art, at first identify the denizen of *Inachevé*, I did not bring to mind, then, that the agonic phallic metaphor, implicit in the two phoenixes, had anything to do with the greatly chastened, elusive Dame Blanche on the wall before me. The genre of the phoenixes is peculiar. What are they, zoölogically? Doves? Pigeons? Certainly, as phoenixes, ideal birds but not notably fantastic ones, not Birds of Paradise, not even supernatural-seeming except for the phantomlike female heads inside their bodies.

Both essentially are in the same posture, pouter-pigeon like, the breasts swelling with overlaid "penmanship" spirals that make La Dame Blanche, in each case, a traumatic female head with hair arranged startlingly like Picasso's ram-woman fantasies: in lolling fleshlike volutes on either side, meeting under the chin. The birds' wings are in rest position: flight is suggested by a sort of fixed expansion that swells the bodies up under the neck as if pregnant with the female head (the effect resembles the kind of flight devised by Brancusi for his sculpture, *Bird in Space*). If the face of La Dame Blanche here is ugly, Medusa-like—a joined sequence of abstract, bloblike mounds with eyes lacking irises—the phoenix housing her has a rich restrained elegance, its body being essentially a slanted, up-ended egg with the smaller extremity attenuated into a brief, blunt tail. Altogether it is anything but the traditional, pheasantlike Chinese phoenix. The bird's head is graceful, modest, poised, and the closed beak has somehow the sweet expression of a human mouth. I think of the bird as female if only because the barnyard hen, which it resembles, was an important and early figure of Tchelitchew's private symbolism. The upward thrust of the phoenix's whole body is unmistakable but relatively it

* The half-rings, lower down, are slots for carrying-straps.
** July 16th, 1945, New Mexico desert outside Alamogordo.

is anchored by the ghostly presence of a containing, purely linear network, which in the second, more dramatically drawn bird is repeated to surmount its head. This network refers to the first, tentative version of the dancing boxes that, as it were, both "hearse" and "give birth to" their inhabitants. The faint rickety geometry in these cases follows the lines of an armchair, which in the context (allowing for the astronomic character of the Celestial Physiognomies) can be identified as a throne, especially since a second, smaller chair serves as a crown for one bird.

The ancient texts of symbolism yield a further signification: the throne as such has no wheels, but chariots are thrones or chairs on wheels, and in fairy mythology are harnessed to doves or pigeons—the latter are mentioned thus by Perrault in *La Biche au Bois*. Then in more standard myth, there is the Sun's Chariot drawn by horses. Tchelitchew's symbolism for La Dame Blanche was doubtless largely intuitive yet his symbolic nuances are ever lively and tentacular. The material body, in mystic doctrine, is a vehicle. In the Dame Blanche of the sketchbook, the material body's symbol is probably the faintest present: the environing chair itself. It suggests a token cage for the phoenix, in fact, rather than a chariot to which it is or might be harnessed. There is an overtone of cremation, moreover, in the archetypal symbol, the Chariot of Fire, which, as Loeffler says, when it bears a hero, "becomes the emblem of the hero's body consumed in the service of the soul."

How exactly and broadly Tchelitchew's idea of himself coincides with these large mythic patterns, and how vividly he often illustrated this idea with his work, is probably unique in twentieth-century art and certainly one of its rarest phenomena. By involving so many archetypes, one packed symbol of Tchelitchew tends to be inexhaustible. As if under this symbol, placed like a noonday sun over the end of his life, he had chosen to be cremated long before the moment of his death. His patronymic, which he used to mention with pride, is based on the Russian word, *tchelo*, somewhat in disuse now but literally meaning "forehead," thus signifying by its derivatives, to the fore, at the head of. The inevitable association is with the human head itself. For Tchelitchew, therefore, his name came to apostrophize both intellect and leadership. The patronymic, *tchelo*, evidently bears upon his late development of the image of La Dame Blanche through the Zodiac.

We must always hold in mind what a sacred character the Zodiac had for this artist. It is the ramlike character of the sketchbook's Dame Blanche that provides the connection with Tchelitchew's name and reinforces her function as a Jungian archetype: the *anima*. As the first sign of the Zodiac, Aries the Ram (pictured atop the horoscopic circle) symbolizes the creative impulse. As J. E. Cirlot explains, because "the Zodiac is the symbol of the cycle of existence, Aries, its first sign, stands for the original cause." Psychologically and zodiacally, in other words, Aries the Ram has a strict identity with

tchelo, root of the artist's patronymic. "In Egypt," Cirlot writes, "the ram was the symbol of Amon-Ra and the god was depicted with ram's horns. As regards human physiology, Aries controls the head and the brain, that is to say, the organs which are the center of the individual's physical and spiritual energies, as Parabrahman (in Hindu symbolism) is the center of the cosmic forces." Consequently, as the beginning of a cycle, Aries, the first sign of the Zodiac, corresponds to the cycle of resurrection symbolized by the Phoenix. Since Spring (a maiden) mythically initiates the cycle of the seasons, a woman is associated with Aries and is sometimes pictured above the Ram's image. For his own reasons, Tchelitchew placed the ram's image *in her* and *her in* the Phoenix. Assuredly, plastic fundamentals guided his mind. But so did the paradox of his sensuality.

The zodiacal sign of Aries is a frontal ram's head conventionalized into a linear hieroglyphic based on its nose and horns. Standing for man's own head when the Zodiac is correlated with the upright human figure, it naturally found place as a general norm of draftsmanship. We find it representing the eyes and nose of men in archaic, primitive, medieval and modern self-taught art; moreover, many animal heads, frontally seen, have tended since ancient times to be portrayed thus hieroglyphically. A hieroglyphic ram's head is visible in the physiognomy of La Dame Blanche irrespectively of how (like Picasso) Tchelitchew has carried out the ram's-horns pattern of her hair. To appear overingenious was a risk regularly assumed by Tchelitchew. It was as long ago as the twenties that Jean Cocteau rashly, if with genuine insight, dubbed him a "puzzle-maker." I must risk being overingenious in solving his "puzzles." Later, Cocteau began seeing the charm of puzzle-making.

A man's intense desire to *re*begin life, to be reborn, is the best possible matrix for the biography of his past life. Tchelitchew was such a man: living, dying, working in accordance with this intense desire. La Dame Blanche, the paradoxical spirit of *Inachevé*, yields the keynote of Tchelitchew's apotheosis in death, the very dawn of his Paradise. I noticed on the sketchbook page that the knobby, internally complicated dummy-head, with female face flattened on its skull, is a mushroomy, truncated sort of priapus. Internally it betrays the structural presence of the three eggheads which Tchelitchew variously painted in Paris, in 1925, as dispersed and collective units of the human head in three positions (his version of the Cubist triple view). The same abstract humanoid shapes came back in 1950 as he began to found the Celestial Physiognomies. The inflection controlling them in the phoenix-woman sequence is that the woman's skyward face dominates them and gives the unit they make an agonic "swollen" expression, shuttling from the anguish of physical or spiritual pain to the pseudo-anguish of the sexual spasm. The reason why the latter comes foremost, it seems to me, is that the fixed and abstract character of these human features excludes the potential gamut of

emotional expression, even neutralizing what otherwise might be the frozen horror of Medusa's face.

There is no question that the face on the dummy's skull and the heads respectively impregnating the two phoenixes are one and the same woman. This woman, as I say, has her own biography, her specific mutations. Russian folklore had bequeathed to Tchelitchew a repertory of semi-mythical terms by which he freely identified friend and enemy. The great mock-comic suite of freaks in *Phenomena* is a plastic expression of this habit. Any pair of names could be end-terms of an ambivalent regard for one of his best friends or worst acquaintances. Sometimes he translated them into colloquial English. Kirk Askew, his dealer, told me what Lincoln Kirstein had said to him concerning the suggestion that a volume of the artist's letters be printed posthumously. "You should see what he says about you," Kirstein remarked as to their "unprintability." To which Askew replied: "Yes? Well, you should see what he says about *you!*"—that is, in his letters to Askew.

Tchelitchew used the resources of his native tongue to invent nicknames for people. "Sitvouka" ("good old Sitwell") was a private epithet for his dear friend and patroness, Edith Sitwell; its familiarity could be benign but also ill-tempered. When he first made her acquaintance, he would sometimes utter it in the sepulchral, make-believe voice of a person telling fairy tales to children. In *Phenomena*, the Hell of his trilogy, he was to show the late Dame Edith in apotheosis: an ethereal image in the closest, most benign relationship to himself: virtually his guardian angel, a kind of muse. Yet, both before that time and later, depending on mood and occasion, he could sustain quite contrary reactions to her—in the same hour and nearly the same breath. La Dame Blanche, by the time of her "assumption" in *Inachevé*, 1957, had lost both witchlike and phallic connotations, so that the phoenix-borne woman of whom I speak now is essentially a preparatory sketch for the unpainted painting which would have served as a central medallion for the projected Paradise. It would have been, I am sure, a beatification of the woman in *Inachevé*.

If I discredited, on second thought, the phallic involvement of the dummy-head as perhaps too coarse to be essential to the Dame Blanche suite (or, if valid, involuntarily present), I believe I was self-corrected when, among the ruins of Delos, I encountered two brave, nude generative divinities in marble —colossal organs of the human male—that are the victims of time's carelessness or deliberate vandalism: their tops are missing. But, should the casual looker doubt their identity, it is certified by identical, unharmed bas-reliefs on the respective pedestals carrying them: a frontal gamecock is shown, and patently its neck is in the zoömorphic flux of becoming a priapus. In fact, it is a version of the Phallus Bird of Dionysian revels. I saw that the dummy-head of Tchelitchew's sketchbook could supplement the fragmentary anat-

omy of the two sculptures on Delos. I also noticed, after scrutinizing the sketchbook birds, that the phalloid dummy-head, in reduced and phantomlike form, has been punned by the artist with the neck and head of both phoenixes. Never, speaking personally, had I underrated the deviousness of Tchelitchew's voluntary and involuntary symbolism. Had I, perhaps, neglected its perfect clarity?

Second Manifestation

Whatever else the "doves" of La Dame Blanche may be, they are symbolic of a resurrection by fire, and thus phoenixes. The intuitive figure in my cablegram to Ford had not been merely apt and conventional. It was clairvoyant and specific, and in all ways consistent with my idea of Tchelitchew as a man who heroically submitted himself to the flames of suffering, then death, firm in the sincere belief of his potential survival—if not the immortality of his person or soul, the immortality of his art. A man's art, intact after his death, acquires a new materiality: it becomes the circumstantial evidence of a previous existence and replaces the doctrine of the resurrection of the body. As I said, Tchelitchew ordered the cremation of his corpse long before his decisive heart attack. It had been the summer before his last appearance alive in Paris: when his show took place there in November, 1956.

His sister Choura (Alexandra), the only relative of his immediate family to have fled Russia in 1920 to live with him in the West, had presented him with a bottle of Guerlain's Vertivere, his favorite cologne, and he had jolted her with the words: "I shall be dead before this bottle is finished." Mme. Zaoussailoff, telling me the story, added: "As you know, he was . . ." The artist's two intimates of oldest standing, herself and Ford, were used to predictions of this doleful sort in later years; indeed, as his domestic companion, Ford finally found his patience much tried by them. Mme. Zaoussailoff's exclamation, showing her brother how foolish she thought his pessimism, was somewhat feeble as an echo of the more serious exchange they had had a few days before. Returning home to the old studio (where she had continued to live following Tchelitchew's move to America) she was asked by Tchelitchew where she had been. During the period of the German occupation in World War II, her husband had died; she had just paid a visit, she answered now, to his grave.

Unexpectedly, Tchelitchew said: "I want to be cremated when I die." Mme. Zaoussailoff froze in dismay. Writing the artist's old friend, Allen Tanner, after his death, she gave this account of the brief conversation that followed: "I even became a little angry with him and tried to dissuade him. But he said, 'This is my wish and you are going to do exactly as I say!' And as I was far from the idea that this would actually happen, I told him that as I would die before him, I would not be obliged to do it. So here we are,

Alloushenka,* I have been obliged to do it and it has been terribly hard for me to arrive at this decision, but as I happen to be the only relative on hand in the West, I could have done as I wished. I have always done as he wished and so Pavlik was cremated."

By the time I saw the sketchbook page sent to illustrate my obituary, I had had news of the cremation from Ford. The already discussed images are a typical nervous metamorphosis of Tchelitchew's last period and altogether make a little paean to resurrection: not jubilant, not morose, yet with an old hermetic anatomist's awed, solemn sense of dealing with strange marriages of form: officially profane but actually, as long-surviving white magic, sacred. Even the illustrators of the great anatomist Vesalius, flayer of men and their dauntless inspector, were moved to preserve the sanctity of the body's inmost secrets by picturing them as basically alive, undiscomforted in the light, and posed with the grace of pagan statues. Tchelitchew learned this sacred manner and was always, with increasing inspiration, to practise it.

His Celestial Physiognomies of 1952-57, in pastel, gouache and oil paint, gradually compassed the whole figure and are essentialized things, clarified of protean incident. Rather than an art of reading men and things, it is an art of rendering their sublimation to the absolute spiritual state, Paradise. Yet the spontaneous sketches for them (like the complex Dame Blanche which I have been analyzing) are the opposite; they point to the *earth* and to the *past* of the Physiognomies. In the artist's old studio at 2 rue Jacques Mawas, Paris, I had seen in 1960 a series of sketchbooks marked Kiev, 1918, to Frascati, 1957, and had fallen in love with the newborn look of the work in them. These were the occasional first fruits of Tchelitchew's imagination: delivery room products, buds, branches, scarce-flowered hybrids still warm-wet with existence. Concentrated here was the legacy which Tchelitchew had taken mainly from Doré, Grandville and Bosch, then with the help of Vesalius, visualized, evolved and corrected fastidiously through all the years, finally to raise it into those pseudo-geometric figures of grandeur that remain only themselves: the Physiognomies.

What finally struck me not least about La Dame Blanche was the effortless manner with which, on the sketchbook page, she both identifies herself with the content of *Inachevé* and liberates herself from it—not only as the apparition which the boy Tchelitchew first saw shaped by an idiosyncratic illusion at the end of an alley of larches on the family estate, Doubrovka (an illusion invariably seen there at a certain time of day), but also as the zoömorph of these sketches before me, in which she was part bird, part woman, part urn or hydria and insidiously, severally phallic. Here were some metaphoric constellations (including Cassiopeia's Chair or Throne): animal-object multimerg-

* A Russianized diminutive of Allen.

ings not whimsical as in Bosch or Grandville, nor nominally freakish as in the artist's own *Phenomena*, but purified of the human and social satire that appear alike in Grandville's and Lavater's caricatures and Tchelitchew's serio-comic freaks inundating his Hell. The chief Dame Blanche images wear the "expressionless expression" of ritual objects. Ritual objects are by tendency muted: undazzled, undazzling of aspect. They do not come one inch *toward* one, or even beckon; one must go all the way *to them*.

Divinely impersonal, the fading Dame Blanche of *Inachevé* lives in a still vacuum of the Heavens. Orbiting? Perhaps. Or, as Ford maintains, an image of the Sun. Within herself, La Dame Blanche is perfectly still; it is as if, only her head being visible, she space-walked, serenely oblivious, on a tightrope. On the other hand, the Dame Blanche of the sketchbooks has the archaic air of a mortuary vessel, dug up from a past civilization and meant, hermetically sealed, to preserve the viscera and pudenda of the dead. I was too much impressed, at first, with the insinuating phallicism of the dummy-head, topped by the female face, to realize that Tchelitchew's sketch has a positive affinity with the reliquary busts of female saints. When at last I investigated this association, an exciting and curious set of facts emerged.

The appropriate relic for such a bust as the sketch suggests is the head, a big of the cranium—by all means, thus, the *tchelo* itself! The practice was followed in the Middle Ages to deposit this relic in a *repoussé* head including the shoulders; the top of the head is a lid with hinges and the face (sometimes painted) a mask of the saint. If the oval lid be removed, and one looks into the hollow sculpture, so as best to see the face from inside, one finds it exactly in the position of the face on Tchelitchew's dummy-head: its features illu-sively supply the head's missing "crown"; i.e., the removed lid.

I could not help being arrested by a further fact. It happens that with a number of these reliquary busts the original face (revealed, as just mentioned, by removing the lid and looking at the inside) is not only differently modelled but that of a presumed *male* saint. Alchemically considered, the male-female amalgam, as found in the dummy-head by anatomic displace-ment, suggests the marriage of the sexes whose product, in one process, was the Hermaphrodite. The phallicism of the dummy-head, reflected in the crudity of La Dame Blanche's features, is simply a physiognomic nuance of the artist's magically rooted, playful, untrammeled imagination.

His canonic punned heads, even in the 1940's, when they were complex vivisections of true inner anatomy, were invested with the simultaneous going-and-coming (reversibility) that in the 1950's became purely linear with the Celestial Physiognomies. A single head, by its ingenious concave-convex treatment, had begun to look like two heads, and in reverse, two heads to look like one. Through *transparency* Tchelitchew came gradually to *trans-mutation*, every distinct anatomic structure being translated into a network

of immaculate spirals echoing, in effect, the geometric domes and windows of Santa Sophia, different seen from the inside, and yet the same.

In that church, Tchelitchew, having escaped to Constantinople after discarding the uniform of the White Army, stood long, amazed; he had never seen anything so abstractly enchanting before, no ensemble of architectural unit and detailed decoration so perfectly balanced and conceived. Indeed, it seemed to hang, as tradition said, on a gold cord from Heaven. The very elision of East and West suited his mood of the moment while the sequence of spheres evoked the role of the heavens in the mystic cult toward which he was already leaning: Astrology. Three decades later, the solemn Byzantine in Tchelitchew began to brood hieratically over the calm distant symbols which had evolved out of the chaos of his life and which he was now setting up in a Heaven of his own making. Mercury, the Pitcher Woman, the Man with Hoop, even the Fatma, with the placid Oriental jingle of her frivolous extremities, perform the same sedate, prescribed dance, fixed and moving, which is native to altars and to the stars. Tchelitchew had dedicated his last artistic gestures to bringing to visibility the inherent anthropomorphism of all space. This was very plain! And overwhelmingly plain, too, was that exactly this had divorced him fatally from the mainstream of twentieth-century art. I specify art because Tchelitchew had professed it, and been earning his living at it, since he was twenty. His fate and his fortunes were unalterably bound up with it from 1918 on.

There may hide in the earth's history a religion of Man, and the traditional Humanist (with all his hermetic underpinnings) may be its Messiah. Tchelitchew is the only candidate I know for this Messiah's incarnation. A relentless modernist, as he immediately and expressly decided, he followed trends, borrowed plastic notions or used them as take-off points, without immersing his consciousness in them. If his fortune (he clearly distinguished between fortune and fate) was to succeed by being fashionable and competing in novelty and sensation, his fate was to cling with blind instinct to certain old mystic postulates and the moral law abiding in occult superstitions. He also exulted in being loyal (until the very last) to the most venerable and noble religious traditions of his native land. As a free lance and lone wolf—a worldly vernacular suits his case—he refined these roles into the immemorial being he called the Faithful Knight, part folk hero, part emblem of chivalry, whose life mission was to capture the Magic Fern of Christian-Russian folklore.

Doctrinal heresy per se became as unreal to Tchelitchew as to a horoscopist or a teller of fortune by Tarot cards. To modernism he had brought, utterly untainted, the supernatural intuitions of the ages. Like the Nature he always termed "Mrs.", as a title of respect and mark of personal affection, his intuitions remained sacred to him. Much that he read in books as a man

confirmed the religion and morals instilled in him by his nurses rather than anything he had learned in school. When he read in Paracelsus, "There is no part of man that does not correspond to an element, a plant, a measure in the Archetype," he believed him as readily as he believed in the price and healthfulness of canned grapefruit juice, and allowed Jung, when he joyfully discovered this philosopher, to confirm and fortify Paracelsus. Tchelitchew, a man of the twentieth century, did not need to be told by another man of the twentieth century, Papus, that "the earth moves and breathes like a human body." Nor, knowing it by instinct, did he need to be told that modern astronomer-physicists entertain a theory that the universe itself regularly pulsates.

In an artist's life, cause and consequence are curiously transposable. As an art scholar, Jean Lescure, has said: "An artist does not create the way he lives, he lives the way he creates." A self-authorized anecdote about Tchelitchew, familiar as part of his personal legend, dates from his Paris period in the middle twenties. Having previously been chiefly concerned with the theatre, he now first felt his destiny as an easel painter. Gertrude Stein had rather dramatically discovered him and elected to be his patron, slyly playing him off against Picasso. Once the latter found himself seated at Miss Stein's dinner table so as to face, on the opposite wall, a work by the newcomer, Pavel Tchelitchew; when Picasso would not respond to the gambit, Miss Stein brought up the impression Tchelitchew had made at the last Salon d'Automne with his *Basket of Strawberries*; Tchelitchew always claimed this work was the matrix of the Shocking Pink that in later years became fashionable in the domain of cosmetics and clothes.

"Picasso broke the object," Miss Stein said to the young Russian in her maternal, lecturing, deceptively offhand manner. "Pavlik, don't break the object." Tchelitchew would repeat this, through the years, like gospel. According to a lecture he gave on Gertrude Stein at the Ringling Museum, Sarasota, the aesthetics of object-breaking was a grave one to his patroness, whom he looked on, he said, as a sort of White Goddess. He maintained that she expressed the "repulsion she felt contemplating a broken object"—"once it is broken," she believed, "it is no more an object." She "praised me greatly," he reported, "for not doing as the Cubists had done." He was impelled to agree with her that breaking an object (she apparently did not distinguish between life and painting) was a confession of impotence in relation to it. Cézanne and he, she told him, went "around the object" instead of "bursting into it."

Undoubtedly, Miss Stein also meant by this advice that any artist desiring to succeed by being original should not repeat an innovation such as the Cubists' but should find one of his own. If Tchelitchew took her advice as a mandate of professional strategy, he had even more affinity with it as a dogma

laying down the physical inviolability of the organic world, particularly the human body. His aesthetics were certainly visceral, not rational, but they were also mystical. Only a born mystic, I think, would have developed such tenderness for the material body's canonic safety as did Tchelitchew. When preoccupied in the twenties with painting figures and incidents from the circus, he visualized a poised safety in the air travelled by acrobats. Yet he knew that both acrobats and equestrians sometimes fell and were killed. It was a sort of self-imposed agony for him to paint the accidents of the circus, his emotions involving a certain degree of sadism and erotic fantasy; at the same time, what obviously engrossed him in fallen acrobats and riders was the superficial intactness of the corpse or the unconscious body; it had lifelikeness except for the deadweight of carried bodies or limbs sprawled in caricature of living postures.

The artist's profound concern points to a concept of material transcendence which is essential to all resurrection religions. To say, however, that Tchelitchew was an ascetic, or even lived voluntarily a moderate epicureanism, would be misleading; it would give the lie to his private life and the pervasive phallic preoccupation that created many sacred/profane emblems of his art. His temperament was profoundly, lucidly dualistic. The bird-urn-woman, La Dame Blanche, is as phallic, and thus as pagan and primitive, as the Delian sculptures whose sight made me positive of the phalloid kinships in the sketchbook suite. That the images of divinities of the past should be found *broken* is a pathos of history to which some contemporaries still find it difficult to be indifferent. But with Pavel Tchelitchew, it was not a matter of archaeological passion; nor was it romantic sentiment, a philosopher's pathos-of-distance or sheer eroticism. One might call it (thinking of Bachelard's phenomenological poetics of space) a desire to live within the body like a house, thus to move in and out of it (oneself or another) magically, not to break into it, as if its doors were material and found locked.

The idea of the broken image (or broken "lock") attacked Tchelitchew's solar plexus with as much immediacy and disturbing force as had a cadavre being dissected in the University of Moscow, where in his youth he was transiently a medical student. Tchelitchew's great susceptibility in this respect could easily resemble ordinary fear. He was terrified by mice (apparently because of the childish myth that they were invaders of privacy) and could not bear to crush insects, especially dangerous ones. In Italy, scorpions were to be encountered. Once a scorpion appeared in his bedroom at Frascati, whereupon he called for Ford's assistance: "Charlie! a scorpion!" And when Ford arrived on the double: "Stamp it!" he superfluously ordered, pointing. The deed done, Tchelitchew did not forget his strange scruples. "Exe*cu*tor!" he hurled at the departing Ford. It was the best he could do with the word, executioner.

As a youth, faced with the choice between studying mathematics or medicine in prospect of a career (his father had ruled out painting and dancing), Tchelitchew had chosen medicine because of the information it would give him, already a student artist, about anatomy. He and a fellow student at the university went to a dissection class armed with heavily perfumed handkerchieves, which they expected to clamp to their noses when the smell (which they feared most in anticipation) should become too awful. One imagines, however, that sight rather than smell was the sense so effectually assaulted in young Tchelitchew that his next awareness of the world, after a little while in the surgical amphitheatre, was the exterior of the building in the open air: he was prostrate on the ground and being revived by his friend. These reawakenings to the bliss of life in its *wholeness* became visionary to the artist who had committed everything, in 1919, to exile from his native land.

What is the true disaster in the integument of dreams and all lapses into unconsciousness, including sleep? These states signify the threatened *fragmentariness* ever implicit in existence: the vestiges of memory that ape and anticipate death. When the formal question arose of how Tchelitchew's remains were to be disposed of, Choura Zaoussailoff had to remember the artist's injunction (never mentioned in the grievous weeks when he lay so close to death in a Roman hospital) that he be cremated. One may wonder if he did not prefer instant destruction for his body to gradual disintegration or the mere idea of an autopsy. Mme. Zaoussailoff knew that cremation was contrary to the mortuary usage of Russian Orthodoxy and feared that it would be difficult to have the regular ceremonies performed for Tchelitchew at the local churches.

It was not that Tchelitchew himself had been ignorant of the impending difficulty. It was only that, when he dared on the basis of faith, he dared all. At Grottaferrata, his home just previously to Frascati, there is a Greek Monastery of the Basilians, established in 1002 on the site of a Roman villa, traditionally that of Cicero. In a twelfth-century church, quite small but with a mosaic over the portal, services are held by the Basilians. Tchelitchew was in the habit of attending them, and once in 1954—the last time I saw him—I had gone with him to witness the black-garbed and hatted monks, packed tight into their stalls, chant responses and bob forward (every few seconds) at every response; beside me, Tchelitchew bobbed in time with them. Clouds of incense billowed from behind the ornate little altar whose doors and curtains mysteriously opened and closed as the august pope (every priest is a pope in the Orthodox Church) performed the steps of the service.

In her troubled mind, Mme. Zaoussailoff was turning over the responsibility of arranging her brother's funeral ceremonies when Charles Henri Ford suddenly recalled that Tchelitchew had been acquiescent to his suggestion

that, as long as he had decided on cremation for his corpse, his ashes be scattered on the sea. Ford now mentioned it to the artist's sister, who instantly put on a disapproving expression. "He didn't tell me that," she said in positive tones, "only that he wanted to be cremated." Ford saw no point in insisting. When I read of this incident in Ford's diary, the first thought that presented itself was that Tchelitchew had welcomed a typical poetic idea. It was not at all strange, for romantic poets had shared many of the notions which the artist's mystic and pagan promptings made normal to his imagination. But later Tchelitchew's sympathy with the idea became fertile with occult associations involving the phoenix as symbol of resurrection by fire.

An artist is cremated. The event may portend more than a mortuary convention. Tchelitchew knew very well it was against religious usage. The Phoenix makes frequent appearance in graphic Hermetic symbols, while another bird, the Pelican, feeding her young with blood pricked from her own breast, is the Philosopher's Stone in the ordination of Alchemic symbols. The concept latent in the accomplishment of the Magnum Opus by the Alchemists was resurrection, making the Pelican's self-destruction parallel to the Phoenix burned in its nest by self-exposure to the sun's rays. The Pelican, found in one emblem feeding its young on top of a Cross, represents Christ; below, in the bowels of a zoömorphic bird like a griffin, the Salamander in its flames is encircled by a Snake with its tail in its mouth—the last being a primordial symbol of Eternity. Eternal life through death was the doctrinal goal of the search for the Philosopher's Stone and its creation in the *athanor*, or oven, of the Alchemists.

Tchelitchew's existential relation to the Alchemist's oven and the ritual of blood sacrifice is clear from manifold signs in his life and art. Perhaps the most convincing proof is that solemnly, explicitly he once identified himself with blood-sacrifice. Less than three years before the heart attack that decided his earthly term of life, he began to suspect that he had a tape worm and soon the tape worm became more than an hypothesis. It was as if the amoeba that had been diagnosed as causing his chronic colitis had proved to be an Alchemic Elemental of the water in his bowels. For many years he had had doctors busy in the search for a guilty bacillus; there had been many diagnoses and a supposedly decisive finding (called *lamblia*) yet no cure; at least, none that endured.

In the summer of 1954, Tchelitchew complained of fatigue more than ever and was subject to a gourmandise uncharacteristic of a man who had learned to limit his foods by medical prescription. One of his standard complaints against Ford—so hallowed that it began to sound like a quotation from the Bible, a book with which Tchelitchew always travelled—was: "You're *eating* me!" The situation was the more "biblical" in that nothing in heaven or earth could induce him to part with his poet friend, not even when Ford (about

this time) started to abandon poetry for painting and daily practised the same art as Tchelitchew. Astrological doctrine was sacred to the artist in its own right and he interpreted it freely in terms of convenient ambivalence. In the past he had accepted Ford's astrological sign, Aquarius the Water Carrier, as a good omen, part of his own good fortune. Now the Elemental in water, and everything associated with water, was automatically suspect as working evil against him.

The far-reaching magical things that bound the poet and the painter together are too numerous to name, though "names" in themselves were not lacking between the two men. If Tchelitchew called Ford "un monstre d'egotisme," Ford called Tchelitchew "un monstre des toutes les vices et tous les vertus." Both epithets were uttered of course in the mock-murderous voice of hallowed domestic squabbles. If, for Tchelitchew, they were (among other things) "two mad monks" and their home (though this was inaccurate) a "two-man monastery," for Ford they were (with greater plausibility) "two egotists incarnate"—as both understood, all such mutual accusations came to much the same thing. Tchelitchew was very willing to call the tape worm by its name. Confirmed malingerer as he was, he had a sublime humility before the tyranny which base matter wielded over him in his sickness. Fretful, mutinous, now constantly demanding Ford's attentions as nurse, the artist endured signs of the tape worm's occupancy somewhat like Job, somewhat like the Celestial Physiognomist he was . . . and by all means like a magus.

Anchored astrologically by his birth date, September 21st, to the House of Earth, domain of the Virgin, he felt his true mission in life was to reach the air and had appropriated this element, not earth, as his by superior right. He could have found a basis for this assumption in the Tarot pack, whose eighth card of the Greater Arcana is the Virgin, also called, because she can be both Saint and Magdalene, Astraea the Star Maiden, who presides over the upper air. In any case, as the situation between him and Ford worsened in step with his health, he insisted that his friend was "dragging him down" as well as "eating" him. Why? Because, representing water as Aquarius, Ford deprived him of the essential breath of life in the way that water drowns the natural breathers of air: sucks in, strangles.

While summering in Porto San Giorgio, that crucial year of 1954, the artist yielded to the promise of a local Mago (since ordinary medicine seemed unavailing) that the tape worm could be expelled "in no time." He consented as soon as he heard that a séance was necessary. As one Mago to another (the literal term was Professore) he would charge Tchelitchew, he said, only a third of the usual price, which was 45,000 lire. The patient discovered that not himself, but the doctor, was to go into trance. During this trance, he would divine the exact position of the tape worm and also diagnose other maladies that were harassing, and had harassed, the patient. The willing

Tchelitchew allowed the Mago to crook his little finger and join it to the corresponding member of his own hand as the other shut his eyes and began to declaim.

Since, of course, the Mago would not be able to remember what he had said in trance, a buxom female secretary was present to take down every word as it fell from his lips. The séance went off smoothly. Tchelitchew's Italian was not good enough to understand everything the Mago said but he was duly supplied with a transcript. After reading it himself, the Mago pronounced everything satisfactory and seemed optimistic. Ford had not been present at the actual séance; instead, he had gone to a cafe, and while there had had a fortune-telling bird pick out a card on which his own immediate destiny was written. It had no bearing comparable to the Mago's reading of Tchelitchew's.

The next step, it happened, was for the sufferer to take an old-fashioned remedy that night, a quarter of a pound of pumpkin seeds, and the next morning, a purge. Tchelitchew had resigned himself to something like this and obeyed more than the letter, downing three *etti* of seeds and two of sugar: a pound altogether. And he took a good purge the next morning. This was not the first agony of the kind but it was different chiefly because now Tchelitchew could comfort himself during the suspense of waiting by reflecting on what the Mago had seen in his trance. Not only was the exact position of the tape worm revealed but also the artist was amazed at other truths in the transcript—some of them confirmed by his own experience. He learned the shape of his prostate (an "acorn") and even more intimate physical conditions. The Mago's divinatory eye had even seen the intestinal worms from which he had long suffered although he was assured that these were not "dangerous" and "would go away." He was informed, not to his surprise, that in addition he was "neurotic" and that his neuroticism, what the Mago termed his whole "ferment of ideas," was caused by a highly developed brain too large for his cranium.

At this diagnosis, the "ferment of ideas" must have rung out with an ominous "*Tchelo, tchelo!*" The best of all, he would become much more famous posthumously and be recognized as the greatest painter his time had produced. The "posthumously" was the only evil note, but after all, every great artist ran the risk of earning his greatest repute too late. Tchelitchew needed, however, a long rest—the Mago advised—to ensure the serenity in which to accomplish his work, which, added the Mago, had its origins in remote antiquity. The artist felt like a satisfied customer, at least so far, and he was even surer of the Mago's powers when he read that, on the other hand, there was "someone" in his life who "always disturbed him." Naturally, this was Ford.

Meanwhile the pumpkin seeds and the purge, aided by the sincerest good

mental faith, were working. In its usual way, the tape worm had the habit of coming out in parsimonious, ringlike fragments when it came out at all. Now there were exciting signs that the Mago's special inducements, all of which were carefully being followed, were having unusual efficacy. Suddenly a glad cry came from the sick quarters:

"Charlie, Charlie! It's stampeding out! . . . Bring me tea!"

Ford obeyed. The tea was for his strength because actually the vigil had lasted two hours. The decisive appearance of the beast's head had to be awaited; if that did not come, the tape worm in its dread way would, of course, reconstitute itself. Anguished and exulting, Tchelitchew realized that at last it had been put to rout. There it was, in slowly writhing, all too visible coils: no old wives' tale but a veritable enemy of the body, of life itself! It seemed endless . . . "It bites like Hell!" Tchelitchew wailed. Finally, despite the artist's doubt that the head had appeared, all seemed over. Having seen the tape worm's position and just how long it was, the Mago declared that the head was out: the patient was cured.

Still trembling, perspiring, trying to feel "cured," Tchelitchew stubbornly retained his scepticism. On the spot he had told Ford, "I was probably nervous and it broke off, that's all."

"How do you know?" Ford had countered.

"I know."

One need not speculate about the immediate effect of this harrowing experience on the artist's mind and nervous system. If he felt better, and mentally relieved, he did not feel quite well. Tchelitchew was only too conscious of how much the strength he was hoarding for his Magnum Opus, the Paradise, had been sapped by this extraneous, prolonged combat with an Elemental. Bitterly ironic it was, too, that the tape worm should have, by its very nature, a sacred patronym in the hermetic Snake—some called it the Worm Ouroboros—whose complete circuit of tail-in-mouth was supposed to hold life itself secure and round in Eternity. Instinctively, the artist greeted all such symbols as real. Thus he would have been the first to turn from consciousness of the actual tape worm's malign function (once it had been expelled) to its possible, and even practical, benign functions. Mere Christianity and its evil Serpent of Eden were easy to forsake; more naturally appealing was the snake sacred to Aesculapius, the pagan god of medicine, and the two intertwining snakes on the staff of Mercury, identifying him as Hermes Psychopompos, guide of dead souls to the haven of the Underworld.

To my friend Tchelitchew, it was art that authenticated the great Archetypes, rather than vice versa. In late years, he would write me of his mature theories of art. Referring to "the famous triangular pyramids of the chiaro-oscuro relation of the object and the universe (Egypt)," he said that this

plastic development "had completed its cycle and now is demolished brocken [sic] asunder by the so-called Cubists and their followers." Thus readily he transposed again and again (more rapidly and efficiently, I think, than any other twentieth-century painter) the substance and natural character of objects to their inherent principles of form without denying or sacrificing their physical status. The tape worm, alas! had been a reality, but as an aftermath to his ordeal with it, what emerged as most important to him was the psychic principle underlying the Mago's physio-therapy.

It seems to me that Tchelitchew made plain the rudiments of his mystical theory in a letter of holiday greetings to me the same year that he had (he hoped) bid the tape worm goodbye. He was speaking of the importance of maintaining the world tradition of an ordered inner vision of things. I give (as always) his idiosyncratic style and spelling unchanged: "Outside world will always be outside of us—inner world is our own. I met a strange man—a Mago endouted [endowed] with an extransensorical perception. He can by his 'dedoublement' enter inside of others and walking and exploring in the inner 'interior landscape'—see all the scars and traces of previous illnesses and diseases. He says every disease leaves a scar on our inner organs. He can transport and enter everything at any time. Most astonishing indeed. I had a terrible shock when he told me of all what had happen to me since my birth. Lots of things I never knew and I understood now many whys. I think how that psychic body of ours also bears scars of all the passions, worrys, desires, hatred, etc etc—this what we bring with us to our lives—a psychic body which had forgotten the scars, but the scars still remains on it—like hyero-glyphs of Egyptian pyramids and obelisques! It is maybe a strange idea—but this is the explanation for "Karma": destiny - this nett in which we are trapped - we trap ourselves. You see, art is the only answer in the field of life-death - there are no other replies—". Not one word, observe, about the tape worm. Eventually, I had its story from Ford. From the above letter it would seem that the Celestial Physiognomies were intended as clarified and harmo-nized "psychic bodies" from which all *scars* have been erased. In art, all man-animal, man-object, hybrids are thus justified by but one principle, signified graphically by the "open" anthropomorphism of all space; in the turn of the eons, man has *partaken* of every element, hence he has an immutable affinity with them all.

Up to the moment of his death, however, Tchelitchew was condemned to be poignantly aware of every scar, new or old, to be found on his material body. He and Ford used to speculate whether the painter's continued chronic tiredness—he was tired even when he arose in the morning—might be due to the supposedly vanquished tape worm. An ominous piece of news had been betrayed by the conscientious Mago: Should the tape worm have been a female, she might have laid an egg in Tchelitchew, and if so, even after her

own expulsion, the egg would eventually hatch; the period might amount to months, perhaps a year, but develop again "a" tape worm would. Tchelitchew's heart had sunk. He continued to have a terrified feeling that his cycle of doom was yet to be played out.

During this period, latter 1954, the artist was still suffering from colitis and he was "upset," as Ford's diary puts it, that his London show of that season, at the Hanover Gallery, had not done "better." Because of the frigid winter, he had not ventured to be there for it. One day, Ford lured him out on the terrace of their Frascati penthouse (the only one in town) to pose for some snapshots. Even in the sight-eye of the camera lens, Tchelitchew looked, said Ford, "pathetically weak, old and tired, even ill." Several nights later, Ford had what he called "a terrible dream." It began with Tchelitchew's having condemned someone to be flayed alive.

The victim, a man, was pleading for mercy and momentarily Tchelitchew seemed to relent, and looked pitying, only to resume his adamant attitude. "I was there," recounted Ford. "We saw the man flayed alive, strung up." The raw skin was drawn down again and again over his limbs as in film montage. Tchelitchew vomited. Then Ford vomited . . . "Hard little clumps like lumps of black blood," Ford wrote in his diary. The dream ended. Hearing about it next day, Tchelitchew declared it "a dream of sacrifice," and it was clear that he referred to himself when he added, "I'm killing myself. It's the highest form of death: self-sacrifice." The association with symbols of his art is self-evident. But as I read the passage in Ford's diary, I recalled, while a dull horror threaded my veins, that the first symptom to alarm Tchelitchew, when he awoke at three o'clock on Christmas morning, two years later, was blood coughed up from his lungs.

Seven days before Christmas, he had chosen not to leave the house because his horoscope had pronounced it unpropitious to do so. Actually, he had had a fever, but it had disappeared when he had taken his arthritis medicine. On the night of the 21st, his throat had been sore and he had coughed up a little blood. Next day, in reaction, he kept up a non-stop flow of entertainment. But that evening he wilted badly so that an engagement with Mr. and Mrs. Laurence Roberts of the American Academy, for Christmas Eve supper, had to be cancelled. Then, at 3:30 on the fatal morning, he called Ford because he was continually spitting up blood and said that he had better phone for an ambulance. Thinking, then, of a Russian woman friend who knew of a lung specialist, he reconsidered calling Salvator Mundi.

The night before, they had listened with qualified enjoyment to a radio concert. His gall bladder hurt him terribly, Tchelitchew had said, and then he had warned Ford about his sexual indiscretions and the consequences they might bring. Something unusual, however, was laying a pall over the music they were hearing: something different from the customary upbraidings by

his friend. "My heart was always like a snail," the artist remarked incredulously; somehow, he always mentioned his complaints like this—with "magic" incredulity. "Now," he continued of his heart, "it runs and jumps too fast." Finally, he had to abandon the idea of calling in the lung specialist.

"Charles Henri! Get Salvator Mundi—get the ambulance!"

Anti-Manifestation

Some time before or after he arrived at Salvator Mundi (there seemed an immense amount of red tape about securing the ambulance), Tchelitchew saw La Dame Blanche in her apparitional form; it might be that she made several appearances before he died seven months later. As for the Phoenix that was her apotheosis in the sketchbook, Tchelitchew had painted it in various habits and habitats; it was called a Lyrebird when he surrounded it, in a superb late painting, with his dancing boxes; this bird is as self-contained, as composed, as a tall elegant vase. Though each ultimate rendering of this period is to be considered an Archetype, every visual concept of Tchelitchew's, placed beyond its own borders in the esoteric and common myths that nourished it, assumes a multiple identity. One is tempted to call each Celestial Physiognomy a sum result of Karmas. The underlying common identity is represented in the world body of myth formed by the voluminous Hermetic tradition, which descended from priestly and sectarian sources in Egypt and the Orient to mould Orphism, Neo-Platonism and, in the Christian era, Gnosticism and Alchemy. Susceptible to every strain of mysticism by virtue of poetic intuition, Tchelitchew became a painter who portrayed Hermetic eclecticism in a conscious series of real and ideal prisms. His white *anima* is blood sister to the remote White Goddess, whose heir in the Olympian pantheon is Aphrodite. The latter's birth, one may remember, is extraordinary: the result of an act of physical violence practised by one god on another.

Aphrodite, say the texts, was the direct product of castration. It was the semen of Uranos, released by Kronos and falling into the sea, that gave birth to the love goddess, full-blown and upright on a shell. Tchelitchew's priapic Dame Blanche is very far, therefore, from being a mere accident of aesthetic meditation or a zoömorphic whim from his private subconscious. She belongs to the procreative firmament and is importantly identified in the personifications of Alchemy, with which Tchelitchew maintained a profound and unfailing sympathy. She is, indeed, the white vapor that appears at a certain stage of the Magnum Opus and was considered by the Alchemists an essential turning point. In the mid-forties, the poet Philip Lamantia recalls, he lent Tchelitchew two rare volumes of Paracelsus' works. The artist fell so much in love with the pioneering adept's fusion of medicine and alchemy that he declined to return the books, finding excuse after excuse for the delay and

suavely bullying Lamantia as he customarily would younger men. He wished to keep near him everything that confirmed his childhood experiences.

La Dame Blanche, reduced in Tchelitchew's art to the simplest erotic dimension, manages to be overpoweringly exact. As an eidolon of knowledge and of death, she is as valid in the language of copulation as in that of mysticism and dreams. She may well, according to the artist's fixed superstition, have heralded his death, but if so, she indeed becomes, and by doctrinal right, the angel of his resurrection. In the Biblical tradition assimilated by the Elizabethans, *to cohabit* is *to know* as well as *to die;* to cohabit again, therefore, is to know oneself reborn. It was only squalid in this life to fear the consequences of sexual "indiscretions"—part of the ignominy and burden of actually being flesh and individual, and so subject to social supervision. Whatever Tchelitchew said to Ford, he knew that the language of Alchemy was essentially a dialect of the language of Art and that, to quote his above-given letter, "there are no other replies."

No one was more aware among painters that sex had the majesty of profoundest magic than was Tchelitchew. Conception (the coupling sexes) and pregnancy (a pregnant woman) form the nuptial symbol of achieving the Alchemist's Magnum Opus by "the humid path." In conventional representations of this symbol, flowering vases house the two successive images as if in alembics. When I saw two drawings of this type, I was struck by their analogy with Tchelitchew's phoenix, pregnant with the head of La Dame Blanche. Standing on the altar during the funeral service for Tchelitchew held in Rome, red roses, tiger lilies and other flowers were banked around the urn with his ashes. Seen in the mythic and transparent dimension of his paintings, these flowers take on the shapes of molten zoömorphs: candidates for the Archetypes. It is the effulgence of the full-blown rose that attached to it the ancient superstition by which it represents the very flower of faith and consummation in the world of spirit, Rosa Mundi, another Archetype.

A great bunch of roses on the altar in Rome happened to be red. *Rubedo* (a precise shade of red) is the color of the fire that was supposed to notify the Alchemist that the process had reached its perfection. The alchemic Rose is a symbol of marriage as well as of the Hermaphrodite. Mystically speaking, the Hermaphrodite is severally the product of marriage, cognomen of the Philosopher's Stone and culmination, with the Phoenix and the Pelican, of the whole alchemic mystery. Every moment of our natural life is pregnant with some elusively maturing process, however conscious we may be of it; it might be called a magic emulsion of the "sexes" of coincidence. The biographer's search is itself a planned labyrinth of suddenly revealed ripenesses: disclosures that arrive as pure and perfect as Aphrodite from the sea.

Such things have happened, as a matter of fact, from the beginning of my work. One of them is very relevant here. I had just become certain that I

would receive my first grant to do this biography when, in my capacity as managing editor of *Art News Annual* (the job I was vacating to start the book) I began negotiating with Miss Patricia Blake of *Life* (this was 1959) to do an article on Vladimir Mayakovsky. Agreement with her had not yet been reached when unfortunately she had to break off negotiations temporarily and thus I had to tell her that further talks would be with my successor. I explained why. At Tchelitchew's name she gave a startled exclamation.

"I wish I had known about it sooner," she said. "A very old friend of Tchelitchew's, with him in a barracks in Russia during the Civil War, has been in this country and at this moment is out at the airport about to take off for Russia."

"Who is it?" I asked. "How unfortunate I couldn't talk to him!"

"His name is Sergei Yutkevitch. He's a stage and film designer."

"Oh, I know of him," I said.

"I saw him in a liaison capacity when he was first here," Patricia Blake went on, "and again when he came back from Hollywood, where his group went to 'study conditions' as part of the cultural exchange between us and the Soviet Union. One of the first things he asked me about was Tchelitchew. He didn't even know he was dead. He was much disappointed, and saddened. As a matter of fact, he asked me to find anything that was published about him. The only thing I knew of was the old monograph issued by the Museum of Modern Art—some time ago, in the forties, wasn't it?"

"Yes, 1942—"

"I know. It's out of print, and though I tried lots of bookshops, I couldn't locate a copy. I did get, though, a copy of the poem you wrote for those Tchelitchew drawings of children. I handed it to him just a while ago, when I told him goodbye."

"At least I'm glad of that," I responded. "Imagine the Museum letting the Soby book go out of print! I have an extra copy of it—I'd like to send it to Yutkevitch."

"Well, I'll give you his address. But it may have some difficulty in reaching him, you know. It would be better if someone took it to him. I know a woman who's leaving shortly and she could take it."

I said that was very kind of her. The book was taken along, as Miss Blake told me later, by her friend, but it was confiscated (I learned ultimately) on her entry into the Soviet Union. Duly returned to her when she left, it made its forlorn way back to me.

Now I said to Miss Blake: "What did Yutkevitch tell you about Tchelitchew? Something, I hope."

"Only a little, really. I can tell it in a few sentences. Yutkevitch unexpectedly met him in uniform. He was stationed in a filthy barracks, somewhere, when Tchelitchew appeared, looking immaculate in a brand-new

uniform: a regular dandy. He remained untouched by the mess, Yutkevitch said, despising it, 'above it.' Their friendship was a consolation to both. That's all . . . Oh, yes! Tchelitchew had brought a sketchbook with him. But all he drew in it, so far as Yutkevitch could see, was pregnant women."

"Pregnant women—that was *all?*"

"So he said!"

I knew of some deliberately brutal Adam and Eve figures which Tchelitchew had painted, apparently in the very early twenties, under the Cubist influence. Yet I hesitated to assume he had drawn on his "pregnant women" for Eve. However, when I saw Tchelitchew's sketchbooks at 2 rue Jacques Mawas later, I identified the very figures Yutkevitch may have seen in a slim sketchbook marked "Kiev." There, animal protuberances in female and male could have started as sententious Cubist volumes and ended as, among other things, pregnancy . . . ended? I mean of course, *begun over* . . .

It hardly matters just what shape Tchelitchew's small funeral urn had. Actually, as a cinerary urn, it was sealed. Mystically, on the sketchbook page with La Dame Blanche, its equivalents are open with mouths that pour: the two hydrias I have mentioned. Much as a connoisseur may admire the sentient informal curve on the lip of an ancient vessel for wine or water, it is hard to think of a smile there or even the mobile truthfulness of a mouth, unless the vessel has been made in the image of a person—and then, of course, the lip of the vessel may not coincide with the mouth of the person.

La Dame Blanche of the painting, *Inachevé*, has no mouth, no indubitable orifice. As the face of Paradise, she and her habitat have the sublime good will of the quiet night sky, featured and figured (even if ablaze) only as a Platonic idea—closed in perfect, fathomless totality. One may recognize something of what I mean in the Mona Lisa's smile. It appears there as the effort of Leonardo to turn off her sex, even as the equivalent smile on that artist's Baptist (though less successfully) tries to turn off his sex. I used to catch the same orally composed expression on Tchelitchew's face, where it seemed in a permanent liquid solution of mocking good humor, miscellaneously, organically "open."

That this expression had its effeminacy was nothing to make it extraordinary. The young Tchelitchew, as shown in snapshots taken on the beach in the early twenties, was obviously a fun-lover who threw himself into every game. Portrait photographs taken at this time reveal on his face a self-conscious beauty, coquettish if only because of tenderly bee-stung lips and a dark melting look from heavy-lidded eyes. Well made and slim, his body yet had the muscular development of one with a dancer's training. So native a gayety was the happy possession of this young man that his enthusiasm for life seemed untiring: the poised, prose aria of a great lyrist of life.

However, lips that sang were a curious part of his intimate legend. Fasci-

nated by the idea of reincarnation, he would wonder as a youth who he could have been in the past. As he told Ford, the shape of his mouth had decided him: it was Adelina Patti. In later years Ford learned, a bit startled, that Pavlik's mother had expected a girl and was prepared to christen her Irene. Perhaps this name was chosen for its connotation of peace. Yet it made me think of the fact that in tracing La Dame Blanche in Byzantine art, I came across a mosaic image of Irene, Empress of John II Comnenus, with hair curling around her cheeks to fall in loose plaits. White stones stand out from her crown and costume in strange echo of the points of light in the Celestial Physiognomies. The Empress's face resembles Edith Sitwell's . . . But a male child was born and his ruling planet was Mercury, which decided much for him. The young man's glowing presence, as it matured, teased the senses with a truly mercurial charm.

That at times, as he became worldly and self-confident, he pitched conversation and gesture at "camp" treble threw a certain sort of witnessing heterosexual into confusion and perhaps resentment. Securely male, Tchelitchew did not have that affectation of virility that tends to be pedantic about the distribution of the genes. His person carried a masculine weight, indeed, which one did not have to literally ransack him to apprehend. Timid or belligerent heterosexuals, somehow guessing this, would grow—at least figuratively—red or green with it. One such belligerent observer had been Ernest Hemingway, especially irritated because Tchelitchew was a favorite with Hemingway's wife, Hadley. Allen Tanner, Tchelitchew's constant companion in his early Paris days, speaks of Hemingway glowering at Tchelitchew from a cafe table and verily puffing with indignation. He looked so much as if he were about to spring on the uninhibited, nonchalant young Russian that Tanner would manoeuvre his friend to another part of the cafe. I must be pardoned for making this sexual separation to help convey the quality of Tchelitchew's personality, which was capable of militant virility and could be like steel.

Searching Tchelitchew's old studio apartment in the rue Jacques Mawas, to recapture as much of him as I could, I was passing along the walls looking at the pictures when I came upon a tiny item, a reproduction of which I remembered having seen before. It is an affectionate caricature of Tchelitchew's head made during his Berlin days (1921–23) by a friend, Count Alexander Rjewouski. My notebook says that it suggests a cross between a Beardsley drawing and an image of Nijinsky or Fokine in the role of Harlequin. I was surprised to see that it was fancifully colored: the subject has red hair. Tchelitchew then wore his hair parted deep on the left side and combed to the right in a voluptuous wave that went diagonally across his forehead, to drop in a bold curlycue next to his right eye. He had been caught by Rjewouski in his typical young exuberance, his mouth wearing its naturally upcurved corners, here daintily exaggerated into a simper.

To look absurd? One is not sure of the caricaturist's emphasis. Tchelitchew's only concession to the art of camouflage (unless we assume some artful cosmetic touches) was to ham up his restless vitality: to clown. That he was aware of his facility at theatrical imposture (it turned into a drawing room art) is revealed in a photograph taken in Berlin during the making of a film whose costumes and sets he designed. Stage workers and actors in bizarre Cubistic costumes surround Tchelitchew, who wears a topcoat and hat, the latter's wide brim turned up rakishly in front. The motif of the amiable caricature, with lax arms opened out, is unmistakeable: it is the angular attitude, fixed eyes and vacant smile of Petrouchka, the lovable and lovelorn, persecuted marionette.

On Mme. Zaoussailoff's wall, the smile was in any case as much Tchelitchew's long-studied exercise in allure as the caricaturist's contribution. His lips were expressive rather than thick, and their smiling curve (à la Adelina Patti) was the pretty crescent, resting on its bow, his mother had observed and interpreted on him as a boy. "Your mouth," she had said, "has the shape of a crescent because Venus smiled at your birth." It is true that this loitering smile of sensuous lips, poised to open, had a bland Venereal effluence. It was provocative: sensually provocative and, at times, sensually funny. It grew wraithlike as he got older; grew no less authentic—this mouth *amusée* and *amusante*—but more and more wraithlike.

"Très chi-chi!"

This quiet expletive came from Mme. Zaoussailoff, who was showing me about the apartment, and was her indulgent, good-humored impression of the caricature, whose grimace she also mimicked. Her voice had a slight "Russian" huskiness and she put a bubbly chuckle behind the "très chi-chi," giving it an odd resonance, ever so remotely dry. I turned, smiling, to this short, deceptively plain woman, a little stooped and crooked with illness, but with a lambent flicker of spirit recalling her brother. "Une vraie Tchelitchew," as she insisted of herself, she could flash with pride, courage and wit. Her irregularity of feature was interesting rather than homely; according to photographs of her young womanhood, her face once had a full, fresh, feminine attractiveness.

I seemed to catch in Choura Zaoussailoff, now, something of a double Dame Blanche: traumatic (earthly) and hieratic (heavenly). Fleetingly, too, I caught something slightly more specific. Or was it there? I thought it a Byzantine image. I turned back to the less elusive truth depicted on her brother's youthful image by his friend. That truth was, indeed, concentrated in the mouth, but one would have had somehow to force the lips open to find the ultimate tranquil curve written everywhere in the Celestial Physiognomies, whole and impervious, formed as if to greet Eternity through mounting flames.

Tchelitchew never painted his own Celestial Physiognomy. Why should

he have? Part of the point was that he was painting himself then as a composite phoenix: setting up *his* Zodiac. There are nevertheless some fine, revealing self portraits. But each is "mooded," refers to a subjective state of mind, and thus of mask. A wash drawing of remarkable lightness, strength and felicity (circa 1933) shows him with lips curled in expectancy and eyes wide enough to swallow the vanishing point on which they seem fixed. Nearly all photographs of Tchelitchew betray the dandy who is inseparable from the artist-aristocrat as a scion of ancient blood and manners. Even his studio dress—a workman's overalls or apron—was worn, to perceptive eyes, with finesse. Only as the author of *Phenomena*, in which he shows himself painting, does he strip himself wholly of every charm and display the adamant surface of his mind, the depth and mystery of his anger.

Eventually the curled-up expression of the sensuous lips began to be haunted by a thin ascetic line, coached by illness. Yet the triggered mouth, with certain character wrinkles about the face, a sidelong glance of the eyes and a cock of the head, still proclaimed the surviving clown and the surviving flirt. An elegance of Tchelitchew's was also to affect the savage in rages half mockery, half an hysterical need, behind which one sensed the obstinate purpose of a serious artist in the throes of a frustration half real, half imaginary. He was petulant, he was a prima donna. Decidedly. And to the end. But he was also solid as a rock. The rock began refining its look as soon as he arrived in Paris.

The artist's profile, though it was not before me when I saw the caricature of which I speak, I recalled as having the clean, restrained, minimal aquilinity, the cameo firmness of mouth and jaw, that bespeaks a natural aristocrat. It belonged to the one of whom the Grand Duchess Marie (a Romanoff) said, turning to a friend as she sat in a theatre box, and indicating Tchelitchew, "There is someone who is nobler than we are." She meant that Tchelitchew's family belonged to the Old Nobility of Russia (Boyar descent) and probably did not have in mind that he himself claimed a fantastic catholicity in his lineage, including a Turkish princess for a grandmother. According to this indubitable Russian, German, Polish and Scandinavian blood ran in his veins from of old. A hint of the German showed in his longish, straightish upper lip and the prim sternness into which it could freeze when he was angry or troubled.

The little caricature in Mme. Zaoussailoff's apartment was but a floating image among floating images of Tchelitchew that I was calling back from space and carefully memorizing—yes, it was always from space, not from time, that they came. I see Tchelitchew as a composite of his physical ages, a sort of Archetype which has to be separated into its concrete phases. It was then 1960. In a few more hours, while I was at the Jacques Mawas apartment, I would be diverted from all personal images by the sketchbooks, which caused me—a few months later when I had come back to America—momen-

tarily to abandon the biography as such and compose a long poem using Tchelitchew's biographic figure only as an armature for an analysis of the sketchbooks.

I could not wait for the Phoenix of my cablegram to show itself in an unexpected but decisive manifestation—something straight from inspiration, tied to the white heat of the hours I had spent alone with the sketchbooks. I called the poem *Canto of the European Sketchbooks* (the sketchbooks filled in America were stored in this country) and a fair copy was in typescript by the end of August, 1960. I recorded the *Canto* with my own voice on tape just as I was approaching the crisis of my health. I remember what a tense inquietude my breast held as I listened to a playback with Charles Boultenhouse and Allen Tanner, the latter seated like a Buddha, his flesh gathered ceremonially about him. Tanner had been as generously and sweetly helpful to my work as Choura Zaoussailoff had been. From my tape recorder, he was hearing of the Berlin-Paris period, 1922–1934, when he had occupied something like Ford's place in Tchelitchew's life. Now his white hair was so closely clipped as to make his skull visible. An aspiring pianist in those old days, he had been a gilded willowy youth with a shock of black hair, a soft, half-hidden, languishing glance, a handsome face and the primmest lips and largest romantic ideas in the world . . . His lips are still very prim.

With the biography in semi-ruins three and a half years later, it was plausible that I should clutch at some redemptive phoenix of my own that might have been bred from the holocaust in my apartment. What but my *Canto* about the sketchbooks? It had La Dame Blanche and some of her metamorphoses, it had the urn-priapus and other things I have already mentioned, besides much else. My literary agent, in whose hands I put the manuscript, soon found an interested publisher who had under way a program of art books in facsimile. Since my poem required the reproduction of numerous images from the sketchbooks, preferably whole facsimile pages scattered throughout, my project would fit into the proposed series.

I was never able to elicit from Mme. Zaoussailoff just what reports or gossip about the fire and its consequences she had had from persons in this country, or what she had heard of my biography's impasse, about which, for my part, I had written her rather frankly. Now the woman who had been so faultlessly kind and coöperative till this point, who had taken the great trouble to write me out a voluminous memoir of the young Tchelitchews and their elders at Doubrovka and Moscow, returned a repeated "No" to my urgent cables and letters, which I took care to duplicate in French. She was just as lucidly negative to a friend of mine travelling in Europe, who at this juncture turned up and consented to be my personal emissary to her. Despite all this, I am happy to say, she remains my good friend. Like many things in my subject's life, this mishap has its enigmatic signal, as of a closed mystery.

There had been a considerable fire in my apartment, but my *Canto* was not

to become even its subsidiary phoenix. The book could not be issued without the proper illustrations, and in proper force, so it had to be called off. Despondently I turned my weary attention, and aggrieved spirit, to the coming chore at the Gallery of Modern Art: reassembling my chaotic files (they kindly offered me an office there) so as to help compile the catalog for the Tchelitchew show. There are phoenixes and phoenixes. This one, presumably, was a matter of anti-matter . . . At least, with a whimper, it had exploded into thin air. It was a flying-saucer manifestation, I daresay.

Five days before he died in Salvator Mundi Hospital, Tchelitchew was visited by a Russian priest to whom he confessed—so he said afterward—and who gave him extreme unction. He told Ford and his sister that nevertheless he had asked the priest to pray not for his soul, but for his life. A typical Tchelitchew gesture: it is very possible that the priest heeded it. Since death stepped in, the prayer became superfluous. Nothing was now problematical about Tchelitchew's death, from the world's viewpoint, but one thing. His cremation, duly accomplished, was a stumbling block to the sacred proprieties which Mme. Zaoussailoff was determined to carry out insofar as they lay in her power. She would do everything to assist her brother toward the orthodox Paradise in which essentially, equally, she felt, they both believed. Their family had been reared in the Russian Orthodox Church and she herself had never swerved from devoutness in this faith. Her brother's absolution before dying would entitle him, she hoped, to the Church's indulgence. Furthermore his cultural eminence in Rome, his fame as an artist, his privilege as a Russian exile and member of the Church, were all in his favor.

Choura Zaoussailoff laid these tangible facts before the Bishop of the Orthodox Church in Rome in the Russian language. Despite her pleading, and the tears she could not restrain, the answer she received was a firm negative. Mme. Zaoussailoff turned her defeated face to Ford, who had stood there while she was telephoning the august person who had denied Tchelitchew's soul the most precious of post-mortem rites: there could be no official absolution, no official prayer for the repose of his soul. They made, she and Ford, a somewhat striking mourning group. The lone, loyal sister had had to wait for her brother's death to reassert in him the domestic rights which his friend had annexed about twenty-three years before. That had been when Ford induced Tchelitchew to abandon Europe and come with him to the United States; the painter had wanted to stay in his new setting and soon he had persuaded the poet to come live with him.

The international move seemed made under happy auspices (of course,

horoscopic advice had been obtained) and Tchelitchew had remained to have his career quickly reach the peak of its success. Though he was always on good terms with his sister after 1934, these terms, while perfectly intimate, were not perfectly good: their relation was an old family affair in which both were far too "Tchelitchew" to do other than show a stiff independence of personal spirit. Her nominal obedience to his wishes, at times more show than substance, did not always issue tranquilly. Choura had been married before the artist left Europe, but not advantageously enough for Tchelitchew to dismiss his old responsibility for her welfare. Never dreaming of neglecting or abandoning her (especially after she was made a widow in World War II) Tchelitchew resented the situation and neurotically, in his paranoid way, would break out in greater resentment perhaps than he really felt. Ultimately, the artist's grievances against destiny always went beyond personalities. Domestic relations had not been resumed between brother and sister except during his annual visits to Europe, taking place in either the spring or fall, when he would stop over at the old Jacques Mawas apartment that was still Choura's home and a European home-base for himself.

For a short while now, death had brought her and the artist together as they had not been since their youth in Russia. With tears staining her cheeks, Mme. Zaoussailoff realized that Ford was trying to console her as she stood there, unable to move away. But their intimacy was irremediably awkward. There had been a moment of unavoidable friction between them in which Ford had yielded to a long-rankling personal grievance: he thought of how often Pavlik had cried aloud his bitterness over carrying the "burden" of Choura.

In an outburst of emotion, Ford had said: "You know he always said you were his cross!" The cruel words, if not the ambiguous truth behind them, had surged over Mme. Zaoussailoff without destroying her poise. The terrible capsule of the past, trembling and breaking open in Ford's sentence, had assumed a grandeur of fate. She had blurted back at him in sombre guttural tones that bit to the bottom of her martyrdom:

"Oui, moi-j'étais sa croix!"—"Yes, I was his cross!" It was as natural to be a cross to this man, in fact, as to be, or try to be, his saviour; he himself, not willingly a cross to others, would have liked to save many (he had in him a streak of the evangelist) and through instinct of power and self-confidence he was generous enough to try to save others in more than one way. It was only himself he could never "save."

Ford and Mme. Zaoussailoff, by the bed of the man who was now utterly lost, had risen together to a level of mutual good will. Each sincerely, during this time, suppressed dissidences, promoted harmonies. There had even been a flux of sentiment when they had promised each other they would try thereafter to be like brother and sister, as if Charles Henri were to take

Pavlik's place. At the moment they very probably felt in earnest. But both, of course, were curiously exalted. Instinctively they sought an attitude to one another which the dying great man might approve. Still, when it had come to outright, unrestrained grief, they had turned automatically to privacy and dampened those small, agonized hours in solitude. By the time everything was over, Mme. Zaoussailoff wrote Allen Tanner in America (still on the old affectionate terms with her) that she had cried her heart out. A few tears were still left and they were in danger of wetting Ford's shirt.

The poet (now also a painter) stood by her in thin, erect self-possession: not short, not tall, but aware of the value of height. Though younger by several years than Mme. Zaoussailoff, he was an adult stamped with permanent boyishness; this same guessed-at faculty had fascinated Tchelitchew with him from the first. Transition from limb to spare, attenuated limb in Ford is brief; his unimportant neck supports a surprisingly impressive head, long in the profile with good prominent bones, a strong sweep of jaw, wide expressive lips and a straight beautifully articulated nose with swelling nostrils; the blue eyes, shedding their confidingness remarkably like a child's, are set in his face like stones. When he was quite young (I knew him then), the whites of the eyes seemed to curve round his head and make a gesture of spacious looking. Now his tanned skin dimmed the blue glance with encroaching puffiness. Of late a ghostly uneasiness had shown like a shadow behind it. But this was the only spiritual sign of advancing age in him—unless, one might say, a certain shortness of temper (again boyish) had turned into vague crotchetiness. Occasional uncertainty of mind was likely to betray the forward precise bearing that still governed his stripling limbs; the eyes would blink, the proud firm corners of the complacent, somewhat pouting lips would loosen. But that was all. He would recover lost assurance by outstaring it. Ford's chin, making a triangle from the front, is not unpleasant but a trifle unexpected: rather like an undue emphasis of the voice. Once, in Italy, a fortune-teller described his gait (one leg is unnoticeably shorter than the other): "He walks like a hare." And in hushed, wondering mimicry, she repeated the phrase: ". . . like a hare."

Naturally deliberate in all his movements, Ford dropped his eyes to Mme. Zaoussailoff's head in her momentary loss of self-control. Both knew how dearly Pavlik would have wanted everything the Church could offer him. But its chiefest benefit was not to be. He noticed that Choura wore the gold chain of holy medals that had been Tchelitchew's and that the artist had cherished; customarily he had pinned it to his shirts, and he wore it in the hospital. Choura had gravely undone it as he lay dead and placed it on her own bosom. Ford could hardly have objected had he wished to, and really he did not wish to. What he had possessed of Tchelitchew was his forever; it had been the best part of Pavlik's life. Ford had wanted it and had gotten it.

After all, his sister, whom he was now soothing, had had to be content with the lesser part of the artist. Not for a moment did Ford doubt that this was fate, and therefore not merely accomplished, but also right.

"My symbol is fortune," Tchelitchew had repeatedly told him, "yours is fate." It was true that such texts of character, as for example in a reading by Tarot cards, might be turned about, exchanged. This fact, in Tchelitchew's eyes, did not affect their tactical truth. For his part, Ford had had a way of accepting the all-powerful reality of the artist's superstitious convictions, which thus gained a hold on him that would not have been so strong had he accepted them less passively. Very much had been made "easier" for Ford by the companion of his days and nights. In his fashion, he had never ceased being grateful. Finally, an empathy had arisen between them that had gone beyond emotions, beyond events.

There was no difficulty in arranging a service for the repose of Tchelitchew's soul at the little chapel in Grottaferrata. Personally, the artist might have preferred an Italian priest at Frascati, Don Giuseppi, to perform this office. A genuine friendship had grown up between him and Don Giuseppi, who had interested him even more when he learned that the priest had acted Hamlet when a youth. But for Choura Zaoussailoff, nothing could replace the authority of the Orthodox Church, especially now that no such service could take place in Rome. Rome would have had more importance in that the church was larger and more people would have been present. Her recourse was to the Non-Catholic Chapel of the English Cemetery, situated at the Pyramid of Cestus and famous as the burial place of Shelley and Keats. Here a regular Ponichida, or ceremony of supplication, was sung in Russian by a very frail, white-haired Russian priest, his piping voice supported by an unseen choir without musical accompaniment.

This service was extremely simple, and for that reason, Ford thought, the more moving and dignified. It was a little awe-inspiring for him to hear Pavlik's given name called out by the old priest in the Russian tongue; it sounded very unfamiliar to an American who drawled the affectionate diminutives, Pavlik or Pavlousha, by which the artist's old and close friends called him. Actually, new acquaintance had enjoyed falling into the use of the diminutive, pronouncing (and sometimes spelling) it "Pav-lick." Mme. Zaoussailoff wrote Tanner how very old was the officiating priest: "so good and so gentle," she put it, "like a holy icon." Of this ceremony, an old friend of Tchelitchew's who happened to be in Rome, Mrs. Oliver B. (Isa) Jennings wrote very touchingly to her husband, who was one of the artist's collectors: "I just came back from the service for Pavlick and of course feel very low and sad . . . lots of flowers and the American flag and candles around the ashes . . ."

During the Ponichida, everyone in the congregation is given a lighted candle

to hold. Alberto Moravia had come with Mario Praz to pay their respects to this distinguished man with whom each was only slightly acquainted, but who had elected to make Italy the home he finally preferred above all others. The lame Moravia could not manage his candle well and its wax spattered everywhere. Fabrizio Clerici and Afro, two Italian colleagues of the artist and his warm friends, also held candles. "Everybody wept," continued Mrs. Jennings' letter. "After[wards] we kissed Charlie, the sister [Mme. Zaoussail- off] and the Ford [family] and I left because he [Tonio Selwart who had come with her] could not speak to anybody. We walked a little in the beautiful graveyard and went home . . . I really loved Pavlick and cannot believe he is dead."

Mrs. Jennings, a South American who usually spoke French when tête-à- tête with Tchelitchew, brought to her passive unfamiliarity with English some of the primitive directness which the artist himself, who never quite mastered English idiom, had developed into an aggressive art of personal eloquence. Glenway Wescott, who knew Tchelitchew from his Paris days, once said that he exploited broken English with the dexterity of a Shake- speare. Mrs. Jennings' friendship with the artist was not a very deep one yet it had the simple, informal intimacy of footing which Tchelitchew was a past master at establishing with women who liked him—and many, many women liked him.

Ford's sister, Ruth, and her husband, the late Zachary Scott, flying to Rome from Venice, had not been in time to see Tchelitchew, for then he was extremely weak and it was felt to be a matter of hours before the end. The lavish red roses on the altar at the Non-Catholic Chapel were from the Scotts; the tiger lilies bore the card of Mrs. Jennings and her husband. The latter flower, Mrs. Jennings had recalled, was a favorite of Tchelitchew's. Ruth Ford Scott was one of the women most indebted to Tchelitchew's paternal kindness and professional advice. A great costumer, Tchelitchew could easily adapt his professional manner to mufti; often, for formal occasions, he had "dressed" Ruth Ford in the old days and she had acquired some of the touch that could be so transmissible, so immaculate, of taste. When she became a professional actress, shortly after Tchelitchew arrived in America, he would treat her to hours of assorted advice, to which she listened obediently and did not fail to memorize.

Gratitude can be quite as spontaneous as tears. Perhaps tears of gratitude are more spontaneous, and therefore better, than other kinds. As a natural safety-valve, they may flow all too easily. Thus tears are at once self-explana- tory and morally suspect: too much of a physiological privilege. After all, the most "natural" of their rights may be the right to self-pity. Exactly this makes them morally suspect, for a moment comes when pity for others is hardly distinguishable from pity for self. When this has been said, we can

take human pity for the charity it wishes to be. Tears are capacious; to mourn the dead, with inner or outer tears, is to celebrate the privilege of having known them, the pathos of having to live without them.

If only one could be satisfied with the legacy of a man's posthumous personality: the image he has patiently accumulated all his life and that lies open to possession by relative, friend and public! But life is not constructed to make this legacy final and efficient. The dead leave something else behind them, something more immediate, rather ambiguous, always a little embarrassing: material possessions. These remain just as before and must be transferred to the heirs and assigns even before impartial posterity has a chance to evaluate them for themselves, to judge them as imaginative objects. Who would inherit *Inachevé** and all the works from the artist's hand as yet unsold? Shortly after Tchelitchew's death, Ford wrote Lincoln Kirstein that a "fortune" lay in the Jacques Mawas apartment, where most of Tchelitchew's artistic past was stored or recorded. He did not refer to bonds or jewels.

It was general knowledge to his close friends that Tchelitchew had made a will in due legal order in 1949, with Morris Fish as his lawyer, three years before his departure from the United States. As was generally anticipated Mme. Zaoussailoff inherited all existing assets and all her brother's personal property with the exception of special bequests of art works, most of them made to various friends of the artist. Certain works left in Paris actually belonged to Allen Tanner. Ford and Tanner were to receive all portraits of themselves not already in their possession. One bequest caused universal surprise and speculation—more actual surprise and speculation, I should say, than it deserved. Yet it easily arrests the attention.

Tchelitchew had left his Hell to the Soviet Union—that is, he had bequeathed *Phenomena* to the Tretyakoff Gallery in Moscow. Plainly he wished his native land, regardless of its political complexion, to have something from his hand; his precise motive, certainly, invites a somewhat larger interpretation. Lincoln Kirstein traces Peter the Great, one of the central figures of *Phenomena* (though not so pivotal as he implies), to Tchelitchew's desire to express his patriotism. If Kirstein's textual reading is correct, the gift by that much gains moral plausibility. His identification of the figure is partly based on a child's head in pastel called *Peter the Great* (1934); the artist himself may have mentioned it informally in *Phenomena*, where it is actually named "Infant Prodigy." This "Peter" is engaged in batting a tennis ball to a girl opponent, not with a racket but with his hand. In his preface for the 1964 exhibition catalog, Kirstein saw here a reassuring clarity in the ambiguity of Tchelitchew's symbolic method. He describes the said figure as "a red-shirted prodigy [who] lobs back the ball of history tossed him. He is the baby giant, Peter the First, who opened Russian windows on the West,

* Ford states that Tchelitchew's working title was *The Sun*.

creating modern Russia, our opponent in the games and conquest of power."
This may have been true in 1938; the artist himself probably supplied the cue
for it. But at the time of making his will, he had reflected more maturely on
Peter the Great and taxed him with an offense against art which will be taken
up later.

In a letter of 1958 to Alfred A. Barr, whose kindness was solicited in first
approaching the State Gallery in Moscow, Kirstein had said that "the child
Peter, batting the ball out of court," was "in the light of Sputnik . . . rather
an awesome fulfilment of Pavlik's quasi-prophetic powers." Barr felt that the
gift would be welcome because the Soviet Union would be interested in
Phenomena as "Western decadence"—somewhat more intentional, one may
add, than that supposed of Matisse and Picasso. However generally plausible
all this, I think we have to question the tenor of Tchelitchew's wisdom in
committing to modern Russia a work of art whose truly symbolic nature is
antipathetic to the Soviet temperament and its artistic rule-of-native-thumb.
Certainly it was, this great gift, the most romantic of posthumous gestures
and a little tainted, I imagine, with delusion of grandeur. A long time elapsed
before the work (79 x 106½ inches) was delivered by Lincoln Kirstein to
Prof. P. I. Lebedev, director of the Tretyakoff Gallery. Barr had written
Kirstein that this gentleman had looked at a reproduction of *Phenomena*
"with great interest though he did not show great enthusiasm at the idea of
the bequest." How thoroughly Soviet Union!

Lately on loan from the Tchelitchew Estate, *Phenomena* had for years
been hanging, with rather superficial propriety, at the Ringling Museum of
Art in Sarasota, Florida, winter quarters of the Ringling Bros. Circus.
Tchelitchew had always hoped to sell it to some art institution. If it was at
the Ringling, it was only because of the personal taste of the late A. Everett
Austin, Jr., then director of the Museum and one of the artist's more fervid
admirers. After Tchelitchew died, I longed for it to stay in this country;
preferably, that the Tretyakoff people would simply forget about their
eventual acceptance of the gift. But Kirstein, accompanying the New York
City Ballet on a visit to the Soviet Union, finally carried it over, unstretched
from its frame and rolled for convenience.

To the last, Kirstein kept up a lugubrious bravado that he might, through
enlightened mediators, persuade the State Gallery of the work's importance,
and that before his return to America, instead of being relegated at once to
the cellar, it would be hung in the Gallery with suitable fanfare. A greater
likelihood, as indeed happened, was that the painting should go astray in
transit. When it was found, Kirstein's efforts broke on ears trained to be deaf
and there is no evidence, to my knowledge, that the Russian public has ever
seen *Phenomena*. When the work was lent by the Tretyakoff to the Gallery
of Modern Art for the memorial exhibition, it was found to have numerous

small spots where the paint had wholly peeled off. Later, I understood that a condition of its loan was that it would be completely restored before going back to Russia.

If only because of remarks by Nicholas Nabokov in a letter he wrote Kirstein at Tchelitchew's death, one wonders if the artist had not completely lost interest in the provisions of a document (his will) which would become legitimate only after he was dead. Perhaps he was far too busy searching for the lineaments of his Paradise to care about the posthumous destiny of his Hell. In 1949, according to worldly perspective, *Hide and Seek* was his success masterpiece, *Phenomena* his failure masterpiece. Nabokov's just-mentioned evidence is challenging on its own grounds and cannot be suspected of malicious exaggeration or distortion since he had for long been Tchelitchew's sincere friend. He told Kirstein that the artist in his later years was "terribly anti-Russian, not anti-Soviet but anti-Russian." It is hard to believe and one suspects an ambiguity somewhere. But if it had been true, did it mean that somehow he shared modern Russia's contempt for the past?— even for true-red Russian heroes of the past? As we know, Tchelitchew had a very complex relation to anything that can be called "modernism." Personally knowing nothing of Tchelitchew's anti-Russianism (except for his criticism of Peter the Great) I assume that in a mood perhaps unusual with him the artist was more confidential with his compatriot, Nabokov, than with friends born in his adopted country. Was he trying to explain, rhetorically or in earnest, his having become an American citizen, and so forsworn his Russianness?

It may be remembered that the Soviet Union, through its films, had periodically tried to create a tradition of progress for its historic past, portraying Peter the First and even Ivan the Terrible (at least by official intent) as men of vision whose acts, however violent, effected necessary political change, changes which inevitably brought the future nearer. Even if speciously, both Soviet ideologist and Tchelitchew in his White Russian exile had put deliberately inflective fingers on one of history's own ambiguities. It is logical to argue, it is even dialectically logical to argue, that without the past, just as it was, the present could not, just as it is, exist. Of course this is *a posteriori* reasoning. But it would serve to explain the peculiarly modern political philosophy that "the end justifies the means." In one logical operation, evil is thus gathered up in the same arm with good through a presumed law of historic necessity. An implication of this viewpoint is that the past be considered past as quickly as possible, and the future paid the fullest address if merely in the hope that improvement, not deterioration, will result. It is a philosophy of compulsive optimism. The political mandate becomes: incessant change as guided by perpetual program.

Here we happen upon the peculiarity of the very impulse that enjoined

Tchelitchew to bequeath to his native land, however humanly and artistically compromised that land, the fruit of his past—to be exact, the fruit of his Hell. Tchelitchew had hoped, through painting the Purgatory, *Hide and Seek*, to have buried the Hell of his previous picture: the first of the trilogy of his *Divine Comedy;* then successively, picture by picture, he hoped thereafter that he was burying his Purgatory. In this way he was coming within reaching distance of his full, impregnable future. Universal fame was only the mundane term for the paradisial future he so much desired; inwardly, spiritually and philosophically, his equivalent for universal fame was nothing less than immortality: the blood of the Phoenix as pun for a very different "red."

In this respect as in others, Tchelitchew strewed his daily life with explicit verbal clues. When I asked Choura Zaoussailoff to mention the outstanding proverbs which the proverbially proverbial Tchelitchew was fond of quoting, she gave me the one she recalled most frequently on his lips: "One must forget the past," he would iterate in his urgent, didactic way, "and look before, never behind." Superficially a tenet of his own cult of modernism, this was really, more accurately plumbed, an aphoristic harness for the Phoenix: his own avant-garde Bird of Paradise. He had left behind him a Russian Hell and achieved an American Hell; he had gone on to a quasi-universal Purgatory with American and Russian ingredients. In approaching Paradise, he thought it was time to drop nationalities—and even, one may speculate, to de-modernize modernism. Behind the legacy of *Phenomena* to the Soviet Union—a gesture which he probably never felt the impulse to negate—lay a reflex of his magic psychology: the act was a way of pacifying the spirits of his native land, which might never have forgotten his resented desertion.

In Rome, where the artist had been cremated, all pivotal moments had come and gone: his personal past was ready for burial, or rather, literally, for shelving, since his ashes were to be transported by his sister to the Columbarium at Père-Lachaise. He was Russian, but he was international, too, and belonged finally to the world. Père-Lachaise had been agreed upon between Ford and Mme. Zaoussailoff as the logical destination for the artist's remains. It turned out that not she, but Ford, would actually accompany the funeral urn to Paris. After the service at the Non-Catholic Cemetery, Choura Zaoussailoff could not leave Rome quickly enough. Partly, her reason for haste was to make arrangements for two more ceremonies: one at the Orthodox Church in Paris and a service by a Russian priest at the Cemetery. Intervening formalities, even a certain dreadful moral lethargy of her own, had slowed things down. In Paris, Father Alexander of the Russian Orthodox Church consented to preside at a service over the urn. Tchelitchew in the old days, even when he lived at 150 Blvd. Montparnasse, used to travel a long

distance by Metro to attend important services at this church. The old Russian God and old Russian customs, then and always, were as essential to his luck as making a hit at the Salon d'Automne or selling a work to an important collector.

Mme. Zaoussailoff was the only passenger besides the undertaker in the old-fashioned, high black hearse that approached the great wrought iron gates of Père-Lachaise with the remains of Pavel Tchelitchew. The artist's friends and admirers were naturally well pleased that he should rest with so many of the great of France and other nations; most would have been displeased by any other repository. For Tchelitchew was singularly cherished among the high art and social circles of Paris. He had never attained the security of eminence that is the heart's desire of the intensely ambitious, but he had been one who counted, who was welcomed in the fashionable world. As a stylish painter whose products were bought, he had behind him the complete financial success of the previous November show, which left no doubt about him among those already inclined to acknowledge his stature. These, and more, congregated at Père-Lachaise with a certain rhetorical emphasis for many of those present were conspicuous on the international scene.

The composer, Henri Sauguet, had offered to pronounce a eulogy at the deposition. Sauguet had been a member of the group that had swelled the cafe sessions in Paris in the middle-twenties when Tchelitchew, Christian Bérard, Eugene Berman and Léonid, Virgil Thomson and a few others were making their brilliant bids for success. To be sure, they had vied with one another but were drawn together—the painters at least—by a desire to disavow the current Cubist vogue and explore the general direction of the pre-Cubist Picasso; Tchelitchew, transiently, had also come under the spell of the Spanish painter's neo-Classic style. A select group show at the Pierre Loeb Gallery, introducing Tchelitchew, Bérard and the Berman brothers had made a noticeable stir. The critic Waldemar George is credited with the distinction of having dubbed the movement with the later confusing and disputed term, Neo-Romanticism.* It was indisputable that a strong faction running against the grain of the times had appeared.

A rivalry began between the personalities and high-stepping wits of Tchelitchew and Bérard: the former volatile, a whirlwind; the latter flamboyant, insouciant. Universally nicknamed Bébé, Bérard was a pudgy, dishevelled, half-hysterical, appealingly pathetic man-child who soon grew a thick beard as the primitive defense-mechanism and dignity badge which, since then, the beard has popularly become. On Bérard, the beard had been as much a bib as a badge. In the more or less good-natured duel fought by him and Tchelitchew around café tables, thrust and parry of shriek and splutter, merry and *méchant*, would give way to the bared teeth of malice. Some of

* See the General Bibliography. It appears that George's basic term was, rather, Neo-Humanism.

their companions, finally, felt obliged to take sides. The pitilessly aggressive Tchelitchew tended not to inspire as much sympathy as the more defensive Bérard. Henri Sauguet, eventually siding with the latter, had become anathema to Tchelitchew.

However a dramatic, complete reconciliation had taken place when, more than a decade later, the painter and the composer had met in professional collaboration. This had been when Tchelitchew, answering Louis Jouvet's cablegram inviting him to come to Paris to costume and set the play, *Ondine*, had arrived to find that no other than Sauguet was to do the incidental music. Now, all of thirty years later, with Tchelitchew just gone and Bérard also dead, Sauguet was all the freer to recall with undimmed pleasure the fresh-cheeked youth with the irrepressible Russian spirits, avid of everything, always ready to laugh, and nourishing a serious art that his companions had seldom equalled. In those old days, the acid tones of Tchelitchew's *humeur noire* were notably bland if vociferous, his rage (at least superficially) a virtuoso play-acting. This was "Russian"—at least the way Russians have been perennially understood and misunderstood.

Ultimately, it is the fine distinctions that are important. Yet funerals have a way of helping death dispose, briefly, of the more *difficult* distinctions. That is one of the virtues of funerals, perhaps their lone virtue. With the overwhelming sweep of a brush dipped only in goodness, a man's old acquaintance step confidently, conqueringly across the canvas of death painted by his funeral cortège. When the priest, Father Alexander, moved to the little urn to offer his prayer, all present knew that none could have given himself more to the world and its worldliness than had the man whose merest vestiges were present. Some of them, all the Russians certainly, also accepted the priest as token of another truth about Tchelitchew. The old reverence for sacred things instilled in him since childhood, the instinct to honor the impalpables, had never left Pavlik and had woven about him a distinctive aura. Truly, this surviving spirit of the man did not require the environs of a church in order to establish its essence. It had stirred in Tchelitchew, and bowed its head, whenever the scaleless grandeur of childish wonder possessed him at contact with some heavenly image, some errant glimpse of divinity in the man-massed cosmos. The physical reality of a human body, the physical reality of Santa Sophia, had at last become the same divinity in the eyes of Tchelitchew's soul.

On the other hand, probably nobody at Père-Lachaise but felt a certain humility mixed with pained regret that it was not, this funeral day, an occasion of public mourning for Parisians. A large funeral party was paying last honors to a most distinguished man, but the obsequies were conspicuously private. Newspaper obituaries over the world—those mongrel, pitiless documents that measure worth by earned lines of prestige publicity or (what

is worse) inert local importance—had been hardly more than routine; at times their degree of enlightenment had been compromising. Tchelitchew, especially as a stage designer, had earned in Paris multiple columns of publicity, but he did not have the flourishing local cult of his old rival, Bérard, who had become the darling of a strong Parisian élite. Bérard's funeral had had cathedral dimensions, touches of his own hysteria, and the mass-demonstration character that confirms Fame with a capital letter.

Not that the world of Paris did not doff its hat to Tchelitchew's memory and shed its decent tears. Art in Paris, as everyone knows, is a social hegemony as much as an hegemony of the studio and the critic. An early collector of Tchelitchew had been the late Christian Dior, and he was a mourner here as doubtless he had been at Bérard's funeral. By a curious irony—interesting for connoisseurs of hazard and the world's less clamorous disparities—the Paris Herald Tribune's issue of August 2nd, 1957, had carried a 27-line obituary of Tchelitchew, captioned in (I should guess) 30-point type on Page 2.

On the first page, containing live news of the greatest interest, the newest dress shapes as decreed by Dior found the prominence of more than 27 lines and ran over, to incalculably more space, on Page 5. Dress styles die with no repining, hence all is jubilance, congratulation and ecstatic gossip by Fashion editors. At the worst, last year's dresses proceed to the Heaven of Thrift Shops unless some woman of taste keeps them on. This casual point may strike the reader as naive or even in bad taste. It should not so strike anyone who knew Tchelitchew well, for as I say he was worldly-of-the-worldly. He measured his fame (such was his fatal character) with the ruler of a press agent and the agile eye of a bank teller.

The London Times asked Cecil Beaton to write the Tchelitchew obituary. Beaton had long been an admiring friend of the artist's though, like others, not always one in his good graces. Beaton's notice was very proper; it was also brief, its presentation was underplayed, and its subtitle rather automatically spoke for the sort of fame in which its author participated: that of the theatre. My own obituary in America, as I have said, was perforce not a eulogy, although as a magazine piece it was the highest honor paid Tchelitchew in this country's print. Doubtless newspaper obituaries should not be eulogies, and rarely are unless by the main force of ineptitude that statistics may so stubbornly retain. But there is room, in regard to persons of serious fame, for such documents to cultivate more character and grace. I think the incident of death is horrid enough to warrant a new precision of propriety in the standard obituary. Tchelitchew's death is a beautiful case in point.

One finds it consoling to think that not all, and not the best, service of this kind made its way into print. On the day the American papers carried the news of Tchelitchew's death, Allen Tanner in his tiny studio room in New

York was reclining on his bed in the daily act of reading the evening tabloid. He almost gave a cry as his spectacled eyes fell on the cruelly brief obituary. The moisture of the close summer evening stood out like brilliants on his forehead and a swift shudder, as if time's cold fingers had stroked him, went down the passive length of his burly form. The door of the past blew shut in breezeless space. The ugly sound left him with misted eyes into which small lines of type steadily burned. A few nights before he had dreamed about the companion of his greatest days. He lost no time before writing Choura Zaoussailoff—"ta vielle Choura" as she signed her letters to him—all the consolation he could think of. Their past had unique things in common; together, they had lost Tchelitchew . . . Her reply reinforced the eerie feeling possessing him at this moment, lying there, still as an artist's model, with the tabloid clutched stiffly in his hands. "I believe," Mme. Zaoussailoff wrote, "that this dream you had when Pavlik came to your bed and spoke your name was truly his coming to tell you goodbye because I am sure that we are going to find him again up there. I embrace you . . ."

Poor Tanner had had to relinquish in advance any thought of making the trip to be present at Père-Lachaise. There the solemn single face of the gathered mourners represented all facets of the Tchelitchew cult except a special American branch: the men who had officially supported him in institutions and published writings—Kirstein, Monroe Wheeler, James Soby, myself. No doubt the sad and precious futility that is a funeral had been a factor in deciding some of us not to make the effort of a trip abroad specifically to attend the ceremony. In any case Tchelitchew's memory had its brightest future among his numerous American friends. One heard the overtone of a livelier participation than facing the stark arcade of the Columbarium and seeing the pathetic small urn inserted in one of the compartments built in tiers.

The artist's reputation, having steadily fallen off internationally since 1950, was obviously to be reclaimed and this demanded, as everyone knew, a good deal of thought and application. An emotional response wrung from the composer Nicholas Nabokov, at the moment of Tchelitchew's death, sounded this urgent note at its sharpest. A fellow Russian exile, Nabokov felt deeply about the artist with whom he had collaborated on the historic Diaghilev ballet, *Ode*, in 1928. A flame of blood had been fanned in the two men whenever they met through the years and they were often in contact. In a letter to Kirstein, dated August 1st, 1957, Nabokov expressed a valorous impatience: "Pavlik is gone and I can't tell you how horrible the loss is for me. Please do everything you can to have a representative exhibition of his life's work in New York." One excellent "everything" Kirstein did was to suggest to Robert Beverly Hale, Curator of American Painting at the Metropolitan Museum of Art, a show of three Americanized foreigners: Nadelman,

Lachaise and Tchelitchew. It did not materialize. The one-man show that did materialize (at the Gallery of Modern Art) took almost seven years but it was handsome enough to have been worth waiting for.

The monumental grill work of the gate at Père-Lachaise was passed, the mourners were grouped before the urn, and the impressively robed Father Alexander was intoning his prayer. The presence of the priest was perfectly symmetrical: Tchelitchew's art had preserved something both preciously Russian and preciously human. A contingent of Mme. Zaoussailoff's Russian friends could understand Father Alexander's prayer; in addition, some old personal friends of the artist understood it: Nabokov (there with his wife), Nicholas Kopeikine and Pierre Souvtchinsky, all native Russians. A musicologist, Souvtchinsky had known the young Tchelitchew during his first years in the West when the former had headed the Eurasian Movement and gotten the artist to design the cover for the first issue of its official organ. Souvtchinsky's mother, now dead, had been one of the maternal women to yield to the spell of Tchelitchew's contagious appeal. "They were awfully fond of each other," Souvtchinsky himself recalls.

Dry in look, thoughtful, a typical European intellectual, the musicologist had become critical of his ambitious young friend to whom, when first he had struck out in Paris, no height had seemed unattainable, no nearly-achieved altitude too high. Even before Mme. Souvtchinsky's death, Tchelitchew had drifted apart from her son, who had permanently joined the Paris colony of exiled Russians. For others than Souvtchinsky, attendance at the ceremony was less a patriotic and social duty. Dior was there for the cult's inveterate sake. Large-featured, grey, curly-topped Nicholas Kopeikine, a pianist with rings of nimbleness on his fleshy fingers, exuded grief from every inch of him. Also an emigré to the United States, he had been a favorite portrait model for Tchelitchew throughout the years. Heaving almost visibly, almost audibly in his graceful rotundity, Kopeikine was like a beardless Santa Claus, blending a rosy childlike vivacity with the conscious dignity of years. From the moment Sergei Diaghilev had introduced them in Paris in 1927, he and Tchelitchew had been blood brothers in an exile whose paths seemed magnetized to each other.

The painter Léonor Fini, trance-eyed, indelibly chic, another representative of the Paris cult, was poised lightly, a bit unsteadily, on high heels. But she had (with no fooling about her) the hieratic composure of a sacred cat. Tchelitchew and she had felt an "emotion" for each other, pure and purely spontaneous. Yet periodically they had been at odds—these proud, thin-skinned creatures—over interpersonal protocol as if deep in the ego-game of one-upmanship. Maybe it was the sublime feminine in both of them; at least Tchelitchew was animated by a subtle instinct for generosity. Not long before his death, Mlle. Fini had been miffed because he had not rushed to her

defense in a quarrel she had with André Pieyre de Mandiargues. She knew of course that Mandiargues was a critic who looked favorably on her unsleepingly sensitive friend. Long, charged letters were necessary to reconcile the two painters in their mutually offended prides. The feline metaphor was consciously incarnated by this extraordinary woman, intensely feminine as only militant Parisiennes can be; this occasion to honor the deceased Tchelitchew had given that metaphor extra line and ritual weight.

Matta Echaurren, the brilliant Chilean painter, felt the nostalgia of a distant uneven friendship with Tchelitchew. Paternally encouraged by him when he had come to New York as one of the Surrealists fleeing the European war, Matta (as generally he is known) began feeling the older artist was trying to dominate him, and having a hot-blooded temperament of his own, had rebelled and joined the "enemy" forces. Always sympathetic to Tchelitchew, though not as close to him as others here, several members of the Paris milieu were also among the mourners: Henri Michaux, Alain Bosquet, André Ostier and Janet Flanner. Miss Flanner's wavy grey bob was as archaically reminiscent as a photograph of Gertrude Stein in her long hair. In the milieu where Tchelitchew had found himself at home, art, fashion, nobility and journalism had been at their highest mutual fusing point. Typical of this milieu at Père-Lachaise were the suave Marie-Laure de Noailles, whose salon had been a haunt of the artist's, Philippe and Pauline de Rothschild, Fulco di Verdura, George and Peggy Bernier and Nora Auric, wife of the composer.

Tchelitchew's last commissioned work had been a colored drawing made as a label for one of Rothschild's Chateau Mouton wines. The work has a resonant interest relating to the names of both artist and client. Within a horizontal oblong of unusually symmetrical dancing boxes, as strict as the twelve houses of the geometric Zodiac, a burgundy-colored splash like a fallen drop of wine (or blood) contains the golden-spiralled effigy of a ram. Of course it refers to the two rams *rampant* of the Rothschild coat-of-arms, but also (as inferable from the above discussion of the ram and Tchelitchew's patronymic) it is virtually Tchelitchew's own coat-of-arms; in other words, we may assume that Tchelitchew had put himself "at the head of" the group of artists commissioned by Rothschild to do a series of labels.

Among Tchelitchew's American friends present were R. Kirk Askew, Jr., his New York dealer since World War II, and his wife, Constance, who had been the subject of one of the artist's major society portraits; also, Miss Alice De Lamar and the Misses Eileen and Sheila Hennessy. Miss De Lamar's position as a patron of the artist, though well known, had tended to seem less important than it was; personally a bit reticent, she had consistently and sensibly befriended him. The former lead of Louis Jouvet, Madeleine Ozeray, represented the long-standing affection of the French stage for Tchelitchew;

she had played the title role in *Ondine*, the Jouvet production of 1939 which had marked the artist's greatest success in theatrical designing.

The modern-looking Columbarium with its endless compartments, most of them labelled with a name, was poor testimony, after all, to the glories of the world. This afternoon of October 8th, 1957, it was better to be fanciful and imagine Père-Lachaise a scene through a pair of French doors, courageously opened wide to the cold air of Eternity. There it debouched: a backdrop for the uncommunicative Columbarium, impassive cold home of ashen spirits, while the outlying tombs, the walks and the shrubbery, formed the stiff side-flaps of stage scenery. So it might have seemed to Tchelitchew. Ford's mute profile (he found the Columbarium quite unsympathetic) was as fleeting and enigmatic as when it had served Tchelitchew for a Veronica's Veil image in his least personal image of Ford: in *Phenomena*. The triangular chin was less elevated than usual. A thought stirred behind his eyes: he saw his ashes next to Tchelitchew's.

The moment for Sauguet's eulogy had come. The scene might have been photographed by Henri Cartier-Bresson, the peerlessly poetic photographer who stood near Ford. In his blond, sad-sweet boy's face, always adult with that ultimate "French" gravity, Cartier-Bresson's transparent eyes looked out from under a mellifluous, lengthening brow. As an old friend of Tchelitchew, of course, he was not there professionally. Every ear, and a few eyes, responded to Sauguet's forthright eloquence. Lyric, concise, it at once shone out quietly, splendidly happy. The mood of the mourners turned them as one toward the entrance of the Columbarium, tensely agape like the mouth of a mask. There was something curiously right—personal, intimate, exclusive, French—in Sauguet's choice of addressing himself to the absent artist:

"Before leaving this place which you have chosen above all others to come and rest, to lodge the fragile remnant of your earthly envelope, we wish another moment in which to tell you how much we loved you. In these streets, where so little time may be left, these streets you animated with your warm presence, your brilliant talk, nervous, agile and profound, which so often you wound up with your laughter, so large and spiritual, we shall not be able to cease listening to you, seeing you, thinking about you. But if, hereafter, you are to be verily part of ourselves, secure in our inner memory, still more visible shall we find those most enduring traces of your presence: your work; your life's essential part, rife with all the motions of your being, your thoughts and your heart; rife also with your secrets, which give us in full bloom that radiant flame, that segment of the divine world to which, from now on, you will always belong.

"It appears, you see, that your death clarifies the labors of that so-thrilling light; imparts to it its full range, its whole spiritual gamut. What sprang originally from representing the most perishable and changing, the most

fugitive, elements in human existence, what depicted the very look of being and things—this you raised, little by little, with an artist's implacable will, up to that mysterious ideal realm of signs that constitute the movements of universal harmony and that you knew by touch. This invisible yet present world you have been able to perceive and render sensible to the eyes. How can we not imagine that you have found yourself in this hereafter, that it is there we must look for you?—there we shall find ourselves when we have need of you to divine the way as we draw near the place where you now live?"

Sauguet's voice, rising, did not waver. It seemed to have a life of its own: sharp, clear, efficient with the stroke of a bird's wings.

"Dear Pavlik, thank you for everything you have given us, for that ardent and heartfelt testimony you leave in our hands of your power, your presence, your valiant strength, material and immaterial at once: a kind of sacred fire over which, from now on, we shall be the watchful guardians. Here is buckled for you the great buckle of earthly existence. Now begins the serene and worldly life-span of your work. We still have to travel a little of the common road behind your light, which confronts us now profoundly, now provocatively, with this sign you have made us with your hand—with the feverish and pulsating movements of your immortal soul.

"Goodbye, dear Pavlik, goodbye."

Before dispersing, the funeral party waited for the urn to be carried in, deposited and sealed up. Then they came back to the world. ". . . this sign you have made us with your hand—": the phrase must have lingered in a number of minds. Tchelitchew believed in all gestures of the hand. Some of his portraits spell the names or initials of their sitters in manual language. The long religious tradition is filled with sacred, and secret, signs of the hand. They figure a supernaturalism of the air: control from on high. The artist's first trip to America had not been made in company with Ford, who found it tactful under the circumstances to go separately on a freighter while Tanner accompanied Tchelitchew on a ship of the Arnold Bernstein line. The separate voyages had a complex single suspense for the three men. There would be a split and a new merging.

A storm arose as Tchelitchew's boat advanced toward Ford's native land, which had been the object of so much speculation and magical weighing. The artist's mind could not tear itself from the hostile element raging about the ship—*Ford's* element, he reminded himself, with an impulse of fear, and quivered. Yet no: this was salt water . . . Neptune . . . The hydrias seen in representations of Aquarius carried pure, drinkable water. Two years before, he had drawn an image of Aquarius, in fact, for Glenway Wescott's *A Calendar of Saints for Unbelievers* . . . No, no, something *else* was working against him out there. He was too frightened to imagine just what it

was. At last, he thought he divined the presence of something out on the heaving seas. It was his mother's hand extended over the waves! What difference did it make what was working against him? Mama, dearest Mama, had come to his rescue! She had died the previous year in Russia and now she was in Heaven. Yes, there was her hand, just as he remembered it, calming the sea . . . The storm at once died down.

There was more potent magic in such a vision than one might have supposed, one that confirms Sauguet's phrasing and is connected with the above anecdote. A childhood memory of the Tchelitchews (which no one at Père-Lachaise knew of except Mme. Zaoussailoff) was an image of Nadyezda Pavlovna, Tchelitchew's mother, playing a drawing game that consisted of making geometric flowers out of dots connected by straight lines. It seems most unlikely that this game could have had no part in helping to construct her son's Paradise: the framework given the Celestial Physiognomies . . . the gay and glittering framework . . . the *saving* framework . . .

Like life, all biographies are bent toward the moment of death. That given moment which, just because it is given, life and the biographer join in pushing into the future. There is a will in nature against it and this will must be reflected in anyone's life story; this will exists in the subject himself, beside him and far beyond him. Does it have a locus of its own? Perhaps it is Paradise . . . this against-death. I have plotted to bring Tchelitchew's death unconventionally close; to begin, rather than end, with it. Still it evades the page and escapes from sentence to sentence. Various omens, Tchelitchew's presentiments, Ford's dream that has been related, built up a general air of fatality and suspense for the pair who lived "monkishly" in the only penthouse in Frascati. This building, actually only five stories high, looked down on the old houses of the town. Ever sensitive to immediate environment, anxious to avert the bad luck of places, Tchelitchew had requested his friend, Don Giuseppi, to bless the new apartment. The priest, after reading from a Latin textbook and making the sign of the cross three times, had used a solution of kitchen salt and tap water to sprinkle throughout the rooms. Ford and the artist were at first delighted with the airiness and the luxury of bedrooms opening onto their own "individual" terraces.

The run-around terrace was a medium of both privacy and publicity because Ford's was not quite his alone so long as Tchelitchew could sally onto it from his own bedroom and look at him through the French doors even though his inside door was locked. Once, lying on his bed, Ford was concentrating on a drawing when he was aware of Pavlik's form peering in at him curiously on the terrace. The artist had been restless and "impossible" of late. His eternal complaints of fatigue were almost too energetic. Ford was convinced he deeply resented his having begun to paint. At first Tchelitchew had been sarcastic about his perseverance in painting and they had had several tilts over it. Then grudgingly ("kicking like a mule" as Ford told his diary) he had come round to conceding Ford's talent and even given him praise as well as advice. Here he was, the great artist, on the prowl again, and eavesdropping! Was he interested in whether he was at work? More likely,

he was concerned over whom he might be seducing at that moment, and of course hoping there *would* be someone . . .

Ford's temper (which he invariably regretted) flared up. "Go away," he shouted, "go away! I have no protection from you!" Tchelitchew, his face darkening, stood his ground a moment, then rejoined:

"Let's have tea, son-of-a-bitch." And he disappeared.

Of course the invitation was consciously ambivalent and coy. Those unfamiliar with the mock ferocity of which Tchelitchew was capable may find it hard to savor the prodigiousness of the riposte. This anger was virtually a child's tantrum put on desperately to gain sympathy through being amusing. At the same time the artist was expressing the most reasonable resentment: he felt neglected when Charles Henri withdrew himself and could never forgive him any assertion of independence. Having tea was as good a pretext as anything else in this house, whose spirit somehow remained alienating.

Perhaps it was something Tchelitchew had mentioned to his sister about the penthouse, but at any rate Mme. Zaoussailoff in her post-mortem letter to Tanner explained her own reaction against the quarters where abruptly her brother had met the final terror. Naturally, she had lived there during her stay in Rome. "I am always very, very alone," she wrote her old friend. "But at present it is worse because I am not chez moi in Paris. Here the apartment I do not like. I have never felt that Pavlik lived in it. There is no 'soul,' if one can express it like that, in this apartment, as if no one had ever lived here before, and above all, not Pavlik." Yet it was the last place Tchelitchew called home on earth. Perhaps it had come to be the unreassuring vestibule of a Paradise to which he had literally drawn nearer than he thought and feared. The sturdier the barrier that seemed raised between him and Charles Henri, the more powerful his impulse to disregard it. This place, for them, was "chez nous."

The ninth-century Japanese poet, Lady Komachi, has contributed a profoundly individual inflection to the traditional Buddhist paradise, where according to orthodox belief the highest joy was to occupy a lotus leaf with one's beloved. "We must be living in Paradise," her remarkable sentiment goes, "else we should not mind everything here so much." The tightening apprehensions of Tchelitchew's last years may have been due to a similar intuition that Paradise is not actually a separate place but an elusive state of being here and now; that what the human soul abhors as death approaches is not the pains of a possible Hell, the loss of a possible Heaven, but the virtual flaying alive of the material body that consists in the mere naked submission to its death. Did Tchelitchew believe in Heaven and Hell? Perhaps the most accurate answer is that he did not dare disbelieve in them.

Ford records Tchelitchew's direct reaction to their penthouse. "There's something strange about this apartment," he told him, "strange and spooky."

The artist had just finished his old refrain that he was tired and looked "ninety years old." He was growing too old, too fast, and he himself had called "temporary" the ugly furniture they had had made for utility's sake. Their maid of all work, Gaetana, happened to drop Tchelitchew's bedside rug over the terrace while shaking it out. "That means I'm going away," the artist pronounced. It was not really a bona fide prophecy, nor did the "going away" mean to imply the tragic significance of oncoming death. The words had hardly even sounded sententious. Tchelitchew was merely asserting the psychology of superstition: an already scheduled event is given added authority if it anticipates itself by signs. A premonitory knot of tension, in fact, existed in Tchelitchew because, as a naturalized American, he was due back in the United States after five years of absence. He greatly feared the hazards of all journeys, especially one across an ocean. Though, at the moment, the enforced move was almost two years away, he was already beginning to "adjust" to it.

Tchelitchew found something discordant, if not precisely unnatural, about the swanlike modern penthouse, and in two more years the feeling had not deserted the place. Late in 1956, he had been promised an elevator the next January. The holidays were approaching, it was a harsh winter and heat had been lacking. Morbidly, with superstitious alarm, Tchelitchew shrank from all violations of protocol. For him, protocol covered a very wide field: from the seating at dinner parties and the sale of his work to the installation of elevators and the conduct of radiators. Even the personified Nature he so venerated could be, inscrutably, in the wrong. If there were a downpour he might say: "Mrs. Nature is out of humor with us today, she's in a fu-ry, she spreads her legs and pisses on us!" Yet his tender, joking, profane familiarity with the muse of all flesh, that Fall and Winter, had been in abeyance.

Tchelitchew longed for January if only because he would not have to walk up five flights on returning home. Almost anything about his apartment (that, for instance it had $1 + 7 = 8$ doors: he and Ford had counted them and held the ratio as unlucky) might have put it in his bad books. Since childhood he had believed in haunted houses, and if forced to stay in a house or castle reputed to be haunted, he would refuse to sleep alone and spent, in any case, hours of nervous wakefulness. After the nightmare of his double attack on Christmas Eve, he had returned to a house haunted by life. This seemed the uncanniest of all. A cold hand had closed about his heart when, back home, he realized that since the elevator was still not in action (it was over two months late) he could not leave the building unless he was carried back up, for his heart was too weak to permit his walking up. Periodically he had to visit the hospital for check-ups. On these days he would go downstairs on his own steam, but later two strong men had the honor of linking their arms and carrying up the "famous professore" between them.

It was March. The glorious and miserly Roman spring was barely showing.

Tchelitchew was fond of walking in the countryside and he felt a numb shame in being sequestered on the once-admired terrace, pacing back and forth like a prisoner: he had always been a great one for "constitutionals." One twilight he had been on the terrace and looked toward Rome; the elevation of the countryside helped give the penthouse a "view." The city's lights sparkled fantastically amid the crepuscular tones of the distance: pigeon's breast tones, he thought. He had called Ford to see it: "You should better come out. Rome looks like a necklace in the air." It was the mundane vision of the near/far Paradise whose forms he was busily engaged in inventing for his new Zodiac: *Le Chat Volant*, the *Vaso d'Oro*, *The Lyrebird*, *The Bull*, *Genesis*, *Perpetuo Mobile*—and the one he titled *Itinerary of Light:* much like *Inachevé* untenanted by La Dame Blanche.

Truly, the twinkling points of intersection in his dancing boxes, and the steady curves of the ovals and spirals inside them, resembled diamonds strung on spiderwebbing and held in perfect balance and tension over the abyss, whose black light played on them with a ceaseless iridescent shimmer. Obviously, the look of altering position he had portrayed at their edges expressed the faculty of change that inheres in every seemingly still body of the heavens. The forms within the boxes, their "kernels," stayed in the same relation within themselves; hence these central images were true constellations, throbbing in space the way the heart does in the body. If, in these "convalescent" weeks, he looked through the same twilight to see Rome, he thought of Salvator Mundi, its doctors and nursing nuns and of that sign of succor within a curse: the oxygen tent.

At the moment, Choura was still uninformed, at his express order, about the true seriousness of his past illness. When she became anxious at the long gap after his last letter, she heard from Ford, finally replying, that he had suffered a bad case of bronchial pneumonia but was recovering. On the 29th of March, amid the apartment's frigid alienation, Tchelitchew sat down to write me and began with a most familiar refrain: "I wanted to write you since ages . . ." The standard apology beginning "but . . . ," which invariably followed, now had a painful significance: " . . . but I could not because my hands trembled so much from more than 100 injections most of all antibiotics! Your short letters touched me more than the long ones in which the heart was absent. When one is very ill (and I was at the end of the line) - one feels so acutely the real and the false! Since March 7th I am here, as a prisoner, because the elevator which was promised in 10 days in Jan. took two months to be finally opened one of these days. Do you know the words 'agony' - 'patience.' This was it for 72 days. The good sisters were really angels of goodness and regarded me as sort of their 'miracles' because many have gone to the land of no return with much less than myself. I had from 25/XII/56 till March 7/57 Double broncho-pneumonia (streptocoque) and

heart attack. On 25, XII, 56 my heart was making 168–200 beats—they expected me to leave the world very soon . . . Then the heart quieted down. The double pneumonia was clearly seen in the X-rays of 27th and on Jan 21–22, week after my German doctor returned from vacation, I was to go home but one of my visiting Italian friends and collegues [sic] had reinfected me with the same deadly bacilla-streptocoque and I had a month in bed fighting the Flu (infections) everybody of visitors were banished and I saw onely C.H. [Ford] for an hour a day."

Tchelitchew had an inveterate dread of people with colds. He meant that an artist friend had visited him while suffering from a cold. "I didn't write," he continued. "I couldn't read or draw—I was a wire structure after I was up on Feb. 16–17. It took me three weeks to learn to sit and walk and I am still not myself. I have no desire for anything neither painting nor drawing nor reading - except the few chapters in the Chinese book of "I Ging" [*I Ching*], the book of transformations, and naturally as soon as I was here the heating stopped and now since March 26th we don't have heat with evenings, only electric stoves. From all the antibiotics all my body is thorn [sic] to pieces and I feel so cold—goal bludder kidneys - stomach intestines - but C. H. with his 'wishful thinking' recognizes a 'millimeter' of progress. Doctors dont want me to go to U. S. A. this year as they think it is very dangerous. I have to make all sorts of inquiries to get permission to stay here. I can go to Paris to consult Prof. Le Negre the great cardiologist but no further - I have to take medicines for the rest (what is rest to me!!!) of my life."

Aside from the wildly deliberate pun on rest, some of this letter's naive liberty with English idiom was too painful to be funny. The writer's distortions often amused because one could imagine his intonations of voice as he juggled with the satiric innuendo of the accidents he encountered in speaking and writing English. In a letter to the Zachary Scotts, about the same time, his ignorance of how to spell the plural of streptococcus gave arch verve to his make-do: "streptococki." But the most heartrending part of the letter to me, ominous as were the insinuating facts, was the handwriting itself. Always tending to be illegible, it usually went on with that mad career that was so-Pavlik to his friends; an effusiveness one never rejected as affected or redundant, accepted only as "too much for itself." An inveterate economy caused his sentences to run around the margins (almost non-existent anyway) of the transparent airmail paper, scored on both sides, and to cling to them; then with farewell fervor, he would turn the letter upside down and fill in the space about the address, date and salutation on the first page; often, in consequence, it was hard for one to detect the dates of some letters amid all the encumbrance. One beheld, in substance, a hopeless if ingratiating paranoia.

One must conjure with Tchelitchew's paranoid tendencies. Paranoia does

not have to be a pathology in the modern sense; it may be, in the medieval sense, a "temperament." Psychologically, it is simply the mind which cannot prevent itself from automatically imagining the worst, the very worst, any more than it can prevent itself from saying "I." The individual's moral antidotes for it are something else again. The point is that, to begin with, the "I" is very, very afraid or it would not be tempted to imagine the worst. Temperamentally paranoiac, Tchelitchew was: beyond contradiction or much amelioration; or rather, the only amelioration was the thought that, meshed with the hysteria in him, was the rockbottom desire to be liked, to be cherished, to be honored. Is there, when it is genuine, a higher social aspiration? Tchelitchew, with the bound of his penmanship, leapt into the arms of the world's affection. His spitting, ranting anger was that of the rejected, though at times the rejection could be less real than imaginary. All the same, by and large, it was real enough to justify 80 per cent of his fuming. At that moment, what above all dragged at my heart was the physical testimony to the trembling and the weakness. He himself, being sardonic but not funny in a letter to Kirstein, had compared his writing in this period to "chicken feet in the barnyard." His letters to everyone attested it. I beheld in his letters a broken spiderweb which the moment before might have been seen poised serenely, linked against all winds.

Ford is emphatic about Tchelitchew's fear of being "forgotten" by his friends, especially those in America and England whom he had not seen for several years. Attempting a soft touch on the ironic-grotesque, he even wrote Kirstein at the beginning of 1956 that he was "astounded" his friends still remembered him. Not only with his dealer, Askew, therefore, but with all, he kept up a more or less regular correspondence. In his gradual decline at Frascati, he began thinking his evening letters were never good and on a sudden impulse tore up one he had just written Kirk Askew: the act undoubtedly caused him some real anxiety. In profoundly nursed superstition, Tchelitchew felt not so much the mere fear of being forgotten as the necessity to fill his friends and supporters with good thoughts *from* him, so that by suggestion their thoughts *of* him would be equally kind. Around this time he was corresponding with Erica Brausen, his English dealer, director of the Hanover Gallery, London, and the late Peter Watson as well as with Edith Sitwell, with whom all "differences" had been patched up. Watson wrote that he had recently escorted Dame Edith to the artist's London show. At bottom, Tchelitchew felt traditionally as do the religious in convents: perpetual prayer, night and day, must be maintained if evil is not to prevail in the world over good. Hence giving and taking good thoughts was a daily part of the world's protocol, over which he kept a magically intent watch.

Letters of sympathy naturally poured in to him when news of his collapse on Christmas Eve reached his friends. The victim was not too ill, as soon as he could manage to read or listen, to scrutinize these letters for betrayals of

conventionality and hollow good manners. According to Ford, he gave them marks for genuineness and depth as if they had been term papers on what it might mean to the writer and the world should he be lost to them. He was moved to designate the best, even the two best; the prize, it seemed, was divided between me and another veteran admirer, Elsie Rieti, wife of the composer and a resident of Rome. He himself explains his attitude in the second sentence of the above-quoted letter to me.

I was greatly affected by the letter about his illness. Unmistakably it had the tragic note. "What will become of this man?" I thought. "Whatever he is like, whatever the real facts of his illness, he is plainly being martyred. It is a tremendous crisis in his life." Then, without notice, I heard he was dead. I mourned especially because something magnificent in the humane tradition had also died—that tradition so constantly and consciously vilified in this century, even by those who nominally may remain in it. Self-betrayal: this is what man, should he continue to be a planetary history, must answer for to the future. A witty art commentator, Pierre Schneider, not long ago wrote a magazine article about Giacometti, the late very accomplished modern sculptor.

Giacometti's sculptures distinguish themselves in being nervous impastos spread unfeigningly along wire armatures of human figures. Their finished state looks somehow rudimentary as if a more conventional physical concept of man had been shunted, sabotaged. But of course they are aesthetically complete. The statement in Tchelitchew's letter which hung clearest in my daily memory was "I was a wire structure . . ." It was a plastic idea of Tchelitchew's with a long history. It had not attained a simple authenticity (as one might say of Giacometti's art) and stayed that way; *its* nervousness lay in a plastic chameleonism: the vital desire, not to survive, but to evolve. In the "transformations" of *I Ching* Tchelitchew had merely found a most impressive illustration of a principle he had long adored and exploited.

It is this sort of sensibility that feels the keenest alarm at signs of "wrong" transformations or some stoppage or decline in movement. One may think: "Poor mankind, placing its little faith these days in *surviving*, when it should be, while evolving, *aspiring!*" Accurately, Schneider says of Giacometti that his is a "style of survival." The sculptor's elongate, emaciate persons, standing in three dimensions with surfaces as if "ruined," might be, as Schneider says, the survivors of "a shipwreck or a mining disaster." The real secret however comes straight from Giacometti and apparently applies to his work from 1918 (the very year Tchelitchew started his career in earnest) on: "I have enough trouble with the outside without bothering about the inside." Said with the precision of an artist. Exquisitely.

Giacometti reveals his method as hacking away at his plaster: reducing and reducing—from the outside. "It is a purely optical exercise," the sculptor says in reply to those who think of his work as metaphysically motivated. Critics,

aestheticians of form, may prate all they like. Giacometti's works are plastic ideas—and their one plastic idea is *man;* the artist starts, that is, with the archetypal phenomenon inhabiting the planet and walks around it. There he ends. What he shows is a minimal kind of nakedness, as if—say, on the victims of concentration camps—there could be no more "hacking away" if life were to be preserved. Therefore his figures are incarnate wills-to-live, still moving of their own volition and locomotion; confidently or unconfidently, one cannot tell, but without aid. Schneider expresses it in capsule form: they represent "minimum man." This is their maximum energy, the flesh that will not rot off, that clings to the bone as if eternally—in beauty or ugliness, hope or despair—married to it. Is there even any "bone" in them, anatomically speaking? It does not matter. The idea serves not anatomy, but itself.

As in all art of the kind I have identified with ritual objects, pathos and pleasure are far away from them; even pain (though conceivably implied) is irrelevant to Giacometti's figures. They have the stark naked assertion of people who have been under torture and no longer feel normal sensation or *any* sensation in the normal sense of the word. The temperamental difference between Tchelitchew and Giacometti is that the latter never had the visceral and X-ray apprehensions that always possessed and haunted Tchelitchew: the anatomic dialectic at crucial grips with its own inwardness. Tchelitchew's anatomy, subcutaneous and celestial, implies *all* sensation because basically it is perfectly healthy and normal; thus (as I said in an article of 1947) nothing is lost by this aesthetic "vivisection." Even what is not visible in Tchelitchew's denuded eyes, skulls and muscle systems of the forties, is present—and in the way, I contend, that Christ's body is present in the Host. Poets other than Tchelitchew have seen the skeleton beneath the skin. Tchelitchew saw— that is, touched—the skin beneath the skeleton.

Suddenly thinking of the artist himself as a wire structure, a man who in person, through ill health, had turned into a terminal, breakable armature, I was overcome with the tragic fact of it because its issue might be fatal. Yet I was exalted by its reference to his virtuoso applications of plastic feeling to the so-called wire structure: to *the idea.* A unity of art and life was his first and last form of heroism. In retrospect, instances of it rush to my mind. Foremost comes what I think his best actual sculpture with wire: the one of Edith Sitwell (he did another of her and one of himself) that was seen in the big memorial show; because so fragile, it was not exposed on the preview evenings. The work was a true presentiment of the future. If previously unknown, it might strike one at an uncertain distance as some exotic immobile bird, stuffed even, imperious on its perch in a cage of glass. It is Tchelitchew's most brilliant portrait of the many he did of Dame Edith. As little facial resemblance as it bears to the canonic Dame Blanche that culminated in *Inachevé,* one feels it fundamentally to be a version of the *anima.*

Despite its chronological place, the exquisite head of wax on a wire armature (technically a mask) relates to the earliest form of what Tchelitchew termed his "wire basket idea," which came to have a plastic genealogy both copious and very subtle. In the most accurate sense it was a kind of transposable plasma capable of various corpuscular forms: it is detectable as the pseudo-seaweed I have pointed out in *Inachevé* and it denoted the sea in an important Tchelitchew of 1926: *The Ship.* This basic plastic concept (the Celestial Physiognomies' first unit of life) derived from the artist's fascination with a commercial object intended for household use. One day, while Tchelitchew and Tanner were living in Blvd. Montparnasse, the latter brought it home from a local dime store. It was simply a continuous set of thin interlocking wire ovals—usable as bowl, basket or collander—that could be freely flexed into different shapes and turned inside out. It exists statistically as a container for fruit in *Pears in a Basket* (ca. 1928). That an actual market bag of string, holding vegetables or fruit, was its natural kin, became evident when repeatedly Tchelitchew used the market bag as pun for the human stomach in *trompe-l'oeil* anatomies; once, in a portrait of Gertrude Stein, it punned for female breasts.

More äerial than frail, definitely larger than life, Dame Edith's mask holds the unique secret of duplicating the live human presence. Tchelitchew expressed with it his finest formal understanding of the subject's head and it ranks thus with the greatest portraits of the twentieth century. It was the strength of the mere line, that essentially *wiry* strength, that the artist was ultimately to incorporate by different means in the Celestial Physiognomies. The number of these in the Gallery of Modern Art tended to overwhelm the solitary mask. And yet, out toward the middle of the floor, it inclined its head securely alone. As the artist's chameleon *anima*, a version of La Dame Blanche, this Edith Sitwell is irreproachibly authentic. At first, in its waxen subdued tone, seeming mummified, the mask assumes the hue of life even as one looks: a transmuted blood starts flowing under its "skin." It has no surface agitation of choppy water, as do the persons of Giacometti; it is the flesh of life's last, smooth word. The head's cast and austere declination are religious, as if she were some transformed Madonna, perhaps a saintly empress with an added accent of personal character. She is not so much emaciated or bony as spiritualized. The globelike lidded eyes, the nose's lifted wing, are stark immemorial vestiges: chaste statements of irreducible bulk. The diminished mouth has the solemn unalterable droop of acquiescence to all things in life and death. Unavoidably a plastic factor, the delicate twisted wiring visibly forming the back of head and neck, though schematic in its variant criss-cross, seems to wander, blind, in an artless rhythm of veins: yes, here is the skin, and the flesh, beneath the skull.

There was more than the skull in the depth of Tchelitchew and his works.

Much of his worldliest self was sunk in an unreachable domain at the bottom of his "house of earth." *How* much of him, he was reluctant to guess when it came to a showdown with his conscience. For, always, he played a double game. Coiled in him was the power of pythons, and in spite of his frank sensuality, this could abash and frighten him. With the advent of the tape worm, the Virgin, his astrologic House of Earth (that is, his visceral region), took on a malign aspect which left him in a mood of stoic helplessness. He had relinquished voluptuousness although not sex; this meant simply that the pleasure function of his vitals had yielded the prime place to animal spasms: a desperate hygiene meant to offset his crowding ailments. Everything physical and mental, in the two years before his attack, had frightened and depressed him, tending to make him hysterical and inconsolable. One of the doctors attending him at Salvator Mundi kept telling him that fright, only fright, was keeping his heart at its terribly high rate, that he must calm down without delay. He did not calm down. He remembered that his regular doctor, convinced of his psychosomatic temperament, had urged him years ago to forget his ills (colitis, fatigue, the tape worm) and eat what he pleased.

For many years now, he had been accustomed to a persecuting fibrillation of the heart. His New York doctor, A. L. Garbat, a friend and admirer, was kept informed of his health by correspondence after he left America in 1952. Garbat found reason to compliment his old patient on his scientifically thorough awareness of his own case. Faithfully giving answer, he reassured him however that fibrillation was not necessarily disastrous and could be "lived with"; if Tchelitchew took good care of himself (there was nothing organically wrong with his heart according to his history), Garbat thought that he need not worry.

Two sentences from a letter to the Zachary Scotts substantiate his bad conscience on the score of taking "good care of himself." He wrote: "Probably these five years in Europe have been more than trying for my poor heart and body. It is all my own fault." His mind here, in fact, dropped to the level of sheer bad conscience after having visited the illuminated dimension of fate. Had he not told Ford, a little more than a year ago, that he was killing himself, and that "the highest form of death" was "self-sacrifice"? With what had he been killing himself? With whatever, his hands had been his guide and "exe*cu*tor."

Less and less, Tchelitchew felt in his body the true feeling of *flight*. Arriving at the foot of his observatory of the stars, the penthouse, he still tried to read his fortune every time his eyes wandered to the heavens—his hands, that is, would seek it. I remember his desire to take me to see the feeble ruin of a temple to Fortuna near his home in Italy. He pronounced the goddess' name with a caressive lilt and said that of course it was, this temple site, the very highest place around. We never went. Now he had to negotiate five flights: the weeks went on and the elevator was still inutile.

The observatories of the first astronomers in the Middle East were magnificent sacred buildings called ziggurats. Archaeologists have been struck by the fact that, at their entrance, it was customary to place an unusually high first step—too high for mere men to take with their natural span. The mythologically-minded then asked: Was it perhaps meant for a God's span? Tchelitchew's little ziggurat, where he presumed to consult the figure of his fortune, had a step five stories high. When he returned from what can only be called the performance of his show at the Galerie Rive Gauche in November, 1956, he was not in a condition to take it easily.

For he had come back quite breathless. In recent months, a certain manual impotence had actually overtaken him. The ruler still secured the fixity of his dancing boxes, but in handling things casually he had begun to drop them. The embarrassing accident became so frequent that Ford noticed it and worried. Well he might have. Every sensitive observer was aware that Tchelitchew had taught his soul and his hands to spread their wings. How dolorous, then, it was to see, reposing in the ample, gracious apartment of the Zachary Scotts (in the wonderful old Dakota building in New York), a bronze cast of Tchelitchew's hands folded in death! I missed in them a certain feeling of majesty, of large implicit soaring, that should have been evident: they did not make the immense statement of the skies that I had expected. Of course, I had heard of the cast but not seen it till that moment. There are two bronze casts of the original plaster mould, the other being in the possession of Mme. Zaoussailoff. Ford eventually explained the source of my curious disappointment in this sacred object.

Tchelitchew had been interested in a young sculptor, Dmitri Hadzi, who was then in Rome, and immediately on his death, Hadzi had come posthaste to the hospital to make a cast of his hands. Ford's diary speaks of his first sight of one of the bronzes. Knowing Tchelitchew so well, he knew the imposing though not especially large size of his hands. They were so expressive of strength, however, that Edith Sitwell, in the most beautiful statement she ever made publicly about her friend, speaks in her autobiography of a sight she had of him shortly after their first meeting: "The snow was thick on the ground, and he was leaping in the air and clapping his large painter's hands together, because the snow reminded him of his childhood and youth, before the misery and the grandeur began." Crestfallen, staring at the cast, Ford said to Hadzi: "They look shrunken!" The explanation was a technical one and Hadzi supplied it: both the original plaster and the subsequent bronze shrink in the process of drying.

If the casts of the hands were too small, the brain itself (so the Mago had said) was too big. The psychology of magic, for which an imagined diagram is more valid than an X-ray, overlooks the discrete relation between physical size and visual metaphor. Undeniably, it was the instrument of his hands that had put Tchelitchew "at the head" of things and shaped for his friends the

authoritative legend of his art and his life. Mercury's head and ankles are winged; so, for Tchelitchew, were the hands of his patron divinity. Yet now the sinew and bone behind the figurative feathers could only be still and tremble for the shame and terror of being flightless. Tchelitchew would heed every sign he passed in the skies of daily flight. Born under Mercury, the planet closest to the sun and circling it most frequently, he felt his position permanently advantageous: he would outstrip everyone. When he learned that Allen Tanner was born under Libra, the Scales, he was delighted with the portent. Regarding human anatomy, Libra refers to the hands. Tanner was a pianist, and through his own hands Tchelitchew was lifting himself in the sight of men and at last had devoted his labors to the creation of a Celestial Physiognomy.

Faced with the social ritual of preserving the essential forms, Tchelitchew never hesitated between the claims of common sense safety and those of magic instigation; however much more tiring the latter, he invariably chose it. Like the rest of him, his hands were already tired in the very act of gripping the hands of people attending his latest show in Paris. Christmas was almost here and still he had not recovered from his great fatigue. Every holiday season he would send the standard wishes flying in all directions to his wide circle of friends and this Christmas would provide no exception. His letters were sometimes brief but always had the hearty ring that one could detect like a voice issuing from the rapid, nervous, strong rhythm of his pen strokes. There were so many letters to write each season, and he wrote them at such high speed, as Ford says, that he could easily upset his stomach this way, possibly bringing on an attack of colitis. The spasms of his colon, the spasms of his good will: *both made him run too fast.*

This year, he started composing his letters about ten days before Christmas. One of the first was received in New York by James and Minnie Fosburgh, two inveterate friends. "Dearests Minnie and Jim," he began with carelessly charming redundancy. The "dearests" was not merely an unconscious, incidentally endearing solecism. Tchelitchew wished to give everyone his due, even a bit more if possible; hence the double greeting was an enrichment of language: it expressed a cognizance of the individually merited affection he had for each of this married pair. The public melodrama of a war threat, he informed them, perhaps to take effect at midnight of the day his show opened, had been a false alarm. "In 24 hours," he wrote, "it all cleared up politically and the pictures are all gone [i.e., sold]." He was especially excited by the sell-out because, as he continued, "12 out of 18 remain in Europe." This meant a long wished-for dream come true: his popularity in Europe seemed to be oustripping his popularity in New York, hitherto the stronghold of his success. "All this, really and frankly," he added (I am afraid rather disingenuously), "without help from pushers and promoters—

only friends' efforts and thoughts." By the latter, he meant something quasi-magical, something socially rather than commercially "practical." The fact was that the Rothschilds and the Vicomtesse de Noailles, among his more loyal French collectors, impelled others to imitate them merely by their example. Such is noble ease in the spasms of the art market.

Panting is not easy to convey through the ceremonious, conventional language of the holiday greeting. But, as Tchelitchew's handwriting told his correspondents these days, anxiety and haste are as communicable by the hand as by the word and its rhythms. His limp calligraphy leaned forward in the slant of a runner desperately trying to reach the tape ahead of his exhausted strength. Obviously, Tchelitchew believed that his friends could lend Mercury help with extra lung-power: "I think in general," his letter to the Fosburghs continued, "that friends' thought and love is a great magic engine; it can crush all opposition, all "ennemies.' " Why did he put the word, enemies, in quotation marks? Conceivably because he was unsure of its spelling—but considering he was aware of his liability to misspell, such a scruple would be rather special. In fact, he invariably put two n's in "ene-mies," and probably because the French (*ennemis*) is so close to the English. Self-consciously, he knew that calling a vague group of people by so nasty a name, he might (according to superstitious belief) magically call evil upon himself. My notion is that he may well have regarded the word with unusual daintiness because it resembled "enemas," which recalled the ambience of his trial with the tape worm. Especially in his breathless haste, misspelling, he knew, was a risk to be taken with exquisite abandon. In writing important letters of a semi-formal kind, he would get Ford to correct what the latter termed his "abominable English," but to friends this precaution was as undesirable as it was unnecessary. His English was among the things idio-syncratically Pavlik. Mere distortion? That made the things named the less recognizable to spirits that might resent them and retaliate.

Tchelitchew felt close enough to the Fosburghs to be confessional. "This exhibition in Paris was a dreaded thing to me. As I knew how one has to watch one's step there. People are very confused but they see immediately the real world and a very serious one to [sic]." He was referring to the war atmosphere and one could never accuse him of false piety. For him, worldly pieties (all social and political conscience) were adequately covered by the concept of protocol, to which he had a morbidly attentive sensitivity. His customary bad spelling was apt to emphasize his feelings unexpectedly. Invariably, it is my repeated impression, he dropped an "o" from "too" as he did above. Actually, Tchelitchew had an instinct to exercise the widest economy. This had been ingrained in him ever since the Russian Revolution had reduced him and his family from riches to poverty. It might be called to his attention that "too" means something altogether different from "to." The

extra "o" on the all-important infinitive might still strike him as a pointless expenditure of energy.

More than a matter of personal temperament, his confessed dread of Paris and its imperious attitude toward art and other conventions, new or old, was eerie in its superstitiousness. In 1954, friends of mine, the Norman Borisoffs, had been invited by Tchelitchew to his current vernissage. Mrs. Borisoff, wanting to pay this charming man a simple compliment, brought a bouquet to the gallery. To her amazement, the artist looked much embarrassed at its presentation. "Thank you very much," he murmured nervously, obviously intent on getting the bouquet out of sight, "but one doesn't"—he managed a crippled smile—"put flowers up in a gallery." He had dropped his voice with kind indulgence. In a twinkle, the bouquet was whisked away. Not he, but Paris, was (or would have been) shocked by the gaucherie. It happened that once I had indicated to Mrs. Borisoff that Tchelitchew debonairly flouted all conventions by repeating his remark that a truly fashionable woman is moved to wear a new hat upside down. My friend was deeply impressed by this idea and realized now that it was to its author that she had really offered the bouquet. The explanation for Tchelitchew's behavior is simple enough. He was certainly never a slave to chic. But all high and viable custom, all reigning protocol, commanded his superstitious respect. That was the substance of what he meant by having to "watch one's step" in Paris—and that was all he meant.

The success of the 1956 show, he told the Fosburghs, was "like a stone fallen from my heart." If it was, it should have improved his breathing and his general health, but it is doubtful if it did. He was already, as the same letter to the Fosburghs complained, anticipating the next great exertion in store for him: his return trip to the United States. "Now my visit," he said, "is also a difficult step, a comeback to Manhattan after five years of abscence [sic] and in the meantime the nonsense of abstractions etc grew denser than Johnsons Grass. Oh these 'Herculean tasks' - the cleaning of the stables of Augeas! I wonder who has the forces." The implication was, of course, that he hoped *he* had. He certainly desired to have the "forces"—a significant plural for he never used the singular—with all his heart. So many statements by him attested to this desire and yet in all reasonableness he could not, at this point say he was ready for the task. "Much work before [me]," he rounded off this letter, casually dropping out the pronoun of the hero, " - but I need rest, rest, *rest.*"

When I saw the magnificent and startlingly divinatory figure of his *Mercury* (bought unseen from the Paris show, on excellent advice, by Mrs. Lloyd B. Wescott), I could not help being arrested by the fact that the figure of the flying god and the speediest planet is seated in a kind of crouch as if immobile on the ground of the starry void; that is, the form we see in the

celestial web Tchelitchew has painted, though itself composed of the usual spirals, is not found in anything like the traditional attitude of the god's statues and pictures. The faceless figure, with none of the god's regular accoutrements except for a hint of the hat's brim, somehow suggests the shrouded moment of a distance runner taking time out on the roadside. If one remembers that Mercury is, among other divine things, the spirit of speed, and that Tchelitchew was in dire need of a long rest when the picture was sold, the pose has a dramatic impact. Nor can one avoid noticing that his Mercury's wrapped-up posture is not only curiously foetal but suggests the way certain primitive peoples swathed and trussed their corpses for burial. I think of La Dame Blanche, too, her features close-coiled like some ineffable tape worm in the breast of the Phoenix! Tchelitchew might be able to sketch her but he could do very little else. He could not fly to America or walk upstairs or even do anything with the stars but look at them from afar.

Even when on the penthouse terrace, he felt himself at the foot of the ziggurat.

It was not yet 8:30 on the evening of July 31st, 1957. Telephone lines between Rome and Frascati were in confusion. Two parties were trying to reach each other at the same time. Two calls, not one, were coming from Salvator Mundi Hospital, the other from the Frascati penthouse which Pavel Tchelitchew had abandoned forever; they could not connect. On different floors two of the Hospital's nurses, Sister Dora and Sister Adelaida, were phoning Charles Henri Ford at Frascati. Minutes and minutes passed. There seemed to be a conspiracy on the exchange not to let the two calls make contact.

With a start of muffled pain, Ford was reminded of that other call to Salvator Mundi after Tchelitchew had wakened, his lungs flooded, and told him to phone for an ambulance. Then the artist had thought of calling a lung specialist to his side, but thoroughly frightened by his symptoms, had capitulated at the prospect of the hospital. But he had not wanted Charles Henri to drive him: he must have the ambulance. There was fuss even before it started. A handkerchief to his mouth, he lay gasping. Telephones! They could be *so* irritating.

On East 55th St., where the two had had their New York penthouse on the 16th floor, the telephone (before the days when the ring could be controlled by an attached switch) had had to be relegated to the closet and covered with an overcoat during the mornings when both of them worked. Yet how Tchelitchew had loved to talk on the phone, never for a moment recognizing it as a hindrance to absolute communication, including gestures that became the more expressive since they were invisible to the person at the other end. If only phones were more communicative in themselves: they might at least be instantaneous.

On Tchelitchew's arrival at Salvator Mundi, a large, very new building with well-running elevators, the doctor had been most concerned over his palpitation. "Take it easy," he told him in the soothing manner doctors are apt to assume in crises. "Your heart could win the Olympic Race!" Immediate X-rays of Tchelitchew's chest indicated tuberculosis but this reading was

abandoned almost at once. The artist's regular doctor, A. T. W. Simeons, was on vacation and his return would have to be awaited. Meanwhile . . . Then the artist's heart calmed down. The encouraging verdict came that he could be out of the hospital in twenty-four hours. Was the attack over?

Not according to Tchelitchew's own cry, "Je suis foutu!" ("I'm done for!") It had hit Ford's ear so suddenly, that terrible Christmas morning in unawakened Rome, that he had not had time to repel it. Like a liquid poison, it had seeped in and it took days and days to go away. The hospital doctor, G———, favored the theory that Tchelitchew was lucky to have survived a serious heart attack; the blood-spitting, he thought, was not in itself significant. Yet he believed the patient still in some danger. At last, on the morning of December 25th, Tchelitchew was given a sedative. Privately to Ford, Dr. G——— conveyed that the X-rays had uncovered T.B. scars, old ones of which Tchelitchew may not have known. Perhaps the all-seeing Mago of the Tape Worm had overlooked the scars even if now his diagnostic theory emphasized their importance. The artist's heart had been increasingly bothersome to him in the past few years, though without exception every examining doctor had assured him there was nothing "wrong" with it. After being told that Tchelitchew could not talk, Ford left promptly for Frascati.

"I'm a strange man," Tchelitchew informed Dr. G——— before getting to sleep. It was a tactful hint of a who's-who kind. Did it register? The next evening Ford learned that on taking a sleeping pill and resting, the artist now felt better. The day after Christmas, Ford found him agitated, however, breathing very rapidly. The "Olympic racer" apparently could not "run down." Why should he? The race had not ended! When Tchelitchew insisted on a heart specialist from outside the hospital, Dr. G——— was offended. He had duly pronounced the artist's condition "serious" and wore an appropriate expression. But apprehensively Tchelitchew recalled that Simeons had once termed G——— the hospital's "concierge." Mercilessly the concierge had shown him, spreading his hands apart, just how big his heart was. Indelicate, to say the least. Ford was on the verge of tears at the spectacle of the artist's agitation. His pulse rate was still 120 and he could see Pavlik's chest visibly panting through the hospital shirt.

A war of prima donnas between doctor and patient seemed forecast. Ford wondered if it was out of spite that Salvator Mundi's doctor said he could not "read" the cardiogram that had been taken. In any case, he was sure that G———'s hard, impatient, somewhat contemptuous manner was upsetting Pavlik and that the doctor seemed actually unaware of Pavlik's identity. Maybe he was just insensitive to protocol—but that was just as bad, if not worse. Ford continued to be alarmed by the mere sight of his dear, irreplaceable friend, with whom relations had grown so "impossible." Yet it was not the impossibility of present relations that mattered, but the sweetness and

preciousness of past relations. Even when Tchelitchew seemed a little better the next few days, Ford felt disturbed. Tchelitchew told him that the sleeping injection had given him nightmares in which he believed himself about to die. Charles Henri himself had a hangover. The night before, in Rome with a friend, he had gotten drunk and vomited on the train back to Frascati.

Tchelitchew's ills piled up now as they had done for so many years. He even had conjunctivitis: one eye, Ford noted, was "all pussed up." The artist said, however, that he liked the German nuns; also a new Italian nun despite the fact that she was "stupid and unwilling." He retained his dislike for a Chinese nun who had once called him "stupido," years ago when he was having tests for the amoeba, because he had misunderstood a direction about depositing his stool. The verdict of pneumonia as the chief cause of the artist's clinging illness was now positive. At his next visit, Ford heard that the oxygen tent had been beneficial. His tension was eased but aroused again at the size of the blood clots Tchelitchew was still bringing up. Antibiotics for pneumonia were being given by injection. Though the cultures for the sputum had turned out negative, it seemed they might become positive at any time. A week from that day was the time set for Tchelitchew's release from hospital.

The lung specialist, Dr. L———, who came on the twenty-ninth, prescribed a heart stimulant and said Tchelitchew would be home in five days. His diagnosis confirmed G———'s but more medicine was his only prescription. Tchelitchew took the stimulant reluctantly, convinced that it was "wrong." To his chagrin, Ford had not discovered, despite questioning the doctors, just what an enlarged heart portends. Tchelitchew was feeling nauseated and feared the lung cancer which had nauseated his friend, Florine Stettheimer, and from which she had died. On New Year's Eve, although agreeably companioned, Ford felt lonely amid the audible gayety of horns and firecrackers. Next day he found Tchelitchew feeling better than ever. But he told him of visions, probably induced by his sedatives, that recalled the settings of his painting *Phenomena*, the Hell of his trilogy. He had seen, he said, "whole towns made of rags." The rags came alive and there appeared "wavy doors of straw" which water would invade, out of nowhere, making weird patterns. The image was so full of obvious implication as to make both of them tongue-tied. At such a time, the most alarming omens registered like anything else. Good things, bad things: all seemed completely homogenized and indefinite. Was not the very clock marking time and doing nothing else? Ah, time, at last, was *pure!*

In a few days, expecting Tchelitchew out very soon, Ford found him more "normal-eyed." The artist told his doctors that his heart actually felt better than it had six months before but added that, after this, he was sure it would

never be the same. Another week was almost over. The patient, though still in the hospital, could sit up in bed: he had expected to be able to walk by now. Then Ford heard something that was perhaps not so indefinite or homogenized. A young painter, visiting Tchelitchew, had been asked to pay the hospital bill in Ford's absence. Speaking to Ford afterward, he had ventured to repeat something Tchelitchew had said. It was: "Charlie doesn't love me any more." In substance, that had been said hundreds of times, to his face, in the past ten years. The present accusation, made to another, had a curiously upsetting edge. How many years ago was it that Ford had written in his diary: "I think, I think Pavlik loves me"? At any rate, that moment was in the past, for now, regardless of whether he, Ford, reciprocated, nothing was the same for either.

Tchelitchew's morale, to all appearances, was emerging as excellent. The artist said of the nuns: "Their kindness is beyond praise." But he also told Charles Henri how close he had felt to death. "I myself was not I," he said, "I was outside, a little bird, like one sitting on the shoulder while the tissues fought." Always the mythical vision and with it, like a lover, the anatomic vision. On January 10th, feeling "like a little child," Tchelitchew had walked about his room. On the twelfth, when Ford brought along a young friend, the artist could joke: "When the Roman Empire comes in to wash me . . . " He referred to the Italian orderly. Before Tchelitchew's return home, now scheduled for the fifteenth, Dr. Simeons was expected back from his vacation.

The general signs began to be "good." The artist's voluminous letter-writing, which had of course lapsed, started again. He visualized himself carried "packsaddle" up the five flights to the penthouse by two strong young men. Duly returning, Dr. Simeons took Tchelitchew's heart condition seriously and said it would take long to mend. This was a truly "homogenized" statement. What was really good, what really bad, anymore? There was something called life: that was all. Even time had managed to efface itself, as if ashamed, from the clock, whose hours meant (all the same) life or death. Tchelitchew kept his heart medicine beside him. Just now, he began realizing the full extent of his weakness: the toll of all the antibiotics he had taken; one of the nuns, he reported to Charles Henri, had exclaimed loudly at the sight of the numerous punctures in his poor behind. Simeons agreed that Tchelitchew could never again climb the stairs to his home and suggested he find an apartment in Rome. The artist vetoed the idea if only because, in little more than two months, he was scheduled to return to the United States. Now this previously repellent prospect almost had a charm. Alone with Charles Henri, he told him how much he had cried. "Cry a bit for me," Ford rejoined. At this, they found it hard to suppress the tears that suddenly welled up and pushed hard against their eyelids.

They were readying themselves, psychologically, for the return to Fras-

cati. Still stretched on his bed, Tchelitchew accused Ford of having broken his heart the last few years and even referred to the ill which he declared Ford's mother had wished him. When her son had been confidential with her, Mrs. Ford had merely said that since separation from Tchelitchew was inevitable, the sooner the artist realized it the better. Had Pavlik "guessed" her attitude? Even so, that was not wishing him ill. Magic used against him: this was one of Pavlik's pet manias. It became especially painful because the previous winter Mrs. Ford had been killed in an automobile accident in Mexico. Ford was positive in denying his mother's ill will and was relieved when the artist seemed to retract by suggesting that Don Giuseppi say a mass on the anniversary of Mrs. Ford's death, now two weeks away. It was time anyway, Tchelitchew added, for the apartment to be blessed again.

When, on January 20th, Tchelitchew was still unable to leave Salvator Mundi, Ford asked Simeons for a clear picture of exactly what had befallen the artist. The doctor replied that he had passed through a very critical time and had been in danger of death from a flux of blood in the lungs which the heart had been too weak to take care of. Tchelitchew had experienced a curious reversal of feelings about Dr. G——— and Dr. Simeons. At this point, Ford believed all the latter had done was perfectly right. While still resenting G———'s manner, however, Tchelitchew liked his coming in his room to talk of worldly extraneous things and so take his mind off his illness. On the twenty-second, after having had gas pains for two days, the artist had a vomiting spell and felt worse. He was very tired and asked that no visitors but Ford be admitted. The hospital food, he complained to his friend, was uneatable.

Although soon found sitting up again, Tchelitchew complained of his shakiness. Today, at Ford's visit, he was utterly disillusioned with Simeons, who, he said, knew all about the stomach and intestines but really nothing about the heart. In turn as he felt better or worse, evidently, his doctors pleased or displeased him. He had been told, he imparted to Ford, that he might live ten more years even if no cure for his particular condition was discovered. Early the coming week, moreover, he was again due to leave Salvator Mundi. On the twenty-eighth, Ford entered his room to find him being shaved. The patient gazed at him silently, shaking his head (when free) slowly from side to side. Ford sensed oppression in the air; lather covered Tchelitchew's face as if it might be smothering him. When the shave was over, and the maid who was clearing up had gone, the bad news came out. During the night, he had coughed up more blood and an injection plus pills had failed to put him to sleep. He moaned pathetically, "I thought I was losing my mind."

It was a compromising note because soon Tchelitchew was saying, with deep resentment, that Dr. Simeons had joined the camp of those who thought him "a mental case." He looked sharply at Charles Henri because he had

believed his mother belonged to this group. In retaliation, the patient decided that G——— was a gouger and Simeons a fussbudget. This was rather weak stuff from a man given to warlike epithets. The anticlimax of the illness was all the darker, too, because the day before Tchelitchew had been up and about the room and had enjoyed his dinner. A new X-ray, moreover, had shown improvement of his original condition. By the twenty-ninth he was full of energy again and resigned to returning to the unattractive penthouse. In expectation of this event, Ford had warned their landlord that it was imperative the elevator be in running order. The artist was still coughing but now the sputum had no blood in it. He still felt something wrong with his chest. Dr. Simeons, however, would not listen to his arguments. Tchelitchew was prompted to render a more concise verdict on his medical gifts: "He is a great man from pubic hair to navel."

Simeons' medicines, especially the sleeping medicine, seemed to work, yes, but there were so many of them! Ford had brought him on this visit his little gold chain of three medals which he always wore pinned to his shirtfront: a Madonna of Lourdes, a St. Anthony and a Madonna of Loretto. He put it on, saying, "Now I am a real Christian." First, Tchelitchew was a cavalier; second, a believer in religion. There was no reason for him to remember that during the Second World War, when he corresponded intensively with Edith Sitwell, he had didactically declared that every church vestment hid a pagan heart. Theoretically his medals were transposed with a change of shirt, but at times the chain had gone into the laundry and Tchelitchew could not rest till it was recovered. Now it could not take his mind off Simeons and his numerous medicines. "He's a fraud," he said in grim disillusionment. The artist's mail had risen to floodlike proportions and he kept track of those who wrote and those who didn't; exactly what each one said was carefully weighed. He caught fresh cold and was dismayed to hear a new antibiotic recommended. Was there another crisis in view? Ford wondered if they should complain of Simeons to the lung specialist.

January passed. Ford hated coming to this insolently high modern structure, Salvator Mundi, beautifully equipped with elevators: he knew the chief reason Pavlik himself was reluctant to come back to Frascati. On February 3rd, a new culture was taken of the artist's sputum and streptococci were found. Penicillin was forthwith administered. Ford too, besides being involved with a love affair, had caught cold and so he stayed away for several days. Pavlik appeared in his thoughts prostrate on his bed and talking, as he did now, with eyes closed. A Dr. B——— had taken over and had changed the artist's medicine. Sister Adelaida, once a favorite with Tchelitchew, was in disgrace with him because, it appeared, she had tattled to Dr. Simeons. The patient was quite weak yet it was with remarkable vigor that he repeated to Charles Henri a little exchange between himself and Simeons:

SIMEONS: The only way to treat you is to be cruel and bully you.

TCHELITCHEW: The only way to treat me is to be lovey-dovey. If you're going to be cruel and bully me, watch out, you'll break your horns!

The ram (or *tchelo*) motif . . .

Obviously, Pavlik was better. Indeed, he steadily improved from then on. On the eighth, his blood pressure (it had been too low) was up and his blood count satisfactory. Still, very little was required to upset the action of his heart; once, it had been only because the man who washed him every day was late in arriving. More important, he and Ford now argued over where they would live in the United States. The latter favored their old home, New York City, where his sister resided; Tchelitchew now wanted to live in Denver because of the Palmer Chiropractic Institute. "Imagine!" thought Charles Henri. "He's thinking of chiropractics!" The discussion ended by the artist's saying: "Call Sister Catherine. Tell her my heart dances."

St. Valentine's Day came along. It was warmly, appropriately celebrated by Ford, who never failed to have tardy pangs of conscience about such private liberties. When he saw Tchelitchew again, he was walking the hospital corridor on the arm of a male nurse. The thought crossed his friend's mind that he was still too ill to put on the "seduction act" he practised on men, women and children, innocent as this form of coquetry might be. He found that Pavlik was worrying about the extension of leave from his adopted country, for it was clear now he would have to ask it. For his part, Ford was seriously preoccupied with the project of adding a third member to their domestic establishment in Paris. In his opinion, as he felt privately, Pavlik would never be able to travel back to America, and according to his present plans, Paris would logically become their home.

One very, very dark hour was spent between the two discussing the possibility of a new will. Aroused, but somehow like a stone, Tchelitchew said to Ford that he could promise to leave him nothing. The fact was that, apprised of the proposed *ménage à trois*, he dearly objected to it. At last Charles Henri reluctantly, but with good grace, withdrew the proposal. Then, however, he thought it fit to criticize Tchelitchew for his general bitterness. He told him he should be less hard on those who had done much for him instead of complaining that they did not do more, and ended by saying that he was betraying his own greatness. Suddenly, with their hostility at its height, the inherent truth of the situation overwhelmed them and automatically the course of their thoughts changed. Tchelitchew was a sick man and would be one, perhaps, for the rest of his life. Ford was a healthy man: so healthy that at this moment he was ashamed. In his sickbed murmur, Tchelitchew intoned:

"There are two worlds: the world of the sick and the world of the healthy."

"But there are really three," Ford replied, "the world of the living, the world of the dead, and the intermediate world of the invalid."

He knew how steady his eyes could be; he tried to keep them unblinkingly on the face of his poor, dear, great friend: the friend of his lifetime. The friend of his lifetime still looked very distressed and did not answer.

They were both right, I think, about the worlds they were invoking. But a further truth of the matter is that Ford's three worlds, psychologically, make up the world of the healthy. It was not the technical division that mattered but the degree of participation in this world or that. Ford, being alive and healthy, had known but one world. Perhaps this thought passed through Tchelitchew's mind and enjoined on him that most pregnant of all truths: a speaking silence. When necessary, the ill make their supreme comment simply by eliminating consciousness of *the* world. Yet the artist was still well enough to be aroused by Simeons' refusal to give him vitamin pick-up shots.

Tchelitchew swore he would pay his bill, however high, rather than give him the colored crayon drawing he had decided upon as proper remuneration. Shrewdly he complained by way of Sister Adelaida and got the shots from Simeons. Momentarily, doctor and patient were all smiles with each other. Then Simeons dared to pay him a visit with a cold. Tchelitchew, forewarned, received him "Turkish bride style," as he said, a towel wrapped around his face for protection. Through a slit in its folds, he told Charles Henri later, he saw the guilty man blush.

By March 7th, Tchelitchew was home. Yet he and his doctors, not surprisingly, remained of different minds. Dr. B———'s opinion was that the artist's heart suffered from progressive sclerosis. Dr. Simeons went further and declared there was a murmur and a valve lesion. They would allow him to paint and to take his constitutionals, but not to swim (there was no danger of that) or to climb stairs; in other words, nothing strenuous was possible. After talking privately to Ford, Dr. Simeons informed Tchelitchew: "Charles believes only what he wants to believe." Yet it was only Tchelitchevian, after the artist's death, for the poet to tell Choura, "He was not only a body, so he is not dead." Undoubtedly, Tchelitchew's bosom friend had his way of being consistent. The artist duly reported what the doctor had told him. To his diary Ford admitted that it was true. He did not wish to believe that Pavlik was as ill as he was: it was that simple. He felt encouraged because Tchelitchew was beginning to look something like his old self again.

On the other hand, writing even one letter tired him. In an assiduous letter writer, whose correspondence was lagging, this was hard to overlook. Trying to behave like a convalescent, the artist became moody. On stepping to the ground before the apartment in Frascati, he had said, seemingly uncheered by his return, "My heart is half stone." He could scarcely believe he was out that hospital and felt, he told Ford, that in the ten weeks he had spent there he had been quite alone. Ford did his best to understand and to help. He even tried to understand when Tchelitchew (still carried upstairs because even a conspiracy with the other tenants had not produced a working elevator) said to

him that the words of "a healthy person" seemed "like a dagger in his heart." There was nothing to be understood or even thought when later the artist had exclaimed: "I've hardly been here six weeks and you've stabbed me to the heart again." Why? Ford asked himself. Because his plans for the future were those of one who expected both of them to live? But Ford knew himself helpless, fundamentally, and lived in a sort of forced, reciprocal hysteria, only different from Tchelitchew's in that it was better suppressed. If he knew what might, on his part, produce in Pavlik a tragic reaction, it was only something which both knew had been true, and evident, for many years.

Earlier, Tchelitchew's mood had improved after his arrival. Yet Ford noticed his swollen feet and was told that his night sweats had begun again. About a year ago, Ford recalled, he had complained of swelling in his fingers and of feeling faint; also, of "dark water in front of his eyes." Charles Henri had blamed it on the weather. Now Ford wondered if it had not been a premonitory stroke. The night sweats ceased. Suddenly the artist said he was sure the tape worm was bothering him again. Had the fatal egg of a female been hatched? Indeed, did a woman abide in Tchelitchew and go through transformations? It has often been said that one exists in every male genius—and in a sense different from the *anima* that appears in dreams.

Ford could not even shudder any more. He felt in Pavlik's presence a general numbness which it was hard to shake off. Getting insomnia again, Tchelitchew resorted to the sleeping pills but after a few nights decided to quit them and take rose-petal tea instead. "In the evening, I tremble," he told Ford one morning in unusually plaintive syllables. It was like a dirge under the breath. "I feel like a zombie," he had said earlier. "I think a zombie took my soul away from me." Ford would have liked not to listen. Once their maid, Gaetana, having observed Tchelitchew's strange avidity for Ford's attentions and his lynx-eyed supervision of his movements, had said to Charles Henri: "He's afraid you'll escape." Escape! He had not, he thought, wanted to; he still did not want to. Yet he saw how, mechanically, the avenues of escape seemed now tightly closed. He dismissed the idea of any choice. He not only stayed; he listened.

But the very air of the stirring Spring seemed changed. It held no "promise." "It's terrible to become an invalid," Tchelitchew went on. "It's the last thing I wanted to be. It's some kind of punishment. I don't know what. That's all what it is."

The artist dreamed he was walking and came to a square hole. There, two flights below, a lily was growing. He wished to give it water.

"Your soul," Ford interpreted.

Perhaps it was the static elevator on the ground, unable to "grow" even as far as the third floor.

Tchelitchew could not work because his hand trembled so much. He had

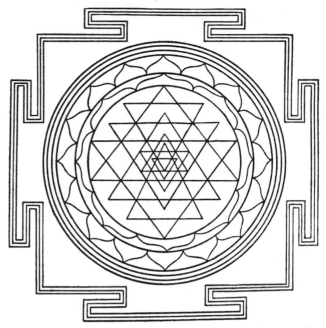

Above: Shri Yantra, Hindu diagram for mystic contemplation.

Below: TCHELITCHEW: *Inachevé,* 1956, oil on canvas. Collection Mme. Alexandra Zaoussailoff. Compare with images of La Dame Blanche on the following page.

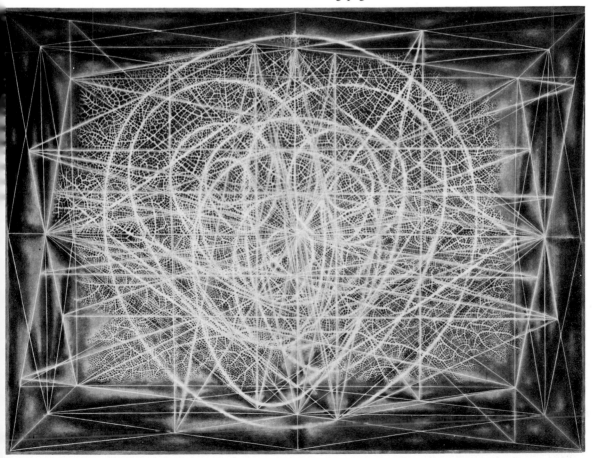

Metamorphosis of La Dame Blanche (Death) into a Phoenix, 1957: Last sketchbook page on which Tchelitchew worked shortly before his death. *Photo: Josephine Powell, Rome.*

TCHELITCHEW: *Portrait Mask of Edith Sitwell,*
1930, wax with sand on wire. Collection of Mr.
and Mrs. R. Kirk Askew, Jr.

St. Juliana, ca. 1376, reliquary bust, Italian. View
of the features on the inside of the *repoussé* head.
The Metropolitan Museum of Art, Purchase, 1961,
Cloisters Fund.

Above: The artist's mother with Fyodor Sergeyevitch Tchelitchew, his father, some years after their expulsion from the family estate near Moscow, Russia.

Left: Nadyezda Pavlovna Tchelitchew, the artist's mother.

Below: Students of the Gymnazia, Moscow, about 1910. Tchelitchew, who would be about twelve, is in the first standing row in light uniform, hands joined before him.

On the wide balcony of Doubrovka, manor house of the Tchelitchew country estate, July 1914. From left to right: Varya (the artist's half sister); Tchelitchew; his nephew, Vova; Sonya (Vova's mother, also his half sister); Choura (his sister); his uncle Mitya.

Croquet at Doubrovka, 1912. From left to right: Varya; Alyosha Zaroudny (Varya's fiance); Vera (Zaroudny's sister); the artist; Manya (the artist's half sister).

Christmas, 1908 or 1909, in the large children's room at Doubrovka. From left to right: Mischa (the artist's brother) a governess; the artist; Natasha (his half sister); Lyena and Choura (his sisters).

Art classroom at the Gymnazia, Moscow, where Tchelitchew studied. Note the cube, pyramid and cone on the wall.

Above: Pavel Tchelitchew, Berlin, aged about 23. The German inscription of his name is polyconsonantal.

Above right: Alexander Roumnyeff (né Zyakine), the artist's chum since their schooldays in Moscow.

Below: Theatre group in Kiev, 1918–19, before a backdrop by Tchelitchew. The artist, in light-hued topcoat, is seated in the first row; to his right, Mme. Alexandra Exter; above, standing, Varya (in white).

Above: Tchelitchew in Berlin, about 1921, before one of his theatre designs.

Right: The artist (custom-tailored to his own pattern) with Edgard Varèse on the beach at Baabe, Germany, perhaps summer, 1922.

Below: Berlin, about 1922: Tchelitchew à la Petrouchka (center, topcoat and hat) with actors and theatre workers before one of his décors typical of this period; his assistant, Joseph Lubitsch, is seated on the steps below.

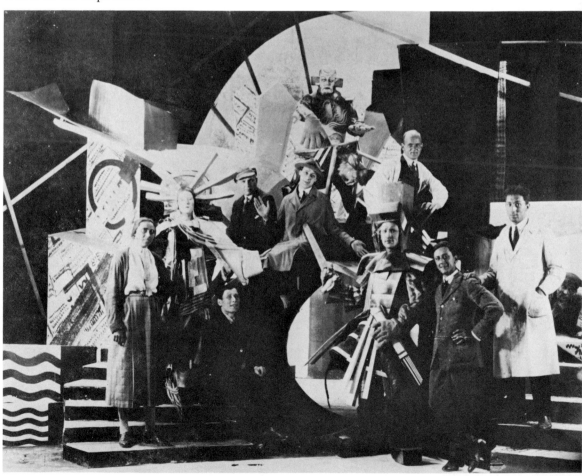

Tchelitchew on the beach at Baabe with dancers and other friends, probably summer, 1922. From left to right, seated: the artist; fourth from left, Catherine Devilliers; standing: second from left, Natasha Glasko; fourth from left, Djanet Hanoum.

Tchelitchew (at left) being the life of the party. Other individuals are identifiable by consulting the caption at left.

Left: TCHELITCHEW: *Portrait of René Crevel,* 1925, oil on canvas. Collection Mrs. Edward Maast.

Above: René Crevel, the French poet who be-came the artist's close friend soon after the latter's arrival in Paris.

Below left: Tchelitchew à la Comédie Française with Margaret Anderson, editor of *Little Review,* late twenties.

Below: Tchelitchew at Monte Carlo, 1928: the foreshortened hand (see opposite page) is pro-phetic.

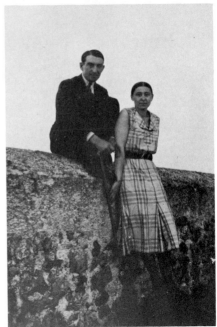

Above: Gertrude Stein seated in Godiva, Tchelitchew and his friend Allen Tanner on the running board, snapped by Alice B. Toklas.

Above right: Prince Pierre Galitzin and his wife Alexandra, Tchelitchew's cousin Choura.

Below: TCHELITCHEW: pen and ink wash drawing for the cover of catalog for his first one-man American show, December 1934, at the Julien Levy Gallery, New York. Collection Allen Porter.

Above: TCHELITCHEW: *Portrait of Allen Tanner,* 1925, oil on canvas. Collection Allen Tanner.

Below: Tchelitchew painting in his studio in the rue Jacques Mawas, Paris, about 1930. Two versions of *The Fallen Rider* are partly visible.

Below right: Allen Tanner, who first met Tchelitchew in Berlin, in a photograph arranged by the artist, Paris, 1925.

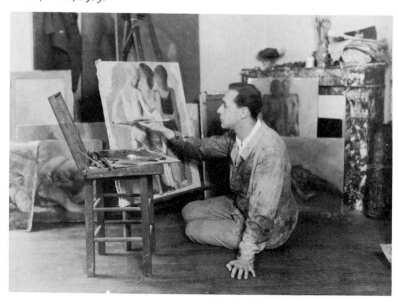

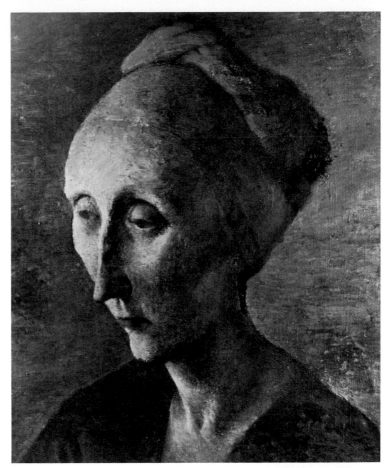

Above: TCHELITCHEW: *Portrait of Edith Sitwell,*
1930, oil on canvas, Collection University of Texas.

Right: Edith Sitwell at Guermantes, late twenties,
before the country house lent the artist by Stella
Bowen (Mrs. Ford Madox Ford).

Below: The artist, Edith Sitwell and Tanner at
Guermantes, about 1930. Compare Miss Sitwell's
head with portrait above.

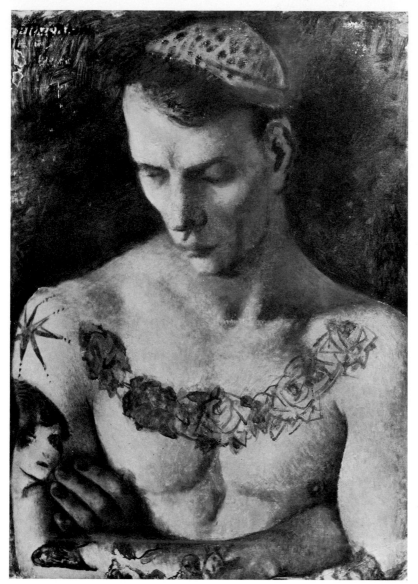

Above: TCHELITCHEW: *The Rose Necklace,* 1931, oil on canvas. Collection Mrs. Edward Maast. Posed by Charles Vincent, the artist's favorite male model in Paris.

Below: The artist and Allen Tanner's mother in the garden at Guermantes.

Right: Charles Vincent, Tanner, Natasha Glasko.

Above: TCHELITCHEW: *Portrait of My Father,* 1939, oil on canvas. Collection Edward James.

Left: TCHELITCHEW: *The Green Lion,* 1942, watercolor (another "father image"). Santa Barbara Museum of Art, Santa Barbara, Calif.

Below: The artist's father in Losovaya, Russia, 1930.

Tchelitchew photographed by George Platt
Lynes in his penthouse studio in East 55th Street,
New York, 1942. The artist's unfinished portrait of
Lynes may be seen directly behind him; a subject
on the Derby Hill theme is on the easel and another
in that series is on the floor behind it.

lost, he said, his imagination. "Nothing makes me happy," he added. "You should be glad to be back," Ford urged him dutifully. "I came from too far away," the artist replied. What can one say to the line of a poem? One only learns and repeats it. He was trying, he often told Ford, to forget the "horrors"—the *angoisses*. Oh, yes, the same *angoisses*, the heritage of his childhood terrors! A perpetual see-saw of health and mood set in. Mostly, as Ford observed in his diary, the mood was "black, very fearful." A black dog, purely hallucinated but always in wait for him in Moscow, had been one of those childhood terrors. Imprisoned by the inactive elevator, Tchelitchew could work up no hope for a future. For him, this failure of an essential urge meant more than for another.

What existed but the future?

After one of the regular examinations, Simeons gave his consent for the artist's return to the United States. There was little cheer in the news. Nevertheless a new date for departure was set and accordingly Charles Henri wrote some of their friends in America. Doggedly, Tchelitchew had resumed his correspondence with a few closest to him. He wrote Kirstein: "I walk for ½ an hour a day twice - but all my body hurts - I have a very short breath - my left ear is deaf (sclerosis too) and can do very little in general with 3 wks notice to leave for U.S.A."

His illnesses in fact were pitilessly on the prowl, returning at all hours of the day and night, staying, tormenting him. He had chest pains and a new attack of diarrhea. The artist's sister, Choura, at last informed of the truth, was expected in Frascati to help nurse her brother back to health. Ford had finally prevailed on Tchelitchew to allow him to write her a truthful account of everything. Yet the artist could neither promise to keep the schedule of the return trip nor agree to the *ménage à trois* in Paris that was Ford's fixed wish. He and Tchelitchew now perpetually wrangled on the subject.

Charles Henri had decided to install his young friend in Paris quickly and have him waiting there on their arrival. He still did not believe that Tchelitchew would, or should, make the trip to America. Suppose that Pavlik should never paint again? he reasoned. Suppose that the artist would be, as he himself feared, a perpetual invalid? Ford had determined never to desert him. Yet he desired a sensible compromise, domestically, as only fair all around. He could not look forward solely to being the great man's Nanny: he was an artist himself. The diarrhea continued and, on the sufferer's insistence, a new laboratory test was made. The report was bad: new *lamblia* were visible.

It meant a Pyrrhic victory over Simeons, who had claimed that the current symptoms indicated only the usual colitis. The doctor utterly discounted the agency of a new tape worm. When the artist told Ford that he was determined to stay in Europe and would immediately return to Salvator Mundi for a complete check-up before going anywhere, Charles Henri could only

acquiesce. He was being swept along by the current of Tchelitchew's fate. Or was it his sick, arbitrary will? There were times when a common sense skepticism overwhelmed him about all Tchelitchew's luridly superstitious intuitions. Well, no matter: there were certain pivotal facts. Ford had received a small inheritance from his mother and now he dreamed of buying a Paris haven for the *ménage à trois*. He would save the great Tchelitchew! He would *force* him to listen to reason; Pavlik would have to submit to his proposal and he imagined the artist himself would begin to see that submission was the better part of his weakened valor.

The days went on and Mme. Zaoussailoff arrived. Though informed of the worst of the artist's past illness, she had been led to believe he was convalescent. Instead of finding him convalescent, as she eventually wrote Tanner, she found him dying. There were still hours of life for Tchelitchew and the clock proceeded to accomplish them. He thought of writing "Linc" (his diminutive for Kirstein) of his dead friends and colleagues: "Bébé and Jouvet and Dougie . . . one never knows . . . it is cold, rough here . . . Oh, how I would like to get a studio pour le reste de ma vie and a Nanny to take care of me!" He meant, of course, a real Nanny, like his old nurse in Russia.

His gall bladder was definitely out of order again. And his breath seemed shorter and shorter. It was time to have done and tell Choura and C.H. that he must consign himself again to Salvator Mundi, come what may! He felt he might be getting a goitre. Choura had one: it might run in the family. As for his family! His dear Papa had had a mania that his children were always sick and that only one remedy existed: quinine. They had been dredged with quinine for years. One of his stomach doctors, not long ago, had revealed that what plagued him was a lack of acid in his stomach. Obviously, the quinine had eaten away his stomach-lining. The moment had come: he said the word to Charles Henri. The ambulance arrived. He looked at Choura. He did not think of her goitre; he did not think of her. He thought only of the rapidity of the wheels.

As he usually did every night after returning from the hospital, Ford was phoning to get the last bulletin on Tchelitchew's condition before retiring. There was no doubt now in anyone's mind that it was a matter of days, if not hours, when the artist would breathe his last. Ford and Choura had left him about six o'clock (their visit would last an hour) to drive back to Frascati. Dr. Simeons had recognized the gravity of the current situation, which had been building up since the artist's return to the hospital in May, and he had specially instructed the nurses to observe the right moment to give Tchelitchew the injection on which the action of his heart depended.

Ford and Mme. Zaoussailoff had come away from the hospital this evening stilled, as always, reluctant as life itself to give up hope, yet inwardly reconciled by the minute to what seemed inevitable and on the verge of being true. Mme. Zaoussailoff afterward wrote Allen Tanner that up to the end she was convinced that C. H. (the artist usually referred to Ford in his letters by his initials) was fighting against the belief that it was possible for Pavlik to die. Something kept holding him to his forlorn obstinacy. The artist was the great ancestor of so much of Ford's being, more so than his true parents, and sovereign of the world of reality that ticked away with every heartbeat of his and Tchelitchew's; that ticked, now, louder than ever, this mutual beat, drowning out everything else.

The friend and the sister were quiet only with the bursting fullness of their reverence for the one who was dying, whom they remembered too well ever to forget. It was not a simple question of love, though what goes by the names of love was variously present in Ford's breast and hers. The greatness of a being who had securely appropriated so much of their lives was what mattered for each, what measured the difference about to be. That his occupancy of their lives had sometimes been neither willing nor smooth and easy, nor always "fated," mattered in itself less than ever. Nor did that Paris haven, the *ménage à trois*, seem either pertinent or real any more.

Ford had confessed, to me and to his diaries, the nature and the terms of the long domestic struggle between him and Tchelitchew, bound to one

another by a law that was puissant, evidently, if only as a design behind Tchelitchew's forehead. As long ago as 1950, laconically, with the driest of gloomy tones, Ford had characterized the domestic state that had come to be almost daily: accusations, threats, insults, denunciations. "The worst," he had called them. We were sunbathing, by ourselves, near Alice De Lamar's swimming pool in Weston, Connecticut. I had expected serious confidences from him on that visit; I had not exactly anticipated "the worst." And to it I could only murmur my unimportances.

There is a mystery beyond love, perhaps a mystery which is the special child of love. It would be a bastard: a divine bastard, half habit half need, one might say, an inutile but supreme hermaphrodite. Ford had been the more passive in the contest since he was younger and was willing, finally, to look upon the past as the past. But not so his life's companion, as addicted as he had always been to casting off the past in favor of the future. Apparently the dissatisfied partner, the one hurt, neglected, abused, "eaten," Tchelitchew was the aggressor, and yet automatically, voicelessly, as sure as the clock, he would retract each threat of rupture with Ford; their life would go on exactly according to schedules hallowed by the decades. More than once, Tchelitchew declared he saw in Ford the visage of fate; he may have come to feel that he could not afford to be mistaken. Hell is, among other things, fate; it might not be too much to say even that Hell is a sine qua non of Paradise.

Without realizing it, the friend and the sister, having had dinner on July 31st, 1957, felt the futility of the oncoming darkness, of the stars' reappearance, of the ebbing of the day's heat. These were not the *true* orders of time. The Moon might appear. But if Tchelitchew had died, it would not be the same Moon. At this very moment, miles away, he might already be dead! Both of them, though from differing angles, held in abhorrence the very rooms where they lived, where they would go to bed tonight: they were the rooms where Tchelitchew had lived and not lived, and which they seemed due to leave, with a shudder and unwilling sighs, as if they were discarded skins. There was to be a moment of unique softness between them after tonight. Mme. Zaoussailoff would come out on the terrace and spontaneously put her arm about Charles Henri. "I know," she said, "it is terrible for you." Their humble, helpless grief became as one; they were sorry for each other, for themselves, for the one who had left. Every harshness between them seemed, now, really healed. But this future moment, they discovered, was illusive, a collusion between fate and the fortuitous. They had bowed to it, adapting their very bodies to its mysterious prompting, its evocation of possibility. Yet it had shrunk between them like a dissolving physical weight and disappeared. Only a certain tenderness remained: that ghostly tenderness that clings to the loveliest of impossibilities.

Ford's niece, Shelley Scott (his sister's child by a previous marriage) had

arrived in Rome and twice seen Tchelitchew. In Venice, the Zachary Scotts had been ready to fly at instant notice to Rome. But since the medical opinion, on July 29th, had been that Tchelitchew was "holding his own," Ford had wired his sister to that effect, and they had not taken the plane. The artist, though very weak, had been touched by the charming young Shelley's devotion and had made an exception by consenting to see her. Choura had frowned at this irregularity. She was certain her brother's life, at least its remaining duration, depended on quiet, and that his hand had been forced on Ford's mentioning that his niece had come. C. H. had replied that the artist had given Shelley his first big smile for quite a while. This was, Choura thought, Pavlik's inveterate, limitless kindness! Charles Henri should still not have spoken.

Ford and she had taken Miss Scott on an excursion to the Villa d' Este at Tivoli. The poet found that somehow the gardens there "were less enchanting, less mysterious than before." Perhaps the summer season, he speculated, had something to do with it: so he reported that night to his diary. He knew quite well what was the real matter but the human desire not to credit the imminence of a fatality is the most lawless thing in the conscious universe. Ford felt disappointed that the breasts of the Sphinx at Tivoli were not flowing, and hypocritically he "guessed" that his "disenchantment may have come from that." So much water flowed at the Tivoli gardens. Why not *that water?*

Hanging in the minds of Ford and Mme. Zaoussailoff was Dr. B———'s pronouncement, made a few hours before, that Tchelitchew's condition was lower than at any time. His heart was still laboring to pump the water out of his chest so that periodic injections were needed to make his breathing easier. For some reason, he had refused the oxygen tent. Choura supposed, later, he had felt its aid was useless, artificial, only a buffer, and wished to live the rest of his life as "normally" as before. That same morning, Dr. Simeons had called them saying he expected Tchelitchew to go into a coma at any moment. The artist had not been talking at all. Sister Adelaida had asked him if he wished "the family" to come (Ford and the artist's sister). All along, Ford had been known to their community as Tchelitchew's nephew. Now there was the less reason to disabuse anyone of the convenient fiction. Tchelitchew had answered Sister Adelaida, no, the family's visit had better wait for the usual hour of five o'clock.

When Mme. Zaoussailoff and Ford made their appearance, Tchelitchew began to talk as usual but soon fell silent. He lay straight in his bed, the image of stillness, yet in that subtle suspense which every living thing communicates when deliberately at its quietest. His face wore a calm expression, so calm that Choura noticed the extraordinary absence of lines in it. His head rested on a small, square pillow placed over two large ones. As usual, his hands were

folded on his body (much in the position in which Hadzi made a cast of them) and Ford and Mme. Zaoussailoff took turns in stroking them. Often they sat in silence, like this, and for a while none of them spoke.

Tchelitchew had loved to have himself massaged, and especially—to soothe his nerves—to have his back gently scratched. His nurse used to soothe him this way as a child at Doubrovka, and in his maturity he would ask casually visiting friends to do so. In recent years his back, in chronic trouble, had gone particularly bad, and was now a center of his supposed arthritis. Ford had been accustomed to answer a plaintive peremptory call: "Charlie, come push my back!" A New York chiropractor had demonstrated a type of massage seemingly efficacious and simple and the artist had taught it to Ford. Tchelitchew always claimed that the noticeable hump in his shoulders (technically no more than an exaggerated roundness of the spine) resulted from a nurse's having dropped him when a baby. Choura, hearing this, invariably denied it as chimerical, but without discouraging her brother, who would say, ill-tempered at being contradicted, "You know very well it's true!" He was always advising people to hold their backs straight. The truth he did know very well was that the chief daily trouble with his back was the stoop into which he lapsed while at the easel, for he seldom ever worked sitting. As the lines of his work grew finer and he peered closer at them, the stoop had grown concentrated, rounder.

Everything seemed subordinate to the tension with which Tchelitchew now rose from the level plane of his bed as if with his whole body, stretching it out deliberately between life and death. Ford knew that not only had he been fighting for his life, but that he had known it for some time—perhaps from the first instant his collapse had come. Had he not said—? But it was too awful to remember. Suddenly Ford, stroking Pavlik's hands, found it hard to restrain himself and had to retire to the lavatory, where the sobs burst out. Tchelitchew, he could see, was conscious but not lucid. This had been true recently; his nurses said that in this respect, sometimes his mornings, sometimes his afternoons, were better. Once Ford had presented for his endorsement two checks, made out to him, in order to change them from dollars into *lire;* the artist held them up before him, gazing and not moving to sign. At first it appeared he could not understand the figures on the stubs of his checkbook. Then it struck Ford, with a dismay he dared not show, that Tchelitchew felt unable to write his signature; Charles Henri casually drew away the checks and the checkbook. Later, Pavlik asked if he had signed the checks and Ford replied that he had.

Sister Adelaida declared that her patient was always observant whether or not he gave token of being. Ford and Choura, repressing their anxiety, always wondered just how conscious he was. At one point, Ford had been convinced that he looked into their eyes and the eyes of the doctors and nurses to find

certain answers that he sought in vain. Then again he would just lie, as now, with eyes closed, only a little of their whites showing. Nothing, truly, had to be said: his eyes told them how sick he was. Yet, as they agreed, while Tchelitchew's eyes looked sad, they did not speak of suffering. The worst of all was when Ford and Choura were aware that things they said were not registering on him. They were aware, too, that he knew this for he would signify it by raising a forefinger gently to his forehead.

The day before, Tchelitchew had asked his sister to make him one of his favorite desserts, and she had brought it. When Charles Henri had gone to the lavatory, the artist said, without opening his eyes, "Last night was the most dreadful night I ever spent in my whole life." Choura quailed, not daring to speak or even, for a moment, to stir. He opened his eyes, fixing her vaguely, and repeated: "It was the most terrible night I spent in my whole, whole life." Mme. Zaoussailoff hardly knew what she replied; her sentence seemed to stop in the middle. Speaking Russian to her brother was the greatest luxury, a precious sort of nostalgia, now. But not even a reassuring Russian phrase would come at first. She had left off stroking his hands but she now reached forth and resumed. She could feel him quiver ever so slightly beneath her touch and tears rushed fierily to her eyes. Yet she held to her composure and merely continued stroking.

Here was the man—so he had said more than once—who was dying from his own "folly." Yet he knew, too, that it had been from conscious choice and with conscious knowledge of the risk, even with certainty of the foretold "self-sacrifice." Ford's dream had not been the only sign to show itself. The preceding October, when he was in Paris for his show, he had begun a letter to me thus: "I wanted to write you since months but couldn't—my life: *was* work, work, work and work. Work not onely on canevas but other kind too— seeing people talking trying to make them see what they are not quite used to, or even not ripe too [sic]." He had added another laborious touch: putting that superfluous "o" where it shouldn't be. As I guessed anyway, his hysterically joyous boast to the Fosburghs that his show's success was not due to "pushers and promoters," but to the "efforts and thoughts" of friends, was not altogether true. In my presence, often, he had tried to explain how his Celestial Physiognomies "come and go" in space; yes, even to me, for I admit that I was one of those who could never grasp, optically, this most self-desired and self-valued of his immediate plastic effects. To myself, I had deplored the indignity of what seemed as much a salestalk as a classroom demonstration, and this made me seem to Tchelitchew less comprehending than, on the whole, I was.

"Maybe," the letter of October 30th continued, "I am only a mad lonely turtle that hears the sublime sound of the harmony of the spheares, the incredible beauty of its revolving lights, the forms not seen, the sound not

heard before—I am not at all surprised that, in times when art is born out of a 'pig pen' - all snouts, asses and tails included, I cut a figure of a 'Don Kichote.' " And thus he had painted himself, coyly and more good-humoredly, a long time ago, with an inverted vanity that must have come back to him, at that recent moment in Paris, with a cruel pang of irony. "Do you know," he had said to me years before in America, "I'm going to Paris and if I see Picasso, I'm going to say to him, 'You always thought I was an old fool, eh? Well, it was true, and what's more, I'm still an old fool!' "

The invincible courage, the desperate pride, could not be missed; the bravado, too, as immense and eternal and ineradicable as Don Quixote's; and more: something more mature, more "modern," than the Don's pure chivalric heroism! Tchelitchew did not realize, in that supreme moment of mock self-abnegation which he imagined before Picasso, how close he was to the same abysmal state he now proceeded to assign as the disgrace of other painters: ". . . But a vision of a world is one thing, and the activity of smearing endless surfaces [Action Painting] is another—which reminds me very much of a certain insane lady who expecting her doctor's visit promptly took of[f] all her clothes and smeared herself from head to foot in excrements being sure it will act as a 'love potion' on her doctor. You remember Dr. C. Jung's [book]."

Shortly before he died, Tchelitchew said to Ford, bemoaning with unconcealed fear, "I've been a dirty man." Ford felt the thought ridiculous and false and hastened to deny it. But what Tchelitchew knew, he knew; what he felt, he felt. One cannot question a statement of that sort. All one can do is to attempt to put it in its just context, which may not be immediately visible. That is the great difficulty of reporting a complicated truth such as a man's life: it is so dull to offer it piece by piece, like the limbs of a wretched cadaver. When the letter I have been quoting refers to "the incredible beauty of its revolving lights," it is most desirable to know how much Tchelitchew was thrilled by the mixture of fused and undiffused light admitted into the interior of Santa Sophia by its numerous windows, filling its overlapped spheres with a fantastic and altering luminosity as the position of the sun changes. As for being the "mad lonely turtle that hears the sublime sound of the harmony of the spheares," he was not pretending to be too common an animal. I remembered, on rereading the letter in question, that the Homeric Hymn to Hermes (not, perhaps, without a certain obscure authority) says that Hermes, when he constructed the first lyre, used the back of a turtle.

Since the last sketchbook, which I saw at 2 rue Jacques Mawas, is marked "Jan. 1954—April 1957," it implies that Tchelitchew actually worked in it after his collapse and during the supposed recuperative period at the penthouse. He must have seen, during that time, La Dame Blanche. Only in May did he become too weak to draw and then he returned to Salvator Mundi,

where presumably he touched nothing but the pen with which he could hardly write his signature. But if the hands lay folded, the mind lay with spread wings: in the posture, and perhaps with the power, of flight. If the nights were terrible, they were terrible with activity. And with what activity if not, amid the rest, the dancing boxes and their inmates? Yes, those: detached, often, as on the Dame Blanche page, moving of themselves in the night's white eye, and outside their paths as well, as if in the head of the artist where they had been born:

> The pitchers are like owl
> —Athena symbol?—"Grand Duke of Russia"?—
> Owl's nose punning
> With the spout—punning, so is said—
> And fantasy of woman teapot
> *Limone:* like a constellation of eggs: transparent—

> Little
> Beautiful
> Dancing box fantasy
> Doves small: front and profile
> One tiny with wings raised

> LION BULL STEER
> Heraldic style RAM: the stars:
> The stars—the—

> Next to Lion: PHOENIX
> Rearing horse and electric-fan DOVE
> Incense-burner bird with visible anus
> Anus: ah—but—

> Cross-section LEMON anatomic fantasy
> Planets its seeds: spun with spinning of the hand
> Contents of the Ark "celestialized" (ask C. H.)
> New Zodiac: all all in shimmering spectrum
> Appearing over black: my black
> Which is *not* black

> The LYREBIRD here sky'd up
> Like a rainbow—no, not Peacock!
> Cht-ccchh-tttt-TCH—bad luck—
> But hint of woodgrain; hint of dragonfly

Like those of Cretan earrings—
"Don't treat me like animal,"
I told the doctor when I'm at Salvator Mundi
"I am dragonfly"
I said to: "Watch out . . .
You will break your horns!"
My head is bigger, better

PITCHER GLOBE OWL: which: all: man's fate
Man's fate? To be sky'd up—
"Celestialized"—DAME BLANCHE
BULL PITCHER PHOENIX
LION FOETUSLIKE MAN
The earth: one animal
That breathes: Yes, bring me tent—

Who I am? *Do* you know?
TCHE-LIT-CHEW
TCHELITCHEW—like
Locomotive sound say someone writing
—Another: like sound of surf
Coming up on beach: Tchelitchew
Ffffff

Triple images for meshed perspectives
Triple perspectives for meshed images
—And more perspectives: how many?
Many—many—

From step to step
From rung to rung
From ee-mage to ee-mage
From FOETUS to MERCURY
From top to bottom
From bottom to top
To AIR: AIR:
Yes, bring me tent quickly

Astronomic Lemon
Vibrates like Sun
FROG—DRAGONFLY
MERCURY—PITCHER WOMAN
Not two: one

FROG-CAT-DOVE maybe three
BEETLE—JAPANESE BEETLE
PHOENIX—BUTTERFLY
And a flying DOVE
Like the Holy Ghost
Phantom BUTTERFLY: JAR
—Like the Venus of Lespuges: JAR

On a corner of page
I will write:
 La tête - lune
 respiration - soleil
 spleen - Saturn
 vesicule biliaire - Jupiter (in liver)
 Les Reins - Venus
 Foi - Mars
 Lungs - Mercure
OWLFACE—CATFACE
NESTLING—PITCHER
And PITCHER WOMAN with arms raised
Beautiful as a dancer

PROPELLOR—PETALS
Spiral cornucopia in spiral egg
And LYREBIRD *rayonnant*
—*Rayonnant* like the souls in Doré's *Paradiso*
An arc: nervous
I was more nervous: more precise
—That's why

Lots of PITCHER MAN—MERCURY
Seems to rise and dance now
Then what? becomes like acrobat
Like Rodin's satyr
Head pushed through own legs
Half upside-down thing
Symbol *you-know-what*

And BULLFROG—JAR
BULLFROG *rampant* and SHEEP
SHEEP—RAM
SEATED MAN—JAR—sitted?

From jar-arm Cupid's
Bow and arrow coming
Madonna and Child
In two heads cross-wise with each other—
And again CUPID'S BOW AND ARROW
Two dozen images of this: two dozen?
My dear!—at least!

BAT—SHEEP—OWL
And again MADONNA AND CHILD
Perhaps: imitation of Leto
Holding Apollo as child
To kill the Delphic Dragon
No?—with bow and arrow?
Yes, I, child Tchelitchew
Mystically born once more
And kill dragon of my entrails
Like the tape worm was kill—
But *head*—? Did the Mago know?

Two cheel-dren
Me and Choura?—
Me and Mischa?—brother killed dead
I loved him so: I had fever: I——

Oh, it bit like HELL
SITTING WOMAN here: *femme assize*
Couchante enceinte
With child in—POIRE-LIMONE?

HEAD—HEAD—PHOENIX
In dancing boxes, dancing boxes:
Dancing boxes—
Dice of *I Ching*: dice
Thrown on floor of Heaven
—And what they read?
Tell me, Charlie, tell me!!

—SITTING WOMAN
On throne of Phoenix: Kachina Doll or Eskimo
SITTING SITTING WOMAN = face =

"Dearest sweet Edith . . . "
How many times I wrote her in the war
She was sitting in all those horrors in England
Silent—in my dream—
Too tired to talk—
And me here, on the roof,
The moondead city of the blackout
All I saw——

New York—and a rather realistic
Very slight HEAD
PHOENIX OWL and suddenly: light small
Hydrocephalique
And more of him, more—

Cylinders opposed
Now geometric Apes
And tiny cubist STAR
And PITCHER WOMAN—hint of child in arms—
CATHEAD LEMON—tête—
Page after page after—page—

I have spoken of those—en ANGLAIS
I mean "dancing boxes"—
To many kind but doubting old friends
And they nodded, old old friends
Trying to smile intelligently
To say the right things: I saw that—
I saw, yes, those who have loved the flesh
I always painted, they always loved it—
Even illusion of limbs on skinned bodies:
Flayed beautiful flayed bodies:
Even the skulls—still
My *côté humain!*
But do they know? how can——?
Now they miss something!
Yes: the organs—the organs most of all—
Somewhat to the faces: the portraits—
They are loyal but too kind
Some of them—Linc, Fidelma—faithful
Yet too much patting-on-back

Hélas!

Va, va—
Ma petite mère! !
—Nahalki, all of you! *Scat!*
J'adore les chats!—you make me not too

To Grottaferrata and Frascati
To Connecticut they came
And for lunch to
For seeing maybe
They had their medals of friendship
Dis-creetly wearing them on sleeves
In-dis-creetly wearing them on—
So few, so few saw into
Interior of interiors
Where I'm hiding—hiding always—
And seeking, seeking——
Cache-cache—never find!

Organs! Yes, the organs
Sticking out still
But they cannot SEE—them—
Ah, Sitvouka, SITVOUKA!
Like the others, like Liompa
—For you only "living—"
—See: dead now or just as bad—
It is to laugh, *enfants*, perhaps

All of you *là bas*
Like Lucifer in *enfer*
At lowest bottom spot
All gripped in ice—to waist
I bring you up—
My hands—did—do—
Up in sky to

BULLFROG—CAT—
PHOENIX in boxes nesting
Woman-breasted PHOENIX
Avec la coiffure

Sphinx's *coiffure?*
BULLFROG BULLFROG BULLFROG it is
And woman-head with face raised up

Hint hint of double-head FISH
And webfoot SPIDERWEB
Here myself: the Crazy Spinner!
"You think I am mad, eh?
Well, I am!"
I told to the world
Not to onely Picasso
To Caca-pisse—
Of course turn it round
And when pottery factory came—
Pot-cassé!

IT IS TO SCREAM

NOT they do not understand
Why Mercury sitting
Is like king—like foetus
Or swaddled baby royal
Kinglike facing space—all space—

Roi! roi!
A pleins poumons!!
I cough blood, blood—
Charles Henry, phone—

FISH: fantasy of Mercure's joined hands
Clutching his knees
Not clutching his knees
(Everything hurts
Does it hurt more?
I do-ant know)
Hands folded over my body
Over my body
Over

Does someone say "Very nice, very nice"
About my dancing boxes
On my walls at Frascati?—
My dancing: "very nice"?

GLOBES in GLOBES
BOXES in BOXES
Like things in (egg?)
In *L'oiseau de feu*

Fever looks from my page
Page all *gestes des mains*—
WHAT *gestes des mains*—
Crumpled eyes in crucified face
I see myself in hospital bed
Small square pillow under my head
Two big pillow beneath:
Partez mes enfants
M'endorme
M'endorme

Constellations: look!
OWL CAT PITCHER—
Never you see me more—
TEAPOT RIDER CAVALIER
Three at least in one
Constellations: look!

Loose in my sketchbook orbit
Like our satellites
Loose in the sky—
I talk, I fly—
I talk—I paint—
What is it? I know—
BULL EGG FISH

LEMON
Again crucified: *exactement*
In box crucified
And its cross section
Constellated, geometrized—
"That how you say—?
Charles Henry, you won't tell?
Down on your knees! SAY!!!"

Many EGGHEAD WOMEN with raised up faces
Lemon Catheads ah! Léonor *volante*
And OLLIE: *Mio*
Carissimo gatto PERSIANO
My ark—my flood—
My blood—

Woman sitting inside box
As if on box throne
Hint of fruit hint of many-breasted
Diana of Ephesus at Villa d'Este
Tits: TITS on TITS; rows
Halfway down like this—
But dry—dry—

DRAGONFLY into WINGED GLOBES
PHOENIX SITTING WOMAN
PHOENIX LEMON
With woman sitting inside
All turning to FEMALE HEAD

—ANIMAL HEAD URN
GLOBE URN—
Gamecock as on herm
Have seen it somewhere?—Ah!—Hah!

A horn on her head
It is PENIS ERECTUS
—Polite—

I have drawn it
I have drawn it—

WOMAN-HEADED URN OF THE COILED PHALLUS

I have drawn it: PHAL-LOOZE: so
It comes out
Always
If-they-only-know

WOMAN-HEADED

No? Yes! RAM to—

CHE COSA
TERRIBILE

My *tirra ossa*
Tirra ossa my
CHE CO-

SA TERREE

BEE

LEEayyyeeee

CHOURA-Mmm

Paradise could be but an antidote. This was, I think, Tchelitchew's conclusion. The incredible, gorgeous yet peaceful and tangible antidote—or, should one say, *antibiotic?* That would be consistent with his idea of death, the final idea which came to him when he had spent months surviving on antibiotics.

In past years, especially during the Second World War, when he was in constant communication with Edith Sitwell, he had had more elementary and conventional ideas of death. Magical as he was, and in love with the idea of immortality through reincarnation, his immediate sense of death was existential. Of course, as he explained to Dame Edith (then without her title) in 1940, his experiences with death were multiple because of his past lives. "Death was always," he wrote her, "in the background and oftens [sic] even nearer." At the same time he was realistic and skeptical: "I am not at the time when I was a child and listened to Nanny's explanations." And he added (it was the ambience of the war), "How sad it is to be an ill tiger with my claws and tusks taken out by illness."

He was much upset to hear of the death of a young writer who had written the then Miss Sitwell on the day of his death. The news precipitated a judgment of death: "Death is the end of everything - it is the horizon of our life - there where the two plans [planes] of our dimentions meet to make a third one. She [Death] is the [?] beyond any dimentions - the end of everything - I think when people die - they are so glad to know this end of pains horrors and abuse - often they smile - except for people who kill themselves." The last clause is probably an afterthought: one of Tchelitchew's superstitious reflexes. These reflexes often came too late to avoid betrayal.

One detects—even aside from the ambiguous dot-dashes by which the writer separated his rhythms—a special agitation in these letters which formed a sweet and very sacred communion between himself and his correspondent. One imagines that he was referring, conventionally, to ordinary suicide. In any case he had not imagined the "self-sacrifice" which he confessed of himself in later years. That he should put death in the feminine gender, as above, might be taken as a mannerism of foreigners who mix up English usage as to gender. For Frenchmen, death is female (*la mort*) and Tchelitchew inclined to think in French and translate into English accordingly. That the gender here was not incidental, however, the artist often testified both pictorially and verbally. "La Dame Blanche" is simply an aspect—I should say the death-aspect—of "Mrs. Nature."

After his first hospitalization at Salvator Mundi, during his supposed convalescence, he wrote me more concretely and more existentially, and surely more psychosomatically, of death: "I know now that no one who described, as writer, the death never had experienced it himself. Neither Flaubert, nor Tolstoi, Dostoevsky or Balzac or Dickens. There were no antibiotics. They onely saw people die—but it is altogether a different thing. This memory is difficult to forget because it is a different dimention than the ones we know on earth: and many things on earth seem absurd. It was a terrible price to pay for Paris succès . . ."

A "terrible price"? The knowledge of what it was to die: a *preview of death!* He no longer speculated about the "folly"—it was the very folly of which he had boasted in the act of confessing and lamenting it. In his own eyes, he had proved to Picasso—and nature had collaborated with him at last—that his sublime bravado had a supernatural prescience. The "old fool" really knew . . . Yet it was hard, morally and efficiently, to convey to people that he *was* dying all this time: the revelation that had come was that between *death* and *dying*. Technically he was convalescent; he was even able to work spasmodically though he could not walk upstairs. And death, as such, was four months away when he wrote the above. To imagine, however, that he was virtually willing to die if the price of staying alive was to stay away from Paradise on Earth, this (he thought) seemed too proud and a tiny bit perverse. Doctors had said he might never be able to work again. *Who* would understand this new thing in his life? He had been trying to explain so many things to so many people for so long . . . even to Charlie . . . and, of course, to Choura. Could he really tell himself, too, that the common remedies and ministrations at Salvator Mundi had been, and were, all beside the point, ultimately useless? Did he not, like everyone else, *desire* to live—to paint—to achieve . . . yes, to achieve Paradise? For some reason, he invariably spelled "live" "leave," as if onomatopoeically transferring pronunciation of the French "i" into literal English spelling. It is his most sublime uncon-

scious pun in words and may be considered his own ideogram for death (leave-life).

He had returned to the woman's image in *Inachevé*. It made a fresh beginning. Madonna, she is, in her way: La Dame Blanche of *Inachevé*. I shan't alter the accidental rhyme; it is simple and naive: as Byzantine as Tchelitchew's antibiotic concept of death. Surely, to have been close enough to death to live it ("oftens," as he had written, "even nearer") was to have achieved the rapture and ecstasy of a saint; at least, to have occupied its technical space: its "sickroom" in the mind and the cosmos. Bliss, true bliss, that would have to be an anti-antibiotic. The spectral Dame Blanche may be an expression of an anti-antibiotic Paradise: strange enough for the history of art, and for history.

How deceptively light and casual, how much a "wire structure" is she who came to incarnate the first—that is, the loftiest—sign of Tchelitchew's new Zodiac! She was destined to be, I am sure, the central medallion of the unpainted Paradise. Plastically affiliated, in Tchelitchew's early analytical anatomy, with his treatment of the eye as a "sun," she emerges rather as a version of Christ Pantocrator in the traditional mandorla. Tchelitchew did a perfect model of the mandorla, so titled, which was not in the memorial show but was reproduced in the catalog. It is a superb abstract head in a set of dancing boxes and suggests subtly the infant born in its amnion. Christ and the Madonna, under the pressure of "zodiacal" geometry, had been fused into the "one" who was La Dame Blanche. As firm and simple as a Gregorian chant. As tensile, as schematic, as subtly irregular and complete, as a spider's web.

Of his last pictures on the wall of the Galerie Rive Gauche, in the sell-out show, Tchelitchew wrote me: "I wish you could see these strange frail proud pictures facing the shitt of the world before them. They 'dance, they sing' unconcerned of what others think, unconcerned of the gross apauling stink and all . . ." So much for the dreaded Parisian "protocol" when he was face to face with a friend and really talking art. Indeed, the pictures were unconcerned. He had painted them that way. It was integral with their mission that they should be. Yet it was not they, or even La Dame Blanche, that had a vision of the *cosa terribile*. They represented the special human privilege Tchelitchew had conferred on himself. He once said: "The stars pull the strings." According to astrology, yes. But he had attached strings to the stars and pulled the strings himself.

At eight-thirty, Sister Adelaida triumphed over the telephone system and reached Ford in Frascati. "You come here," she said in English, "I will tell you everything." Tchelitchew had stopped breathing about half an hour before. Just when? Ford and Mme. Zaoussailoff wanted to know when they arrived. They heard that Tchelitchew had asked that only Sister Adelaida be

with him when he died. She and Sister Dora were not certain of the moment of his passing; they had been very agitated, going in and out of Tchelitchew's room, their white habits fluttering and swishing, and trying to get Frascati on the phone. Was it five to eight or ten to eight? One nurse was inclined to think it was ten to eight, the other five to eight. Ford seemed worried by the contradictoriness, the uncertainty.

He and Mme. Zaoussailoff held before their mental eye the scene that had been their last sight of the living man. As usual that evening, he had said to them in his faint, patient voice, "Partez, mes enfants." He may have said, before or afterwards, "Je suis fatigué," but in any case the statement was implicit. Tonight he had also said something far more decisive, which they had tried to dismiss even as it clung to their minds for dear life: "Je suis perdu." It seemed not an emotional outcry, but paradoxically sober, and a confession. As they thought about it on the drive to Frascati, it seemed more and more a mere statement of fact: authentic and distant and minimal as the evening star.

But to Ford there also came the terrible words which Tchelitchew had pronounced, as with his last gasp of breath, when the ambulance had rushed him to Salvator Mundi. I have already translated them: "I'm done for!"

"Je suis foutu!"

The French hits the ear with a far greater force and finality than any English equivalent for "foutu" even if we try to find a stronger, and slangier one, than "done for." A brutal despairing profanity explodes in the French. He might have said, had desperation driven him into using English, "I'm fucked!" Perhaps not a negative scruple, but a positive impulse of taste, brought French to his lips. "Foutu" has the "f" sound common to both words yet is also combines "ou" and the French "u" in an expletive of precise elegance: magnificently oral.

Ford and Mme. Zaoussailoff had stood on either side of the bed for a few moments, holding one of his hands in one of theirs. He always blessed them, and when he had done so tonight, they had left as usual. Sister Adelaida said that Tchelitchew was thoughtful of others to the last, even asking that the man who washed him be given ten thousand *lire* for each month he had spent in this duty. Ford and Choura were agreed that it was best this way: Pavlik had sent them away, just as always, because he wished to spare them the suffering. Sister and friend, for the moment, had never felt so far apart as before the corpse of him who had been, despite everything, the most of mankind to them. Dry sobs shook Ford. Now Choura stepped forward and undid the gold chain of holy medals from the dead man's garment.

She left untouched the other charms Tchelitchew wore to the last: an amber bracelet and the bracelet of simple strands of red yarn he had worn even longer than the others. I recall noting the yarn bracelet soon after he

came to America; it would often provoke people's curiosity. Tchelitchew usually gave as his reason for wearing it that it helped the blood circulate or that red was a lucky color for him. He told Monroe Wheeler that it warded off evil. For one thing it was a color ritually associated with Aquarius, Ford's zodiacal sign, and is prominent in the "red portrait" of Ford, which contains poppies.

The artist would answer inquiries about the bracelet with a delicate sibylline smile as if there were about it some deeper secret even. There *was* an esoteric secret about it and I suspect he knew it. A habit of the followers of Pythagoras was to wear red yarn about their wrists. For a while, in the ancient world, an Orphic sect was established at Delphi, and there, it was believed, the center of the world was situated. Its mark was the Omphalos, or Navel Stone, preserved today, on whose phallic knob fillets of wool are sculpted like sacrifices of semen. One is led back to the image on the last sketchbook page . . .

Sister and bosom friend wanted to know Tchelitchew's last words. Sister Adelaida's face took on the solemnest of expressions as she tried her best to remember. She looked at them vaguely and said that it was hard to say: Tchelitchew had been incoherent. Yet at the very last, Dora had also been present, and she said the last words she could make out were, "che cosa terribile!" Unflinching, Ford was looking intently on the face of his friend, his dear, his dearest friend. It was so still now! He leaned over and kissed it on the cheek. Choura could not move. She stood there amid tears.

When she was under control, she and Ford asked the two nursing sisters to give a complete account of Tchelitchew's death. There was little that could be dramatized, little that was even pertinent, which did not bear on his low ejaculative cry: "che cosa terribile!" What had he endured? What had he *seen?* Sister Adelaida thought that his eyes had seemed to be seeing visions; she was not sure. Who could be sure in such cases? But his going, on the whole, had been quiet. He had simply expired. The sick man had endeared himself to the sisters over the months and it was clear they were trying to conceal their feelings.

Choura interpreted the last words spoken by the artist as a "good sign." Meanwhile time flowed on: the bottomless, unconcerned, unchanging river where we all live locked as in crystal, completely visible, unable to hide or escape or alter our living element so much as by ripple or stir. Yet often, like frantic drowners, we behave in this vacuum as if we could save ourselves or really breathe and act in another sphere. Like the Russian Orthodox Christian she is, Mme. Zaoussailoff believes implicitly in the next world. Thus, she said, Pavlik's last words had been the soul speaking at sight of the body so sick, so changed, that it was leaving behind. In a way she was also following her brother's essential supernatural logic—not merely as a Christian but also as a portraitist of the world for which, wherever it be located, the soul is destined.

How gaily, with what serene detached dignity, Tchelitchew composed the places of that place beyond time—as if they were homes among the stars: verily the Paradise of a different ether! Basically all art is structured thus. Tchelitchew conceived his Paradise individually in terms of some of the oldest, most explicit myths, ordering them by the modern discipline that is "abstract" only because it participates in the origins of philosophic thought. Astrologically, human hours sound on a cosmic clock and echo in innumerable rhythms on the finest wave-lengths. To ask Dr. Simeons—large, florid, white-haired with his mercilessly medical eye—for a complete case-history of the dead man, cost Ford an effort, a revulsion of incongruity. But Choura joined him in the routine desire to know.

Eventually he gave them what Ford termed, possibly only as a devout Tchelitchevian, a "superficial summary," quite unsatisfactory to him and Mme. Zaoussailoff. There had been considerable differences among the gathered specialists and Tchelitchew's regular doctor, and these were constantly modified, of course, by the sick man's waxing or waning faith in this or that doctor and his current diagnosis. Thus Dr. Simeons' case history, however much it aimed at conscientiousness, was necessarily, concluded Ford, only *his* version. He and Choura were disappointed, a little irritated. But the formality was in any case, they knew, a futile thing. It was like the pathetic shell Pavlik had left behind in his bed.

"8 heures moins 10."—"Ten to eight."

Ford now decided that at *that* moment Tchelitchew had died. The reader remembers, perhaps, that this was the hour specified in Ford's cablegram to Tchelitchew's friends announcing his death. There was a reason for his preference over "moins 5," and it was based entirely on the magic accumulation of thought that Tchelitchew had made the nucleus of his true religion. In this instance, it was testimony from the Tarot pack. Tchelitchew had once searched the cards of the Greater and Lesser Arcana for evidence of two that might stand respectively for himself and Ford, and to his private satisfaction had been successful. As customarily, astrology had been his chief, if not his only, guide. Card Eight of the Greater Arcana is Virgo, the Star Maiden, wearing a crown and the dress of a Magus and holding scales which signify that she judges the souls as they leave one incarnation and enter another. She is one more version of La Dame Blanche.

That Virgo's qualities are ambivalent accounts for her being, astrologically, the House of Earth, and in human physiology thus governess of the entrails. In Card Eight of the Lesser Arcana, the suite of Pentacles (Platters or Diamonds) represents "the sculptor at work" and connotes the professional side of art—skillful hands, commissions, ambitions, glory. "War may come but there will be triumphs and glory resulting." In the Greater Arcana, Ford was seen by Tchelitchew in terms of Card Ten, which is the Wheel of Fortune, meaning good or bad luck according to whether the card appears

upright or reversed. This was, so to speak, Ford's aspect for Tchelitchew in particular: the variable law of the artist's life, his Karma, to which he had to submit himself.

It was easy to connect this with Card Ten in the suite of Pentacles, where it has Hermes (Mercury or Tchelitchew himself) for patron deity, depicts a family, and connotes dangers, inquietudes and the fate of possessions through law. Tchelitchew foresaw Ford's role in his posthumous life and moreover his position in his earthly life had made him an ambiguous "member of the family." In all probability, Tchelitchew also noticed that the next card in the Pentacles suite is the Page, a youth who, as one commentator says, "manages others in his quiet way and governs through persuasion." The Page's Zodiac sign is Ford's: Aquarius. How often had Charles Henri "governed" him by persuasion—and what persuasion! Card Ten of the Greater Arcana conforms in that the initiate of life, shown in two aspects bound to the moving Wheel of Fortune, is being readied for judgment by the Sphinx of the Mysteries (in other words by the Magus) who, lodged above the wheel, is supervising the initiate's trial; so Tchelitchew imagined that, come what might, he was supervising Ford's trial through life. He had said to him once: "When you hear my voice for the last time it will be a sad day for you."

As happens in magic psychology, Ford at the moment of Tchelitchew's death was the less interested in the content of the manifestation of Eight and Ten, the more interested by the timing of their apparitions. It was enough that the pattern of their mutual lives, his and Tchelitchew's, had "worked out," had about it an inevitability dominating all commonplace moral issues. It was not only simplifying but also, he thought, poetic and thereby reassuring. It put the proper formal conclusion on the cruel reality of his great friend's death and suggested to him the perfection adored, however unconsciously, by all artists. Instinctively Ford embraced the idea that the past had been perfect: a true perfecting according to laws honored by the dead man and tacitly, for that reason, to be respected by himself. "Magic" had no office now, either specifically scientific or specifically religious. It simply happened to be part of the normal human machinery one brought to bear against the intractably tragic fact of death. Ford, as an individual, worked very economically in all ways. He had become a master in the mystery of the posthumous Tchelitchew.

What the artist had become to himself in space (a Celestial Physiognomy) he had become to Ford in time. On August 1st, 1957, the two stood eye to eye on a direct line of vision stretching from the living to the dead. It might be somewhat simpler to say that the hour of Tchelitchew's death was poetically timed. Regardless of content, poetry is the perfect resolution of relationships. The artist expects to find poetry among the ordinary phenomena of life as well as on the canvas and the page. At least Tchelitchew, as

we have seen from previous quotations, believed that art was the only "reply" to the rough and confused questions with which life abounds.

But what am I saying? However true all that may be, the greater remainder of Tchelitchew's life is still to be told: Purgatory itself, Hell itself. All the fiery splendor, mainly, of the flesh; not the Celestial but the Mundane Physiognomy. Art's own physiognomy: *its* frenzies, too. If I begin next with Purgatory, I still begin with birth. For Purgatory, if not Paradise, is surely, visibly, tangibly of the world and in the world. As Dante indicated in his Purgatorial Cantos, where he listens to the great singer, the severest burden may be lightened by *the aria* on which Tchelitchew himself put so much value: he regarded its principle as one of his talents. In Purgatory, everyone pauses, rapt, to listen. Hell, on the other hand, is fatal prose, experienced always with feet on the ground. Hell here will be a climax but will spirally lead back to the threshold of Paradise and be its anticlimax.

Before writing the interlude which follows, I am prepared to say that Pavel Tchelitchew was born on September 21st, 1898, on his family's estate, Doubrovka, near Moscow in the Department of Kaluga, in what then was Russia.

As a creative genre, Biography is perhaps, more than any other literary form, crippled by a debased slavery to scientific thinking on one side and to conservative fiction on the other. On our library shelves we have the biographic romances, to one of which I shall have occasion to allude: Merejkowski's *Romance of Leonardo da Vinci*. However, it is striking that the romantic genre began not as biography proper (unless we wish to emphasize Plutarch's *Lives* or the Biblical account of Jesus as largely fictitious) but as *auto*biography; the best-known autobiographies in the West are most likely to be Cellini's, Rousseau's and St. Augustine's. On the other hand, the modern spirit of documentarism has been active in bringing humdrum history into biography (so many heroes and heroines of life are rulers of nations!), but here I am even more heterodox. I repudiate what I shall be radical enough to term the historic *tense* that represents biography (and other things) as chronometric history. It doesn't suit imaginative (as distinguishable from imaginary) content; above all, it doesn't suit a spirit such as Pavel Tchelitchew's, which, happening to obey Hamlet's caution, was much concerned with "looking before and after" the precise moment in which he lived and the simple, overt subject in hand.

The existence of supernatural fate, of the seer's ambitious omniscience, of another order enigmatically shadowing the surface of worldly things: all this makes the simple historic tense a pedestrian matter of form; this tense would mean a way of looking at Tchelitchew as a curiosity, in many senses "dated" and, from the vulgar viewpoint, rather crazy. To have referred to the artist's dancing boxes as dice, in my freely imaginative account of his delirium in the hospital, was certainly a romantic licence; the metaphor is mine, not his, although the preponderance of his personal expressions in that passage are more or less direct quotations from him composed into one synthetic pattern.

Already mentioned is the fact that *I Ching*, the Chinese Book of Changes, was the only book Tchelitchew felt able to read in his state of physical enfeeblement and mental apathy while supposedly convalescing after his sojourn in the hospital. The truth is that from the dancing boxes one gets as much of an impression of the yarrow sticks cast to obtain answers from the *I*

Ching as of dice. In any case, the tremor and mystery of both are portrayed in the Celestial Physiognomies. Fortunetelling was to be an early pastime of Tchelitchew's youth. If I chose dice in my metaphor of delirium, it was for two reasons: they are more universally known than other implements and Mercury himself, according to the hermetic tradition, cast them for divination.

At Doubrovka, the family's country estate and chief residence, a fortune-telling game was played during the Eves of the Baptism (Krestchensky Vyetchera), climaxed on January 6th with a fête for the baptism of Jesus.

The game was called Divinettes—and it was played on water. Water was to participate in one of the most decisive moments of Tchelitchew's life when he escaped from defeated White Russia on a French battleship, and a large tureen of water provided hazard for the little ships of fortune set afloat at Doubrovka. These "ships" were nutshells carrying slips of paper on which the most fantastic predictions had been written. Every household, indeed, loads its own dice, and everybody at Doubrovka, even to the chambermaids, joined in the madly festive game. A small taper accompanied each nutshell carrying the paperslip of fortune. The water in the tureen was stirred up by one's finger, causing the nutshells to swirl around till a taper ignited the paperslip, at which moment someone grabbed the fortune and snuffed out the flame (for the fortune was now his) so as to be able to read it.

One can picture little Pavlik's enthusiasm in prosecuting this exciting form of harnessing the future. As a forecast of trial by fire and water, it was to be codified, sublimated and signed as a cosmic wonder through his painting, *Hide and Seek*. A variation of this mode of fortune telling also anticipated the artist's future interest in doubles, which often (like the Hermetic Androgyne) were to be self-duplicative figures contrasted with each other by light and dark tones. In this game, pieces of wax were melted in a spoon, dropped into water, and when cooled, removed in shapes that had become strange and irregular, perhaps beautiful. These were held up before a light so as to cast shadows on the wall: Tchelitchew was to make shadow-casting conspicuous in his theatre devices. The point in the game was to interpret the shadows in terms of one's fortune.

Without, I trust, seeming pretentious or bizarre, I admit that the form of this biography might have been determined by some such divinatory method. Suppose I, or in fact Tchelitchew, had cast the forty-nine yarrow sticks of *I Ching* and come up with one of the hexagrams (prepared answers) indicating that my starting point should be Tchelitchew's death and his post-mortem phase? This would impose special considerations on the sort of narrative form the biography was to take. C. G. Jung, desiring to present the *I Ching* to the Western World, first consulted the Book itself to obtain its opinion on the project. I daresay Tchelitchew read the result in the Foreword to the Book,

where Jung gives a detailed account of his procedure. Instead of the yarrow
sticks, Jung employed the simpler method of casting with three coins, and
first obtained an answer whose number marked it as of special importance:

> There is food in the *ting*.
> My comrades are envious,
> But they cannot harm me.
> Good fortune.

Like all oracular answers, this must be interpreted, here both in substance
and as applicable to the particular question asked. With much plausibility,
Jung interprets it as meaning that the Book, having been directly addressed as
a sibyl, speaks with equal specificness in the first person. The reading of the
first line is: "I contain (spiritual) nourishment." Accordingly, the remainder
of the hexagram's text means: "Since a share in something great always
arouses envy, the chorus of the envious is part of the picture. The envious
want to rob the *I Ching* of its great possession, that is, they seek to rob it of
meaning, or to destroy its meaning. But their enmity is in vain. Its richness of
meaning is assured . . ." Thus the final line: "Good fortune." The ancient
wisdom will always prevail.

I cannot think of a better modern defence of all ancient wisdom than
Jung's foreword to the *I Ching*. Tchelitchew, I assume, was in full and
wistfully exultant agreement with him. For that he identified himself with the
sibylline Book speaking to Jung, I cannot for a moment doubt. A more
explicit commentary quoted by Jung from the work's translator, Wilhelm,
seems to make the point conclusive: "This describes a man who, in a highly
evolved civilization, finds himself in a place where no one notices or recog-
nizes him. This is a severe block to his effectiveness." In these words Tcheli-
tchew, the Faithful Knight who had set out to capture the Magic Fern, was
to read a portrait of himself at the end of his life.

It is futile to argue that Tchelitchew was in fact far from being unnoticed
or unrecognized. When all the chips are down, such realities are relative.
Tchelitchew's complaint (like that of Kafka's rebel artist, Josephine of the
Mouse Folk) was that he was not noticed and recognized *for the right
reasons*. Had he been, he would have attained much greater fame. The deep
message of the Celestial Physiognomies (not to mention his less specialized
styles) was that, as magic and mysticism, it was too rare, too arcane, to be
understood, much less appreciated, by the modern art world. At his weakest
and most despondent, Tchelitchew only accused himself of calendar crimes
against his own creed; he never wavered from the mystic position he was to
adopt in the early forties and develop till his last breath. From the moment in
1942, when the art scholar, Edgar Wind, pronounced *Hide and Seek* "a

magic picture" and dwelled on its importance, the artist recovered from a reactionary spell of self-doubt and valiantly proceeded with the mystic motif of his style.

I have recorded that his sister, Choura, observing him shortly before his death, remarked the impressive scarcity of "lines" in his face; she was doubtless thinking of marks of suffering. Aside from that aspect, the strong sedatives administered to him must have relaxed his facial muscles. Actually, the character-lines of his mature visage bore striking evidence of his personality as a modern magus. Fortunately, a large photograph of his mature profile reveals that his forehead (a feature, as we know, peculiarly important to him) had clearly etched on it all seven of the horizontal lines ascribed by classic metoposcopy to the influences of the Sun, Moon and the five planets, Mercury, Venus, Mars, Jupiter and Saturn.*

It does not seem to me extravagant, in a case so extravagant as Tchelitchew's, that I should employ specific tenses of the verb to characterize the periods of his life representing the great divisions of *The Divine Comedy*, which he accepted as a model for his art. The precise moment a question is put to a sibylline source has as much importance (Jung emphasizes this point) as the moment of birth has in horoscope-reading. But the magic inflection of time, while utilizing clocklike precision, relates to that vast complex of time factors called, in duo, Fate and Fortune. Much shall be said of our hero's Fate and Fortune and his psychology created therefrom. But the one outstanding element was his deference to Karma (oriental Fate) as reincarnation, a subject I have gone into regarding La Dame Blanche as a Phoenix.

Thus a mystic instinct bade me, contagiously, begin this biography at the crucial moment of *rebirth* rather than *birth*. So it is that here Tchelitchew's earthly life, told in terms of his paintings of Hell, Purgatory and Paradise, appears in *re*ordered narrative form and in tenses which continually indicate the viewpoint of an omniscient agency, aware at any given moment of Tchelitchew's whole story. In effect, the assumption of the gradual rendering of the future into the present and then into the past (the simple grammatical base of both fiction and history) has been discarded. To portray the inherent time conditions of my narrative, I have chosen "characteristic" tenses based on the special qualities of Tchelitchew's supernaturalist awareness of life. Having begun with Paradise as a past, it seems natural for the narrative to align birth with rebirth and expose my subject's actual childhood in both natural and supernatural aspects, especially as his Purgatory, the sphere where one can aspire to Paradise, is represented by a painting where indeed he embodies the essence of his youth: *Hide and Seek*.

Purgatory is the very realm of anticipation. And so is childhood. If Tchelitchew's earthly search for Paradise had to end (as has been related) in

* See cover photograph by Melton and Pippin.

his natural death, that earthly life automatically became a closed past on which a new life was predicated. Paradise, therefore, as the telling of this story has fallen out, represents among the conjugations of life the "has been." Purgatory, however, can be nothing but expectation; whatever its suffering, it is illuminated with hope and a strong feeling for the future; as involved with a sense of Fate and Fortune, further, it is combinatory, so that we have the Purgatorial tense of "was to be."

There remains, to complete the conjugation (whether from chance or hidden design) only the present tense itself; thus "is" is the only partner left for Hell. All my intuition urges me to accept it implicitly. For the painting *Phenomena*, Tchelitchew's rendering of Hell, is a portrait of the artist's dynamic relations with society; it marks the pivot of his professional career, the beginning of a lifetime physical illness and a moment of crucial moral suffering when he had to choose one of two roads. The crisis embroiled him with a Hellish "historical present" for the remainder of his life.

Two
PURGATORY

Marya Gavrylovna Popova, Tchelitchew's old nurse, had charge of the children in turn, from birth to the age of two, when they were turned over to Elyena, the general nurse, who supervised the growing, rather regularly spaced brood. Elyena (Helen) divided their care thenceforward with the governesses, mostly French and German, who came and went and were responsible for their scholastic education. The precocious Pavlik soon nicknamed Elyena "Tyapotchka," a name from an old song that she taught the children. Both the Russian domestics were categorically called Nyanya (Nurse), a term which Tchelitchew, in English-speaking countries, was to convert into Nanny.

Solemnly, once, when the child was still very young, either the elder or younger Nyanya appeared before her mistress at Doubrovka and announced that the first-born Pavlik, who already drew and colored, was destined to be an artist. Mme. Tchelitchew took the news graciously, with a surprised little smile not without a hint of complacence. If it was the old Nyanya and the time was winter, she was wearing her *doushgreika* (soul-warmer), as the children called it, a padded vest that covered her ample torso and was fastened in front with a row of many buttons. Her hairline was barely visible under the close-fitting cap she always wore and her grey skirt whispered along the floor as she passed. When very ill in late life, as we know, Tchelitchew was to long for the care he had had when still a little child. The boy was not slow in seconding his Nyanya's prophecy that he would be an artist. In fact, he was to recall that he himself, when still very young, had gone with that announcement to his parents.

Mostly, Pavel Tchelitchew's aristocracy was to be a strict orthodoxy of social and individual privilege, the same, historically, as that enjoyed by the traditional privileged classes, but somewhat more as well. In sensitive and talented beings, exceptional privilege is always exciting, sustaining and endangering. It creates pride and the pleasure of pride; obviously, it also lays the groundwork—unless one is extremely self-sufficient and insulated from the world—for almost certain sufferings and certainly great tests of character.

What was to happen to Pavel Tchelitchew to make him think himself unlucky?—that is, prior to the Russian Revolution that was to turn his whole world inside out?

Many things, according to his own testimony, perhaps more than he was justified in calling unlucky. Ultimately he had to earn his own living, not simply adopting a profession as a well-to-do member of Russian society, but leaving Russia as an exile to make his own way in a foreign world. Therefore he was never slow to blame circumstance for putting obstacles in his way. He attributed the "hump" on his back, as we know, to having been dropped when a baby, apparently by that very Nyanya who was so devoted to him, whose memory was to remain dear to him; on the other hand, it would have been typical of him to lay the blame on some ignorant, officious servant girl.

He became a spoiled darling in the classic sense despite the rule in the Tchelitchew household that no favorites were to be played among the children. The four eldest of the second generation were daughters of Pavlik's father, Fyodor Sergeyevitch, by a previous marriage, the oldest, Sonya, being married and living on the estate with her husband and child in a cottage near the manor house. There may have been, largely and technically, no "favorites" at Doubrovka. But what child does not accumulate a list of prime injustices at the hands of even the most adoring parents? Tchelitchew was to accumulate quite a list.

All the same, the family rule was as liberal as it was methodological. Everything matriarchal and patriarchal was enlightened order, enlightened reason. Papa and Mama, indeed, could be called enlightened tyrants, educated by the most advanced sentiments of the time, each supreme in his or her domain. The Froebel Method was extant among educational ideas at the turn of the century. This decreed that children should always be "doing something," and doing something the Tchelitchew younger ones always were, from breeding tadpoles (whose eggs they called "caviar") to learning French and German and the constitution of the heavens.

Having reached the age of four, each child began spending the day with the governess, their nurse's province then being reduced to the routines of rising and retiring; the latter meant such soothing things as telling them stories or scratching their backs to help them go to sleep. Elyena too, however, was indoctrinated with Froebelism. If, during the day, she caught a child sitting idly, a-dream, she would be apt to say, "Don't sit there like Ilya Mourometz, who stayed sitting for thirty-three years, at the end of which he became a *bogatyr* [knightly hero]. For you can stay sitting there for a hundred and thirty-three years and you'll never become a *bogatyr*."

Usually Mama, Nadyezda Pavlovna, a small woman who knew her own mind, had the first and last word on matters strictly domestic. She was

universally known to the family as the Little One and petted as much as her very real dignity would allow. Her children had an indelible memory of her ensconced in her easy-chair—virtually "lost" in it—with one leg tucked under her and otherwise invisible because she held up before her a widespread liberal newspaper, engrossed in its columns. The only exceptions to Mama's regular jurisdiction were awfully difficult cases, which were rare, or instances of violence, which were not rare; the latter were savage squabbles among the children, and here only Papa's hand would serve because the children's physical passions usually went into instant action with accompanying clamor.

It was Choura, as one of the underdogs of the contentious playroom, who recalls the mythic battles that might start with a word or a push, and before one could think had engaged every child present. The combatants always included Pavlik's brother, a year younger than he, named Mikhail or Michael (Mischa), Choura, five years younger than the first born, and Lyena, the youngest of all. These were Nadyezda Pavlovna's children. But also present might be two of Pavlik's half-sisters, the younger ones, Marya (Manya) and Natalya (Natasha); Varvara or Varya (Barbara or Barbe) was to marry early and live away from Doubrovka, with her husband's family.

An horrendous racket might start in the schoolroom, or indeed almost anywhere in the house where the children happened to be together. On the floor was a writhing mass of childish limbs, in the air a medley of unrepressed shrieks: noise was as much an instrument of battle as anything else. Neither nurse nor governess nor male servant, much less Mama, would dream of correction at such moments. As for Mama, if she heard the sounds of strife, she retreated as far as possible and shut the door. If Papa were not within hearing distance, Nyanya or another servant hurried to apprise him of the event.

His reaction was invariable. Arriving at the scene, he hung over the lao-koön of childish frenzy and waited till he saw a detached limb which, regardless of the individual to whom it belonged, he held on to till the maddened person was safely separated from the rest. Once securely in his grasp, this person, whose noise and anger ceased at once, was carried directly to M. Tchelitchew's office, his sanctum of privacy and, in cases like this, parental discipline. Rendered just as mute, the other children would pick themselves up and trail after Papa as he carried the luckless one, tucked under his arm, to inevitable punishment.

Choura remembers these battles distinctly enough to say they were numerous and that she was at least twice the scapegoat whose arm or leg Papa managed to get a grip on. But the ritual was the same for all. In Papa's office, after being offered a glass of water and invited gently to calm down, the scapegoat was allowed to sit in one of the chairs for a while. Then he might have the privilege of looking through one of Papa's photograph albums or

one of the magazines with which the office was always full. This was the standard punishment in its entirety.

Maybe it was a wise one. For her part, Choura found the ordeal very tonic. However, Pavlik's fights with Mischa, who periodically had to be taught his place as the junior, turned out quite differently. They were undisturbed and surrounded by a tense quiet, his sisters looking on silenced by fear and awe. The male champions looked so much as if in earnest! Being the stronger, Pavlik nearly always came out on top, and, Choura says, his triumph was cruel and most solemn to behold. Poor panting Mischa (the family's only blond) would be supine on the floor. Pavlik would then release him only in order to grab a certain chair and place it over his body. It happened that the bottom rung of this chair was low enough to press ever so slightly on Mischa's breastbone, somewhat incommoding his breathing. With the fierce face of a vindictive torturer, and panting himself, Pavlik would then sit on the chair and fold his arms, glaring around at his sisters as if to say: "See what happens to anyone who crosses me?"

Owing to the thoughtless impulses of children, Choura and Lyena also earned disciplines from Pavlik, though of lesser severity. As he grew older, Pavlik in fact showed a propensity for playing the cavalier quite seriously. Once when Choura was recovering from a bad cold (she always suffered from her chest) and could not sled with the others, Pavlik wrapped her up warmly and on his ice-skates pushed her along in his sled till she was well again. Still, Pavlik could work up a passion even against his favored half-sister, Manya, whom he admired as she grew to be a young lady because of her talent for style. The First World War had started and by that time Pavlik was adolescent and Manya and Natasha young ladies. The servants could no longer address them in the familiar. For instance, Manya was "Miss Manyt-chka," a respectfully inspired compromise. For her gallant half-brother Pavlik, however, she was, at odd moments, just another object to arouse his ire and invite chastisement.

One evening in the dining room, Pavlik and Manya unceremoniously engaged in fisticuffs over some casual argument. Choura remembers it as their last hand-to-hand battle before Doubrovka had to be abandoned. The fight scandalized Mischa, who had become very chivalrous in temper, and his outraged cries made the combatants suddenly desist. "If you were not my brother," he shouted at Pavlik, "I would challenge you to a duel for one does not fight a lady!" Pavlik's anger quite evaporated at this rebuke from a champion of the ladies. Secretly, he felt he knew much better how to deal with them (he was seventeen) than did Mischa. What immediately happened was that both he and Manya, enchanted by Mischa's naive chivalry, burst into uncontrollable laughter and their battle was over.

As always, there was a great deal going on in the family of which its head

was increasingly ignorant, owing (if to nothing else) to the well-known official preoccupations of heads of families. It is also meaningful that the greatest sign of anger in Papa Tchelitchew, in Choura's memory, was "a slight frown." During her life together with Pavlik in Europe, Mme. Zaoussailoff recalls, Tchelitchew would tend to imitate this frown when he was displeased with her. "Don't tire yourself," she would say to him. "That frown has no more effect on me than Papa's used to have." In terms of daily routine at Doubrovka, Papa had a great deal to do to administer the affairs of the estate, composed of vast forestland, with many peasants living on it.

However, Fyodor Sergeyevitch, who discouraged his own frowning, was a model of justice, and no one need fear not being heard; no one need fear a hasty or unreasonable decision from the Barin. He received the peasants in his office, one foot on a chair, gravely puffing at his pipe and in a "listening" attitude. Papa was a Tolstoyan. He looked like Tolstoy; usually, about the estate, he dressed like Tolstoy, in peasant blouse and boots, and to his annoyance, was even sometimes mistaken for Tolstoy. Highly educated, especially in mathematics, a philosopher by bent and a great reader, he criticized Tolstoy on occasion, an act which bolstered his amour-propre. His criticism of the famous Russian author and religious thinker did not blunt his admiration for him. For one thing, this man provided an image for him to live up to in his wife's eyes. Never did Nadyezda Pavlovna waver in her veneration for Tolstoy, and even, in her woman's way, was destined to deceive the Church in order to pay homage to Tolstoy's memory when he died outside the benefits of orthodox religion. At that time, she asked the village priest to say a "mass for Lev." As the priest started and regarded her suspiciously, she blandly rejoined (as she had planned) that the mass was not for Tolstoy but for a cousin of hers named Lev.

Doubrovka, the family's estate, had an ordinary, rambling manor house whose most distinguished feature was a great balustraded balcony on the second floor; it swelled out in a leisurely semi-circle and at either side unbanistered stairs descended to the ground. It was where the family liked to take their ease in the summer and was a favorite spot in which to be photographed. The house was old and the family themselves thought it ugly. Yet it was much beloved, so much that whenever repainting its pale pink was mentioned, a general outcry overwhelmed the idea and it retained, much to everyone's satisfaction, its sweet old patina.

The manor's main entrance even lacked a front stoop; two small steps led up to the unimposing door. However, Pavlik the first-born son, was to make a giant step of these, taking them in a single stride, as soon as he could. Inside, the manor was no more distinguished. That the house had, in a sense, "seen better days," was betokened by the fact that the children's schoolroom had once been a grand reception hall with four windows, each fourteen feet

tall. From a very early age, Pavlik had made the most of what grandeur there was at Doubrovka. The temperature in winter fell to thirty below zero, so that the panes of the tall windows become frosted over despite being washed with vitriol. A birch forest was to be seen outside, and the black and white fantasy it made through the interfering frost induced the dreaming boy, who already loved the theatre, to imagine a whole ballet about Don Quixote. He was never actually to do a ballet about Don Quixote; rather he himself, by his own authority, was to *be* a Don Quixote, and meanwhile do ballets about Orpheus and St. Francis and Apollo. It is not hard to imagine, for the dreaming Pavlik, a four-sided personality made up exactly of this set of legendary heroes.

In Orpheus, particularly, would be found the artist's personality as it compassed the prophet's. When visiting Tchelitchew's sister in Paris after his death, I asked her if she considered her brother to have had a "tragic nature." Her answer was, ""No, he had the prophetic gift." She did not merely mean that Tchelitchew was keenly intuitive and had accurate, acute premonitions but that the gift of every profound artist enables him to transcend suffering and even death: art itself is his "prophecy." After Orpheus is torn apart by the Maenads, his head, according to one legend, is thrown into a river and floats out to sea uttering prophecies. It was to take a remarkably short time for the infant, Pavel, to discover his creative gift. When a man, he declared that he was only six months old when he possessed a set of nine blocks, out of which he could make six complete pictures.

When he was still very small, the first playing cards he handled had more to do with his adult destiny than the Tarot pack itself. On their backs were reproduced masterpieces of classic painting, which he soon learned to identify. One of his Nyanyas (possibly even the old Nyanya Popova who had him till he was two) would carefully tear colorful reproductions of paintings out of books and magazines and tack them on the walls of the schoolroom, so that Doubrovka had a more or less permanent "art gallery." Sedately, the nurse and her young charge would make the full turn of the room and discuss over and over the merits of the pictures. One may think of the two Nyanyas as having the prototypic relationship of St. Anne and the Virgin as seen in Leonardo's painting, the daughter seated on the mother's lap. In the future art of their little charge, the relation would tend to appear as two positions of a single person. In fact, this painting of Leonardo's has the remarkably prescient quality of suggesting the Futurist effect that was still centuries away.

One side of the three-storied house at Doubrovka overlooked the garden, the other three the courtyard. The garden, into which the stairs descended from the balcony, was large and was cut through the center by a handsome alley of larches, which turned all golden in autumn. At the other end of this alley, at certain hours, the play of light could produce an illusion—as

Tchelitchew's sister, Choura, put it—that a "person in white was coming toward you." This was Pavlik's first sight of La Dame Blanche. Another section of the garden had its beds cut into the shapes of stars, sun and moon. It was the scene of the artist's first practical initiation into the nature of the heavens. Even on nights in deep winter, he and Mischa would go out with their telescope and map of constellations (the girls were afraid of being frostbitten) and study the blueblack, begemmed arch above them. The boys came back, indeed, frozen; Pavlik with a huge red ear that stung him and required instant attention: it was a precursor of the great foreshortened ears of his paintings.

The lovely fat old house, up to the moment of their farewell to it, retained its washed-out pink. It was much like a stout woman of 1900 with only one precious dress, from high neck to floor-touching hem, to cover herself. But the Tchelitchews were in all ways unpretentious despite the fact that their forests, owing to M. Tchelitchew's innovations, were models of scientific forestration and worth a great deal of money. Directly before the manor grew two enormous old maples, whose leaves in the Fall became golden-yellow and red. They were surrounded by a thick, leafy hedge of lilacs, so that the whole group formed an oval islet. Between this islet and the house there was just enough room for the carriage and horses to pass; as unextraordinary as it was, this carriage and its uniformed coachman were one of the family's prides.

In the middle of the courtyard flourished a little thicket of pines, lindens and birches, which sheltered a wooden table; here the servants had their tea. Nearby was a shed where, during the summer months, many kilos of jam were prepared. Vegetables and fruits were cultivated in the garden that stretched beyond the house, and in the shape of a rosevine, the flower garden climbed to Mama's bedroom window; for she loved roses above all. Next to the shed, in the thicket of trees, were two seesaws, one for the smaller children, one for the bigger. At this spot, there was another plaything that assumed great importance for the first-born as soon as he had his legs and as soon as the pride of being handsome and adored swelled up in him and made the heights his own particular niche.

Pavlik and Mischa were natural partners in play and sometimes would exclude their younger sisters even when they started growing up. Driven to despair at her exclusion, Choura would don pants and beg to be allowed the humblest role in their play, which often was rough. To Choura (she herself said in her maturity) Pavlik was "Czar and God," only this supremacy standing between her and her sisterly worship of Mischa too. An ailing and evidently emotional child, Mme. Zaoussailoff says that she quickly decided (though, as a fact, it is doubtfully true) that she was the homeliest of the Tchelitchew lot.

Even if the seesaws in the thicket of trees were popular, it turned out that Pavlik did not care much for the rather monotonous occupation of seesawing: it was somewhat too democratic for him. He much preferred, as the family phrase came to be, "playing the star" on the Pole for Giant Steps. This contraption provided for three to be Runners and the fourth the Flyer. Ordinarily, Pavlik was the Flyer, Mischa, Choura and Lyena (nicknamed Bombotchka, "Little Bomb," because she was so lively) the Runners. This was more absorbing than driving, or even riding horses, for here the workers themselves did all the directing, which was mechanical. If three stayed running on the ground, holding the ropes which turned the pivot at the top of the pole, the fourth, simply by grasping his rope firmly, could soar at his ease and pleasure in the air. Naturally, each wanted his turn as the Flyer, yet in reality it was itself a pleasure to behold Pavlik lording it over them, up there. The sight of the wild joy printed on his flying form and transfigured face was magnificent enough to keep the three younger children long and willingly at their posts as Runners—perspiring but spiritually exalted.

From his height as he circled the Pole, Pavlik could glimpse the field of pink and white daisies where the horses were exercised in a circle. There the children aspired to the equestrian world by playing "horsie." Pavlik became very fond of the use of the whip, always claiming, in answer to cries of protest, that he was simply trying to be realistic. Now and then, Mama Tchelitchew was fond of a canter, and for these occasions had a riding habit. It was her most romantic image in little Pavlik's eyes and the subject of his first production as an artist. He portrayed her, he was to recall, "as a blue velvet Amazon sitting sideways on a horse whose name was Please." She wore the customary veil, which was also blue, a Prussian blue; this veil was the prototype of the Veronica images (most of them portraits the artist would paint in later life) for it floated out behind Mama's head, framing her face.

Mama as a gracious equestrienne, Pavlik as Lord of the Pole for Giant Steps: these were images of noble ease, noble height; altogether fine, joyous, patrician. But in any domestic concentration of space, indoors and outdoors, there come willy-nilly the ignoble falls to be endured and survived. Pavlik, too, was destined to ride a horse. He started by riding uneventfully with the other children although this amusement was never much to his taste; he preferred horses attached to a carriage. As a schoolboy in Moscow, wearing the school's military uniform, he particularly asked for a gentle horse when the first parade day came around.

His wishes were usually respected and the grooms furnished him with a horse that was docile and graceful. Pavlik was delighted. But this horse (though the fact was unknown to its rider) was docile and graceful because it had been circus-trained. At the first strain of music by the school band, with Pavlik poised in the saddle like a little prince, the beast's second nature

answered and it began to dance. Totally taken by surprise and frightened, since the horse did not heed his orders to stop, Pavlik promptly fell off with as much grace as possible. Furious and profoundly humiliated, if unhurt, he would not remount and swore never to ride again. Unable ever to forget some of his schoolmates' laughter, he kept his word. In Paris, in the twenties, he would be moved, nevertheless, to paint equestrian accidents and rearing horses.

An ordinary mechanism, to be sure: symbolic compensation, perhaps a touch of masochism or paranoia, based on plain unmanliness. But a little more, too! If artists live the way they create (as I have asserted) rather than create the way they live, they must fall the way they create rather than create the way they fall. The net in Tchelitchew's art was to become conspicuous in myriad ways, both plastic and symbolic: it is the net which catches the falling acrobat, and in the form of the spider's web is verily the architecture of home, which likewise, as a "prison," can trap one's enemies. Tchelitchew was to live to term the "nett" (as he spelled it) a trap, the very skein of his own fate, so that the reins in which the mythic Hippolytus became entangled are an echo of Pavlik's generic and ambivalent "nett."

In the entanglement sense, the net may have the benign aspect of the labyrinth whose secret belongs only to the builder or to a stranger (the initiate in mystic ritual) who conquers its puzzle by intelligence or fails to do so and is doomed. Tchelitchew was to evoke Arachne as the muse of his painting of Purgatory, *Hide and Seek*, whose structure has a spiderweb tension despite its elaborate presentation of the physical world. *Hide and Seek*, closely studied, quickly yields this plastic "secret" of its nature. Everything presumably solid in it is painted as a sort of illusion: earthy bodies are everywhere qualified by wateriness, airiness or a kind of X-ray revelation of skeletonic structure that lightens its look, as is literally the case with the boy representing Winter. Superficially and anatomically *analytical*, the device becomes ambivalently constructive: a principle of unity that is responsible for the painting's composition; everything is held tight in a sort of expansive and contagious tension, visibly vibrating yet fastened down.

Physiologically, the net is a modification of the armature, composed serially of blood cells, pores of flesh, muscle-and-bone scaffolding, and so on; in other words, a sequence of linked and similar or duplicated units: the innermost texture of life as it exists on superimposed, communicating planes. When attacked in the region of the viscera, his weakest spot when a man, Pavlik would evoke "dear Papa" as the unconscious villain who had ruined the lining of his stomach with perpetual doses of quinine. Ocean waves, sand and seaweed in Tchelitchew's work were to suggest, through evident plastic treatment, both blood cells and the cellular lining of the stomach. It is also the nimbus or caul we find about the head of La Dame Blanche in the artist's last

painting, *Inachevé*, and in its most spiritual aspect is to be taken as a mandorla. In fact, in *Inachevé*, it has the mandorla's general shape, which is formal not naturalistic in origin. The orthodox aureole, on the contrary, is supposed to follow the shape of the object it surrounds. Mythologically, the mandorla is formed geometrically by the mutual part of two overlapping circles placed horizontally, one circle representing Heaven, the other Earth; hence, Christ is found in an upright mandorla because he combines humanity and divinity.

The symbol is further connected with Christ through perpetual sacrifice and thus with reincarnation and the ceaseless evolution of life. Pavlik was quick to seize, during his boyhood, on the subtlest signs of growth and change as manipulable things. Morphologically, the mandorla is linked with the spindle of the Magna Mater and thus with the spider as magic spinner. Arachne the Spider Woman, as seen in *The Divine Comedy*, is a denizen of Purgatory being punished for her pride in rivalling the skill of Athene. Doré shows her perpetually suffering metamorphosis from human to enormous insect. In his illustration her prostrate torso and outstretched arms are startlingly arranged like the posture of the little girl representing Arachne at the center of *Hide and Seek*.

We are reminded that Arachne wove tapestried pictures by much other symbolism in Tchelitchew's future art. In 1933, he was to paint *The Concert*, showing four quasi-musical instruments being played by clowns. One is a toy globe or top governed by a pull-cord, one a cat's cradle anchored by the teeth, another a balloon being inflated by mouth and "plucked," the fourth, one of those party favors that inflate and unroll simultaneously when blown into through a mouthpiece. Each in its way is a cosmic symbol (the balloon also has the strange connotation of a womb) while the cat's-cradle is a striking prediction of the structure of the dancing boxes that were to house the artist's Celestial Physiognomies. The aureole about the subject's head in the "red portrait" of Charles Henri Ford is literally a harvested wheatfield stretching behind him and "draped over" his shoulders; it has an illusive dimension by seeming to follow the spherical shape of the earth and thus resembles a curving mandorla. The form was actually inspired by a huge straw hat whose brim was pressed into an oval; of course, weaving is another sort of "network."

Youth, especially a creative youth like Tchelitchew's, is a period of anticipations which are *precipitations*. Thus, before we know it, the things of life turn into the things of art and (conveniently for the alert biographer) foreshorten the hours on the actual clock. This is the psychological explanation for the foreshortening that began to shape Tchelitchew's painting by 1928; see, for example, the *Green Venus*, where incidentally a hammock incarnates the net motif. Sharp foreshortening of the figure (distorted delib-

erately in the work just mentioned) was to become a sign-manual in the artist's bullfight pictures of the thirties. The torrid heat of Spain, in a metamorphosis of temperature extremes, was to suggest the huge frostbitten ear of his star-gazing at Doubrovka; it appears, aflame with sunlight, in the work titled *Bullfight* (1934). As childhood's fables teach us very early, nothing is so fascinating as that which can change into its opposite, or double, at will. To surprise these acts of magic by mingling with them: this was Pavlik's first passion. From there to *making them* was only an arm's length, or less.

In attaining shape by discarding the past and hastening to meet the future, my narrative reflects Tchelitchew's own temporal urgency. Everything true can wait (since, being true, it cannot be eliminated), yet the truer it is the more impatient it is to show itself. Pavlik's old Nyanya, to avert the Evil Eye, would throw over the baby boy, in his cradle, a blue veil. She was certainly hastening everything; not only tempting destiny (Pavlik's alliance with Mercury the Fleet One) but casting it directly on her little darling's eyes. The blue sky was not only something "up there," the home of the stars, the clouds and the sunshine, unreachable and intangible. It could be a little blue veil *and taken on and off!* The color of such an object, echoing as it did the marvelous sky, was bound to be symbolic from many viewpoints. A piece of paper could become the sky simply by being painted blue; in the same manner, it could also become, properly coaxed, his mother's equestrian veil.

The young artist (only eight then) presented the equestrian portrait, his first production, to Nadyezda Pavlovna and she preserved it with happiness and great pride. However it was to be one of the things that disappeared when the family was cast out of Doubrovka in 1918. Mama Tchelitchew had given Pavlik a smart looking box of Winsor and Newton watercolors for his birthday and the first use he made of it was to do the equestrian portrait. He had been set dreaming after seeing some amateur watercolors by his uncle. The nature of the dream was as redolent of sexual symbolism as these particular pigments were of honey. As Tchelitchew was to recall it in later life: "I came to the chest of drawers where my underwear, shirts and pants were and when opened, I saw there nothing but wonderful enormous boxes of Winsor and Newton watercolors, glowing like precious stones and smelling of honey (of which they really smell because they are mixed with honey)." Grammatically speaking, the apposition between "opened" and "I" in this sentence is a very common error. But as often with Tchelitchew's speech, the error is unusually informative and here within a Freudian pattern: he himself, not the chest, is "opened." The gleam and chaste form of precious stones were gradually to represent a permanent ideal of his art: the metamor-

phosis of earth into its final, most spiritual and "eternal" form. At first gems
are locked in the earth and one must dig to obtain them. The parallel between
an ordinary physical action, the personal labors of art and supreme spiritual
attainment was to be the governing principle of Tchelitchew's life.

Yet his impulse toward painting was by no means a "sport" from the
family viewpoint. He was to live to call himself a sport amid his profession,
but at Doubrovka he was simply the star of young culture and the incipient
arts. Drawing and painting were a wide family occupation; all the children
did it at first, just as all of them studied great pictures and produced ceramics,
made costumes for holidays and *tableaux vivants*, acted in scenes from plays.
Pavlik naturally became leader of the entertainments and chief costume
designer as well as the family "artist."

Aside from my own direct knowledge of Tchelitchew, I have not looked
further than into my subject himself, to members of his family (primarily his
sister Choura) and old intimate friends, for my authority concerning the
facts of his life—no further, I mean, in that very seldom have I sought to
verify what I learned by turning to more impartial sources, such as official
documents. I did verify that the Book of the Old Nobility, in an edition
published in Berlin, contains the name "Tchelitscheff," and Mme. Zaoussail-
off (Choura) kindly furnished me with a copy of Tchelitchew's birth
certificate. Otherwise, such a type of research has served exclusively as a
minor corrective rather than a large contributing factor. The commanding
truth about anyone's childhood and youth, surely, is the family imagination
itself.

Mme. Zaoussailoff's vivid recollections form a duet with Tchelitchew's
various autobiographic sketches, conversational anecdotes, interviews and
letters. That Tchelitchew's raison-d'être should be painting may appear to be
a logic drawn from *a posteriori* evidence. Consequently all facts, so called,
would have come to be "colored" and otherwise slanted by the professional
perspective on the artist. Theoretically, such does not hold, on the other
hand, if the principle I have already instanced be acceptable: an artist lives the
way he creates rather than creates the way he lives. Then his art is his *first*
creation, his life his *second*. The common family memory is stirred: images of
Tchelitchew as a budding artist immediately take precedence over other
kinds of images. Yet it is not as if these budding-artist images could stand
alone. The more significant, more clarifying, fact is that they represent
Tchelitchew's first conscious assertions of originality and individuality; nec-
essarily, therefore, they were to come into conflict with every other disci-
pline, with all family obligations and with parental authority.

It would be very strange if evidence of these conflicts were lacking;
fortunately, they are not. I learned that Pavlik's half-sister, Manya (Marya),
recalled his first absorption with drawing as a gesture of self-isolation in

defiance of domestic routines. Manya, like all of them, was aware of Papa Tchelitchew's "iron discipline" as something which Pavlik had his special means, and reasons, for escaping. He would seek out a corner in the garden or a spot in the forest to be alone to draw. Once, when he was "missing," he had not gone very far. Manya remembered that he was only on the balcony outside the "children's room," drawing the clouds.

A son's contest with his father is so much a routine part of human life that it does not invite much elaboration, especially in our day of post-Freudian surfeit. Yet to overlook it in Pavel Fyodorovitch Tchelitchew's case would cheat us of some engrossing and important moments of his boyhood, one might even say, some fatally decisive moments. Before his education for a career became an issue between himself and Papa, when the scene was Moscow rather than Doubrovka, he had established a footing of personal discord and eccentricity of temper with M. Tchelitchew. It was very soon that illness became a magic factor in the younger Tchelitchew's survival: an invalid, often, is a passive rebel.

Originally, with much significance, one of Pavlik's health complaints was diagnosed by the family doctor as "nervousness." At eight, just before he was to start school in Moscow, he suffered simultaneous attacks of diphtheria and scarlet fever. He was left in such a delicate condition, after recuperating, that the doctor forbade his going away to school and prescribed cold showers for the boy's irritability and jumpiness. It was not Pavlik himself but Tya-potchka, his Nyanya, who took most alarm at this news. M. Tchelitchew ruled that the doctor be obeyed. Tyapotchka, a person whose voice was so authoritative as to have domestic weight even with the senior Tchelitchews, raised it in protest but finally her employer put his foot down and the morning baptism took place. It was disastrous, Pavlik stamping and yelling throughout the dousing. Tyapotchka was very sorry for him but could not repress an I-told-you-so look directed at M. Tchelitchew.

However, the head of the house could be very stern and he did not hesitate to order the cold showers continued. Then Tyapotchka, with the inspiration of one who knew her Tchelitchews, thought of a stratagem. "If you think cold showers are so good for the child, Barin," she said in a respectful but offhand manner, "why don't *you* take them too?" M. Tchelitchew was so surprised at this that he considered for a moment. That was his Waterloo. He was one to whom the processes of reason appealed and Tyapotchka's challenge was "reasonable." Why should he himself not take a cold shower in the morning? It would probably refresh him for the day.

The first thing in the morning was what the doctor had ordered. And the first thing the next morning, Papa arranged for his valet to assist him in this extraordinary health measure. It was noticeable, for the rest of that day, that he was in a positively bad humor and for no discernible cause. He did not say

a single word about the cold showers for Pavlik after that, and the subject was dropped as if it had never been the doctor's prescription; dropped by all, that is, except Tyapotchka, for whom it was a signal victory. Whenever the subject was broached, thereafter, about a "prescription" for someone in the house, Tyapotchka would be bold enough to say: "Another stupid perform-ance like the cold showers for Pavlik, I suppose?"

Tyapotchka may not have noticed it in her selfrighteousness, but the moral victory was by way of being one for Pavlik as well. The boy had once again shown he was capable of escaping the "iron discipline." However, parents seldom let such a thing as filial rebellion rest on its laurels. Papa knew he was losing a victory to Pavlik every day of his life and did not—what father ever did?—find the feeling comfortable. The Devil nevertheless comes to the aid of desperate fathers as well as desperate children. As the first-born (and, despite all deliberately applied rules, his mother's favorite), Pavlik quickly became an object of special consideration. It also happened quickly that he took advantage of such consideration to render it a set of privileges, dubious in substance but eloquent in form. It amazed his family that he could invent a manner to suit "privileges." Hence it was mostly out of parental pride that Papa Tchelitchew, thinking he was being cute, started to bow when he would encounter his son in a doorway, and stepping aside, would murmur, as if he were some elder menial, "Nasledni Knyass!"

It was Russian for Crown Prince.

Pavlik, already aware of his personal good looks, and precociously self-confident as he entered his teens, justified his father's wit by accepting the homage with composure. Already the cupid's bow mouth could convey a devastating mockery and condescension by the most minimal exaggeration of its natural curl. Not for a moment did Papa relent in his basic authority, not for a moment did he relax (anyway in principle) the famous iron discipline. But another point had been won by the junior Tchelitchew in his contest with his father. Such was the state of things till the fatal day when Papa's humorous wit, in answer to a whisper of the Devil, inspired him to make a play on an alternate nickname for Pavlik (diminutive for Pavel) that brought Papa's score up to a little more than even. But perhaps, in justice to the fatefully illuminated parent, one should cite a few of the symptoms in his son that made Tchelitchew senior so spontaneous, so humble, a vehicle of the Devil's prompting.

As a boy, Pavel Tchelitchew was not really effeminate in looks; rather, his rapid way of "growing up" tended to bestow a manly air on him. Nor was he effeminate in manner, aside perhaps from certain hauteurs that proclaimed a coquettish, self-conscious vanity: a kind of regal capriciousness. That he was quite as sensitive to masculine as to feminine admiration is shown by his recalling their coachman, Philippe Kirillitch, as "one of by first great ad-

mirers." It is doubtful, as was implied by the phrase, that he had in mind only his early accomplishments as a painter. Something that disconcerted Papa, though the ladies in the family were delighted with it, was Pavlik's unrestrained interest in women's clothes. He criticized everything the females in the family wore and often, throughout his youth, chose colors and styles for them. This was an especially delicate matter because, when it first struck Papa Tchelitchew, his subconscious had to recognize it as, in some degree, an inherited gift. The fact was, as the whole family knew, that Papa had once (as it was put) "designed the robes" of his first wife, Natalya Mikhailovna, who had been gay and party-loving.

A onetime governess of Pavlik's, Yekaterina Ivanovna Nikitina, recalled that the boy himself was "immaculately groomed." It was a family legend that unpressed pants were an abomination to Pavlik and he would demand fresh pressing at any cost to the general convenience. All this was a budding "virtue." And provided he could visualize his son as a future designer for the stage (which he did not particularly wish to visualize him) M. Tchelitchew found Pavlik's interest in "costumes" all very well. But when he kept talking about the charm of the new styles in women's fashions (he was to term them in later years "a mad fantasy"), when he fussed about the contents of his sisters' wardrobes and adopted a dictatorial manner even about what his mother wore, the subject became onerous and somewhat grating to Tchelitchew senior.

It was thus, one day, that the Devil made his voice heard. Actually, Papa himself, as Pavlik could see, was speaking to him, and his salutation was only an alternate diminutive for Pavel, Panya. However the scarcely veiled irony with which Papa pronounced it, the depth of his bow, and the sensational substitution for the usual title, Nasledni Knyass, turned the joke from a compliment into an insult, from a flattering one into a nasty one. Indeed, it made Pavlik sick. He knew, as did his father, since they were a most linguistic family, that in Roumanian, Panya is the word for Miss or Mademoiselle.

The cruel truth was that the elder Tchelitchew had served notice on his son that he was armed, and in the field, so far as all "effeminate" tendencies should continue to be cultivated by Pavlik. The term was to remain a weapon in dear Papa's hands for the rest of their mutual life. To the very end, when Tchelitchew had left Russia and his father wrote him from there, if Tchelitchew senior was at all out of humor with him, he would not hesitate to begin his letter, "Dear Panya." Sometimes it would seem he did it only because, now lonely, unhappy, poor, he reflected that Pavlik had the opportunity in Paris to be successful and happy—and on his own young terms.

During one period, in the days when Tchelitchew lived with Choura in Paris, if a letter came for him from his father, he would automatically, with a scowl, hand it to his sister to open and read, so fearful was he that he would

glimpse the dreaded word at the head of the page. Actually only a pale souvenir of a joke from the distant past, it might seem to invite easy indulgence from the worldly man Tchelitchew had become in Paris. But not so. Later, the same day as a letter from his father was received, he would ask Choura in a casual tone, "Did Papa have anything to say?" Sometimes Choura would play possum and retort, "Here's his letter, why don't you read it?" But Tchelitchew would decline to take it: "No, tell me what he has to say."

In the world of Doubrovka, Nasledni Knyass was still Nasledni Knyass in an uncontrovertible sense. Yet in his father's eyes, he had had to forswear the title at a certain point. This was to make itself plain in the months and the years that followed that first inspired "Panya!"

There is a realm in which extraordinary individuals, those of true creative gifts, are always quite certain of themselves; they proceed with those perhaps obscure-to-others but innerly plain-speaking and peremptory dictates which make their creations, their work and their life, what they come to be. And yet so infirm must be the tightest human grip on reality, perfect control of these things is never attained. The wildest prophet and most adventurous thinker, the most modest and scrupulous historian, may prove equally right or wrong. Both race and individual have to cope with past and future tenses as equally unknown in their long-range results. Tchelitchew, developing so practical and instrumentalist a nature, thought that the past should be, and could be, discarded; he even thought so—such is the paradox of mystic and superstitious logic—when he was convinced the past could not be wholly discarded because at least its "scars" remained: so the Italian Mago was to persuade him late in life.

Ethically, it would seem that only what is evil ought to be eliminated from life; ethically, Tchelitchew had a certain simple-mindedness. One might think from his early attitude toward conduct that the past was something to be eliminated the way the body eliminates its waste matter. The instrumentalist, aiming at a definite goal, may get a great deal done as the future becomes the present. He behaves *as if* everything were choice, *as if* he had not begun with given advantages and disadvantages, whereas no individual, even the most gifted, can have chosen the family, the nation, the whole actual environment, immediate and less immediate, into which he was born—or why not say, *was to be born?* For surely something fatalistic inheres in origins, imposed or elected, major or minor. In this sense our "origins" never cease: every new alteration by choice is a new origin, and thus a new "fate." If we look at the bare biographic facts of Tchelitchew's life, we see choice and character being exercised by him from a very early age. But we may remark that the choice, if not the essential character in its potentialities, was normally limited, and that in many cases the youth Tchelitchew was to be on the defensive, even on the run, as literally when he escaped from Russia after the final victory of the Red Army. When a fugitive, it is best to travel very light.

Upon artists, however, the fairy godmother who presides over the birth of each bestows a special kind of gift: the most precious of all. This is not the faculty of individual choice (though this may be very rich) but the ability to imagine an invisible world, whether large or small, near or far potentially, close in nature to the real world or very contrary to it, over which, at all events, oneself is the sole ruler. To the gardener at Doubrovka, who bore the given name of Pavlik's father and sometimes told the children forbidden stories, and to Tyapotchka, who filled them with Russian folklore and respect for religion, the little Tchelitchews owed the groundwork of their imaginative activity, something of the very cast of their minds and morals; from them, Pavlik first got word of invisible worlds over which one could have a secret but efficacious power.

The family's intellectual atmosphere, created by Papa and Mama, had certain aristocratic advantages. It was free-thinking for those times, hospitable to international influences, as was the Russian intelligentzia as a whole, and combined a certain social exclusiveness with political liberalism. The country gentry about, who did little but play cards and go hunting, were not good enough for the matriarch and the patriarch who presided at Doubrovka. The Tchelitchews were quite rich enough to "entertain" but they did not do so. This was not owing to any special vanity about their lineage but to a genuine distaste for the vulgar idleness and emptyheadedness they saw in the social world.

Doubrovka was blessed in being feudally isolated despite political upheavals. Mama and Papa in their regimes answered, thus, to nothing and to no one. M. Tchelitchew was a thinker and a worker and devoted to the idea of useful education for his children. He was quite resigned to taking political "reforms" in stride. It was simply that after the 1905 revolution, politics and economics were too unsettled to suit theoretically even an enlightened landowner. His was the old liberalist situation of approving progressive changes but not outright revolution, which held in this instance the Russian bugaboo of Nihilism. Doubrovka had survived that decrepit early revolution (Pavlik was then seven) in perfectly sound health.

The atmosphere at Doubrovka was gauged ideally for its brilliant heir, Pavlik, to acquire a general character of ease and superiority, to be seriously well educated and to look forward to a career. This character the first-born was to fulfil with style, if also with a little too much originality of impulse. A glint of character, showing the true depth of Tchelitchew's soul, appeared in one of the most critical phases of childhood, "asking questions," questions, that is, regarding the facts of life. Such things were far too personal to ask of the governesses who ruled over the schoolroom at Doubrovka. And the Nyanyas might be supreme authorities on the fairies and on God in Heaven and the religious laws one must obey. But their knowledge was entirely limited to these things. Papa and Mama were the only legitimate sources of

worldly knowledge—of the kind one wanted to know—at feudal Dou-
brovka. Of course the Moscow schooldays were to make things somewhat
different and yet scholastic routine and schoolroom propriety were dis-
couraging.

As for Mama and Papa, they made, in practice, a most disheartening team
of experts. The children quickly learned there was a point beyond which not.
Moreover they found to their surprise that it was Mama who would ask *them*
questions about a word across which she came in a book and that provided a
stumbling block to meaning. Everyone in the family read widely; there was a
reassuring licence in that respect. But if Mama referred her question to Papa,
he might well say that it was a word improper for her to know, and
Nadyezda accepted his verdict meekly, implicitly. Thus grew up the ambi-
ance of "bad words" in the Doubrovka household. The children despaired of
perfect enlightenment in this respect; the only other recourse was the servants,
and their moral outrage, especially Tyapotchka's, was to be feared.

Pavlik, senior of the intimate brood, grew the most impatient of all. The
girls were girls: they could wait for their husbands to enlighten them if
necessary, but why should he, on whom distant family members, the servants
and even casual strangers looked admiringly—why should *he* be considered a
child and kept ignorant of the world and its truths? Added to his strong ego,
he had a somewhat more than normal sexual curiosity; at least in terms of
acquiring knowledge of words and of the world beyond Doubrovka. About
himself, him the private ego and body, Pavlik, he soon had no doubt.

Spontaneously he had made a conquest of the wonders of sex in the passive
and awestruck person of his young valet, Fedya. This was an inexperienced
peasant hired for the position only because he was too young to be drafted
into the Army. Mama Tchelitchew always preferred female servants and till
he was sixteen Pavlik had a maid. Now, in 1914, he was a young gentleman
and required male attendance. The revelation for Pavlik had a manual charm
which fascinated and enslaved him and was partly to account for the sensual
draftsman's line he developed as soon as he freed himself (after he came to
Paris) from the unsympathetic geometrism of the Cubist style. The weight,
plenitude and texture of what Tchelitchew was to nickname the Velvet Doll
spread throughout his anatomy of male and female: it was like a wilful ghost
to whom closed doors and the natural order of organic differentiation are
equally inconsiderable things.

But the knowledge of the body's functions and uses for refined pleasure
was very inward to Pavlik at first. The greater thing then was the social
thing: the status which sex had for all men and women. Did the world know
as much as he, Pavel Fyodorovitch Tchelitchew, knew? This was what
harassed his sense of curiosity long before the awkward young valet was
employed to attend him. Was he, this most extraordinary person, as rare and

precocious in his sexual knowledge as in his personality? It was all-important that he make sure! Feeling so vain caused him to be cautious and shy with his schoolmates. Some deeplaid instinct, moreover, bade him be self-reliant before everything. Events (as they have the habit of doing in such cases) were to bear out this instinct with remarkable force.

Mama was, in a word, impossible. Papa's extended iron discipline prohibited any questions about suggestive words in suggestive contexts. Tchelitchew himself told the story of the crisis he was to experience after he had begun going to school in Moscow and craved some fundamentals of the world's knowledge beyond what was held to be the right of a nice boy his age. His Aunt Sacha, though personally swathed in whalebone, was the fond, yielding tyrant of the Moscow household, delegated thus because Mama and Papa did not wish to forsake their beloved Doubrovka. From the first, the enterprising boy (Mischa, younger by a year, had not yet joined him) behaved unconventionally by not wearing his school uniform in public, as the rules said he should. Automatically he would change into "civvies" to go to a party, a concert or a ballet, running the risk of being seen by an unfriendly school mate or headmaster, and reported. Aunt Sacha, who reproached herself for the forbidden favoritism, was excessively fond of her dashing, handsome, growing-up nephew and defied Doubrovka by variously and secretly indulging him.

If the young Tchelitchew did not obtain knowledge from women (he would learn to love, on the contrary, being their teacher, counsellor and disciplinarian) he often did obtain what was to prove much more important to him: their complete sympathy and devotion. This was true of his mother (in contrast with his father's rather formal affection) so that in his mature life, he was to declare axiomatically that he had inherited his mother's nature rather than his father's. The rest of the family's females were hardly behindhand in promoting his feelings as an adored and triumphant male. He even learned a little independent style and romantic loftiness from his Aunt Assia, an enthusiastic horsewoman who galloped through the forests followed by her groom, mistress and man disdaining the hazards of overhanging and projecting branches. Aunt Assia's conduct, though she got away with it, was viewed by the community as unbecoming to a lady.

Aunt Sacha would not betray him but at home she spent hours of anxiety that others would see him out of uniform and tattle. However, Pavlik could congratulate himself on his luck in this early adventure in non-conformity: he was never to be caught and thus suffered no discipline for his regular treason to the school's military ideal. According to the artist, he came across Freud's book on Leonardo when he was ten years old. Taking the facts of this statement literally (especially his age in relation to the first publication of Freud's study) offers problems, but the problems need not detain us. The

book, anyway, is more apt to have been Merejkowski's opulent romance about Leonardo. But of course Tchelitchew eventually came across Freud's book and was impressed with its bearing on his quest after knowledge. Whatever the book, he had borrowed it (according to his story) surreptitiously from his elder half-sister Natasha's room and it contained a mysteriously suggestive word which interested the young reader greatly.

The word may have been (if it was Freud's book) homosexuality. Automatically, because of the importance of hidden images in Tchelitchew's art, one might think of the famous and miscalled "vulture" which Oskar Pfister ingeniously found concealed in the pattern made by the Virgin's clothes in Leonardo's picture *St. Anne and the Virgin*. The image is directly related to a dream of Leonardo's that is the center of Freud's analysis of his personality. Sophisticatedly, Freud did not reject Pfister's finding, actually viewing it, I imagine, as something inspired and thus complimentary, but he did refrain from authenticating it. Later it was pointed out that Freud had made use of a German text that mistranslated the Italian word for "kite," thus turning Pfister's confirming discovery into something of a fluke; for a kite, although a bird, has almost nothing of a vulture's character. On the other hand, the outline of a vulture-like, if not kite-like, bird is clearly present in Leonardo's painting, of which a reproduction was published in an English edition of Malraux's *Psychology of Art* showing the vulture with an imposed outline, its tail being inserted into the Christ Child's mouth as the kite's tail into Leonardo's mouth in his dream.

If Tchelitchew had any such idea in mind when, after due struggle with himself, he knocked on Natasha's door and entered her room with the book in his hand, the question valiantly framed on his lips, one can imagine his taut suspense at a time when Freud's theories were still considered by many an insult to the decencies and the intelligence alike. A curious point is that, in the forties when I was at Tchelitchew's house in New York, I asked him if he had detected the hidden vulture in Leonardo's painting, and he denied it was there. Unfortunately I spoke at a moment when I did not have Malraux's book with me. Perhaps Tchelitchew had heard that the bird in Leonardo's dream was really a kite, a fact which compromised the whole issue as presented by Pfister. But if so, the artist did not mention to me his knowledge. At the time, I did not myself know of Freud's translating mistake, and so could not bring up that aspect of the matter; however, I clearly saw the plausibility of the bird's outline in the reproduction in Malraux's book; in fact, I was pleased because I had found it myself before seeing this illustration and I wished to know if Tchelitchew had been able to find it.

The artist to whom I rashly brought up this questionable instance of visual punning was then a past and deliberate master of such punning; perhaps, with the extraordinary naïveté Tchelitchew would evince about the issue of

originality, he wished to minimize precursors in a specialized artistic department which found a certain security in being esoteric and oblique, if not also novel. As *Hide and Seek* shows, however, no artist had been so daring in the multiple-image as Tchelitchew. Many years after his confrontation with Natasha, he was to paint a sumptuous pair of erotically relaxed nudes as an anthropomorphic landscape: *Fata Morgana.* Out of nature he was slowly drawing a unique atavism, as if once mountain, tree and earth had been born from the womb of mankind and now, under the searching gaze of race memory, their lineaments could revert to type.

Fata Morgana was painted in 1940, when the great *Hide and Seek* was already projected. At the moment of which I speak, when I temerariously brought up Freud and Leonardo's painting, *Hide and Seek* had been painted and had won Tchelitchew more glory, in the United States, than all his other work combined. Bought with the Mrs. Simon Guggenheim Fund by the Museum of Modern Art, even before its first exhibition in the artist's one-man show there in October, 1942, it was the painting by which Tchelitchew, even anonymously, came to be reputed, and by which he is best identified in America today. Yet almost nothing has been said in print of the sexual symbolism that overwhelmingly pervades this masterpiece.

Besides being the Purgatory of the painter's Divine Comedy, it is the reigning masterpiece of Doubrovka, for it is the outdoor world of Doubrovka as an imaginary object that Tchelitchew recorded at the age of forty-four when at the peak of his powers. It is the whole story of the game of growth from pubescence to the climactic intuitions of adolescence; directly, it expresses a particular dream of ecstatic discovery: the game of hide-and-seek as a child's fantasy of birth, copulation and premonitions of death. *Hide and Seek* is the kind of picture which has so many "obvious" charms, the children, the flowers, the leaves, the broad dancing prism of the seasons, the total sensation of having before one a world in little—a snug yet voluptuous microcosm of sheer physical consciousness—that the work's precise structure, its message in depth, are apt to elude the ordinary spectator; even to seem to him, if told of them, not exactly relevant or important.

The truth was that the man to whom I mentioned the pseudo-vulture was in his person the home of a very intimate reflex that can be identified in the history of religion with secret societies, the old pagan mysteries and the whole mystic tradition; all such hermetic beliefs ostensibly have preferred to exist (at least toward the completely uninitiated) in symbols rather than through literal identities, in the symbol proper rather than through its interpretation. This does not mean that literal identities, the physical base of human life, are concealed in *Hide and Seek;* it does mean that exactly those were to be (as here) transformed, ratified and guaranteed by absorption into a supreme system of signs; technically, symbolically and religiously speaking,

these signs hold the essence of the human experience, its innerness rather than its outerness—or rather, its innerness *plus* its outerness.

With conscious guile, Tchelitchew was to paint the subject of *Hide and Seek* in the manner of Neo-Platonic symbolism reoriented, in one major phase, to sexual anatomies, but sexual anatomies perfectly transmuted into a metaphysics, a religion, of the sublime. The huge dominant image of the tree belongs to primordial emblemology of the Cosmic Tree of pagan religions and is related to the Tree of Life and the Tree of Good and Evil in the Bible. Sexuality is present in the work not only by suggestive incidents and contiguities between the children and the tree, but quite literally in the great penises (from the normal to the erect state) which modify the articulation of the tree's secondary manual and pedal anatomy: a giant hand (the branches and most of the trunk) grow directly out of a giant foot (the lower trunk and roots). This complex image has Tchelitchew's former use of the triple view of one object now transposed to three orders of overlaid objects (tree: human hand/foot: organic sex) all freely punning with each other. One must note the "freedom" because here boundary lines are not true and technically effectual (like those between a political exile and his native land) but merely formal and illusive. Some of the tree's modulation suggests the female while a vulva is located specifically between the great and long toes of the tree-foot. Since an actual baby has apparently just issued in birth, the mythological echo of the vulva's placement involves a sacred-profane play on the idea of the Virgin's having been fertilized in a miraculous place such as the ear.

As restively distinct as is the artist's concourse of images pocketing his previous work, *Phenomena* (the Hell), everything in the Purgatory, on the contrary, is dovetailed in firm and easy intercommunication. The tension is all one tension: centripetal rather than (as in *Phenomena*) centrifugal in impulse. Thus, despite what may appear startling or daring in the composition of *Hide and Seek*, it is controlled by suave and meticulous dynamic relationships, as of things quietly flowing—flame and water alike; the painting has the dynamic stretch, one might say, of gradually multiplying and mutating cells in the body. In terms of an anthropomorphic cosmos, the artist's anatomic sensibility here reached apotheosis. The harmonizing of diverse elements, the prevalence of natural change, the sense of imperceptible growth and expansion suggested by the color prism as well as by the graduated modulation, all form the mechanism of the work's cosmic effect, which otherwise depends on self-evident mythology and symbolic punning.

Once asked casually by Charles Henri Ford what his totem animal was, Tchelitchew replied: "The turtle . . . or the snake." Rather than indecision, the alternative indicates a double or crossbred nature consistent with the sometimes strenuous dialectic of impulses of which the artist was aware in himself. Even in slow rhythms, the snake differs greatly from the turtle in quality of movement, and of course, when aroused, the snake can act with the

speed of lightning. A mention by Tchelitchew of the turtle in relation to the harmony of the celestial spheres was given above: a union of opposites. Yet I feel sure that the artist then meant, as in his answer to Ford's question, that a prime thing he had in common with the turtle (speaking in the fundamental spirit of the bestiaries) was its congenital slow pace, which imposed on him a severe morality of patience. This was to be especially true in late life when the fine lines of his last style were so complicated and he spent so many hours of arduous labor at the easel.

Not arbitrary but thoroughly traditional, the artist's imagination derived his symbolic system in *Hide and Seek* from old, well-known sources of which the Hindu bed of snakes and the pan-religious Cosmic Tree are but two. The snake as the artist's *totem* must be accepted as phallic in bearing because of the tree's sexual articulations. As a sacred animal, the snake is prevalent in the oldest religions and its hermetic survival has been identified above. Tchelitchew may have noted that it was said to symbolize mercury: "The water that does not wet the hands." C. Kerényi asserts that one of the sacred objects, carried covered in the processions of the Dionysian mystery, was a phallus of figwood: this would account for the symbol's gradual transformation in Christian times into the figleaf.* Moreover it is fairly certain, despite the prudish scepticism of scholars, that representations of the sexual organs, male and female, were among the sacred objects climactically revealed to initiates in the Greater Eleusinian Mystery. Tchelitchew's totemic snake was to have a curious mutation as the train of a female dancer in a ballet he was to do in Europe nearly a decade before he finished *Hide and Seek*.

If, next his heart, Tchelitchew nursed the sleepy power of pythons, he was also lightning-quick to sense outside him the presence of a kindred spirit in word, paint or person, and sometimes could not help manifesting an instantaneous reflex. It was to the great mystic sensibility, so refined and clairvoyant in its young voluptuousness, that the artist was drawn in the work of his favorite poet, Rainer Maria Rilke. Some of Rilke's posthumously published verse (unlikely, as a matter of fact, ever to have been seen by Tchelitchew) is notable for frank and lovely phallic metaphors of the utmost elegance. These occur in more personal poems often addressed explicitly to women. But in this large group of often fragmentary pieces, *Poems 1906 to 1926*, issued in English translation in 1957, there is one poem which virtually puns with the sensual imagination that devised *Hide and Seek*. I quote the greater part of it:

> All unexpectedly, while gathering roses,
> she clasps the full bud of his vital part,
> and, at that sudden difference, with a start
> vanish the gentle gardens she encloses.

* Kerényi: *The Gods of the Greeks.*

You've all at once, you summer's imitator,
updrawn my seed into a sudden tree.
(Feel in yourself, so spacious inwardly,
the over-arching night, its consummator.)
It rose, and to the firmament would reach,
a risen reflection, imitating trees.
Oh, fell it, that inverted, it may go
into your womb and ultimately know
that counter-heaven to which it's really surging.
Bold landscape, such as gazers will begin
to see in crystals. That Within
to which the stars' outsideness is converging. . . .

Already with our glances we're connecting
the circuit where white tension whitely drops.
Already your unknowing command's erecting
the column in my sight-eluding copse.

Gifted by you, the god's own image thrones
upon the silent crossway I'm concealing;
my body's all named after him. We're feeling
both like a region his enchantment owns.

But round the herma to be grove and heaven
is yours. Give way, then. That the god, set free,
may quit with all his rout the column riven
asunder in their ecstasy. . . .

By too vast space, how we've been rarefied!
Abundance suddenly regains its senses,
and now through kissing's silent sieve commences
to percolate the bitterness we hide.
How much we are! Another tree uprears
out of my body its topheavy head
and mounts to you: for how could it have sped
without that summer which your womb inspheres?
Are you, am I, the one we so delight?
Who, as we swoon, will say? Yet there may be
a column of rapture rising out of sight,
vault-carrying, and decaying less rapidly.

What are we near to? Death, or that whose day
has not yet dawned? For what were clay to clay
unless the god himself formed feelingly
the figure growing between us? For just see:
this is my body, that has risen again.
Now help it from the burning grave into
that heavenliness which I possess in you:
that its survival may be boldly plain.
Young place of flight into the deep aloft!
You dusky air with summer pollen dusty!
When within you its thousand spirits grow lusty
my stiffened corpse will once again grow soft.

Parallels between the sensibility and imagery of the painting and these verses are extremely vivid. What emerges as of special interest is Rilke's impress on the Platonic concept of material things as reflections of metaphysical entities, a concept that was extant in the Orphic tradition and had been extended from the primordial Cosmic Tree as a model for actual trees. For Rilke, in the above poem, speaks of his organ's "risen reflection, imitating trees" and reaching to the "firmament" which has its "counter-heaven" in the womb itself. Originally, in a drawing of 1938–1939, Tchelitchew had conceived his symbolic tree as two hands joined at the wrists, rather than a hand-foot, thus suggesting the concept of an earthly reflection of heaven.

A bird's nest is something to induce children to climb trees. *Hide and Seek* holds a conventional one in the upper left corner. Yet there is another, rather disguised one. One might study the picture for a long time without realizing the way in which the artist, despite abandoning the idea of an inverted mirror-image as part of the tree's structure, has included a reversed image of the whole picture to symbolize this orthodox sign of the below repeating the above. It is one of the "hidden" things which Tchelitchew's hermetic instinct kept urging him to incorporate in his work. Directly below the third toe of the tree-foot is a much reduced image of the whole tree, upside down, with the surrounding boys' heads duly indicated. But there is an important change in the design itself: by placing a light-colored oval back of the girl's figure, the artist gives the impression of a broken and erupting egg lying in its nest. Thus, allied to the idea of erotic pleasure on which Rilke's poem concentrates, we have in this particular device a reinforced assertion of the resurrection idea. The image-in-little is right next to the newborn baby. So the clock of life has come fullcircle: from human birth to superhuman resurrection.

Young Pavel's confrontation of sexual enigmas took place long before Rilke was to become his favorite poet. Now, in his half-sister's bedroom,

Pavlik's dark eyes, already heavylidded and provocative, and his lips, already formed in proud and conscious sensuality, composed themselves grimly on facing Natasha, who had turned from her bureau and fixed her eyes suspiciously on the book he held. She recognized it. The young woman suspected him of stealing into her room and borrowing books without her knowledge. His first words made her certain of this and her features broke into an expression of anger and repugnance. To his alarm (he was never to be morally prepared for a rebuff) she snatched the book from him at the sound of the word whose meaning he wanted to know. Then she drew away, calling him a nasty, filthy boy and forbidding him to mention the subject again or ever to borrow a book without her permission.

The humiliated, blackly disappointed Pavlik had to retreat. But at once an unspoken resolution took up its steely residence in his soul. Never more would he humbly, suppressing his qualms, approach an elder, man or woman, who "knew things" and ask him or her for enlightenment! He would find out everything for himself—*everything!* He was to claim that, throughout his life, he was faithful to this distant moment of supreme self-determination.

If we anticipate the kind of plastic inquiry Tchelitchew was to make into the human body, and look backward at the kind of Paradise he took for his goal (for it has already been described in this book), we see that many casual bits of his life fit the same pattern no matter at what point we attempt to fit the individual piece. Thus his work is not at all like jigsaw puzzles, only one given piece of which can fit at one given spot. A mere such puzzle (M. Cocteau's spirit, take note) is two-dimensional in distinction to the three or more dimensions of paintings and labyrinths. There was, then and later, a reflex of precipitance in Pavlik's responses to life and in his painted images; precipitance in this sense is close to premonition: to the prophetic gift. It is the creator's divine impatience, unusually alive in Tchelitchew, unusually alert. The corresponding opposite to his resolve not to ask questions came to be not to answer them; when he gave lectures, for example, he prohibited questions being asked beforehand or afterwards. But why, it occurs to one, should he wish to refuse to others what he once so much resented being refused to himself?—i.e., knowledge?

We may assume a degree of trauma in young Pavel's reaction to his half sister's angry and humiliating snub. Like his father's unexpected conversion of Nasledni Knyass into Panya, Natasha's sudden and terrible condemnation of a subject which stood very close to his heart, and seemed serious knowledge, produced a stunning effect in the boy's hypersensitive organism. The two actions did not discredit knowledge as such, but were a criticism of its mode of transmission; indeed, they put in doubt the wisdom of any transmission unless very carefully considered, and virtually eliminated literal or blunt sorts of transmission. That certain things, in their true and "secret"

forms, are dangerous to know was in fact an axiom of the mystic sects and an antique rule of the hermetics. In his Leonardo-Freud moment of exaltation, the boy Pavel intuited this occultist principle. Essential knowledge, accordingly, is sacred, and one runs the gravest risk to convert it into ordinary or "profane" form, to make it available to the uninitiated. All his life, Tchelitchew was to behave as if certain technical secrets of his art had an alchemic magic. While on an exhibition tour, *Hide and Seek* had a hole punched in its canvas accidentally; when the experts who were engaged to restore the damage applied to him for his method of mixing paint, he called it a "secret" he would never divulge. He himself did the final restoration.

It was to be a very long time, and then he would be at his lowest ebb of energy, before the artist would brand himself in anything like the manner Natasha branded him for his childish curiosity. As I have stated, there were important contradictions in Tchelitchew's character: a constant and sometimes violent dialogue between the flesh and the spirit. His whole instinct was to give the flesh its due, and maybe a bit more, and yet as, in the shape of illness and decay, he found the flesh more and more vulnerable, an old mystic voice awoke in him, echoes of his Nyanya as she held him in her lap and discoursed of the Holy Virgin and the Holy Trinity. The child must have found especially hypnotic her story about one's Guardian Angel, for he was perpetually to appeal to people in his manhood to incarnate this role for him.

"When we are born," said Nyanya, "a Guardian Angel brings us into this world of woe but has planted in our hearts a lovely blue flower, blue as the summer sky. The Guardian Angel watches this flower grow. Passions, envy and lies burn the plant as with fire, and so do laziness, idleness and despair. Tears rot the plant like too much rain and then the flower begins to wither. The Guardian Angel does his best to save the plant from destruction; he gives courage and always tries to help. But if he fails and the plant is lost, he leaves in tears and never comes back. Beware of passions, lies and despair!"

So Nyanya, according to Mme. Zaoussailoff, would finish the story, to which all the children of course became listeners. As to laziness and idleness, these must have been comprehensible very early to the little ones at Doubrovka, but we can only wonder how Nyanya explained to them, even to Pavlik, just what passions were, and despair and envy. But the boy was certainly to develop quickly his own interpretations of the symbols of the Guardian Angel and the flower of the heart. The latter changed its species when it became, in another of Nyanya's stories, the mercy of the Holy Virgin. The Holy Virgin, Nyanya told them, walks along a rainbow in times of plague, famine and other tragic moments in the Fatherland. All the while She is sending us her mercy: the heavenly flower we cannot see because of our sins. Nevertheless the invisible flowers of the Virgin heal the sick and

restore courage, comforting us and supplying us with the strength to go on living. Events in Pavlik's life, and his temperamental paganism, were to separate him from such orthodox Christian folklore, but only insofar as it was transmuted by his personal experiments with the religious instinct: *creative* experiments.

Modern art, in its purely profane way, was to uncover to the young Pavel a plastic conversion of Nyanya's story of the Holy Trinity: the three aspects of one object presented as a unit. Nyanya informed him, in a voice that sent awful thrills through him, that the Father, the Son and the Holy Ghost are "one and indivisible." The Holy Ghost in itself was exciting enough: for it to be the "same" as Father and Son! When he questioned her on this seeming paradox of mathematics, her reassurance was sharp and urgent, if a bit specious. Nyanya had her own way of explaining the Holy Trinity with three very lucid commands having but a single point: "Don't think! Don't brood! Believe!" Yet he did brood. And ultimately, in a sense, he believed.

To Tyapotchka the foreign governesses were the *infidèles*, the domestic servants, the Nyanyas, the *fidèles*, and she never let the children lose sight of this supreme distinction. With Pavlik's faith she took particular care. "Don't be like the pagans, the infidels," she said, fixing his little eyes with her own, "don't be like your governesses, who have a living God-Pope enthroned in Rome and call themselves Catholics! Don't listen either to the Protestants, who have no respect for the Virgin Mary. They are all heathens and infidels! Pretend to say 'yes' to them, Pavlousha, but don't listen to them. Believe . . . believe in the one and only Greek Orthodox Church!"

And she would insert, ominously, a figurative physical taboo in these exhortations: "Don't *touch! Believe!*" How astonished Tyapotchka would have been to realize that she was talking to the future painter of Hell and Purgatory! Her pupil was to deny nothing physical or spiritual its sacred status in the highest forms he could conceive, forms which went far beyond all Christian orthodoxies. Yet at the edge of death and foggy with sedatives, he would pin on his chest his little chain of holy medals and say to his friend, Ford, in the utmost simplicity, "Now I'm a real Christian." He was to say this when the body's strength was virtually exhausted, when he had lived out his earthly life. At the same time, the Faithful Knight, the half pagan hero of Russian folklore whose destiny was to capture the Magic Fern, was a character with whom Tchelitchew would consistently identify himself as the years passed.

The boy was spellbound by Nyanya's stories about prophets and sibyls, who saw into the future, about the fiery handwriting at Belshazzar's feast and the Fire Chariot of the Prophet Elijah and its four "fire-horses"; at a very early age he was to fall in love with horses and carriages, only to fall out of love when he rode the circus-trained horse and was thrown. The story with the most enduring fascination was probably that of the Magic Fern: "Once a

year, on the eve of St. John the Baptist's birthday, there blooms in the deep woods, on a dark moonless night, the flower of the Magic Fern. This flower is the color of cold fire, blue, and grows at the foot of a great tree. The fiery flower shines but does not burn. If one is courageous and has in one hand the Holy Cross and in the other a shovel, one can obtain the flower despite all the monsters, the dark unclean things, that guard it. One digs beneath the fern to the roots, and there is the treasure: the unbelievable treasure which is Eternal Life, the life of a legendary hero."

At the foot of the tree in *Hide and Seek*, we find, to be sure, a subterranean sign of human life. It is not precisely the soul and it is doubtfully eternal. It is the newborn baby: the veins on its head as sharply visible as if it were still in the foetal state. Perhaps a sign for the Magic Fern in the picture is the exquisite dandelion puff that puns for the cheekbone of the boy's head representing Spring. But nothing magical inheres in the baby itself; in fact, it appears with candid realism as if just issued from the vulva hallucinated in the tree behind it. Tchelitchew was to go far beyond the primitive folk imagination of his "Nannys." It was precisely at the time he was painting *Hide and Seek* that, with naive irony, he could write Edith Sitwell that he no longer heeded his "Nannys' explanations."

Possibly the tale of the Magic Fern is a parable of parthenogenesis and thus would symbolize the birth of the soul with its immortal potential. Tchelitchew may have supplanted the Magic Fern of the childhood fable exactly with this in mind. The nest and the egg (already mentioned as a reduced mirror-image at the foot of the tree) may be, after all, a direct symbol of the resurrective fern: it is translucent, illusive. Beyond question, the baby in *Hide and Seek* is sacred, while the emphasis on it, self-evidently, is pagan and pantheistic rather than Christian. The symbolism in *Hide and Seek* compasses Christ only as do Alchemy and Gnosticism; that is, as a metamorphose symbol of self-sacrifice with the widest elasticity of form and content. By now (1942) the artist was a convinced paganophile and saturated in occultism of all kinds. There is, of course, a rather conspicuous and traditional symbol of the soul in this painting but it is pagan and hermetic in flavor: the butterfly next to the right hand of the girl hiding her face against the tree.

Tchelitchew's sacred art was to evolve gradually from a romantic sort of naturalism, through various stylizations of psychological, emotional and mythological import, to a more or less direct grasp of the symbolic status of the human body, purified of many of its previous mundane associations. This turn marked the beginning of his period of anatomic symbolism prior to the emergence of the Celestial Physiognomies. *Hide and Seek* was to realize the climax of his search for the body's potential ritual function in art: a reclamation of classic anatomy in the old sense that the human being in his material form is the priest and priestess of his soul, its only keeper and inseparable from it. Little Pavlik was wise in resolving to be self-taught for only the self

can ultimately teach one anything true about the soul. Nothing happens to an artist the importance of which does not commend itself to his memory. Nothing is memorized by him which does not anticipate, more or less abruptly, the future he is to act out step by step, indivisibly, in art and life. When still a child, Pavlik was given a toy Harlequin: a marionette that worked on strings.

He was to remember the arbitrary fate which he himself inflicted on this beloved toy. One day, seized with a terrible impulse to know what was inside the Harlequin, the boy took up a pair of scissors and ripped up his stomach—ripped up, that is to say, his most attackable point as if in a stiff frenzy of desire in which he could not distinguish love from hate, creation from destruction. It could hardly have been "simple curiosity" for most probably there is no such thing. Rather, it was the first symptom of the fused anguish and delight of the visceral sensibility that was to be so powerful a motif in the mature man's art. A great ambivalence was to stamp Pavlik's view of the dissected corpse in the surgical amphitheatre. When eventually he discovered the drawings in Vesalius' anatomical treatises, he beheld the entrails exposed in figures taken from the images of Greek gods. This was both aesthetic and religious, this graphic vivisection, an experience not at all medical or mortuary.

The stylish Vesalian investigation of anatomy was to have for Pavel Tchelitchew, with his twin religious allegiance to the pagan and the Christian, to the sensual and the ascetic, a curious pertinence involved precisely with his great model-to-be, *The Divine Comedy* of Dante Alighieri. There the Hellish punishments imposed by violations of the body were to be commuted by Tchelitchew into a Purgatorial (and unavoidably "purgative") mercifulness. He must have read with horror—and felt more horror at Doré's literal illustration—of that arch "fomentor of dissent," Mahomet, who is punished in the typically symbolic way chosen by Dante to characterize crimes that condemn their perpetrators to Hell. A figure of religious schism, Mahomet is suitably mutilated:

> No cask without an end stave or a head
> E'er gaped so wide as one shade I beheld,
> Cloven from chin to where the wind is voided,
> Between his legs his entrails hung in coils;
> The vitals were exposed to view, and too
> That sorry paunch which changes food to filth.
> While I stood all absorbed in watching him
> He looked at me and stretched his breast apart,
> Saying, "Behold, how I now split myself!"*

* Dante: *The Divine Comedy: Lawrence Grant White translation.*

As one with so vulnerable a sensuous imagination, Tchelitchew found the male genitalia a formal extension of the intestines rather than a functional unit in the differentiated physiological order. All plastic approaches of abstract art that resembled the entrails as a writhing mass of excremental or snakelike character (one may think of Lipchitz' sculpture) were abhorrent to Tchelitchew. When the tape worm came, therefore, it was to affect his tortured sensibility and anxious mind as a dangerous Elemental: a variety of demonic possession. On the other hand, this artist had, by then, brought to high development his impulse to place what was hidden, because "immoral" or "indecent," out in the redeeming light of artistic portrayal; to clothe it in honest grace, magic charm and complete lucidity.

So came about his aesthetic strategy. The plastic intercommunication between the wondrous phallus and the hopelessly unaesthetic entrails (multiply unaesthetic because his own were to prove a bane by misbehaving) had to be purified. In the aggregate of forms inside the great tree of *Hide and Seek* there is at least a nuance of the glutinous viscera themselves: a shadowy fourth level of imagery. This, I think, was deliberate but its admission into the artist's scheme could have been only on a magical basis. There is ambivalence in the way nature disposes of the male genitalia externally, as if waving a hygienic wand over these excremental vessels. Tchelitchew, in this difficult and precious, yet touchingly earnest, sense, wished to imitate nature. Among his documents were all kinds of photographs of male nudes; one of these, exhibiting what is known in physical culture as a "double abdominal isolation" suggests (in high relief) a pun for the priapus. Tchelitchew must have greeted this as a happy surface transformation of the intestines behind the stomach wall: it is only a gymnast's extreme contraction of his highly developed abdominal muscles.

With this in mind, how can we understand the small boy's wilful attack on the Harlequin except as a symbolic anticipation of the sexual act, riddled with the anguish of fear and overflowing with blind pleasure? Yet he stood aghast, disillusioned, at the tangible result of his action: nothing was inside but cotton wadding—and the poor Harlequin was spoiled! The tears came: a flood of impotence hot, indignant, incoherent. He was ashamed, stunned and terribly puzzled. Above all, he was visited with an unbearable stab of remorse. Nyanya took pity on him. She snatched up a needle and thread and proceeded to stuff the cotton wadding back into place and carefully stitch together the edges of the slashed cloth.

Pavlik was grateful and tried to smile: he loved Nyanya and Nyanya loved him. He looked at the Harlequin's front and saw a series of neat X's made by the white thread down his torso. He was marred! Spoiled! The child could not play with him again. And yet the same act of ripping and tearing something to expose its insides—the result of sudden, obsessive curiosity—

occurred again, and still again. Unfailingly Nyanya's needle and thread would come to the rescue. But to no avail! The toy, the doll, became taboo. He would not touch it again.

Through violence, an even earlier moral had been pointed to guide his future conduct. His soul said to him: "Don't break things open to find out what's inside them. Leave them alone, leave them as they are." He was to hear something very similar on Gertrude Stein's lips and it was to echo like gospel in his soul. It was a shibboleth of peace, a creed of reverence.

His experience in the surgical amphitheatre was to take place regardless. But then (like Dante) he would faint dead away, as promptly as if he had planned the drama and its dénouement to instruct himself in the ways of peace . . . the ways of grace . . . the *courtly ways* to discover what lay inside something. Nyanya's loving stitches were not to fade away, were not, finally, to signify the profane touch, but the super-surgical. For they would furnish the cradling net: the caressive: the ultimate net of his art.

Fyodor Sergeyevitch's most intimate, unspoken opinions of his elder son may have worried him. But the father, known to his family as a "living encyclopaedia," was, as an oracle, to grow further and further away from Pavlik, whose independent pride had been dealt so informative a blow by M. Tchelitchew's view of his effeminate traits. And, since his encounter with Natasha over the mysterious word, Pavlik had become slightly quelled: cautious, devious, private. The ego and its conduct must be distinguished from the molten inner workings of the soul, the heart and (in an artist's case) the hand. "Knowledge" was to be the youth's own personal conquest—something for which he could take *all* the credit. Undeclared favorite of his Aunt Sacha, he was to be granted secret drawing lessons (though they came to an immediate stop when he and his master disagreed over the color of a clock he was to draw) and also, while in Moscow, to be allowed to take ballet lessons, which Papa Tchelitchew had expressly vetoed.

The artist's statement, "Questions started to be my pet hate, I tried never to ask questions and never to answer any," meant specifically that he had started to grow a protective covering for the inner self and its wilful activities. He was in-hiding in the moral sense of which the child's game of hide-and-seek is but a first casual and outward token. An artist is not one who can be told things and let them go as tall talk, hearsay or make-believe meant for children. This trait—though the fact is seldom acknowledged—makes artists the world's outstanding psychological realists. Every imaginative vision was to be for Pavlik a testing ground for reality. Mischa, the brother who idolized him, and all the women in the household, were conspiring to make him feel the "wonderful exception." This caused him, constantly, to be a little difficult to manage.

Tyapotchka, determined to produce a perfect little gentleman in Pavlik, admonished the boy never to indulge in laughter that was "loud and long." Alas! a rather boisterous gayety seemed Pavlik's only really bad and defiant trait. Whatever their outbreaks of childish passion, the young Tchelitchews were reared to be genteel in the extreme. "Do not be *la bête humaine*," was a

repeated adage of Mama, who must have had a speaking acquaintance with Zola's novels. Tyapotchka warned Pavlik, "If you laugh too much, your fine hearing will be spoiled and you won't be able to hear the music of the growing grass."

The music of the growing grass? Another marvel!

Tyapotchka was always a very reassuring, reliable image: her calm poise was partially the reason for the respectful admiration she aroused in her charges. Tall, with hair parted in the middle, smoothed down and coiled in a neat plait on her neck, a composed face under a broad brow, an immaculate apron and an infallible attentiveness to match, Tyapotchka was a person to inspire love and confidence equally. Impressed so much by the alleged music of the growing grass, Pavlik could not let the matter rest on Tyapotchka's word. At dawn the next day, before anyone else was up, he was out in the garden with his ear pressed to the green turf. Still in his nightclothes, for he hadn't stopped to dress, he was suddenly aware that someone had approached and he was being lifted bodily from the ground by his nightshirt. It was the insensed Tyapotchka, who took him inside, despite his protests, to wipe the dew from his face and dress him quickly lest he catch cold. "But I didn't hear the music of the growing grass," he told her with grieved indignation. Tyapotchka admired the boy's gesture but she forced her eyes to flash as she tossed his nightshirt to one side. "No? And why do you suppose you didn't? Because you are a noisy and boisterous child!"

But the seed of a thought was already flourishing in the noisy and boisterous child. It made him unusually quiet that day. There was a relation between the movements of nature and music: a mysterious relation which he would make it his business to find out. Nature's movements were available to the boy in a large framework. The forests at Doubrovka typified the great natural mystery to the little Tchelitchews and were also a loved and rather awesome playground. Though the woods were large, various and many, they were well ordered because of M. Tchelitchew's impeccable planning, so that there was little chance of getting lost in them by wandering. One was a forest of cedars, planted in rows but unusually prolific in growth, so that their branches intertwined and made an almost impassable barrier. The difficulty of penetrating this forest fascinated the children and their disobedient impulses were the despair of Tyapotchka. For despite her reproaches, they would invade it at their pleasure and emerge, as she said, "as dirty and bedraggled as terriers."

Innocent Tyapotchka did not know how necessary it was for children to perform symbolic conquests during their first responses to the lurking sexual mystery. In another of the forests, during a picnic years and years ago, Papa had proposed to Mama. The children would tease Nadyezda Pavlovna because, on being asked just how Papa had phrased his proposal, she had been

reluctant to mention a single sentence and never altered her refusal to repeat what Fyodor Sergeyevitch had said to her on that momentous occasion. Instead, half humorously, she would scold her children (who sometimes assailed her en masse so that she cried out for air) as persistently impertinent in their curiosity.

The forests of Doubrovka, except for the tantalizingly intertwined cedars, were pure dream and excited in the children a gamut of emotions. Choura vividly recalls their magic: each had its name and ambience. Rostcha was spacious and all of white birches; its flowers during springtime looked like pink caterpillars swaying at the slightest touch of the breeze. The Russians referred to these flowers as "the birches' earrings." In the spring, too, tiny tender leaves made a green mist above Rostcha, and then Tyapotchka invariably would say: "Rostcha is beautiful like a bride." With the summer, a horde of butterflies took over the birch forest. In the future, when Tchelitchew had become a professional painter, he would echo his father's shibboleth, which had been "I labor for God—and for myself." Young Pavel, all on his own in Paris, had absorbed and converted this motto. Now it was: "I was born a butterfly but unfortunately I have become a workhorse." Father and son had phrased an historic portrait of two generations. The butterfly in *Hide and Seek*, with extraordinary significance, contains a miniature landscape and is perhaps the work's most exquisite "microcosm." The soul is unchangeably the soul, but as the symbol of labor it was also to be, for Tchelitchew, an elaborate landscape–within–a–landscape.

When the children were growing up, the forests of Doubrovka typically presented an infinity of luxuriously doing nothing: playing, riding, walking, dreaming. Though the statistical origin of the tree in *Hide and Seek* (speaking of the objective world) was a striking, not very large tree shorn of its leaves, found by the artist on Edward James's estate in Sussex in 1934, the painted tree was probably inspired by a sleeping memory of the most magnificent of Doubrovka's forests, Kolpin Bor. Yet it is unfair to pass quickly without identifying the subjective origin of the tree in *Hide and Seek*, an origin intimately plastic and situated at an early stage of Tchelitchew's life: when he was a boy brooding long over the wonders of the way Gustave Doré visualized *The Divine Comedy*.

In Canto 13 of Dante's poem, the suicides in Hell are found turned into trees, their hands and feet growing into the earth like roots. We are bound to think at long range of Tchelitchew's own terminal self-sacrifice as a suicide confirmed by the present token; he could not but have felt a guilt in the very labors of building his Paradise, for these labors had brought him knowingly to the very verge of death; morally, for years, he had been reconciled to a self-sacrifice which was a conspiracy with himself. One is tempted to notice, moreover, that the evil and prophetic bird-women, the Harpies, who haunt

the stricken suicides in Hell, recall the sketchbook version of La Dame Blanche as Death. Though the latter is expressly a Phoenix, as we have seen, and thus benign, the bird contains a hideous woman's face coiled in its torso like entrails. In his final painting, *Inachevé*, Tchelitchew was to liberate and beatify this woman, but in the sketchbook, however fine the Phoenix as such, its swelling bosom suggests what Dante's poem, describing the Harpies perched on the human trees, calls "feathered bellies huge."

Unconsciously, during his correspondence with Edith Sitwell during the Second World War, the artist was to furnish a matrix for his birdlike Dame Blanche: the Phoenix with the traumatic female head lodged in its bosom. As related to the Harpies of *The Inferno*, the bird about to be mentioned italicizes the image of the Phoenix as a bird prophesying Tchelitchew's peculiar form of suicide. "Paracelsus," wrote the artist to Dame Edith, "says that nature often creates wonderful objects which have many forms or images in them . . . which can be explained and which can do wonders, if understood. He says man can . . . do them and then they are even more wondrous. So from the antient [sic] times humanity wanted to equal nature in the way of creating multiple visions, transformations, her daily work, multiple meanings in one - the origin of metamorphosis - of perpetuum mobile - I mean spiritual. The name of those objects is given by Paracelsus - which resembles very much a name of mythological Russian birds - half woman half bird - one was predicting sorrow, the other joy - they were called by the same name - the birds of wisdom - so my idea of multiple vision was right and I suppose I am right in looking everywhere inside of in [sic] instead of outside." " . . . the birds of wisdom . . . " One might hazard, therefore, that they were owls, or as hybrid humans, owl-*like*. This is interesting because we are about to see just what spirits, at once benign and malign, haunted the beautiful forests at Doubrovka.

Situated twelve versts from the manor house, Kolpin Bor was, in Mme. Zaoussailoff's words, "an immense forest of 100-year-old pines, without lower branches and so tall that one could scarcely see their tops. Their trunks were so thick that we had to join hands by threes to circle them entirely. They rose up like marvelous columns. Kolpin Bor was like a majestic, entrancing cathedral. The ground, covered with ancient pine needles, had neither grass nor flowers, but in some places tufts of whortleberries and red bilberries. The light, coming in shafts from high up, shone on the rose-yellow trunks, which were very gnarled; this light sifted through a veil of faint-colored air as in our churches when many candles are burning amid the incense. No one would have thought of crying out there, or raising his voice. Indeed, as there were hardly any songbirds in this forest, silence prevailed there except when broken, from time to time, by a cuckoo's voice, or more often, by the drilling of a woodpecker—that great worker of the forest."

In the great "forest" of Europe, primarily a place of cities for the painter Tchelitchew, the "great worker" animal was to be (in reference to the above quotation) the butterfly turned into the workhorse. As a residue of fantasy, much in *Hide and Seek* is recognizable from Mme. Zaoussailoff's description of Kolpin Bor. So keenly aware of metamorphosis, both in things and fortune, Tchelitchew was automatically to exchange the candle-lit Russian churches for the more richly suggestive and magnificent Santa Sophia: itself a symbol of contact between Eastern and Western Europe, the Occident and the Orient, and great enough to unite infidelism and Christianity into a kind of Byzantine pun.

The young girl who, pressed to the thick tree in *Hide and Seek*, has arms outspread, evokes Choura herself stretching to help compass Kolpin Bor's pines with Pavlik and Mischa. Time and place, the age of youth, all human occupations, had much changed when Tchelitchew was to find himself painting *Hide and Seek* amid the wooded hills of Vermont. As in dreams, everything was the same as in the artist's childhood, the same and yet different, and the canvas was a singular mirror for this metamorphosis. Now many things, principally sex itself, were quite in the open of consciousness, not enclosed in the fearfully avid, restless, peering and uncertain cell of the child's organism. The girl playing IT in the game of hide-and-seek in Tchelitchew's masterpiece is still, at the moment shown by the picture, "blinded" according to the rules of the game. If her arms are outstretched, it is in anticipation of catching the boys whose images hover fantastically, fashioned of air and moisture, among the branches or casually, in smaller forms and solid flesh, are lodged in the tree or hover about it, sometimes aping its autumn leaves.

I have always felt that the dominant intuitive texture of the thin, glistening, iridescent coloring of *Hide and Seek* is that of the eyeball itself—and not merely as the agent of sight and symbol of what it reflects. The visible objects, in both mottled color and swimming texture, suggest the situation of the retina, firmly floating under the solid casement of the eyeball. Tchelitchew was destined to have, just as he prepared the project of *Hide and Seek*, bad eye trouble of a very suggestive kind. At this period, Edith Sitwell was to be his great spiritual confidante in a correspondence terminated by her visit to this country in 1949.

In 1940, the artist wrote the late Dame Edith that an optometrist had discovered that the trouble came from the inability of the iris of his right eye to open wide enough to admit the light necessary for him to paint easily. He happened then to be working under disadvantageous studio conditions respecting the light. The eye condition itself, moreover, had an interesting bearing upon his art and life whose telling is still to come in these pages. At all events, it is the speckless clarity and untremulous security of Tchelitchew's metamorphose masterpiece that engages us at this moment. It had transmuted

his subjects—this eyesight of art—but had done so with a definite, a clarid, purpose. The congregated children are childhood itself and its game of growth, intimate and immense, all the future and the past hanging from the fingers of the centrally placed little virgin, who surely represents (for the myth most available to the Western World) Eve just before the Fall: but eager for the Fall, not reluctant or ashamed. Like all great symbols, she is charged with variety.

Much, much had been concentrated by the artist into this major work, which is a superb lyric emblem of the sexual consciousness. The Serpent that successfully tempted Eve is here not coiled about the trunk of the tree or one of its limbs. It is *of the tree:* its inner structure, its motivating nerve and most articulate muscle. Eventually, in the pagan dimension of the painting's deeply insinuating, capacious myth, one cannot help thinking of the girl against the tree as a version of Daphne. Pressed so close against the tree that she seems to merge with it, even her outstretched arms repeat Daphne's ironically yearning gesture of escape. Here of course—the trait is indispensable to Tchelitchew's Daphne—the female is the pursuer rather than the pursued. This was the incarnation of even the young Pavel's established moral concept of woman as a sex: the avid, swift, threatening pursuer. The young man, like the boy, had his ways of coming to terms with women, for he enjoyed them and dearly desired their friendship and service, their intimacy and liking.

There are strong determinant features in the Daphne-Eve of this picture: she is a trifle Amazonian (we recall that Pavlik conceived even the Little One, his mother, as a mounted Amazon) and she is, as we have seen, arachnoid. Her sturdy legs, healthy frame and attitude like the flexibly pointed "star" of Vitruvian man,* bespeak the female as a good pursuer and a successful one; her natural avidness will provoke and educate the male and eventually make her pregnant—a destiny more than imaginary according to the carnal pun taken by the space between her widespread legs.

Tchelitchew was ever alert to things and their patterns as they were capable of making *signs* in the Jungian sense of being forms outside nature and yet things in themselves. His art tended always to return these signs to nature, and thus the pentagrammic Star of David, its five points made by the extremities of man's head and extended limbs, found a central place in *Hide and Seek* as the little girl spreadeagling the tree. Reading in Pythagorean legend doubtless disclosed to Tchelitchew the pentagon that for Pythagoreans was the sign of Health and that reproduced the frontal silhouette of Apollo's temple, where (say the canonic writings) Pythagoras had the revelation of the famous geometric theorem.

The stripped columnar trees of Kolpin Bor, the conjugative embraces they received, must have accented (Rilke's above-quoted poem is a demonstra-

* Familiar in Leonardo's famous drawing.

tion) the inherent phallicism of tree-trunks. Surely these pines suggested to the mature painter of *Hide and Seek* as much reverence for pagan religion as for Christianity, as much feeling for pagan sensuality as for Pythagorean asceticism and its sacred marriage. *Hide and Seek* is a closely packed, a very *full*, painting, but it would be an error to say it is dense and certainly (as I have observed) it is not, like *Phenomena*, crowded. It has, as it were, the *possessive presence* that Kolpin Bor must have had as a sacred collective emblem of sex and its cosmic power: one might say its macrocosmic power. The sinew and groin of sex leap past the individual's skin and promiscuously join with the world: Tchelitchew's picture is the great paradigm of this timeless feat achieved in some degree and form by every human organism. The feat's sublime candor and religious scale, its entire sober ecstasy, is what strikes us in this greatly symbolic, greatly realistic, painting.

The lolling and bending, unbent, convex sexes, modified by the universal wrinkling and crevicing, conform skillfully to the anatomy of hand and foot. But besides, all the busy modulation reminds us of the sinuous, profuse, miscellaneously male and female secrecies of Indian temples with erotic couples on their sides. This tree, then, magnetizes the children, draws them, boy and girl, loitering or tense, engaged or unengaged with the sport, surely to its heart as if it were a vortex . . . and it *is* a vortex in more than one way. It is a cosmic vortex: a veritable detached universe that is like some flaring, erratic spiral, fixed yet infinitely far away and seen through a telescope. So eloquent are its textures, however, homogenized as they are by the pervasive aqueous feeling of the paint, that every recognizable object seems likewise tangible: a matter of touch as well as sight. Sight and then touch: this is the sequence of the game of hide-and-seek. This idea is rendered directly by the overall division of the tree into hand (upper part) and foot (lower part): the foot pursues, the hand tags . . . Invisible at first, the eluders hide and then, detected, are to be caught in flight. The trunk and branches of the tree are in the exact pattern of the girl's right hand and encompass in its "fingers" four of the aërial boys. It is magic, majestic expectation that shapes the girl's outstretched fingers into a ritual gesture of seeking and finding, a gesture that might be taken from an ancient mystery.

Which ancient mystery, it is impossible to say; the reference of *Hide and Seek* is to many such. At the time of painting this work, Tchelitchew was repeatedly to exclaim: "Divine Arachne!" Unquestionably, in the forefront of his mind, he bore the idea of Arachne's achievement as the Magic Spinner of which the spider is the symbol in nature. In the Olympian pantheon, the honor of inventing the industrial craft of which Arachne, a Lydian woman, was supreme mistress, had gone to Athene, Zeus' virgin daughter who taught men several crafts besides that of war. It was she who, insensed that Arachne should challenge her to a contest in weaving, punished her by turning her into

a spider. Doré's already mentioned image shows a creature with female torso and immense spider's legs, supine on (supposedly) the remnants of her work that Athene has just destroyed.

Several points in the mythic perspective are worth observing as they explain why the arachnoid character of *Hide and Seek* tends to transcend, while assuming, both the Olympian and Dantean views of Arachne: the tree-hand has an actually spidery look in the work's weblike tension. Rhea, the Mother of the Gods, is remotely connected with spinning and weaving, and in the pagan tradition is the equivalent of the deity Tchelitchew reverenced with his own personification, Mrs. Nature. The whole hermetic tradition negates the Olympian pantheon (to which Dante pays casual tribute) through preferring its sources. Yet the subject of Arachne's profane tapestry (destroyed by the jealous Athene) is significant for, we are told, it was the life of the gods. This fact suggests the "profanity" of the human painter presuming to deal (as did Tchelitchew) with divine mysteries, finding in nature itself, as did the magus, the divinity exclusively appropriated by the anthropomorphic gods of Greece and the Christian God. The airy and watery aspects of *Hide and Seek* coincide with Athene's special domain (the weather) as well as with the precepts of alchemy.

I have already called the girl against the tree a symbol of dawning sexual knowledge; indeed, as Eve, that knowledge's very instrument. As Arachne (she is at the center of the painting's "web"), she has a further malign-benign function that reverts to her status as Purgatorial in a Dantean sense. The sexual habits of the spider could not have been unknown to Tchelitchew. While implicitly a ritual gesture and a "playful" one, the girl's extended hand (according to the game's own scheme), is predatory; as *arachnoid*, it is also lethal. This, as I have said in previous connections, is consistent with Tchelitchew's typical view of the female as pursuer and even destroyer. *Hide and Seek*, in its primacy as a paean to nature and sex, involves the remote legendary roles of its heroine. In effect, the little girl cannot be understood *simply* at all. As we shall continue to find, she is a visual trope incarnate. Indeed, I have still to supply quantities of evidence that, however tardily, Tchelitchew was to conclude that his masterworks were thoroughly arcane, complex and magical.

In a sketch of 1935, the scene of *Hide and Seek* was to be rendered quite realistically: the artist was merely, then, approaching his ultimate conception from a beckoning distance. One of the boys in this drawing has climbed the tree and is embracing one of its branches. He was to be translated, in the final painting, into the rather inconspicuous image of the naked boy just on the right of the girl. Tchelitchew doubtless recalled that he and his brother and sisters (as Choura Zaoussailoff records) had been inveterate tree-climbers. But the girl in the 1935 drawing is much larger than the phantom boys who (in

the final painting) are the work's principal males. Tree-climbers as such are in
Hide and Seek itself, but much reduced figures as if they were far away. If
the girl, eventually, dwindled in scale from the original version of her and the
tree, it was only because she would be more closely identified with the tree
constituting her temporarily blind state. If the boys in general are now larger
(though magnetized more obviously to her whom technically they elude) this
was so as to characterize the way the girl sees them in her imagination:
close, as a world full of males, compact with the very air, the masters of total
space and its brimming flesh . . . Here all space is flesh—and more than
flesh.

In the concept of the visual pun, which identifies and overlaps the forms of
different objects, lies the principle of *compression*. Why, then, does the space
of *Hide and Seek* seem neither, as I say, dense nor overcrowded? Not only
because of the amplitude of anatomy apparent in the way the artist has drawn
and painted his figures, but also because he has elided everywhere, in various
degrees, the separate elements of the planetary cosmos; nearly everywhere
three are elided: earth, air and water. Systematically, thus, the refractory
mass of matter is opened up. In the space of what is about a twelfth of the
work's area (the one-to-two on the cosmic "clock" of *Hide and Seek*) fire
takes over the substances of earth and air. In most traditional punning or
multiple-image paintings (for example, the works of Arcimbaldo), and in the
modern work of Dali and the Surrealists, nearly all such effects involving the
actual elements are fairly static in mode of identification. Metamorphosis as
the energy-unit of growth is what stamps and differentiates Tchelitchew's
punned figures (not of course here only, but everywhere in his work of this
sort) and imparts to them their peculiar liveliness, their palpitation as of
actual things.

This breathy elasticity of composition is the very style of Tchelitchew's
plastic sense in the phase of which *Hide and Seek* is the arch example. Like an
alchemist—I mean consciously like an alchemist—aiming at the metaphysical
goal of the Magnum Opus, Tchelitchew creates the emergent substance of
nature in *Hide and Seek* as a gold of the cosmic texture: the one and perfect,
the most desirable, substance in which all relative substances have coalesced
into nuances of a blessed, blessing and absolute "gold." He creates, that is to
say, the process of the work at the moment when all its elements are relaxing,
dissolving, yet are driven as surely toward unification as the hiding boys are
yielding in their hearts to the girl about to launch herself in pursuit of them.
The catalyst, the activating element, is exactly and solely *sex as the creative
principle*. The four elements, the four seasons, have become a circling,
hypnotized, miming "servant" who will lay at the foot of the tree the infant
that symbolizes ceaseless creation on earth.

But *Hide and Seek* was only Purgatory: the Purgatory that was to lead,

indeed, to Paradise and its zodiacal wealth of purely ethereal beings. There is just one, muted, little-noticeable gap in *Hide and Seek* so far as the homogenization of its space and substance goes. In the upper lefthand corner is a fairly candid, deliciously undisturbed patch of blue sky, and in it (as if they were mates) two birds are in flight, seemingly *away from* the centripetal core of the painting. Of these birds, Tchelitchew was to remark to his friend, Agnes Rindge Claflin (then unmarried), when she asked him about them, "That [i.e., the patch of sky] was the only way for me out of the labyrinth." His statistical answer to Mrs. Claflin's statistical question is heavily weighted with meaning. In defining the work as a labyrinth, the artist was positing both its intentional complexity and the existence of a secret solution. He was also expressing his inveterate desire to be done with an achieved work and go on to further, presumably more advanced, stages.

When the Tchelitchew children roamed and dreamed in Doubrovka's forests, their statistical present could ratify the future *Hide and Seek* and its creator's leading statement made to Mrs. Claflin. Beyond the forest of Kolpin Bor there was a clearing that blinded one with its streaming light after one issued from the gentle, floating luminosity of the forest depths. The two birds of *Hide and Seek* appear to me to be in that clearing—if the space is not blinding to us, it is only because we are plunged into the relative point of view in the main portion of the painting. *We are looking into the forest depths*—into the depths of nature and all its conjugative relations—while the open sky hovers only on the edges of our perspective. At the center, things are relatively illuminated; their brilliant pigment clings to them but in a shifting solution of light and shadow similar to that under a forest canopy variously penetrated by light: the "cathedral" effect. The artist was to claim, when he actually painted the work, that he was looking into the sun. As everyone knows, one cannot look *directly* into a blazing sun.

The clearing in Kolpin Bor, for which a party of visitors would keep a lookout, marked the position of the Yisdra River, which went through the whole estate and at this spot made a long, graceful curve. It was altogether a tortuous river, its banks very steep and bordered with tall trees on both sides. Thus the Yisdra was a tangible symbol of the forest labyrinth's secret solution: at once its symbol and a literal path through it. Small, swallow-like birds swooped over the water of the Yisdra, but at the least alarm (says Mme. Zaoussailoff) would dart back to their nests, which were almost indistinguishable holes in the steep banks. I daresay two of their descendants fly with as much excitement as of old in *Hide and Seek* and make their magically quick escape.

Tchelitchew was to develop no special fondness for birds; he much preferred cats, as pets, for their obedient sensuousness, their contented responsive animalism. Louise Dahl-Wolfe, with whom Tchelitchew collaborated on some fashion photographs, recalls his habit of honoring cats with the

title of Mister—regardless, perhaps, of sex or sexual preservation. It is well never to forget, in discussing the affinity of people with certain animals, not only that animals have a traditional place in the bestiaries as symbols of human character traits but also that certain animals, in the orders of mystic thought, are at times corresponding opposites, like the thesis and antithesis of logic; for example, the bird and the snake, whose unity appears in world myth as the Mexican god, Quetzalcoatl, the Plumed Serpent, who typifies the marriage between Heaven and Earth. Tchelitchew was fond of plumes but he was assuredly more sensitive to the power, if not invariably the charm, of the snake, for (as was noted) he thought it one of his totem animals; as such, following the pattern of primitive psychology, it could have functioned also as taboo.

Tchelitchew's sympathy with the meaning of alchemic signs, of which the snake is one, was never a mere fad or a vague sentimentality, but plastically and morally always real and decisive. He believed very soon that, as an artist, his astrological connection with the planet Mercury was highly strategic. The alchemic texts he ran across were in the habit of confirming this; for instance, in one of his favorite mystics, Jacob Boehme, he read a great alchemic maxim phrased thus: "Mercury is the moving life of all . . ." He was to base the structure of *Hide and Seek*, as he had based that of *Phenomena*, on the pictorial conceptions of astrology, alchemy and allied mystiques: specifically on the cosmic emblems seen in old drawings and prints.

The great aim of dialectic philosophy, as to which its occult branches are perfectly orthodox, was to unite all opposites in imitation of what appeared to mystics, at least, as the universal harmony; in terms of the primitive past of religion and its animal totems, this meant taking the curse off a taboo. As we know, the special office of occultism was to preserve the most archaic beliefs. Hence we find among alchemic metaphors a Cosmic Tree figuring as scene of a mystic divination of essences and their basic unity. According to the hermetics, obeying the canons of their authority, Hermes Trismegistus, the contentious elements in nature can be magically controlled by knowledge.

An engraving by Basil Valentine, a famous adept, shows a Sage and a Scholar conversing on either side of the Tree of Knowledge, whose branches are tipped with the Sun, the Moon, and the Planets; the faces of the Sun and Moon inevitably evoke a parallel in the faces of the boys around Tchelitchew's great tree, while the relative qualities of the seasons in *Hide and Seek* (dry and liquid, hot and cold) suggest of course the humors of the planets as alchemically analyzed by the adepts of Hermes Trismegistus. Above, I spoke of the cosmic notion of *reflection* that inheres in *Hide and Seek* and in a poem quoted from Rilke. The hermetic canon says that "the below [Earth] is like the Above [Heaven]," a statement interpreted to mean that in our cosmos things are perceived in reverse as in a mirror.

Tchelitchew's planet, Mercury, occupies the midmost branch of the tree in

Valentine's engraving just mentioned: supreme symbol of the process of fusion. It is striking that at the corresponding point in *Hide and Seek* appears the image of the boy whose inverted body contains wheat, that is, summer's harvest. Tchelitchew's figure combines, thus seasonally interpreted, what is both to his right and his left on the "wheel" of the tree, his seasonal opposites or contraries. He is very warm, yet not fiery with late autumn or icy with winter; at the same time he is not liquescent, like spring, for in him the moist generation of spring and summer is climaxed. In short, he is the very peak of the natural gamut of plenty. A clear token of this is the perfect apple which is found as the shoulder knob of this illusory Mercury. In connection with the tree's Eden symbolism, the apple is ambivalent; indeed, we can descry in this figure the scene of battle amid the Children of Adam that appears more plainly in peripheral studies and paintings by Tchelitchew. Of course, natural processes are not without struggle and pain. In this painting, the artist decided to express the strife within nature by the fighting leaf-boys of autumn seen in the fiery section. In preliminary drawings, he had conceived the wheatstalk as a weapon in the hands of fighting boys. The final "wheat figure" was mainly to express the *pacific dénouement* of nature's struggle to create.

In another alchemic allegory (also by Basil Valentine) the figure of the god, Mercury, is shown specifically as a symbol of the "reconcilement of irreconcilables." On either side of him, two human figures, respectively allied with Sun and Moon, are posed in fighting attitudes. Though each of these wears masculine dress of the seventeenth century, they are supposed to represent the sexes. The allegory, titled "The Fixed Volatile," is a simple illustration of the faculty of the substance, mercury, whose *stable* element is identified with the male and *unstable* element with the female. To signify them further, the male champion is equipped with a sword about which a snake is coiled, the female champion with a sword on which a bird with upraised wings is perched. The point is that the combatants are being "reconciled," that is, fused together, by the bisymmetrically posed Mercury between them, carrying in each hand his symbol, the caduceus.

We find a related but larger allegory in the conception of the sky as the male principle (in the myth of Uranos and Gaia) which, through sunshine and rain, fecundates the earth as the female principle. Mysticism displays such "popular" myths in arcane forms of metaphysical tendency. A typical example is the concept of the male principle as the soul and the female as the spirit; the former is "fiery" and "active" (that is, aggressive), the latter "moist" and "fugitive." Again we have the two contrary faculties of mercury: stable and unstable. As the fiery and stable faculty, the snake appears as the salamander, who lives in flame, while the eagle, which flies, is the "fugitive" and unstable faculty. On the other hand, classic myth is not without its resources of adaptiveness. Such an allegory is obviously related to the story

of Apollo's pursuit of Daphne, which one version interprets with a pseudo-hermetic inflection: Apollo is the Sun which, rising every morning, dries up the dew (the literal meaning of Daphne) on the vegetation.

Indisputably, Tchelitchew was preoccupied enough with visual metaphors and mystic writings to absorb their mythological content without deliberately borrowing any precise system, special interpretation or literal vision from them; after all, he was concerned with his own systems, interpretations and visions. In the same way he adopted the manners of contemporary painting he admired and proceeded to convert them easily, and more or less consciously, to his own uses. In *Hide and Seek*, as has been shown, he reversed the symbolic qualities of male and female by technically, according to his realization of the game pattern, making the female "aggressive" and the male "fugitive." His reason was complex and part of it was his own personal view of women. But in the end, it does not matter either for him or his picture, for male and female are to be (whatever the method) "reconciled," and in the prime physical sense will indeed copulate. Of course, alchemy did not insist on the sexual differentiation in its allegories of human experience. Soul and Spirit may shed their sexual vestments and become only aspects of the male, as in allegories of Body and Soul reunited by Spirit: Soul and Body are respectively Father and Son while Spirit is a winged man. One might be persuaded to see here a version of the Holy Trinity of Christianity, in which the Father and the Son are united in the Holy Ghost.

But no matter where the labyrinth of *Hide and Seek* may take us, we are always within hailing distance of Doubrovka; we can always catch hold of some tangible point to reorient ourselves. The truth about the myth of labyrinths is that the doom supposed to lurk at their center is not to be avoided, but found, and that this is as much a "way out" as lifting oneself on wings and escaping the whole struggle. Daedalus, constructor of the labyrinth at Cnossus, could escape it (as the myth says) by "flying" out, but the hero, Theseus, had to penetrate to its inmost part, and kill the monster there before he could achieve his mission, which was one of liberation. The artist must observe the same manners toward the labyrinths which *he* invents: Tchelitchew may have found his personal way out of *Hide and Seek* with wings, even as Theseus was led back by Ariadne's thread which Daedalus had given her. The artist wore on one wrist, it will be remembered, the bracelet of red yarn while, in Salvator Mundi, the little bird on his shoulder (himself) watched "the tissues" fight. Though he was to lose to the monster of the labyrinth in this last fight, he had found his way out of many a labyrinth by virtue of the magic red thread about his wrist.

Above all we must not lose sight of the fact that our hero was, like Orpheus, a charmer of beasts and, like Apollo, a master of snakes. As he recorded in notes for a lecture, he was fascinated by the figures of Greek

mythology when a child, and not least by the Medusa, of which he did his own original version. It is startling to learn, without elaboration, that his attraction to the Medusa arose from his "passion for fish." But again, by a rapid foreshortening made with the aid of the wartime correspondence with Edith Sitwell, a phase of the continuity of Tchelitchew's art becomes crystal clear. In the early forties, he was in the midst of evolving Paradise from the "interior landscape" of the human body: "skinned" female heads with veins flowing into tortuous hair would tend to shock and amaze, rather than attract, viewers. "Now," he wrote Dame Edith, "all my friends tees [tease] me that all my life I was in love with Medusa - the one I painted when I was 8 years old - and strangely enough she had a green face and eyes like telescope-fishes and the strange shape of her head still is in my actual drawings and dispositions [sic] of my pictures." The image strongly suggests the alchemic symbol called Mercury of the Philosophers: a huge fish with a man's face and legs, a bat's wings, a snake's tail and an octopus' tentacles. The artist's Medusa must be the "first state" of the long metamorphosis of La Dame Blanche.

Water and its denizens were to appear unattractive and brackish in the Hell of *Phenomena*, but nothing appetizing in that work is left untainted. Tchelitchew was to declare that the great tree in *Hide and Seek* is also a lake. A strange light is shed on this magic metamorphosis by the ambivalent figure of Mischa when he and Pavlik were boys. His weaker, sibling rival had a charm for the older brother. He wrote poetry, played the piano and was stimulated by errant whims to perform more strenuous feats. On the estate there existed a certain little swamp whose presence was unpleasant and yet suggestive. Becoming visionary, Mischa decided to emulate his father and convert the smelly, brackish place into a delightful pond. He altered its marshiness by changing the vegetation and draining it, found its source of fresh water, planted lilies and other flowers and populated it with exotic fish. It became a dream-place which was a favorite refuge for all the little Tcheli-tchews, who would come there alone to daydream. Pavlik, in particular, must have admired Mischa's personal achievement—how imaginative, how meta-morphose!

Yet he must have realized how much larger his "scale" was to be than Mischa's. The woodpecker of Kolpin Bor, the swallow-like bird of the Yisdra River, were far from being the most significant bird at Doubrovka. More mysterious through being connected with a legend, this bird was the owl. An owl appears, in the late sketchbooks of the artist, as one of the birds used for his perpetual experiments with the Celestial Physiognomies. In my account of his delirium as he lay dying at Salvator Mundi, the owl appears as it does in a sketch: punning with a pitcher.

Objects in the Celestial Physiognomies, as it were, have absorbed the universe, whereas in *Hide and Seek* the universe seems to have absorbed, or to be absorbing, objects. The latter work's concave-convex modulation of space

is partly abstract; that is, the result of a plastic method of drawing and painting. But in certain respects, it has to do with natural phenomena as such. The watery texture of much of the painting's area suggests reflections on water or things seen in or through water. The rotating seasons have been anthropomorphized as the heads or whole bodies of boys, beautifully anatomized and characterized with wonderful variety and invention, altogether human and boyish yet inseparable from the tree, whose outer contours their own contours obey; contrary elements, pigments, textures are being "alchemically" fused by the "fixed volatile" of the plastic imagination. One head is literally a drop of water through which, or in which, all nature is seen. Summer seems choked with flowers in full bloom: never has the anthropomorphic pun made flesh so exquisitely, suggestively out of something else. In the neighbor of the autumnal boy whom I have aligned with Mercury, the flames flow (they might also be "blown") as if reflected in water or mixed with it.

If we scrutinize the exact quality of the tree or hand-foot itself, we find a thorough illusion of watery transparency despite the modelling that faithfully represents both wood and human flesh. On the right, the bones of Winter's torso are visible as if by X-ray, carrying out the motif of branches denuded by Autumn's "fire." This suite of fluid effects, from running to frozen, was quite intentional with nature in mind: Tchelitchew was making the dominant image of his canvas a *lake* no less than a *tree;* around it are, as it were, the effects of irrigation. In the lake proper, the prismatic mingling of dark red and dark bluish green establish merging currents.

What very few observers might guess, since there are no strictly plastic or mythological clues to it, is that still a further punning dimension exists in this *lake, tree, hand, foot* and *bed of sexes.* The artist was to allege that he himself discovered the hidden image after the painting was evolved and almost completed: it is a sleeping memory-image of a Viking ancestor's head—its left eye is indicated by the butterfly, its nose puns with the girl's dress, and the lower or pedal section of the tree stands for its beard; of course the tree-branches are the antlers of a Viking helmet. Such an ancestral beard could hardly exclude his immediate father's beard.

There is a great deal of plastic heterogeneity about this hirsute appendage. Its convolutions are believably beardish as well as liquescent, fleshly and arboreal. Our analysis has told us that paint is being used here as an instrument of alchemy: substances are being fused by the "dry" and "humid" paths of the Magnum Opus, by fire and water. It is interesting that the tree becomes a sort of *athanor,* the alchemist's oven, and more interesting that the original *athanor* of the painting was the artist's own childish hand and that a beard was involved in the event. Of course, as he was to reveal, the tree-hand and tree-foot were taken from his own hand and foot.

Among Tchelitchew's recollections of the regular art classes he attended at

the Gymnazia in Moscow was that the classroom's walls displayed, in the time-honored fashion of academies, many plaster casts of classic sculpture that were to be drawn by the students; fortunately, we have a photograph of this wall. But we have more: Tchelitchew recalled vividly how much he was bored by being asked to do a realistic drawing of the head of Jupiter. He did not mention this in any connection with the Viking in *Hide and Seek* or any particular future painting of his; he was thinking only of his first plastic apprehensions. What attracted him primarily about Jupiter's head, he recalled, was his beard—it was alluring, mysterious, somehow challenging. That quite innocently he also called it a "lovely jungle forest" serves practically to fill in the distance between Doubrovka and the two years he spent painting *Hide and Seek*. A beard diversifies and identifies boyhood's home and manhood's emblem—both facial and pubic.

Pavlik's reaction to Jupiter's beard, we learn, was in keeping with his peculiar susceptibility in the visceral area, which in babyhood is allied with digital curiosity and playing with the feces. The artist related that one of his personal methods of drawing and painting was to make what he termed an "omelet of colors" in the palm of his left hand (apparently they were soft crayon) and then modulate and "draw" in it to convert it into a picture: once there emerged a stately dance of ladies and gentlemen of the eighteenth century. Casually, it might seem hard to believe that the small palm of a boy's hand could yield so elaborate and detailed a scene, something that might have appeared on the stage. But Tchelitchew was nothing if not precocious, and after all the "omelet" in his hand yielded only the sketch or idea of a finished picture. The point is that the direct inspiration for it was Jupiter's beard.

One of the functions of art—unhappily too often lost sight of—is its creation of the portraits, the personalities, of the artist's forebears. In place of the conventional family portrait may appear the equally conventional escutcheon and the illustrated family tree; the artist was constantly to speak of "my family tree" and of himself as its "last leaf" after *Hide and Seek* was painted. There is no difficulty in seeing that the work contains a tacit escutcheon which is the symbolically charged tree, a family portrait which is the antlered Viking. Tchelitchew senior was a tree-planter and forestry genius; once a party of agricultural experts came from abroad to study his achievements in reforestation. Of this, and the vastness of the family's tracts of forest, Tchelitchew junior, the future artist, was well aware as a child. Two portraits of his father, done when a mature man, were to be totemic: animal heads traced out of landscape.

There was another family estate, Votcha, far to the north in the district of Vologda, and larger than Doubrovka. An occasion came when Pavlik and Mischa were taken by their father for a visit there. At first the boys were all for sleeping overnight in the manor house, always uninhabited, for the

caretaking couple lived in a separate cottage. Theirs was a daring idea since the house was supposed to be haunted and Pavlik had not yet acquired his terror of such dwellings. It was on actually hearing some of the tales about the manor from the caretaker that the boys lost their nerve and gave up the project. The next day, however, Pavlik was taken on a tour of the estate by carriage. The caretaker drove along miles and miles of forest, of which no end became visible. As they passed various thick tracts, Pavlik would ask, "And to whom does this part belong?" No matter how many times he asked the question, which began to be a game, the caretaker duly replied, "To your father, Barinitch!"

He, Pavel Fyodorovitch, was heir to all this, as well as heir to the family nobility, which was of the Old prestige. The latter would keep of itself, like a fine garment never to wear out, but what of the former? Pavlik did not know exactly what he wanted to do with all these forests or if he wanted the responsibility of owning them. That he had reason not to keep the responsibility of *selling* them, we shall see later on. However, after he returned from the visit to Votcha, he was gay and talkative; he was seldom ever to think of the problem, any more than he now thought of Doubrovka as anything but his home: the home of his youth of which he was in the exact middle, and where he stayed, carefree, till Moscow and the preparation for a career came into sight.

Hide and Seek is, besides a family tree and an escutcheon, the total recovery of the voluptuousness of life's first shoots of growth; a "fores-trated" eroticism, it reinvoked the aesthetic motif in the boy Pavel that had gloriously begun in ambisexual pantheism and arrived at alchemic subtlety. That the Viking image should appear as the patron genius of his early visionary possession of the world—an all-embrace in the making—was the result of the individual's watchful consciousness that selects, fashions and finally characterizes the progenitors which nature has provided. No detail of private experience, official record or natural myth is ineligible for this project; voluntarily, Tchelitchew barred none. The great elastic cell of the imagination cradles and coddles and criticizes all these in order to arrive at their true synthesis. The "lovely jungle forest" of a beard connoted the ultimate sexual secret, but it was not confined to growing on his father's or Jupiter's or the Viking's chin; nor was it, with any inescapable stress, either pubic hair or feces. It possessed a genealogy of its own, and part of this was in the folklore of the forests which Tyapotchka taught the Tchelitchew children.

M. Tchelitchew, as his son recalled much later in the United States, was known to the Russian community as the King of the Forests. "But," said Tchelitchew, "I used to call him the Ehrl Koenig, which gave him another kind of kingdom." That is to say: the kind of kingdom of which the son

read in fairy tales, the magic kingdom of nature about which Tyapotchka
was always telling stories. The generic forest spirits were the Lyetchi, whose
beards were the green moss that hung from the birch trees. Pavlik would
take this moss and fashion costumes of it for himself, his brother and sisters,
costumes that trailed like royal robes; another origin for the dancer's train in
a future ballet, *L'Errante*.

But Tyapotchka added a curious human note to the story of the Lyetchi.
"When they laugh," she said, "people think it is the Grand Duke." The
Grand Duke! Someone distant, formidable, noble—though not so noble as
he, Pavel Tchelitchew. The alchemy of Tchelitchew's imagination, con-
sciously and unconsciously, was to work on this humanized aspect of the
Lyetchi for many years. He knew what the peasant superstition meant: the
Great Horned Owls of Russia were called Grand Dukes and their hooting
seemed the derisive voice of a powerful overlord, one not necessarily
friendly. The "Grand Duke's" horns, in the years to come, would be
transformed into the Viking's antlers and the ambiguous overlord would
become a benevolent ancestor. The actual legend posed a real danger at the
whim of the laughing Grand Dukes. If anyone angered them, it was said,
they set fire to the moss, so that whoever was in the forest at that time would
be terror-stricken, forget how to follow the paths out of the forest, and thus
perish.

Pavlik could tell himself that personally he had nothing to fear; he was
never in the forest at night, and moreover, Papa had planted his trees at
intervals, in hectares, with small paths running between them into large ones
that acted specifically as fire-preventives. If anyone was trapped by the
malice of the laughing Grand Dukes, it was because they did not know the
true magic of the forest and its labyrinths. He, Pavlik, by his father's beard,
was to become a master of these same labyrinths: a master different from his
father but just as ingenious and efficient. And the labyrinths were to be,
essentially, only one labyrinth of great complexity, and different—yes, im-
mensely different from his father's: altogether a *magic* Doubrovka.

Edgar Wind was to reiterate that *Hide and Seek* was a "magic picture."
And Osbert Sitwell was to call it so. It was therefore to stimulate the growth
of magics around it. Though at first Tchelitchew always called it *Cache-
Cache*, its public title was always *Hide and Seek*; gradually, since nearly
everyone referred to it by its English title, Tchelitchew fell into the habit of
doing so. But when he had to spell it, it came out *Hyde and Seak:* one of his
more significant unconscious (or at least subconscious) puns. For it was part
of the picture's magic that it should have in it a Mr. Hyde as well as a Dr.
Jekyll.

Tchelitchew throughout his career never lost sight of his lineage and took pleasure in anecdotes about it. The most important legends he himself related only obliquely—perhaps because a certain twin legend was contradictory and had other compromising elements, about which he had come to private conclusions. But his sister Choura, the present Mme. Zaoussailoff, has recalled faithfully, with the conscience of an historian, this important "compromising" legend. It was to be more in Tchelitchew's personal style to romanticize his ancestors when he came to speak of them to the world. By his authority, the Scandinavian current in his blood arose in the person of a man—presumably a descendant of the Viking of *Hide and Seek*—who taught a Russian czar to ice-skate: just which Czar the artist either did not know or did not say. But it is of marked interest that this story, in regard to the Viking himself, is consistent with the symbolism of *Hide and Seek*. For on nothing, plausibly, except the frozen water of sea, river or lake (with which the Viking's image puns in *Hide and Seek*) could Pavlik's ancestor have taught anyone to ice-skate.

Another progenitor that Pavlik was disposed to retain in his family tree was the Turkish princess who, according to the legend, was made a prisoner in the war waged by Catherine of Russia against the Turks. Her personal captor, who chivalrously proceeded to marry her, was the artist's paternal grandfather, Nikolai Tchelitscheff. Here I give the partly Germanized spelling of Tchelitchew's name, which in fact Mme. Zaoussailoff herself has adopted when writing it. From the marriage with the Turkish princess came twelve sons and one daughter. The first eleven sons died childless. The last and youngest son, Sergei Nikolayevitch, was the grandfather of Pavlik's generation. When I read Mme. Zaoussailoff's account of this branch of the family, I could not help recalling one of the most ancient family legends of the Western World. Gaia the Earth had twelve children in all by her husband, Uranos the Sky, only the youngest of whom, Kronos, was to provide the continuation of the race.

The lone daughter of Pavlik's great grandfather chose a chaste conventual

life and died the abbess of a nunnery, having taken the name Magdalena. The many jewels left her by her father (so the family was to bear witness) had gone to adorn the convent's ikons. Grandfather Sergei, when more than fifty years old, had married the daughter of a friend, Fyodor Stchoukine. Thus was one Sophia Fyodorovna, at the age of fifteen, fated to be grandmother of the children at Doubrovka. She was held a great beauty and only Pavlik, of his generation, was thought to resemble her. She was so beautiful that, sitting in a box at the Opera, she was noticed by Czar Alexander II, a friend of her father's, and forthwith invited to be lady-in-waiting at the Czarina's court in St. Petersburg. Only the speediest action in getting her married forestalled this often coveted social destiny; as a result, when she moved into her husband's house, Sophia brought her dolls and toys, with which she could not bear to be parted. Because of Pavlik's eyes, he was thought by his maternal grandmother to resemble his mother. In 1922, in the opinion of Allen Tanner, who met Tchelitchew that year, the artist resembled early photographs of his mother. Choura once said that he bore a greater resemblance to his pure Russian grandmother. I tend to agree with those who see the prevalence of the Turkish strain in Tchelitchew's looks, at least when he had reached manhood.

Mme. Zaoussailoff can point to a written version of the history of the Tchelitchew family; or, to adopt the internally preferred spelling, the Tchelitscheff family. For a while, in Europe, Tchelitchew was to conclude his signature with the two "f"s as do both French and German, and in Paris, was even to indulge the idea of calling himself Paul rather than Pavel. Each nation, each publication, has its own way of electing to interpret the Russian diphthongs. In Germany there was a grotesque coagulation of consonants that at times amounted to something like Tschelistscheff. At all events, the family history is dated 1893, titled *Collection of Data for the History of the Tchelitscheff Family*, and represents the personal labors of a cousin of Pavlik and Choura, André Tchelitscheff.

Mme. Zaoussailoff kindly rendered for me an account of their origin as given in that book: "In the year 1237, a man by the name of Wilchen came from the German regiments to the house of the great prince, Alexander Nevsky. Originating in the territories of Lüneberg, he was a descendant of King Otton, the Kürfürst of Lüneberg, of whose last in line Wilchen was the grandson. Entering Prince Nevsky's service, he spent a short while in Litva, then went to Greater Novgorod, where he embraced the Russian Orthodox religion and received the name Leonty; his godfather at the christening was the younger brother of Alexander Nevsky. Leonty, in reward for his services to the great Prince Nevsky, was given the city of Toropetz and the village of Kouridge in the Department of Nevsk."

It is from tenderest infancy, says Mme. Zaoussailoff, that she recalls an oral variation of this account. In the year 1240, Alexander Nevsky waged a

decisive battle against the invaders of Russian territory: the German regiments under their formidable Knights. This was no other than the famous Battle on the Ice, Ledovoe Poboistche or Ice Victory, which Sergei Eisenstein imaginatively reconstructed for his memorable film about Nevsky. In that battle, it was said, a certain soldier on the German side fought very bravely but was wounded and taken prisoner. Nevsky, it happened, was a personal witness of his extraordinary courage and remembered his face. After his recuperation, the soldier was offered by the victorious prince the captaincy of his own regiment. At that distant era, this meant that he was (using the English equivalent already mentioned) "at the very forehead" of the regiment, so that he was, linguistically, its *tchelo*. Tchelitchew, the extended form of the name, was to mean "very much of a head" or "very foreheadish"; thus, the "very best."

On analysis, it is plain that these two stories of the family's origin are not necessarily incompatible. At the same time, one may be literally true, the other literally false. There is little to be preferred between an oral and a written tradition, as such, because in history one of them regularly grows out of the other. What makes the historic legend of the Tchelitchews more interesting is still another memory of Alexandra Zaoussailoff's. According to the most fabulous of the accounts, the Tchelitchews are connected with the life of the famous prince, St. Dimitry Donskoy. It seems that Donskoy was about to wage a battle with the Tartars when rumor came that, in order to defeat the Russian forces through panic, the Tartars would perform the "impossible" by first concentrating their powers on killing Donskoy. This was so dangerous an outlook for the Russian side that military wisdom advised them to hide their leader for the duration of the engagement. To insure the success of the ruse (ostensibly their leader was to be present) a substitute to impersonate him had to be put in the field.

Who did this substitute turn out to be? No other than (as the scion then wrote his name) one Tchelitsche, who apparently resembled Donskoy physically and who appeared in battle wearing his leader's costume. As everyone (including Tchelitsche himself) knew, this device of impersonation invited the worst of fortune's favor for the impersonator, so that his comrades viewed Tchelitsche's action as virtual suicide. And so it turned out to be. The heroic Tchelitsche was killed, the Russians won the battle and St. Dimitry Donskoy was preserved by the Will of the Lord and the strategy of man. One assumes that poor Tchelitsche left genuine progeny to enjoy the reputation of his great self-sacrifice. For a twentieth-century scion of the same family was to sacrifice himself, as he explicitly alleged, in a quite different cause: his own.

Indeed the legend, for this distinguished scion Pavel Tchelitchew and his family, was to develop several points of much interest. Donskoy's conduct had been both sensible and orthodox according to the old ritual tradition of

using a scapegoat, but in the more modern idiom of military heroism, it was no less than a blemish on a saint's reputation. Papa Tchelitchew, a Tolstoyan liberal, did not hesitate to aggrandize a justifiable grievance. He would employ in regard to Donskoy, who during the vital engagement with the Tartars had hidden himself in some bushes, an obsolete expression that signified "to go off into the bushes" (that is, to answer nature's call) instead of the ordinary expression meaning simply to hide oneself.

Of course, the naughty anachronism became a revered household joke at Doubrovka. After all, it was indeed an honor to be connected with a saint if it was only to save his life by getting oneself killed. At the same time, it was humanly dishonorable to suffer another's fate, especially since, judging by Christian morality, one consents to die only in imitation of Christ; that is, were someone to be martyred in the Christian tradition, the honor ought to go to the saint himself rather than to a stand-in. Moreover, and preferably from the worldly standpoint, a man lives and works for himself—as M. Tchelitchew declared in his personal motto, according to which he *first* worked for God.

There was a profound irony in the homely little joke Papa Tchelitchew had made about the conduct of St. Dimitry Donskoy. Perhaps none appreciated it so much, at the time, as one who emulated the example of its manner; this was little Pavlik, who began to use archaisms generally as a form of elegance in conversation. He had a child's love for the German fairy tales, as he once confessed, but also, even in his childhood, a "French sense of ridicule" (as he put it) when observing the realities of the broad human condition. The ironic wit of the French, the world's most urbane, made an instant appeal to the *sensible* child, who felt in himself an obscure awakening of the most primitive mysticism no less than a keen criticism of human shortcomings—a criticism that would approach cruelty in its impartial realism.

When we are young, avid as we may be, we are content to wait; for we sense, if normally healthy, a great deal of time ahead of us. Yet character formation is like a set of germs. It cultivates itself in much secrecy and throws out symptoms at its own will—symptoms that hardly get noticed by the subject himself, or if noticed, often forgotten. In later life, Tchelitchew was to grow increasingly certain of his destiny as an artisan in symbols, and thus increasingly negligent of just what date a practical realization of this or that symbolic motif had appeared in his work; all he could do was to place his symbolism in a creative *durée* that compassed his lifetime. And basically he was right in assuming that plastic motifs had been long and indefinitely at work in him before emerging into complete mental consciousness: he would read the past by considering it a palimpsest where the bottom layer, among many layers, was still visible.

Toward the close of his informative correspondence with Edith Sitwell over the war years, he was constantly to refer to his more and more self-aware destiny as a symbolist artist and kept recalling the deep past to demonstrate this truth. He agreed with Fabre d'Olivet (he was to write the late Dame Edith in 1948) that "Eurydice was Orpheus' astral soul." This remark immediately plunged him into the kind of generalization that had become habitual. "I am deploring," he went on, "the vanishing use of symbols because I see on [sic] myself that is the way I thought all my life. One day I will tell you how surprised I was this year to find myself thinking in symbols. Do you know that in 1380 my ancestor the great friend of Prince Dimitry of the Don[skoy?] in the battle against the Tatar [sic] Khan exchanged his silver armor with Prince's golden one [and] was killed because the Tatars thought he was Prince Dimitry. My ancestor was the Bogas [?] Brenko [?] Tchelish [sic] (it means 'before anybody or anything') - was killed by an arrow in his forehead. 'Tchelo' is old Russian. There are things in our lives prepared and knotted long time ago - "

His letter goes on to other matters without transition. Already knowing the Donskoy legend, we are in a position to see how Tchelitchew glamorized it with gold and silver armor and with that "great friend of the Prince." Yet the essential point must have been veiled from the letter's recipient, who must have felt challenged to read any specific relevance in it. At the same time, one who knew the writer not at all might conclude that some death, parallel with or like his ancestor's, was reserved for the speaker. As Tchelitchew did not die of a blow or stab in the forehead, or from cerebral hemorrhage, his ancestor's death, aside from being picturesque and suggestive, would best symbolize, I think, the kind of wound that Philoctetes suffered: the wound of genius that both exalts and damns, brings suffering and sublimity. What could the piercing arrow itself symbolize except an idea, thus a mental inspiration?—logically, a submission to the fate of a creator *willing to die for an idea?* Tchelitsche's (or Tchelish's) change of identity would mean the well-known impulse of the creative temperament to renounce the family tradition and inaugurate a new one with itself as the founder.

Here is the deep dimension of the Donskoy legend of which the boy Pavel could have had little or no conscious notion when he first heard it. Yet even before his teens, the legend unquestionably awoke strange emotions in him: ambivalent impulses of fear and bravery, shame and pride. Pavel Tchelitchew, from the cradle on, was a natural dandy. Such a temperament implies a great many scruples and exactions from self and others. When still very young, his sharp sense of outrage at human misdemeanors—a prelude to his worship of protocol—derived from a special aestheticism toward every aspect of the sensuous world. One of his French governesses, naming the Champs-Elysées in Paris, evoked that city as the Elysian Fields themselves. As I have

said, the Tchelitchews were multi-lingual, and household protocol had established that French and German should be spoken on alternate days, the only exception being at meal times, when conversation reverted to their native tongue. This state of things gave each child a catholic outlook on history and religion and a certain primary cosmopolitanism. Thus the street in Paris became for Pavlik (he himself was to recall) a generic Heaven: the home, it might be, of all paradises. From that moment on, his reverence for the French capital was to be colored by his ecstatic anticipation of a unique and flawless happiness already resident there.

Another French governess, a Mlle. V———, was to give him quite a different idea of Frenchness and to help plant the seeds of his future expertness in feminine chic. Mme. Tchelitchew received this governess at Doubrovka as one well recommended by a person in whom she placed much confidence. Therefore she tried to overlook, after verifying her capability as a school-mistress, that she rouged her cheeks rather conspicuously. The governesses sat at meals with the family. One evening, Mlle. V——— appeared at table, not only with her remarkably red cheeks, but also with a bright red flower stuck in her hair.

Everyone for the moment proceeded to ignore this inconceivably coquetry except Pavlik, who sat there paying no attention to his food, his gaze rivetted on Mlle. V———'s red flower. It was soon the governess's turn to ignore something and she did so for some minutes more, trying to eat as usual. Then Pavlik's persistent stare—transparently critical and accompanied by his silence—grew too much for her. "Insolent little beast!" she blurted, glaring at him.

Pavlik did not answer but dropped his eyes and started to eat his meal; a faint smile (quite as insolent as his stare) hovered on his cresent-shaped lips. The incident, as such, was over. But next morning, at breakfast time, Mademoiselle was missing from her place at table. She had sent down word that she had a headache and desired breakfast in bed. It was brought her, with a word from Mme. Tchelitchew that her presence (as soon as she was finished) was required in her office; for Mama also had an office in the manor house. At lunch, and ever afterward, Mlle. V——— was conspicuous by her absence. She had departed from Doubrovka.

As we know, Mme. Tchelitchew did not approve of *la bête humaine*, and neither did she believe—as might be construed from Mademoiselle's rebuke at table—that Pavlik had become one. Still the fact was that the French governess's bad taste *had* aroused a certain beast in the boy: his passion for good taste in artifice. The red flower, he thought, should have been quite differently placed in Mlle. V———'s coiffure. He would have been happy to give her advice on the coiffure itself; she was an attractive woman and an attractive woman should do the best possible for herself.

The verbal or the decorative: each level was a level of the use of manners,

at which the young Pavel was soon to be generally expert. Yet if we hesitate, and search all the facts of Tchelitchew's life, the Donskoy anecdote of "going off into the bushes" acquires a curious and suggestive emphasis. In its light, the multiple imagery of his art, its transparency, its punning habit of overlap and making two or more of one and one of two or more—his whole plastic world of ambiguously charged meaning and X-ray vision—requires special examination. This world could be a product of emotions deeply stirred by the Donskoy-Tchelitsche legend and cultivated and crystallized by very real events of his late youth, making him a fugitive and an exile: conceivably a more or less voluntary scapegoat.

That distant Tchelitchew's way of dying, however laudable, was ignominious in one special respect: it became distinguished by taking on another's identity, it actually suppressed one's own name while elevating another man's! This could in itself only have sat ill with the imagination of a boy so vain and ambitious as Pavlik—I say "vain" because all pride which may meet sore defeat and disappointment, which may suffer accidents that scar with a sense of degradation, must to some extent deserve the name of vanity. Pavel Tchelitchew was to plot his worldly career in every respect, and not only through great personal ambition but from sheer economic necessity. Every effort at achievement thus had an instant signal of failure or success; it might have a carry-over value too, but it could not avoid the immediate verdict of the practical test.

I have said that our hero was to turn out an inveterate coquette. When this is understood as a matter of personal temperament, its meaning is far from being exhausted. When I talked with Edith Sitwell about Tchelitchew, she was deliberately reticent about the personal angles, but at one moment, when I said I planned to portray two Tchelitchews—Pavlik I and Pavlik II as I put it—a spark was aroused and she spontaneously exclaimed: "That's a very good idea . . . That was *true!*" Eventually, as a formal procedure, this original plan was to strike me as too artificial. It became more subtle to *show* the doubleness of Tchelitchew's nature than to adopt a device of repeating it by name and number. I think I have followed exactly what was to be Tchelitchew's opinion on the same point. No man, indeed, finds any advantage in representing himself as a double, while he might find much advantage, perhaps even necessity, in sometimes being invisible. Indeed, speaking categorically to Edith Sitwell in much later years, he would write: "I believe in disguise . . ."

The man who was to claim that he decided in early youth neither to ask nor to answer questions was simply and solely posing the moral strategy of *an art of camouflage.* Certainly, during the First World War, which rudely broke up the idyllic peace of Doubrovka and then snatched it away, the aspiring artist would read of the military art that hid one from one's enemies. As a man who was to develop an insidious paranoia in his professional

economic struggles, war and the art of disguise—a costume art, a *feminine* art—were never to be quite separate in his mind.

That shrewd, urbane and knowledgeable art critic, the late Henry Mc-Bride, was not to overlook a peculiar strain visible in the work and the temperament of a man whose shows he had been reviewing since 1934. Heading a new review, "Russian Overwhelmingness," the well-disposed McBride, as was his wont, gave some personal impressions of Tchelitchew and invoked his past as a fugitive from Red Russia and a self-exile. Frankly, he attributed the artist's concept of natural scenery as imbued with human imagery to the personal fear of feeling pursued—the feeling, precisely, that the woods were "alive" with enemy soldiers . . .*

Visceral to the quick, young Pavel was to wince and collapse at the sight of a dissected corpse some time before his army experiences. Yet he was already fond of the "greasy pastels" which he moistened in one hand and esteemed the knife itself as, he once said, "an assisting instrument" during his period of experiment as a schoolboy artist. At Doubrovka, he read his strange visions, the origin of all his "metamorphic landscapes," in the bark of a tree or the ceiling of his bedroom indiscriminately, even as he was to read them in Jupiter's beard. The future could not be too deep, too mysterious, too challenging for the gifted schoolboy to scrutinize and anatomize it in advance. Like all youthful beings, he did not really know, when he started going to school in Moscow, exactly what he wished to be, to do, as a professional. He knew, like all the gifted, he wanted to do great things. But what great things? Their *whatness* did not matter so much as their *greatness*.

Pavel Tchelitchew had a name, a great name, that had come down to him and was a source of pride, a source of consolation at the darkest moments of the present. That name was almost always behind him—whether in the distinguished teacher of ice-skating, in the brave German who had won the favor of Prince Nevsky, in the fabulous, self-sacrificing Tchelitsche who had saved the life of a Russian hero and saint. Back there, in those far, uncertain depths, he saw a single undivided greatness: his own future. Past all the frightening things—the black ones and the red ones—he was to keep his eye fixed on greatness: *greatness only*. For what was his own, his private and exclusive, stake in the curious Donskoy-Tchelitsche legend? We have seen how he remembered it as a mature man. No: it could not remain a mere family joke or a distant branch of the family tree any more than the mere origin of Pavlik's taste for archaisms. He himself would have to be a hero of silver and golden armor: a hero with an arrow magnificently piercing his forehead. His name earned him an inalienable right to that sublime and agonizing arrow.

* New York *Sun,* Oct. 30th, 1942.

Meanwhile in those continuous depths where "the tissues fought"—fought in relative health or relative sickness—he, he the body, Pavel Tchelitchew, was being so much, without naming or knowing what that "so much" was. Biographic time separates the "greasy pastels" that made an ordered chaos in the schoolboy's palm from the skindeep paint, applied with the greatest finesse, covering the surface of *Hide and Seek*. But nothing else is between them; nothing, that is, save the steadily evolving alchemy of art that is like the body's alchemy as it lives secretly, manifesting itself day by day, week by week, year by year.

Pavlik had acquired, as he said, a "bosom friend" in Alexander (Choura) Zyakine, a young man of similar temperament and ambitions who, as the October Revolution approached, had known Tchelitchew for about ten years; ever since they went to the Gymnazia together. Zyakine was now an actor in the Moscow Kamerny Theatre and had adopted the professional name of Roumnyeff. And he was the schoolmate who had accompanied Pavlik to the surgical amphitheatre with the legendary perfumed handkerchieves. Pavlik's half-sister, Manya, kept the piquant story alive, but while she told it to fresh acquaintance, the youth would only smile enigmatically and neither confirm nor deny. Both Zyakine and Tchelitchew nursed tendencies toward designing for the stage as well as dancing there. Inevitably, the cynosure of such noble aims was the Imperial Bolshoi Theatre.

The war's enervating atmosphere was to stimulate them to imaginative measures, especially as a career was still an ambiguous quantity to Pavlik. One day found them both with great portfolios under their arms and on their way to an appointment with K. Korovine, head designer of décors and costume at the Bolshoi. The autumn of 1917 was at hand. Since Pavlik had brought landscapes inspired by the frosted and sunlit windows of the Doubrovka schoolroom, the eminent professional quickly perceived his talent for fantasy; there were also some clever costume drawings. Korovine, as Tchelitchew was to relate in one of his biographic sketches, clearly distinguished him from his chum as the truly gifted member of the pair and turned to Zyakine to advise

him to go on dancing and acting. To the novice, Tchelitchew, however, he proposed then and there a collaboration with himself on a forthcoming production of Rimsky-Korsakoff's *Snow Maiden*. To the designer's great surprise, Pavlik, seeming to consider for a moment, declined.

Korovine assured him that he would be given a free hand and would make lots of money. The young man laughed and said that all he wished to do, really, was to paint pictures and nothing more. The strange reaction had another dimension that went unperceived by the Bolshoi's designer. On another occasion in his maturity, Tchelitchew was to claim that he had been suspicious he would not get proper program credit for his collaboration; in other words, his *name* would not be advanced. For this reason he had declined so flattering an offer. Two months later, in any case, he was to be sorry (as he recalled) for the October Revolution erupted, and with the rest of the Moscow household he had to decamp, at once, for Doubrovka.

At that moment of an unseized chance to begin a career, he could not help but wonder in retrospect if he had not been wrong, if some machine of fate or fortune had not been at work without his knowing it. On the other hand, perhaps his whole future would have been settled by this time had he been enabled to pursue his old adolescent desire to be a dancer . . . He would still have had the leisure to paint! But that point was four years ago, when the European war had not yet destroyed the beautiful, leisurely rhythm of his days. Then he had been fifteen, not almost nineteen, as he was now. Then one might have passed his room in the Moscow flat and seen him in dressing gown and slippers, as was his wont, practising the dance steps he had learned in the studio of Mikhail Mordkin.

None but the best of teachers would do for Pavel Tchelitchew. Scrupulously, of course, he was trying to develop his own style. These lessons were quite clandestine, taken in defiance of Papa's edict that his elder son was not born for the career of a ballet dancer. He had to thank his blessed Aunt Sacha for the connivance, and the money, which made his heart's desire possible. Neither Manya nor Natasha, furthermore, would (he was certain) betray his treacherous rebellion. With the former, he was closer than with the half-sister who had denounced him for filthiness in his quest for adult knowledge. He was to hold both Manya and the married Varvara, who lived elsewhere in Moscow, in respect and affection. Yet, going to school in Moscow, his domestic preference was decidedly for the more understanding, indeed the more stylish, Manya.

In her, he sensed a certain neurotic and self-indulgent egotism akin to his own. Though later she had love affairs, Manya was to remain single. For that matter, so was Natasha. But the latter, having turned sixteen, was obviously destined to be the family's "old maid." *Toukanchik* (Jerboa), as she had been nicknamed by her father, was Papa's tacitly acknowledged favorite. As we

shall learn, Pavlik did not at all care for mice, whether ordinary or so exotic as the jerboa, and this distaste may well have been an element in his coolness toward Natasha. For he was ever suggestible to human likenesses with animals: a fact that was to turn into one of the magics of his art.

With Manya he would curl up in a corner and discuss the wondrous risks of a career. He liked the fact that she got unabashed crushes on prominent males whom she did not know but whose photographs were kept on her dressing table, till suddenly a new crush would supervene. Manya's elfish face reflected some of Pavlik's own mercurial texture, a hint of his passion. And she too was something of a problem to Mama and Papa. Brother and half-sister were playful—who could be otherwise with Pavlik?—but an undercurrent of seriousness ran through their relations like the Yisdra on its secretive, tortuous way through the forest.

A girl friend of Manya's was married to a landscape painter named Milman. With another painter, Mashkoff, Milman followed the bright new way of art by setting up Cézanne as a canon and intented to establish a school in Moscow. At the moment of refusing Korovine's proposal, Pavlik decided to study with Milman—but it was September, 1917, so that his new art studies came to an abrupt end in another month. In 1913, however, he was in the delicious throes of learning to dance from Mordkin; candidly, he saw himself on the stage of the Imperial Bolshoi as a great dancer.

Mme. Zaoussailoff well remembers an occasion when Pavlik was to demonstrate his accomplishments at the kind of semi-private function that was much the thing at that period in Moscow. Was it to be an Apache or a Gypsy dance?—perhaps even a Beggar dance? Memory cannot be certain. What is certain was the young performer's intense concern over the rightness of his costume. While Aunt Sacha trembled, her chin bulging over the high collar of her bejeweled dress, while Manya and Natasha sheltered good-natured smiles and Choura gazed in forthright admiration, Pavlik spent at least two whole hours before the mirror trying on handkerchieves of different colors, winding them about his head to let them trail over one shoulder. Choura was too young to go to the affair but both the older girls went. It was the young ballet student's rendering of this same dance which had such gratifying repercussions that Papa, all the way out in Doubrovka, heard of it. Not, however, with the pleasure that the youngsters and their sophisticated elders had exhibited as they applauded the bowing, ravished and self-ravished, Pavlik.

The next time the son saw his father was instantaneously, insofar as the railroad schedule permitted, and their interview signalized M. Tchelitchew's diabolical use of the title, Panya, which opened their conversation and roused a livid flame in the adolescent's proud and pretty cheek. M. Tchelitchew was very angry as he watched that livid, now also thinning, cheek. Pavlik was

growing up, indeed, he was no longer a schoolboy, and this incident of disobedience showed what a froward and perhaps dangerous spirit he had. Papa, with the old-fashioned egotism of Papas, had so hoped that his first-born son would follow in his footsteps. He had begged Pavlik to take mathematics at the University instead of the medicine which had been their compromise; in later life, the artist said he regretted not having taken his father's advice, as of course the medicine had come to nothing. M. Tchelitchew also knew that his son attended lectures on art by new-fangled painters and really wished to be an artist. No: the father could not see the youth before him as a future doctor! Naturally he was aware that his offspring was genuinely talented. But being an *artist* is not a rich landowner's idea of how one moulds one's nature into reliability and manliness.

If only—thought M. Tchelitchew as Pavlik dared to outbrave him—there were not this persistent effeminacy in his handsome son, this drive toward sympathy with everything that Tchelitchew senior associated with the fair sex. If he did not resemble his mother, he resembled his Turkish great grandmother; no matter where one turned his son's figure about, some angle that was graceful, yielding, *unsoldierly* met the eye. Moreover, he feared that glint of self-will, that flame of the virile ego, that he could read in Pavlik's eyes, which seemed so powerful and yet so futile—so perverse. There was something eager, even predatory, about it, some fantastic romanticism that explained all his artistic notions about designing for the opera and dancing on the stage. What could he, the responsible father, do about it at this slippery turning-point? Obliquely, a strange memory brought its flash into the father's head.

Always he had tried his best not to let the women of the house, including Tyapotchka, spoil and coddle the young dandy whom he called both Nas-ledni Knyass and Panya. Yet some demon of inspiration had always come to his son's aid and vanquished the ladies' resistance. Tyapotchka herself, a good disciplinarian, had once reported to him, a glow in her eyes, that grotesque incident in church that should have shocked her pious nature. She had been close to Pavlik when he took his first communion. Then the boy's face was quite round, altogether different from the lean, mature cheeks that were before him now. Pavlik had solemnly received the Host on his tongue and a moment passed during which he duly swallowed it.

His eyes, Tyapotchka saw, were shut. Everyone sighed with relief that Pavlik had behaved so becomingly, just like a little adult, and as if he were taking communion for the two-hundredth time. Then his little voice was heard—at least it was heard by his nurse and the priest. "Some more," it said. Tyapotchka could not repress an incontinent satisfaction. "You understand, Barin?" She rushed ahead, quite regardless, "he asked for some—." But Fyodor Sergeyevitch's stare, seeming to go right through her, had brought her up short. The father now remembered.

Above: Hermetic Circle, engraving.
Below: Alchemical Allegory: The Fixed Volatile, engraving.
Both figures relate to the centrally placed Lion Man of *Phenomena.*

Left: *Hermetic Scheme of the Universe.*
Below: *Hermetic Cosmos,* engraving.
Both designs relate closely to aspects of *nomena*.

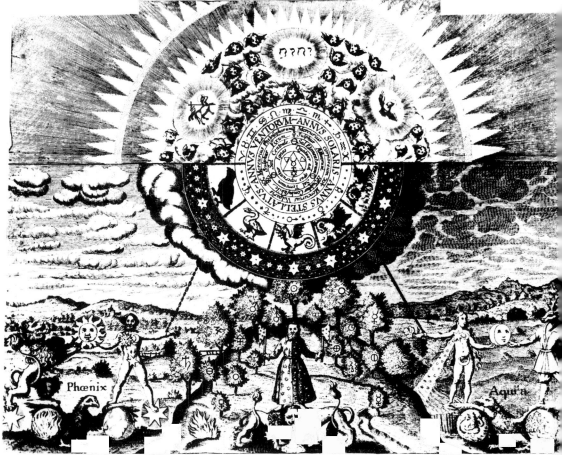

Above left: The Twelve Divisions of the Horoscope.
Above right: Scheme of the Configuration of the Planets.
Below: The Gateway to Eternal Wisdom, engraving.

These designs relate variously to the structures of *Phenomena* and the Celestial Physiognomies.

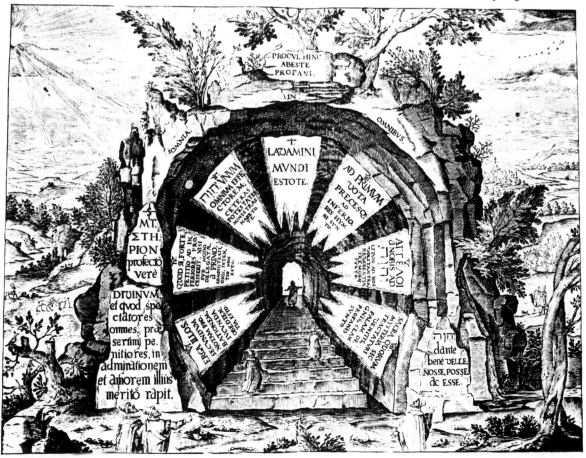

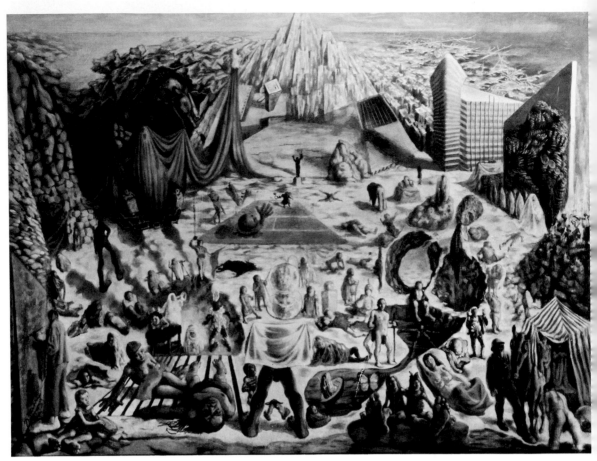

Above: TCHELITCHEW: *Final Sketch for Phenomena*, ca. 1937, oil on canvas. Collection Charles Henri Ford.

Below: Snapshots of Charles Henri Ford that cued two of the figures in *Phenomena*.

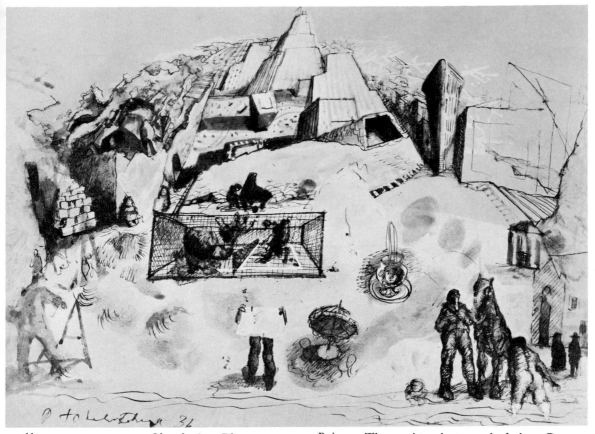

Above: TCHELITCHEW: *Sketch for Phenomena,* 1936, watercolor and ink. Collection the Museum of Modern Art, New York.

Below: The artist photographed by George Platt Lynes before the unfinished *Phenomena,* 1937 or 1938.

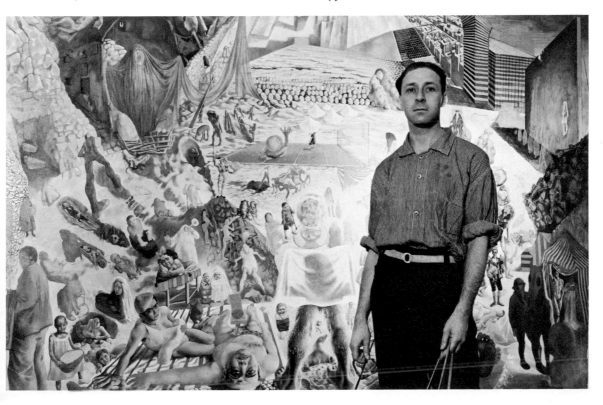

Above: Phenomena, detail: Sitting Bull and The Knitting Maniac (modelled, respectively, on Gertrude Stein and Alice B. Toklas).

Below: Phenomena, detail: the artist painting and The Sequestered One (virtually a portrait of Edith Sitwell).

Above: Léonor Fini photographed in an *oda-*
que pose suggesting the figure below.
Right: Phenomena, detail: The Lion Man (mod-
ed on the snapshot of Ford).
Below: Phenomena, detail: The Man with the
ird Leg, The Elephant-skin Girl (modelled on
onor Fini), The Two-headed Man (righthand
ad modelled on Edward James).

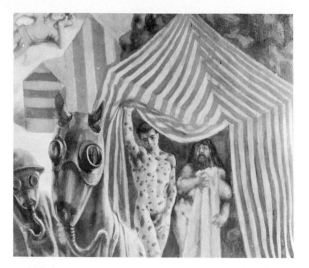

Left: Phenomena, detail: The Leopard B []
(modelled on Nicholas Magallanes) and []
Bearded Lady (modelled on Christian Bérard).

Below: Phenomena, detail: The Armless Won[]
(modelled on head of the author), Sealo (model[]
on Virgil Thomson's head), Serpentina (m[]
elled on Elsa Maxwell's head).

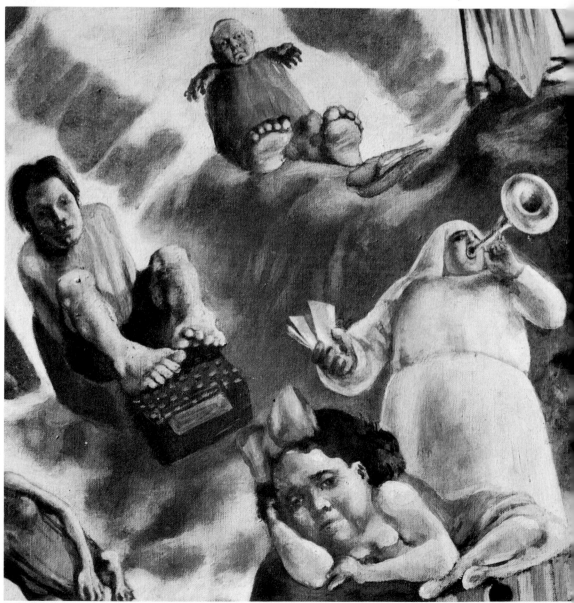

Top: TCHELITCHEW: *Tree in Sussex*, 1934, brown ink. Collection The Museum of Modern Art, New York, Mrs. Simon Guggenheim Fund.

Center: TCHELITCHEW: *Tree with Children*, 1935, brown ink wash. Collection The Museum of Modern Art, New York, Mrs. Simon Guggenheim Fund.

Bottom: TCHELITCHEW: *Tree into Double Hand*, 1938–38, ink wash. Collection The Museum of Modern Art, Mrs. Simon Guggenheim Fund.

Several animal heads are "hidden" in these drawings.

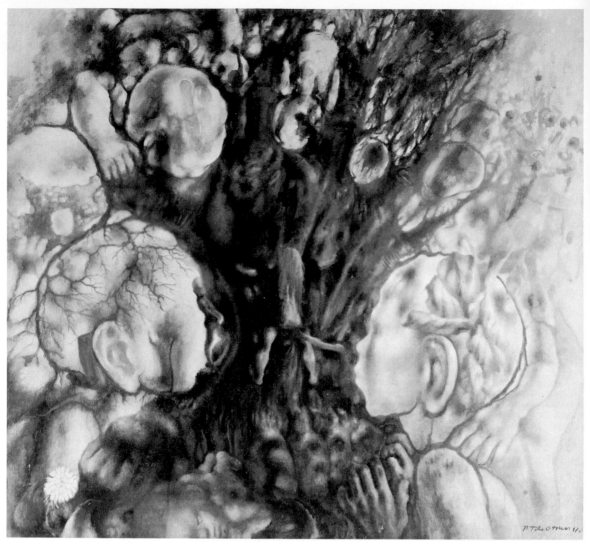

Above: TCHELITCHEW: *Sketch for Hide and Seek,* gouache, 1941.

Left: Hermetic Conversation, engraving, an occult model for various features of *Hide and Seek.*

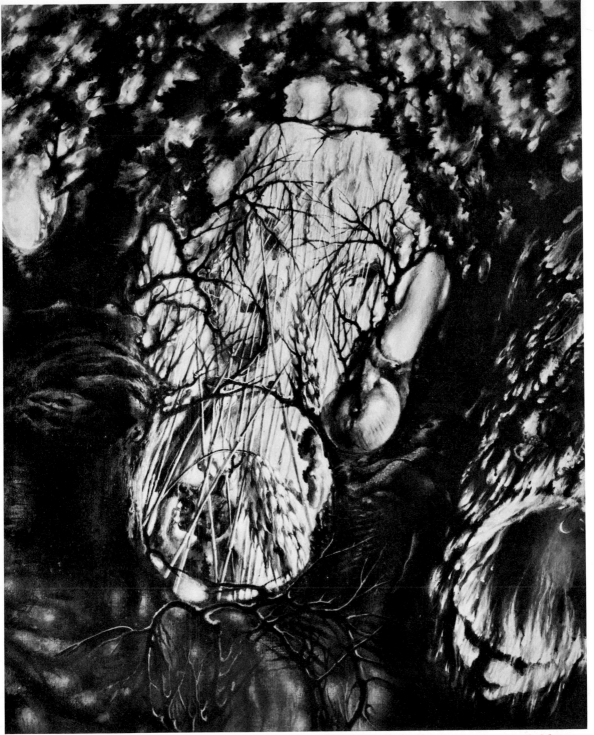

Hide and Seek, detail: the autumnal Mercury figure at top. Compare with *The Green Lion* as well as the Celestial Physiognomy titled *Mercure* (frontispiece). *Photo: Colten.*

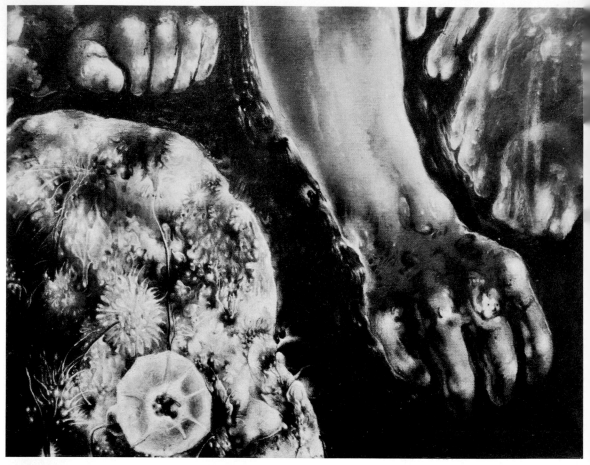

Above: Hide and Seek, detail: Head of Summer with forearm of figure whose head represents The Drop of Water.

Left: Hide and Seek, detail: Head of Winter. *Photos: Soichi Sunami.*

TCHELITCHEW: *Hide and Seek*, 1940–42, oil on canvas, 78½ by 84¾ inches.
Collection The Museum of Modern Art, New York,
Mrs. Simon Guggenheim Fund.

"Artists in Exile," participants in an exhibition
held at the Pierre Matisse Gallery, New York,
March 1942. From left to right, first row, seated:
Matta, Ossip Zadkine, Yves Tanguy, Max Ernst,
Marc Chagall, Fernand Léger; second row, seated:
André Breton, Piet Mondrian, André Masson,
Amedee Ozenfant, Jacques Lipchitz, Eugene Ber-
man; third row, standing: Pavel Tchelitchew, Kurt
Seligmann. *Photo: George Platt Lynes.*

"Yes, that'll do," he had returned firmly. He had been about to let a smile escape him as he noticed Tyapotchka's unusual flush. The women must not get excited over Pavel Fyodorovitch's tricks . . . And now, when his son was so much taller, he was still the stubborn, self-willed boy, ready to overwhelm the women. M. Tchelitchew cut short Pavlik's account of how well received his dance had been. "I don't care about that!" he shouted. "You disobeyed me knowingly, slyly, deliberately. What can you say? Nothing!" Controlling his voice (which he tried never to raise) he paused, realizing that he had but one move to make. The most he could expect from this brilliantly disappointing son (if only Mischa had Pavlik's natural gifts!) was something *negative*. But that something he meant to have.

"You must promise me never to be a professional dancer. I simply won't tolerate it! So these ballet lessons have to stop." The fury of a thwarted prima donna raged and then ceased in Pavlik. Tchelitchew senior perhaps had transmitted more character to his son than either fully realized. Papa was scrupulously superstitious and would return home, abandoning his affairs for the day, if on going out he should meet with a bad omen; Pavlik was to mirror this behavior throughout his life. But he was now beginning to learn a stoic detachment from his father's irresistible dictates. He had decided that a mute look of hostile endurance might be his "best face" since, a few moments before, Papa had brought out his silly little motto about rearing his sons: "Boys should not be brought up as if they were girls in gowns of tulle." He was sure Papa had begun to read scorn in his face that the man who held such a virile sentiment had condescended to design the dresses of his first wife.

The curt readiness with which, suddenly, Pavlik at last gave him the required promise caused M. Tchelitchew a certain alarm. Was the boy mocking him? It crossed his mind that there might be something more terribly unorthodox in his son than he had ever suspected—something powerful and obstinate that would frighten him if he knew just what it was. The disturbing emotion brought revenge to his lips: "Do I have your word of honor, *Panya*?"

"My word of honor, Papa," returned Pavlik firmly, straightening his back; a redness had automatically replaced the lividness of his cheek.

"That's better, Nasledni Knyass!"

It may not have provided the deciding factor for Pavlik himself, but previously an accident, which gave him a small lifetime scar on his forehead, must have indicated that perhaps the perfect destiny for him was not that of a premier danseur. A gluttonous reader, he seldom let other occupations, also to his liking, prevent a sort of simultaneous indulgence. He would read even while shaving, the latter now being a ritual attribute of his approaching manhood. The enthusiastic artist could no more think of himself as too precipitate in behavior than as redundant or overambitious. Greediness? That word was absent from his vocabulary. He would learn to seize with strong

retentive hands the near, invitingly foreshortened opportunity. Like a magician, he could do with one hand (the artist's) what another would have to do with two. So he came around to compressing the tenses of existence; so he was to reach the "simultaneity" and "laconic image" of his art.

If he wished to enlarge his experience of reading by dancing as well, the simultaneous acts lent a strengthening rhythm to the print, whether that of a poem or not. He also had the advanced conception of assimilating knowledge by the method of helpful association. Thus it happened that he *danced* his lessons, sketching out his steps as he held a textbook in one hand, changing it to the other when a gesture was required on the other side; always, as he swayed, curveted, gave a half turn or a leap, he kept the book in line with his eyes. This way, he found, learning was painless, even pleasant.

Under him he felt his carpet slipper twist about; he almost lost it and his foot came down turned under. He tried to recover the false step by breaking the little leap he was about to give, and in doing so went sharply sideways, meeting the end of his wooden bedstead. In the midst of the danger—or rather the humiliation—that threatened, before he even struck the bed, his apprehensive mind shook for the shining dignity of Pavel Tchelitchew—he, *he* the poised one, the handsome young dancer—falling, wretchedly falling—Pavlik, a mere clumsy fellow, who had tried to do two things at once, and been so unwary as to wear carpet slippers and not look just where he was going? No!!

But he hit the bedstead anyway, and furiously, desperately bearing to the free side, he tripped on the slipper and went quite hopelessly down, face forward.

Never!

His forehead hit the wall.

Aunt Sacha, who had shrieked on beholding him, sitting limp, Petrouchka-like, with his back against the wall, had disappeared to get first aid. He put his finger to the place on his forehead. It was bleeding. He did not know what to do with the blood on his finger.

Would there be a scar? Yes, there was sure to be a scar. He could tell. He also knew something else: the body was not the same as the soul, not at all . . . It was alien, independent, it went its own insolent way regardless. And yet look how vulnerable it was, how weak! He could cry for the absurdity and injustice—yes, injustice!—of this paradox. Suppressing a desire to jump up, to scream, to bandage himself and stop the bleeding, he sat still—and shed some tears.

He felt prescient: it was one of his first consciously "prophetic" moments. He could anticipate the time in 1944 when, in the midst of wartime, he had set out, as he put it, "on the road to Paradise" that he was never to abandon. Then he would encounter in the writings of Paracelsus, whom he had just

joyously discovered, a maxim about the soul that contradicted Aristotle, who placed the soul in the body. No, no! Three decades from now, he was to be certain that Paracelsus was right. Basically, body and soul were distinct and it was useless to identify them. Still, the Pythagorean writings were to have a charm for him and apparently Aristotle agreed with them. The soul, the great mystic was supposed to have said, is located between the heart and the brain; the mind is in the heart, reason and intuition in the brain. Now his head was suffering—the *tchelo!* But already, somehow, he intuited his future desire to leap clear of the physical consciousness centered in the solar plexus: to leap clear of the body through the sizeless window of art.

Could this be done with the legs—the legs of a dancer? Perhaps not! But with an arrow—?

"Inasmuch," continues Pythagoras in the canonic writings, "as the ether is invisible, so is the soul. The links of the soul are the arteries, veins and nerves." It would be a long time before his eyes would meet these words or he would imagine the interior of the body a crystalline world of colored minerals. Now some of his veins were broken, bleeding. He felt the blood running down his cheek. It fell on his dressing gown as he heard Aunt Sacha ordering the servant to run for a doctor in the next block.

Pavlik was smiling. It was the smile with which he was to greet the Pythagorean doctrine that Mercury is the steward of the soul as, resembling the body, it is cast forth on the earth and wanders about . . . At some point called death, Mercury conducts the souls from their bodies to the highest regions and does not allow the impure ones to approach them or to come near one another. He commits them to the Furies, who bind them in indissoluble fetters.

At this moment, Pavlik cannot see for his suffering head. Yet there fermented in his soul the visions that were to deck the person of Hermes Psychopompos in the Stravinsky-Balanchine ballet, *Apollon Musagête*, which he was to do during the Second World War, and to deck the person of the Student, Initiate of Isis, that he was to do for *Ode*, the Diaghilev ballet based on a poem by his countryman, Lomonosov, in 1928. There would be fetters on the Student—but breakable fetters, fetters that would turn into a cat's cradle! And for Apollo there would be . . . swaddling bands . . . Quickly he wiped away, not his blood, but his tears.

Aunt Sacha's step was at the door.

Tchelitchew's friend-to-be, Geoffrey Gorer, told me that he suspected the surviving Russian custom of swaddling infants must have been to blame for Pavlik's curiously aggressive and neurotic personality as a man. When I asked Choura Zaoussailoff if Tchelitchew had been swaddled in his infancy, she exclaimed and said, "Certainly not," that in their household, at least, swaddling infants was viewed as "something the peasants did."

In any case, true swaddling bands, their nature and how they are wound and unwound, are products of the mind; which is to say, of the imagination. Being a liberal, Nadyezda Pavlovna had discouraged the peasant custom around Doubrovka.

About the wound of the arrow now: a bandage.

In life or literature, the tyranny of the nurse is found everywhere—everywhere that she can consider herself part of the family, indispensable as the guardian of her charges' welfare. Pavlik's Nyanya was not just the two muses of nursery and playroom, but chthonic as well as celestial spirits: the prototypes of the muse Tchelitchew was to call familiarly, when English too became his language, Mrs. Nature. He was growing to know her full tyranny, good and bad, her entire repertory of pleasant and unpleasant tricks, while his beard made its appearance and he understood that sex, career, even "name," were matters of *choice* as much as of *necessity*—matters of Fate *and* Fortune.

Wonderful, *wonderful* choice! the more wonderful in possibility, the more bountiful Mrs. Nature has been in her gifts. "The good woman hasn't treated me too badly," Pavlik once thought to himself before a mirror; "when it came to a certain decision she did not stint herself at all. I cannot complain." If he had not been shaving at the moment, he would have practised the enchantment of his smile in gratitude. For no reason at all, there then crossed his mind something Papa had told them when he was speaking of Peter the Great and his reforms. One reform was rather harsh for he had forbidden the monks to continue with their art, so that (as Pavlik would decide in the future) Russian painting declined from that time to the present. This Czar had also compelled the Boyars to shave and wear wigs in imitation of the courtiers in Europe. "Très amusant, n'est-ce pas?" his stilled tongue now murmured. Papa he remembered, had let his hand wander to his own beard, as if to say (it was so plain) that again the provincial nobility were free to grow long beards, court or no court, if they chose.

A beard for him, Pavlik? Ha! ha! It was to laugh. Never, *never!* He would not cover his lips. His ancestors would never have conferred on him such lips if they were to be disfigured by hairiness. No: hairiness belonged elsewhere on one's person; although some ladies, he knew, did not think so. Beards and mustaches for men, like artificial hips for women, had gone in and out of fashion like the seasons. Why had men shaved their faces in the first

place? It was civilized to do so, that was all, and hygienic, too. Mrs. Nature appreciated man's cleanliness. She was grateful and smiled and shone at her best when cleaned up and kept neat. *Regardez là!* There was Mischa's pond. One had to be careful and not offend Mrs. Nature; the fact was that she took offense, sometimes, too easily. And La Dame Blanche, the apparition at the end of the alley of larches: he could not think of *her* without shuddering for she was as strange as Mrs. Nature was familiar. What to do? "Only one thing, Pavlousha," he told himself, "charm them, charm them all: *all the ladies!*"

Tyapotchka, yes, Tyapothchka, too! At Doubrovka, Nyanya was a benevolent tyrant, a solid double for the cosmic Mrs. Nature; in some ways, she had more powerful an influence than had the actual mother, the Little One. With Tyapotchka, story-telling became an instrument of discipline as well as pleasure-giving. A certain ikon at Doubrovka had been in the family for five hundred years. It was a head of Christ and painted so that the eyes appeared to follow one around the room no matter where one went to avoid them. Tyapotchka said that the children had better watch out, for these eyes saw all, and if they were not careful they would be unable to swallow communion. The children were supposed, technically, never to be frightened. But a pious bugaboo, with religion squarely behind it, could not (by Tyapotchka's logic) be harmful to anyone. To Choura, with a vulnerable chest, the thought of the sin she might commit by being unable to swallow communion gave her throat a feeling of constriction; as a result, she would practise swallowing water beforehand. But for Pavlik, as we know, nothing came easier than downing the divine substance.

Mama felt she was not very good at story-telling and so she let the servants assume this function of ritual entertainment. At twilight, by a cheerful fire in her own boudoir, Nadyezda Pavlovna would sometimes join more extraordinary sessions when the gardener, Fyodor, would weave his wondrous, and at times scandalous, stories. One of them was a folk tale in which a gigantic and obstreperous pig was a covert symbol of mythical sexual scale. Just when Fyodor was telling this story, Papa paid them a quite unexpected visit, and at once recognizing the scandalous pig, lost his temper and denounced Fyodor, forbidding him ever to tell the story again as it was unfit to be heard by children. At which the mild Fyodor, informed as to fables but lacking any Freudian education, protested ineffectually by saying that the little ones could not possibly understand the meaning to which the Barin referred. Papa simply stalked out and Fyodor dared not continue with the innocently meant amusement he had chosen that evening. Since Tyapotchka was in every way chaste and had the viewpoint of her employer, she never told this profane sort of story.

But the tales she did tell, such as that about the Magic Fern and stories

from the Bible, held the little imaginations at Doubrovka (especially Pavlik's) in greater thrall than did Fyodor's tales. It is not recorded just how Pavlik took a story that came directly from Tyapotchka's experience but it may well have impressed him as a parable intimately applying to the very idea of home: the ideal home that, like Heaven, was "somewhere else." The Tchelitchews were to be expelled from Doubrovka and all their lands when Pavlik was about to turn twenty, had the scar on his forehead, had initiated himself into the mysteries of sex and launched himself in the direction of several careers. There began to be an insidious, unmentioned fear at Doubrovka, to which the Moscow household returned in the summer and on holidays. At large, as if lying in wait for them, it would mingle with the air and the very taste of the food.

This fear was total revolution and its barely guessable consequences. Doubrovka was a symbol of quiet feudal isolation. It simply was inconceivable that living here would not go on and on, like day and night and the seasons. However alarming the European war, whatever ill omens disturbed the political order and the social peace of Russia, Doubrovka with its splendid forests, Fyodor Sergeyevitch with his position as loved and respected lord of the domain, seemed as firm, as safely remote, as the stars in their courses. Besides, every private aristocrat such as the first-born son of the Tchelitchews would regard what worldly privileges he might possess as earned by natural merit rather than bestowed by man and his political whims. At least, the old courtly ideal of Russian life, even in this Boyar-originating family, seemed to lift Doubrovka beyond such things as mere civil war; nowadays, feudalism meant "peace." Even if the Czar's enemies were not outside Russia, that was where they should be!

But Pavel Fyodorovitch, the self-indulged, the privileged, though he felt perfectly at home in Russia (where Doubrovka was), was a little more than Russian in being an international dreamer. The true place he had learned courtly manners had been at the Imperial Bolshoi Theatre in Moscow, for which, one day, he hoped to design great productions. Yet he could not exile from his restless imagination that unique city which possessed, it seemed, a Champs Elysées as one of its principal streets. He knew that Paris also had an Opera House and that ballets were to be seen there. Still, when he thought of the great capitals of the world, such as Berlin and London and Moscow itself, Paris assumed some elusive supremacy because—so he had the fixed idea—something heavenly dwelt in the streets themselves—publicly, out in the open. He was not so certain that he was destined to be a great dancer. And if he could not really participate in spectacles like *The Snow Maiden* and *The Sleeping Beauty*, he would have to design them. He was sure of that alternative even should he never see a capital other than Moscow. But what about living such manners, such beauty, such spectacles?

There was a wonderful old coach, with the Tchelichew coat-of-arms on its door, that still stood, wheel-less, an unused heirloom, in the stables at Doubrovka, and years ago had been a virtual castle to the children. Gorgeously upholstered in sky-blue satin, it was luxuriously designed for sleeping purposes and so large that six horses had been needed to draw it. Their stylish coachman, Kirillitch, would have kept it like a museum piece except for the children, whose obsession it was to make it the scene of play: "Marriage" was the favorite game their naughty precociousness liked to stage there. Family legend had it that Pavlik's grandfather had travelled in the coach all the way to Paris and back; in that case, the boy believed, it must have been driven along the Champs Elysées! As a young man, he could not but look back on the grand old coach rolling across the Fields of the Blessed as the image of a child's dream. But Tchelitchew was always to reconsider judgments based on adult sophistication. Was it so childish, indeed, to think of Heaven on Earth? Where else would that magical thing, *marriage*, take place?

All the same, one could never avoid the real practical aspects of living. Doubrovka was by no means the only "home" belonging to the Tchelitchews. Was there not also Votcha, the even bigger Votcha, and could they not live there if they wished? Then there was the Moscow establishment. If the worst came to the worst, they might have to give that up, but Doubrovka —the minds of the young Tchelitchews, as the war years began and did not end, paused in puzzlement and unquiet if they were so bold as to give close inspection to a certain strange tale that had cast doubt on Doubrovka as their original, rightful "home." An old story of Tyapotchka's was actually responsible for this outlandish thought. It had seemed all the stranger, from the first, because of the great conviction in Tyapotchka's voice. She always spoke with authority as well as charm, and the little ones never doubted that she was in possession of the most important family secrets; she seemed to know everything—everything, of course, except what Papa had said to Mama when he had proposed to her on that picnic in the forest!

"Doubrovka," the household sibyl would tell her listeners, "is not the true home of your name." Your "name"—that was a curious way of putting the matter! Well, name as such—as a Tchelitchew ought to know—may mean something of vital importance. Tyapotchka went on to say that the *true* Doubrovka, this one's predecessor by name, had been hurriedly sold by the grandmother with Turkish blood, Sophia Fyodorovna, along with half the estates her husband had left her when he died. This happened, Tyapotchka hastened to add, because Sophia Fyodorovna disliked everything that was "truly Tchelitchew." These words always cast the children into a spell. One and all, they would beg Nyanya to repeat the tale, though it was very short and simple, and otherwise only a description of how the "true Doubrovka" looked. It seemed as if Nyanya would purposely hold back a few moments so that she would have to be implored. And implored she was.

Their mythical home, thrust out of their lives forever, had been more impressive, it seemed, than their dear old Doubrovka, painted a permanent faded-pink. The true Doubrovka had been a large, shining white house with tall columns on the outside, and inside reception halls and grand salons with fine furniture and rich carpets, numberless mirrors and pictures. There was a stately garden with fountains and various bodies of water on which white swans glided; marvelous flowers grew there, such as supposedly grow only in fairy tales, while everywhere on its paths peacocks strutted with tails outspread. One might have concluded that the true Doubrovka was a veritable Champs-Elysées, an expanded "family coach."

If Pavlik formed any such idea as that, he must have decided that the Serpent in this Lost Paradise was the peacock, for that bird remained throughout his life a bad-luck sign. Plausibly, birds may never have much stirred the affections of Tchelitchew because, as a not always amenable counterpart of the snake, the bird may have meant for him the malign aspect of the phallus: the aspect which typified conventional mating. Regarding the latter, he may have been wiser about symbolism in fairy tales than the gardener, Fyodor, imagined. A disdainful "peacock" might seem more menacing than a gargantuan "pig." Again, the psychic forms in which male and female symbols appear can sometimes be deceptive. Tchelitchew was preternaturally vigilant on the subject of warning signs. The peacock represents pride, which in others can be insufferable. Moreover, the ends of its gorgeous tail feathers contain "eyes" and any such manifestation in nature could be interpreted (as often it was) as the Evil Eye. Were a peacock's picture to turn up in Tchelitchew's manhood, or one be named, he would instantly resort to signs of counter-magic, including (when circumstances permitted) a touch on his genitals.

If the children grew tired of the stories from Grimm and Andersen, they would clamor for a tale with a Russian hero, and Tyapotchka had quite an assortment of such tales. They learned of the brilliant Fire Bird about which Igor Stravinsky was to compose a ballet. The period of *Hide and Seek* found Tchelitchew preoccupied with flamelike motifs which (as one subcutaneous "portrait" head of a woman illustrated) would engender fantasies of forest fires, in which birds and animals looked trapped. The firm of Capehart was then collecting paintings by prominent artists as part of its regular promotion. Tchelitchew averred that this firm "mistook" one of these fantasies for the Fire Bird; anyway, it was bought to advertise the Stravinsky music.

The children also learned of a Grey Wolf which spoke in a human voice and by dashing its body against the ground could turn into a marvelous horse, a princess, or the Fire Bird itself. This magic faculty was obviously to be a model for Pavlik's future metamorphic manner: the transformations and the individual's power to multiply and divide himself. The glamorous Fire Bird had a disgusting relative Baba Yaga, or Bone Leg. This was a female monster

that lived in an impenetrable forest in a house without doors or windows, where she sat squatting on her chicken feet.

Pavlik, as some of his pictures and adventures reveal, was to regard even the common hen as a magic animal, ambivalently good and evil. He and Mischa would play a horrid trick on the poor woman who kept their poultry yard. When she wasn't present, they would sneak in the hen house and hypnotize the hens. It was a practice they had learned somewhere and to their delighted wonderment, it invariably worked. Simply by taking the hens up, holding them for a moment with hands over their wings and then placing them carefully on the ground on their backs, they could induce immobility in them. There they would lie, when the poor poultry woman returned, claws awkwardly hanging in the air and ridiculously inert; the foolish creatures evidently had no idea what had happened to them. Meanwhile the boys hid to witness the coming scene, and not till the poultry woman's shrieks and pleas had gone on for some time would Mischa consent to appear and (as she believed) remove the spell by making a magic sign and setting the hens back on their feet; whereupon the hens behaved, after a moment of uncertainty, as if nothing had happened.

Even if their Doubrovka were not the "true" one, it was Doubrovka and belonged to them; it would belong to Pavlik, it seemed, when Papa and Mama died. The girls really did not look forward very gaily to leaving it, even on that distant day when they would get married and be taken away, as Varvara had been, by a husband. But *was* Doubrovka always *to be?* The vague threat to it, and by inference to them, the Tchelitchews, brought into view the whole question of time and duration, however obliquely. The question of the growth of things: the future of self and destiny and the reality of goals. This vague issue was common to all the young ones. It was just as common, and sometimes less vague, to numerous other Russians. The great question was (and always is) what was to be—about to be, should be, might be . . . Doubrovka was becoming a most sensitive barometer for the tenses of Fate and Fortune.

My manner of dealing with this situation at such an historic moment for Doubrovka, for Russia, indeed for the world, may strike the reader as a little abstract, a bit free and easy, or just arbitrary. But he already knows from the section, *Interlude*, my grounds for employing various biographic tenses. Tchelitchew could anticipate in ways lucid and obscure the road ahead, which turned in the early forties into his climb toward Paradise. Still it is true that when the narrative form mixes past, present and future, a necessary temporal ambiguity is created.

Tinting, as it were, the pigment of the past with the tense of future fate, I have fluidly mixed verb forms as the paint of *Hide and Seek* mixes the four elements of our planet and its environment. This, I grant, is not a simple

course to follow. Like history, formal literature of all kinds overcomes the disadvantage of life's uncertainties by tensing events according to facts plainly seen achieving themselves and passing smoothly away to make room for further facts. Such eventuating facts are already accomplished; "now" (thus the convention) their *durée* is being represented by the continuous narrative. Especially if a fiction writer, an author displays a concept of fate that is usually tacit, inherent in the overt nature of his happenings and not a matter for special argument.

I beg, at this point, to italicize the inspiration for my procedure by again citing Tchelitchew's art as a direct medium of his temperament. His foresight, as I have said, arose from impatience of a paranoid complexion and, I may add, of a libidinous one. In the thirties this was to be expressed by precipitate foreshortening of the human figure in his painting. In 1940, I termed this usage the Emotional Perspective. It is a distortion of true proportions obtained by abrupt confrontation of an object when one is impelled by the desire to possess it; the plastic case is that one anatomic part is enlarged at the expense of another. This may be said to "dramatize" an object and required skill to avoid falsification and absurdity. It is a mode of optical seduction which, becoming habitual, tends to compass the environment as well as the object. It does not render a "classic" world in which all is in the right scale and the right place; hence Tchelitchew's reputation as a painter of baroque temper. In another decade, he was completely to eliminate the feeling of perspectival intimacy with an object and shift to a physically abstracted view of all matter.

If, then, I have repudiated the simple historic tense, I repeat that I have done so in emulation of my subject, who continually strove to surprise the future in the present and to read in past events (like a fortune teller) what *was to be* since it had been determined in the more or less distant past. Theoretically no door of divination—from the heavens' configurations in astrology to the mysteries of childhood's diseases and accidents—is closed to this inspection of the continuous chain of cause and effect, whose plastic symbol became, for Tchelitchew, the *net*. Self-evidently, Pavel Tchelitchew lived a more comprehensive tense than the mere historic past serves to render. The presence of *The Divine Comedy* as the program for Tchelitchew's art after 1938 is the chief reason for allowing the tenses of Fate and Fortune (as psychic forces if as nothing else) to govern the integument of his biography.

So it came about that I began with the end of my hero's life in order to accommodate a total rebeginning, which, while in his prime, he gradually predicated upon his mystic-aesthetic creed. Squarely behind the supernaturalism implied by *The Divine Comedy* was the doctrine of reincarnation that grew to be another "object" of Tchlitchew's restive desires. Let us review just why this book is chronologically not laid out like Dante's epic poem. Its

scope has another dimension: it is about the making of a Divine Comedy and is the story of the man who made it. And yet, of course, the order of this book's sections, while their elements are the same as *The Divine Comedy's*, departs from Dante's order: Hell, Purgatory, Paradise. Tchelitchew's own life helps to authorize this departure. As commentators have long remarked, Dante's poem has the sequence of a ritual ordeal and imitates the path of the soul as it journeys through its earthly phase to its ultimate spiritual refinement. At least, this is the way Dante sought to preserve the form of the old mystery rituals under the aegis of the universal Western religion, Christianity.

Life itself, however, is not laid out like a ritual ordeal, at least not precisely, any more than it is laid out like chronometric history. The concept of reincarnation, with its omnipresent principle of the cyclic, accounts for the fact that while Tchelitchew's *Phenomena, Hide and Seek* and the disputable *Inachevé* correspond, as respectively his Hell, Purgatory and Paradise, to the Dantean orthodoxy, he himself was to attest to a revisiting of Hell between his Purgatory and his Paradise. Again, I have recourse to the very enlightening wartime correspondence with Edith Sitwell; there he says that following *Hide and Seek*, he indeed sighted Paradise and set out on his road to it. But it was *now* that he first realized the mystic necessity of going down into Hell before gaining access to Paradise. It is significant that Charles Henri Ford was to suggest that his *Hide and Seek* followed his *Phenomena* as Purgatory follows Hell in *The Divine Comedy*; at once, Tchelitchew perceived the deeply intuitive trend his masterworks had contained and clearly saw, as well, the features of Purgatory (*Hide and Seek*) succeeding the features of Hell (*Phenomena*).

But not till now was the full ritualistic weight of the matter apparent to him. Now he saw the interior of Hell mystically rather than mythologically. *Phenomena* had been the climax of life in the world: the very presence of Hell when everything material and materialistic was most onerous and most ecstatic: its monstrous vices and opulence of device correspond to the Earthly Paradise of Bosch's *Garden of Delights*. One thinks of the recent theory that Bosch was actually a hermetic and painted the Paradise of his great work in service to a secret society of nudists. However that may be, just so did Tchelitchew "paint in" this sort of Paradise in his Hell: truly a garden of profane delights.

Another personal truth about Tchelitchew's achievement of his Divine Comedy is that he saw that his Purgatory referred to a point back of the time when he had become the mature, wary, critical, poor and sublimely cynical painter whose self-portrait is seen in a corner of *Phenomena* gazing at the world he is painting; *Hide and Seek* referred, as I have been demonstrating, to childhood, all its naive paradisial desires, its strenuous and inflated ecstasy, its militant unflinching at the threshold of sexual experience: its triumphal

innocence of sin. This second member of the trilogy is really first in being the Garden of Eden; that is, Paradise before the Fall, and thus too Paradise Lost. Lightly, as was his wont when speaking sometimes of the deeply serious, the artist told Dame Edith that it is wise to visit Hell first rather than have to fall, like Lucifer, into Hell all the way from Heaven. He meant, as he said in the same letter, that the Hell he was entering was the human body itself, its *inmost* inwardness, that this, precisely, was his "road to Paradise" and that he visualized a way at first very difficult and dark; it was specifically a search for the light: thus it corresponded, in this respect, exactly to Dante's Comedy.

It was to be in 1938 (as Lincoln Kirstein reports) that the artist "abandoned" rather than finished *Phenomena*. And it was to be during the same summer, in Dubrovnik in the Dolomites, that he contracted the diarrhea that would lead directly to his chronic colitis. The great painting was a judgment of the world, specifically of its human society, but it had been, it seemed, too precipitate a judgment; it was not really out of his system if only because of the foreshortened desirability in which both flesh and fame continued to appear to him. This Hell was a convulsion of the physical and moral senses whose sinister and seductive Lucifer was sheer cynicism: a Dionysian orgy with a flavor of sour grapes. We shall see how documentarily true it was that the real Hell was the human innards, beginning with his own, and the real Lucifer a spoiled and gigantic glory at its bottom. . . .

In this chapter, more than ever, Doubrovka, the home of Tchelitchew's youth, is my theme and yet I may seem to have stretched my tenses pretty far. But I think it is not irrelevant (magically, it is certainly not) that the name of the town where Tchelitchew contracted his illness in 1938 was Dubrovnik, which linguistically is rather close to Doubrovka, and that not long afterward he was to embark on the epic of Doubrovka, his Purgatory. The times of art and life, and thus their verb tenses, are radically involuted. The curious thing about what I have been calling the tenses of Fate and Fortune is that those nouns form a dualism; they are like the horses of Plato's myth, which draw the same chariot but oppose each other. The oracular West, with its early tragic fate of paganism, is deceptive; when we think of Fate in archaic and classic times, we think of the classic drama of Athens as the model. Yet in practical terms the oracles were used for obtaining clues to the future in the immemorial sense of fortune-telling; they were often consulted for advice on business as well as military matters; they had as much to do with worldly success as with the soul. Fortuna was an actual deity (possessing both masculine and feminine manifestations in Italy) and unquestionably was sought for contemporary advice to the lovelorn and expectant mothers.

As I have said, Tchelitchew was not only well aware of the subtle distinction between Fate and Fortune, he insisted on it and even in terms of sexual

counterparts. But like all with an extravagantly fatalistic cast of mind, he also embraced Fate's equally ambiguous partner, Fortune; when thus allied dialectically, Fate is doom, or "tragic," Fortune is good luck, being favorable in the classic sense of "comic," the sense followed by Dante in naming his epic. The *durée* of life as existence, rather than as myth, however its hours be counted, is subject to private temperament. Since Tchelitchew's private temperament verged on the paranoid, with hysteria as a running base, it was the suspense of the issue betwen Fortune and Fate (good and bad luck) that created a great deal of personal damage to him in terms of disquiet.

The crux of Tchelitchew's personality, the "temper" in his "temperament," is universal and situated most anciently in the concept of Karma, which is cyclic fate involving a succession of lives on earth, with complete spiritualization as the goal. Tchelitchew was to accept this supernatural law in every detail. But Karma, which in Buddhism and other religions appears as a specific myth, remains, humanly speaking, an abstract ideal. With the transcendent vision of mystics, Tchelitchew tried to demonstrate its validity on earth: thus the figures of his Zodiac, the Celestial Physiognomies. Yet he was not only in danger of not completing the true mandala of his mystic universe, he was perpetually suffering, physically and spiritually, in attempting it.

At first he was rather (as we know) an oracle of his own; he was never to abandon this position technically, but in the advanced state of his ill health, he was impelled more and more to rely on advisers (including, alas, doctors!) and to puzzle over the sins he must have committed in past lives, and in this one, to deserve what was being inflicted on him. Originally his vanity made him hold back from recognizing Karma in his illness and in the great pains he was having to take with his last style. "I don't know what it is . . . What is it?" were his refrains to Ford and to friends casually visiting him. Finally, when the omens multiplied and he felt worse and worse, he would say, though with the same bewildered, incredulous air, "It must be something I did . . . It must be some punishment."

This was to be the trap's ultimate form: a consciousness of the past (Fate) as so saturative that no cleansing or burying, no looking forward to favor through good performance and better, could counteract the malignity. Yet this premature doom was overtaking him just when he had refined his art to its extreme spiritual state. Thus the tenses of his Fate and Fortune have what in grammar are called "aspects." We must remind ourselves that in terms of time action, the *durées* of myth in Hell, Purgatory and Paradise, are closed affairs with given permits and taboos of ingress, egress and progress. Basically, considering the ritual root of *The Divine Comedy*, the time spent there by its "visitor," Dante, is continuous, so that as a whole we have one continuous action. The concept or department of Purgatory, however, is where the reincarnation element of Karma is centered, for it implies dialectic

development, up or down, but with the same goal always: Paradise. Thus Purgatory is the existential tense, the central *durée*, of *The Divine Comedy* which relates it to earthly life as the nucleus of the soul's progressive struggle.

Hell and Paradise are taboo to each other; Purgatory, however, is their means of communication. Some of the same sins, we find, are being punished in Purgatory as in Hell; therefore, it is the sinner, the human personality, that makes the difference. As Tchelitchew himself analyzed it, the application of paint in *Phenomena* has a dry brutality, a coarseness reflected in the drawing and in the rendering of anatomies, but in Purgatory, this was to evolve into a new fluency and delicacy; the paint in the second work was at once brighter, intenser and more transparent. The latter, as I have said, was oriented to alchemy. The mystic process of the Magnum Opus was to reconcile opposites by a solution of matter in which all four elements, earth, air, fire and water were involved. Paint, itself, is thus grandly and specially Purgatorial. As the communicating center of the Divine Comedy, Purgatory is that particular stage of the process to be called molten, destroying separateness and causing fusion. So if there is a tense of Purgatory (as I imagine) it is the imperfective —the tense on its way to being perfect. Hence it is full of grammatical aspects. On this authority I have sought to parallel with my verb forms the mercurial paint of *Hide and Seek*. The object in this painting is both actually and symbolically dissolved in accordance with the alchemic mystique as it refers to mythological figures and actions. This is interesting, with regard to our theme of Fate, because the Greek word for fate, *moira*, originally meant boundary-line. In *Hide and Seek* there are *no* inflexible boundary-lines and its *plastic form* communicates this.

My path here may be somewhat labyrinthine; it is not digressive. If Pavlik dreamed, as a boy, of the Champs-Elysées in Paris, he was dreaming of a *durée* of which the "true," the mythical, Doubrovka was a symbol. Eternal happiness, as it could be a street, could be a tree. It was Doubrovka's hidden *durée*. I was greatly impressed, while investigating Tchelitchew's Russian background, to come upon the transcript of a lecture by Jane Harrison, whose theme was the Russian people's "hunger for durée" as expressed in their language. She presented it* at Cambridge in 1915: the year when the adolescent Tchelitchew's future hung suspensefully in the balance. Russian, Miss Harrison said, is "weak in tenses . . . because the time interest is not in the first plane. Russia lives sub specie aeternitatis." Primarily, of course, she was speaking of pre-Revolutionary or indigenous Russian psychology.

Her point is paradoxical in the light of history. Russia had been living, then, under a total moral condition that was precisely opposite to that of its Revolution, whose successful outbreak was only two years away. I have, on a previous page, allied Tchelitchew with the Revolution's course. His obsessed

* Available at the British Museum, London.

desire to forget the past and immerse himself in a fresh future, which may be interpreted as his modernism, I related to the psychology of the Russian Revolution: "ceaseless change as guided by perpetual program." In the light of Miss Harrison's above assertion, the Revolution in Russia would have been a violent dialectic reorientation of what had always been peculiarly Russian— that is to say, what had been, not *White* or *Red* Russian, but *idiosyncratically* Russian.

Her lecture continued: "Time is order; the Latin languages love order and are precise as to time. To the Russian, quality of action is of higher importance, so he specialized in aspects. Immediately what we get from Russia is the impulse to live in the living fact rather than outside it; to look for process, *durée*, rather than achievement." Alas, I interrupt, the Tcheli-tchews as a family did not look for anything better than to "live in the living fact" of Doubrovka—that *false* Doubrovka—with no thought of "achieving" a Revolution! Russia, on the contrary, suffering, it would seem, from a similar selfish love for *durée*, was made at last to understand that this overindulgence slighted the achievements of historic evolution; a great wrench was therefore necessary for the Russian nation to reorient itself dynamically and to accomplish its purge and a new beginning.

The Oxford Classical Dictionary says of Slavonic grammar that its imperfective "is applied to a form or aspect of the verb expressing action not completed (either continuous or repeated)." Insofar as the spheres of *The Divine Comedy* are eternal states, their verbs denote that action is continuous or repeated; this is because the only true climax of all action in the work is Paradise. Each sphere has a *durée* insofar as it is limited, has a "fate" or "taboo"; hence only insofar as the action is continuous throughout, as the three levels intercommunicate, can anything to be called dynamic movement or dialectic change take place in the *Comedy*. On the other hand, outside the myth constituted by the poem, man is free to act and invent or revoke the taboos of time and space. Only with this freedom indeed, does the concept of reincarnation in Karma have any validity; otherwise, progress on the road to perfection would be impossible. So the curses or taboos of the past are remitted and Hell itself put in question.

Desperately, the Russians invented Nihilism to rescue themselves from a stagnant, redundant love of *durée*. But Nihilism itself was a *durée*, a malign one of perpetual chaos and destruction, so that as a political solution, Nihilism merely posed a problem greater than the preceding stagnancy. Miss Harri-son's development of her idea works out most interestingly. She cites an expert on Russian grammar to the effect that the imperfective is, "among the grammatical aspects of the language in which its exists, the one which has the deepest psychological roots," and further, "the imperfective stands for the ten-dency to see and evoke and consequently represent the action itself rather

than the abstract result; the tendency to see and evoke is the essential tendency of the Russian imagination." General though the observation is, Russia's novelists, Turgenev and Dostoevsky, amply attest to such an imaginative faculty, for their works, with Chekhov's plays, projected the ferment of Russian stagnancy and its Nihilistic reactions as a lurid, self-defeating sort of treadmill.

Developing her argument, Miss Harrison herself supplied the nexus that has proved useful to the present theme: "The singular, the characteristic trait of the Russian language is not that it has a perfective—we all have that—but that it clings to the imperfective, at all costs, *even at the cost of having laboriously to create a new form*." [My italics.] By a veering inspiration of thought, Miss Harrison provides, I think, a logical formula by which both Tchelitchew and his nation may be understood more fully. Was not Russia, once the violent break was made with its political past, to go on clinging instinctively to its indigenous, *durée*-loving character while devoting itself to the task of evolving a new, universal society?—what I have termed its "incessant change as guided by perpetual program"? At least, whatever be the present state of things in the Soviet Union, that was its working postulate for the first two decades of the new Communist society, which coincided with the first two decades of Tchelitchew's career. Once the artist himself had made the more or less involuntary but decisive break with his Russian past, he was desperately to cling to its *durée* while using all his strength deliberately to evolve a communicative, or universal, art.

Simultaneously I touch a political nerve, a grammatical nerve, a personal nerve. The Marxist theoretic spirit that prevailed in Russia was a drastic conversion of the past imperfective (*was being*) into the future imperfective (*was to be,* or more accurately perhaps, *was to become*) The aesthetic grammar is quite Tchelitchevian in kind and overlaps on the very anatomy of his art. From the moment he was to cast the dice of his fate in Kiev, and read them (with the help of a Staretz) in Sevastopol and Odessa, he was to bend himself toward a program of progressive change conducted as rapidly as possible and to keep it for the rest of his life. If we were to choose a moment when the young Pavel experienced his first intuition of his future's fatal grammar—its *durée* and counter-*durée*—our best choice might well be August 14th, 1918.

During the previous months, the inmates at Doubrovka were busy making as few concessions to the times as possible. Delicately, like diplomats, they were understating some things, overstating (just as delicately) others. Theirs was, first, a well-run household. Pavlik had fluttered them agreeably by having won the Gold Medal in passing his second Baccalaureate. But that was the spring of 1917 so that his achievement could not be honored with special festivities. The Russian community was at war and they were part of

the Russian community. The girls at Doubrovka were knitting sweaters and scarves for the soldiers, while Natasha, the youthful "old maid," was visiting Moscow hospitals to write letters for the physically disabled and the illiterate.

No nationalistic furore could prevail at Doubrovka. They were being essentially, purely imaginatively and conservatively, *imperfectively* Russian. Pavlik's sleep was being disturbed by images of terror—the *angoisses*—which he thought to have exiled from his high and mighty, secretly self-governed adolescence. One night, there seemed to be a sound in his room. He woke up, terrified. There in the dimness was Nyanya (or was it some servant, some young girl, who had been put up to it?) who once, to frighten him with a foolish prank, had donned a black overcoat that covered her like a shroud and suddenly entered his room. He was never to forget his terror: it would haunt him even more persistently than the memory of the black dog that would cross his path in the open streets of Moscow. This last was a hush-hush, barely tolerated fable in the family. Witnesses had said that the dog was chimerical; nevertheless, Pavlik knew that he was in danger of fainting at its appearance, so that his Nyanya, for a while, had followed him in the streets to be on hand if he should see it. These days, even the black dog was receding into the past.

Pavlik's face could assume great seriousness of expression and Doubrovka's inmates noticed it frequently nowadays. He did not let on to it but he was thinking of himself in a uniform which perhaps he would never be able to get rid of. Then, growing self-conscious as the months passed, he laughed rather more loudly than usual—with a wanton, transparently misplaced coquetry—at a traditional family butt: the thoughtless, precipitate remarks of blond, boyish Mischa. It was he, Pavlik, who had impishly given Mischa a special nickname, Drop—Knock over—and Break. But they did not have any more childish family battles or any clashes between the male champions. They were all as if in step with some hidden, not very seductive music, marching through the days with an added uprightness and dignity.

They were keeping in mind that, not long ago, mobs had disgraced the streets of Russian cities, and so had blood. Treachery had been suspected in the very palace of Russia's rulers. If the palace itself were truly Russian, its rulers could not have been called quite so, with a German-born Czarina and that disreputable "genius" to whom she listened as if bewitched: Rasputin. It seemed only retribution that, with Russia internally tainted, its armies should recently have met reverses at the front. Fyodor Sergeyevitch, however, tried to discount these humiliating military defeats. "Has Russia ever been conquered?" he observed one day at dinner table. "No!" His first-born son was to say exactly the same thing over two decades later when the German armies were pushing back Russians into Russia. His country, M. Tchelitchew

further considered, had weathered more than one serious revolutionary crisis. When news had come that the Nobles, in traditional fashion, had made a macabre end of the mad, debauched Rasputin, the lord of Doubrovka had reflected that it was a better action than the Duma could have taken.

Unfortunately, during February of last year, mob excess had again broken out in Petrograd (no longer St. Petersburg) and all Russia had been shocked on hearing that Rasputin's corpse had been exhumed from the Neva and burned. The Russians were still living "inside" the action: *in its imperfective!* The burning revived the ambiguous nightmare at Prince Yussupov's palace in 1916, when the wicked monk had supposedly been poisoned and stabbed, then thrown into the Neva through a hole made in the ice. When the ghost of an action must be laid, surely that action has been incomplete.

The superstitious Tchelitchews, though one hesitated to discuss it, remembered that at the first appearance of the Czar's German bride, a grandstand, erected for the citizens to watch her progress, had collapsed and killed hundreds of Russians. No wonder there was a strong Revolutionary party like the Bolsheviks! The fool, Kerensky, should have been more decisive about them. Fyodor Sergeyevitch was certain of this when Kerensky's government crumbled and the Bolsheviks took over. Of course, that had been last Fall. They were as far as July, 1918, and no disaster had yet befallen Doubrovka—or Russia.

For the family, it was a cheerful note that Mama continued her little drawing exercise, making over and over again (it made doodling into a *courage*) her four geometric flowers. The tense of fate, strangely, is the very verb of suspense. One may be doing something specifically to avoid some prophesied evil, like Oedipus, and yet, step by step, be furthering the accomplishment of that same prophecy. Hence arises the mental anxiety of those wishing to be acquainted with the designs of fate, so, if they are evil, what is supposedly unavoidable can be avoided. Fortune, in this aspect, is the mere negative verb of fate: a not-doing that may spread into the disease of inaction. The family even surprised Mama trying to draw her eternal duck. "Really," she said as usual, "I'll never get it right. I know I shan't!" Pavlik looked at the duck and murmured a dreamy, smiling affirmative: an affirmative that meant assent to Mama's negative. Mama's duck was never, never *to be.*

It was said that the Treaty of Brest-Litovsk was a bad setback for Russian interests. But at least, thought Fyodor Sergeyevitch, they in Doubrovka were far away from the fierce battle that was going on right now, and on which the outcome of the European war seemed to depend, the Battle of the Marne. If the rest of the world was still in a ferocious uproar—that could not be denied—Doubrovka had come through it all intact. Suppose there was a Soviet, as indeed there was, in Doubrovka Village? Fyodor Sergeyevitch was

still the Ehrl Koenig for his family and for the peasants of Doubrovka. How in the world, and why in the world, should that be changed? After all, the truth was the truth; moreover, it was literally Tchelitchevian.

A new hospital and a new mayor's office stood as the fruit of M. Tchelitchew's progressive efforts for the village's good: these had preceded all this Bolshevik pother. So, in fact, had the library Nadyezda Pavlovna had created for the school with her personal supervision; she had been directly responsible, too, for altering the paganish murals in the village church to truly sacred subjects worthy of Christianity. Yet, on August 14th, when agents of the Soviet of Kaluga came to the door and handed them an Order of Expulsion, Doubrovka itself, the house and everything around it, the very forests themselves, all took on a false identity.

It was like the magic transformation of the palace in *The Sleeping Beauty*, when human life is arrested, inanimate things stay the same and the woods alone grow and grow. To be a good substitute for the true Doubrovka of Tyapotchka's tale, their Doubrovka at least would have to retain the family themselves and not merely their ghosts. Even Papa and Mama, who never wasted more than half a thought a year on Doubrovka's phantom predecessor (sold by the unTchelitchevian Sophia Fyodorovna) felt this abrupt, inexplicable alienation from the manor house. They hardly dared show one another the frozen desolation in each heart as it crept out into the glare of mid-August that cloaked the pink house, its gardens and the islet of trees. Printed on every physiognomy was an irrational bright faith in the Soviet of Doubrovka Village. The local Soviet would do something for Fyodor Sergeyevitch . . . or for Pavel Fyodorovitch . . . or . . . for poor Doubrovka. Yes, perhaps just for *Doubrovka* . . .

Pavlik went to the schoolroom, which was seldom in use now except for keeping the implements of the court games they still played: tennis and croquet. The artist was to think up a devastating pun, many years from now, regarding his memory of this tennis court in Russia. Also in the old schoolroom, in a cabinet, hung some of the marionettes Pavlik had made, years and years back, with costumes on which paillettes gleamed with rainbow colors. He well remembered the sensation those paillettes had made and the whole success of the little pageant. But the soft bright air of this dear place was full of a fresh darkness: the future. He was practically a man and it was very possible that soon he would be virtually on his own. Papa was hoping that the Soviet at Doubrovka would support him by giving him an important official position that would save them all, perhaps Doubrovka, too. But he, Pavlik, did not really know; like the others, like Papa, he just had to wait; wait till night, till the morning and next day. He could still hear, he thought, the voices of Mama and Papa trying to console Choura and Bombotchka, who were whimpering.

Tyapotchka, the sibyl, had been behaving for some time as if she had grown deaf or had no tongue. When the Order had come, she had embraced the Barin and Barinya, bowed, and gone straight to the kitchen, obviously for a conclave with the domestic staff. Where was she now? Would she desert them? Poor Nyanya Popova. What if she were alive? She would not believe her ears. She had been retired some years ago and lived in her own little cottage on the estate till she passed away; its window boxes had been bright with flowers. Then for some reason, his thoughts scattered and the clear image of an impending disaster (yet one that had not taken place really) rose in the air before him, absorbing his attention.

He could hear the wheels of the carriage, the cries of Philippe Kirillitch to the horses, and Fraulein Leiffert's spasmodic admonishments for them not to lean too far out of the carriage. They were all, the children, in their bathing suits and they were going to the Yisdra, where they always bathed when the summer afternoons grew hot. In later life, Tchelitchew could hardly be said

to "swim." Though he liked the ocean as a spectacle, he would never go in deep water, agitated or still, but only dog-paddle on the edges. Their beloved mongrel, Nelly, a descendant of the Witch Dog Vyedma, was along with them in the carriage. Nelly had been taken over the protests of Kirillitch, and half out of her mind, was yelping madly. Round and round went the wheels. One could hardly hear anything but Nelly. . . . It was very gay.

But . . . But *what?* . . . Once Mama had fallen out of the carriage when out driving with Aunt Sacha—or was it with Natasha?—and by a miracle had been unhurt. It had happened when that good-looking horse that was Philippe's despair had shied violently—"always at the same place," as Philippe commented bitterly every time it happened. It was the stallion, Elegant, the lead horse, who was to blame. A tree had been struck by lightning at a turn of the road and instantly at sight of it Elegant would rear and swerve as if he had seen a ghost. Only once had Philippe's control permitted an accident to take place, and then, even before poor little Mama was picked up—shaken, with only a few bruises—the coachman had exploded at the horse: "Always in the same place!" And beside himself, had added an abusive word. But no, Pavlik wasn't really thinking of that, but of a more exciting accident . . . a nearer non-disaster . . . years ago when Choura had been almost drowned.

Poor Choura! Pavlik's chivalrous heart, full of fine gestures that were by no means empty, stirred and pitied her. Her health had been guarded ever since she was five, when she had had a bad case of scarlet fever; after that, she was supposed not to be so active as the others; it was the following winter that she had been unable to skate and Pavlik had pushed her along in his sled. Yet she had grown better and taken, with a stout heart and wonderful endurance, the cuffs he and Mischa gave her as part of their games. Nor would she keep apart from the fights. Aroused like them all, as if at a signal, she plunged in and struck out like the rest. Pavlik smiled his crescent smile, which looked at this moment a bit chessy-cat.

Choura had been unlucky about water, when very young she had fallen into a pond and had to be fished out by her governess, fortunately at hand. But it was the second time Choura had fallen into water that came into his head and beat time with his heart, which usually he couldn't hear at all, but that sounded now a little tattoo, making him nervous so that he did not dream of taking up pad and pencil to draw. He was looking out the window toward the alley of larches. It was not the hour for La Dame Blanche, the person in white who seemed to come toward you. Of course it was a woman. But who *was* she? Would he ever see her again if he left Doubrovka? The terrible thought went through his mind like a shadow in broad daylight. *She meant his death.* At this moment he was certain, but actually he had always known: something always told him these things. Some day when she appeared—

though he felt it would be far from Doubrovka—she would announce his death. Then he would no longer be young—what would he be? Where? And *how old?*

Automatically his mind shifted to the memory that was fighting to assert itself fully. They were all gathering lilies at the large pond, which was a favorite recreation spot. When the railway bridge had been put through at that point, the Yisdra had had to be diverted from its course, and some charming ponds were the result. Pavlik held a soft spot for the railway itself. His uncle had been responsible for its construction and he and Mama had had the honor of riding, alone, in the first coach on the train's inaugural run from Moscow to the local station, the line's last stop. Marvelously, water lilies had sprung up near the shores of the upper pond in the Yisdra. Choura, he remembered, had already gathered a large bunch of them. But one more, very lovely, blossom had appealed to her. It was rather far out and she had to reach for it; she was a little apart from the rest. No one had noticed her daring manoeuvre with the stick that brought the lily somewhat closer. The next they knew was the sound of a splash that turned all heads that way. Choura had vanished. But instantly Fraulein and Pavlik recalled where she had been and they dashed for the spot.

They saw her come up as if blindly, her eyes obscured, but holding aloft both stick and bouquet as if they were the things to be saved! Standing at the edge of the pond, Pavlik and Fraulein Leiffert saw Choura go down again. They waited for her to come up. It was evidently hard for her to do so for she was being entangled by the long roots below the surface. When Pavlik saw her head again, he screamed, "Hold out your stick!" Fraulein found herself dumb with terror. Choura heard him and understood, she held the stick out and Pavlik grasped it tightly. "Hold on!" he said to her, and to Fraulein, "Take me around the waist and *pull!*" Fraulein was sensible enough to obey.

By this time Mischa was there and he took Fraulein about the waist so that the three pulled together. Choura held on and was dragged to shore, where she was propped up against Mischa's knee; she was stunned, but conscious and obviously breathing. And very wet but still clutching the bouquet in her hand. Oh, how wet she was and more frightened than dishevelled! Pavlik's eyes were now witnessing the scene itself and his lips parted rhythmically in their crescent smile, like a wave beginning to be wide; his dark eyes, gleaming, were very fixed. His body was slouching a bit over the window sill, in the negligent debonair way he had, and if he could have seen himself, remembering his ballet classes, he would have straightened up.

His activated heart thrilled at the memory that was flowering in his mind and he almost laughed aloud, stifling himself only because someone might be near. He now looked in the direction from which, that sensational afternoon,

poor wet Choura had dragged home her waterclogged self, Tyapotchka's hand grasping hers and making her go faster . . . After Choura was out the water, the first thing that stilled and stunned them was the Fraulein's hysterical outburst of weeping. One might have thought her heart was breaking or that she had gone mad. The poor woman did not seem to realize that Choura was now safe! Somehow Pavlik gathered that Fraulein was frightened for herself—that she thought she had been guilty of neglect, that it was *her* fault Choura had fallen into the pond and that she would lose her position because of it.

Pavlik's heart seemed almost to leap at the recollection: it was so strange and funny and—quite weird. His eyes seemed to have no horizons. He did not even want to laugh. It was not that. It was all too fantastically wonderful, even now, to cause laughter. Yet the incident was not to hang in his memory and to persecute or regale his later years, as so many other incidents in the past would do. Choura herself was to be too much on his mind as a woman to allow her childhood to preoccupy him. *This* was the pure moment of the accident and he was living it over for the last time. He did not dream of asking himself why all this, which he knew in advance, was certain. Maybe it was because this particular incident seemed outside of fate, outside of the things that mattered, the things he could make of himself and the world— that he fully expected to make of himself and the world. It was just that it was there—or rather, *still* there, and happening once again.

Fraulein Leiffert was weeping hysterically and nothing could stop her. She looked very strange and would pay no attention to Pavlik's shouts that Choura was safe, or his finger pointing at her. Even Choura had forgotten herself and her recent danger because of Fraulein's incoherent, ridiculous behavior. Then they became aware that the train was announcing its passage; it would pass, rather close, just above them. The familiar sound of the wheels and the shrill echo of the steam came plainly to their ears. But evidently Fraulein did not exactly recognize the train's approach, or if she did, they saw, she was terrified by it—and—*what was she doing?* Why, she was running for the tracks! Apparently she wanted to throw herself before the oncoming train. It was incredible and a gasp came from Pavlik's throat as he stood by the schoolroom window. A gasp that was partly a laugh of Olympian amusement with a shadow of disdain falling across it. But he had to act. "Mischa!" he ejaculated. Simultaneously the boys made for the distraught woman, whose skirts flapped like wings up the embankment. Just in time they reached her, took hold of her, dragged her away from the tracks. The wonderstruck face of the engineer saw the group, recognized their white faces all turned up at him, transfixed in the seconds it took the engine to pass at its even, chugging rate. Then it was gone . . . And yet for Fraulein, the train had been only a symbol, only another aspect of a danger that still threatened, that blackened the sunlight and withered the world.

Now Pavlik thinks of Choura. "Go home!" he shouts. "Choura, go home and get into some dry clothes! Do you hear?" Brought back to her own situation, Choura obeys. The boys are trying to calm Fraulein, but in vain. What on earth can be the matter with her? Choura, doing the best she can, having abandoned the stick but not the waterlilies, is on her way, trotting back to Doubrovka. Oh, how heavy and nasty wet clothes can be! She has reached the lower lily pond and is puffing hard. A figure looms near her. Who? Why, it's Tyapothcka! Tall, stately Tyapotchka, arrayed in her best, for she is coming from her devotions in church. She looks very prim, with her black baboushka neatly framing her tranquil face. But at the sight of Choura her dignity vanishes. She is galvanized, runs forward and without a word seizes her hand; for the rest of the way to the manor house Choura is half-dragged.

In no time at all, Tyapotchka has her warmly tucked away in bed with hot raspberry tea at her lips. As for Fraulein, at the lily pond, she is still inconsolable. Pavlik and Mischa have to lead her home, panting, her wits deranged. She too goes to bed—and stays there for two days. Pavlik still smiles. Thus at Doubrovka would the imperfective—disastrous, near-disastrous or joyous—sink lovingly into the arms of the incidental present. But there remains, in Russia as everywhere else, something external to this benign and consoling process, soothing and delightful as it is, with its dangers half real, half chimerical: this *durée* half true, half fanciful. One might call that "something external" by many names—the most famous of them is history.

At Doubrovka

History ground on, just like the train that had passed after Choura was rescued from the lily pond. Coming in a straight line, the Juggernaut was to pass, to disappear in a straight line out of sight. That episode had been so many years ago. Long before 1918, the distraught Fraulein Leiffert had gone and been replaced. Even the era of governesses was over. What, especially now, would a governess be doing at Doubrovka? She would be an embarrassment and possibly objectionable to the new Government, which already Pavlik had begun actively to hate. Always he had felt contempt for anything like military discipline, if for no reason except its stiff, dull uniformity.

The moment he had seen the military cap worn by students at the Gymnazia, he had scorned it and determined to do all he could to make it look different. About all he could do, to the limit, was somehow to alter its conventionality. This he did by dunking it thoroughly in water, twisting it into a new, desired shape, and then placing it under his mattress so that it would dry that way. Then he had worn it at a cocky angle—an angle that suited *him*. Now the cap was gone forever. He did not in the least miss it. But Doubrovka—*that* was not at all the same! It had secretly ceased to be, their false Doubrovka, and he was to reclaim it only long afterward (in a game of hide-and-seek with its memories) in paint.

Members of the Soviet in Doubrovka Village, at the direction of the Kaluga Soviet, had delivered the Order of Expulsion. The men had behaved to M. Tchelitchew as if he were still lord of the domain and they were handing him something quite contrary to this horrible official document whose purpose was to rob and ruin him. It was common knowledge that once the Barin had been offered many millions in foreign money for his forests and had turned down the offer flat. Could these forests now be taken from him by a mere piece of paper even if Government people had signed it? On due deliberation, the Doubrovka Soviet came forward with what they trusted was a sound solution. Whatever happened to the forests, Fyodor Sergeyevitch Tchelitchew and his family should be left with the home which was

theirs. Soon, therefore, Papa received word that the local Soviet had appointed him Director of the Saw Mill and the Flour Mill. That had possibilities! It might mean the difference of staying undisturbed at Doubrovka, whatever else happened. For a day or so, the family was in a fever of incredulous joy: they chattered and giggled.

They joked about the pomposity of the new Government in Moscow. Reds. "Reds" they were called and they had a red flag! By what right, Pavlik said, did the Government appropriate this color and then leave it blank as if . . . as if it were blood or a mere square of pigment in a box of water colors? It was important that colors should stand for something wonderful! Then he suppressed his wilder thoughts to speak of more practical things. The Tchelitchews began to feel themselves a match for the new Government. Papa began to discourse on the possible merits of the new "reforms." The children thought of the Army and how for months they had seen deserters wandering through the estate, hardly even hurrying or trying to conceal themselves. They had constituted a certain danger—but hadn't Choura and Bombotchka alone been a match for them? One night the barking of the dog had awakened Choura and Bombotchka, who had a room together. As they listened, petrified, and heard scraping noises downstairs, Bombotchka whispered: "It's those guys!" They had gotten out of bed and crept nearer; yes, it was certain that some deserters must be trying to pry open a window. Then suddenly there was a murmur of voices and all sounds ceased. They had gone away.

Maybe it was all some absurd bugaboo, this business of an "expulsion," even a bureaucratic error. Yet the hours were to inform them that such detached, debonair thoughts were doomed. The higher Soviet pronounced M. Tchelitchew's appointment to a Government post a transparent local manoeuvre and sent off word at once that the Order of Expulsion stood: the Tchelitchews would have to abandon Doubrovka, with whatever personal belongings they wished to take along, in forty-eight hours. That beautiful imperfective of an existence, Doubrovka's tacit *durée*, suddenly vanished like the last ray of the setting sun, and everyone found himself intently, sensibly packing and imagining just where he was going to be forty-eight hours from now. Did Papa know? At first nobody asked him.

Pavlik, hastening upstairs to his room, froze. Fedya! Young Fedya, his valet!—his leading admirer and a perfect slave! He would probably have to leave him here. There were too many in their family, aunts, grandchildren; besides, he was sure the Army was now reaching out for Fedya to put him in uniform. A tear, which he wiped away instantly, wished to run down his cheek. Yes, even this lovely natural thing, a tear, had to be thrust out of existence! What had caused it was a memory of a sentence of Fedya's which had gone straight to his heart and taken root there, burning in blue purity,

like the Eternal Life at the roots of the Magic Fern. It had been during some
dark days of the war. "I won't shine my brother's shoes," Fedya had told his
master, "but I'll shine yours." In a twinkling, now, Pavlik's heart went stony;
his mind was blank. And he went on upstairs.

There were no "scenes." The Tchelitchews were far too proud and well-
disciplined a family for that. Each was incredibly busy yet it was as if they
were packing for an important excursion in which all, for some reason, were
to take part. Every voice seemed at the same even pitch; not so strange a
thing, but, as Pavlik thought, like some chorus on the stage which was not
projecting properly, could not be heard well. This annoyed him somehow. In
fact, he disapproved of the dramatic stage, where only conversational and
largely prosaic speech was used. He appreciated only the opera, where people
sang out their thoughts and emotions in enchanted sounds and the rhythms of
récitatif. Everyone must have said his own private goodbyes to the old coach,
the horses, the playthings, their rooms, to the dear painted wood and all the
trees. But no one *saw* or *heard* anyone else do it.

Papa himself was strangely silent in company as if utterly preoccupied.
This seemed to mean that now they, the young ones, had as much say-so as
Papa did. The Ehrl King, thought Pavlik, had lost his kingdom! Poor, poor
Papa! They all—including Tyapotchka who was staying behind—pitied him.
For to Mama and Papa, more than to any, Doubrovka *belonged.* It was *they*
who had clung to it, they to whom it was the very earth underfoot.
Tyapotchka put on her really serious face and worked like a machine, as if
without feelings. *She* was staying only because of her own daughter and
grandchild. Fleetingly, the young ones wondered what would happen to her
and her trunkful of treasures, the fabulous *soundok,* which on special
occasions, when they were small, she would unlock so as to display its
contents. Into the *soundok* went all the gifts from the family, for birthdays
and holidays, and all the souvenirs its owner had ever collected; a group of
colorful postcards, pasted in orderly rows, lined the entire inside of the lid.

They could scarcely believe it. They were all collected and actually on the
train and they were going away from Doubrovka for the last time . . .
They even neglected to wonder if anything had been forgotten . . . One
could hardly bear to look at the Little One, Mama herself, huddled against
the window in the train. She was like a precious piece of furniture of which
special care must be taken in travelling. Had they bid the village priest
goodbye? Pavlik, studying his own image in the reflection of the train
window, wondered but actually could not remember. So many people had
been kissed and embraced, their features distorted, barely recognizable as if
the contact of flesh with flesh had crushed them.

They were in Red territory still but as the stations passed, they were
approaching the Ukraine, where a boundary line separated Red territory

from White. When they arrived at the last Soviet station, Papa said, to everyone's stunned surprise, "I leave all the direction to you."

"You?" their minds echoed. What exactly did he mean? Was he gently shifting the responsibility, the responsibility he could no longer handle?

There was a ghastly hollowness in each breast but no one asked. In unison, including all except perhaps the two youngest, the Tchelitchews realized that the youth was meant: they, Pavlik and Mischa, principally, the other males in the family. Was it possible it was happening? One might have imagined it all yet only as a fairy tale—like that of the "true Doubrovka." Life seemed in a sort of artificial present tense, a reluctant present that left them stock still, so that the very wheels of the train were turning only on a treadmill. Neither they nor it were moving of their own volition: they were being pushed by something, awful and intangible, from behind. Every foot of ground seemed uncertain, a fairy tale space beyond which, ahead of them, only the abyss existed.

Pavlik stared at life as if it were a personal demon which must be hypnotized into subjugation. There might be a jolt, a whirring and trembling, and they would go sailing off into space, off the tracks—off the globe maybe!—in a straight line and destined for an unknown place. But time passed and they had to alight, all but two of them: Aunt Sacha and Natasha. The fact was, after a struggle of conscience, these Tchelitchews had decided to throw in their lot with the new Russia and live, if possible, at the old apartment in Moscow, for which the train was headed. The decision of Papa's favorite, Toukanchik, cost him a strange pang. But it was covered up by all the hoarse reassurances, the lingering embraces, the suppressed gasps from perspiring Aunt Sacha and the idiotic brave smiles from all. Lots might have been drawn, the separation was finally so unreal. The main group had to take some sort of conveyance for a few kilometers to reach the border of the Ukraine, now governed by a German hetman. A blank prospect stretched before them. Papa's curt silences had not been merely unthinking, however. He was worried by the fact that the Kaluga Soviet, which had also denied them the right to live in the north, where Votcha was, had omitted permission for them to live anywhere. They were automatically exiles. Outcasts. The four peasants who had decided to accompany them—Fedya was not among them—scouted about and procured, fraudulently, four farm wagons to take them to the frontier.

However, Red soldiers were everywhere, and most probably, if they took a passable road, an outpost would be encountered at the frontier. The family made too many, and carried too much, to go otherwise than by an ordinary route. They must all disguise themselves, therefore, as peasants. At this point, Fyodor Sergeyevitch forgot his fatal abdication of authority mentioned on the train and spoke, looking at his elder son: "Pavlik must not wear a Russian

blouse. He would *look* disguised." The compliment was tacit and ineffable, and for a brief instant, the proud blood mounted to the young man's cheek. It was just as if Papa were calling him Crown Prince, "Nasledni Knyass," all over again! Nobody could take *him* for a peasant. His blood ran consciously, beautifully exulting through his veins; he felt it exploring every part of his body, and cheering him jubilantly, in a loud collective voice, as if he wore, indeed, a crown and royal robes.

Taut, as if watching with one eye, the cortège passed several Red outposts, its soldiers staring at them steadily but indifferently, and telling them they could go on with a nod or a gesture with a rifle. The *last* outpost was what mattered . . . In 1960, almost forty-two years later, it was with quiet gayety that Choura Zaoussailoff said: "We were a real caravan—four wagons and twelve of us." She could be light-hearted about the crisis because the caravan had made it, had passed the last Red outpost in safety. Yet this might not have been so, according to Mme. Zaoussailoff, had it not been for Pavlik. They knew they could still be turned back, that one and all they could be arrested and perhaps imprisoned. They had told each outpost they passed that their village had been burned down the night before and they were now on their way to relatives in a village near the station of Konotop, rumored to be occupied by the Germans.

Perhaps they would manage not to run into another Red outpost. If only the kind Russian God would look down on them and arrange it! Tyapotchka would have appealed directly to the mercy of the Holy Virgin. In any case, the arrangement was neglected. At the very last, there before them, is an outpost of three Red soldiers. The caravan halts. For instants, nobody at all moves. They barely manage to breathe as usual. Now one of the peasants gets down and goes to M. Tchelitchew, who is wearing his Russian blouse and equally Tolstoyan boots. "There is only one way, Barin," says the peasant. "Go and speak to them."

Papa realizes that, despite his rejection of further leadership, it is the only reasonable thing to do. He gets down from the first wagon and goes toward the three soldiers. All of them, he notices, are bristly-chinned, unshaven. He makes only one small mistake, which seemingly isn't noticed. He starts speaking a bit before he would be certain of being heard: "I am a landowner who has been dispossessed and expelled with my entire family. There they are." He half turns, pointing to the wagons. "We have been denied the right to live in the north and they did not give us a permit to live anywhere." He has told the truth and it is as if poetry had spoken on his lips. "But," he finished, "if you don't pass us, I don't know where I can go with my children."

He did not even try to read the answer in the faces of the three Reds, none of whom spoke immediately. Two of them looked wonderingly at each

other. Was that a wink from one to the other? No answer. The third made a sort of sympathetic sound with his tongue but that was all. Papa took action. He beckoned them to the wagons, where he began to name the occupants, courteously, quietly. Last of all, as if by intention, he comes to Pavlik. His hand gestures, and hangs for a second in the air, before he speaks: "And this is my eldest." He did not mention Pavlik's name!

One of the soldiers then spoke while looking at "the eldest," who looked back expressionlessly, only opening wide his lovely Turkish eyes and feeling his back automatically straighten. "One can see," says the soldier respectfully, "that he's a young gentleman."

Not one of Pavlik's eyelashes quivered. Nor the mouth that he was to decide resembled Adelina Patti's. For the first time in his life he understood what it is to be a mere image, to present in one's person a picture; he realized one could do this, and successfully, perfectly, simply by *being* something, by *doing* nothing. It was just that, inside one, a fire had to be blazing, lapping about the heart with its precious, secret, wonderful blue flame. Blue, yes, like "the Eternal Life of a legendary hero." So blue, so deep, as to look black. There was a moment's pause when everything, even the soldiers, made a *tableau vivant*. Pavlik stared, strangely happy, as if he had arranged it all, had told the soldiers where to stand, and to be taciturn, and to let the top button of the collars of their uniforms go unbuttoned, exposing the chest.

And then, in the midst of his triumph, something dreadful happened; something which seemed to apply to him alone, which he did his utmost to conceal as he sat there. A black hand seemed to pass very close in front of his eyes so that, when the scene about him again appeared, it was as if cut in half. Yet it also seemed whole. An *angoisse* more terrible than any other seized him, bringing all the pain of his and his family's loss to lodge in his solar plexus. A black *angoisse*, it was, making the waning afternoon like night. It was a vision as clear as the dreadful black dog, his enemy, and yet it was simply the world itself . . . hacked in two . . . like a cadavre which has been put together again. He felt his mouth sicken and he ached lest someone, perhaps Mischa sitting next to him, should notice the change.

He was now in the *other* half of the great world—or would be, once the boundary line, such a short distance away, was crossed. And now a memory of his old governess, Emma Johnson, came to him. For there had been one Russian-American governess at Doubrovka. She had become a symbol of the world's densest outermost reaches. The language she spoke was not only that of England, but also of the United States, which was part of a vast continent across a wide ocean, connected with legends of red-skinned savages who ambushed white men. The great world was now to be his judge and he stood alone, with a very problematic future. How responsible would he have to be, now, for his mother, for the females in the family? He trembled as he

recalled how Emma Johnson would "saw his soul in two" (so he was to express it in later years) by ruthlessly correcting some confusion of his among English synonyms. A real anxiety of his future manhood in America was to be his realization that, while he had assumed several languages, he had quite mastered no language in the world. During the Second World War, in New York City, he was to lament that he had forgotten some of his Russian, and how to spell it!

"Barin," said one of the Reds eagerly, "will you give us cigarettes?"

Fortunately, Fyodor Sergeyevitch had some and he passed a packet to the soldiers after taking one himself. The four of them saunter off a few paces and smoke in silence. A lifelike murmur breaks out in the caravan. Mama thanks God in as small a voice as possible, but aloud and fervently. Fyodor Sergeyevitch, after offering the Reds another round of cigarettes, has shaken hands with each of them. The wagons, beckoned, slowly file across the boundary line; meanwhile Papa still stands smoking with the soldiers. Only Mama nods her head, in a gracious way, as they pass. A serene smile can be seen on the face of Fyodor Sergeyevitch past his flowing beard. With dignity, when the caravan is across, he gestures to the Reds and goes to take his place at its head. "Now, my dears," he tells them in penetrating tones, "I will resume the powers of Governor and Director of our movements." Mama gasps as if there were something unusual about this. Sonya, her youngest cradled in her arms, gives a sigh.

That was all. History resumed its interrupted, oddly complacent way. The wagon wheels turned and kept on turning. They were safe! "What luck!" pipes Mischa, only to be crushed by a jeering little laugh from Pavlik. It is for him only, perhaps, that history will never, never be quite the same again. Something like a coo is heard from the direction of Choura and Bombothka. And Mischa, as if to redeem himself, calls to Fyodor Sergeyevitch, "But what did the soldiers say, Papa?" It is Choura who laughs now, but congenially. Papa accommodates the common curiosity, first clearing his throat and then imitating the soldier's voice. His words spread like a little canopy between them and the sunlit sky.

"He said, 'All right, kids, we'll pass 'em—neither seen nor heard. Go, Barin,' he said, 'and don't say that Red soldiers have no heart. We, too, have children at home. Go!' "

At Kiev

Mischa's ecstatic giggle could not be repressed.

"Ahhh!" said Mama as if in her infinite wisdom she had known all along it would be like this.

Pavlik quivered as if something horrible in his mouth had at last been swallowed and he could breathe. The *angoisse* was quite gone. Instead,

something comforting, strong expanded in his midriff; he felt it make its way, leaping in a dance rhythm, through all his veins. What was that? It was himself, a little ahead of the caravan, alone. He would try never to allow the world to detain him in this way again. Oh, no! For that was the worst *angoisse*. He would make perfect friends with the world. He knew how so well. He would lead the way in it, others following, while his eyes stayed on the most distant point in front—there—where the lines of the road converged. It was Kiev, of course. But it might one day be Paris, be Berlin.

He shut his eyes lest his soul fly out of them.

But it wasn't precisely his soul he felt possessing him. Not his soul that throbbed now, shook its feathers, stretched one wing. He looked again. Something was necessary to push apart the closure of the pyramid ahead. He knew what. He had it. It flew like an arrow.

A natural conspirator with the clock, history is absolute time fused with absolute space. Pavlik saw it all as if it lay behind a veil. It is what is irrevocably done and over with. The dead. The indisputably dead. Its grip, like the legendary dead man's, is fierce, inert, seemingly unbreakable. Pavlik's soul stretched lazily in his body and he forgot about all that. He was busy planning the steps of his career, whose setting would be Kiev.

The trip ahead was to be dreadful. The train they took was frightfully overcrowded; one died with the heat; one feared the illness that was consuming others; one was thirsty. It was ugly, and nasty, a bad play: prose. Reality. Sonya had three children. Pavlik, idiotically, counted them several times, as though he had not realized before just how many they were. The relentless grating of the car wheels was broken only by dialogue about money. Luckily, Papa had on hand some cash reserves. They were not utterly poor, utterly destitute. One and all, they had a chance. Papa was widely known; there would be friends in Kiev—other refugees from the Red Revolution. Papa and Mama were speaking about friends who might be in Kiev. Now, they—they, the Tchelitchews—were Whites. They were not headed for peace, for haven, for rest. It was war: war more than ever!

The voices of Mama and Papa reminded Pavlik that his married half sister, Varya or Varvara (Barbe as he was to name her when in France), was a Zaroudny and that her husband Alyosha's family had a country estate near a town called Losovaya in the Ukraine. But they suspected that Varya and Alyosha were still in Moscow. Pavlik thinks of Natasha: Toukanchik. She was the smallest of them all and perhaps for this reason the little desert mouse had gnawed at Papa's heart. How all of them, the children, teased her about *beaux* because they were convinced she would be an old maid. Well, there might be no more teasing, ever, no more gnawing. "Mon Dieu! we are growing up!" And Pavlik's eyes fall on Choura's bosom, which, because she is thin now, at fifteen, is rather modest.

Nevertheless (Pavlik thinks) poor Aunt Sacha, a champion of whalebone, had considered Choura had enough roundnesses to merit a corset, so she had insisted on making her one. Choura felt rather proud at this womanly prospect but when she finally saw herself in a veritable monument of pale blue tissue, all whaleboned, she almost, as she said, "died." Yet for several reasons, she dared not surrender this mark of maturity. She did, however, get Lyena to help her remove all the whalebones. Even then, she thought the corset made her look like a pouter pigeon. It was not till Mama herself next visited Moscow that poor Choura had been released from her humiliating prison. Mme. Tchelitchew's first look at the carapace was final. "It's like a tray," was her verdict, "on which twelve glasses could be carried."

Pavlik should be laughing inside but he isn't. The whole thought fades and he thinks again of Natasha and Aunt Sacha. His very forehead seems to strain, compassing the future. He thinks of Moscow and thinks of evil. Not the black dog. No! Of evil for poor Aunt Sacha and little Toukanchik, Papa's favorite. The evil came true. They were never to leave Red Russia. They were to stay in the old apartment while it filled with perfect strangers, who had been assigned residence there under the new housing system. Perfect strangers they were and perfect strangers they were to remain. In 1920, Natasha's weak heart was to fail her; she would die in her room. Grieved and lonely, half-paralyzed, Aunt Sacha was to go live with relatives in Toula. The Tchelitchews were to hear that these people treated her with inhuman cruelty and that she died soon after coming to stay with them.

Pavlik's lips move: he is imitating the music of the growing grass at Doubrovka, the music he was unable to hear though he had been so silent he hardly breathed and had pressed his ear very close. He heard something a little strange but it was not exactly music. Now, past this grunting, threatening pandemonium, he thought he *could* hear that music. Every sound in nature was audible if only one listened. Yes, he was certain of it. Doubtless he had heard it without recognizing it, *the music of the growing grass*, but now he recognized it. He was used to imitating sounds: the wind in the trees, for instance. He remembered imitating an aspen tree, pretending he was the aspen; then Tyapotchka, with a cry, had told him it was the tree on which Judas had hanged himself.

The music coming directly from nature: this was to be a specialty of Pavel Tchelitchew, and by the time he painted *Phenomena*, the whole animal kingdom was to be his music, including the human. Cecil Beaton was to remember how he could imitate the flight of a butterfly, the trembling of an aigrette, the noise of the wind blowing a paper off a table. I can remember how marvelously he did the last.

As for human voices, imitating them was the order of the day if he wished to relax or amuse someone. A comical falsetto was likely to crown such a

performance. Then, if pressed, he would do a favorite routine. In his way of revering the royal of the earth, the world of insects was typified by a gamut deriving, as it went to the ultimate diminuendo, from the kingdom of the mice through the kingdom of the mosquito to the kingdom of the flea. I was to be fascinated by the fact that while the mosquito was quite audible—a fabulously exiguous susurrance from between almost motionless lips—the flea could scarcely be heard. I put my ear almost as close to his lips as his ear had been to the growing grass of Doubrovka's turf. In fact, I suspected I did not hear it at all and that it was a trick performance of Pavlik's. Yet somewhere in his throat, the *gloire* that was always there must have been quivering in ecstasy. Surely the precious sound was coloratura: this was his mother's register, and while Choura asserts that he had many of his father's traits, he was always to insist that he took after the Little One.

"Dura!" It was the juicy Russian expletive meaning "Fool!" It tumbles out of Pavlik's mouth like a magic object in a fairy tale. There is a distant shrieking. But it is mechanical. There are other turbulent sounds: new ones.

"Durak!"

"Duracha!"

These sensual variations of the term, voluptuously Russian in a tenderness for all epithets, fall out of his mouth like the "Dura!"

They are in Kiev! They are getting up! They are taking out their belongings! His nostrils have a way of ballooning in anger. He is a little angry with himself for dreaming of nothing. Above his closed mouth and clenched teeth, he feels the muscles which tighten and make the nostrils flare. The ballooning nostrils seem very close, as close as if they were not his . . . What "balloons"? Why, it's Philippe's shirt as he sits on the driver's seat taking them to bathe in the Yisdra! But their life in Kiev was to be far from phantasmal. Pavlik was to put most of his fantasy into his work. And he was to work hard, very hard, with a sort of monotonous intensity, level, undramatic, as self-insulating as possible. Only Pierre Souvtchinsky was to think he was not working very hard. He was insulating himself from what was rocking all Russia, the civil war, making Kiev a grotesque nightmare: the continuous performance of a grisly, half-comic melodrama which he watched with alert ironic eyes and a cynical heart. Seventeen times the city was to change hands. The enthusiasm on his lips—well, that was just enthusiasm for life, which he carried like a wallet or a portfolio.

The gun was an abhorrent substitute for such useful personal articles. During the Second World War, Tchelitchew was to agree articulately with words of Trotsky's he had read: Artists should be in a safe isolated place during wartime, else they cannot devote themselves properly to their natural tasks. This was logical, concrete, unimpassioned reasoning. Tchelitchew even saw humor in it: artists should be gotten out of the way or politicians would

simply find them nuisances. Their patriotic odes of the past, their paeans to valor, should serve the present while those of the future (which they could compose at leisure) eventually serve the historical present . . . It is true that here I interpret as a biographer. Tchelitchew's own words were to be far less ambiguous, less temperate.

He knew that essentially all this was Plato's view though Plato had put it with less consideration for artists and in different terms. But at least it was classical statesmanship. While Pavlik much admired the *Timaeus*, he felt that the *Republic*, regarding the status of artists, must have influenced the leaders of his country's present revolution, which was eminently practical. Personally he was averse to assigning artists a definite political role as if they could form a department of propaganda. If they did serve immediate propagandistic aims, that was their stupidity—and their sponsors' stupidity. In Kiev, our hero was to have his private slogans aside from the public ones circulating on all lips.

As he was to be in danger of being drafted into the United States Army—he took out his American citizenship papers during the Second World War—so, in Kiev, he faced the possibility of being recruited into General Denikin's army, which after all was fighting the despoilers of the Tchelitchew fortunes. Nowadays he would think of those festive hours when the Divinettes had made fortune-telling into child's play. It was he, Pavlik, they said, who saw the most ridiculous and unrealistic things in the shadow-throwing wax. As if he could have restrained the play of his imagination! What was that childish imagination, anyway, compared to things that were actually happening in Russia? Not so long ago, he had seen terrible omens in Natasha's revolving fortune, changing its shadow on the dining room wall. Toukanchik herself had become angry and all had reminded him that only the one who has melted and cast the wax is able to discern his true fortune in its shadow. He had meant no harm, he was simply—well, they would see . . . Prophecies warn of approaching dangers and offer time to prepare for them. One should be in tune with everything that *was to be*—no matter what!

The Tchelitchews were to consider themselves lucky during the first few months of their stay in Kiev, or rather in Losovaya, outside Kiev; for immediately they found they could live at the Zaroudny estate, Damasha, where old M. Zaroudny, Alyosha's father, resided. Now all but Pavlik tried to think themselves comfortably fixed. The smaller members of the family believed they had been rescued out of charitable kindliness, but later a letter of Papa's to Pavlik proved that they had been "paying guests." Pavlik himself was restive. He did not wish to tarry at Damasha, he wished to get at once to the center of things.

When the family alighted from the train in Kiev, the city was a dead echo-

ground for the deafening music of the flower parades that had feted Russia's upstart savior, Kerensky. Now that savior was himself a refugee, fulminating in Paris against the Red régime. Pavlik determined that his personal program would be sensible and, if possible, canny. He would meet artists and intellectuals and go on with his work. His first aim was to attach himself to the cultural centers. The chief of these was the Kiev Academy, where he heard that Mme. Alexandra Exter, a former pupil of the already eminent Fernand Léger, taught. He wanted to get to know theatre people, too, and he was delighted to find that Kiev was full of an undiminished, indeed constantly augmented, cultural activity. Being at Damasha, he reflected, was like living in a truly false Doubrovka. He felt it false despite the air of princely finery at the Zaroudny estate, which evoked the fabulous Doubrovka which Tyapotchka had called "the true home of your name." In stories about his abandoned home, told to his friends in England and America, Tchelitchew was to transfer to Doubrovka certain luxuries found at Damasha. The Zaroudny carriage outdid theirs and the Zaroudny horses had several magnificent sets of harness, one of which was entirely of lace.

Was it not the Tchelitchews, however, who imparted to Damasha what true nobility it had? He, Pavel Tchelitchew, he clearly saw, would one day make lacelike fantasies in preference to riding behind the lace-caparisoned Zaroudny horses. For that matter he would prefer riding down the Champs Elysées to flaunting himself about the uninteresting Losovaya, which in fact had its dangers. Abroad in the country was a veritable demon, a bandit who led a gang of criminals in pillaging communities outside Kiev. He was actually a former schoolteacher of Losovaya named Machno, a fat old *rouquin*, hysterical and (supposedly) quite mad. After this man's death, though all the governments of the Ukraine had tried to exterminate the Machnos, they had survived and prospered on the chaotic situation. When the homeless Tchelitchews arrived at Damasha, these brigands were at the height of their terror and the women visibly trembled at the thought of them.

That soon there would be peace in Europe, Pavlik was certain. During that September and October, news came that the German forces were losing everywhere to the Allies. The Kiev newspapers were increasingly unreliable as the civil war raged in the Ukraine and the city was perpetually threatened again by the routed enemy. News from Moscow and Petrograd regularly arrived a day late. Then, when one picked up the paper, one found that the censorship had blacked out the disheartening items that spoke of a victory or advance by the enemy; in consequence, the pages resembled checkerboards. A sick disgust was not slow to plant itself in Pavlik's diaphragm and grow larger. This feeling, of course, had to be dissimulated—and what was so dissimulative as artistic activity?

Even the mirrors at Damasha had started haunting the family's elder male scion. He feared to encounter in them some unhappy omen—suppose he should see his own death? This was a time of great peril. He looked skyward, over the flourishing wheatfields around Damasha, and thought of the Holy Virgin whom Tyapotchka had told him walked along a rainbow and sent down Her Mercy in times of trouble for the fatherland. Frankly, he could neither see Her nor feel Her Mercy. Was this because he was *wicked?* Was Nyanya right? It would have been easy for him to paint the rainbow—but that would be imagination—and art! He was certainly to saturate his future work with rainbow colors but the wheatfields of the Ukraine and the Crimea he was to revive as symbols of war as well as of plenty. While he was painting *Hide and Seek,* he would put spears of wheat in the hands of fighting boys.

He felt something like a time bomb ticking away in him. His heart! He must listen to that and to the voices of prophecy, his own voice and other voices. Yes, in Kiev, there was a famous Staretz, a very wise monk who lived at the monastery of Petcherskaya Lavra. He must go see him soon, confess his sins on his knees, and ask his advice. It was said this wise man could see into the future. Pavlik's steady heart would sometimes skip a beat if he thought suddenly of the Staretz so that sheer emotion, for a while, postponed his going to him.

At Doubrovka there had been a fortune telling ritual that was not precisely amusing, and which it was the family habit to foist on the chambermaids during the holidays when the wildest fun was *de rigueur.* Quite alone, one sat in a dark room lit by only two candles, placed on either side of a small mirror facing a larger one. Looking in the small mirror, one saw a dark corridor stretching into infinity with rows of candles on both sides. One fixed one's eyes at the end of it, or where the end seemed, and anything that appeared there was one's fate. This ordeal took courage and ordinarily there was general reluctance to submit oneself to it.

But on one Eve of the Baptism, a chambermaid, Maryosha, was flattered into trying it. Belowstairs, the gathering waited and waited for her to come down and report the result. As she failed to appear, the suspense grew too much and in a body they all went to the scene. At first they beheld only the two mirrors, the two burning candles; then they noticed, on the floor, Maryosha. Apparently she had fainted. On being revived she explained, in a sleepy voice, that she had sat and sat and seen nothing, then she did not know what happened.

"Dura!" exploded Pavlik, in a voice hollow with mockery, "You must have fallen asleep and slipped off the chair!"

He recalled that, on a different Eve, when he had been very, very young, another chambermaid at Doubrovka had been coaxed into trying the ordeal.

In only a few moments, she had come screaming down the stairs, hysterical and incoherent. Steadied with a glass of champagne, she had explained that her own death had appeared at the end of the dark corridor.

"Life is like that," Pavlik reflects. "Some are clairvoyant; some are not." He was clairvoyant. At this thought, he shivered between exquisite pleasure and a crude abysmal fear that suddenly closed on his vitals like a man's fist. He was standing in a public garden near the band stand in Kiev where, during the first summer, the usual symphony concerts were still being held. Now, from this platform, political orators would charge the air with raucous rhetoric, irking Pavlik, the lover of arias, more than he found it discreet to convey. Alone or with a friend, Pavlik still found consolation here, his mind fixed on the magic of harmonious sound; the band was not very good . . . still . . . On this occasion he was alone and neither music nor oratory was in session. A short Russian prayer leapt to his lips in a single breath like an ejaculation. He found himself clutching his stomach. Was it something he had eaten? Was it—fear? A presentiment lay in him but it was vague. For an instant, he saw the large soup tureen at Doubrovka that had floated the Divinettes with their wondrous futures. Then he realized that the soup tureen was—so it seemed for a few more instants—inside him . . .

Yet the hours were going too fast for a casual malaise to detain his thoughts long. Mme. Exter, at Kiev Academy, was charming to Tchelitchew. And she was charmed by him. Seldom had she met a young artist so eager, so gifted, so full of ideas and enthusiasm. He was almost too full of ideas, for he wished to learn from all. At the Academy, he attended classes in drawing but he also studied privately with Basil Tchakragine and Isaac Rabinovitch. Something was always simmering in him, his masters noticed, and really they did not know exactly what was to come out of this young man—but something would.

Cubist-Constructivist ideas, under the leadership of Malevich, were then in the ascendant among Russian artists. The leading Kiev painter, Bogomazov, was a Cubist and all at once young Pavel felt his hand drifting toward the brilliant prospects of an art style that the new régime had not yet banned as counter-Revolutionary. When it came to the point of practice, the academic standards were simply not in it. Aristocrat though he was, he was also—his heart plainly told him now—an artist and nothing took precedence of this fact. If art practice essayed the mysteries of abstract form, then he would be an adept in abstract form.

With Pavlik living in Kiev, the family at Damasha wondered about the fortunes of the eldest of Nadyezda Pavlovna and Fyodor Sergeyevitch. Mischa did nothing but moon about Damasha, imagining himself in uniform and feeling he ought to be fighting the Reds. As we know, Pavlik did not in the least consider military service a duty yet he knew it was lying in wait for

him; the proper moment simply had to arrive for Denikin's White Army to establish itself in Kiev with time enough to look over the list of eligibles for its ranks. Unless, of course, the Whites won the day and everything would be as it was before. But no: something told him that would never be. He acquainted no one with this information supplied by his inner voice.

A week or so before Christmas, when Doubrovka was a memory of four months, Pavlik received Papa's letter stating, among other things, that the Tchelitchews were paying guests at Damasha and that his money was running low. Papa's money running low! The time bomb in his son's breast sounded a few ominous ticks and his eloquent lips did an unusual thing: they dropped apart and stayed foolishly open for a few moments. They closed when a vision of the Champs-Elysées quite irrationally crossed his mind. The Fields of the Blessed Souls had been saved from destruction. It was still there! His eyes went back to Papa's handwriting, only slightly aslant, long, fine, narrow.

As Papa knew, Pavlik was now a house guest of two new friends, Pierre Souvtchinsky and his mother, Anna Ivanovna. They were to prove themselves two of his most loyal patrons for some years and he was ever to dwell lovingly in the bosom of Anna Ivanovna, who at once had begun being a substitute mother. Out in Damasha, the Little One, Nadyezda, often thought of her son, but obviously a new era in their lives had started. Pavlik was destined, she felt, for the world and there he had to make his friends, especially now that the family fortunes were ruined by the Revolution. Neither she nor Fyodor Sergeyevitch dared hope for a reversal in Russia unless foreign powers intervened. In the Ukraine, M. Tchelitchew had no profession; he was still one of the "rich" expropriated bourgeois with the shreds of a fortune left in his hands. Also, last and first, they had no true home.

In his humble bed at the Souvtchinskys, Pavlik would lie awake with anxiety, tortured by the thought of Manya and Choura (the latter no longer a child) exposed to contact with the German and Austrian officers who were stationed at Losovaya. Damasha was only three kilometers from the village and these swaggering, coarse officers found excuses to visit the Zaroudny estate just to flirt with Manya—Manya, he knew, was romantic . . . Eventually, it was for Choura to inform him that another danger, an intimate and daily one, had threatened the girls at Damasha. Old M. Zaroudny had become infatuated with Manya's fragile bloom and did not disguise the fact but went gallantly into the field; thus she and Choura spent a good deal of the time hiding from their host.

Then Pavlik came to the passage that caused a minor explosion in his breast. A division of troops commanded by the notorious Colonel Petloura had actually been quartered in Damasha, and perhaps because of Manya's

coldness, had held her and Mischa under suspicion as spies and packed them both off to Losovaya! The eyes in the tense young face of the reader raised themselves. They had the expression of one who expects anything. The "anything" quickly developed.

It was quite an anticlimax to have Papa conclude his letter by a gentle inquiry as to how he was getting ahead with his work. Two nights before Christmas—it was probably the reason why Christmas time always upset Tchelitchew during the ensuing years—the Machnos descended on Damasha like a whirlwind. Maryosha, the chambermaid who had waited in vain before the magic mirror, had come with the Tchelitchews. She, Papa, Mama, Choura and Lyena barely had time to take refuge with the head cook before the brigands were installed in the manor house. Soon sounds of carousing reached them and not long afterward their worst fears were realized. Two of the Machnos came looking for the Barin with shotguns and found Fyodor Sergeyevitch, who was ordered to go outside with them. Choura took Papa by the hand and they went out with the men.

They were all sure that Papa was to be killed. Yet no shots were heard by those inside. Paralyzed with suspense, they waited. Finally the door opened quietly and Papa appeared, Choura's hand still in his. Again his imposing air and good sense had turned the tide of misfortune. He was just as he had left them except that he no longer had his watch.

Choura Zaoussailoff was to recall for me what had taken place. Outside Fyodor Sergeyevitch, had halted with the Machnos and, no slightest quaver in his voice, asked: "What do you want with me?"

"To finish you off," one boldly replies.

With the most natural movement in the world, Papa slips out his fine gold watch, flicks open the lid and looks at the time in the light of the lantern carried by one of the brigands.

The man who had spoken, Choura notices, glues his eyes on the watch.

"Would you like it?" Papa asks and adds smoothly, "As you mean to 'finish me off,' I shall have no need of it, so you may as well take it as a souvenir."

He flicks it shut and makes a move with his hand toward the Machno, who silently accepts the watch and examines it. He has a heavy black beard. The watch disappears inside his coat and his eyes look into those of Fyodor Sergeyevitch.

"They are already drunk in there," he says, jerking his head toward the manor. "You can hide in the village—someone will help you . . . Well, thanks for the watch!"

Then the brigands walked away.

The cook consented to drive the Tchelitchews, that night, into Losovaya to stay in the house where Mischa and Manya were living. The next night, an

excited man ran to them with the news that Damasha must be burning because the sky in that direction was reflecting flames. With deadened hearts, they go out to look. Indeed, it must be true! Next morning, they learn that Damasha has been burned to the ground. Whatever possessions they had, if not stolen, are destroyed. They are stripped—stripped of everything but a little money.

Pavlik is apprised of the terrible news when the family appears in Kiev to take refuge in the apartment of a friend of Fyodor Sergeyevitch, Alyosha de Vitti, who lives in Lipki, the city's "elegant" residential section. His apartment is large, on the ground floor, and at the back, through French doors, gives onto a pleasant garden. The tense of the historical present (which, being really the disguised past, has no future), extends itself in behalf of the shattered Tchelitchews. For the family nucleus is being steadily deprived of its former delightful imperfective. Like animals, the young ones are being flung by a series of calamities into shifting for themselves even earlier than they expected.

After the Damasha calamity, Manya and Mischa decide to make a team and try their luck in Kremtchoug. This leaves only Papa, Mama and Lyena in Lipki with M. de Vitti. For even Choura has taken up quarters elsewhere with her half-sister Varya and Alyosha Zaroudny, who have managed to get to Kiev from Moscow. At Doubrovka (which is still a place and where the old manor is still standing) it is Tyapotchka who clings to the vanished present and feels anguished by the vacant ugly face into which the past has changed itself. She is to die, grief-stricken, about a year from now. But at the moment she is very much alive. The news of the Machno affair at Damasha affects her sterile existence much as did Choura's apparition as she encountered her on the day, many years ago, she was nearly drowned in the lily pond. Their Nyanya plunges into action by making sets of underwear for her deprived Barinya and her daughters. These needed clothes appear in Lipki in one bundle with whatever articles from the precious *soundok*, the trunk of treasures, Tyapotchka thinks might be useful to them. Nadyezda Pavlovna is very touched and grateful. But none of them are to see Tyapotchka again. As the contents of the soundok were rifled and dispersed, so are the Tchelitchews to be. With Tyapotchka's great gesture, the tense of the senior Tchelitchews irrevocably has entered the past.

So Pavlik had divined as he read poor dear Papa's letter at the Souvtchinskys'. The two haunting images in his head were coming closer—even as "the person in white who seemed to come toward you" at the other end of the alley of larches. One was the black bugaboo of military service; the other was the increasingly positive feeling that time had irremediably cut him off from his family, that this was apparent in his mirror of fate: the one he held in his forehead where the influence of the heavens was to make itself

clearer line by line. When a new success of General Denikin brought the Whites to the environs of Kiev, the work on *The Geisha* abruptly had to stop since many involved with it had to flee the city.

The fact was that a great deal more was going on in Pavlik's head. Despite his easy, articulate application of Cubist-Constructivist principles in his work, some instinct, not yet quite clear, misgave him about its perpendicular rigidity: a kind of architectural limitedness. What of the sphere that was the natural counterpart of the flat circle? All the painters in Kiev dinned into his ears the importance of the straight lines which make angles. True, these arrowy forms were symbols of penetration—Pavlik involuntarily started and a curious little squiggle fled down his spine while a burning spot seemed to rotate about his navel—and these forms logically pointed to the future.

Even in Moscow, he had heard of the Futurists and their conception of motion as true form: a form ideally expressed by the sharp angle of a projectile. But at that moment he had been still interested in Doré and the work of the Polish artist Vrubel, whose romantic, dense chiaroscuro held a sombre appeal akin to Doré's. Laryonov and Gontcharova, the modern artists whose lectures he had heard in Moscow, had called that sort of thing manneristic, old hat and so on, as if the object, the figure, no longer had an integrity of its own, but must be reduced on principle to basic geometric parts and combined to picture "reality." Pavlik and Natasha, returning from one of these lectures, would send the company at home into ecstasies of laughter by their imitations of the high-pitched, militant, didactic manner of the lecturers.

Here in Kiev, there was not much point to laughter loud and long (that old bugbear dear to Tyapotchka) since what reigned was talking loud and long. Pavlik was a contender in this occupation but he could not assent as enthusiastically to the fashionable art viewpoint as he did to the immediate practice of art . . . Heavy shadows, it seemed, were just atmospheric and led one away from the naked truth of form, of which mere movement was one of the chief motifs. Pavlik's hand, his mind, and above all his ambition, were very agile and adaptable. Yet, in his palm, he recurrently felt the itch for that "incredible omelet" and those gorgeous "greasy pastels" from which his first fantasies had been born.

In later years, as when he was to give James Soby his memoirs for the Museum of Modern Art monograph, he was to picture himself in Kiev "assisting at the endless discussions about realistic and abstract art, which," he added with a Tchelitchevian quirk of vague positivism, "still goes on and probably will until everything becomes clear to everybody: that the importance of the new dimension in contemporary art is far more urgent than the quality of form." He meant the *fourth* dimension. "I had my primal point in these discussions," he continued, "I thought that because of the spherical

form of our planet, any line drawn upon its surface, whatever its length, would be, naturally, part of a circle, however great the circle might be. So, at the age of 21, I made a decision of the kind felt by Dr. C. Jung to determine the whole future attitude of any given individual." By the year when he spoke, he was free of the mechanical Cubist-Constructivist formula and once more an exponent of the true organic object, however much this object was illusively portrayed and elided. "I plunged," he said of his direction in Kiev, "into the curved line . . ." That is, into the element of his fortune. And this was to be, in material terms, the waviness of water.

The sketchbook I found in Paris in 1960, marked Kiev, displays the artist's conflict, his quite personal inflection, in those "pregnant nudes" which Sergei Yutkevitch was to mention he had seen Tchelitchew draw in the army barracks. Pavlik seemed to be practising the contemporary idiom in a magical sense, experimenting with how the application of force adapts itself in nature into rounded rather than pointed angles. The sharpest instruments designed to penetrate are usually destructive or leave no traces of themselves, except perhaps scars. Automobiles were to have noses shaped like torpedoes and ships' prows are sharpened to force a passage through water. Yet the phallus and the foetus, both equipped with rounded heads, remain the most significantly creative angles of force.

Among Tchelitchew's first experiments with geometrism, according to the Kiev sketchbook, was the application of angular force and columnar strength to forms associated with the office of perpetuating human life. Conjuring with Cubism, he was patiently conjugating the verb of his plastic future. The sensation of angular force found in the pregnant, interpenetrative forms of *Hide and Seek* are curvilinear and richly round. The boys in the air, between the tree-branches at the top, seem plunging headfirst toward the trunk. The surface of the painting seems to ripple with myriad thrusts, all given at once but subject to a certain gentle arrestment. Like all bodies whose impetus is destined to interpenetrate rather than destroy, the organic masses of *Hide and Seek*, variously disposed as they are, are endowed with a mathematical capacity of compromise; they dissolve in each other with a mutual caress rather than break up in collision. In the play of concave and convex here (sometimes that between *shapes* rather than *movements*), one was to witness only that of which procreative nature itself constantly furnishes proof: the passionate aggressiveness of the concave and the yielding passivity of the convex. Sexual conjugation itself was to be the artist's resourceful model of energy.

How could he answer Papa's query about his artistic work except to say that he was "in the profession" and working hard? The drawing lessons at the Academy were in truth only an "academic" gesture and had about the same function that work in the Paris ateliers was to have for the more

advanced artist: the best thing about them here was that they were "open": one paid no fee. Pavlik, on the other hand, was interested in procuring fees. At the moment, Rabinovitch and Tchakragine were engaged in making Cubist-Constructivist sets for the theatre. When the latter had some programs to do for a music hall of the Chauve-Souris type, he was glad to have Tchelitchew's assistance. Bogomazov, commissioned to prepare a series of Festival posters, also called upon the young artist's inexhaustible flair. He seemed never to shun work, he stayed late, he tended even to finish things faster than others. The programs of the music hall changed weekly, so in general Pavlik was busy enough to be a little happy. Only once in this period, when he happened to be hanging some paper lanterns, did a black and bitter memory invade his soul. For many years, on Mama's birthdays, he had arranged such lanterns in the gardens of Doubrovka.

Still there was no peace in Europe, no final issue of the strife. Lately he did not have to encounter mirrors to think of the candle-lit infinity surrounded by darkness at Doubrovka. The flight of one of Kiev's leading producers, Mardjanoff, for whom he had been doing *The Geisha*, quickly ushered in the Whites and after them the Reds . . . On the streets could be seen, side by side with the Festival posters, official Soviet posters which announced death for the bourgeoisie. "Well," thought Pavlik, "there will always be two kinds of posters as there will always be, at least, two kinds of art." And yet the thought shaped only the surface of his mind. For Pavel Tchelitchew, things were always to be objects of endless, if reverent, curiosity: appearances with multiple layers and mesmeric secrets of internal form. Had not someone already told him that his work tended to be mysterious, opalescent?

His true mind was excited less by the checkered fortunes of the civil war than by Kiev as a city half Medieval Russian, half occidental, half historic, half modern. Leading to Lipki, the elevated residential section, where Mama and Papa were staying, were luxurious modern thoroughfares. Was not Papa comparing them to his former forest paths? Alas, perhaps he was! Yet *he* was not Papa. To an artist's imagination, it is hard for time to eliminate anything once it is accomplished, once it has filled space with new objects. Whatever painting might be now, Pavlik admired most in Kiev the sixteenth-century churches that raised their golden domes in the neighborhood of the splendid parks. Inside Santa Sophia, his attention fixed itself particularly (as he was to write Edith Sitwell) on the late Byzantine mosaics. "The Madonna is rightly," he thought, "fourteen floors high, larger than any other figure in the church, because of her importance." He was to grow to dislike most "colossal" pictures because of their great overstatement, and to agree with Edgar Wind when Wind said of Picasso's *Guernica* that it was better suited in scale to its postcard reproduction.

The sensation of seeing the domes in obverse arrested his eyesight, made

him linger, in the churches. Convex was simultaneously concave: a great charm seized him at the thought. Swelling, rounded off, at once male and female in implication, the domes formed layers of flesh that were part of the church's anatomy. At that moment, it was the style in art to conceive everything, including the human figure, in terms of cylinders as well as sharp angles: broken arcs, detached conic sections of spheres. All the clutter, the flutter, of analyzed planes suggested motion, even incarnated motion, but it was the motion of machines, or rather parts of machines. Take the domelike female breast and its nipple: these are rounded, not pointed; and so, on a gentle bias, is the male sex—only the slice of the latter's mouth, to Pavlik, was a bit disturbing.

A vision of architectural origins floated across his eyeballs. Sacred buildings had imitated the dome of heaven, man's head, woman's breast, the human body; in the herm and the stupa the sexual organ had arisen, in the column of the temple, the tree . . . But all this seemed simple and archaic beside the nervous mathematical rhythms of the Constructivists and the Futurists. He liked the spherical bareness of the Romanesque; the Gothic spire with its reaching point left him cold. Transparency and easy interpenetration: these were the architectural elements that interested him. And *light* was a signal of success in the use of architectural dynamics as the simultaneous passage of inside/out and outside/in. It relieved the formal rigidity and made a building into a complex unit with, essentially, neither inside nor outside!

His future in art seemed so close—as close as the real human bodies he now loved to caress. Soon he would—he, Pavel Tchelitchew—have caught up with time and be able to make that one crucial step that would outstrip other artists, burst the bonds of the present so as to be in rhythm with the future . . . What was he doing: thinking heresy? No matter! He had found it hard to argue for the natural curve when mathematicians said that a circle was composed of infinitesimally small straight lines and nature itself was capable, as in crystals, of making straight lines. "Pavlousha! you scamp! You're thinking that some Futurist paintings, despite the rhythms of their geometry, look like heaps of débris!"

How sweet and comforting it was to have these secret thoughts, thoughts of his own! Most people, even artists, would think some of them lewd or downright silly. Well, just wait. He would find ways of saying such things that would charm and amuse, not disgust or annoy! It was only a matter of time and the time was quickly growing shorter. His thoughts always returned to the human body itself as the first and last point of reference: the measure of things. It might be the mode of future art to *lay bare* geometry as if *that* were what existed under the clothes of human beings: solid, opaque geometric form. No, no! He would have to find *some way*. It was more interesting to imagine the body itself as "clothes," something to remove, and

to depict what lay under those clothes . . . under that skin. Again something stirred—this time something beautiful—between Pavlik's navel and pubis. If only women would refrain from being such nuisances—sexy nuisances! If only they were all Anna Ivanovna's age, one could have a lovely time with them. All his life, Pavel Tchelitchew was to believe that, as he put it, "only women know how to comfort, men don't know how." Comforting him was to be the main function of the women attracted to him.

It was much better if they, the women, were married. Unmarried women, he thought, were too frightening. If they were young enough, he could big-brother them, as he had his sisters, but when they were of age—"Mon dieu!" One had to defend oneself. It was simply scandalous! However, in Kiev, he had met a married couple who were ideal friends, as ideal as Pierre Souvtchinsky and his mother. This couple, Paul and Zossia Kochansky, he had met at the Souvtchinskys, whose place was a magnet for an increasing crowd of artists and intellectuals. Kochansky was a noted violinist; his wife was a woman of quietly sparkling, gentle ways who found the young Tchelitchew enchanting. Pavlik had already become the boyish cavalier, frothing with fun but so seriously ambitious, infinitely gay but with the readiest pathos. The Kochanskys were Poles, they were only a little older than Pavlik, and his temperament seemed specially designed to effect a Russian-Polish cultural entente. Mme. Kochanksy became the model for Tchelitchew's first portrait in Kiev. Seeking the human face and its message, he avoided extreme Cubist severity but retained some of its rules and manners; the lady's face was decidedly yellow in the portrait and did not convey the original's delicate refinement. Her husband in fact disliked the portrait, believing that it made the subject look two weeks in her grave.

So I was to learn, a year after Tchelitchew's death, from Mme. Kochansky herself, who granted me an interview even though a mysterious illness confined her to her apartment. She spoke with nonchalant humor of her husband's opinion of the portrait. I found her prostrate in bed wearing an elegant dressing gown. The immaculate bedroom was full of memories and mementoes, but the poor lady herself, closer to death than she imagined, could do little more than point to some Tchelitchews. A strange quick rhythm of agitation imbued her and I was touched by her alert willingness, laboring obviously under her sense of a quite drifted, obscure past. I recalled her as very dignified, and rather sombrely dressed, presiding over a samovar in Tchelitchew's New York studio in the forties. She was a widow, her husband having died in 1937 and (as she told Tchelitchew) taken music out of her life.

As she tried to answer my questions, I observed her thin face with its delicately ghosted beauty, enlivened only by a perpetual odd roving of the eyes and quivers of the lips. Now and then a smile fleeted by, wistful, more

asking than answering. She suddenly arose once to lead me to something and tottered as if about to fall. I had to urge her back to bed. When I asked where the Kiev portrait now was, her startled face shed a look of distress. "I don't know! I don't know where it could be. Maybe Z——— took it to Moscow." Of course I knew that she and her husband, as well as Tchelitchew, had become refugees from the Revolution. I had little knowledge then (the summer of 1959) of Tchelitchew's social and private life in Kiev so I wanted her personal impressions of him. "He looked fifteen," she said, "but he was eighteen." In fact it was the year that was eighteen, he was twenty. But I did not correct her. "He had run away from Moscow," she continued, "wanting to be a painter. He was courageous and always reading mysterious books."

In two brief sentences her mind must have compassed a quarter of a century; he was probably far too active in Kiev to do much reading. Anyway, her version of Tchelitchew sounded like one of Tyapotchka's fairy tales. Pierre Souvtchinsky's memories of the Kiev days were to prove more concrete than Mme. Kochansky's. He and his mother were among the many refugees from Petrograd now in the Ukraine. As editor of the musical review, *Melos*, Souvtchinsky at once became a dynamic figure in Kiev's large musical circle. He had met the young Pavel through a mutual friend, Vladimir Nyelidov, and in turn had made the artist known to the Kochanskys. As a catholic connoisseur of the arts, Souvtchinsky put his faith in a total organizing of culture and soon was induced to join forces with Prince Nikolai Troubetzkoy in the Eurasian Movement, in which survived Russia's old ideal role as mediator between Occident and Orient. Others than Tchelitchew who gravitated to Souvtchinsky's cultural nucleus in Kiev were the noted professor of music, Blumenthal (Vladimir Horowitz's teacher), the singer-author Kochitz and Count Alexander Rjewouski, the author of the little caricature of Tchelitchew which I saw in his sister's apartment in Paris.

Souvtchinksy remembered the twenty-year-old who "looked fifteen" as "very young and exuberant, with wild hair and exactly like Rjewouski's caricature of him." Rjewouski, then a leading musical theoretician of Russia, was said by Souvtchinsky to be "typical of the people who were 'taken' with Pavlik." Actually, he must have meant the men, and among those the metropolitan, rather than the provincial, admirers. For a few precious months, Tchelitchew was to be part of what Souvtchinsky defined in retrospect as "a great gathering of youthful creative force all at one moment." The ugly objective truth was that while the young artist was laboring to get *The Geisha* on the stage, using only burlap, sheeting and a little paint, the Red Army was taking over the Ukraine. Once established in Kiev, early in 1919, it made the prospects of that "youthful creative force" very ambiguous and eventually wiped them out.

Simultaneously with the halting of artistic projects was the materialization

of the worst of Pavlik's hidden *bêtes-noires*. Clearly now, every young male Russian of White persuasion must consent to conscription into Denikin's army as the last hope of the old Russia's survival. Ironically, it was supposed to be an army of volunteers. When the White general, about a year after the Tchelitchews first arrived in Kiev, triumphantly entered the city in another turnabout of fortune, Pavlik was expected to exchange the short *moujik* coat that had become his civilian uniform into something military. So it was that Tchelitchew junior and senior met for their last personal interview over the future of Pavlik's disputed masculinity.

Fyodor Sergeyevitch's sensible concern was for his son to enlist without delay, since if he waited to be conscripted, he might be thrown, said Papa, into any old regiment. Getting wind of this advice, Anna Ivanovna, the surrogate mother, grew emotional over her favorite's peril and blamed M. Tchelitchew for being premature in sending Pavlik off to fight. Hiding his agitation, the young artist (doubtless after a heartrending duet with Mme. Souvtchinsky) enlisted and eventually appeared in the uniform of His Majesty's Uhlans, a regiment under the command of a cousin of Alyosha Zaroudny. In this outfit, which he seems to have worn like a masquerade costume, he met his new friend, Yutkevitch, and drew those somewhat brutal and foreshortened anatomies which the other mistook (I assume) for pregnancy.

If Yutkevitch referred, wondering, to the pregnancies, the young artist must slily have joked about them and spoken of the incredible mystery of Mrs. Nature's ways; of how, to attain her ends of procreation, she must momentarily bulge, distort and give pain; for example, the male erection sometimes swells till it hurts. "You understand, my friend? All is not simple pleasure in *la condition humaine!*" The other must have thought his aristocratic friend already very Parisian. One can witness the sibylline curl of the artist's tender lips and the birth of the chessy-cat smile. In any case, his exceptional talent for drawing, and probably his exceptional talent for personalities, made him eligible to be a cartographer rather than to fight in the front lines.

At Sevastopol

With the Whites in Kiev, the fortunes of Mama and Papa Tchelitchew had taken a turn for the better because money was again legitimate and in circulation. But the rosiness was short-lived. The Reds came back and barter once more replaced money. Mischa, having entered the Mounted Guards, was thought to be in the thick of the fighting. Still in Losovaya with her children, Sonya, the eldest daughter of Fyodor Sergeyevitch, fell ill with typhus. At certain times, disaster has a way of lengthening and feeding itself like a tapeworm, sustained in a perpetual present whose only past is a

deathlike paralysis while the future ends a little distance away, in a precipice. About to start to Sonya's assistance, Choura learns that the Reds have already occupied Losovaya. Sonya dies. Together, Choura and Manya manage to get her children and proceed with them at once to Sevastopol. There is now little hope for the White cause in Russia: its army has been driven into the Crimea. As for Sonya's husband, he had had an old record as a political agitator and for some time now had deserted his family.

Mama and Papa can see no logical prospect but that of foregathering the family in Sevastopol. In high but mournful Lipki, poor Nadyezda Pavlovna has shrunken with grief and anxiety, Fyodor Sergeyevitch grown longer and graver, as event by event, time has robbed him of sustenance and hope and crippled his authority by destroying and dispersing his family. He shuddered to look at Nadyezda; she was hardly the same woman who had been Doubrovka's domestic ruler. Now she went about in a strangely indifferent numbness and neglected her looks. What could possibly lie ahead? Poor Lyena, while studying music in another city, was soon to die of pneumonia.

Papa's finger might have been stirring the water in the soup tureen at Doubrovka, seen the paper slip ignite, snatched it to snuff the flame and read there the word "Sevastopol." Once all the facts stood clear, he and Mme. Tchelitchew packed very quickly and departed from the ghostly luxury of M. de Vitti's apartment. Pavlik's future motto of always looking ahead and never behind might have been derived from this anguishing fatal moment of the family history. One hardly dared look behind, for only the future, uncertain as it was, seemed to exist.

Is there really a common time, an historic tense, in which we all are caught, held fast, no matter when, or where, or how we move? If so, it is the most impersonal time in the world! Experience teaches us how fluctuating is the verb of life, how delusive. And for every "tense" there is a distinct, real quality of feeling, a curious stance fixed only momentarily. At a mere option of the mind, we can look before or behind it, temporally, and this mutability is bound to suggest a spatial change, too, with the past behind one's back and the future facing. There was very little time, and a negligible amount of space, between the moment when Pavlik, exhausted from work on *The Geisha*, fell asleep in the theatre late one night, dropping to the floor among some tangled paper with his coat for a pillow. Awaking, he found himself as if imprisoned, bound to the floor. He had a split second of panic before he discovered he had laid himself down in some spilled glue. It was to be an anecdote to amuse, a bit of nostalgic sentiment of the sort that survives to help paint oneself a hero.

Yet each piercing moment of fear like that is inward and prints its vague little scar on the brain, and not being isolated or unique, but repeatable, lives on, nourished and renourished in the skein of one's nerves. Truthfully, the feeling that Pavlik had, immediately on quitting Doubrovka and crossing into

the Ukraine—that feeling of the family being pushed from behind, using no locomotion of their own—was the very tense in which he lived after being mobilized into the White Army. Years later, when he was to paint images "like the landscape of the Moon," he was really recalling his native land, Russia, as it last seemed to him: a desert of ordinariness, a land of automatic exile, lit palely as by a false sun. What could be more "alienating" to Pavel Tchelitchew than a soldier's uniform? At first a dandy, as one of His Majesty's Uhlans, he soon wore the uniform like a prisoner's. Only about two months was he active as an army cartographer. General Denikin's volunteers, valiantly pushing toward Moscow, began regularly to lose their encounters and ignominiously fell back again to Kiev.

When the Russian-Polish war broke out, the supreme crisis cost Denikin his command and General Wrangel took over the leadership of the White forces. The White and the Red! Life had a burdensome, insoluble doubleness —and at last, as the White Army retreated from the disaster at the Don and had to evacuate even Novorossik, a city in the Crimea, Tchelitchew himself caught typhus and was hospitalized in an auditorium, one of the many public buildings utilized in Novorossik to house the sick and wounded. It was still 1919 . . . The young artist, in a fever of despair as well as a high temperature, realized he had attained his majority under the gloomiest of auspices. When the truce was signed between Russia and Poland, the Reds were free to drive the Whites to the sea, where already they were dispersed and helpless.

Pavlik's fever seemed to have deprived him even of his Russian identity, its last vestige being the uniform they had taken off him when he was put to bed here. His semi-delirious mind held the image of each of his family in turn: he did not know, at the moment, where a single one was; he could only guess. What haunted him was that not circumstance, not some obscure fate, had separated him from them, but an act of his own will. Most people would think him merely irrational, but inveterately his deepest thoughts were beginning to be premonitory. He would learn to dread these moments of clairvoyance, for without partiality, it seemed, he saw vividly the pleasant or the unpleasant, the life-giving or the death-giving. And he dared not doubt anything as that would be to commit the ultimate sin: to deny his own, supernaturalist powers.

After another World War had taken place, in a bitter moment, Tchelitchew would declare that he had become what he was, not because of his family, but in spite of it. In other words, during that future moment of artistic self-assertion (an "historical present") he would quite forget his surname and its old, heady grandeur, the heroism and princeliness of his forebears; he would dismiss the natural bonds of blood and answer only to the artist's religious impulse that is like Christ's: the renunciation of all ties of family, even those of father and mother. As he had then learned from the precepts of Pythagoras, one should have a second birth in this life, *but the*

second birth must be from a virgin. This, Pavlik was to understand, is the individual's birth into the eternal cycle of being: a sublime *accouchement* among the stars . . . Yet never would he be, in this life, a saint, a really great mystic. He knew this as long before 1941 as now, in Novorossik, lying prostrate with typhus.

Once in this auditorium, as in the bandstand at Kiev, there had been music. Some of the folding chairs were used for bedside visits and consultations, since everything here was pitifully lacking and dingy. The platform was still at one end of the building, of course, and Pavlik knew whenever doctors, nurses or orderlies trod the little stairs attached to it, for they persisted in creaking even at the gentlest pressure. Maybe operas had been given here—he had had no chance to look at anything but the ceiling which was hardly ornate—or at least singing concerts: a small, dusty pile of music scores, with an aria from *Evgen Onegin,* had been found under the little stairs. Besides the insidious reek of carbolic acid, the spasmodic coughs, an occasional delirious moan and spurts of conversation, the place had nothing to relieve the oppressive weight of death except that persistent music that Pavlik heard inside his head—which he could neither identify nor remember—after he had had a little of the sedative they gave him.

It was, here, like some ruined landscape. He was just one of the many brought low, levelled, with old Russia's brave hopes. Bravery! Who was he to be brave or cowardly? How little he had done, how little he *was*—what, indeed, and *who*, was Pavel Tchelitchew, now? Kiev had been a Paradise as compared with this entrance into Hell . . . this . . . this No Man's Land . . . an English phrase he had read in the papers came to his mind. Would he ever, ever, be reunited with his friends made in Kiev? With the Souvtchin-skys!—with dear Anna Ivanovna and Rjewouski, who adored him! They must have fled to Europe already. They must be in Poland—or perhaps in Constantinople.

Tchelitchew! And Pavel! A name—*one* name. The whole of life was a great deal for one name to bear! He tried to drive the images of his family from his head. But each had a way of coming back when he was about to fall asleep and when he awoke, head aching, throat dry, yearning for water. What had happened to Choura? In Kiev, she had expressed her intention of becoming an army nurse. If only she were by him now! And poor, jolly Lyena: little Bombotchka! She had thought of the family dining, when food was especially scarce in Kiev, on a good slice of Choura's bottom. That sweet family gayety, that lightheartedness of the children, it was gone, totally gone . . . The sick youth's silence told him that that divine chatter which had made Doubrovka's air bloom, and given extra scent to Mama's roses, had no more tongues to utter it. It was a dead language . . . Kiev had seen its pitiful little death-agony.

He strove to shut out images of Mischa and his sisters by pressing his seared eyelids together. For a few moments he lay attending to the various sounds in the dreary, stifled space of the auditorium. Was there a rhythm in them? He tried to imagine them as instruments of the orchestra and ended with a shooting pain in his throat. They were all too far away—centuries and centuries off—and hardly to be located in time or space. The typhus lay on his face, even on his ears, like a mask of fur. Suddenly he opened his eyes. He thought that Manya had spoken his name so clearly that she must be standing by his bed . . . No! It was only his nurse, addressing him by his military name.

He did not know it yet but Manya, after Mischa had gone into Denikin's army, had left for Loubrou to take a post as governess, teaching French to two boys in a Jewish family. Loubrou was a pretty little town. Manya, however, found life there unhappy; it seemed (she was to tell Choura) as if she were expiating all the sins she had committed against her own governesses. When finally Pavlik was to hear her story, it reminded him that other members of the family had done their best to maintain their solidarity, somehow or other, while he . . . His fever, he was to remember, made him yearn to rejoin the current of the family blood; he was sure that misfortunes were to befall them all, and if they had to suffer, perhaps it were best they do so together . . . When the Reds took over Loubrou, Manya met a young Commissar who had actually, she learned with delight, been educated by Papa himself. The young man fell in love with her, and believing her job as governess unbecoming, arranged that she head one of the Children's Houses being instituted by the Soviet regime. There, to her dismay, she had to fight with officials to keep the icons on the walls of the transformed convent and even to continue the daily prayers.

This situation ended when the White Army's success compelled the Reds to evacuate Manya and her children to Kiev, where she stayed in hiding under the young Commissar's protection. Prostrate in his cot at Novorossik, Pavlik felt behind his forehead the second sight of distressing things taking place at a distance. Manya had been parted from her Commissar and gone to Losovaya with Choura at news of Sonya's being stricken; then they had taken her children to join Mama and Papa in Sevastopol, where Manya herself caught typhus and almost died. Recovering at length, and with difficulty, she had hallucinations. She believed she was married and her wedding ring, she claimed, had been stolen by Choura. Her storming and weeping held back her returning health. The most patient and reasonable persuasions would fail to dislodge her fixed delusion. Gaunt with the disease's ravages, she was the girl who had once, to get what she wanted, played at "being sick."

Pavlik, fighting his typhus, held a very true secret in his breast and no one,

not even any of his family, as yet, knew about it; only in Paris, eventually, was he to speak of it to Choura. Before leaving Kiev, he had been to see the Staretz at the monastery of Petcherskaya Lavra. Semi-delirious in the auditorium at Novorossik, he saw himself in Kiev as if sleepwalking, first going up some steps, then down, as into a catacombs. In fact, it was with a stilled, panicky sense of fatality that he felt himself *descending* in order to approach the wise man, the Christian seer, whose image now, through his fever, came to him indistinctly. He was to be afraid of the depths till that distant day when he fully realized they were, as in *The Divine Comedy*, a necessary vestibule to the heights.

No, *no!* The Staretz was not actually indistinct to him. Rather, he was the image of a picture! The Staretz of Petcherskaya Lavra had an almost white beard, and his living lips, in answer to Pavlik's humble request for blessing and guidance, had told him that he had very little time left to him in Russia, which he would leave never to return there, traversing great oceans, meanwhile, and living in foreign cities. In the Staretz' dim cell, lit by one candle, Pavlik trembled visibly and invisibly at first: with his outer flesh and inside, at his solar plexus. He strove to suppress these tremors and felt that, at least outwardly, he soon succeeded. What was strange now was that those mysterious lips, that bearded face, were those of Father Amrovsky! He was the Staretz who had guided Papa Tchelitchew in his youth and the story was that Dostoevsky had modelled his famous character, Father Zossima, of *The Brothers Karamazov*, on this extraordinary man. Papa had always spoken of him in the solemnest tones; his large portrait, hanging in M. Tchelitchew's office at Doubrovka, had been an object of love and reverence as if it had been a holy icon. It was a large square painting, done by a Novice in the traditional icon style, and it had been willed to Fyodor Sergeyevitch at the Staretz' death. Father Amrovsky was shown all in black in the usual habit of a Russian monk, wearing the *klabouk*, or high round hat, with its black veil falling to the shoulders.

Father Amrovsky was very emaciated and also pale, with white hair and a long white beard. In fact, the only detail in which the Staretz of Petcherskaya Lavra differed from his father's teacher was that the former's beard was still a little grey. Yet what Pavlik saw in his mind's eye was Father Amrovsky as if come to life. The picture on Papa's wall seemed to move. The eyes were sad, as always, though they held an abiding expression of goodness and gentleness. The hands, long and delicate, called attention to themselves by being reposed on a large book . . . Yes, it was a hand of Father Amrovsky that moved as Pavlik, eyes shut, watched.

With a fluttery twinge, he remembered that, for some inexplicable reason, the portrait had been left at Doubrovka. "Why?" Pavlik asked himself. *Why did Papa forget to take along the Staretz' portrait?* He stirred restlessly in his

bed, agitated. There was no explanation but *forgetfulness!* He had been present in Kiev when someone—it must have been Mama—had asked where it was so it could be hung on the wall at Damasha. Papa had immediately looked both grave and troubled, and what was quite unlike him, had mumbled something they could not understand at first. He blamed one of the peasants who had come with them for forgetting his explicit instructions to take down the portrait and wrap it well. That unique, precious object! Why, with his own hands, did not Papa—?

A black wave of distress, that blackness that would illumine the unwelcome future, swept through Pavlik. Perhaps all the Tchelitchew luck had disappeared with Father Amrovsky's picture; perhaps that same thought had troubled Papa, who was as superstitious as anyone. Or their luck *would* have disappeared were it not for the living Staretz at whose knees he, Pavlik, had knelt in the cold, bare stone catacombs at Petcherskaya Lavra! He had no doubt now, not the least, that all the good fortune of his life lay beyond the borders of his native land, that he would have to take a real ship, that the Divinettes in the soup tureen at Doubrovka were all simply precursors of the true ship which he would take toward—toward—

Someone was speaking to him. He opened his eyes again. It was an orderly he had never seen before. He was rather good-looking and Pavlik tried to look wide-awake and to smile . . . *"Tu es un numero,"* he heard himself say and he drooped his poor, parched eyelids with a coquetry he had not used for weeks. "Isn't it strange," he was to write Edith Sitwell many years later, "ever since my childhood, I would say to friends, 'Really, you are a number' (tu es un numero) and we all are but we don't know." The expression is the vernacular of a universal and variable slang, but what Tchelitchew meant in this remark, made to the late Dame Edith, was that it implied numerology: the magic science to which he had become devoted.

At the moment when he called the strange orderly "un numero," he had the taste of salt on his lips. Would he have to swim the ocean itself to get away from Russia? More awake now, he did not feel so certain of the fulfilment of the Staretz' prophecy. Like a thunderclap, he saw the water of the Yisdra and Choura fighting it to keep from drowning. But the Yisdra wasn't *salty*. Rigid, terror-stricken, he stared at the orderly, who was asking him (since he had just spoken French to him) if he were really Pavel Fyodorovitch Tchelitchew. Vaguely, Pavlik saw a paper in his hand. Not Choura, but he, Pavlik, was drowning in the Yisdra! Yet no, he was in bed, *sick* . . . He looked at the coarse, creased white sheets, at the namelessly grey blanket. And he shut away the sight of the orderly. A good-looking number. True! But . . .

Clearly, on the inside of his eyelids, he saw Choura's whole form, not immersed in the Yisdra, but as in a dark pool, looking like a bas-relief on the

water's quiet surface, and flashing many bits of color as did the mosaic Virgin of Santa Sophia in Kiev. He saw her from the back and against a tree, arms outspread as if swimming . . . Long after starting to paint *Hide and Seek*, he was to realize (he said at the time) that the girl pressing her body against the great tree was swimming—that she "starts to swim as soon as the boys appear above her in the branches." The thought was to come to him as suddenly as this apparition: from the depths of his mind and not from the surface of the painting. He was to believe, and to assert, that an artist thinks in images, symbols or not. Agreeing with Edith Sitwell that "an artist is an artist," and thus "a different kind of animal," he evidently meant an animal who characteristically thinks in images.

"My soul is drowned in a salt lake and my body is her prisoner."

Often, without notice, the voice of a sibylline utterance spoke in him like this.

As the strange orderly stood there, he felt bathed in perspiration. How well, and how thoughtlessly, Tchelitchew would always *think*, no matter what he *said*, in images! But why, in that image so deep in the future, would the lake be *salty?* and whose "prisoner" was his "body" to be when, in 1941, he wrote the sentence I have quoted? Apparently, the prisoner of something with a feminine gender. He would develop the habit of thinking in French as well as in images. Since *lac* is in the masculine, the prisoning element would have to be *âme* (soul) which is in the feminine. Partly, assuredly, he was speaking of his daily work at the easel, but this assumption does not shed enough light. I fancy that, grammatically, he was automatically effecting a "confusion" of the sexes while thinking primarily in mere images . . . that the lake which was to imprison him was the zodiacal element of his friend, Ford: Aquarius.

The orderly was still thrusting the paper at him. "Yes," he replied weakly, "I am Pavel Fyodorovitch Tchelitchew." And he took the paper. The words on it were very official and said that Mikhail Fyodorovitch Tchelitchew had died in the line of duty while fighting in the vicinity of the Don. The orderly saw the young man in the bed convulse himself in one prolonged, unachieved sob; a tear forced its way from either end of his eyelids as the handsome face distorted itself and the fingers lifelessly held on to the paper in them. The orderly would have been amazed to hear that in later life this young man was to declare that the news of his brother's death marked the moment when he attained his real manhood.

His mind one flame of horror and grief, Pavlik felt his veins were filled not with blood but with hot metal. Melted rubies! Man, like everything else, had come from the depths of the earth, where fire was, and there glowed the great jewels. He saw them all at once: a bottomless prism. They were present all the time! Human flesh hid them from sight. Every true drop of blood in

him raced toward expelling from his body the sense of the words he had just read. What hideous truths ruled the world—truths as hideous as lies! Would it always be so? Everything in Russia seemed to have turned into an evil illusion. The Reds had practically won the Civil War—and what had they done in Kiev but first promise the people everything and then threaten them with deadly reprisals? He saw the dining room at Doubrovka. They were all at table: Mama, Papa, himself, Mischa, Choura, Lyena, Sonya, even Natasha! It was August 14th, 1918, and there was a thunderous knocking on the front door, then at once a noise of many footsteps. This was no dream, but reality; more real, by far, than the paper he held in his hand. Some Red soldiers burst into the dining room as all of them except Mama jumped to their feet. Mama seemed to collapse in her chair. Mischa's hand moved to a knife on the table. They heard a shot. And there was Mischa, stretched dead at their feet, killed by the revolver still smoking in the hand of the Red soldier.

Such was Pavel Tchelitchew's version of the way his brother, Mischa, died, as he told it to friends he was later to make. To all appearances, he was never again to think of the ineffably cruel words of the official telegram that had given him the news. There was someone else at his bedside. Weeks had passed and he was recuperating. His head no longer ached nor did he have a fever. And his bed had been moved to the platform. He felt stronger although, till this very moment, he had been lying there hour in, hour out, thinking of his problematic future: just how he was to escape from the disastrous end of the Civil War. Actually, he understood, the White Army still existed, still represented the Russia that was. Every now and then he wondered about Mama and Papa and the rest. But mostly he thought of the Staretz' prophecy, now more and more certain of its fulfilment. In a week or less, he would be up and automatically would have to join the remnant of the Army; there was no other course. Somehow this prospect did not depress him too much. Wherever he went, he expected it to be a seaport.

Standing by him was a living, incarnate hope in the shape of a woman. The event was like magic. He thought of his Guardian Angel, and in his heart thanked Tyapotchka for having taught him the wise way of pleasing one's Guardian Angel. Do not despair! Believe, believe . . . He believed, now, in everything: the Staretz and God and the Holy Virgin and this woman by him. Though he knew her, she was as strange and vaporous as La Dame Blanche herself. How beautiful, just now, the light made this dingy, ugly auditorium. Meanwhile the lady was speaking truly heavenly words and his face reflected their beauty as he listened.

She was the wife of a friend, Alyosha Zaroudny's cousin who had commanded His Majesty's Uhlans. "Oh, I am glad, Pavlik, so glad!" she was saying. "To think we have found you and that you are well now. Before coming in here, my heart was very low. I was sure we would fail. For we

have been everywhere, everywhere . . ." His lips apart, he felt the fixed smile on his face. But he knew how inviting his opened lips could be, the soft gentle breath flowing in and out between them, their corners turned up.

"The doctor tells me you can get up in two or three days," the lady went on. "We must act quickly because . . . I mean my husband is commandeering a vessel—we can leave for Fyodocya with a hundred soldiers from Denikin's regiment—and with you!"

The White Army might be retreating—even into the sea itself—but he, Pavlik, was advancing, always advancing. If necessary, he would walk on the waves.

The Mouse

But, to leave Russia, he would not be obliged to walk on the waves. A most unexpected being came to his assistance at the last moment, and pointed the direction out of his uniform and out of Russia. He simply had to seize the opening and follow it through. This being was the animal kind he most feared in the world. For with Lyena and Aunt Sacha—sometimes he thought it must be an inheritance—he shared an abnormal, unmanly fear of mice. Yet a mouse, like a deus-ex-machina, arrived as in a play—yes, like Apollo himself—to solve the impasse into which his return to the White Army uniform had involved him.

In *The White Goddess* by Robert Graves, Pavlik was to read with credulous wonder and amusement that, among the early origins of the Olympian god of beauty and the arts, Apollo, was his identity as a mouse-demon. The artist then exploded with that healthy inner laughter that makes all incongruous things, both absurd and terrible, fall obediently, naturally, easily into place and live in one abundant order. Of course, in New York, when he read *The White Goddess*, he would think of Russia and the General Headquarters at Djanskoy, where he had taken again to drawing maps.

Inconceivably futile and foolish, life had become since he had left Novorossik; and frustrating. He had gone with the kind lady as in a dream and boarded the ship, "an old galosh" as he later termed it, as in the same dream; it required all of three weeks for the contingent to reach Fyodocya. Pavlik had called up all his reserves of daydreaming and common wit. Exhausted, he had been received once more in the Army as a cartographer and been duly transferred here to Djanskoy. Now he sat and drew, half-stunned by the thought that old Russia still imagined herself alive. At times he joined others in incoherent, hysterical hopes, flecked by gayety, that visualized a reversal for the Reds. His heart was not in it. The Staretz' prophecy absorbed all his true faith and daily he felt that from among the tall ships in the harbor, one would signify it was the ship of destiny. Yet the days went by and nothing whatever happened. He had reached Varvara and her husband in Sevastopol

and would have loved to see them. Yet he would have to conceal from them the momentous secret of his future.

Is Tchelitchew's story about the mouse, duly confided to Choura, true? One might as well ask if J. F. Darlan was really the famous French admiral or if a French battleship was in the harbor when news came that the Whites would have to evacuate the city. Or whether Tchelitchew himself was then at Sevastopol! One would have to doubt that M. and Mme. Tchelitchew were eventually to go back to Losovaya, and end their days under the new regime after their son took ship from Russia forever.

It is not hard to believe that Darlan, meeting Pavel Tchelitchew, was entwined quickly in the personal spell that became familiar to so many in Berlin, Paris, London and New York in the years to come. The most natural thing in the world would have been that the supposed cartographer would have revealed to the naval officer with zest, and his flair for dramatics, that he was really an artist and that a Staretz had predicted he would travel far over the seas and never return to his native land; maybe Darlan was the first recipient of the tragic story of Mischa's death: shot dead at Doubrovka by a Red soldier. As the battleship was to approach Constantinople, one can see Pavlik in Darlan's cabin, over a glass of wine, voluble on the subject of Paris and the exquisite wonders of the Champs-Elysées . . .

The manner in which he came to Sevastopol was this:

Tchelitchew had begun to live in the historical present; that is, in the heavenly-hellish imperfective of time being: the sacred *duré* that will be his from now on. Subjectively felt, basically, this tense can still be ratified at any given moment by reference to the tangible facts. One day Tchelitchew was to contend that people saw only the shell of his head, not what was happening inside. "It is maybe," he then wrote, "that timing of certain people is very different from others and even being very young I felt myself already [as] if I have done what I have to do laeter [later]. I really think that as a flower knows what she is—we know it subconsciously since the childhood and we get angry at people who think that we are onely pretentious youth and that we should better behave. Parents often are the cause of so many miseries in this sense because being parents they dont want to admit that the child is something different from them—physically yes but there is something besides the physical too—that makes the sum being completely different from the father or mother etc. The number we become, as we are born, the day, the month, the year, the hour, the minute, the sun, moon, stars, etc. all this is as important as our bones, flesh, nerves, veines, arterys . . ." In other words, numerology is but one pattern of the ritual law of personal uniqueness.

When the modern atomic discoveries were made, Pavlik was to become terrified "about," as he said, "playing with the Moon and all the radar-atom business—it might disturb celestial equilibrium, make calamities, floods might

result of [from] man-made deserts." When he spoke thus, he was already to have visualized the disastrous inequities of Hell and his own role and fate therein. His personal equilibrium now depends upon a radar which never sleeps in a world capable of inducing the most terrible enemy of all from the infinitesimal world of the atom. Pavlik has begun to have the paranoia of the open, vulnerable microcosm of the individual in the modern world. And he takes it all *very* personally!

With *Hide and Seek*, he was to make the immense discovery that every true painter makes in one way or another, and which is a deep plastic axiom. The year is 1941, the month August, and he is in Derby Hill, Vermont: "I have discovered now a very interesting and important thing—in the picture [*Hide and Seek*] it is not only necessary to organize the figures and let's call it the solid parts of the composition. It is also necessary to organize the places between them. Not only the space like does S. Dali but the enumerous [sic] quantity of all sorts of spaces should be organized as the solid forms are too . . ."

If not, the wisp of chaos that will undo everything can slip through: the very air will grow the enemy. "It is like," he finishes, "the intervals and the pauses in music." These, too, form the links . . .

Pavlik is sitting in General Headquarters at Djanskoy with a Colonel and a General of the White Army. Maps are between them on a table. He is trim, a little taut, deferential; really, he is exploiting all the courtliness that military manners will allow. The heads of the two older men are bent over the table, studying something the cartographer has pointed out. Their talk ceases for a few moments. In the pause, Pavlik hears a faint, warning scamper, ever so feeble; after all, he has the ears of one attuned to hearing the music of the growing grass. His head turns as if he had heard a gun fired. Along the wall opposite, a mouse (he sees) is running in retarded little spurts. He stands up and the mouse, startled, dashes frantically past the table, diagonally, to a dark corner of the room behind them.

Pavlik's scalp shrivels and congeals. Never can he forget Aunt Sacha's terror, the way she once drew her legs up on a chair and wrapped her skirt about them in the ritual panic of ladies who hallucinate the mouse as a peculiar invader of feminine privacy. Lightly, without a thought, Pavlik jumps on the table; he is between the Colonel and the General, kneeling on the map. Too late, he realizes his awful *gaffe*. He is pale as death and becomes paler when his mind registers: "I'll have to explain to them." Hardly knowing what he says, and squatting on the table, he does explain.

"I . . . Excuse me, please . . . I just *saw* something!"

The mouse has disappeared. Neither Colonel nor General have noticed its passage. Both men have arisen.

"What did you see, Tchelitchew?"

"Something—I—I over there . . . in that corner." He points to where the mouse has disappeared.

The Colonel and General look and exchange glances with each other. They are utterly blank, of course, dumbfounded.

"Do you feel ill, Private Tchelitchew?" The Colonel is courteous. "There is nothing there. Look!"

Pavlik's hand goes to his forehead for now he is merely scared and confused. What can he say he *saw?* His hand drops across his eyes so that his superiors will not see the sudden glimmer of guile that appears there.

"You had better see the doctor," says the General severely.

The last two days Pavlik has been riding around in an open automobile in the hot sun. Smoothly, he slips into a standing position and sways slightly. "Do excuse me, sirs. I feel a bit dizzy."

Immediately the General calls an orderly and has Private Tchelitchew escorted to the doctor's office.

Tchelitchew has seen this doctor often and they have their little jokes together. Pavlik stares for a moment, now, at the friendly man who is searching his face. "Have you fainted, Pavel Fyodorovitch?" he asks. "Have you seen a ghost?"

"No," thinks Pavlik, "it will not do to try to carry it through with this medical man. It might lead to complications. I will make it simple!"

Suddenly the young cartographer relaxes with suppressed laughter. "You will never believe it—you will never believe it!" His subdued falsetto gasps out as if he were bursting with the fun of it. "I have just jumped on a table out of fright because—because—I was sitting with the General and the Colonel . . . Right on the map between them I jumped, yes, because . . . I saw a mouse, good doctor! You see . . ." Humbly, his face assumes more serious lines . . . "I am really afraid of mice—it's ridiculous but it's true"— he stamps his foot with the ecstatic absurdity of it—"it's even crazy, but it's *true!*" And with another gushing sigh, a ravishing smile garlands cheeks which actually have begun to blush.

The doctor's face, eyes wide, is a *tableau vivant* of amused surprise.

The young man now completely relaxes and his voice becomes steady and soft. "I told them I saw something—you know, an hallucination or something. Dear doctor, you must get me out of this. I can never confess the truth!"

"You—you say you jumped on the table, between them, just like that?" The doctor is terribly amused. Pavlik just drops his eyelids and slowly raises and lowers his head in majestic ascent, like a prima donna portraying an empress.

The doctor slaps Pavlik on the shoulder and gives a roar of laughter, which he abruptly checks.

"Sssh! Not a *word!* But you probably need a rest, don't you, my boy? I shall write in my report that you have a touch of sunstroke—that will account for the hallucination—and I'll suggest a furlough—you haven't had one, I believe. Two weeks. Will that do, eh?"

Pavlik starts beaming. "I'm so tired, truly, truly! Thank you. It is wonderful." He embraces the man, kissing him on both cheeks. "I must thank that mouse, too. Really, it is too funny, no? Oh, you are good! I want to see my half-sister, Varya, who is in Sevastopol with her husband, Alyosha Zaroudny. I will go to them!"

Three
HELL

> Verily I swear by the stars which are
> retrograde, which move swiftly, and
> which hide themselves; and by the night,
> when it cometh on; and by the morning,
> when it appeareth; that these are the words
> of an honourable messenger, endued with
> strength, of established dignity in sight
> of the possessor of the throne, obeyed
> by the angels under his authority, and
> faithful: and your companion Mohammed
> is not distracted. He has already seen
> him in the clear horizon: and he suspected
> not the secrets revealed unto him. Neither
> are these the words of an accursed devil.
> Whither therefore are you going?
> MAHOMET

At Sea

Close to the bare feet of Pavel Tchelitchew, in his self portrait standing at the easel in *Phenomena*, is an expanse of brackish water representing the edges of all natural bodies of water and going almost the width of the scene. It is murky, shallow, semi-transparent, populated: the purlieu where scum and waste collect, dead things are washed up, slimy water-creatures breed. Macrocosmic, rather like a map's coastline, it is a version of the primordial ooze out of which life first crawled. Now Tchelitchew sees the invisible port of Sevastopol, miles behind him, also crawling, but with ships and ranked soldiers, confused, struck with fear, in the turmoil of flight. Russia, *his* Russia, is now the dim distance, dropped back of the sea's broad blue mountain. This particular ship has sailed, however, from Odessa.

In November, 1920, the Western army of the Whites has to let go its last hold on Russian ground. Ponderously, with sinister jerkiness, the desperate General Baron Wrangel, routed after his recoup of the war against the Reds, starts to move his beaten troops to Constantinople, occupied by the Allies. Months before, Pavlik's mind, attacked by the emotional arguments of Varya and Alyosha, his brother-in-law, has faced the alternative of being Sovietized or Europeanized. As a White soldier, what chance has he—? The Staretz' prophecy and his own obscure demon combine to decide him even as he sympathizes with Varya and Alyosha, who wish to stay, adapt themselves to what they call the "inevitable." Manya, now back in good health, has already declined an opportunity to go abroad as governess in a well-to-do family.

Away from his military division, Tchelitchew sees his destiny materialize in the negative. He is cut off. Instead of behaving like a fugitive White Russian soldier, he will behave like an adoptive European citizen: so, as a speaker of

French, he has gone to the French naval authority with a personal appeal. A curious weight hangs beneath the civilian raincoat (rather worn) Alyosha Zaroudny has given him, a weight that is half his mourning, deeply stirred heart, half the wad of rubles pressed into his hand by Varya at their farewell. Too big to fit into his wallet, the wad lies where he can casually, spasmodically feel it whenever he thrusts his hand in his trouser-pocket.

The fatal order of evacuation (another official order!) has not caught him unprepared; no more alarming is it than what he used to call "the crash of Brunnhilde"—from now on, he expects Wagnerian, operatic climaxes in his life. Musically initiated, far seeing, he is the brave hero who can, with the help of magic, circumvent or annihilate disaster. He knows that for many hours now a tempest has seized on his mind and tongue. J. F. Darlan, his intermediary, has noticed and tried to assuage it. It is the tingling future possessing him, he tells the sympathetic naval officer, who responds by painting Europe as welcoming a refugee of genius such as Pavel Fyodorovitch.

"C'est très bien, mon ami," Darlan assures him. "All Europe is before you. Constantinople is the doorway to everything—to Berlin, to Paris. You belong in those cities, eh? You will get to Constantinople and you will be safe. There will be theatres—peace such as it is—no Reds . . . Don't look as if you had seen another mouse!" The genial man's laughter rings out and is music to Pavlik's humming ears. He tries to respond to it: he has practised his laugh in Kiev as if it were a soaring coloratura, an aria with wings above the heads of the chatterers at the Souvtchinskys'.

"There will be thousands of Russians, I mean Russian civilians, in Constantinople by now," Darlan goes on. "You will be at home and it will be your first taste of internationalism, of the true Europe! You say you have Turkish blood. So it is perfect, n'est-çe pas? Constantinople has Christian blood!" He laughs again. "Wait till you see *our* Santa Sophia: a dream beyond your dreams!"

Pavlik is feeling queasy; he keeps noticing the wine in his glass as its surface trembles and tilts with the motion of the ship. He would really like to be in bed; he is infinitely weary. "As for being poor, some of the refugees are doubtless poorer than you at this moment." It is still Darlan's voice. "Anyway, you have the key to the Golden Gate right there!" Adroitly, the naval man taps Pavlik's fingers as they grip the stem of his glass. Once more the young artist has been told of the Golden Gate by his kind new acquaintance. It already floats in his mind as a tangible thing; indeed he has thought of it in the first redgold light of dawn, facing him now. He can hardly tell why but he is on deck this morning just as the first rays of the sun appear. The cloud-sown West toward which the ship moves is not yet alight above the colorless mass of the Black Sea, although the East, toward which he turns again to

watch his first "European" dawn, is steadily brightening with its lurid promise of the day.

His effusive thanks to Darlan last night come back: "How can I ever thank you for your kindness? You, *you* are my guide through the Golden Gate! I am homeless, a real exile." In another leap he is on the poetic, the operatic level. "You are my *Virgil!*" Driven on deck so early, from a sleep broken with rolling from side to side, avoiding the black *angoisses* of his dreams and always, persecutingly, against the insistent pitch of the ship, he surprises in his head a new clarity, itself a dawn: almost a new balance as if he had caught and mastered the sea rhythm. He has recited his past to his host, even the stories of his ancestors, but he has omitted the Staretz's prophecy, which is a little too sacred. This is the first ocean, Constantinople the first city, of the old monk's illuminated vision.

Pavlik's imagination clutches reality to him like a luxurious fur coat. Why is he suddenly aware that there is a *lunar* as well as a *solar* dawn? Because he left Odessa at such a time and because—because, last night, he mentioned Virgil as Dante's guide! Of course. There is a moment past sunset, in the great poet's journey up the mountain of Purgatory, when he drops exhausted to the ground and sleeps through the night before he and Virgil enter the Gate of Purgatory. Wakened in agitation by a dream, he stands and then Virgil shows him the gold and silver keys that open the Gate. It is dawn . . . the dream . . . that was the point! Dante dreams that he is caught up, like Ganymede by Zeus, in the talons of an eagle and is carried so high that the sun scorches him: this is the moment when he awakens.

Yes, Pavlik can clearly remember a certain phrase of the poem that makes him, Tchelitchew, like Dante in the rôle of Ganymede. And why not? Has not Darlan caught him up at Odessa as if to drop him beyond the Golden Gate at Constantinople? And do the Elysian Fields themselves not lie in Europe—in Paris if nowhere else? His mind is still drunk with the wondrous reality of the world in front of him. Out here, the wild fresh air is sobering, sustaining.

Gold and silver keys . . . holy keys. He has told Darlan of the gold armor of Donskoy which his ancestor, Tchelish, exchanged for his own silver armor. Yes, yes! From the lunar to the solar gold! And the arrow that pierced Donskoy-Tchelish's forehead, it killed him—that is, killed *Tchelish*. But symbolically he lived on, in Prince Donskoy, the saintly hero, as well as in himself, his descendant, Pavlik. So the arrow is magically plucked out, the hero's forehead healed. In fact, the sky in *The Divine Comedy* symbolizes something strangely his own: the poet mentions that the constellation Aries is ascendant; that is, he speaks of the Ram, some words about the sky as a bed and the Ram (that is, the *tchelo!*) "bestriding" it with "all four feet." Freezing tears—despite the fact that he is huddled away from the knifing sea

wind—have formed in the young man's eyes. Is there not also, along there, an image about a happening being "nailed in the midst of" Dante's head? Ah, how much is miraculous if we look closely enough! Then Dante's forehead received the ritual imprint of the seven P's, the Peccati, standing for the seven deadly sins.

Tchelitchew has counted, some time before, the forming lines in his forehead (only five now) and does not know that the future seven will represent, according to astrology, the influence of the Sun and Moon and the five major planets. On his first voyage, he thinks the lines are Dantesque and that maybe he is doomed, being only human, to commit the seven terrible sins. He wipes his eyes, a sort of breathless little sob in his throat, and looks West again: toward the dipping prow. The seething watery vista—is that a hint of Turkey beyond?—seems solid, as if supporting the faint pink invalid of the sky. The world, while he lay with fever in Novorossik, seemed the same hot sick color as this.

Pavlik quivers. Yet it is not a sob, but ecstatic joy, that tends to choke him. Fear is simply a small icy point veering around crazily in his stomach. What he needs now is a cup of hot, hot tea! Without another thought he dashes below.

And in the hatchway, he has to clutch the rail to prevent himself from falling forward with the ship's perpetual lurch. It is as if a thought in his head—another memory of Dante's poem—had been dislodged and flung against his eyes. He used to wonder what Dante meant by saying that, when Zeus kidnapped Ganymede and brought him up to Olympus, the latter was "abandoning his people." It was, of course, a reference to the fact that Dante, a *White* Guelph, was banished from his home, Florence, and wandered Italy as an exile; then, when allowed to return eventually, had *not* done so: Dante had, in effect, "abandoned his people." Now he, Tchelitchew, a *White* Russian . . .

Symbols, symbols . . . He has to jerk himself completely awake.

His feet are planted on real, not symbolic, stairs. He is in the world at last . . . *at last* . . . *at last.*

At Constantinople

A chill wraps the bright air but the young man waiting for the Galata Bridge to close again—wearing heavy corduroys, a gray cossack hat and a striped muffler—is rosy-cheeked and does not seem to mind. Already he is less aware of the city's pinnacled heights, which he saw from the approaching battleship, than of the ground level he has in common with the human and vehicular traffic that has coagulated here before resuming its course over the bridge to Pera. He has been visiting the great mosques in the city proper, where the remains of three walls, built in sequence by Byzan-

tium and the Emperors Constantine and Theodosius, separate the promontory city from the mainland of Europe. This bridge across the Bosphorus is opening for a ship. Trams are also waiting to cross while the ferries continue plying their way back and forth. A while ago, he thought of taking a tram back to Pera, the European and residential quarter, but unexpectedly he felt an afflatus, as if wings had sprouted on his ankles, and he had decided to walk back, at least part of the way.

Young Tchelitchew feels very, very light on the earth of Europe. As one easily frightened, so alert to dangers, he is for the moment extraordinarily confident and carefree. Is it because of Santa Sophia, where he has stayed for almost an hour? The great church is still a mosque, of course, it has not yet become a museum. In the schoolroom at Doubrovka, he learned that Constantinople, like Rome, is built on seven hills, and he knows of course that this holy edifice, Santa Sophia, reflects the historic political changes Turkey has undergone. Byzantium's Christian Empire fell nearly five centuries ago—Santa Sophia was the futile refuge of frantic Christian ladies appealing to the Virgin. But these poor women were dragged away, shrieking, by the Turks, and the orientalization of the church began at once. In distant centuries, the same seesaw happened to Constantinople as happened recently to Kiev in months.

Soon, in Russia, there will be little or no religion; for some reason, Pavlik's lips silently pronounce the word, religion, as did Emma Johnson, his old "American" governess—that is, he tries not to make the first "i" sound like "ee." He hardly succeeds. As for religion, he knows that Turkey's government, anxious to modernize the nation, decided long ago that secularization was the thing. That is why even the fez is not very frequent any more. And the fez supplanted the turban, which was officially banned by edict. Now more than ever, in this time of war, Constantinople is polyglot, international, heterogeneous; it also, Tchelitchew notices with distaste, has an enigmatic mixture of sloth and energy, freshness and decay. The young artist's delicate olfactory nerves are too often antagonized in these streets. The Great Bazaar? All Constantinople is one! In the Galata region, they sell almost anything in the world—from trained fleas to furs—and one hears the hawkers competing with the sound of phonograph records. As for phonographs, their sound is the young man's first big black mark against his new homeland, the continent of Europe.

People have told him he will find the mosques almost empty, and it is true; almost empty of worshippers, yes, but not of light. He is rather soothed by the scattered sound of prayers in Santa Sophia. The many-domed church is flooded with sunlight, both direct and reflected; the interior, punctuated by hundreds of windows, is subtilized by the busy, lavish filigree around the porches and the tops of the great columns; the whole place glows as if the

suffused light came from within, not from outside. The labyrinthine formalized designs, clinging everywhere, communicate a perpetual motion, a fine rhythmic pulse, to the inhabiting light.

The Turks, whose religion forbids representation of the human form, have left only a single mosaic over the central doorway of the great church: a figure of Christ. Extraordinary, thinks the young man in the cossack hat, the Mohammedans actually esteemed Christ as a saint and thus today this figure of Him is intact. The great legend of this place is true: the expanding hemispheres, seen from inside, make the marvelous building float; they spring aloft and make the whole church hang—yes, quite true—on that gold cord from Heaven. Santa Sophia is intensely exciting. *Here* he does not feel alone, or adrift in a strange land, a grim adventurer; he is caught up as one in a great soothing element like some synthesis of earth, air, fire and water—some magic synthesis.

Perhaps (he reflects as the Galata Bridge is nearly closed) a certain gracious severity is contributed to Santa Sophia by its complicated traceries, affording a foliage for its treelike columns, so much like the pines of Kolpin Bor which he will never see again, he supposes; never, never again. Is it possible that the mixture of styles helped produce a masterpiece purer, even if not more "perfect," than the original Byzantine church? Pavlik decides this is so. That irresistible light, penetrating to the very soul, is superior, no? to the concentrated shadow of Russian churches, the latter lit (it is true) by many candles, but still only a brilliantly illuminated gloom . . . not the full lucid grandeur of the sun itself: a saturating sublimity, that somehow is neither Christian nor Mohammedan, but beyond all creeds . . . an epic poem of light, the song of the heavenly spheres—

The Blue Mosque of the Sultan Ahmed nearby is, from the outside, more beautiful than Santa Sophia because of its superior detached minarets: so slender, like poised dancers in choral formation. The Galata Bridge is closed and he starts across in the human stream. Even while thinking of Santa Sophia, the young man has allowed his eyes to fix first on one military uniform then another; they hover and disappear sooner than he would like because of the crowds hustling past, never really still. Constantinople is full of Allied soldiers, mostly the British, and he tries to study each face— usually young, refreshingly open—to descry the nationality indicated by the uniform; very soon, since landing, he has become a savant of military styles. And tomorrow he begins work on his first theatre project!

To his joy, his very first inquiries about the city's theatres have turned up the presence of a small dance company headed by a Russian, Victor Zimine. Zimine! A pupil of his own ballet teacher, Mordkin. Things could have been much, much worse. At least, he is in harness, making progress. Zimine's

theatre is not much, only another cabaret affair, with limited resources, but it is part of a hectic liveliness pervading the whole city. Once in Constantinople, his anxiety about money has been strangely allayed. Having little, barely enough, is so common here. The city indeed is full of Russian refugees. But Pavlik dreads meeting these as much as he welcomes it. Particularly the faces of the women disturb him. They make him think of his sisters, above all of Choura, of whom the family, he learned in Sevastopol, has lost track. She was a *sistritza*, an Army nurse. In pained wistfulness, he wonders if she could possibly still be attached to the Army; if suddenly her face will appear here at a cafe table or on this very bridge! What would he do? She would be so unlikely to have any money. As much as he tries, sensibly, to dismiss thoughts of the family he has left behind, every Russian face, every Russian word, evokes them. He *must* get rid of this black response which makes his heart turn over in his breast.

Bon Dieu! He is in the middle of the bridge and has just seen a woman's face, oddly familiar. No, she is not Choura, of course! Yet he does not need to be clairvoyant to know she is Russian. Her face is whisked away as their eyes meet, stay fixed for three or four seconds; now she has turned on her heel, putting her parasol between them. His impression is only confirmed. Within the spiked oval of the parasol, her silhouette shows. The face was haggard, not even pretty, but it was outrageously powdered and rouged, the lips falsely curved and emphasized as if for the stage. This woman in the flimsy light blue dress and dark brown fur jacket is surely a whore! There are so many of them in Constantinople, brazenly identified by the standard umbrella, large purse, painted face and cheap frills.

He prefers not verifying if this one is Russian. So abruptly he hurries on, almost getting involved with a pushcart loaded with postcards and other souvenirs. To his dismay, he finds the Turkish vendor only inches from his face, feels his hand on his arm and smells his horrid spiced breath. Startled even more, Pavlik glances down. Being pushed into his stomach is something like a deck of cards—the top one is a pornographic picture! In a split second he sees a naked man and woman cohabiting—he in a fez, she with veiled face; the man has the ecstatic grin of an idiot. "Svinya!" ("Pig!") Pavlik growls, and thrusting the man aside, dashes on. An aria of persuasion follows him.

Enough . . . Is it possible that his poor destitute people, fleeing from revolutionary Russia, have come to this? Who knows, he may even have met that unfortunate woman in Kiev at the Academy or at Souvtchinsky's! She looked like a lady in disguise. Despite the moisture in his eyes, his jaw hardens. No, no, he simply cannot let himself be cast down by such things. He must be full of cheer, he must woo—he must charm, charm, charm. It is gloomy enough that he, Pavel Tchelitchew, has to sell his artistic talents like a

putana. One momentous fact (aside from finding Zimine) has encouraged him. Led on his first night in the city to the Lighthouse, a cafe like a villa, located in Pera and organized by the American Y.M.C.A. for Russian refugees, he has met a compatriot whose story is very similar to his own, Vladimir Dukelsky (later Vernon Duke). Dukelsky also was in Kiev with his family and contrived to get to Constantinople. He is a composer and remarkably congenial: often he sits at the piano in the Lighthouse, playing his own songs, or entertains soldiers at famous Turkish cafes.

Pavlik has elected the Lighthouse, naturally, as his own headquarters during many waking hours. It is good and bad to taste old Russia away from home, to hear his language as usual. The British who are in uniform get maudlin sometimes and bawl out the soldier songs: "Tipperary" for instance; the exotic word, the colloquial speech, fascinate Pavlik—nostalgic, sentimental, unutterably vulgar yet somehow, in this strange nameless milieu, also genuinely moving. These singers, too, are far from home. At times, Pavlik sits with a dreamy, coquettish smile sculpting his lips, listening to the incredible foreign songs. There is a horrible one, so inept now that the European war has been won; once, when a stranger insists on it, Pavlik hears from Dukelsky that it is American: "Johnny Get Your Gun." The fired, hortatory monosyllables commanding young men into uniform, seem repulsively harsh: "Get your gun, get your gun," and something about "keeping the Hun on the run." Slang itself is an abyss! The song is grotesquely sad, grotesquely funny . . . like a voice of the dead loud in the ears . . .

The Tommies are typically lean, more so than Americans he has met, crude yet likeable creatures, surprisingly refined, oddly informal, sociable. Pavlik is attracted. If officers, they have the chic angles of the English quicker-than-the-eye-and-ear style; clipped, overassured. Even the humble Tommies have traces of that. However Pavlik is training his eye to be unsurpassably swift, and beneath the manner, whatever it be, the flesh, with its muffled wishes and habits, does not elude him. At the same time, he tends to slide off the hard, polished outer English surface; the thing is to say nothing explicit, feel for the soft spots indirectly; they are there . . . Pavlik's manoeuvres, nevertheless, are wary; his halting English is a perfect gambit. He is forever laughing with the Russians, sad as some of them are. Laughter's universal language helps authenticate the wariness needed in this "new world" of Europeans and Americans. In certain matters, the young artist notes, Europeans are apt to present more positive or more negative reactions than do Americans. Americans, it seems, have a sort of innocent neutrality about sex. Pavlik is unsure if this means they are less disposed, or more, to the peripheral things that engage his sensual life. In any case, it does not matter, for they are big babies and nothing of the kind can be serious. More even than to flirt, Pavlik loves

talking about the Allied soldiers to his friends, speculating, making naughty jokes and slyly pantomiming them.

Dukelsky, in his volume of reminiscences, *Passport to Paris*, recalls the times spent in the Lighthouse and describes Tchelitchew as "an apple-cheeked Adonis . . . fond of exuberant laughter and good-natured practical jokes." The distinctive Tchelitchew aria gets much exercise in the smoke-filled, noisy cafes in Constantinople. Its keynote is teasing. What Dukelsky calls practical jokes serve as gentle provocations with a safety-catch. Pavlik's practical jokes are rhetorical, a form of conversation. "Cock-and-bull stories," Dukelsky casually terms the other young Russian's fund of teasing: stories about "vicious criminals," as he reports them, "lying in wait on dark streets" and "300 lb. Galata belles lying in wait to seduce him." With melodramatic seriousness, Tchelitchew has begun his lifelong game of drawing people out, tricking them into possible self-betrayals, intimacies of confidence. It is all, primarily, not life, of course, but theatre. Pavlik knows that sex can be a form of metaphoric bottom-pinching, and that metaphoric bottom-pinching can be, ought to be, a comic art.

Perhaps young Dukelsky is not quite aware of his new friend's special temperament. But his new friend is himself deeply aware of it. *He* is afraid of that midnight Oriental look, the hint of knives and soft-footed violence, and acutely embarrassed by the trafficking "belles" who unknowingly challenge his manhood. What never flags is the joker's gayety, at this stage untainted by malice, and his erotic zest: another lighthouse. Occasionally the sexual *élan* is serious underneath, but always, like a jester, wears a coat of playful innocence. The young artist's sexuality is only that of the archetypal child: defined by Freud as "polymorphously perverse."

His colleagues at Zimine's theatre see in him a true Russian who is a bright young spirit, energetic, talkative, always *present;* little else matters. In fact all of them, including the female dancers, like the young artist; his expressive mouth and eyelashes, his explosive good humor, the waving hair that he trains across his forehead, one errant lock always escaping under his hat; even the perpetual teasing. Some women are flattered by so much warm attention from a handsome male; nearly always they guess it to be erotically "harmless," yet for that very reason they are grateful: one can have the pleasant atmosphere of courtship, so to speak, without its hardships, its danger to the heart. The Tchelitchew shoulders are elegantly hunched, creating a roundness at the back that is really a depth of chest; he looks, striding rapidly along, like a runner getting set for the starting mark. The hands are eloquent, fluent, the elbows trained close to the waist in good style. In walking the feet are placed at a curious inside bias, as if he were slightly pigeon-toed, but he is not.

Here, as in Kiev, Pavlik must work with his costumes simply. His balletic ideal is still Ivanov and Petipa—the sure, soft but grand, wingèd courtliness. Yet nowadays something else pervades even balletic air; here, moreover, the imposed economy suits the trend. Tchelitchew cuts his costumes straight, like the basic upright of buildings, but keeps his eye on the human being wearing them, on the chance anatomic bias, the points where the breaks come: the articulation meaning movement, as in bends of knee and elbow, and at the waist—the true axis of dancing. Sometimes he gets to talk of these things at leisure, around a cafe table. Here, with gestures, he designs costumes in his imagination. Once he is demonstrating how an actor at Mardjanoff's theatre stood for half an hour while he cut out a costume on him without pattern or sketch, straight from his head. He sees a man enter the cafe and guesses he is Russian—but he turns out to be not "only another Russian." The painter, Serge Soudeikine, is there and brings him over while Pavlik's hands still mime the costume.

"You know Pierre Souvtchinsky and Anna Ivanovna!" says the man to him. Pavlik jumps up, embraces him. "Oh, my friend, yes, and you are *très cher* to bring me news of them! How are they? And *where?*"

"Here in Constantinople! They are dying to see you, Pavel Fyodorovitch." Pavlik kisses him and desires the address of Souvtchinsky and his mother. "Ah, my guardian angels!" quavers the ebullient sentimentalist, all flushed. Without ado, Anna Ivanovna's favorite procures paper and ink to write her. Doubtless the Lighthouse will have their address; he will write even before seeing them. How vivid in his mind's eye is his dear Anna: the small, plumpish woman with the habitual squint that can be so scrutinizing—not that she ever finds anything amiss with him! Anyway, he thinks her rather like a wise Buddhist nun with her mongoloid look. Once she was quite wealthy. The pity of it! But his friends cannot mean to linger here in Constantinople. There seems little future in Zimine's theatre, while in Berlin, in Paris, great companies perform. He has met young Boris Kochno, who is full of stories of Diaghilev's Ballets Russes, which have defied the war and during 1919 and 1920, have held London and Paris seasons . . . He will speak to Anna Ivanovna as if she were sitting across from him.

At the top of his sheet he has written "Ma chère Anna Ivanovna" when, at the table directly behind him, a British officer who has been chuckling, starts laughing, then begins to choke. All at once a tremendous sneeze explodes as if down Pavlik's neck. The young artist goes rigid. Now, three sharp sneezes: in quick succession. Have the Tommies' officers no manners? There shoots through his mind the thought that the man is catching cold. *Horreur!* Pavlik does not speak but swivels around, his lips one tense line, all the curved coquetry of his features turned to a harsh, level-eyed rebuke. If present now,

and clairvoyant, one could see this expression exactly as it is where he stands at the easel in the painting, *Phenomena*, sixteen years later, casting upon the world a reproach mute, aggrieved, haunted, askance, abrasive. At the moment, the face is dewy, full, handsomer; later, it will be mature, somewhat gaunt with experience.

The uniformed sneezer, however, has not noticed Pavlik and is smothering his discomfort in a handkerchief. The artist reaches for his own handkerchief and conspicuously, after turning back, wipes his mouth with it and then his neck. Why is his handkerchief so meagre?—it also, he notices, has a torn edge. Ah! When working at the theatre today, he found his nails were long and rather dirty, and was shocked. Obtaining scissors, he carefully trimmed and cleaned them, something he nearly always does at home, for of course the nail-parings must be burned . . . Ever since their maid, Maryosha, told the children about the haunted peasant, right on their estate, who failed to dispose of his nail-parings and was bewitched by an enemy, Pavlik ritually observes this preventive measure against hostile magic. He recalls now that he tore off a good piece of his handkerchief and wrapped the parings in it, putting them into his shirt pocket. He means to burn them in his room for he dare not simply throw them away. Suppressing a sigh, and smoothing back the lock drooping over his right eye, he begins his letter:

"To think that we are all here, not there, not still in our unfortunate ravaged country! I cannot tell you how I felt to be torn away but it was like some voice telling me I *have* to get away. Wait till I can tell you all. I was kidnapped like Ganymede and dropped beyond the Golden Gate. *Un rêve, vraiment!* But my family, it is of them I dare not speak or scarcely think. I have to make my way and am working at Victor Zimine's theatre here. But there is nothing uplifting about it, and so little money; one can do nothing in the grand style, which is what I constantly think of. Oh, my dear Anna, now you *will* have to be another Maman to me! We Russians carry much of Russia in our hearts, but not all. Besides there is reality, the human touch, the voice, the living presence. That is the selfish secret of La Nature. Art can only imitate it as best it may.

"Ah, you should be sitting in this cafe here! It is a strange place for a young Russian who enjoyed all of life's luxuries in his own house once. Our Russian Lighthouse is somewhat different. But I have to mingle, get used to the rest of the world: the cosmopolitan world. Kiev, I see, was only a training school for this Europe, where now I must build my own 'castle,' maybe of sand, who knows? But it must be real, and strong, I have only my hands, or rather, *hand*. You understand me, dear Anna Ivanovna, like no one else, truly. I can hardly hear myself think even, much less write. My friend Vladimir Dukelsky, who was also in Kiev, is playing now the most fantastic songs,

some of them his own, he has what he calls 'jazz style'—*par exemple!* Yet he is a good boy, *gentil*, talented; he is even doing the music for a Zimine ballet I am designing.

"When M. N——, who was here a moment ago, told me that you and dear Pierre are in Constantinople, I could not keep myself from grabbing pen and paper. I swear, if you could see some types coming here, you would not believe your eyes. *Barbares!* You would look once and creep away. You could not 'stop, look and listen.' All languages, though mostly English, and some American, are spoken here—if you could hear the American, not to mention the Cockney! You would not understand the words, but the appearances and the sounds, the gestures and laughing faces, are more than enough for good, educated Russians. Well, 'the Lighthouse' is a strange name for a cafe, *non?* It is a 'house of lights,' I say, going on and off, winking, if you know what I mean, my dear Anna Ivanovna. I am a bad boy, verbally speaking, you know that, but the language in my ears at the moment—*c'est dégoutante, simplement dégoutante.* It is not just sexy, one can be sexy and sexy, there is *such* a difference!—no, I don't mean that. It should be an art, like everything else. I mean something like children's language, like so many Gargantuas in one crib, babbling, singing and laughing. Really, poor boys, I like them and pity them, despite all this. Some have been through Hell, I understand. But it is all over, thank God, in Europe now, and they can all go back, I guess. I give them my Russian blessing. For I think, in my own humble way, I am a sort of holy man in the bud, an evangelist of good and special thoughts.

"But I—we—*we* cannot go back, can we? I think of hundreds, maybe thousands, of my poor countrymen in this city, including women, destitute, with nothing, no money, no hope, friends maybe, but all in one boat, almost starving. I don't know what to do or say to them. The heart is wrung till no tears are left. The more I think of it, it seems everyone, some day, must go to Hell—on this same Earth, I mean, while still living, walking and breathing. I have been in Hell, I think, and I am not sure at all if I am out yet, or ever will be. But with wonderful friends in the world, one can move, one can rise and go away. That is something. Embrace Pierre for me and a thousand kisses for yourself. I shall come to you. *Je t'embrasse aussi!*

> "*Ta pauvre*
> Pavlik."

At Sofia

Sofia. Sophia. The name of the great churches. Oh, there is a vast continuous pattern in human existence such as only the stars, truly, are in a position to detect: stars and star-taught men! Tchelitchew is again on wheels. He thinks

of the curve made by the earth and how illusive, especially when moving, is everything that pretends to be perfectly straight. In his heavy suitcase, for instance, are drawings marked Odessa; surely he stayed in that city for a while—how long? The drawings show the figure in semicircular joined lines: his protest against the sharp angle. Cézanne! For all the official *can-can*, there *is* something bright and new about that French painter, with his genius for simplification and structure. In Odessa, there was a theatre . . . Is it always to be like this—his life? One looks toward a point in the distance behind, from which one is moving away: it becomes smaller and smaller, this point, and vaguer, confused with things around it, perhaps blotted out before distance swallows it. Just what is left, even in his mind's eye, of Constantinople? Such is the past, the clumsy past. Eyes ahead! Watch for the tricky turns of time . . . No sooner was he mailing his letter to Anna Ivanovna than, spank! he ran square into them at the Lighthouse. They were soon to leave for Sofia. Mme. Souvtchinsky said there is work there in the theatre. Why not come? Pierre has gone to this Bulgarian city for the sake of an old ideal in a new dynamic form, the Eurasian Movement, in which he will join the distinguished Count Troubetzkoy. They mean to start a magazine and work very hard.

Anna Ivanovna's rather nasal, expletive tones have taken on the breath and warmth which inform her son that she would dearly like Pavel Fyodorovitch there too. Yet the actual invitation to the young artist has arrived only after mother and son are settled in Sofia. Pavlik is very tired, jolting in his seat in the railway coach. His eyes close as the glad smile fights to maintain itself against the gathering dusk. Why, he vaguely thinks, don't they light up the coach? But light, what will it show but common, stupid, suffering, fearful humanity all around?—he has enough in common with them without light, too. The dark—the dark—it is a sort of handcuff binding him to them all. When he becomes drowsy like this, he often thinks back to the Russian folk heroes with whom he identified himself when a child.

A volume of Russian folk tales supplemented Tyapotchka's orally told stories at Doubrovka. Though preferring the religious tales, Tyapotchka had her own versions of some of the others. Which? It must have been, of course, that about Emelyan the Fool! Could he be a sort of Emelyan now? True, he did not like him when he first heard of him, for he was a regular village idiot, but it turned out he was a great knight, anyway—a Bogatyr, *par exemple!* In the end, by inconceivable great deeds, he triumphs over everything till he achieves the greatest luxury and happiness—and of course the hand of a princess. Maybe he, Tchelitchew, is also a young fool for carrying only his bundle of drawings and paintings on his back and hoping to make a fortune. Certain fairy tales are too trite and facile. Perhaps he could have told Emelyan the Fool—the real Emelyan—a few things, for since he left Dou-

brovka, he has learned a lot about the world one lives in. Yes, starting with Kiev . . . And suddenly he recalls the Robber Nightingale, the villain of another tale.

Was not the Robber Nightingale somewhat like Machno, the bandit who pillaged the Ukraine till finally he was caught and killed? Dozing, Pavlik hears a piercing whistle from the train's engine and starts up, eyes wide. *Bon Dieu!* How he dislikes such absurd frights. The Robber Nightingale, says the tale, *had a whistle that killed.* The hero is a mere child, Ilya of Murom, and yet he is thirty years old before he can walk! He has made himself a suit of armor, if you please, and a spear, and with them he appears before his parents. "Dear Father and Mother," he says, "grant me permission to go to Kiev and deliver the city from the pagans." Yes, *Kiev!* Going there on his fine steed, Ilya meets a whole army and defeats them single-handed; the city is freed and again becomes Christian . . . Wanly, Pavlik smiles. He too went to Kiev but he could pretend to no motive like heroic little Ilya's; no, his talent is not in that direction at all. The artist recalls more: the Robber Nightingale, still a menace, has a nest on top of twelve oak trees, but Ilya, brave, all alone, seeks him out because, just as did the Machnos, the Nightingale persecutes the countryside around Kiev. Taking an arrow from his quiver—Pavlik winces. The Devil!—why, Ilya forthwith shoots the Nightingale in the right eye and kills him! Before now he never made this peculiar connection with himself. But it's all ridiculous, *enfin:* he, Tchelitchew, is an artist, and if a hero, will make his fortune as such. As for armor, that is quite symbolic. Real armor, and all that, means war—there is too much war in fairly tales: *that's* what is wrong with them!

A volume of Krylov's tales was also at Doubrovka. Tyapotchka did not like these because, she said, they were about the wicked world. Pavlik wonders now if she read the one about Apelles, the ancient Greek artist. Poor Tyapotchka, this little tale would have puzzled her greatly. But the young inquirer after worldly knowledge felt certain that *he* got its point: he is sure of it now and thinks it even funnier. As for its truth . . . well, wait and see. Krylov, famous Russian, wrote of Apelles as if he were alive today. There was, he says, a "little ass" who became aware that the great painter was paying him court because he wished him as a model. It is all in rhyme, making it the more divinely absurd. Pavlik does not know it, but a future commentator will affirm that the fable was based on an actual experience of the author's about a young man who complained of his attentions when they would meet at the library. The fable goes:

> Apelles, meeting with the little ass,
> Invited him to tea that very night.
> The little ass was trembling with delight.

He prances through the wood; he pesters all who pass:
 "Apelles bores me so;
He will not let me be, you know!
 Whenever him I see
 He asks me in to tea;
I'm sure he wants to paint a Pegasus from me."*

Pavlik laughs out loud, a restrained laugh, all to himself; for his eyes are still closed. It turns out that the great artist wants to paint a "Judgment of Midas" and wishes to use the little ass for his long ears: the *longest* he ever saw. Delicious, delicious! Who knows—? The rosy young Russian jolts contentedly along. Symbols, symbols . . .

Souvtchinsky declares that Tchelitchew, in Sofia, promptly embraced the concept of Eurasianism. Undoubtedly it assuages the artist's gloomy conscience about his country and the Revolution that is now established there. The essential idea of the new movement is Russia itself as distinct from both Asia and Europe. In any case, Tchelitchew is well fitted to design the cover of the first number of *The Eurasian Manifesto*, the title of the movement's literary organ. Now, already, it is spring; he has spent barely six months in Constantinople. But he is rather disappointed in Sofia; the theatres are hopelessly dormant, their directors "worried." Pavlik works at the easel, however, and holds an exhibition of portraits and landscapes in oil. The ambitious youth misses, in the public's reception, the acclaim he is certain awaits him in Europe's big capitals of culture.

Sitting at Anna Ivanovna's feet is a perfect position to induce her to look up at him—so humble, so young and gifted, so yearning and enthusiastic. Nor is this posture insincere: Tchelitchew admires the culture of this kind little old woman, to whom he comes in the spirit of respect which the well-brought up young of his time are supposed to feel for their elders. Count Troubetzkoy has a true philosophic mind and Pierre is simply the perfect apostle of their "idea" but . . . it is clear to Pierre's intelligent mother, before the young artist gets to his feet, that Pavlik's career just can't be held down to its present horizon.

The summer passes, lazy and luxurious for a poverty-stricken artist. Yet under its bland surface beats an incessant pulse: "Berlin! Berlin!" Several times, Souvtchinsky has mentioned this city as the place to carry the message of Eurasianism; the Russian colony there, it seems, is enormous. Tchelitchew's cover design for *The Eurasian Manifesto* helps explain why Russians in particular should find it easy to merge with the capitals in Western Europe. The design, in black and red, is a very bold one. Drawing on his recent experience as a cartographer, the artist has made a map in which the

* From *Krylov's Fables,* translated into English verse by Bernard Pares.

Continent of Europe represents for Russia what the oceans represent for other countries: one smooth, open path of communication spreading everywhere. This is the implication of the Eurasian precept—and the Staretz, thinks Pavlik, must have known about it. Yes, for the wise, everything has its paradox.

Setting out for Berlin with the Souvtchinskys, Pavlik realizes that, despite his accord with Anna Ivanovna's son, Pierre is not, for him, a certain quantity. For *his* emotional nature, Pierre is too mad on ideas, even on idealism. Souvtchinsky and his mother are very much in earnest, to be sure—were they not, in their palmy days, Prokofiev's sponsors? Yet Pierre's intellectual type is too cool, too distant from the heart. Pavlik wonders about the Kochanskys, Paul and Zossia, the friend with his own given name—maybe, in Europe, *he* ought to be "Paul" rather than Pavel. It would be more Eurasian. Now there, in Zossia and Paul, is *heart:* the true temperamental Polish heart: so akin to the Russian in spite of their nations' old enmity. The Poles are proud and tender; the intellect they can take or leave, but art, this comes first with them. Whereas the Russians . . . Actually, Souvtchinsky's concept of Eurasianism is ideal for refugee Russians thrown upon the European continent; it makes the future beckon and seem easy as if they had visas marked *Anywhere, Any Time.* Still, this assumed a curious thing: there must be something about Russia alien to the rest of Europe. Well, Russia has the blood of the Orient, a Tartar strain and, in him for instance, Turkish. Could anyone better qualify as a Eurasian incarnate than he?

The Kochanskys, meanwhile, have left Europe for New York, and when Pavlik is in Constantinople, they are settled in that city at the Wellington Hotel, the site of a large flourishing musical colony. Recently Zossia and her husband have met a sympathetic, starry-eyed young pianist who has put up at the Wellington and who dreams of pursuing his career in Europe. He has brought personal recommendations from Chicago: his name is Allen Tanner and distinguished musicians speak in his behalf. From Anna Ivanovna, the Kochanskys hear of Pavel Fyodorovitch, who is staying with them in Sofia; later they receive word that he will go with them to Berlin. Finally a letter has come from the fervent, tireless youth himself. "What courage!" exclaims Mme. Kochansky, stirred by memories of chaotic Kiev. "What *courage!*" One is tempted to see forming in New York, at the Wellington, those lines of Fate and Fortune in which Tchelitchew increasingly believes. For one thing,

Tanner (as yet unaware of the fact) has been born just eight days away from Tchelitchew: on September 29th, 1898.

In our hero, what the world has come to classify as base superstition has achieved a personal status of the noble. To "believe in" the stars and their influence is, like poetry, a legitimate attribute of the sublime. Nor is this attribute to be thought a mere dignified vestige of romanticism. In all common sense, the importance of astrology as a science of myth has not been tossed aside by all twentieth century thinkers. Jung, for instance, has posed in concrete form an argument tripping up the rationalist position on astrology. Scientific rationalists assume a causal relationship is supposed to exist between the fortunes and nature of the human individual and the nature and position of the heavenly bodies at the time of human birth and later moments of crisis in the human life span. Jung* replies that this is a misconception of the object of criticism; the basic astrological principle is not *causation*, he says, but *synchronicity*, or the ancient concept of the unity of things as reflected in the total prism of the cosmos, which like a clock has its own time. What all the mystic sciences deal in, therefore, is not accident or chance as fortunate or unfortunate but *coincidence* as the manifest crucible of harmonious and inharmonious forces: what we call "fate" and "fortune" are the psychological mirror of these forces.

Tchelitchew's known future illustrates the principle of synchronicity. When, on July 31st, 1957, he will die in Rome, his ruling planet, Mercury, will have just passed into the zodiacal house of Virgo, under which he was born according to the system of fixed correspondences. Such synchronicities are deemed to carry special weight; in fact, this repetition of life by death accords with the already documented fact that Tchelitchew, years before he dies, will realize he is courting his earthly end through deliberate self-risk; he bears within him an against-self, or antagonistic double, which matures as he matures. Exactly the same synchronous phenomenon was true in the past, on August 14th, 1918, when the Tchelitchew family received the Soviet order to evacuate their estate and became, momentarily, homeless: *Mercury was then in Virgo*. This was the real beginning of the artist's lifelong exile from his native land (Virgo connotes "earth") and so a critical turning point in which his own decision became a final factor: his choice (motivated by the Staretz) of flight to Europe.

The youth of twenty, suddenly thrown entirely on his own, has long ago exhibited the traits traditionally associated with the two "spheres of influence" (the zodiacal houses under the ruling planets) in which he was born: Virgo the House of Earth and Gemini the Twins, both in Mercury's domain. Long before he becomes acquainted in detail with astrological doctrine, or orders a horoscope, the artist reveals as a Gemini person (besides a pro-

* Quoted by MacNeice: *Astrology*. p. 74.

nounced dualism) "adaptability, mobility and vicariousness," the last to be understood in his case as aesthetic projection; as a Virgo person, "diligence, care, tidiness and correct behavior." All those knowing Tchelitchew in his years as boy or man have supported, or can support, the accuracy of this orthodox reading.

As we shall increasingly witness, Tchelitchew's belief in hidden forces and vital secrets is on a supernatural plane of which astrological doctrine is but a single formulation; as he discovers, there are many other formulations. Uppermost as his character-determinant is the mythological and mystical instinct of his mind. For him, painting quickly becomes a science of emblems, the nucleus of a growing symbology. Not that he ever relents in the attitude of a conscious and conscientious craftsman. Steadily he develops his own speculations which, in the 1940's, will reach a commanding maturity. Lincoln Kirstein has composed a record of Tchelitchew's formulations regarding Perspective, Space and Volume. "An accident in art," the painter asserts there, "is the evident presence of the spontaneous soul's (psyche's) decision against and disregarding the decision of the consciousness." In other words, such a decision is not precisely an accident but an automatic coincidence of unconscious desire and the work being consciously shaped. The element of *cause* is suddenly immersed and dissolved in the final adequacy of *effect*. As in all pure creation, then, cause and effect are not sequent but simultaneous (or, in the wide sense, synchronous).

All Tchelitchew's convictions about the basic formal constituents of art are in process at this time. As Kirstein emphasizes in writing about Tchelitchew, painting as a kind of scientific research persists in the artist's deepest activities at the easel. Coached by the learned men and women who are attracted to his art, constantly prompted by his friend Kirstein's high cultural literacy, Tchelitchew will strive to follow an idea to the end and to formulate its rationale. In 1921, the distant moulders of his visual sensibility have been Vrubel and Doré, both of them, as illustrators, exponents of the supernatural; the latter in the Bible and *The Divine Comedy*, the former in, for example, Lermontov's poem, *The Demon*.

Vrubel's figural work is related to pre-Raphaelitism, keeping the human outline romantic but portraying it with a Fauve-like even *pointilliste* modulation; the dense silhouetting is akin to Beardsley's. Vrubel, called the Father of the Russian Renaissance, uses dark washy tones for the eerie atmosphere of *The Demon*, the strokes and planes being abstractly felt while the figures remain distinct. His is a kind of Expressionist Russian Romanticism, whose shadowy depths speak more plastically than do Doré's of omen, peril and struggle.

Pavlik has been impressed by the report that while working on the illustrations for *The Demon*, Vrubel went insane. More than that, he credits the

legend that the brilliance of the peacock's tail and Lucifer's "sickly beauty" (Vrubel frequently painted the image of the great Fallen Angel) reached so superhuman a pitch that the soul of the artist "collapsed" when in the process of creating them . . . Once more: the peacock's tail as omen of evil! At Kiev, the young artist has paused in long study before Vrubel's fresco, *The Procession of the Holy Ghost*, in the church of St. Cyril. Is there a hint of this work in the mock-religious Ku-Klux-Klannish procession of Confirmation in Tchelitchew's *Phenomena*, with its stout little Bride of Christ? In Vrubel's fresco, the hard upright Byzantine planes have been qualified with Mannerist volumes and postures. The feet of the sacred figures extend suggestively into the nearer perspective marked by several freely curved bands like beaching waves: foreshortening is at least insinuated. One may think of Tchelitchew's own feet, enlarged near the waterline along the bottom of *Phenomena*, and of the way other pairs of foreshortened feet (the Siamese Twins on the other side) abruptly pull the spectator toward the heroic byways of his vision of Hell.

At high pitch as he lays siege to Berlin, the supernatural feature most attracting Tchelitchew is the element of metamorphosis. This yields to him a great plastic as well as moral secret. The plots of many ballets are sheer fairy tales where magic transformations are the order of the day. He has begun observing that the plastic resources of suggesting these magic changes have never been fully explored; there has been too much passive reliance on literary information. A ballet costume is not the same, Pavlik notices, when it is stationary as when the dancer is in motion, so why not, in his stage work, exploit this subtle suggestion of the human core of the phenomena of change? A costume is always a mask while masquerade, or illusion, is compact with magical warfare. The dancer may be a character who collapses and dies (as does Kashtshei, the magician in *The Firebird*) at the touch of counter-magic. The dancer's very costume might intimate this *vulnerability*. Inside, man too is a thing of separate parts, his interrelated organs and muscles, all of which are affected by incidents of change, both internal and external. Poring over certain drawings of Leonardo's has convinced him of the aesthetic possibilities of a "vivisectional" plastique. In following the creed of Cubism, Tchelitchew hitherto has taken his anatomic cue from the opaque mechanized formalism of a painter such as Léger. Men indeed may resemble buildings, but inside the buildings (as in the real world) men live in their true complex of inner and outer surfaces . . . "And what the Hell!"—Pavlik picked up this phrase from the Lighthouse—"human insides are subtler than those of machines!"

The poor little *pension* room which he, Tchelitchew, the vagabond artist, "lives in" in this European capital! As gay as he tries to make his existence alongside his Russian colleagues, life is very, very humble. Affairs with the Souvtchinskys have made it feasible for Anna Ivanovna's favorite to live to

himself in Berlin. Well and good. He is responsible, he has an active career, and certain facts are as they are. If he ponders the aspect of Berlin streets, it is chiefly to compare the magisterial buildings and broad *strassen* with what Donald Windham calls the artist's "memories of the cubed blocks of Moscow houses and rectangular prospects turned by gloomy winter mists into bleak simple shapes." Thus, Windham writes, "the costumes for this tragedy [Gobineau's *Savonarola*] emerged." It is strange but the massive shapes and slow movements required for the pageant-like operas and plays, which Pavlik now designs, evoke the looming cold and blunt chiaroscuro of winter—some of the bitter weight of the past, its solid unthawing chill that invades the heart, and is hard to expel with sunshine. Against it, *within it*, he starts erecting blazoned colors and ingenious bulwarks of décor.

On arrival, he faces the irksomeness of wintry weather and a fresh start in his profession. Soon enough, he concludes that while, indeed, Berlin holds a huge colony of Russian expatriates, these have their own coteries and are still regarded as "foreigners." Even among themselves, the Russians are not perfectly cohesive or harmonious; for instance, he continues to admire Prokofiev's music but Prokofiev, for some (conceivably personal) reason, makes himself personally disagreeable to Pavel Fyodorovitch. Practical shortcomings in the Eurasian ideal can show up glaringly to the fast-stepping but sharp-eyed Tchelitchew. Post-war Germany is in the grip of reaction and inflation is but one of the ominous symptoms; another, already in the air, is Nazism, whose creed is nationalism and intolerance. Hitler is its established leader and "race" pride is rearing up as the backbone of economic recovery. However, in the arts, the cult for internationalism is still thriving. Cubism is naturally "Eurasian" while modern painting (abetted by the *De Stijl* group) has become an international language by way of geometric abstraction; Bakst's robust decorative exoticism fits the theatre with as much ease as does local methodized Expressionism. All the same, Tchelitchew reflects, personal emissaries of art from the matrix of Eurasian unity, Russia, are not so readily accepted in Germany as the products they are importing.

A decisive element in favor of artistic Russians in Berlin is the celebrity attained by the phenomenal Ballets Russes, whose magnificent success in Paris in 1909 made ballet history on the Continent, and even in the United States. By this time, Diaghilev's company, which became independent of Russia in 1911, does everything new, authoritative and exciting in ballet; it is a modern institution. Naturally, Tchelitchew's principal aim is the ballet and the opera, where his fantasy can have freest play. It is part of the set pattern of his career that the first work he obtains is at a cabaret theatre, Der Blaue Vogel (The Bluebird), which, like the companies in Kiev and Constantinople, presents skits in the manner of the Chauve-Souris.

Among Pavlik's assignments are *tableaux* of a Chinese Garden, a Spanish

Carnival and a Dutch Toyshop. "Tchelitchew geometrized the costumes,"
Windham writes in his valuable monograph on the artist's ballet and stage
designs,* "so that cubes and cones underlay their representational appear-
ance . . . in the Dutch Toy Shop number each dancer resembled a blue and
white porcelain doll as he walked or stood still, but when he pirouetted or
revolved . . . he metamorphosed into the absolute geometrical shape from
which his costume had been derived, cone, cube, cylinder or ovoid." Yes, yes,
more than one can play the game of converting man into geometries!—into
things of deceptive facets and secret mechanisms!

Long before, Pavlik has discarded his cossack hat and now wears a wide-
brimmed fedora which he likes to shape as whimsically as he did his military
cap when he went to the Gymnazia in Moscow; the fedora is always, in any
case, rakish. He has a hard time, still, keeping under his headgear the long,
baroque lock of hair that threatens his right eye. As for suits, when "dressed,"
he essays the extreme models of formfits and long-skirted jackets. At this
period, his whole religion is work—work on all possible levels; even "playing
the dandy" is not so occasional as it looks. Luckily he acquires a faithful
admirer and assistant, Ossip Lubitsch. Since Tchelitchew does all the set
painting himself, deft assistance is very handy and Lubitsch reveals himself as
accomplished at it; the latter, too, is an easel artist. This practical experience
in stage work stands Pavlik in great stead as more opulent commissions
materialize.

Caught in the naked flush of leisure, his head is now the subject of the
previously mentioned engaging caricature by his old admirer from Kiev,
Count Alexander Rjewouski, who has joined the swelling Berlin colony.
Pavlik's *tableaux* at Der Blaue Vogel are successful; especially does the late
Medieval period of one, *The King Has the Drums Beaten*, give him a chance
to translate the cone into peaked hats, the cylinder into rigidly folded sleeves
and trains. Humanity seems present only as an armature in the sketches for
this particular work. Perhaps it is his symbolic instinct that enables him to
translate back and forth into each other the vocabulary of human anatomy
and the geometric idiom of architecture; furthermore, without the sensibility
of magic, it would hardly be possible for him to handle so well the monu-
mental style which he imposes even on relatively modest stage spectacles.
Often, as dolls or mechanically controlled beings, his actors or dancers seem
like marionettes and have the breadth, seeming scale and objectivity of the
palaces they inhabit, the thrones they sit on. Literally he builds the Pope, in
Savonarola, into his throne!

Wishing not to lose sight of his career as an easel painter, Tchelitchew
shows a group of paintings at Alfred Flechtheim's gallery but these do not
make so strong an impression as his stage work. The pivotal event of this

* *Dance Index:* III, Nos. 1, 2, January-February, 1944.

period becomes the organization of the Russian Romantic Theatre in 1922 by the dancer-choreographer, Boris Romanov, previously with Diaghilev's company. A Russian lady, now married to a wealthy German, has financed the venture. Romanov promptly invites Tchelitchew to design two productions, *The Wedding Feast of the Boyars* and *The Sacrifice of Atoraga*, both of which (the latter has an Assyrian theme) offer him picturesque opportunities. Tchelitchew's career now takes a big, unambiguous stride. Yet, as surviving photographs snapped on the beach at Baabe tell us, summer intervenes and allows the devoted theatre workers to relax and the Russians to disport themselves *à la Russe*.

The dancers and staff of the Russian Romantic Theatre, forming the nucleus of Pavlik's social life, regularly repair to the Baabe beach on the Isle of Rügen. With these, and a special new woman friend, Tchelitchew appears straight from the historic present in a contemporary bathing suit, differing from the one of vanished Doubrovka only in being bigger. His muscles are also bigger, for he has not allowed those he developed at Mordkin's studio in Moscow to go flabby. At the theatre, he lifts and shoves with the rest, and besides, even with Lubitsch's help, his own brush travels across endless surfaces.

The special woman friend is not one of the attractive female dancers. There are several of the latter for him to idolize: Romanov's wife, Elena Smirnova, a St. Petersburg ballerina of whom he does a large poster in red, black, grey and yellow, Elsa Krüger, and old friends Claudia Pavlovna and Catherine Devilliers. The last named, a former Bolshoi ballerina, is the daughter of a Russian actress and a Frenchman. She once performed for Diaghilev and now dances and teaches in Berlin. With black shiny hair and thick features, including large lips and upturned nose, she is like a handsome negroid gypsy: secretively withdrawn one moment, loud and open the next as her metallic voice rings out. On the beach, the rhapsodic, off-duty clown, Tchelitchew, romps untrammeled: always the one with the archest grimace, the comic interpolation, the "fun" pose.

Pavlik is goodlooking enough to make his antics a sort of courtly condescension—the spice of wit rather than a true physical pattern. Still, the fun is rather *romantische* and if, with a partner, he takes off the bacchanalian deportment of Daphnis and Chloe, an authentic dignity comes through his wildest informality. Society is in an age of passive tolerance and desperate anxiety, which it shields with masks of hope and forced jollity. More of a playmate than Mlle. Devilliers is Natalie (Natasha) Glasko, Pavlik's Chloe, who is the special friend, and alas! no ballerina. She has the sort of figure that is pedantically female; its thrusts of feminine mound and wayward arabesques seem in constant danger of going out-of-gear. Yet Mlle. Glasko is divinely good-natured and Pavlik guesses with sure clairvoyance that the naive co-

quetry of her large, smiling, unpretty features, her redundant self-conscious femininity, are all "for him." He enjoys nothing better than inciting Natasha to act up, to giggle, to laugh out, to be as mercilessly extravagant as he . . .

How Natasha lends herself, thinks Pavlik, to effects of foreshortening! Fabulous. Mlle. Glasko, he also thinks, is a natural concentrated symbol of his art: an art that cheerfully, gallantly lets itself go "regardless." His sketchbook experiments take on the manners of both German and Parisian Cubism— pseudo-collage, imitation woodgrain, cigarbox tops, newsprint, stereo'd letters, all blown up toward stage-set scale; even a whiff of Braque by way of a *nature morte;* its palette: burgundy, soot and yesterday's snow. For his Renaissance things, he goes obediently to libraries and makes astonishingly literal copies of period costumes, later translating them perhaps into Constructivist idioms. Yet, as these sketchbooks show, he does not neglect the nude; there are males and females in ink, very strong, but the line more continuous than the figure as it appears in a finished work . . . not to forget the *gros* genitals, the mock-terrible genitals . . . Ah, yes, *la poupée veloutée!—un monstre de crêpe de chine!!*

Cafe sitters or mere barbarians might well misinterpret the flashing personal exterior of the artist's steely ambition and unflagging technical powers. But people in the theatre know better. About this time, Igor Stravinsky meets Tchelitchew and so does the full-sailed figure of Serge Diaghilev, escorted by the black incandescence of Boris Kochno, whose acquaintance Pavlik has already made in Constantinople. As always, Kochno's eyes move continuously. Is it a form of impertinence? All the same, he has established an implicit *entente* with Pavel Fyodorovitch. The famous Diaghilev (notes the artist with pleasure) has the insolent air of a Grand Duke, dramatically set off by a singsong, almost "Chinese" voice. Diaghilev is charming. He is more! He is *magical:* he accomplishes marvel after marvel.

Stravinsky has come to Berlin to await his mother's long-delayed arrival from the Soviet Union; at last, he has gotten news of her departure by ship. Diaghilev seems reserved but palpably struck with the volatile Tchelitchew —isn't he a bit *too* volatile even for a young, ambitious Russian?—and he regards Pavlik with shrewd, piercing, dark eyes amazingly alive in his pale-faced, grandiloquently large head. He feels at royal ease with him as with everyone, and attending *The Wedding Feast of the Boyars,* guesses more possibilities than others do in the clamorous modern stylishness of his work. Kochno thinks Tchelitchew's theatre work a bit loud: brash. Stravinsky (as the composer later informs Robert Craft) does not care for what Tchelitchew now does in the theatre, but he sees that he is "talented and handsome" and moreover is "quick to understand the value of that in the Diaghileff ambience."* For his part, Pavel Fyodorovitch, eager to impress the short,

* Stravinsky and Craft: *Conversations with Igor Stravinsky.*

incisive Russian composer with the amazingly authoritative nose, is a trifle suspicious of one so evidently built around a hard core of intellect. On the other hand: Stravinsky, too, is *aimable*.

Words of Diaghilev's echo for days in the young painter's mind. They were said with an insinuating singsong melody and yet unaffected sincerity: "You should come to Paris. Why don't you come to Paris? That is where you should be." Three separate sentences, grammatically, but they had the unity of a chorus from a song. Pavlik hoards the unforgettable invitation— what can it be but an invitation since he has heard that the great impresario is disposed to have him do a ballet? Diaghilev's company survived not only the war but also the desertion of Fokine and Mordkin, even the casting aside of Nijinsky! Serge Diaghilev is sensitive to the nascent genius of the young; currently, it is the brilliant Massine.

Tchelitchew shares his dream of Paris with his new American friend, Allen Tanner, who has become the figure people expect to see at his side entering a restaurant or leaving the theatre. He is with Tanner in the lobby of the Russian Romantic Theatre when he points out Diaghilev, imperiously aloof with his friend Kochno, who is high in the ballet's organization. "I hear he would be interested," Pavlik tells Tanner, "in my doing a ballet for his company, but I imagine Kochno, who dislikes me and my work, won't encourage it." The young pianist from Chicago looks carefully at the two, especially at Kochno. Diaghilev's polished henchman impresses him as handsome, "satanically" so; he seems always looking around to encounter things he doesn't like seeing. The American and Russian friends are too immediately involved to realize that Kochno's manner is only an exaggeration of the habit, cultivated in high society, of seeming-not-to-see.

In New York, the Kochanskys have spoken much to Tanner of the prodigious young Russian in Berlin. The couple, with others in the Wellington colony, have arranged for the pianist to go abroad on scholarship funds. The young man from Chicago duly arrives in Berlin with a letter of introduction to Tchelitchew. Thinking himself intrepid, aglow with repressed anticipation, Tanner has to enter a darkened theatre at the moment when a set is being put up. He is somewhat unprepared in the dim emptiness for so much aggressive activity. Is Pavel Tchelitchew among the three men who are hoisting a tall side flap into place—he has heard how he "pitches in"—or perhaps the one on a ladder applying paint furiously to a backdrop?

It seems he is none of them. A loud voice from somewhere calls out what may be a name—Tanner by no means is sure. Later he estimates the amazing sound phonetically: the best he can do with it is "PAHL-FROCH! PAHL-FRROCH!" He is awestruck when eventually Tchelitchew explains that it is his Russian colleagues' hasty contraction of his proper name, Pavel Fyodorovitch. After several such shouts at this point, the pianist for the first time

hears the still unidentified voice of his friend-to-be respond: "I'm coming! I'm coming!"

The meaning of those words, too, he soon discovers; for Pavel Fyodorovitch at once proceeds to teach him Russian by ear. The taut slender figure of the artist followed his answer by flying in from the wings. Even at such a distance, he has come up to the Kochanskys' most glamorous descriptions. On his side, Pavlik thinks the young American most *gentil*, most *aimable*, with his prim mouth and soft, sheltered eyes that flicker with frank signals. Pavlik, however, is soon astounded to hear that Tanner has ideas of how the pronunciation of "Tchelitchew" is to be translated phonetically for use in print and speech. The artist has a moment of undisguised resentment toward his new friend—a potentiality that Tanner quickly learns to fear and avoid provoking. "*You*—" the other vociferates, "you are going to tell *me* how *my* name is to be spelled and pronounced?" Tanner casually becomes acquainted with another device his dazzling friend has hit upon for lending himself personal prestige. It is no less than Balzacian. Once he hears someone in the green room of the Russian Romantic Theatre ask where "Herr von Tschelist-scheff" may be found. Inwardly goggle-eyed, the American hardly dare laugh to himself, much less mention the matter to Pavlik, so really awed does he feel at his friend's palpable consequence.

In general, the young American's traits are extremely welcome to Pavel Fyodorovitch. First of all, he is artistic: he seems to know what an artist is, and ought to be. No, Tanner is not "virile," and perhaps, all considered, it is better so. To be sure, he is attractive; that helps always. Then, he is becoming devoted to Tchelitchew so rapidly that the artist finds it rather uncanny. He is tempted to think it a stroke of good fortune. The most conventional gestures of cordiality have a way of bringing the young man, as it were, to his knees, eyes worshipfully cast up. Communing with the ladies, Pavlik is very good when at their feet, so he has a criterion by which to judge Tanner's *hommage*. It is even a pleasure to play the king, lean over, raise him up and embrace him . . . Again, he observes that his gift of informal fun—an aristocratic sort of flattery—puts one and all at ease.

There are moments of intimacy, thrilling to Tanner, when the Russian's impetuous spring of enthusiasm quiets down to an even, enchanted murmur. It is almost into his ear that Pavel Fyodorovitch pours wonderful words, solemn, husky, vibrating like a stringed instrument: "You will make me a great man, eh?—like Zossia made Paul?"

They communicate mainly in French but have started calling each other Pavlik and Allousha—the Russianized diminutive for Allen. Allousha hardly stops to consider all the implications of the sirenish question just quoted. To its velvety susurrance he assents a thousand times over. From the first, Tanner has confessed to himself he is smitten. As a matter of course, what

money is available to him is automatically at Pavlik's disposal: their economic fortunes are pooled—and that's that. For the time being, the American pianist is eager to put aside his own aspirations toward a career. It is gloriously rewarding just to bask in the handsome, genial presence of a young man who is—Tanner tells himself—"more super-endowed with magnetism" than anyone he has ever met.

The night of their first meeting they dine at the Fürstenhof Hotel, notable alike for its good food and bohemian atmosphere; for a few moments they stop to chat with the travelling American expatriate, Frank Harris. Tanner's problem about lodgings (he has spent the first night at George Antheil's) is immediate yet not, it seems, so unwieldy. Tchelitchew suggests on the spot that he take a room at his own *pension-de-famille* and Tanner is delighted to acquiesce. As the weeks go by, then, it is plain how much more convenient and comfortable would be a whole apartment for them to share. Fortunately, musical friends of Tanner's are about to give up theirs; it is three rooms, with kitchen, bath and foyer.

In no time, the pair find themselves newly, beautifully domiciled. For Tanner, a golden haze now infuses this at-first alien Berlin. Without delay the artist takes his bosom friend to meet a succession of the charming ladies in his life; primarily, those now in the Souvtchinsky menage. This is minus Pierre but includes a very dear friend of Anna Ivanovna's, familiarly known as Aunt Marussia. The two old ladies live in one very small room where, in such hard times, they earn most of their living by making embroideries. Tanner is touched on hearing of their loyal attendance at the theatres, regardless of the weather, especially at those which their mutual favorite, Pavlik, illuminates. There is something a little whimsical and enclosed about Mme. Souvtchinsky (Pavlik says she is "wise and inscrutable") but Aunt Marussia is more direct, expansive, and at least as warm; maybe, Tanner speculates, her heart is a bit more vulnerable than Anna Ivanovna's; anyway, she seems to react more spontaneously to Pavlik's own style, even joining him in his gay scoffing and mock ferocity. Both ladies, obviously, dote on the young genius, Tchelitchew.

Pavlik seems to be employing every possible shade of enchantment to shackle Tanner. The very first lady mentioned to Allousha is Djanet Hanoum, wife of the Persian Ambassador to the Third Reich. "Here," Tanner reflects, "is a man who literally raves about women yet always with noticeable respect and a true air of devotion." Veritably: a troubador of modern Mary-worship! This is a feat, considering the unmentionable things which, in three languages, Pavlik can call the ladies when they put him out of temper. And he is rapidly learning a fourth language of coarse epithets: English. Djanet Hanoum* (the later a term for Princess) is a buxom, vibrant,

* Actually, the feminine form of Khan.

charming woman whose dyed red hair typifies a lurking, although ladylike, naughtiness of impulse. She is so frankly dedicated to the luxury in which she lives at the small, rather elegant Hotel Am Zoo. And clearly, to a rich degree, she possesses the *sine qua non* of women eligible for Tchelitchew's best attention: a deep, unswerving instinct for friendship and understanding. He particularly wishes Tanner to "please her." Djanet Hanoum is a true Oriental of breeding, a woman of the world who seasons her hedonism with good-natured dashes of irony: a trait ever sweet to our hero's emotional palate. With what graceful childlike abandon—on the night Tanner is brought to her—the Hanoum sits at her piano and plunges her jeweled fingers into Persian folk songs as if she were making merry with herself and all life!

The young American is soon aware of the consummate technique his Russian friend has for spiritualizing *their* domestic relations. At a certain point, Pavel Fyodorovitch finds that the other's physical attractiveness ceases and sentimental friendship had better take over. The pianist is too happy in their new apartment (where he has a piano on which to practice) to notice much this technical alteration in their affair. He is certain he has uncovered a genius and "making him a great man" will be as easy, he anticipates, as delightful. Tanner has, just now, no rivals of the same sex. Ossip Lubitsch, he quickly grasps, is Tchelitchew's Man Friday: the very genuine esteem and liking they have for each other is that of colleague for colleague.

Of the ever faithful Lubitsch, Tanner gives a lively verbal sketch: "He was, really, a droll of a character. Of Jewish origin, he looked like an Eskimo, high cheek bones, flat round face and oblique almond eyes. Tchelitchew used to tease him, saying he was sure his mother 'must have fallen over the fence with an Eskimo.' He had a great sense of humor and when it was aroused, his face lit up, his eyes cavorted and the whole expression did a jig. When he was serious, and one asked him a question, no matter how frivolous, he would screw up his face into a frown, maintain a long, emphatic silence, then reply in slow, ominous tones of an oracle, always beginning with, 'Now I'll tell you . . .'"

Production by production, Tchelitchew's career advances. One such step is the tragedy which Pierre Souvtchinsky adapts from Gobineau's book on the Renaissance: *Savonarola*. The ascetic character of the famous monk awakens in the stage artist a paradoxical but suggestive empathy: he seems "a man whose soul is too heavy for his body." Not yet has Tchelitchew been told that his own brain is too large for its cranium. But mind or soul, in his eyes, tends characteristically to be an unmanageable weight, something to reckon with like a passionate vice or a portent of evil. The Cubist-Constructivist style is an apt medium for the play's pageantry and the tragic gloom of its theme. Savonarola's violent preachments against Florence are a curse that

turns inward, proving in the end too frail (like his body) to grapple with the temporal power of the Medicis. In the armor of a knight, whose fantastic hat is a wheel, Pavlik visualizes overwhelming temporal power as if it were a war machine. He has seen an extraordinary German movie, *The Golem*, and noted how a man can be transformed into a dread, massive, depersonalized force.

Savonarola is a sort of swansong for the intimate relationship between Pavlik and his collaborator, Souvtchinsky, his erstwhile patron. The latter is beginning to have doubts about the young artist's estimate of his own potential gift. Just where is he going, or more relevantly, where will he end up? To his literal-minded friend, Pavel Fyodorovitch seems something of a chameleon. At present, his easel work is a formula agilely put together from Cubism, Futurism and Constructivism; all along, for the stage, he has attempted to filter the flowing opulence of Bakst into the massive four-square Constructivist style. It is just after *Savonarola* is presented at the Koenig-gratzerstrasse Theatre, in December 1922, that Tanner has turned up. For Souvtchinsky, the young American emphasizes the Tchelitchevian marks of character that appeal least to the strict champion of Eurasianism. The artist now begins "moving," as Souvtchinsky retrospectively puts it, "in a somewhat different circle." Their relationship will never be the same as of old. Before Pavel Fyodorovitch leaves Berlin, however, his countryman poses to him for a portrait in oil. One reads in this work the worldly warmness that in Pavlik's breast has turned to worldly-warm coolness . . . Its Cubist-controlled modulations make a rather superficial thing: a kind of mind-facial for the idea-engrossed Eurasian.

The "somewhat different circle" cited by Souvtchinsky above undoubtedly refers to what Stravinsky terms "the Diaghileff ambience." But the truth is that Berlin is suffused with an international art milieu of which this *ambiance* is only one theme in a most varied symphony. Other men of creative ability are here to furnish a gamut of interesting tonalities. Among the colleagues Tchelitchew can enumerate in Berlin are Frederick Kiesler, Edgard Varèse, Boris Shatzman, Hosiasson, Boberman and Leon Zack, the last four being fellow-expatriates. The late architect and stage designer, Kiesler, physically so diminutive, sounds a large promising note by coming out for the "round" against the "rectangular" with remarkable force. Many members of aristocratic and art-loving circles, who have fled revolutionary Russia, are also known to Tchelitchew.

One of the most important art collectors in Russia has been Anatol Shakeivitch, whose former house in St. Petersburg was like a museum. Also a playboy, Shakeivitch is in the process of gradually gambling away his millions. Hearing on his arrival that this art collector is in Berlin, Tchelitchew looks him up as an old acquaintance, forging thus an unconscious link with his Parisian future: Shakeivitch happens to be the stepfather of Eugene

Berman and Léonid. While in Italy with Christian Bérard, Berman receives an invitation to the opening of Romanov's Russian Romantic Theatre, and accepts. He finds the "new Russian Cubist style" of Tchelitchew "expressive," although years later he will not rate it highly. In any case, Berman considers the young designer of *The Wedding Feast of the Boyars* "the most striking and original talent" to be found in the Russian group. The vivacious Pavlik, he also observes, knows "better than anyone else how to charm and make friends."

In *Phenomena* (1936–38), the artist's future Hell, there are few or no direct reminiscences of his Berlin days. Most of the landscape effects (other than those taken from photographs of universal planetary features) derive from personal observations made later in Italy, Spain and the United States. The skyscrapers pyramidally collected at top center belong, of course, to New York City, while the horizontally striped tower nearby is Italianate. At the same time, the art of a man who habitually "thinks in symbols" sustains a refining process which transfigures and transmutes rather than eliminates. The very mise-en-scène of *Phenomena* is a meticulous mural composed of Baroque stage perspectives, where expanded or contracted distances are either bird's-eye views or intimate precipitations. The set of *The Wedding Feast of the Boyars*, with its central pyramid-gable and boldly stratified side-flaps (including a brick pattern) are echoed in *Phenomena* by the pyramidal city and the jail of bricks illusively built into it, as well as by the striped tower to the right. The artist's Berlin monumentalism is more than hinted by the enormous, though removed, Potato Woman and the hideously gross Mammon, portrayed on the upper right as a painting within the painting, and made entirely of tumbling stacks of glinting coins. At this time in Berlin, the mark is taking a bottomless dive. The picture-within-a-picture device, besides implying multiple dimensions of reality, suggests the framing-off of illusion signified by stage sets.

One of the most fixating aspects of *Phenomena* is its dominant look of being a pebbly and sandy beach producing a kind of populated, ambiguously watered desert. For an allegorical emblem of the profusion of waste (milk is being thrown away) the artist's conception goes directly to the point. It is with dynamic intention that his Hell seems uncomfortably crowded: the irony is sharpened by the fact that one actual thing intolerably hellish to Tchelitchew is an overcrowded beach with its damp, roving, spilling humanity making drunkenly confused lanes. Nevertheless he loves broad beaches and their contiguity to great oceans; thus, in 1936, he will feel as a true personal affliction the redundant, contorted aspects of dross which disfigure *Phenomena*.

Some of his fairest memories of the numerous beaches where he rests, plays and exercises throughout his life surely belong to the one close by at Baabe.

Significantly, none of his circle of Berlin friends or associates survive as images among the grotesque personnel of *Phenomena*. Tanner is not there, nor is Natasha Glasko. Christian Bérard and Gertrude Stein, invoked as vivid *personae* of Hell, belong to the coming Paris milieu, while many friends and acquaintances who are to fill these strange roles will be met in London and New York. So far, Berlin is the most important European city in the Continental curriculum of the 25-year-old artist. Will it be his home? Early in 1923, he doubts that.

As the dispossessed inheritor of an ancestral estate, Tchelitchew has a forlorn, vestigial desire for roots. If an actor (like the Pope in *Savonarola*) be literally built into a stage property, he is chained to his environment. Pavlik is aware, if obliquely, of having laid heavy foundation stones of survival in this city. His biggest opportunity in the theatre now opens up: a production at the mighty Staatsoper and he seizes with a fierce will on its challenge. The bland Tanner is more than ever certain he has on his hands a fabulous dynamo for companion. The inexhaustible energy of "Pahl-Froch" tends to take his breath away.

Just to see him in action at the telephone is to realize he is a one-man theatre company, or at least is able and willing to be. The old *pension-de-famille* which they abandoned did not have the luxury of room phones: one had to use a wall phone in the hall. Tanner can never forget the sight and sound of Tchelitchew engaged in a demonstration, at times in more than one language, before this instrument. One would imagine from his wild gesticulations that he thought himself visible to his interlocutor. It was usual for Tchelitchew to attract groups of chambermaids and even guests as spectators, all convulsed, careless if their appreciation were noticed. Tanner caught one of the maids mimicking the frantic artist once: he was oblivious—on he went, the perfect performer!

No wonder, at *this* particular time, his Pavlousha is so galvanized. Through an agent, Tchelitchew has secured the commission to do the Staatsoper's new presentation of *Le Coq d'Or* (*Der Goldener Hahn*). Being as fond of the slang of all nations as of Russian archaisms, the artist impresses on Tanner how much this old Russian fairy tale, put into verse by Pushkin, is "up his alley" (colloquial American) and that he will not allow those *mirzivitzi* (Moscow Russian: rascals) at the Staatsoper to cramp his style. *Le Coq d'Or* is pure fantasy. Like *The Magic Flute*, it has a Fairy Queen and even an Astrologer—isn't that, basically, what Sarastro is? From the beginning, the scenic artist asserts himself. Because the Staatsoper wants the work to be done in the true Russian spirit, he is given full rein.

Up soar the costs of the elaborate sets and costumes. Tchelitchew taps the most dashing color ideas from the contents of his portfolio: pink, bright blue, gold paint. He was never satisfied with the Assyrian splendor of the *Atoraga*

ballet; the whole thing, with its ballast borrowed from Leon Bakst, couldn't get off the ground. This time, color alone will provide some *ballon*. His ideas have a playfulness; indeed, the sets with their bold, simple, peasantish patterns look like magnified toy-things, the scenic inventions of Doubrovka's children led by ten-year-old Pavlik. It is glorified make-believe, indisputably Russian: indisputably expensive. The original budget becomes a phantom while the management suppresses a creeping case of the jitters.

Yet nothing is done to stem the tidal wave capsuled into Pahl-Froch, a tidal wave that bears, at the heart of its storm, an insidious caress one. can almost feel on the skin. Secretly, Pavlik has decided to play for all-or-nothing. Can he win a great place in the Berlin theatre—great enough to make him stay here? He is very content with having attached Tanner so firmly. In Constantinople and Sofia, as here, he has been wistful in the need of someone other than close colleagues and useful sponsors, doting admirers and erotic incidents: someone *private*, utterly, eternally devoted to his person. With a face so mobile, a temper so outgoing, Pavel Fyodorovitch is a man hard to imagine as still, pensive, inner. Yet he owns a contemplative faculty and it prevails at the very times one might think him daydreaming or idly relaxed.

Like an animal preoccupied with chewing, its eyes wide and thoughtless, Pavlik sits quietly sipping tea and thinking everything. This Allousha, so sensitive, nice-looking; he cannot but speculate if he will always be the spiritual slave and material helpmate he gives every performance and promise of being. At this moment, Pavel Fyodorovitch is wearing the well-made Norfolk jacket in which Tanner arrived in Berlin. At odd times, Tchelitchew catches the young man regarding him with a certain sweet, steady, detached admiration as if he were some precious objet-d'art in a museum. And besides, does he always *want* someone like Allousha?

With everything in the balance, he is quite presentable, social-minded, serious, artistic. One has to measure the social aspect from every angle, especially that of the fashionable salon, where (it is said) artists may be made and unmade. If he, Tchelitchew, gets as famous as he ought, he can doubtless carry anyone at all along with him. Artistic salons in Paris mean more than their equivalents here. Diaghilev implies in every way their superiority; he is certainly one to hand down the correct verdict. The Germans are almost too questionable to be entitled to "salons"—so vain they are, so prone to display an arrogance that really is stupid, provincial; yes, thick-headed and very unattractive. The truth? Well, no "aristocracy" of art exists in Berlin except what foreigners bring here. There is no Champs-Elysées of blessed artists, only a hustling, idea-ridden, rather smug profession. As to that: how long will the German public be hospitable to Russian ideas? Things are getting too, too "political." Now that he considers the facts, he knows he has smarted from some ugly German intonations, certain German sneers—not toward

BALLETS RUSSES

1928

Actual cover of theatre program by Tchelitchew
for the Paris première of Diaghilev's Ballets Russes,
1928, illustrating the ballet *Ode*. For the surround-
ing tone a dark blue wash was used, for the figure
a dull brown ink and wash. Fine holes puncture
the central anatomy. The traditional images of the
Dancing Shiva and Cosmic Man are connoted.
Original drawing: Collection Wadsworth Athe-
neum, Hartford, Conn.

Above: Dancer in *Ode*.

Above right: *Ode*, Serge Lifar as the Student of Isis.

Ode, 1928: choreography by Massine, costumes and décors by Tchelitchew.

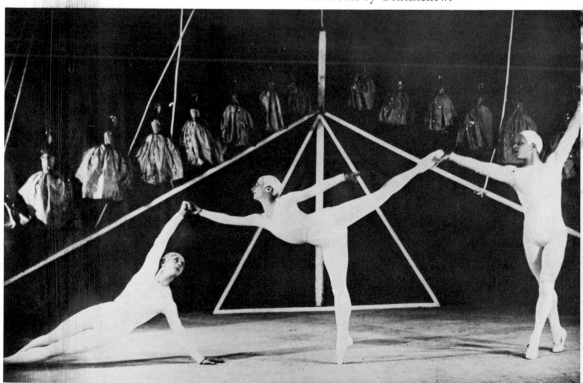

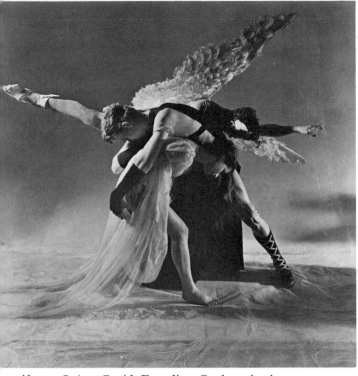

Above: Orfeo: Cupid, Eurydice, Orpheus in the ballet from Glück's opera, performed with the singers in the orchestra pit at the Metropolitan Opera House, New York, 1936. Choreography by George Balanchine, costumes and and décors by Tchelitchew.

Above right: L'Errante: Choreography by Balanchine, costumes and décors by Tchelitchew. Originally performed in Paris and London in 1933, it was twice revived in the United States. *Photo: George Platt Lynes.*

Below: TCHELITCHEW: Costume designs for *Orfeo:* Cupid, Eurydice, a Fury. Courtesy Wadsworth Atheneum, Hartford, Conn.

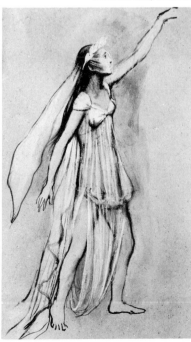

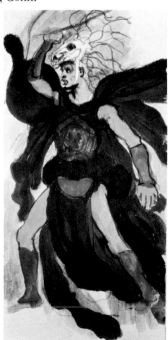

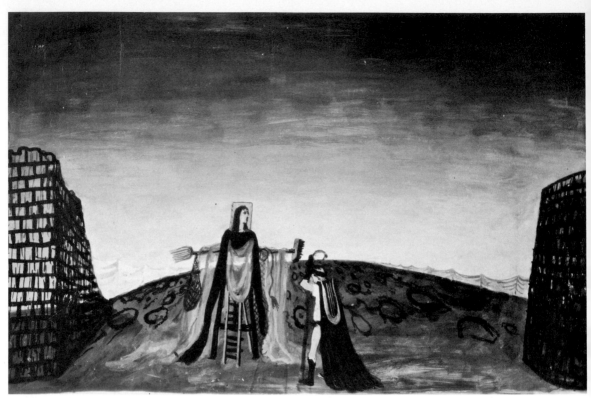

Above: TCHELITCHEW: Scenery design for *Orfeo*.

Below: Orfeo: Preparing the memorial for Eurydice; in the production, the veil painted with Eurydice's head was draped upon an unpainted canvas by a dancer who climbed the ladder seen above. *Photo: George Platt Lynes.*

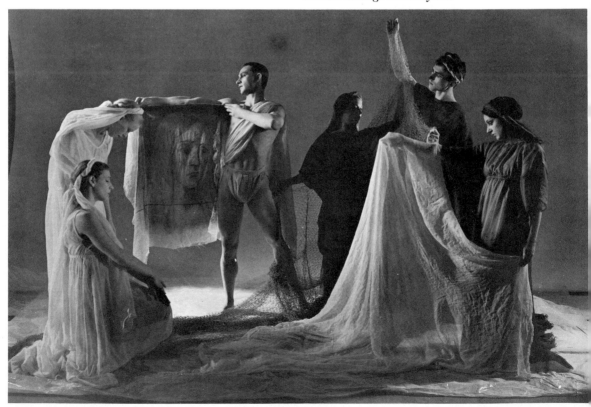

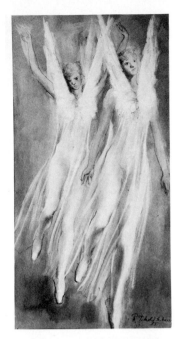

Right: L'Errante: Costume design by Tchelitchew for the Hermaphroditic Angels, 1935. Courtesy Wadsworth Atheneum, Hartford, Conn.

Below: L'Errante: Design by Tchelitchew, 1935, showing the Wanderer's lengthy train. Courtesy Wadsworth Atheneum, Hartford, Conn.

Bottom: The Cave of Sleep: Design by Tchelitchew, 1941, for the unproduced ballet which Balanchine was to choreograph. Collection The Museum of Modern Art, New York.

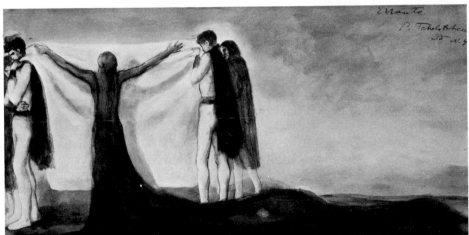

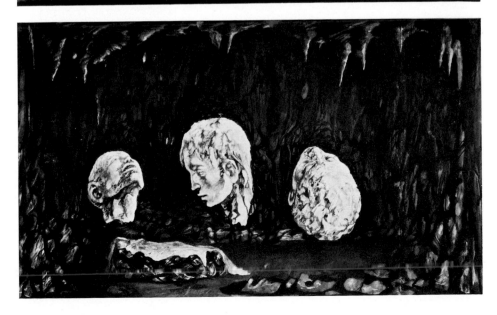

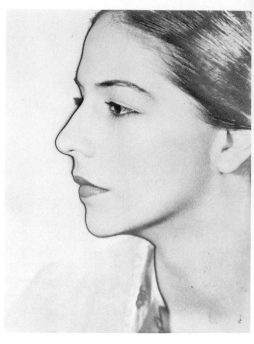

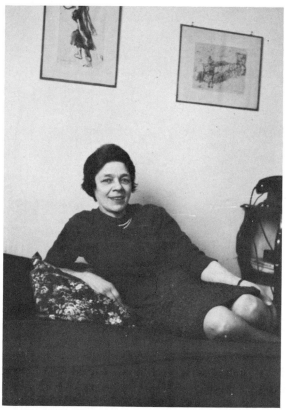

Above left: The artist as photographed by Carl Van Vechten on the former's arrival in the United States, November 1934.

Above right: Mrs. Zachary Scott (Ruth Ford) as photographed by Man Ray, early forties.

Left: Mme. Alexandra (Choura) Zaoussailoff, the artist's sister: an image she thinks of as "moi même."

Below: Mrs. Gertrude Cato Ford as photographed by her son, Charles Henri Ford.

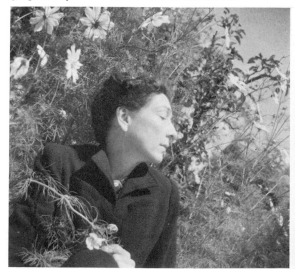

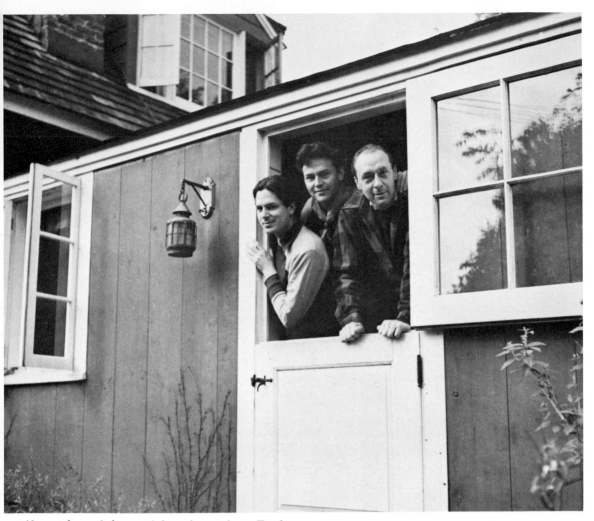

Above, from left to right: the author, Ford, Tchelitchew at the door of the Red Barn, Weston, Conn., about 1938.

Below: The artist at the door of his studio, Derby Hill, Vermont, probably summer, 1941. Much of *Hide and Seek* was painted here.

Below: Alice De Lamar and Tchelitchew in the Red Barn. This and a larger studio residence in Weston were lent to him for many years by Miss De Lamar. *Photo: Charles Henri Ford.*

The mature Tchelitchew as masterfully photographed by George Platt Lynes.

himself, precisely, or "Russian art," but toward the expatriates as an alien group. There are, they say, hundreds of thousands of Russians in Berlin . . . Throwing his head back, Pavlik swallows the last drop of tea and stops thinking.

This spring of 1923, Berlin's very physical temperature is hostile. In the midst of the German language, Tchelitchew finds not altogether agreeable the way its gutturals and sibilants congeal in the cold spring air about the large, fur-bedecked German forms; both the men and women, when fat, are often shaped just alike. Look at that *morda* (Russian slang: mug) and the *nahalka* (Russian: worthless female) next to him! The two inches of fat covering them from head to toe suppress the sexual distinctions. He must overwhelm all this flesh (*Le Coq d'Or* is well into rehearsal) and cut through its vaporous barrage of polysyllables; heat it all, melt it, mould it on the night of the première. Inside the ornate, effulgent Staatsoper, Pavlik and his stage workers sweat from exercise, but outside, the thermometer (throughout May and into June) remains obdurately low. It is a watery, windy, actually scowling spring. *Cold.*

German taste in the Berlin theatre has been altered by so many resident Russians. That is to the good: Pavlik will have many collaborators in the audience. But where are the blossoms on the trees?—where are the blossoms on the tree of the human body that reveal themselves when outer garments are cast aside? In his current décors, Pavel Fyodorovitch has inflected the Cubist manner away from cubes, sharpness, mere mass, toward spheres, rondures, malleable and seductive properties, accents. Rimsky-Korsakoff's opera has retained the vein of broad folk comedy from the literary fable, which in the light of these times has a satiric edge. It has been easy, with sets and costumes, to lighten the rectangular ponderousness he used to exploit.

Ah, the Moon! A huge spheric Moon hangs in quarter phase in one scene but with all its shadowed area quite visible. And right in the center beyond a curtained-off sky! Beneath the Moon are two life-sized horses, pony type, drawn and cut out with fairy-tale primitiveness. The designer identifies himself with them—with both of them. Recalling his youthful fascination with horses, and his abrupt estrangement from them when he fell off that circus-trained horse, Pavlik decides the case is his own narcissism; for he considers his profile to be "horsy." Once, on the Staatsoper stage, he put on an act: he neighed, whinnied, snorted, reared, pawed the air and sidled against the soprano; he had scented, he naughtily said, "the mare." From now on, conscious "horsy behavior," as he terms it, is part of his personal theatre.

The Czar and his court in the opera—oh, oh, what fun he has had with them! They are cartoons of luxury, gluttony, greed—ostensibly the Russia that has passed into history, but underneath, too, the fat German bourgeoisie that is. Daringly, he has emphasized the bosoms, bellies, even the buttocks of

the courtly ladies and gentlemen. Tchelitchew, as he knows, is more and more interested in anatomy as such, in the meaning of the human figure disencumbered of costumes, however amusing or bizarre these may be. What would the stage be without panoply and pageantry—without "costume"? That tradition is the same as being "expatriate." Still . . . he thinks it chic to have smuggled in a touch of the new Russia, the red that is now revolutionary.

Into the brilliant crimson velvet of the Shemakhan Queen's costume—for novelty's sake but also with a voluptuous thrill of perversity—he has introduced motifs of gold nails and sheaves of wheat to echo the Soviet Hammer and Sickle. It is a demonic dig at the foolish Czar, a sensual roisterer, who has the Golden Cockerel keep watch over his troubled country while he carouses with his court. The Cockerel, of course, is a magic bird given him by the court Astrologer, and when finally the Czar reneges on the promised reward, the Astrologer takes a deadly revenge. Tragedy was portrayed by the imposing style of *Savonarola;* comedy is portrayed in *Le Coq d'Or* by the same style turned mocking, whimsical, preposterous—yet with an occult twist. Theatre magic is still alive—that is what the Golden Cockerel represents: theatre magic! Moreover, Russian expatriates should learn to laugh a little, detach themselves from the historic disaster of their native land, revel in the sheer fantasy of being (ironically) alive . . .

The total effect of Tchelitchew's last Berlin production, writes Donald Windham in summarizing it, is Rabelaisan. What is also unusual, Berlin is presenting Rimsky-Korsakoff's opera in its original form rather than as the adapted pantomine (with singers in boxes at the sides) of Diaghilev's balletic version. Everything, finally, but the weather seems to yield to the designer's strenuously applied will. At the opera's première, the middle of June, it is as cold as October and the audience comes in shivering, remarking that last year at this time they would have been complaining of the heat. When the curtain rises, the management is the most shivery of all: a four years' budget has been gobbled up by the stupendous production. The weather's irregularity seems only symmetrical.

If we look closely, we can also testify that the planet Mercury has not been less indicative than the mercury in the thermometer. All during June, 1923, Mercury remains in its peculiar sphere of influence, Gemini the Twins, a sign of fickleness as well as contentiousness. Double luck, at the Staatsoper, has been operating behind the scenes. Tanner has arrived and disclosed that, while he was born the same year and the same month as Tchelitchew, the difference of date puts him just over the line in Venus' domain and makes his sphere of influence Libra the Scales. So close, the pair think, and yet so far away! The fate of *Le Coq d'Or* likewise has a tantalizing twin-ness. The prodigal staging is a personal success for Tchelitchew—making a great quota of Russian stage lovers quite happy—but the public, superficially impressed,

does not wholly thaw out. Some critics term the scenery and general production topheavy, the consensus saying that the singers and the story are somewhat crushed by the staging. Pavel Fyodorovitch discounts the partial letdown by effusively responding to the personal compliments made him. But Berlin—Berlin is now too stuffy, too crowded, too *angular* for the whirlwind expatriate from far-off Kiev.

The city has become like a scene of automatically distorted images that inconvenience both body and eyesight. While working on the cover for *The Eurasian Manifesto* in Sofia—when his problem was to unite expatriate Russians by imagining all hemispheric frontiers non-existent—the artist was aware of an annoying discrepancy, a faint pang of bad conscience, and now this is back. As one moves forward, ever forward in one's career, space must be kept free both in fact and imagination. The inflated masses of his Berlin stage work have borne an inherent moral: the world's pomp can be pompousness—and a drag. This has even been the historic lesson of some of his themes; the truth, he concludes, has been staring him in the face all the while. He has been struggling to lift a very awkward weight, juggling with already dated, pretentious fashions, trying to make them look clever and stylish. In the latter sense, he has succeeded. Experts have smiled on him, less conspicuous rivals grown envious. So—?

As if a black *angoisse* had settled like a thundercloud on him, Pavlik comprehends the absolute limitation of all prevailing ideas of space: intellectual, moral, plastic. In a few more moments, sitting alone in an upper box in the empty Staatsoper, he is looking into the Hell of the world as if it were a jumble of stage sets, all unnaturally connected with each other, contorted and contorting, risky under foot, bewildering enough to make him a little dizzy as he surveys them. The air: it is unnaturally cold, unnaturally hot, in lightning-like succession—arctic visions and the burning mirage of deserts flash into his head like a film passing at high speed. Detritus, defilements, lurk everywhere, leak into the world's hollow hemisphere: an enormous, teetering, shallow cup. The uneven ground has quicksands, is slippery, marshy in some places, rocky in others. Men, cities, everything in nature threatens. People become monstrous before his eyes . . . He is looking into Hell.

There was a moment in 1918, when the Tchelitchews waited in the four wagons to cross the frontier and some Red sentries barred their way. Pavlik literally had to swallow an invisible yet tangible *angoisse* while Papa spoke to the soldiers. When he (Pavlik) was pointed out by Papa, one of them had said, "One can see he's a young gentleman." They were then told they could pass. It was simply the barred passage that Pavlik swallowed like an object. Once beyond the border, breathing freely again, he thought he had only to move quickly enough and everything would be attained. Now, after last night's première, the rising young painter knows that out of the things one can touch, near or **far**, no matter where in space—out of these one must make

one's life, one's career. Every bit of matter, every bit of space, desert or garden, is necessary to build with. Space is never quite empty; no path is clear of obstacles to be circumvented. A picture, itself an object, is surety for this because it reveals the tangible relationships among perspective, space and volume. The paint laid on by the brush, regardless of what is pictured, or how, is a *continuous thing*. An artist too "walks on the water." Yet a painting (or a stage set) is but one sort of object; it is a noble, ideal doorway, if you will, a wall, a mirror. But a *passageway?* A picture, like the world as reflected on the eyeballs, embodies an illusion. Beyond the phenomenon of vision is the real world: a veritable Hell of chance and risk. Not, after all, a possible Heaven: a wonder, a glory?—not the crown and comfort of a hero on horseback, on a throne?

Tchelitchew, in the dark interior of the Staatsoper, laughs deep in his throat like some temporizing demon. Not equine now, the sound is like the crow—half dolorous, half jubilant—of the Golden Cockerel watching for the dawn of danger. Man, the beautiful animal, is . . . a zoömorph. At home, he grasps Allen by the arm: "Listen, Allousha! We will make a trip to Paris. Perhaps in a couple of weeks, eh? We will see—well, tell me! *Dites-moi, mon cher!*" But it is hardly more than a rhetorical question. In Paris, in the future, trembles the mirage of his ballet for Diaghilev.

"Besides," the painter adds with a sudden change of intonation as if things were much more serious, "Choura may soon be in Paris." Russians arriving in Berlin have been able to inform him of his sister's movements as an army nurse. She made it from Sevastopol in the very last ship able to transport the remnant of the White Army! He wrote to her in Sofia, Bulgaria, where momentarily she had found refuge after the dissolution of Wrangel's army on European soil. Choura, he has told Allen, is interested in medicine, wishes to study and he has heard from her (after sending her a little money) that a welcome message had come from Paris: a nursing school in the rue Vercinge-torix wished to expand its activities and usefulness by adding three foreign nurses to its staff. Alexandra Fyodorovna is one. The Princess Elena Belosel-sky and two nieces of a Madame Chaptal are in charge of the school. . . . Of course, Choura may never get to Paris. But *he* shall. As if he had been dreaming, he speaks again, "Say something, Allousha, what do you think?" He has not noticed the other's reply that it would be delightful to get to know Pavlik's sister.

The entranced Tanner nods, speaks agreeable, assuring words. The idea of horoscopes has begun to obsess his friend, although he is now a bit timid about them, as if one might explode in his face. At the last rehearsal of *Le Coq d'Or,* one of the male singers stepped forward and read aloud what he claimed was the horoscope of the opera's opening night, based loosely on the accredited date of the work's composition. There was some polite laughter on stage, some less polite scepticism following it. A female singer wanted to

know, sarcastically, why a horoscope should not be based on the date of the
first performance, then someone rejoined that operas do not, like people, have
"birthdays." There came a burst of incoherent, consonantal rudeness. Wish-
ing on impulse to intervene, Pavlik for once retired, mute, backstage, crossed
himself and "made horns" against the disputants.

The proclaimed horoscope, after all, *was* favorable. Pavel Fyodorovitch
has come to respect horoscopes as much as he does the ritual of the Russian
Orthodox Church. Dear Djanet Hanoum, when she is most serious, speaks
lyrically of the stars, which she said her remote ancestors were among the
first on earth to worship. When he remarked, "Yes, there is also a remarkable
collection of jewels *up there*," she laughed appreciatively because he was
referring to the way she prized her own collection of jewels. Now Pavlik can
be more definite about the dark omen that preceded the opening of *Le Coq
d'Or:* the Staatsoper's chief conductor, Leo Blech, though he stayed to
conduct this last post-seasonal production, had turned in his resignation. "Ah,
that Blech!" says Pavlik. "I think he must have a nose for the future!"

The papers are printing news of unrest in the Rühr, occupied in the last
war by the French. The haughty German pride is chafing, getting obstrepor-
ous. In restaurants, trams, subways, on the street, incidents involving insults
to foreigners take place. In a shop near their apartment, Tanner and Tcheli-
tchew are appalled to be refused service by an insolently deaf proprietor.
Pavlik cannot help rasping out, *"Podlyetz!"*—"Villain!", as Tanner, plucking
him by the sleeve, opens the door for their exit. Outside, his friend can barely
restrain the Russian's insulting gesture. Then, in a few days, they are petrified
on the street when, having dropped automatically into French, they are
aware that two men passing by have halted, wheeled and cast some barely
distinguishable abuse at them. Trembling, furious, livid, Pavlik reaches for
his green card, and speaking German, thrusts it at them. "We will get visas
for Paris," Pavlik, throttling his passion, whispers, "first thing tomorrow!"
On June 30th, 1923, their visas are issued.

The stars have been pulling the strings again, for on the past May 12th, he
received confirmation from Choura of her safe arrival in Paris at the Ecole
Chaptal. So they are soon destined to meet. But no, he will not send Choura
a telegram now to expect him. There might be some difficulty—though God
forbid!—about actually getting into France. He will simply call at the Ecole
Chaptal the moment that his train gets in. Anyway, he replied very tenderly
to her last letter.

For some seconds, he sat with the sealed envelope in his lap, while Allen
stood there waiting to go out with him. Before getting up, he raised his eyes
and Tanner noticed a look he had never seen in them before.

"Choura," said Pavlik with simple pathos, "is another poor little bough
torn by the storm from the immense old tree of Russia."

About the Fourth of July, the friends board the train for the first

instalment of their move to Paris. Ever timid about crucial steps, especially if their execution is early and rapid, Tchelitchew has only valises packed for himself and Allousha. He wishes to leave behind him, as it were, a home base in case of sudden retreat. In terms of classic perspective, he sees himself a shifting figure in the conflux of pyramids whose tip is one mutual vanishing point: he seems set within space as a pure, absolute structure. Yet whether space be considered boxlike, the view beyond a window, or as conic sections of a circle or sphere, terror and mystery adhere to the vanishing point where all perspectives converge: the point represents the beginning of the unknown — simply by moving the point-of-view toward it, the vanishing point is logically pushed even further away. Hence there is no stability in such a world, no end, unless one stops to consider space and perspective as limited— as the *données* of a painting, the *données* of a cosmos; for example, the cosmic wheel of a horoscope! Only so can the paranoia of *the open world* be evaded.

The artist's mind registers a stray flash: Was it not Pushkin who referred to someone's fanciful image of St. Petersburg as "the window through which Russia looked at Europe"? It was certainly some great writer. He must ask Pierre about it. But for him, Russia has ceased to have windows. The windows have become doors—or *one door* through which he has departed, on which he has forever turned his back. He swears an oath that from now on he will always look ahead, ahead to the new horizon where the "point" will not be to *vanish* but to *conquer*. His eye is fixed on the Champs-Elysées. And now he seems to grasp just what volume is: "the geometrical meaning of an object surrounded by space."

But time—*time*— One, not small, incentive for this abrupt trip to Paris is to catch the tail-end of Diaghilev's season.

The Fling

In the little Hotel Jacob where the friends put up, they have a large room with an alcove. There Tanner witnesses a very touching scene: the reunion of Pavel Fyodorovitch and Alexandra Fyodorovna. It is a blur of strange spurting little endearments, cries partly of language, partly of the soul, but wholly (even to a foreigner's ears) "Russian"—an affectionate gabble, loud and soft, which for sensuality no other language can reproduce; at least, not in Tchelitchew's mouth, perhaps not in anybody's. But the American spectator becomes suddenly aware of a hesitant and fearful nervousness in his great friend, a nervousness shaping the repeated hugs that he gives Choura . . . his hand lingering on her waist, his fingers clutching her dress at the shoulder as if judging its cloth. Alexandra Fyodorovna lights a cigarette. Will Pavlik prohibit her smoking? He doesn't smoke and doesn't like others to fill the air with tobacco fumes. But no, the little sister puffs away, unhindered.

As her eyes connect with Tanner's, the friend reads in them a kind of sad-happy, fatal recognition. He, the friend, has been identified: her brother's private personality is finally crystallized forever for Choura. But Tanner also reads there her desire to be friends with him. Amid the flutter, the dancing air as if misted over with tears, it is plain enough: sister and bosom friend must sign a peace pact—they must be allies, the better to be sacrificed to the man they both love. Then there crosses Allen's mind, as the other two sit at last and Choura relates how terrified she was on her way to Constantinople in 1920, the thought he had yesterday when they called at the Ecole Chaptal, only to find that Choura was at the hospital; they had to leave a message for her to call the Hotel Jacob. On first mentioning in Berlin that they ought to visit Paris, Pavlik had added dreamily, "Choura may soon be in Paris." Why, he had received word a month before that she *was* here! A good bit of her is here: she might be called chubby.

The friend observes the little sister and thinks her very pleasant-faced but not much like Pavlik. He had anticipated in her something of Pavlik despite his friend's assurance that his sister hardly bore a family resemblance to him.

Choura is physically unpretentious for it is the way nature designed her. The eyes are intelligent; to be sure, she has character . . . It happened that on board ship, in all the turmoil of the escape from Sevastopol, all her baggage, even her purse, was stolen . . . She is half laughing as she talks, giving swift little sighs. She did not know, she says, if she would ever be "identified" again. For Allen's sake, she is speaking French but every now and then bursts out with a Russian phrase. It strikes her that Pavel Fyodorovitch is already quite Europeanized. Her brother, in fact, looks a complete *Parisian* . . .

Not merely Pavlik's eyes, but every pore of his body, have been kept open so that nothing of the pearly grey coloration of this mythical city (he notices the pearly grey is here even in summer) shall escape. He lets it enter him like a lover, without visa, without rhythm or warning; he grants it the supreme privilege and feels himself its host, not its guest. On sight, he realizes that Paris *is* the Champs-Elysées, simply the leafy symbol of the city as a legend: a serene width, a sure harmony, a subtly insistent style, precisioned richness of spirit and thing. Every Parisian is a "blessed soul," or ought to be, at least.

The pattern is here, ready-made, and artists do "the obvious" only in that everyone expects them to *remake* it. Perpetually remake it . . . everywhere . . . on the stage . . . in books . . . in women's clothes . . . It sprouts every spring, on the walls of the art galleries in the rue de la Boetie, as do lilies-of-the-valley on the little stalls in the streets. The exhibitions are among the first magnetic objectives of the pair. Braque is showing and Tchelitchew renews his admiration for such past mastery in modern technique. To his enchantment, Picasso's Neo-Classic figures are on view, and in them he recognizes something toward which he has steadily been groping: a significance of the figure that is both grand and lyric yet not at once bloated and harnessed by geometry. No pseudo-buildings like obliterative strait-jackets! Pavlik recalls the saying: "The body is a temple." Well, be careful of the temple. Chirico has attracted him but that painter's curious atmosphere of desolation, his resignation to man as a mannikin or a statue, a figment of the past with a remote patina, makes even the brightest sunshine look tired and old . . . There is something too sorrowful, "backward," about all that! Chirico's perspectives retreat: *retreat.*

It seems as if Paris opens her arms, bestowing on the two young enthusiasts every cause for the charming illusion of seeing the city too close to the eyes. Also staying, by chance, at the Hotel Jacob is an American friend of Tanner's, Jane Heap, co-founder of *The Little Review*, whose New York office on West Sixteenth Street the young pianist used to haunt. Moreover, no sooner are they established in the hotel than they run straight into the arms of Michel Larionov, the inflamed "lecturer" from Moscow, who has been creating décors for Diaghilev. Pavlik, since those distant days, has made

friends with him. Now a mad series of excursions, including Versailles and the Louvre, are planned with the obliging Larionov as guide. The mutual intoxication of painter and pianist relegates the city they have just left to symbolic oblivion. This heavenly month is initiating them without discomfort into the future. For everything here seems to fall happily, step by step, into place. A couple of evenings after their arrival, they are passing the Cafe de la Paix and Larionov catches sight of Diaghilev—stiff straw hat tilted onto his forehead, staring through his monocle as if over the heads of people—seated alone at a table.

When they join him, the impresario shows Tchelitchew all signs of graciousness and amiably invites them to be his guests at the ballet. On the program is Nijinska's *Les Noces*, with the long-legged, lissom Felia Doubrovska as the Bride. Almost "Doubrovka": his old home! To the beats of the peasant-dancers, the artist says under his breath: "I must, must, *must* do a ballet for Diaghilev but when, WHEN?" Pavlik is round-eyed before the whole Russian genius of inventiveness while the young males remind him of the lamented Fedya, the valet (four years his junior) who found it so glad, exclusive a duty to shine his shoes! A treasure of the old days. But he is *watching* a treasure of the old days: this peasant marriage on stage.

Jane Heap arranges to take them to Constantin Brancusi's studio. Miss Heap's profile, according to her young, beautiful co-editor, Margaret Anderson, resembles that of Knut Hamsun: if Knut Hamsun were an ideal. But before the visit to Brancusi, Tchelitchew must pay his respects to his old master by-remote-control, Fernand Léger. Still in some awe before Léger's achievement, Pavlik is now rather out of key with it. The red-haired painter, receiving them at his studio, turns out to be a bluff but kindly *homme-du-peuple* who proceeds to show them, with an air of paternal benevolence, his latest work. Comically, when they have left, Pavlik murmurs in his "interior" voice: "Merveilleux, merveilleux, n'est-ce pas, Allousha? Un peintre comme un epicier!—"Marvellous, marvellous, isn't it, Allousha? A painter like a grocer!" Tanner, startled, automatically laughs. He is almost, but not quite, used to the other's naughty irreverence.

The party that takes place at Brancusi's studio is the summit of their visit; veritably, like the vision of Sacré Coeur on its mountain, which they could see on the train while still miles from Paris. Here is the genuine article—the artist's high life: the life of the great ateliers. Around the white stone rectangular table where Brancusi carves his statues, but where now he serves roast chicken, Marcel Duchamp, Tristan Tzara and Léger sit with them. The chickens have been roasted in the white kiln where the artist's works, *Bird in Space* and *Mlle. Pogany*, were fired. The evening's informal cheer is judged by Allen "a rousing good time." The small, genial Brancusi tells them jokes and plays his violin. At times, Pavlik is inclined to raise his voice above the

prevailing pitch. This evokes a hard look or two from these anointed Parisians—the kind of mute irony (typical of Parisians) reflected in the eyes like a change of light. Moreover, thinks the pianist, his dear handsome Russian seems unaware of striking these staccato, "unmusical" notes.

On the contrary, Tchelitchew is not thinking of any particular personal impression he is making. Something like this supplies his inner counterpoint to the evening: "Genius is the only passport, the only calling card, that gets one in the right places: the studios and salons where art is one and the same divinity. I am noble. But who cares? Even Paris society knows nobility only by titles, and they tell me that Parisians don't hesitate to consider princes and princesses insupportable bores and shut their doors to them. 'Status'—status is the word for eligibility here, the quality that is a personal attribute like one's face and voice. This is the quintessence of the Champs-Elysées! Blessed Status. One might say: Les Champs des Qualités! . . . Ah, Pavlousha, what a false paradise it was to think that Paris held a fairy tale world: a Heaven! Heaven is where one does nothing. Here one does everything; at least, genius does.

"Léger, Brancusi—especially Brancusi—have a genius: *le genie ou quelque chose!* Yet only bohemianism saves them from that big streak of *le peuple* in their natures. This streak has a charm, charming uses, "effects." Yet, well, Tzara, for instance, has made a chic of art, an intellectual attitude, an anti-art. Duchamp is much more talented than he, there's an intellectual for you: like crystal and silver . . . a *surface* . . . finished, "finished" in two senses . . . *un goût formidable, vraiment* . . . *all over:* himself one picture surface . . . But Duchamp has shrugged off art like a woman he decided to be through with. What style! That, no doubt, is great chic. And yet. *Alors?* Paris, they say, is a woman. To these men here tonight, art is also a woman. How clear it is. If Paris is a woman—well, *he* will have to see about that! At any rate this city suits him far better than does Berlin, which is a man. Too true. All Germany is a man as all France is a woman. Germany, a "man"—*un homme . . . oui . . . pas de la beauté mais de la bête!*

"That is the *most* that can be said for Germany. . . ."

Once he gets settled in Paris, he will grow mellower, more philosophical, about the issue of beauty in the sexes. Encountering an ugly man or woman, he seems never to tire of quoting the French proverb: "Chaque vilain trouve sa vilaine." ("Every ugly man finds his ugly woman.")

At Home

Getting out of Germany is now only a matter of time and routine. Pavlik's farewells are homogeneous, conducted rapidly on the instalment plan and subject to repetition. Besides, he expects many will follow his example and meet him soon in Paris. Souvtchinsky, in fact, will do so, as well as Lubitsch

and many others. By chance, the determined pair are accompanied on their big move to Paris by two friends, a painter and his wife, M. and Mme. Ivan Pougni. Yet things happen as if Germany knew the revulsion and defiance in their hearts and plotted on the fugitives a last-minute revenge. Their next French visas are dated August 17th, 1923. The German exit visas are stamped August 25th and their actual exit date is August 27th.

During their fling to Paris, Mercury was in Gemini the Twins—all through July and up to August 8th. It will be Tanner's recollection (without prompting by horoscope records) that they leave Paris during the first week in August; in any case, about this time, Mercury proceeds into Virgo, Tchelitchew's special sphere of influence, so that the conjunction makes a sign of fate. The planet stays there till the very date of their crossing the border, when (on August 28th) Mercury is found in Libra, Tanner's sign. Of course, in general, Mercury is a symbol of travel so that its position in a given traveller's special sphere is impressive. Astrologically, one must take these readings as ambivalent and necessarily crude. I do not note them with any particular awe, certainly not dogmatically, but only because, like the symbolic motifs in Tchelitchew's painting, they take on a striking consistency.

No sooner does Tchelitchew's party board the train this time than they are told, insolently, that they cannot have the seats they have reserved as usual. Why? Because foreigners are simply not entitled to them. They appeal to the conductor, who is discreetly mollifying and, after being tipped, manages to find them other places, which however are separated. The day is here when bribes speak loud in the deteriorating moral climate of Germany. It is not a moment too soon to swing clear of a nation where a catastrophe is openly being bred. Eventually a rumor crops up that the train is late, thus imperilling connection with the train which will take them into France.

After a while, without warning, the train stops and forthwith the lights go out. "All foreigners out!" It is a screaming order from the darkness. "Sit tight!" Pavlik mutters, reaching Allen. "It's a trick!" So it is, for nothing happens, the lights return and the train goes on. This is broad Expressionist comedy and seems a cruel farce when officials, with unconcealed malice, inform them that they may expect the French to lose or throw away their baggage. They accept this as a coarse German joke with the usual nasty threat behind it. Maybe train men and passengers have stage-managed a brutal little comedy without any basis whatever in fact; just the same, when again the train stops, the lights go out and the same phony order is bawled out, although now too nothing happens, they start wondering.

Arriving at Cologne on schedule, Tchelitchew and Tanner hasten to the Cathedral. Its beauteous majesty imposes on them awe and silence, offering their disturbed minds a tender touch of consolation. Pavlik becomes espe-

cially absorbed by Dürer's stained glass windows. Eventually he bursts out quietly, *"Sublime collegue!"* Reluctantly they have to go. When their visas are duly stamped on the German side, the customs man tumbles out the contents of their bags in such disorder that they barely have time, amid cries of protest, to get them back in before the bell sounds for departure. Then they find that the German ticket seller, taking advantage of the rush to the ticket booths, has outrageously short-changed them. To express his wrath, Pavlik cannot choose among the tongues at his disposal—Allousha makes to lay his hand over his mouth. "Never mind!" They will soon be in Paris and for good. The divine pinnacle of Sacré Coeur duly emerges like the changeful volume of time itself, more and more distinct . . . and all around spreads Paris in thousands and thousands of facets.

One, two, a few such facets must be their home. A young friend, the painter Eugene Lourié, meets them at the station and takes them to his studio. It is so small that the pair feel, after a few days, they must have other living quarters. The temporary solution is a room, without bath, at the Hotel de Nice on the Boulevard Montparnasse; at least it is in the Quartier. Apartments, as they hear, being scarce in Paris, they expect a long, arduous search before finding a home. Yet Pavel Fyodorovitch is not in the least sorry he has come; no, not even when he has a dream of flying: flying above Paris, above the Sacré Coeur, whose commonplace architecture (when he actually saw it) was so disappointing; it is only a rather ugly church.

Below him, in the dream, is a seemingly endless network of cubby holes, all of which seem to be lived in, for he can see people moving about in them, and beds. As he strains his eyes (he doesn't feel safe, flying like this, and wants to land at the first convenient moment) the cubby holes turn into ovalish shapes, shapes like the human face; Paris, the Champs Elysées, Montparnasse, the Eiffel Tower, are really made of people after all! Short-sightedness has always bothered him so he feels a sharp, hurting anxiety ready to burst in his chest. Into his mind, like lightning, flashes an image from his past: a head of Beethoven made entirely of tiny nudes. Some of the people in the cubby holes below seem quite naked: he strives to see them clearly but he seems flying so fast that his eyes cannot begin to focus . . .

Some of the women are semi-nude, costumed. At Doubrovka, his governess, Fraulein Leiffert, used to gape with him over a set of colored cards, not with the classic paintings reproduced on them, but with pictures of revue favorites, ladies such as Cléo de Merode, dressed in tights and corsets stretched over hour-glass waists . . . Then he starts to fall—he is terrified— falling—falling—— As he gets nearer the ground, the ovals which he thought were human faces look empty, they are holes in a vast net stretching over Paris . . . Will he fall through one of these openings? As he gets nearer and nearer, his vision concentrates on one hole which gets wider and wider. Or is

it illusion and is the net, after all, woven close enough to save him? He never finds out for now he wakes up. He has landed, evidently, in one of the cubby holes, for he is lying in his room at the Hotel de Nice. A sigh of relief explodes through open lips; he is panting softly. They are very cramped here, but this morning as on previous mornings, Allousha will continue his end-to-end search of Paris for something suitable. Working space is essential because making a livelihood is essential.

Dear, quaint, ever attentive Choura Rjewouski is also in Paris. Through his good offices and the enterprise of Pavlik's friend, Mme. Boguslavskaya (another emigrée by way of Berlin) he gets work to do for a small revue being produced by a Mme. Rasimi. It is rather second class, a come-down for the scenic designer of a production at the Staatsoper. But Tchelitchew cannot be choosy; in fact, in his unrestrained, glad way he is grateful to everyone, or at least makes a show of being. Cheeks so young, smooth and rosy as his fairly ooze unspoken gratitude. Through a friend of Jane Heap, Mme. Champcommunal, he procures some designing for the *maisons de couture:* she is a dressmaker now in vogue.

On his "unremitting excursions," as Tanner calls them, he spots a FOR RENT sign hanging in the rue de Copernic, a little street near the Place Victor Hugo. The apartment is very small, in a boxlike building with an aptly diminutive grocery on the ground floor. The rooms are so tiny that Pavlik exclaims in bemused resignation, "We are to live in a doll's house!" There is a kitchen, but no bath and no electricity; only a gas stove. Kerosene lamps must do for illumination. And they have to take what Allousha calls Poodle Baths in a round zinc tub, the water for it heated on the stove and poured in. As the apartment boasts three separate rooms, their friend, Sergei Nabokov (cousin of Nicholas Nabokov) suggests he join them for economy's sake. The rest of this damp, cold winter, their sole source of heat and domestic cheer is the fireplace, which Allen keeps glowing night and morning with plenty of wood and *boulets.*

En Travail

In Paris, one needs more than the two eyes with which nature has furnished man. Why, thinks Tchelitchew, is not every pore of the body an eye? What a wonder the world would become! All the same it would be monstrous, wouldn't it, if not confusing?—since Argus, of course, was a monster in Greek myth. Yet modern art, with its multivision, implies just such "monstrosity." Meanwhile, one's world grows larger, more complex. One gets to know more and more people; one has more to do, more places to go. Still, one has only two arms, two legs, two eyes, one —— Pavlik laughs out. La Nature is a notorious trickster who at times has no respect for her own sacred laws! There *are* such things as freaks, human and animal. Yet a zoömorph is—what

is it? When she gets perverse, Mrs. Nature—she is a married woman, naturally, or she would not have all these children—has no discretion, no sense of shame, no bounds even. Heaven knows what she is capable of doing with divine proportion, with the harmony of forms, with sacred number! It is interesting, nevertheless, to think that not one but two people, in a spiritual sense, may inhabit a single human body.

These "doubles" may well cause friction; perhaps one is good, the other bad: there are many old stories. . . . Leonardo in his sketchbooks used to make parables about such situations; at least, these drawings are strange, strangely suggestive. Leonardo was a strange, unique man. Whatever one might say about that "hidden vulture" (discovered by Freud, supposedly, in the *St. Anne and the Virgin*) Leonardo had an audacious mind and was fascinated by the beauty of men as much as by that of women. Since pleasure and pain are opposites, he made an allegory showing two male trunks growing out of one male lower body, nude; a young, charming man who is Pleasure, an older, bearded man who is Pain. You are free to imagine here more than meets the eye, n'est-ce pas? Leonardo was infinitely subtle, ironic, always with a perfectly straight face; *that* qualification makes him *sublime*. Pain in the allegory is symbolized by arrowheads dropping out of the older man's hand—of course! another such figure is about Envy and Virtue and there are more arrows, whole arrows.

In this drawing, Virtue is the same beautiful young man with flowing locks while Envy is a woman growing out of his stomach like an illusion. Virtue carries a quiver of arrows and is winning the contest with Envy (who has a scorpion's tail) by sticking arrows in her head—one is going into her eye; another—is it her ear? Mechanically, the artist touches his forehead with the wooden tip of the brush he is using then he resumes painting with it. Yes, *he* has a scar. And did not his ancestor die from a wound in the forehead? That self-sacrificing ancestor . . . Perish the thought. Things which are literally true of the past are only symbolic, vestigial, harmless in the present . . . "En tout cas," he happily croons, giving the words a languorous lilt and swaying himself, "Je suis . . . le beau garçon . . . par le nom de Verrr-tu! Je suis—suis—suish—huyisch——" ("I am . . . the pretty boy . . . called Virtue! I am—ammm——")

Eye still on the fabric he is designing for Mme. Myamlina, he suddenly jumps backward, simply delighted with himself, and stamps one foot.

"Pavlousha! Assez, *assez!* Tu n'es *pas* Narcisse!" ("Enough, *enough!* You are *not* Narcissus!")

Recently he has learned more about numerology that accounts for his emerging attraction toward the Cubist format showing three views of the same object. *Three* is the number reserved for his planet, Mercury, whose hieroglyphic is made of three basic forms: A crescent atop a circle and a cross underneath (the circle with only the cross below constitutes Venus' sign).

Indeed, Pavlik becomes grave when considering that Mercury, sexually speaking, supposedly alters according to whether it is associated with Jupiter (the Sun), when it becomes manly, or with Venus, a descendant of the Sun, when it becomes womanly. Mercury minus. Ah, *oui!*

With a former Berlin colleague, Boris Shatzman, he has been engaged to contribute to a new fashion rage: hand-stencilled dress fabrics. For months, Tchelitchew has been doing these designs which are being sold (unknown to himself and Shatzman) at a most disproportionate profit. "Quelle monstresse!" Pavlik calls their exploiter when at last the truth leaks out. To think! He has had to travel all across Paris to get to this lady's *atelier;* it is also far to the Russian Church, but that is quite different . . . The room in the rue Copernic is impossible to work in, he finds, so Pavel Fyodorovitch has taken a small studio with his friend Lourié in the rue de la Procession. Here many designs for the revues (some for the Folies Bergères itself) have been done.

He is used to reflecting that Fortuna, being feminine, is fickle. Yet his conviction persists that she has a kind eye on the lookout for him and again this faith is confirmed. Another, luckily more straightforward, lady engages him to do commercial work in fashions, a Russian, Mme. Elena Medtner, sister-in-law of the composer. One day, reminded of the living conditions of which Tchelitchew and Tanner complain, Mme. Medtner tells them about an available apartment that may be right as both a home and a studio. It is dingy, she says, but large. They rush to investigate. Like their present doll's house, it lacks a bath but it *is* large. Moreover, it is plump in the Quartier, at 150 Blvd. Montparnasse. They do not hesitate. For once, Pavlik's decision might be called instantaneous. Among the place's advantages is closeness to his new colleagues and their haunts. It is near the Académie Ronson and the Académie Julien, where for a nominal fee, Pavlik and others of his little circle gather to sketch the nude.

Among those who sketch at these *ateliers* are Eugene Berman and his brother, Léonid, both of whom Pavel Fyodorovitch sees at their uncle Anatol Shakeivitch's house. The latter is a sort of informal rendezvous; Léonid, in fact, lives there although Genia (Eugene Berman), not caring for the atmosphere, resides elsewhere. Of course, Tchelitchew, aside from his commercial work, is easel-painting on his own. More important is the fact that he has abandoned the lumbering Cubism of his Berlin stage designs and is doing easel figures with a new "Parisian" spontaneity, lightness and casual line. Giant nudes, male and female, have preceded his sight of the girthy Neo-Classic "monuments" of Picasso's recent figures. Now the studied Cubist planes of Man Reading, Woman Holding Apple, Embracing Couple (which he thinks of as following Cézanne) have given way to essays in boudoir nudes; if rotund, their inflection is Renoirish; if slight, van Dongenish.

Above all, he is becoming fascinated, and quite consciously, by the human

face. It is a new direction and its portent for the future stirs him deeply. Lautrec is one of his admirations—no one, he says, could give true elegance to a horse's flank like Lautrec—and there, in those infinitely human faces of people, sits humanity on its throne. All dignity and strength, all frailty and pathos, all irony and humor, live in those delicately but firmly drawn features that tell the age, the sex, the character of the individual as a novelist would—better, more accurately, than a novelist would. Was such abounding scruple of draughtsmanship due to the artist himself being "inferior," dwarfish? Well, no one is doing that sort of thing any more; after all, it is done perfectly—partly in Degas, too—now something else ought to come, true, but not quite so blank and dehumanized as in some cases. Ah, in the *saltimbanque* figures of Picasso one saw already the soul asleep in the faces: slipping out of them like water evaporating. . . . possibly out of the bodies too . . .

Once installed in the new apartment, Tchelitchew experiences a strong, if not altogether clear, revelation. All the methodism of Cubist Constructivism and the like tends to overlay and even disorient the human face, where the meaning of the body, clothed or nude, is concentrated—yes, no matter what nonsense or fantasies painters irresponsibly put on canvas! Modern hieroglyphs of the human lack—well, *respect*. One must be careful how one treats the face. Anatomy is a great science, naturally, it fascinates for itself, but some sort of taboo is hidden there. . . . When he ventures to discuss such matters with his Paris colleagues, he meets with a certain reserve, even suspicious caution. Genia and Léonid are sympathetic and speak out but most painters think it tacit to do what one likes with the human body—cut it up like a fabric to make dresses, show it, like Chirico, ridiculous or piecemeal or parodied. Great fragments, such as the classic statues, headless, armless . . . All very well. Chirico does it with some point. Their condition is a great accident of time, a kind of tragic metamorphosis by subtraction; they have the special pathos of suggesting the calm magnificence and total harmony they once were.

Now these grotesque hieroglyphs of Picasso's, this monotonous plane-making of the Futurists, perpetual motion of geometric forms, tricks at bottom, mere nervous reactions of the eye, flipflops; also violence, war, the destructive action of great machines. Leonardo! . . . He well knows Leonardo's war machines. But that artist was an obsessed man, investigating everything; he wanted to find out the way nature worked; to build, also, and to achieve great engineering feats for man's benefit; he had to make a livelihood just as he, Pavel Tchelitchew, does. A name! *His* name. He thinks of himself as Pavel, but now that he is here, he finds himself acknowledged as *Paul* Tchelitcheff and even signs some works that way.

"Enfin," he complains to Allen. "Painters don't think enough. We are all

like whores. But if I stick a feather in my ass, like some others, at least I know, mon cher, what it is! I see myself in the mirror . . . I'm not like the ladies who think they have chic if they put their hats on right side up. *Mordi* (mugs)! If they could see the effect sometimes."

Little monologues like this can be *sotto voce*, said as if no one were present. If a friend happens to be around, Pavlik's discontented, "cerebral" mood can be quickly turned into gayety. During this period, the middle twenties, the artist weathers a conscious crisis. Already the efforts to continue his bright palette in easel work, with the vivid contrasts he developed in Berlin, have caused sceptical looks and disapproving comments. What did he overhear Kochno say once? He knows why people think thus. Picasso paled, muffled his rose and blue; always it was in Paris light, lyric, delicate but suppressed, never (even with rose) the shocking, light-saturated hue. Yet is it not subtle as well as strategic to be bold—to shake people out of their ways of seeing, even out of "good taste"? The Fauves supposedly did that. *Déjà vu, par exemple!* Redon, with his fantasy, is something to love. There is brightness in his palette. Yes, but he *spots* things, it is a flower, a plume or a fan of light somewhere: an arpeggio of color spots in a luminous haze. No one, anyway, can imitate Redon, or the wonderful mystic, Rouault; so *brusque* yet so *tender*.

Late one afternoon, Tchelitchew runs into Walter Nouvel, friend and adviser of Diaghilev, and they sit for a while at a cafe. He will open up, tell all! Diaghilev, who will let him do a ballet, should hear how seriously he takes his profession, how much he weighs and thinks about the problems of art. "I am wasting my strength, monsieur, while I am forced to do this fashion rigmarole. It is deadly. Bérard docs it, too, but perhaps that will hurt nothing. At this moment I see very well that my drawing is flabby, inelegant; I'm sure you know what I mean. My ideas are not 'interesting.' The German theatre exhausted me, simply took hold of my insides and emptied them out on stage. I wish to do wonderful things at my easel, where an artist can be original and refine his style. I am young, I admit. All the more must I develop, mature, which is why I came here."

Nouvel nods, sympathizes, smiles.

"I don't mean I shall never work for the theatre again. I should adore, some day, to make a ballet for M. Diaghilev, if he still wants me to."

Ever so imperceptibly, Pavlik hesitates, fluttering eyes on Nouvel's eyes, and Nouvel, ever so imperceptibly, nods.

The artist gives a soft, ironic chortle. "But, speaking seriously, I want to do something new, original, in the ballet, something not seen before. I want to get rid of these easel paintings blown-up as backgrounds! I want to put textures and *things* on stage, to make, you know, fantastic theatre . . . not too fantastic, of course. . . ."

At No. 150, he reports his encounter to Tanner, who obediently turns from practicing on his piano to listen. Now that Pavlik is back, he will have to switch to the muted instrument (*piano muet*). The young artist has felt rather grim since speaking so frankly to Nouvel. He faces Allousha with lips solemnly compressed. Pavlik's eyes can dart fire. They seem to be kindling and—is it possible, thinks Tanner, that he's pale? Tchelitchew's brow with its fluent eyebrows looks masklike, set in "tragic" rigidity.

"I am at an impasse, Allousha! I know it, I can see, best of all, what I do. But I have strength. I know how much—maybe no one else does! You will see. *I will break myself in two*—I will discard the branch that is deadwood, even if it means including something that still lives. My country thought to do it for me, to break me off. I can do it better, and leave something to grow, not die, on myself . . . I have ideas simmering!" Momentarily Allousha's lips lose their perpetual pout. The other does not notice: he has torn off his jacket to begin work.

Tanner is embarrassed for he has had it on his tongue to tell Pavlik of a special commission which a personal contact in the Armour Company of Chicago has made possible. The firm is about to launch a new brand of cosmetics and needs shapes, labels. The chance was too good to pass up so that Tanner "made the kill" on the spot. It would be so easy for Pavlik! He decides to spill it at once before the artist starts painting.

For seconds, Pavel Fyodorovitch looks bewildered, like a child hearing news of some distant, unbelievable wonder which, perhaps, is not altogether attractive. Then, learning that he can have *carte blanche*, he snaps out of it, brings out his drawing board—it is prodigious—Pavel Tchelitchew can do anything! In fact, he produces two dozen designs in two days, and since Allen is the go-between, he takes them to "the poor man" who has already bought and paid for some stupid, common designs which he cannot use. Enthusiastically, at once, he selects twenty Tchelitchew designs. Tanner firmly tells him they will be thirty dollars each. It is with "true American kindness," the young American thinks, that Armour's man smilingly consents to this extravagant figure.

Is his destiny, Pavlik wonders, being interwoven with things American? Because of the money, he determines to ride with the currents of commerce a while longer. Summer is almost here; the spring shows have been discussed by Tchelitchew's round table, whose most formidable personality, he thinks, is the temperamental "child," soiled, slightly mad, a roly-poly conundrum with charm and ripening talent: Christian (Bébé) Bérard. On meeting, Russian bravura and French insouciance have exchanged direct looks of mutual respect and inquiring friendship. At home, where company manners are suspended, Pavlik, the unsleeping social satirist, can take his colorful rival apart:

"Mon Dieu! It is of an infantilism, *cette-là!* He has talent and the talent is

growing but not so much as the fat, which makes his clothes pinch him before they wear out. It is as if he outgrew them, *non?* Anyway, nothing will wear out: all the spots dropped there will furnish a quite new material and a new shiny pattern. Always, too, the hand across the breast, diagonal, it hangs onto the shoulder, limp, outside the coat, naturally, for no room is inside . . . *avec le geste d'une grande dame*, supposedly. Like a ribbon of the Empire! One can see his dream: it is not to be Napoleon, no, but Josephine—the soul *décolletée*, the sex, necessarily, more modest—" Ultimately, the ambiguous Venereal gesture of modesty will help clothe the figure inspired by Bérard (bearded) in *Phenomena*.

He continues with a plunge into English: "To be frank, Bébé *loves* if he would be ME. But *le Bon Dieu* arranged everything otherwise."

At this time, Bérard is still clean shaven. He expresses himself in rather guttural Parisian, with squeals and gasps, which at moments give way to a breathless sort of ecstasy, with suitable transfixions of pose. He and Tchelitchew often cross swords in terms of the fashionable *méchanceté*. Pavlik is still uncertain of the flashing idiom of Parisian French—is it all no more than a *plaisanterie de rigueur?* Anyway, it is a prime gambit in the natural war of personalities, to which Paris has made Pavel Fyodorovitch nothing if not hypersensitive. Status is also *de rigueur* but beyond the realm of social banter. If unusually nettled by a sly thrust from Bérard, Tchelitchew will refer to him by a title he has privately conferred: Mathilde, la Marquise de la Méchanceté. If pushed beyond endurance, he will pronounce to his face a less polite *nom-de-guerre*. But, so far, the two are amiable enough colleagues.

This summer Mme. Medtner offers to take the tenants of 150 Blvd. Montparnasse on a little trip through Brittany. Pavlik jumps at the kind gesture. "It is Heaven speaking," he declares. "I will see the stars. In Paris one never looks at the stars. Everyone is too busy being *les étoiles* on the boulevards. I should be making designs for a celestial Folies Bergères, *non*, Allousha?" The speaker frequents a number of studios but is not a recognized ornament at the great salons. On coming to Paris, he would hear of semi-official salons at the house of the famous Anna de Noailles, poet and hostess. He has seen photographs of her, too, in the fashion press, wearing hobble-skirts, showing huge concave eyes and bangs above them like van Dongen's brushstrokes. Other artists—Cocteau and Gide, for instance—go to her house, and a lady whose very name makes a scintillant arabesque: La Duchesse de la Rochefoucauld.

But spring, scintillant spring has gone; this season, there are no more salons. He welcomes the prospect of Brittany and takes along lots of painting equipment; he will even work in gouache, doing the country itself. He will paint in waves: make the colors "flow" on the paper. All the geometry of his previous style, all that stylish eccentricity of line: it has been chiefly *ex-*

ternals. It reeks of *schools*—and of others. Now in Brittany, he will be next to the earth, his special "sphere." For Virgo is the House of Earth. In August, when everyone is away from Paris, not everyone's planet will move into its own special sphere but Tchelitchew's planet, while he is in Brittany, dwells in its own Virgo. . . .

The Figure in the Studio

Tchelitchew has stayed in Paris long enough this summer to test his effect on the art public by showing at the Galerie Henri and in London at the Redfern Gallery. Like his inner development, the response lacks an emphasis. Both exhibitions are limited to drawings, some in color, and in London his ex-Berlin friend, Ossip (now Joseph) Lubitsch, has exposed with him. Teresh-kovitch, Lanskoy and Bart are among other painters in the Paris show. These men, of course, will not really follow him; he will just leave them behind. Does our hero now consult horoscopes regularly? Emphasis here is also absent. His devotion is not conspicuous; even Tanner cannot be positive on the score. On the present occasions he does not seem to care; he may not mind that Mercury will not enter Virgo till July 29th, when the London show will be over.

After all, art has its official seasons and one ought, horoscope or no horoscope, expose during them. The Paris show has yielded the interested presence of the peripatetic Cocteau. Visible, from Tchelitchew, are glimpses of Fontainebleau in gouache on black paper and a pair of acrobats, a *collage*, drawn against a piece of wallpaper peeled from the artist's bedroom. Cocteau, who already has Blessed Status, turns a warm eye on the self-confident invader and is heard to ask, with significantly raised voice, "Who is this young Russian who has so much to tell us and tells it so well?" Later he receives Tchelitchew at home—in dressing gown, *en boudoir*, as is his habit—where his sincerely expressed encouragement delights the eager, solemn Pavlik.

On his return to Paris, Pavlik bears signs of how efficacious have been the breezes of Brittany and everything "earthy" there. He has had a "different" fling: a perfect lark. The superstitious artist was excited, naturally, to sleep in a bed whose surrounding wooden doors, like a cabinet's, are to be closed at night lest spirits come up from the sea and carry one off! Back now, safe and sound, he is tempted to give heed to a place across a big body of water, the United States. Americans are still flocking to Paris in the postwar deluge. One of them is Glenway Wescott, who meets Tchelitchew in the spring of 1925. Pavlik hears from the young writer that he is from the great American grain country. Something strong and alive, "structural," is in his face. One likes the candid outwardness of bone and flesh; it is even a little "Russian" and Pavlik thinks of the Ukraine's wheatfields. Wescott has a striking look and in turn is

quite struck with the young Russian painter, who proceeds to do a head of him in pencil. This is preparatory to an oil painting but somehow the painting never wholly materializes. Its true fate (as we shall see) is speculative.

Tchelitchew moves quickly away from genre paintings of female figures and heads: these are, he sees, passing Parisian manners: "seasons" of himself. The pale blue of soldiers' uniforms begins to attract him; his visits to the Cirque Medrano imbue him with both aërial fantasies and their grievous mundane opposites: the fallen acrobat and the equestrian fall. If he hesitates to paint them, it is because so many Parisian painters, especially the redoubtable Picasso, have given the circus and its personnel an established place in their oeuvres. Think: back of Picasso, Lautrec's bewitching evocations and Rouault's paradoxical *clowns de l'esprit!*

It is in the midst of expanding evenings at No. 150 that Vladimir Dukelsky, the pianist from The Lighthouse in Constantinople, renews acquaintance with Tchelitchew and meets Tanner. In the "big, untidy" flat, where Pavlik paints in the living room and Allen plays on an upright (or, while the other is at work, on his *piano muet*), Dukelsky thinks that Tchelitchew, "all golden hair and plump rosy cheeks," and the "pale, willowy" Tanner are an "odd pair." They certainly are a pair of busy hosts, even if sometimes for customers who come to look at pictures and leave without buying. The Hell of society's Open House is beginning to germinate in Tchelitchew's blood: all that is hypnotically self-centered, callously self-indulgent . . . all that is on display, to devour and be devoured, all the crude gourmandise of conspicuous consumption . . .

Dukelsky finds at Tchelitchew's the "small, silent" Pougni, the "pugnosed, peasantish" Tereshkovitch, Count Lanskoy and Boris Shatzman. Nicholas Nabokov, with his tossed mane and visionary eyes, is already a friend of the house. One day Dukelsky (or rather Duke as he comes to call himself) is introduced to "Valitchka" (Walter) Nouvel, Diaghilev's manager. Another day he plays his concerto to the "odd pair" and catches Pavlik, amid his compliments, giving Tanner a large wink. Tchelitchew speaks of his sister Choura, who has lung trouble and must be sent, he expects, to climates healthier than Paris. Around the corner, on the rue Campagne Première, is Rosalie's tiny restaurant, where sometimes a small crowd of them go to dine. Memories of Modigliani are preserved there; Juan Gris, Foujita and Kiki are among its habitués.

The life of studio and cafe, for Pavlik's group that is turning against the artistic grain, is like a game of Musical Chairs. Which of them will make the first real gesture of freedom from the Cubist tyranny and so lead the way? Who will set up the true sign of liberation? Berman, Léonid, Bérard and Tchelitchew are each revolving about a return to the figure and its untransformed anatomy, its classic integrity. "Romantically," they are searching for

a personal mood rather than for formal system. Yet this mood must have its inspiration in form, color and line, else it will not be painting, and if the formal inspiration is not distinctive, and personally integral, it will not be new painting. In James Soby's opinion of the Neo-Romantic group that is about to emerge, Tchelitchew and Bérard will be the dominant spirits, the best talents, and in his book, *After Picasso* (1936), although he feels Bérard has painted the greatest work of the group at this period, Soby will credit Tchelitchew with being *chef d'école*.

A connoisseur and a man of keen discernment, Soby remains very idiosyncratic in taste. He never, he writes, liked Tchelitchew's color. I am anticipating when I quote him, but this is the very time when all he eventually summarizes in *After Picasso* is fermenting. In preferring Bérard to the other Neo-Romantics, Soby took into consideration that the whole group was bent on "touching the emotions" and that this came from nostalgic reference to the Blue and Rose periods which Picasso had abandoned. Picasso, he thinks, had "direct emotional appeal" while Tchelitchew (though not so Bérard) replaced this with "formal pathos." On the other hand, he attributes to Tchelitchew a "morbid literary nostalgia." Surely the latter applies more properly (since it is a differentiation within Tchelitchew) to the artist's stage work. Critical observers have not in general been conscious of the *under side* of Tchelitchew's development, knowledge of which invalidates a term such as "literary nostalgia." Along with the formal pathos of this artist, indeed part of it, is the emblematic strain in which his main succession of symbols develops step by step with his alterations of style. To characterize this strain as "morbid" is merely to defer to that school of opinion which has always maintained that symbolism as such is "decadent" and so on. Even so, Tchelitchew never becomes anything like a Satanist.

If one may say that a metaphysical vein will appear in Tchelitchew's work during the coming five years, externally it will seem to issue from Chirico. But this vein compasses only the artist's *portraits natures mortes* in which live beings are hallucinated with sculpture and furniture props and pictures-within-pictures. Prior to this phase, Tchelitchew draws a "formal pathos" from plastic effects suggested by direct observation of the figure as the kind of cosmic symbol it is in hermetic allegory. The ballet *Ode* will clearly provide a keynote for this. Bérard, certainly, will stay much closer to Picasso's discarded style though he will give it a great deal of personal freshness. According to Soby, Bérard's best works make those of his Neo-Romantic colleagues look "labored."

What, in 1925, is being prepared by Neo-Romanticism? Berman and Léonid will embrace the figure as nucleus of the romantic landscape given a Baroque flavor; this landscape-and-figure motif is still far in Tchelitchew's future. His plastic responses are deeper and more various—he has, very

concretely, *more to do* than the others. His work at Fontainebleau and in Brittany, his sketching in the Bois de Boulogne, are, so far as "nature" goes, exercises in a search for style. The human figure, with all its anatomic "finish," is the true iris of his eye; it is this "earth" which is his veritable Virgo, or horoscopic house, whose contact revives him. To Duke, a casual observer, Tchelitchew is still manipulating a Bakst-Soudeikine manner, but this impression must be owing to pictures, possibly old stage designs, left lying around the studio; in other words, to Tchelitchew's discarded past.

The agony has become an apotheosis, yet with an odd indirectness. We have Tchelitchew's word that his plastic fascination now belongs to the human face; precisely, in that the face is the body's first doorway and its last human guarantee. "If you wish to know a person's character," Tchelitchew will say in future years, "look at his eyes." Soby speaks of the "emotional appeal" of Picasso's Blue and Rose figures, the *saltimbanques*, the youths and the lovers. Surely this is correct, but little human drama or personality is conveyed by these personages. They have what one might call an imbuing pathos but it is slightly theatrical, rather "masked," as the great *Saltimbanques* group very tangibly declares. They have only to lose their picturesque costumes, their flowery colors, their props, to broaden and grow heavier, and they present the "formal pathos" of Picasso's first Neo-Classic monoliths.

Though Pavel Fyodorovitch now employs live models to sketch from in his studio, and is going about portrait-painting, as in Wescott's case, he has an impulse to turn out a few still lifes; this, he thinks, he can do with easier polish of style. Thus Wescott comes to suspect that Tchelitchew, one day, simply paints out the beginning of the writer's oil portrait and starts over it the pivotal *Basket of Strawberries*. In all truth, the human head is not lost in this work; the strawberries themselves are a direct prophecy of the eggs and the human "eggheads" of the same year, 1925. In fact, the work called *Multiple Heads*, showing elided full and profile views of two heads with a single nose and mouth and a third head bisected by the shadow of the others' neck, might be an arrangement taken from three of the overlapping strawberries in the still life. Wescott, gallantly, is of the opinion that, in the *Basket*, Tchelitchew achieved his first easel work of mature personality; he is very probably right. The shocking-pink palette, with the packed decorative notes of woven basket, wallpaper and tablecloth patterns, makes it seem (so assured is every brushstroke) a tour-de-force. Yet stylistically, *Basket of Strawberries* is successful as straightforward, completely felt lyricism. Aside from a certain rarity in the "aerial" view, it has nothing to surprise or entice and yet is, unquestionably, fetching.

Choura has come to stay at the Blvd. Montparnasse ménage and to some extent acts as its hostess. She runs the household affairs while Allen, as

alternate host, makes the cinnamon toast for tea. Her brother would love to see her the acme of a certain chic; watchfully, he tries to identify in her budding marks of the great salonière but in his heart, in moments of self-examination, he finds that prospect quite vain. Choura is a Tchelitchew, yes, "of a character," but she is humble, proudly humble; she thinks only of being herself and "womanly." That is not enough *for the world*. Is it enough for her? For *him*? He does sense—with a depth that is a trifle dismal—that *he* is enough *for her*. Wescott has the impression that the future Mme. Zaoussail-off is womanly at this time, passive, devoted to her brother, rather innocent and with no pretensions. Doubtless she is a little less innocent than the American writer imagines.

The apartment at No. 150 has three rooms overlooking a courtyard. From her room, Choura can tell whether Pavlik is painting a boy or a girl according to whether men on the same level, opposite, are twisting their mustaches and ogling or a lot of women are shaking out clothes. For the artist, the presence in his studio of the irreducible human volume, blooming, alive, altogether there and nowhere else, is a new axis of reality. The great Champs-Elysées of his art, the plastic constellations, are variously forming. He aims now at a "solidity," a presence of sheer carnality, "human earth," that is not in the stylish decorative manner of a Matisse or a Picasso, nor yet in the arbitrary geometric volumes and planes of Cubism or Constructivism. The real female insidiously comes closer, the real male (his regular familiar) can be held at arm's length; it is a way of equating the sexes, giving them a sort of astronomic orbit within his new sensibility.

His favorite female model is a former Folies Bergères girl, always (according to her stories) "engaged" and yet somehow never married. . . . She is really fond of Pavel Fyodorovitch and he, to his own amused surprise, finds her sexy. She amuses him generally, with her self-assertion that seemingly arises from animal savoir-faire, and he permits her liberties. If anyone knocks at the door, it is she who, in one word exactly, calls out "Who?" If a woman answers, she lets *le maître* attend to her; if a man, she bestirs herself and goes to the door. Once, Allen thoughtlessly enters without knocking and beholds a unique scene: Pavlik's model is sitting on his lap and—he is fondling her! Later, with undue emphasis, Pavlik swears that things have gone no further with the girl than fondling. He gives a curt, mock-derisive laugh . . . And Allousha sees that he is annoyed with himself for something. For what? Tanner never finds out.

Tchelitchew's erotic life is altogether romantic in the promiscuous or unimportant sense of that adjective. He gets "crushes," inevitably, obsessions, mad impulses, but all are fragmentary, nothing like what is ordinarily meant by "falling in love." His sexual temperament is remarkably pure and of a sublime simplicity and directness. He is (as he has known for many years) a

natural custodian of the male sex, proffering it an undeviating religious reverence. When he has a male model alone in his studio, nothing could be more void of evil than the sexual atmosphere. Pavlik is not so pretentious as to think himself a Priest of Priapus. A friend who should know will tell me after his death, "He was the *maddest* of us all!" It is a madness marvelously palliated with method. He is far too appreciative of physiological data for anything so formal and foolish as mock ritual. The only ritual in his studio is the performance of the picture. The rest is just life. Another beauty . . . Oh, a *beauty! Que voulez-vous?* But not the same. No! "*Non! Mille fois —NEIN!*"

"A thousand times—NO!"

Another Bridge

One of the moral hells that will constitute the many-vista'd *Phenomena* is rather tacit, speaking iconographically. For Tchelitchew, personal economic pressure on its positive side has the eternal form of professional competition. This is implicit in the clothes of "the poor" which he wears in the self-portrait situated on the Minus side of his great Hell and not much different from his actual painter's uniform. But also on this side, to the top of the painting, is the dreary dumping ground, at whose entrance sit, like watch-dogs, the female pair one of whom, unmistakably, is the first sibyl fatally to enter the life of Pavel Fyodorovitch, Gertrude Stein. At the moment, I pass over the standing Isolde figure with its comic Wagnerian pitch. Focussing on the two seated ladies (the other being Alice B. Toklas), one detects beneath their feet many stacked canvases, faces down. The allusion is to Miss Stein as a collector of doubtful connoisseur status who has hoarded numerous, intrinsically worthless paintings. The dumpy female miniatures are unparalleled for common veracity toward the portrait-subjects together with suave nips of satire. Miss Stein has a Pre-Columbian laconism of mass.

One need not, in the dimension of time enclosing the tenses of this book, be squeamish about the labels affixed to these gentle caricatures. Tchelitchew's onetime friend and patroness, Miss Stein, will be nicknamed (for the purposes of this transcendental freak show) Sitting Bull, while her companion, with equal justice of touch, will be dubbed The Knitting Maniac. A list of such cognomens will be the only identification available when the painting makes its international tour.* It is the spatial dimension I have accorded Tchelitchew's masterpiece that allows me to run ahead of schedule. We are, at this moment of time, in the autumn of 1925.

Five figures are simultaneously approaching the Pont d'Orsay (so Tchelitchew alleges, Tanner recalls the Pont de la Concorde). They are, in one

* At the time *Phenomena* was first exhibited, there was an official list naming the principal "freaks." However, for the sake of clarity, I have sometimes departed from this list in designating certain figures for this book. The names given the Stein and Toklas figures originated with the artist.

party, the artist, Tanner and Jane Heap; in the other, Miss Stein and her devoted companion, Miss Toklas, riding in their famous chariot, the Model-T Ford christened Godiva. The first to scent the delightfulness of the accidental meeting is Miss Heap. She has heard from Miss Stein that Tchelitchew's work has already happily engaged her notice. On view, at the moment, at the Salon d'Automne, the painter's *Basket of Strawberries* may well be singled out by the art-avid writer, as indeed it will be. Other observers have felt the shock calculated by Tchelitchew with his intensely frivolous colors. After the introductions on the Pont d'Orsay (or the Pont de la Concorde) everything is roseate. Pavel Fyodorovitch sparks with hope: the eminent lady talks not like a middle-aged woman but like a bright young girl. The Sibyl (as Miss Heap insists Miss Stein is) has seen, will see; she speaks and smiles. It is enough for one day.

Inevitably, though, there is a sequel because Miss Stein collects painters—young and gifted painters—as well as paintings. The lady not only has the figure of a matriarch, she is as maternal as a long-established institution. Her physical imposingness (people say she has the profile of a Roman Emperor) does not disguise her mental penetration but on the contrary dramatically sharpens it. Moving through space, she parts time before her as a ship parts the water in its path, with serene, mathematical impartiality. Her youthful voice, an agreeable masculine tenor in prose, has the quiet, good-natured imperiousness of a queen's. This self-possession is the more remarkable because, at this time, she is still trying to get editors to publish her work. Pavel Fyodorovitch, reared a man of the world, is perfectly sensible of the Stein authority and the Stein possibilities. It is very simple. He will become her foremost protegé: her new one. And he does. Yet the manner of this event (described by Tchelitchew as the lady's "violent passion" for his painting) falls out rather unexpectedly.

On the strategic bridge, it was said that the two ladies must, after viewing the *Basket of Strawberries*, come to his studio and see all his work. Now many days later, the frail Godiva stops by the door of 150 Blvd. Mont-parnasse and the Misses Stein and Toklas descend. They have "dropped in" and Tchelitchew is not here! Only Tanner is at home. The latter's excitement is intense; he dare not turn them away. Alas! there is an irksome detail that may frustrate this flattering and propitious mark of attention. Tchelitchew, ever cautious, puts his work away in a bedroom closet, which is usually locked. For some reason, today, he has taken the key with him and is not expected back for hours. This point is explained to the visitors as Tanner, bracing his nerves and his muscles, tries to force the locked door in their presence. Implying with restraint, and a gleam of mischief, that she is used to getting her way, Miss Stein recommends Tanner go down and bring up a wrench from Godiva's tool box. Although, when bought, she was stripped of

all accessories, Godiva has not been left naked; Tanner finds her supplied with a large, heavy wrench. The artist's young friend is startled to have the closet door fly open at the wrench's first solicitation.

For three-quarters of an hour, then, the ladies sit in rapt attention as tempera after tempera, drawing after drawing, passes under their eyes. The closet's contents are exhausted. Miss Toklas has commented on details that she likes, the other lady has preserved silence: like a sibyl in trance. Now they want to see the oils. Tanner obliges, finally reserving one which, he tactfully explains, "ladies may wince at seeing." He has held back a candidly detailed, profusely male nude. "Show it," chorus the two connoisseurs. The only adornment the sailor who was its subject wore, they see, was a pom-pom, the regular French sailors' cap. Evidently amused, Miss Stein remarks to Tanner: "It's quite a peep-show, you're right, but it's very good." She adds, "We like so much that we've seen." And she asks Tanner and the artist to come to tea on their next free afternoon.

Gertrude Stein acquires some Tchelitchews and hangs one of them on her dining room wall in the rue de Fleurus, enjoying the fun of placing Picasso at table so as to face it. Tchelitchew himself, with Tanner, become familiar figures at tea and dinner. The artist does not underrate Miss Stein's taking him under her wing—that is just the way he thinks of the fortunate stroke of her patronage. He feels that it helps promote the group show that opens at the Galerie Druet on February 22nd, 1926, with work by himself, Bérard, Eugene Berman, Léonid and Kristians Tonny. The press is cool; about the only favorable critic is Tchelitchew's old acquaintance from Berlin, Waldemar George. Though in this instance, as in others, more than one allegation exists, George may well take credit for dubbing the school begun by these painters as Neo-Romanticism. At any rate, if later subject to dispute, both in origin and meaning, the term is historically fixed and Soby plausibly adopts it for his book.

There are on hand many friends and colleagues from Berlin to witness the spectacle of Tchelitchew's local spurt. Germany has literally been casting out its "devils," among them the refugee Russians, so that Paris is now the elected headquarters of Europe's Russian expatriates. A cousin of Tchelitchew's, also named Choura (Alexandra), is on the scene, and for her, an eligible scion of the worldliness that Pavlik misses in his sister, the artist has appropriately ambitious marriage plans. Among the permanently transplanted Russians is Pierre Souvtchinsky, who has come here without Anna Ivanovna; the latter, as it happens, is content to keep the humble little nest she shares in Berlin with her friend, Aunt Marussia. Tchelitchew's natural aggressiveness, boosted by Miss Stein's patronage and the emergence of Neo-Romanticism, has increased and there are fewer and fewer brakes on his high-powered self-propaganda.

He and Tanner regularly go about to the studios. To himself, the unhappy Tanner has to admit that his unstoppable friend is not making the kind of

personal impression he ought to: the one consistent with his fond hope of status with a capital S. Tanner at the piano, since he is gifted, is a welcome diversion wherever they go. The Misses Heap and Anderson are his tireless partisans when his name is mentioned—and when it isn't. At André Derain's studio, whose host has a candid liking for Tanner and his playing, the pianist notices that Derain is inclined to make no secret of his coldness toward the splashy conduct of our hero, whose talent, in fact, the other painter holds in low esteem. It is all the worse since Derain observes that his attitude makes no dent on the surface of Tchelitchew's gusty aplomb. Pavlik, regardless of time and place, will not curb his polemical impulse. Allousha broods over this as unfortunate without daring to criticize. Above all, he will not let himself be accused of doing anything to taint his idol's mounting feeling of success.

At home when painting, with a sitter in his power so to speak, Tchelitchew rises to his heights as the enchanting host. Here, in the bosom of his art, he is easiest, most benign; here he weaves his spell as raconteur and great banterer. Insidious compliments are painted in the air with his tongue. In fact, he has a way, as Lincoln Kirstein has emphasized, of involving a sitter with his work that becomes a kind of flattery. *Chez lui*, the painter is king and courtier in one; abroad, he is only another artist climbing the road to success. When Souvtchinsky comes to Paris, Pavel Fyodorovitch is already established in the Boulevard Montparnasse. There is no longer between the two, as I say, the old warmth, the old mutual regard. Souvtchinsky hears stories of his former protegé's spontaneous vauntings as well as his rising star, and running into him on the street (after the Galerie Druet show) he cannot resist giving him a nip. "Mon ami," he tells the artist, who seems wild-looking and rather puffed up, "you had better watch your step! Paris ground is slippery, you know, and you may lose your footing!" Tchelitchew's reply is not recorded.

Chez Gertrude

Herself a fireside, Gertrude Stein is ample compensation for Tchelitchew's technical loss of Souvtchinsky's support. Above all is the Paris of this time molten, elastic, inviting. Americans swarm in the cafes with a force that pushes the historic present as far as 1929. Virgil Thomson eddies against a sidewalk table in Montparnasse and finds himself sitting with Tchelitchew and Bérard, whom he has recently met. The young American composer himself is full of steam, his baldish youth perfectly secure, even now, in the knowledge of having something to say in music and being capable, even now, of saying it in words. Thomson too finds sociability in the Stein-Toklas household, which is a heralded lodestone for young men of temperament and the gift for listening to maternal sibyls.

If Tchelitchew does not make a hit with every American who arrives in Paris in the twenties, it is exactly because he has, among the extravagances

from which he suffers, an overweaning insecurity which he tries to hide with bravado. On the other hand, a little group of Tchelitchew partisans from the United States is slowly taking form. Glenway Wescott listens to the artist say how important it is to keep up with old friends "because," as Pavlik explains, "we are a great generation and should help each other." Wescott readily assents. The next time they meet, the American novelist brings someone along to consolidate the cause. It is Monroe Wheeler. Allen answers their ring and beholds two figures proclaiming their Americanism with clairvoyant insight into the future: they are wearing blue jeans and leather jackets.

About now is the chiming moment when Bébé Bérard takes on hair by growing a beard like an ample bib and Miss Stein takes it off by cropping her old fashioned hairdo (which distinguishes the early portraits of her) for a stripped head incontestably of this century. The local wits aver that Bérard has multiple uses for the masculine ornament on his chin, among which is wiping his paintbrushes on it. Careers and *la méchanceté* rush ahead like waves trying to top each other in a heavy sea. But artists in Paris are ineradicably bohemian. If Bébé Bérard appears unexpectedly at Tchelitchew's door to sleep over, it is no less a favor than he habitually asks of all his acquaintance; he simply arrives carrying a toothbrush and is taken in. Legend has it that he will "sleep anywhere": the luxury of a bed is an indifferent matter. One night, Bébé informs them that his bathing suit predicts the weather according to whether its color turns blue or rose. Maybe this is a shrewd gambit to get a rise from the susceptible Pavlik. If so, it succeeds. "I know the manufacturer,"* Pavlik retorts, "you don't need to tell me." Tchelitchew's temper can be as thoroughly bland as flamingly eruptive.

Internally he is always preoccupied with the voice of his art. Never will he fall into the vulgar error of opportunism or mere careerism. He will attest that he now heeds the shocked reaction of those who see a disagreeable blatancy in his palette: "my peculiar taste in colors" as he phrases it. "I decided to revise my color values," he goes on in this account, "and as a consequence threw away all but black, white, ochre and natural and burnt umber." At this juncture, he starts his first white and grey canvas, the three eggs, from which he derives the "eggheads" of which I spoke above. Sober-suited, he takes up a geometry of nature, and from the anatomic norm of the oval he cultivates the germ of a new humanism. The eggs are pure ovals, but not mathematical, since they allow for quality of outline, paint texture itself and especially shadow. This work, and the *Multiple Heads*, is done in house paint as a result of Gertrude Stein's information that Juan Gris uses it. One easily perceives the organic relation between the two paintings; it is as if the youthful male heads, with their plain sleepy features, had been hatched from the eggs.

* Picasso

The same year (still 1925) he enlists Allousha as a sitter as well as a young American of Scandinavian descent, the poet Bravig Imbs. In consonance with the Expressionist milieu, the artist's linear idiom and physiognomies are eccentric: the oval of the head as if melted a bit out of shape, the eyes and mouth out of natural alignment. But where contemporaries (for example the Expressionist Soutine) employ such effects as terms of violence, Tchelitchew scrupulously gives them a kind of archaic composure. Allen Tanner's face in his portrait, though undoubtedly this is a sophisticated modern work, mono-planed and "rapid," is firmly in place as a volume and beautifully character-ized as a portrait. The painter here makes no sacrifice to the "formal pathos" which Soby will identify.

A kind of dawnpink arises in Tchelitchew's *grisaille* like blood coursing through flesh that has been slapped. It is from a sensual prompting, too, that the artist, when 1926 comes, begins mixing sand with his paint. Braque and Juan Gris have done it, but to Pavel Fyodorovitch it is an optical symbol for impulsive touch, a supercharged skin texture. When the canonic *Nude in Space* is painted, we see two male bodies, literally, in back and front views with heads dissolved into each other. This is a dark canvas burnished with flesh-highlights as if the nude volumes were on a borderline between shadow and light; it has a most natural effect of restful dignity. The male nude, thus doubled, could not be more candidly present, yet far from being voluptuous or erotic, it stands veiled in sacred remoteness. Tchelitchew is already correlating moments of time with aspects of the object. Mysticism has been claimed for this modern device in Cubist theory. In Tchelitchew it is destined to transcend plastic metaphysics, however, and crystallize in hermetic alle-gory.

The frontal *Nude* done in housepaint the same year, also male, with sand and coffee providing a granular surface over most of it, is insidiously blood-warm despite (or because of) its saturating earth-color. A brunette light prevails in the just-mentioned double nude; in this single nude, where no anatomic beauty is attempted, a warm uniform pink-grey serves to make it as blond as a stretch of sand catching the first light of dawn. A grand, particular figural quality of the artist is being established. It is neither precisely monu-mental nor precisely heroic: gone are both anticipations and mementos of Picasso's brawny hieresiarchs seen on Pavlik's first trip to Paris. One might say the new quality is heavyish, a kind of carnal though unerotic indolence, conveyed not by large anatomic volume, rounding chiaroscuro or virile accent, but flatly, mainly by line and proportion. Its rhythm is *adagio* but quite lacking deliberate grace either in subject or technique. This 1926 work is the authoritative statement of Tchelitchew's anatomic quality till the Celestial Physiognomies will emerge about two decades from now.

There is no evidence that the connoisseurship of the era cares much about

determining what Tchelitchew is really doing now. As usual, and as else-where, art politics in Paris is too busy with personalities, reputations and markets: those invisible clichés of art criticism. This element is reflected in the very genre that brings closest together artist and art patron: portraiture of the latter. "The young Russian," Miss Stein's key epithet for Tchelitchew in *The Autobiography of Alice B. Toklas*, embarks specifically on an oil portrait of Miss Toklas, less specifically on one of Miss Stein. The latter is a lady already, and very eminently, sculpted as well as painted. Picabia will dauntlessly execute a portrait after her head is sheared, but to Tchelitchew it is faintly annoying that he cannot do her (*if* he does her) in the simply dressed long hair of Picasso's famous portrait and Jo Davidson's sculpture. Perhaps starting too late, he will not arrive at any but a tentative, rather timid, plastic conception of Miss Stein till the Sitting Bull image of 1936, the inverted compliment of a caricature, but perhaps all he can legitimately add to the massive solemnity of the sibyls conceived by Davidson and Picasso. The Pythonesses of ancient Greece are said to have squatted over their tripods while being inspired. Squatting is how Davidson, magnificently if casually, shows Miss Stein's seated bulk: it is the leisure-hour complement to Picasso's intent philosopher.

Perhaps our hero is subconsciously resentful that he doesn't get his spon-sor's outright commission for a portrait. The same etiquette does not hold for her friend Miss Toklas, whose lack of pretension to handsomeness is an automatic inducement to Tchelitchew's exercise of his new zeal for the face. The portrait is a consciously cool work; energetic, truthful, yet acidly impertinent, like a dry offhand comment that results from long thought and astute judgment. *La méchanceté*, perhaps, in a bored manifestation. There is no reason to think it not a sound painting—but a pleasing one? Miss Toklas will herself tell me that it pleased her—I feel she is being sincere—but Gertrude: "less so." Miss Toklas reveals a delightfully fastidious scruple in speaking of Tchelitchew from the distance of the future; or, to quote her verbatim, "I don't like to be quoted against him." At this time she apparently thinks he knows "where he is going and why." It is possible to regard this, spoken to a Tchelitchew partisan (myself), as somewhat euphemistic. Virgil Thomson retains the impression that some grounds for the ultimate rift between Miss Stein and Tchelitchew lie in the dominant opinion *chez* Gertrude that the "young Russian's" ceaseless drive is to be phrased as always "wanting to be on the band wagon."

At first Miss Toklas did not like her distinguished friend's haircut but eventually she got used to it. Perhaps the same comes to be true of the fate of the Tchelitchews in Miss Stein's collection: one simply gets used to their absence. Gertrude has a room where she puts the paintings she no longer wants to look at. In the course of events, all Miss Stein's Tchelitchews find an

unlimited haven in this unsociable room, are presented to young painters who admire them, or are traded to dealers. Just before Miss Stein gets her haircut, the English anthropologist, Geoffrey Gorer, meets Tchelitchew at her house. There is mutual liking and their friendship—though at first Gorer is more personally taken with Tanner—advances with every opportunity.

Like others, this young Englishman is soon treated to the melodramatic pathos of the artist's life struggle. I have mentioned the happy chance of the designs made for the Armour cosmetics, which according to Gorer enabled Tchelitchew to pay for his sister's passage to Paris and his own move there! The aura of fiction is merely where the aura of fact is given the chance to blossom at its most bountiful.

In perfect truth, the two patron-deities *chez* Gertrude have extended themselves to show Tchelitchew marked and significant favor. Pavlik and Allen are "les enfants de la maison" for Gertrude Stein and Alice B. Toklas; so the ladies tell them with flattering repetitiveness. The title is meant to bear a special compliment since Miss Stein has opened her door to them after a period of semi-retirement. As they learn, this seclusion resulted from combined exhaustion and disillusionment with many well known friends, some at first great intimates, even disciples, of the hostess, but finally objects of vigorous criticism by her and her companion, who judge matters of personal vanity and general protocol in the spirit and letter of no-appeal. The lady's own brother, Leo Stein, Picasso, Robert McAlmon, Hemingway, Lipchitz, Ford Madox Ford, among others, have gone the way of all Gertrude-resistant flesh . . . Picasso, it seems, because of "Olga," Hemingway because of his "independence," Ford because his wife, Stella, "irritates." One's character and private life must be able to bear the hardest scrutiny by these ladies: so tender of the high expectations for others nourished in their own breasts.

Tanner is now official host and helper to Miss Toklas and is pleased to bring to tea Elliott Paul, who is starting *transition* and "wants nothing better than a manuscript from Miss Stein." A new era seems opening to all concerned and all concerned are reciprocally grateful. Paying "duty visits" several times weekly, the fond enchanted youths begin to feel a little spoiled, and actually they are being spoiled; they even say so themselves. At Christmas time, gifts are showered on them; gifts even arrive from the various towns met while the ladies are travelling in Godiva. Sitting with Gertrude Stein as with a sibyl, the artist exchanges ideas on the large, capitalized subjects: Art, Painting, the World, Life, Death, even Immortality. . . .

"Life and death cannot wait, Pavlik. It is simply that. That is the quality you call fate." She is teasing him. He senses it and yet adopts her straightforwardness.

"But immortality, Gertrude, it is the way out, the way of escape."

"If you can wait for it." It is her coup-de-grâce, lucidly enigmatic, every

word weighted equally. She knows that he knows he cannot wait, not even for immortality. The sibylline smile slowly crosses her lips.

"Ah, Gertrude . . ." His low exclamation, pronounced in French, is a tribute to her wit and he does not go on. His eyes seek a Juan Gris still life on the wall and stay there as if he were musing on the question of how long he *can* wait. His mind momentarily turns to a thought hallucinated by the Gris painting. There *is* something majestic about Chirico's melancholy paintings, so silent, spacious, not at all cluttered. Is it—is it perhaps that everything "still" is nor really "morte," that all the "nature" is very much alive: can move, at least *be moved*? Therefore one might make true *portraits natures mortes!*

"But she's taking so much trouble for me," he thinks of Miss Stein, "that's the thing that matters. She *likes* me—and *she*, maybe, is Fortuna." It does not matter that his patroness is not strong on the subject of immortality. She seems so wise about so many things—such as not imitating Picasso by "breaking the object"—that she sits there as a symbol rather than a woman; or, if a woman, a maternal symbol: the Great Mother of transcendent myth. Not quite so important as the one he will call Mrs. Nature for *she* produces real children.

In his all-embracing manner, Tchelitchew pours out everything about himself to Miss Stein, not only his ideas, his worldly struggles and hopes, but all his private affairs, his problems. He does not stop to think that Gertrude Stein is a tyrannical woman with a mind like a man's, a "mother" who wishes to rule her sons by participating in their lives to the full, having her inevitable say-so. This is the motivation for the fatal judicial arraignments that eject friends from her life. At the same time, it is beginning all over again. Kristtians Tonny, one of the recent Galerie Druet group, has been taken to the sibyl's bosom. Other young artists and writers are forming a new circle *chez* Gertrude; some, indeed, are patently jealous of Pavel Fyodorovitch's high favor and would like to supplant him in first place. One sees through them! They dangle before the regal, alert, captious Miss Stein the lure of more flexible and governable natures: a readier obedience.

Guilelessly, Pavlik complains of his sister as one who could mean so much in his house as a great hostess and is, instead, an unpretentious homebody: she will not even wear the proper clothes. He makes frantic efforts—and he should know something, *enfin*, about dresses—to give Choura ideas and advice. He even has her stand like a mannequin as he shows her how to shape something to wear. And what is his reward? Angry sufferance as he kneels, tucks, pins, then a sudden wild scream, a tearing off of the garment, tears, exit and the door slammed after her! Miss Stein chuckles and shakes her head. Though she does not say so, she cannot give her verdict without consulting Choura for her side of this and other questions. When that is accomplished,

privately, she outlines the proper course of conduct to our hero. The advice itself is secondary to the fact that his great patroness has gone behind his back and undermined his domestic authority. Certain of his verbal inflections insinuate to his friend and admirer that she has stepped a bit out of line. It is the beginning of the end.

I have it from Miss Toklas that Gorer, Tchelitchew's first English collector, prods Miss Stein's companion for her real opinion of the artist's portrait of her. "You're not pleased, are you?" he asks, adding suggestively, "So I've heard." The subject is not disconcerted. "You're mistaken," she answers simply. Gorer's object, she believes, is to "make trouble." Naturally a certain amount of intrigue of this type is inseparable from human friendships and is probably timeless. The two hostesses take much frank pleasure in serving the cause of their protegé; indeed, as Gertrude Stein might have phrased it, they take much frank pleasure.

They take much frank pleasure even in the face of certain dubious signs. For they are quenchless matriarchs, no less epicurean than exacting. The summer of 1926 finds Pavlik and Allen enjoying a rather "independent" holiday in Toulon. Choura is along and though the boys fraternize, perchance, with the sailors, Tchelitchew has to forbid Choura the streets, when alone, since several times sailors have accosted her. In this situation, our hero's sister is fatally pretty. While they are still in Toulon, such urgent and affectionate letters come from the Stein-Toklas house in Belley that the *enfants de la maison* decide to accept the ladies' invitation to visit them there. The lovely Rhone is far below the house, in a valley, and all around stretches a tall, soft, continuous outline of mountains. The four make pilgrimages to view Mount Blanc and to inspect the house of Jean-Jacques Rousseau and Madame de Warens; they also go berry-picking. On the latter excursions, Miss Toklas insists on wearing fine white gloves, which become liberally stained as with blood. To Allousha, Pavlik starts calling her Mrs. Borgia.

One evening Miss Stein, who has been busy scribbling, addresses Tanner: "I have just begun your portrait. I'll let you see it in the morning after I've revised it a bit." Of course, she does Tchelitchew's portrait, too, but not till later, when back in Paris. Tanner's portrait will appear in the volume, *Useful Information*, Tchelitchew's in the one titled *Portraits and Prayers*. It may be usefully informative that Pavlik is identified in his by an English pseudonym, but it is hard to get any "useful information" from the portrait as such. That it displays him under a fiction may imply that, as if incognito, he travels under an alias. Maybe he has already become "foreign" to Miss Stein. Maybe the end has officially begun, maybe the sibyl knows it soon *will* begin. Outwardly, things are still pleasant; the favorite still stands, nominally, first at his sovereign's side.

The young French writer, René Crevel, has entered the new Stein-Toklas

circle by grace of Tchelitchew. He is blithe, with his eager expression, broad lippy smile and blond curls, and has hit it off with Pavlik at once. A characteristic Tchelitchew of this period is a portrait of Crevel, sporty, very schoolboyish, in a sweater; not especially strong but, on sight, attractively personal and tenderly painted. Like Tchelitchew, Crevel is prone to break out in the tongue of the many Americans and Englishmen who have become their mutual friends. A sample of this habit (from a letter to Gertrude Stein in Belley) indicates that not every foreigner has Tchelitchew's peculiar gift for turning English to practical account.

The date of Crevel's letter, October 19th, 1926, would make it seem that the *enfants de la maison* are still basking in the prolonged summer of their hostesses' affection. " . . . and the boys?" writes Crevel. "How are the boys Pavelik [sic] and Allen? Say their [to them] my good pensées and when Pavelik will return to Paris (when)? I want ask from he a drawing for a little philosophical book that I will publish this winter at Marseille."

When Tchelitchew's rift does come with his majestic patroness, Alice B. Toklas (in retrospect) feels temperate and objective enough to vindicate the "Adrian Arthur" of Miss Stein's portrait of Pavlik. She says she always found "something very frank about Pavlik's *méchanceté*"—it's just that he will allow nothing to interfere with his career: he is merry—ah, he is merry!—yet he goes armed to the teeth. Behind Miss Toklas' retrospect on what she calls "the parting" is the implication that beneath a superficial clash of personalities lies the tireless belligerence of Tchelitchew's self-interest. On her side, Miss Stein has as radical a respect for protocol as does her protegé. It comes out that she doesn't like "Pavlik's procedure with grande-dames." As she declares to Miss Edith Sitwell, in fact, "He has no respect for them."

When the English poetess appears on Tchelitchew's horizon, his case has become acute if only because there is prospect of Miss Stein's being their social intermediary. "If I present Pavlik to you," she says in her direct, conclusive way to Miss Sitwell, "it's your responsibility because his character is not my affair." Yet the point may not be quite so conclusive. Therefore, with admirable candor, she adds scrupulously: *"Take care . . .* Find him customers!" Neither italics nor question marks, I know, are typical of Gertrude Stein's prose, but perhaps she permits herself some in conversation.

From the vantage point of time, we need cite only the title of the late Dame Edith's autobiography, *Taken Care Of* (1965), to assume that Tchelitchew's future great friend is not in the least abashed at the idea of "taking care of" Pavlik's customers, Pavlik, or anyone else of her acquaintance. Just now, though she doesn't know it, her initial position as the rival sibyl is advantageous. With quiet detachment, perhaps not altogether due to the cooling of time, Miss Toklas reminisces:

"Pavlik thought he'd have trouble getting rid of Gertrude."

Circus

As a matter of course, Tchelitchew gains access to the salons he considers collateral if not directly instrumental to attaining Blessed Status. It is gradual but, as it were, "it is written." For this end, of course, connections are everything just as, to an astrologer, conjunctions of the planets are everything. Is it strange that a man with Tchelitchew's aristocratic instinct should place so much emphasis on common worldly advantage? No, it is the more natural in an unassuming snob of race such as he, whose livelihood is at stake. His blood tells him that true race is inutile for the game of art politics with its social hierarchies and publicity techniques so closely knit to one another. In his freshly acquired worldliness, he likes to pretend to pretend this is not so. But cruel facts force his hand: facts always nourished, magnified, by his Muse of Paranoia. Moreover, when he hears around dinner tables the usual parrot-like *hommage* to Matisse and Picasso, his temper, his blood wrath, betrays him. Inveterately, there is "something very frank about Pavlik's *méchanceté*." Whether or not the occasion disposes him to think of it, he is aware of an extra hump on his back like the bag of an itinerant peddler. Born a butterfly, by his own myth, he has become a workhorse.

He has no patrimony and for himself he cannot think of an advantageous marriage, such as he wants for his cousin Choura. Maybe Choura, his sister, will never be married, but he has in mind a bridegroom for his charming cousin: Prince Pierre Galitzin. The expatriate colony in Paris is full of titled and aristocratic Russians, with some of whom, of course, he is in relation. From the female contingent, Pavlik has elected for his particular attention the lovely Princess Paley of birdlike beauty. She is morganatic daughter of Grand Duke Paul of Russia and at present is married to Lucien Lelong.* The artist finds in her everything rare in feminine grace, elegant in feminine style. Her very bones are birdlike; sometimes she seems to him a being driven from her natural habitat, persecuted by hunters, frozen in passing apprehension. In courting her socially, our hero finds—to his mingled pride and jealous annoyance—that his chief rival is Diaghilev's new leading dancer, Serge Lifar. Eventually he will translate Mme. Lelong's pale magic into a beauteously emaciate, mindlessly rapt *Ophelia* (1932). If Lifar's Russian features have an insolently coarse beauty, his strong limbs cry out for a transparent costume; *un danseur*, yes, a courtly rival, but, to the artist's dreaming eye, some magnificent elusive man-beast . . .

If one can believe the best books, the psychology of manners in the higher social brackets seems to have changed little since the eighteenth century. There is the same practical "sizing up" of the situation, the reconnaissance of the field as if one were on an animal hunt; therefore the deathless phrase:

* Today Mrs. John C. Wilson.

hunting lions. Pavel Fyodorovitch has his own lions to hunt, not always exclusively social lions; one of these he will capture and make a central performer in the circus of *Phenomena*. Reading Edith Sitwell's account of her first contact with Pavel Tchelitchew, one might think that both of them, finding themselves in the same theatre in Paris, were like animals in a forest, casually stalking, not necessarily predatory but scenting from afar, wary. One should remember that Dame Edith was the author of a savagely sophisticated poem called *Gold Coast Customs*, which takes a bland univer- sally satiric slant on cannibalism. Recounting for a newspaper, in 1960, what she titles "Hazards of Sitting for My Portrait," the poet states: "I first met Tchelitchew in 1929.* I was then in Paris and went to the Parisian première of a ballet my brother Sacheverell had written for Diaghilev. During both entr'actes, I noticed a tall, desperately thin, desperately anxious-looking young man circling around me, staring at me as if he had seen a ghost."

I daresay the sense impressions in this brief passage are very truthful. If actually touched up a bit, they owe it to the poetic imagination and subse- quent events. The reason for Pavlik's "stalking" the lady comes out three days later when (as Dame Edith further writes) Gertrude Stein introduces them.

"You are Russian, are you not?" Tchelitchew asks her.

"No, English."

"That is not possible! You must be Russian!"

Pavel Fyodorovitch then tells her that she bears an extraordinary resem- blance to the original of Father Zossima, the saint in *The Brothers Kara- mazov*. "He was my father's confessor," says the artist, "and one of his greatest friends." It is typical of Tchelitchew to enshrine literal truth at the expense of fictional truth. Are not these truths, in the genealogy of the imagination, first cousins? As we have seen, the fictional Father Zossima was supposedly based on the factual Father Amrovsky, who, as the artist knows, was his father's confessor and friend. Tchelitchew does not have to explain the internal logic to Miss Sitwell; Dame Edith does not have to explain it to her readers. The base of the most extreme fantasies is legitimately factual. Yes, the substance of truth is not in names, in persons, but in functions—and the function of all mental operations partakes of what Oscar Wilde termed "the truth of masks."

Room must be made, accordingly, for the common sense mask of some firsthand testimony regarding Miss Stein's function as go-between. Gertrude Stein, according to Virgil Thomson, "had Miss Sitwell on her hands in Paris for ten days and introduced them [Tchelitchew and the English poet] as a

* The year is certainly Dame Edith's slip of memory or a typographical error. She will sponsor Tchelitchew's big debut in London in 1928; the year therefore is, in all probability, 1927, since the first production of her brother's ballet, to which she refers in the next sentence, *The Triumph of Neptune*, was in London, December, 1926.

way of helping to ease the burden of both." I should say that like many collateral truths—such as the report that Tchelitchew, at first, doesn't even care for Edith Sitwell—the casual accumulation of data both reinforces and challenges the constant "truth of masks."

Substantially, it is still 1926. The historical present thus intervenes and we find that Tchelitchew is still not ready to break with Miss Stein. Painting takes his mind even off his career; that is, off his social relations, most of which are professionally motivated. Nervous strains, suspenseful hopes, little manoeuvres and hard frustrations are elements of the Hell of "getting ahead": an everyday matter. He is still far from being ready (or having the idea) to paint this Hell as such. He has an experience, however, that forecasts things to come in painting and in the world. The hags of *Phenomena*—lovely or unlovely, superannuated or super-breasted, sibylline or blank—are anticipated by his chance, melodramatic glimpse of La Goulue, Toulouse-Lautrec's heroine. Tchelitchew is destined to discover freakdom as one facet of the truth of masks: a narcissistic self-immunization as a result of social trauma; that is, the Beast as Beauty.

He and Allousha are in Montmartre, at one of the street fairs with their booths strewn on both sides of the Boulevard. There are stalls and tables covered with trinkets; a shooting gallery; games of chance; various exhibits: a fire-eater, a contortionist, a snake-charmer and so on. They are sauntering down the midway when, with a gasp, Pavlik exclaims: "Allousha! La Goulue! Is it possible? Let's go in!" Thrilled, Tanner swings round expecting to see some elegant, once famous old lady "doing" the fair as they are: they will get closer to her. But Tchelitchew is pointing at a painted sign reading: "Come in and see in the flesh, 'La Goulue,' the famous inspiration of Toulouse-Lautrec. This is a unique and *last* chance to see this great attraction."

The admission charge is three francs. A few watchers are vaguely milling around inside, their interest unable to focus. But the cynosure herself is large and clear as day. A huge woman, weighing possibly 300 pounds and clothed in a loose wrapper, sits placidly in a rocking chair, fanning herself. In the background, like some incongruous butler, stands an old man, toothless but with the famous "Mephistofeles" chin; he is making idiotic grimaces, some of which are downright obscene—of course! he is Valentin-le-désossé, her old dancing partner. And the woman, unmistakably, is La Goulue: the provocative, whizzical face, the pert topknot of hair. As for the rest . . . Will she suddenly get up, throw off her wrapper and make a pretense of dancing—?

The pair who have just come in, hallucinations of Lautrec's pictures buzzing in their heads, cannot stand it for long. In a very few minutes they are outside and have downed, with great rapidity, a *fine* apiece. Why, why, asks Pavlik in his soul's secrecy, does La Goulue remind him of Medusa, of La

Dame Blanche, of Anna Ivanovna, of Natasha Glasko, of Gertrude Stein, even of his mother? His myths, his muses, his spirits, divine companions of youth and boyhood . . . sibyls . . . Sibyls too must have informal moments, human moments, moments behind the scenes. There is his glimpse of Gertrude Stein at Belley one morning, when by chance he runs into her issuing from the bathroom. She is wearing a voluminous white flannel nightgown and about her neck a bright red kerchief—her hair, still uncut, is in braids and flows onto her husky shoulders. At sight of Pavlik, she squeals like a girl and vanishes with a really scared look. But she has not seemed repulsive: he thinks he has just seen the true sibylline Gertrude, officially *distraite*, officially gowned, fresh from some chthonic ecstasy . . . Now, having just seen La Goulue . . .

Really, for a man whose twenties will soon be ended! The *fine* must have gone straight to his head. Many women he knows, including poor Mama, are, in all sobriety, getting older, older; they will all get a big grotesque perhaps, despite their dignity, despite everything. Oh, it is easy for time alone to make one a monster, a freak! Men, too—!

And he has a profound revelation. He cannot be mistaken. He seems to have guessed it before, although never explicitly. It is now perfectly clear, just as if his old fishbowl were before him, and the goldfish—or was it "black"?—with the telescope-eyes. His childish passion for fish caused him to bring his face quite close to the side of the bowl. Seeing the fish coming head on, magnified, as if isolating itself, its fins flickering from its head, great eyes projecting, he once hallucinated the fabled Medusa . . . and painted her. Why this *marine* Medusa? It must have been . . . it must have been because . . . seen thus, its throbbing lips like the welts of a chafed and swollen *glans*, it is, it was, it is like . . . He would love another *fine* but getting tight is against his rules. The revelation is disturbing enough . . . Now he will always associate fishbowls with the traumatic heads of women. And one of them he will imprison in *Phenomena*, an old one, like a baby in an incubator, and (as he puts it) "forcible-fed."

He has been returning to "the earth" with a vengeance. Natasha Glasko now resides in Paris and they have had a reunion. Having altered his palette and augmented the body of his paint, he has associated deliberately with the physique of pigment, heaped this leavened earth as if patting down wet and spaded soil about the roots of plants—or with his hands revelling in mud as when a child . . . that "incredible omelet" of soft crayons in his hand! Naturally. Natasha, the perfect sport, the soul of feminine gayety—he has found Natasha depressed, morbid, a bit too old. "Something has happened to her," Pavlik tells Allen and Choura. "What is it?" Instead of probing Natasha's mind, he paints her portrait. It is all quite natural because, as she can see, his style has changed. With the oil paint, he mixes just a little sand, enough to make the face and hands grainy.

Mlle. Glasko, the grotesque "little girl" of the beach at Baabe, the grandiloquently self-styled "Balletomane and Friend of All the Great Ballerinas of the Period," Natalie Alexandrovna Glasko now appears as a sad clown. The touch, by all means, is Tchelitchew's but this face is as close as he will ever come to emulating the clown masks of Rouault. He may be daydreaming of Modigliani's elongation, too, but there is no precise "African" formalism in this mournful moody face. The sitter's physiognomy has a ghostly finesse: the mouth is only a thin line drawn against the minute drifts of sand. Natasha of the curved, recklessly female, laughing mouth! On he paints her deeper into the shadow, chary of the highlights, long-faced. She of the uncontrollable limbs! Breasts like the plunging tips of waves! The thick crooked torso in its plain dress shrinks, volumeless, into uniform dark.

In retrospect, he will feel himself the first Neo-Romantic "to work through darkness and out the other side." It is as if, in certain fine portraits, like the heads of Boris Kochno and Serge Lifar, he felt his way with his hands rather than his eyes. The luminous dusk that drenches them has a physical palpitation on which the enclosed physiognomy asserts itself like a pulse of individual beats: longs and shorts in "melodic" contour. The anatomic style is not at all naturalistic, but mannered to catch personal characteristics the artist chooses to isolate. The results are charm and signs of the Tchelitchew "modulation" that will be much prolonged. And it seems as if one's finger might make a momentary dent on the flesh, so real and "alive." But color? The flesh is as if subtly dyed.

Gertrude Stein was amazed at the eggs which he said he painted "in color which is not color." Yet the umber, raw and burnt, turns to golden ochre and sienna; is a kind of crawling fire in the underbrush of his palette; it hides in his paint's muscular impasto and liberates itself prismatically, divested of sand, seeking tones of burgundy red and indigo—and Prussian blue like his mother's riding habit—resting, illuminating the shadows like the little white poodle curled up by one of his reclining clowns.

Echoes of the ideal forms that appeared to Renaissance artists like apparitions of the Virgin or chthonic secrets, and hung in the air like that in the portrait of the mathematician, Fra Luca Pacioli, in Naples: these appear and disappear in his canvases during the twenties. He intuits their aërial placement as "astral" just as did the artists who placed horoscopes with geometric facets among the clouds. Black and white linear constructions womb an adult *Thinker* (1927) in a pose more like Michelangelo's absorbed Contemplator, Lorenzo de' Medici, than like Rodin's aggressive *Thinker*. But the erect *Blue Acrobat* (1927), as natural yet as abstract as a drifted dune, holds in his hands a basic form: the archetypal circle; it is hoop and circus ring—and more. The hoop's circle is whimsically freehand; the spirit of the calipers still has a long push to win dominion in this artist; yet calipers themselves: they would frustrate the eccentric curves of bisymmetric nature.

The perfect beauty of the geometric facet will behave in his imagination rather like a will o' the wisp. The icosohedron suspended before Fra Pacioli is a polymorph with twenty planar faces. The idea will assume a naturalistic form in *Hide and Seek* where he will make one face of the "dandelion clock" that of a little dead girl who haunts his memory.

The kneeling, standing or recumbent clowns are lightened, rather than weighted, with the circus personnel that emboss them. Like Astrological Man, nude save for the zodiacal signs, these "cosmic" clowns bear the constellations of the whole circus; the belly is at times a mere circle, but once it is a drum, its crossing cords a subconscious memory of the threads X-ing the sewed-up belly of the toy Harlequin he fatally, as a child, attacked, wept over, discarded. But even more, the sumptuously scored clowns—melancholy or faceless "children"—resemble the allegorical figure of an Astrologer in an old engraving, dressed like a 17th century king and holding in one hand a Celestial Globe: the model of Tchelitchew's future Celestial Physiognomies. In the circle of the bowels of one Tchelitchew clown a trained bear, Russia's emblem, balances on its nose a world-sphere; this animal species, when it appears in Hell, will be arctic: a sign of paradox.

By 1930, his clowns are fallen riders or have the drowsy relaxation of odalisques; their collaged physiques are a mundane inventory of the kitchen. Again the belly (House of Earth in the Zodiac) is symbolic of the mended Harlequin of childhood: a netted market bag of fruit or vegetables. This version of the digestive system persists, appears as Gertrude Stein's whole torso in a drawing, mutates to the time when the circus or kitchen *collage* of a clown's body is instead the *portrait nature morte;* one is a collection of objects on a chair, surmounted by a canvas showing a bald painted head, that of the dancer Harald Kreutzberg. But before this phase he paints, in 1929, the great *Clown*, using Wescott's abandoned head* for the manly *piquant* face, just slightly exaggerated as if halfway made up for performance, a line being drawn round the features to indicate a mask. Standing larger than life, this sombre intense image, immersed in jade shadow with sequins on the costume like stars in a cloudy heaven, has the heroic presence of a Renaissance figure. Yet its folded arms (punned with the bold legs of a female acrobat), its belly which is a pure spheric volume, its clumsy straddling stance, speak surely of moments in which the artist lives. It is semi-blind human earth, every muscle and organ as vivid as if it were a nude. An acrobatic "genius" of one of its legs, supporting the belly's globe, kisses it and presumes to establish, with its own bent leg, an illusion of the master clown's manhood.

In Hell the costumed clown will be entirely superceded by the moral and physical anatomy of clownishness. The permutations of Tchelitchew's style still retain his old abstract motivation, his concern with inner structure, the

* Wescott is my authority for this observation.

memento of plastic and magic antiquity, the nervous play with traditional genres of painting; the obsession with sex. A *Sleeping Spahi* (1931), in full dress, is treated with the simplifying grandeur of Cézanne's drapery turning into mountains, yet his legs loll wide apart; in a *Seated Spahi*, meditative as a saint, square peasant fingers clasp, viselike, in his lap. One of the clowns is almost a straight parody, in posture, of Giorgione's *Sleeping Venus*. The classic gesture of modesty (hand over vulva) will be casually burlesqued in the Leopard Boy and the Bearded Lady of *Phenomena* . . . The artist's Hell is gathering in his imagination like actors for a rehearsal; or better, actors in a spontaneous charade, transvestite perhaps, maimed by time or whim, but as assiduously modern as a crowd in Grand Central Station. The artist's formal pathos seems suppressed, his emotional pathos keyed up, if we regard the total extent of his oeuvre in organic sequence; so much of it is preparatory work for the three large chef-d'oeuvres: Hell, Purgatory and Paradise.

Past, Present and Future, the basic tenses, are *one* tense in overall consciousness. So is Dante's journey one experience and Tchelitchew's Divine Comedy one work. The great lesson of Proust (in whose book the mechanism of memory is only a demonstration of this lesson) is that aesthetic experience naturally becomes part of an individual's permanent equipment, as much so as anything else that happens to him. In Tchelitchew, the aesthetic experience is shaped as powerfully by the physically immanent, the human viscera, as by the physically transcendent, the near and far universe outside us all.

At the end of his style crisis, the artist decides that his first task is "to sift the mystery of the shadows."* Vrubel's chiaroscuric magic still ferments in his veins, purling into shadows that keep dropping into his mind like shrouds. At the heart of this shadow seems to pulse the childhood mystery of the Holy Trinity: the three-in-one. The double too holds over him a persistent optical power that exists inside him as much as in the painting: the Siamese Twins will express it in Hell. From his Nyanya's version of the religious mystery he clairvoyantly derives his concept of the "laconic" (compression of number) and the simultaneous (expansion of number). Sand, typically next to water, is a symbol of "flowing earth": dunes that form rondures like the human nude. Sand, therefore, he employed "to bridge over," he says, "the dangerous point between two projections of the same person."** The mystery of the spirit is for him also a fleshly mystery. It is not something that concerns only air, that takes place in empty space. The acrobat at the circus seems to fly but this is a transient illusion: he starts from earth and returns to earth. Moreover, miscalculating, he falls, he is killed or injured, maimed. The painted funeral of

* Rosamund Frost: "Tchelitchew: Method into Magic": *Art News*, XLI: 24–25, April 15, 1942.
** Frost· op. cit.

the female acrobat, echoing anatomically the *Green Venus* in the hammock, is a melodic variation in distributions of weight, both dead and alive; the weight at the middle, the buttocks, is the weight of relaxed mass at its most inert . . . the region where even the constellation, Virgo, casts all the weight of feminine sex into passive surrender. The buttocks are but the outposts of the entrails: the divan of the pelvis.

The Futurists have plotted the phases of bodies moving in space, shown them as on a graph of vibrating planes, all clustered. Even their war scenes look like a ballet of forms where no one is killed or hurt. Leonardo, in any case, did it much more beautifully in his Deluge drawings. To himself, Tchelitchew, it is more important that the zone inhabited by the flying acrobat is a danger zone. Two projections of the same person: this is like two moments of time, and not abstract (as on the clock) but real, physical. Therefore what James Soby terms "histrionic" in Tchelitchew: a theatre-of-action. Every move in space signifies a minimal risk to the body; thus when two aspects of one body are shown, the body is divided by time, occupying a different space from moment to moment, and yet is, normally, a maintained organic whole. The point is to assume a continuous unity; so, in painting, the movements are to be shown simultaneously. Doubling one is simply halving one *turned inside out*. Simultaneity = laconism = synthesis.

Still the break—*a* break—must come. So drama: theatre. There is "the dangerous point." More earth is needed to hold it firm, like a bandage, like "new skin," till it heals and grows together again. Regularly, Tchelitchew goes to the Cirque Medrano in the late twenties; the poet and critic Edouard Roditi recalls accompanying him often. Arriving with the Hon. Stephen Tennant—a flamboyant young Englishman who starts collecting Tchelitchews—the artist enjoys an entrance producing its own fanfare. The aërial feats of the famous Colleano tend to mesmerize him. Yet he is equally enchanted by the clowns, by Grock and the Fratellini, by their masquerade as much as by their antics. They are the soul of the circus: themselves fantastic bulging tents, menagerie of animal and man, costume and flesh.

His painting, *The Ship* (1926), is really—actual strings composing most of the floating, loosely geometric form—a circus tent anchored among blazing constellations on an ambiguous sea as if held down by stakes in the earth. Sand and coffee grounds are in its sooty gouache and great deposits of this painted soil collect as if they were ocean swells. Time will form abscesses of them* and one will literally, many years later, erupt and need "medical" attention. Over the pebbly sands of *Phenomena*, human society will be erected like a circus, all in severe pyramidal forms like the facets of a diamond, and a bathing beach tent, at the painting's lower right, will exactly echo the central, tentlike nucleus of sails in *The Ship*.

* This is well known behavior in overheaped impasto, a crust being formed over a center of undried paint.

Ode (1928)

Life is a passion play in which betrayal is the vital, indispensable motif—that betrayal of life by life which is the act of organic creation. It begins in the human realm and spreads in every human act: consolidation of self by the grace and disgrace of self- and other-betrayal. Originating in sperm, the human individual borrows, hour by hour, its mother's generous life. Its organic independence emerges as a peace pact and a declaration of war. Do Gertrude Stein's disciples and protegés "betray" her? Do they feed on her and then defy her? It would be only in the natural order. What one "owes" one's other-substance is a high and complex moral question; its truth in action ("repayment" and so on) provokes a fine equipoise between tribute and betrayal, loyalty and rebellion. One aspect of this dialectic—the formal one in logic—is already wearisome in our time.

It is a fashionable axiom in every intellectual category: artistic, political, physical, metaphysical. It is like the skirt in female fashion: there must be some version of it, however brief or negligible, however bizarre. If 20th century painters frequently change the fashion, and their own fashion, there is a dialectic to explain it; an admirable mesh, a logical series of inner links. It is a raid on self or others in terms of about-face, plagiarism, borrowing, whatnot. Just this is already becoming a sore polemical issue for Pavel Tchelitchew. Yet speaking posthumously, one may say that his art is unique of this century in being the only one in which a universal system adjusts and shapes such molten links within one various and subjective order; the only one which places the description of the process of internal change (or "self-betrayal") above the methodical cultivation of its casual products. Not that Pavel Fyodorovitch, like any other modern painter, will cease to methodically cultivate. It is simply that his art is everywhere a translucent medium through which we view an original experience of Proustian integrity and stature, visible in panoramic outline like Dante's *Divine Comedy*.

The key to his Comedy is the hermetic lore that is the oldest religious tying-together of the life experience. There is an indefatigable feeding of Tchelitchew's paint at original springs. The sun, in the naturalistic world, is a *theatrical* element and gradually gave historic birth to the anatomy of chiaroscuro as a painter's science. Light is theatrical throughout Tchelitchew's present phase and yet rebels against what is obvious in this theatricalism. His *Loge* subjects (1931) are monochromatic in red (the human figures "stripped down" in character and costume) to emphasize reflection of light from the stage. And "illegally," as if by self-betrayal, it is inevitably to the stage that Tchelitchew brings his revolution of light as *emanating from* objects rather than *falling on* them. . . . What of man? In the center of nature, humanity may be pawn or master. The melodrama of light is man

(action) plus light (music): action-plus-music is the antique definition of melodrama. Light is the transcendent core of nature and man begins by being its student. Such is the inspiration of the ballet *Ode*.

In one of the artist's brief autobiographic sketches, he is found situating *Phenomena* on the level of allegory through light and its colors. He declares there that his conception of *Ode* was "the seven days of creation culminating with the appearance of the Aurora Borealis, the Northern Lights." A painter's preference is for north light and Tchelitchew will see the real Aurora Borealis while in Vermont in the United States. Thus he adds in this statement: "symbol of light coming from the North." Facing North, we find the sun rising on our right. The artist paints *Phenomena* in this position (namely, in New York) so that, logically, the pyramidal mass of the skyscrapers at the top of this work, supposedly of glass, have an arctic character, are pale, icily prismatic. Of *Ode*, Tchelitchew further says in the aforesaid sketch: "This was my first phenomena of Nature, later to become 'Phenomena' of Mankind in 1938."

Pavel Fyodorovitch is prescient, his very changes as directional markers outrange themselves, are guarantees of fate if not of fortune: I mean specifically his artistic changes. In the realm of art he "betrays" himself ("breaks himself," as Tanner reports, "in two"), and not once but many times. Every stylistic transition is both a rupture and a fresh *entente*. *Ode* is a theatrical graph for this. Each rupture has the suspense of aërial risk, the absolute moment of disorientation that is paranoiac terror. The equestrian accident is still himself, during that parade in Moscow, falling off the dancing horse . . . Thus in semi-dread, semi-delight, he turns from his studio to his social relations. The same space-time dimensions dissolve, vanish, reform: not without pain as not without pleasure; here also is the fatal abrasion, the pierced void made only of "cotton stuffing": the daring, darling, unfathomable embrace. Gertrude Stein and Edith Sitwell are "two projections of the same person," the archetypal Sibyl. Where is the mucile sand to bridge *that* "dangerous point"? Fundamentally it is the person of Pavel Tchelitchew, though one also calls it, commonly, the personality, and stylishly, the *persona*. Soon it must bridge the space between Allen Tanner and Charles Henri Ford; later, in Ford, it must merge as well as define the Lion Man who is an animal demon, the Lyric Poet who is a divine companion.

The italic passages that intersperse the following text correspond to the directions in the scenario of *Ode* and comprise the ballet's main action:

Prelude. *A white cloth used as a screen for photographic projection. A head (the Moon) crosses the screen from lower left to upper right; it is made up white with no expression or facial movement whatever. As it reaches the opposite side, the side it has left grows dark, when it has disappeared, the whole screen goes dark and rises.*

Substantially and consubstantially, the circus ring for Pavlik is the same as the cosmic ring; the acrobat, the Acrobat of God; the clown, God's seigneurial Fool. So are all visible horizons the globe's horizon, multiple, enclosing, with only one sun. Yet the light of *Ode* is not the "histrionic" Sun's, via its surrogate, the spotlight, but the Aurora Borealis, diffuse, flickering, without direct confrontation: a religious masque of insidious, mutating shapes and colors. There is a negative quality, too, as of absolute photographic transposition, since this dawnlike phenomenon, radiating from the Poles, is perceptible nocturnally.

The first step toward this avant-garde ballet is the development of friendly accord between Tchelitchew and Boris Kochno, Diaghilev's dynamic right-hand man. Kochno has been around his studio, cavilling at his "shocking pink" and "baby blues." But Pavlik has richly mollified him: his palette is changing. Besides, he starts talking up that sober Parisian elegance which he knows that Kochno adores. The "skeptic" has come around. Diaghilev, who worships the old Russia, has been dreaming of a spectacle ballet based on the 18th century court of the Empress Elizabeth of Russia. Art-loving and German-hating, the Empress had for favorite poet, Mikhail V. Lomonosov, the author of a poem called *Ode to the Grandeur of Nature and to the Aurora Borealis*. After endless discussions, Kochno and Tchelitchew are assigned to base a ballet scenario on this visionary work, for which, at first, the composer Nabokov had the idea of doing an oratorio. Beyond doubt, what emerges is a true collaboration, with Tchelitchew inventing and investing effect after effect. A complete scenario which will enter a collection at the Museum of Modern Art, New York City, bears the inscription: "Scenario by Pavel Tschelistcheff - and dictated to Pierre Charbonnier." Presumably, the handwriting is that of Charbonnier, who is Tchelitchew's technical assistant for the ballet. On the program Kochno is credited with the script of *Ode*, Tchelitchew only with the sets and costumes. Possibly the latter's "concession" echoes the new rapport between the two men. In any case it would seem the virtual credits (in view of the above-mentioned copy of the scenario) must be reoriented. Tchelitchew is possessed with the most radical and sensational ideas to interpret Lomonosov's poem scenically. For reasons that are about to appear, not all of them will be realized. Yet others replace them.

First Tableau. *The darkened screen rises upon a stage permeated with an intense blue. An opaque curtain of blue gauze is at the back and two stiff curtains of blue at the sides. This is the second section of the stage. Silence. With luminous diadem and in phosphorescent white, a female figure, La Nature (Isis), looks like a great Doric column as she stands on a pedestal of slowly moving clouds being projected photographically from behind. With hieratic step, she descends from her clouds, which move out of sight as she*

touches the ground. Awaiting her stands the Student (Initiate or Disciple of Isis) holding a large, open book. He wears a costume imitating that of a French cleric of the time of Louis XV, tight and semi-transparent, emphasizing his limbs.

The project starts with special excitement because it is a festival of Russians: Nicholas Nabokov will compose the music, Léonide Massine do the choreography, Serge Lifar dance the principal role. Statuesque Ira Belianina (later, Ira Belline), Stravinsky's niece, is to impersonate La Nature. There are several strikingly handsome dancers in the company.

Of a male dancer: "Cute as a little dog, don't you think? Bitchy!"

The speaker is a wavy-haired, animated young man (Tchelitchew) whose acquaintance has just been made by Nicholas Kopeikine, the pianist, who gives solo recitals and plays at dance rehearsals. The two are so much taken with one another that at once they become fast friends, adoring intimate gossip and endless exchanges of "impressions." It is still 1927. They have just been introduced by Diaghilev during a business discussion and the impresario has left them together at a table.

Somehow fresh and wide-eyed as a child, the stout Russian speaks quite naturally with an odd little affected fastidiousness, rather staccato, as if each syllable were something too precious to drop. Answering Pavlik's comment on the dancer, the pianist draws a deep breath and heaves out with muffled emotion, almost prayerfully, a sentence of "babified" words received by Pavlik as absolute agreement.

The artist quickly responds: "On the other hand, something of a wildcat . . . " Three seconds' pause. "To be domesticated, I wonder?"

The other beams at him. Kopeikine is in America when *Ode* is presented at the Théâtre Sarah Bernhardt but his capacious spirit is there in Paris.

Tchelitchew, of course, is quick to come up with his ideas for the staging. Listening to them, Diaghilev grows petrified with horror and surprise. The white delta in his dark hair, like an insignium of royal dignity, seems to start up like a flame. First of all, the designer proposes featureless faces for the corps—he mentions a temporary blindfold for Lifar!—whereas Sergei Pavlovitch (Diaghilev) expected the beautifully made-up faces of a royal court. Then, the dancers are to be clothed more in light than actual costumes, which in any case, except toward the last, are not to suggest the period, but are simply, from head to toe, leotards of white, grey or blue. Otherwise, they will don a universal sort of fishnet, phosphorescent, under which they will stretch and undulate so as to suggest the palpitant shine of live water.

Second Tableau. *The blue gauze curtain has separated while La Nature has descended, disclosing a large circle of transparent white gauze shaded to look*

like a sphere, the Earth. Visible behind it is a large circular platform on which are dancers in pale blue leotards, without faces, but with their costumes marked by luminous geometric figures, the Constellations. At first one tends to see only the luminous signs, then as the diffused light brightens, each moving dancer is distinguishable. During this while, La Nature has been standing in shadow in the first section of the stage. At last, the blue curtains close over the whole scene.

"Incendiary!" screams Diaghilev of the phosphorescence. "And besides, poisonous!" But Pavel Fyodorovitch rushes ahead. There are to be, he says, pinwheels of neon light representing distant nebulae and spirals of neon light representing comets: a galaxy of celestial manifestations. "Are you mad, mon cher?" Momentarily, the impresario seethes with inarticulate anger. Such things, he knows, are unheard of in France. "Completely forbidden!" he bursts out crushingly.

"Yes," assents Kochno philosophically, sighing, "all that, I suppose, is against the fire laws on the stage. Still—"

Sergei Pavlovitch, in an incredulous daze, listens to the persistent *rubato* of Pavlik's voice. "And that is not all," he is saying. "Wait!" On backdrops, motion pictures will be projected. "The Moon will sail past, then nature will grow before the eyes, flowers and fruit, geometrical forms like natural phenomena." He is one-upping the complacent Cubists.

Third Tableau. *A diffused sombre blue light is interrupted by the projection of a great hand on the white screen of the first section as if it came from the sky. It halts and at this point a real box materializes from the screen. The illusive hand continues to descend, and La Nature, stepping forward, receives the box and places it on the ground as the hand fades. She opens it and from it springs (projected in brilliant white on a black screen) a large white oval (a seed) which expands by jumps, becomes a stem and then a cluster. As it reaches this stage, the individual object remains projected. Finally, as the box gives forth more seeds, a luminous tree develops. Magically, to right and left respectively, appear, all at once, a bouquet of flowers and various fruits on one branch. The effect is of four divisions of a compote dish; that is, a* nature morte.

"Five projection machines will be necessary: perhaps—" here the stage designer's voice falters—" to be placed on a 'bridge' near the ceiling of the theatre." Tanner, present at this conversation, says that here Diaghilev looks as if about to have a stroke.

Fourth Tableau. *The curtain of the second section parts to reveal that the simulated sphere is gone: replacing it is a flat plane on which undulating lines*

like water are being projected; above this, brilliantly lit, sits the Student in a boat. From the right come dancers covered with luminous nets, to which are attached fish and shells forming the illusion of a continuous surface. On this "body of water" the Student dances. The compote dish, visible up to now, disappears and the "fluid wall" of dancers, as if somersaulting, deposits the Student at the feet of La Nature. Far to the front, a great horizontal light flashes on, dividing the stage into a light first section and a dark second section—the contrast is white and blue. Large transparent balloons, attached to strings, descend in the luminous part; as each arrives, La Nature cuts its string; rather swiftly, balloons and lights lift together, leaving the shadow visible behind. As the last balloon ascends, the Student magically casts himself up and grasping its string, brings it back, spotlighted, to La Nature, who crushes it. Blackout.

Hastily, Tchelitchew brings his account to a conclusion. "As the climax, Sergei Pavlovitch, a giant spotlight will be turned in the eyes of the audience—you know, like those on the Eiffel Tower—"

Fifth Tableau. *On the darkened screen appears a luminous but amorphous ball, which expands and pulsates as if breathing. Air bubbles develop from it, burst, are replaced by others; becoming agitated, the bubbles finally grow feet and run away. Meanwhile the whole stage has been brightening; as the bubbles disappear, La Nature leads in from the wings mysterious figures, only parts of whose bodies are made visible by light; some seem to have only a leg, others only an arm, and so forth. She conducts them to the back where they start dancing, composing and recomposing human individuals, but never more than one at a time. Suddenly all these vanish and a female dancer appears wearing a leotard, with long luminous hair flowing from a luminous head. A soft blue light covers her as she dances in the second section. Drifting slowly off, she is accompanied by a yellow ray (the Sun) issuing from the screen; the ray remains and starts vibrating when she is gone. Its jerky movements grow more and more violent till it is evident that the gallop of a horse is being imitated, at which point the screen becomes filled with the enormous forelegs of a white horse. Gradually, the viewpoint seeming to withdraw, the whole horse, growing smaller, becomes visible and a rider is seen on it; both diminish till they are only a luminous small point. The Student dances toward this, trying to catch it in vain. Meanwhile shadowy persons, in 18th century costumes and masks, become visible behind the screen. They seem to be preparing a great fête as the Student continues his frustrated dance with the point of light. Here La Nature intervenes, catching the light and presenting it to the Student. However the light now divides itself into two smaller points which elude him by flying off the top of the screen.*

Diaghilev's hand goes up like an automaton's. There is black, bottomless silence. "You are insane and your ideas are terrible!" His gaze sweeps in Kochno, whose crestfallen look is boyishly hard. "All right," says the impresario, leaning toward his friend, "it is *your* baby, Boris, go ahead! But . . . if you give birth to a monster, I'll *disown* you!"

Sixth Tableau. *The Student inquires of La Nature who the dancers are. She thereupon binds his hands (and possibly, in terms of the performance that will take place, also blindfolds him). As she opens the curtain, then, we see the round podium, now with little stairs ascending into the wings on each side. On the cloth backdrop, a large triangle of light emphasizes the perspective, which is enhanced by lines of dolls representing female dancers, strung on wires and seeming, as they get smaller, to go into infinity. In the foreground are the actual male and female dancers, the latter in* bouffante *dresses of bluish satin and pearl grey, the former in costumes of the same colors. Points of light above them depict arches, receding in the distance as do the dolls. Some of the dancers sit on the stairs as spectators while four or five of them, in white leotards, perform in spotlights. Projected on the screen behind, as if in the midst of flames, is a pagan fete, a sort of bacchanal with nude men and women. The vision and the actual dancers mingle like one scene. The luminous arches, dimmed for the dances, return, becoming cascades. Lights jump about and tremble, multiply and turn into fixed signs of the heavens. Like a fireworks spectacle, stars, balls of fire, lightnings, spirals appear and play about. A general light now turns green, blue, yellow, orange, red in quick succession; at last, a quivering white. In sudden changes, this alternates with red, which finally becomes incredibly bright, like fire, and remains. The background lights have been fading and now are bright, silvery reflections, all pulsating.*

Obviously Diaghilev is very upset, yet something in Kochno clicks rebelliously. This ballet *is* his baby, out of Pavel Fyodorovitch. Privately he tells Tchelitchew to go right ahead. He, Kochno, will take all the responsibility, come what may! Feverish inquiries regarding the possibility of realizing the technical effects begin at once and are very disappointing. The legal taboos seem destined to spoil everything. Because the whole company is due in Monte Carlo, where the ballet seasons of Diaghilev are always prepared, they have to leave Paris before arrangements about the actual staging can be settled. Only two weeks remain in which to get *Ode* ready for its première!

Seventh Tableau. *The Student (according to the scenario) tears away his blindfold. But surely he must have done so, or been allowed to do so, in order to see the great fête of the previous tableau. Unquestionably, for different reasons, things are changed during rehearsal. It is certain that the Student also*

unbinds his hands somehow for he performs a solo, in which he stands with one foot on the rope while making various geometric designs with it; that is, he is demonstrating the wonders of nature's hidden geometry, prophesying the Celestial Physiognomies and echoing the net which is already a fulcrum of the artist's plastique. The ballet is an anthology of Tchelitchevian motifs. His wire-basket idea (derived from the kitchen utensil of wire brought home one day by Allen) is represented by the dancers' masks, meshlike, featureless, and by filmed shadows of the revolving basket itself. The Student now proceeds to penetrate the crowd of dancers but is stopped, as it were, by a great shaft of violent white light which also shines directly in the eyes of the audience for about a second's time. There is a second of complete blackness before the Eighth, and final, tableau. We have witnessed the Aurora Borealis.

There will be solutions to most of the difficult problems but at this point no one can be sure of them. Tchelitchew gets his way about the giant spotlight to be directed into the faces of the audience. But to the end, Sergei Pavlovitch pronounces it "brutal—too, *too* sensational." At Monte Carlo, an accelerating madhouse of activity is set into motion. The great ballet impresario has not seen, as yet, a single drawing of the décors or costumes. Poor Diaghilev's dream of another stunning court ballet is already quite faded, but perhaps, he strives to think, something danceable and seeable may come out of this hodge-podge of modern balletic lunacy, "Balletic?" he retorts to himself. "Is it 'balletic'?"

When he asks Pavel Fyodorovitch to see his sketches, the artist replies, with a gasp and a slight laugh, that there are none, at least right now, for he intends to cut out everything necessary on the dancers themselves and to paint things directly on their tights. To pacify Diaghilev, alarmed at this news, Pavlik sketches out a costume on a sheet of the Grand Hotel Monte Carlo stationery, which is handy. As the artist works, Sergei Pavlovitch's mouth curls, waiting, and when he is finished, he carefully adjusts his monocle to look.

Tchelitchew has shown little more than the tights on which he will paint his celestial signs. It is a few seconds before the other remarks:

"Idée formidable! But really, wouldn't a plain birthday-suit be more ingenious?"

"Merci, monsieur," murmurs Pavel Fyodorovitch. "Je regrette—je ne suis pas Dieu!" ("Thank you, sir. I'm sorry—I am not God!")

One day, not distant from this one, a strange echo of the little interchange takes place between the artist and his sister Choura. At first tolerant of her smoking, he eventually bans it. And he keeps lecturing her that the habit is bad for her ailing lungs—in fact, he makes dire predictions about her health. Very annoyed by the deprivation, she once finds Pavlik's omniscient tone unbearable and breaks out:

"Are you God?"

"Didn't you know?" he snaps back, unperturbed.

"No. I'm glad you told me."

It is the eternal *riposte à la* Tchelitchew.

Though dutifully on the spot at Monte Carlo, Diaghilev throws up his hands figuratively; after all, he has delegated the chief responsibility in this case to Kochno. Yet he wants to avoid, at all costs, that "monster." So he wanders in and out the hall, like a large rather threatening ghost, so that Pavlik is almost, but not quite, induced to "make horns" against Sergei Pavlovitch's implacable shadow, majestic with a skepticism that can speak as loudly, as shockingly, as his incessant protests.

At heart, Diaghilev applauds so much audacity; if modern ballets must be outrageous, it is up to the Ballets Russes to be so; his company, win or lose, should lead the way. As if there were any other way! Yet during rehearsal, he cries out in involuntary pain, jumps up and screams: "That won't do, it's too mad. Change it, change it, I say!" Sometimes Tchelitchew or Charbonnier or Kochno thinks of an alternative. Sometimes . . . the point gets lost. "And what, pray, of *divertissements?* We cannot do without them." And Sergei Pavlovitch insists on a long solo for female dancer. On April 28th, Pavlik writes Tanner in Paris that he works on *Ode* from eight in the morning till an hour or so after midnight.

Addressing his friend with the italicized diminutive, "Allyoushenka," he begins: "My dear little sweet soul," and proceeds to give him the lowdown on everything. Behind all his hysteria, he reveals, is his real fear for the final result in Paris. Charbonnier works hard, he says, but is "cocky"—the whole film is "hit or miss." The artist is now attached to Kochno, whom he calls "a little boy." On Diaghilev, he unleashes his arsenal of verbal caricature. He is either "Papa" or "Barinya Diaghileff." In spelling names, Tchelitchew nearly always favors the "ff," rather than the "v" or "w," ending, and in later years he will write "Tchelitcheff" on the backs of his envelopes, though he adheres to the "w" in signing his work. "Papa," he informs Allen, is as changeable as the Paris weather and kicks out someone almost every day. His "grumpy, flighty, little mad fits," verging on apoplexy, make him a pathetic spectacle. "Poor old thing," Pavlik remarks at last, "he's very unhappy." However, when "purged," Diaghilev evidently gets back in good humor and "feels on top of the world."

Nobody, at the première in Paris, is quite so heady as to say that the thing really comes off.

The *ideas* are simply marvelous, and not only in theory, but as theatre; in practice, all the same, many balletomanes miss "the dancing."

Eighth Tableau. *During the moment of blackness, the original blue muslin curtain is lowered and the scene becomes the same as in the First Tableau,*

with La Nature resplendent on her pedestal of clouds. Now, on the illusory platform of clouds, she ascends in apotheosis, surrounded by her chorus of attendants.

"Oh, *Ode* is as avant-garde as you like! Surely it breaks a lot of ground. All that photographic illusion is simply immense—think of poor Charbonnier up there risking his life at those projectors! An acrobat—and he's credited on the program as Tchelitchew's collaborator."

"One has to admit that Tchelitchew, for that matter, is someone to watch. What a host of ideas! He could do some masterful things. Now I wonder—"

Not just a stage, not just a screen, not just a dancer's body, is "divided" in *Ode*. So is public opinion *about Ode*. The ballet does not become part of the repertory. Diaghilev is not scandalized by a monster but he is not enchanted by a marvel. Friends of Pavlik are inclined to say flatly that the work, speaking stage-wise, is far ahead of its time. Unquestionably, they are right. Of course, George Balanchine, who is a Diaghilev choreographer, sees *Ode*, and while he does not like Massine's choreography, he admires the scenic imagination of the young artist he has recently met. Many years later, Balanchine will tell me that *Ode* was "far ahead of its time." In fact I cannot see that, in terms of technical imagination, it drops below anything that has been seen in the ballet during the intervening period.

A noted contemporary critic, Emile Vuillermoz, is wholly won over by the scenic effects. "It is impossible to describe," he writes, "all there is of curious and ingenious newness in the different tableaux which compose this strange fantasy . . . M. Tchelitchew has created an extremely evocative atmosphere from the further dimensions of outer space and of terrestrial realms beyond reality . . . It is really disconcerting to witness the timidity and the slowness our scenic designers have shown in utilizing up to now an element [the cinema] so efficacious in evoking fantasy, and which in its suppleness permits of realizations that can be varied in style virtually to the infinite."

The Sibyl as Virgo

For the program of the season when *Ode* was presented, Tchelitchew does a cover design that creates its own panic of suspended realization.

It is a dance nude, male, with muted face and virtually "triple" (the three-in-one): a figure frontal and posterior with, in the facing position, a third leg lifted and pointed; all five feet, in effect, are slippered. Muscular as a dancer, the figure is rather boyish and by no means "ideal" in anatomic symmetry. The left arm of the frontal dancer looks atrophied and the overall muscular development is whimsical. All four arms grasp an oval linear hoop while all

the anatomy but the feet and two hands fall within a linear rectangle. Framing the whole is an irregular atmospheric wash, printed in blue.

An analogy with Leonardo's illustration of the proportions of Vitruvian Man, inside circle and square, and with the same artist's allegories that were mentioned above, is unmistakable: the anatomically freakish two-trunks-from-one-lower-body. Does Tchelitchew's design also have an allegory? Only insofar as we understand it in reference to *Ode* and to Tchelitchew's general trend toward the emblematic. It is Cosmic Man and the master metaphor here is the circus. The feeling of the figure is altogether harmonious: part of the clumsy grace and dignity (serviceable for both sexes) that has become a favorite plastic theme of the artist's. The method of body-modelling—plain wash and a rapid zigzag line—shows that by 1928 Tchelitchew has become the draughtsman he dreamed of being. As he will say in later years, "I had to teach myself to draw; I had to *force* myself."

What panicks the program manufacturers is the actual pin-pricking that completely covers the frontal figure of the design. Tchelitchew himself uses a pin to prick the original, suggesting of course the pores of the skin, but messengers have to dash all over Paris to find a plate-maker to reproduce them. Meanwhile Allousha is prepared to take pin in hand and lead a cohort of manual workers in pricking each cover individually. In *Phenomena*, one is not surprised to see a descendant of the program dancer: the naked man with the third leg and two figleaves.

As with many of his works, the *Ode* cover instances Tchelitchew's concept of the human figure in temporal depth; in a sense, only one figure is portrayed, showing in the rough several dance positions at once. It is not long after *Ode* that Pavlik meets the lady who resembles the painting of Father Amrovsky, Edith Sitwell, who by the same token automatically becomes sibylline. His mind may even have recalled, thinking of the two Sibyls in his life (Miss Stein and Miss Sitwell), Leonardo's memorable studies for *St. Anne and the Virgin*, in which two women (technically one in the lap of the other) look literally as if engaged in a struggle rather than sitting in peaceful intimacy. Ultimately, Leonardo defined the disturbance in the group as centered in the Virgin's effort to prevent the Christ Child from hurting the lamb.

We may think of some such "struggle" in the mind of the man who, according to the observer quoted above, now thinks he will "have trouble getting rid of Gertrude." At this time, Edith Sitwell is past forty, with a sensationally distinguished, aquiline face (she is a Plantagenet) and an ambiguously distinguished body. On the latter, one can shed light only by noting that at this point her bosom is shallow and she seems conscious of her attenuated, spreading limbs. With a thin, curving neck, she has the ample physical aspect and something of the facial expression of a thoughtful, rather

wan and solitary swan. Also she has—behind the high, broad, rounded brow (the meagre hair is bobbed and quite straight), behind the heavy-lidded, lucid, prominent eyes and the thin, tightening, overbred mouth—a hint of the swan's well-known capacity for rage.

The opening of her autobiography characterizes her as an "exceedingly violent child," one destined, she soon discovers, to be "in disgrace for being a female." The style of speech is not especially either ironic or figurative. To her last breath, Dame Edith will maintain that she never attacked anybody without first being attacked. One is ready to accept this statement implicitly. Yet one must reflect that, as it happens, Miss Sitwell will never be free of the obligation to counter-attack. And she tries to give a little better than she gets. Of these things, of course, she herself has written extensively. It is her public character: carefully self-supervised, regularly well-publicized.

What is not so well publicized is that underneath she is actually a mass of quivering, defenseless sensibility, and it is this excessive "defenselessness" that impels her to arm and armor herself like a female knight in Ariosto. What Tchelitchew particularly discovers in her, at first, is certainly neither rage nor insolence, nothing at all "militant"; it is he who becomes, at whim, angry and insolent toward her. Then they have (to use her own phrase) their "fiendish quarrels." No, Pavel Fyodorovitch discovers in her a beautiful sheltered eroticism, the purely passive, female sensibility that lives forever, a glass flower under glass, behind the opaque facade so remarkable in itself. While this discovery gives him the feeling he can do what he likes with her (she will declare he threatened to kill her), it also frightens him half out of his wits.

For he will never believe (except for casual periods of neutralization) that hers is a true virginal passion, a Platonic affectiveness. It is "Tchelitchevian" to exaggerate, dramatize everything. But the Sacred Virgins—did they not, of old, have ambiguous duties? At the same time, his whole relationship with his new patroness depends on sexual innocence. Dame Edith will maintain, to me, that their relationship was "exactly" that between Vittoria Colonna and Michelangelo. The *exactly* holds a considerable burden yet there is not the least plausible reason to suppose their relations will follow any other pattern. Throwing into charming her all his powers of flirtation, Tchelitchew still cannot rid himself of the idea that she is dying to lay hands on him . . . One can speculate how immensely successful must be his masculine preenings, his glances, his random endearments, his coziness, especially in moments withdrawn from witnesses. She is the epitome of dignity, even majesty. Quite so! One might add: exactly so! He is just as quick to perceive what an unusual magnetic effect his mere personal presence has on this woman of high poetic gift and eyes like a male seer's. Who is to say (not themselves, certainly) it is not a love affair? Moreover, this lady does not equivocate, make intellectual distinctions as Gertrude did; without ado, she tells him that he has genius and

as yet the Parisian public is unequipped to appreciate it. As for the English public, she is going to see what can be done about that.

On the surface a cheerful protocol, smooth as the side of willing flesh, governs Pavlik's early relations with Miss Sitwell. Soon after Miss Stein's formal introduction, he is assured that the new Sibyl is a person of great quality and influence; while certain family relations have been unfortunate, she comes from an historic English line. This, together with her physical presence, inspired Pavlik to project for her a plastic ideal of personality, feature and dress. The lady already has an instinct to make the most of her tall, delicate aquilinity and drooping bodily mass, which unlike Miss Stein's, moves with a kind of solemn grace as if a phantom inhabited it. She affects conspicuous jewels of a bare, barbaric sort of splendor: outsized aquamarines balanced magically on finger rings and an amber brooch that veritably seems huge with absorbed light and color.

Soon enough Tchelitchew sets himself the task of designing dresses for his admirer that will bring out her "Plantagenet look." He finds exquisite this natural way of forming a bond between nobility of character and nobility of artisanship. Miss Sitwell has a chance to wear one of Pavlik's creations at a poetry recital in which she is presented by Sylvia Beach. The English poet's finely modulated voice as of flutes and fountains, distant and alto, expresses itself in readings of Shakespeare and other Elizabethan verse as well as her own. Miss Beach makes much of the occasion at her famous bookshop, inviting all the available celebrities of the art and literary worlds. James Joyce, who comes, is among them, and so are the Misses Stein and Toklas. However, proved enemies make no fuss about sitting in the same audience; at any rate, no patent fuss.

It is Miss Sitwell, rather, who finds herself intensely nervous, certain she will not be at her best in the readings. Afterward she declares, despondently, that she has not been. She knows that Tchelitchew is not seeing their mutual acquaintance, Gertrude Stein, any more and has decided, despite the other dignitary's expected attendance, not to include her work on the program. Pavlik hardly cares whether Miss Sitwell's voice shows at its best. Tanner, who has suggested the occasion, recalls that the English poet is later the recipient of a note from Miss Stein, expressing "in her own curiously indirect way" her resentment at having been neglected. The snub delivered to the ex-Sibyl puts Pavel Fyodorovitch in such seventh heaven that he is aware only of the present Sibyl's glamorous triumph and *his* revenge.

Amber! It is a sign of magic powers. As if every accent, move and thing about this unique woman did not proclaim a precious mystery! She is an incomparable "subject." Already he has executed several conceptions of her head in different media. She has been painted but badly, he understands, by a Cubist, Wyndham Lewis, with whom she quarreled before the hands were

finished. Ah, humanly speaking, especially if one serves a Sibyl, one must quarrel even with *her*! The cutting moment of disillusionment has already come when he has stood with Tanner on the Stein doorstep and been told by a servant that she was not at home. There were dozens of reasons to make him anticipatory and yet—he cannot forgive his former friend that blunt act of cruelty.

The present Sibyl is of more feminine, more tractable material. Yet such great susceptibility, as he knows, has its perpetual dangers. To Pavel Fyodorovitch, every woman is a potential Circe: the male, as in antique times, simply must have ready his counter magic. Now he decides. Edith Sitwell (in his imagination) is the virgin who wishes to be deflowered and for this quasi-sacred purpose, he, Pavel Tchelitchew, *has been irrevocably elected*. His work is surely cut out for him. This Sibyl is just virginal enough, just erotic enough, to be (like any witch for that matter) subjugated—held in masculine thrall. Again he evokes the reversal theme of the sexes that will culminate in the great emblem of *Hide and Seek*: the male as fugitive, the female as pursuer.

Miss Sitwell's very immaculacy is the chink in her armor; he perpetually aims his counter magic at that. The most beautiful and quiet and elaborate etiquette nominally reigns between them, and a wonderful ripening intimacy . . . As in the middle of a play, two years pass. Incorrigibly "magical" as he is, Pavlik can literally cower in front of Allousha and proclaim in extravagant tones of mock-fear: "What—alone with *Sitvouka?* Non, mon cher! What do you want? *I should be raped!*"

Mother Earth

Such are the vagaries of La Nature, whose secrets Pavel Fyodorovitch has sworn to master because he will be eternally her Disciple, her faithful Student. She has a *witchlike* side and nothing convinces the artist so much of this as the existence of Mère Parizot at Guermantes, which he and Allen occupy every summer till that of 1933, which Tchelitchew spends in England. Guermantes is the country place where he relearns what gardening is, to plant flowers and to paint them as well. Fyodor, the old gardener at Doubrovka, bred in him a taste lying dormant all these years. Old Mère Parizot, like Fyodor, is a spellbinding teller of tales.

Really a fiery-natured, brutal old woman, who yells everything like the Russian peasants (who get the habit from calling to each other in the fields), she keeps a profound kindliness, it appears, for the rare people she likes. Tchelitchew at once identifies her with the dark ambiguous aspects of Mrs. Nature, but so charms her that she comes in the evening to entertain them with her fantastic stories. "You would make a great prime minister," Pavlik once declares to her. A bit confused by the tribute, she nevertheless accepts it becomingly. Tchelitchew is certain that she enchants her goats and that her cat carries a magic effluence.

The old peasant walks in a crouch, eyes ever on the earth: Mrs. Nature's lower domain. Now in her seventies, Mère Parizot claims that the crouch is due to a fall she had when carrying her first child. Pavel Fyodorovitch is arrested by the fatality of that distant fall of his—not the one on the dancing horse, when he was not injured, but the more mysterious one, denied by Choura, when as a baby he was dropped, he insists, by someone. His own Natasha Glasko tells a similar story that accounts for the eccentricities of her body. Only once, to Pavlik's and Allen's knowledge, does Mère Parizot ever straighten up. This is when Allen's mother and sister Florence are at Guermantes and take a snapshot of Pavlik and his friend with the old woman standing between them. To everyone's surprise, she unbends for the few seconds it takes the shutter to snap; although stunted, she seems as upright as

anyone. She has unbent, she says, to honor Tchelitchew. Pavlik feels it is an important compliment from a member of the magic sisterhood.

An Australian painter, Stella Bowen, wife of Ford Madox Ford, is one of the women Tchelitchew has won to his cause, and it is her generosity that has made available to them her house at Guermantes, which she had decided not to occupy. At a party at Stella Bowen's, Pavel Fyodorovitch meets, likes and pays conventional court to Hadley Hemingway, the novelist's wife. Invited to Mrs. Hemingway's house, Pavlik is ready to set out, but Tanner, fearing the animosity Hemingway unfailingly shows Tchelitchew, holds back. But it appears the two are separated—they hear Hemingway has already left for Spain. . . . Hadley Hemingway always brightens into a smile on seeing Pavlik. If he liked, he might become a male Circe.

Standing just below the Sibyls is, so to speak, the noble order of House Mothers. Gertrude Stein, while virtually abdicated from the higher position of honor, is still "active" as a Mother. It happens that she sends knocking on Pavlik's door a young American, George Platt Lynes, photographer-to-be. The boys in the Boulevard Montparnasse receive him cordially but he returns to Miss Stein remarking that both of them "look very tired." Spontaneously the suggestion crops up between them that a holiday in a place like Tunisia would be just the thing for the artist and his friend. Can the two be offered it on, figuratively, a platter? Miss Stein says they can and Miss Stein is an official oracle. Thus Pavlik and Allousha get a holiday in Tunisia.

Tanner describes how in the middle of the water journey, rough at first, the sea becomes like glass and their boat glides motionlessly "into an atmosphere of hummingbirds and sun-drenched air." At once the white cubes of houses set amid the palm trees impress Tchelitchew, but even more do the Arabs themselves, deep mahogany-colored, with their proud free rhythmic walk, and often flowers behind their ears. He has no less admiration for the men's simple candor in walking hand-in-hand: what Tanner calls their "slow graceful promenade." Tunisia is only a protectorate of France, not under its government; so the Arabs here, they notice, are more *chex-eux*, not typically cowed, browbeaten, like the oppressed Algerians.

This excursion is in the spring. Another springtime visit has been to Algeria itself, in Philippeville, where a supposed patroness offers them a villa so that Pavlik can paint some murals she wishes to commission. The lure is sufficient to get them out of Paris, where the tension with Gertrude has increased with the economic tension. Arriving in Marseilles, they find that the patroness, who shall be called simply Madame, has bought exactly one second-class boat ticket—for Tchelitchew. This gaucherie is the first "bad omen" to the remorselessly superstitious artist. Madame's husband, Monsieur, residing there in "friendly estrangement" from her, is supposed to have a car waiting for them in Constantine. It is late, and when it comes, it is open. They are driven

madly to Philippeville over very bumpy roads with the fierce African wind blowing dust and sand in their faces all the way. A magnificent setting awaits them, on the edge of a cliff amid luxuriant trees, vines and flowers, with the jade-green Mediterranean a hundred feet below.

Yet Pavlik warily does not cease his dark-colored speculations; he is now quite sure that Madame expects what he is to paint to be "given" her, not paid for. Their petit-bourgeois host is large and repulsive-looking, small piglike eyes being set above an aggressive nose and a more aggressive mustache; the latter does not serve to conceal a prissy, stubborn mouth. Obviously, he does not care for the situation in which Madame has thought fit to place him. Pavlik nicknames him the Minotaur, does caricatures of him and Madame, and feels hardly grateful for the cool, clean and comfortable villa at the other end of the estate, where they are considerably lodged. The house is surrounded by Pavlik's adored eucalyptus trees, whose feathery leaves and pungent odor almost reconcile him to his host.

At the lavish table, they consume lobsters "big as horses." But the Minotaur (always collarless and in house slippers) yells so perpetually at the Arab servants that Pavlik soon contracts an inflammatory indigestion and is confined to bed. A doctor thinks the affliction "serious" and prescribes a concoction which must regularly bathe the patient's insides: its base is the juice of the eucalyptus. Almost at once, the housekeeper is sent over to convey that their host is irritated by "sick persons," so that Monsieur's distinguished guest is virtually ordered to be up and about without delay. Ah, *the murals* must be painted! From the friendly cook, who creeps over at nightfall, they learn that Monsieur considers that Pavlik's "hysterics" should not be indulged. As if in revolt, the artist develops not only a high fever but huge villainous abscesses, which must have compresses applied to them. Although suffering from something similar, Allen stays up all night changing the compresses.

The pianist is contact man between his friend and their loathesome host, who would be agreed a monster if all they knew of him were that, during his gargantuan meals, he goes out to relieve himself upon the gorgeous flower beds. One evening Allen is on his way back to the villa when as usual he passes near a large hen house. Hearing from it bloodcurdling shrieks, sounding almost human, he investigates and comes upon a ghastly animal ritual. A hen with a gaping hole in her side is lying prostrate in a circle made by her excited companions, who "like a corps de ballet of machine guns" take turns darting forward to make the hole deeper and wider with jabs of their beaks. The watcher is so shocked that when he gets home he cannot resist telling his friend of the incident. Pavlik is now up from bed, but hearing this, he has to lie down for a while. At which the gentle Allousha, as if he had caught some of the sadistic mania, starts teasing him, saying the hens are like the painters

in Paris who gang up on their colleagues to honor the Muse of Méchanceté. The other news Allen brings is that Madame is to appear tomorrow.

Madame does appear, every unappetizing inch of her, and she really thinks the work for the murals should have progressed much further. "Why, it is hardly begun!" she observes tartly. Pavlik now feels the place reeks of black magic and does not want murals of his on the premises. He has already nicknamed the big villa the Nightmare of Ceramic Tiles. By mutual agreement with the proprietors, Pavlik decides to retire altogether from the commission. Duly they present themselves to the Minotaur for a laconic "Goodbye", a little finger held out and a few bills to help pay their passage back. Mercifully, Madame is invisible and quickly they make themselves the same. Once out of sight, they congratulate each other on having escaped a fate which might have been, in its way, worse than death. In a few years, Pavlik will paint a picture of a giant hen towering over a prostrate naked man; she holds lightning in her beak. At the artist's feet in *Phenomena*, a hen with an oddly malevolent expression (a bird unable to fly and so on the Minus side) scavenges at the edge of the water. Still this *Phenomena* hen will turn out to be Hell's sign for the Phoenix: the artist, after all, has escaped alive from Philippeville.

In a summer or two, Allousha decides that the Guermantes house is dingy and needs complete repainting and redecorating. "American foolishness!" cries Pavlik, possibly mindful of Doubrovka's "eternal" patina. Yet finally he is persuaded, and as always when undertaking anything, throws himself into it unreservedly. Guermantes becomes in many ways endeared to Stella Bowen's permanent guests, if only as the promise and perfect setting for rest though not, for Pavlik, rest itself. Allen notes that the artist seems to remain high-keyed even after they are settled for the summer. He is so busy making his beloved garden flourish! But when Tanner urges him to lie and rest in the garden, to forget for a while all irritations, his answer becomes classic. "I don't dare to. If I once let down, I should never get up again."

Allen's mother and sister, who get along very well with Tchelitchew, are not the only visitors; Allen has a piano pupil who poses for the *Green Venus*, the nude in the hammock. A favorite male model of the artist's also comes out, Charles Vincent, whose great rose-necklace tattoo affords the occasion for several charming pictures. This fair, muscular young man has that rather indolent, animal-like male nature, self-aware yet unself-conscious, entirely sweet and given up to things as they are, to which Tchelitchew is especially attracted. Such persons have for the artist that *vraie sagesse du monde* consisting wholly in the dignity of the body. "Pas Narcisse, non, non!" Pavlik exclaims. "Narcissus wants to keep himself: he is utterly *vain!*" Not so, Vincent. This is always true of copious natures to whose flesh (Pavlik reflects) God has really been generous. They are only caretakers of what

God has given, and overcome with modesty by such a great responsibility, become divinely charitable of the precious gift.

Guermantes is a haven which might be thought an escape from death, if not also from struggle. But Guermantes is still the world and death too makes itself felt there. In late summer of 1929, it travels from Venice in the shape of Boris Kochno and Serge Lifar, who arrive overcome with the gloom of Diaghilev's death. The impresario has suffered from diabetes and succumbed while seeking rest in Italy following his London season of that year. His loss is a widely felt tragedy, particularly to personal associates as close as Lifar and Kochno. Tchelitchew himself has a beautiful manner (rather like a *piano muet*) when called upon to console, and assisted by Allen, does his best for the two visitors who wear one dark halo about their heads.

An upshot of Diaghilev's death is René Blum's resumption of his tradition in 1932 under the name of the Ballets Russes de Monte Carlo, with Balanchine and Massine as choreographers and Col. W. de Basil (a Russian who has taken a pseudonym) as co-director. One day a taxi from Paris stops at the door of the Guermantes house. It contains Col. de Basil, whose sole errand is to persuade Tchelitchew to do the sets and costumes for a projected ballet, *Choreartium,* which shall have Brahms' Fourth Symphony as music. But Tchelitchew is temperamentally opposed to "symphony ballets" and immediately says No. Hard to discourage, de Basil spends hours, using all kinds of wiles, to bring Pavel Fyodorovitch to change his mind. He must return to Paris defeated. Eventually two old friends of the artist, Tereshkovitch and Lourié, designed *Choreartium.*

Of course, Choura comes out to Guermantes. Yet the fact has become plain, after a few years of Paris life, that her lung condition makes it imperative she spend the really cold, wet months elsewhere. At Christmas time in 1929, Allen accompanies Pavel Fyodorovitch on a trip to the Vosges mountains, where Choura (chubby no longer) is getting treatment in an Alsatian village named Aubure. While it is not one of the gay Christmases for Tchelitchew, he revels so much in snow that he finds the trip pleasurable for that reason. "Snow," he tells Allousha, "bestows a benediction of purity on the earth." As a Russian, too, he feels a special affinity for the glacial substance that falls in millions of flakes and stretches away on earth like vast unbroken plains, hiding all else from sight. Nor is it likely he forgets to associate snow with death—the "eternal cold."

So much taken up with his life's personal project, so paranoid, so fraught with responses to omens and supernatural forces, our hero has developed a complex about his family in Russia. Perhaps no son in his position—the only living male of his generation—could avoid being persecuted by certain feelings of guilt. He helps out his parents, now living very humbly in Losovaya, as regularly as possible. Yet Fyodor Sergeyevitch, because an

expected sum has not reached him, writes Choura during the time when Tchelitchew is doing *Ode* in Monte Carlo. His letter is full of reproaches, the harshest in the son's memory, and alleges that Pavlik has "no character." When Choura sends it on to him, Tchelitchew cannot restrain his hyperbole and writes Allen: "Her letters and those of my father are, I believe, the most poisonous things that one can imagine on earth." It is true that Choura does not hesitate to air her grievances against Pavel Fyodorovitch to relatives and mutual friends. She is perfectly willing, when her health permits, to manage the household and no hidden "issue" throws a shadow between brother and sister. It is just that money never comes easily—and neither does, to a Tchelitchew, humility nor docility. Still Pavlik feels relentlessly concerned about the ailing Choura, his little sister, and when he writes her and Allen, while away from Paris, he begins: "My little children . . . " Or, should their cousin Choura be with them: "My dear troika . . . "

One habit the artist cannot get over is his fear of being addressed by his father as "Dear Panya" (Dear Mademoiselle): the sinister little habit—superficially a pleasantry, actually a persecution—has survived all these years. At times, the artist delegates Choura to read what Fyodor Sergeyevitch has to say to him. In a spirit of mediation, Tanner has inaugurated epistolary relations with Pavlik's father and receives long, confidential letters from him. Yet the old moral split between Tchelitchew and his parents can never really be mended. When he escaped from Russia, he became an exile in every sense. Only for Barbara (Varya) does he retain an active liking and respect. Manya's vivid memory has become a little dim for him. As for Mamma, he scarcely dare think of her. . . .

As time goes on, the swelling ranks of the artist's friends follow a mass of individual lines he keeps on a chart in his head—a chart from which he excludes those in his distant past. Never does he let a current kindness go unrewarded; never does he overlook a current slight, however oblique or unconscious. Allen's sweet words always win his thanks. When an affection- ate letter arrives from Genia Berman, he is convinced that this rival colleague loves both him and Allen. Or he terms a charming letter from young Stephen Tennant, his collector, "full of *esprit anglais.*" In general he is beginning to hold the "*esprit anglais*" in new esteem. Spearheaded by the valiant industry of Miss Sitwell, it is creating a definite upward trend in his career. In 1930, he is a guest of Geoffrey Gorer and his mother, Mrs. Rachel Gorer, in Highgate, London. They have a car which Tchelitchew always finds at his disposal. Mrs. Gorer has outdone her son in becoming an ardent and devoted Tcheli- tchevian; in this lady, Pavlik sees not another sibyl so much as a second mother. It is his old, boyish, passionate need. Alas! Anna Ivanovna remains in Berlin and dear Zossia Kochansky belongs to *his own* generation.

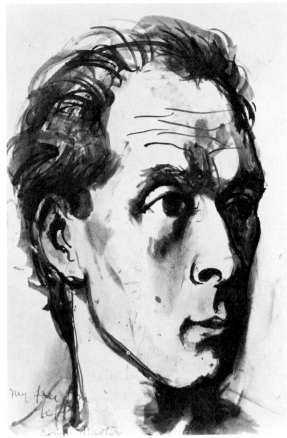

Above: TCHELITCHEW: *My Face from Left*, ca. 1933, wash. Collection Mr. and Mrs. R. Kirk Askew, Jr.

Left: TCHELITCHEW: *Portrait of Alice B. Toklas*, 1927, oil on canvas. Collection Dr. Ralph Withington Church.

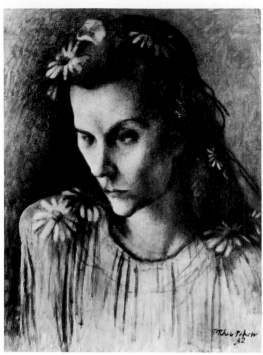

Above: TCHELITCHEW: *Natalie Paley as Ophelia,* 1932, oil on canvas. Collection Mr. and Mrs. James W. Fosburgh.

Right: TCHELITCHEW: *Still Life Clown* (Harald Kreutzberg), 1930, oil on canvas. Collection Mr. and Mrs. James T. Soby.

Below: TCHELITCHEW: *Portrait of Mrs. James W. Fosburgh,* 1943, pencil. Collection Mr. and Mrs. James W. Fosburgh.

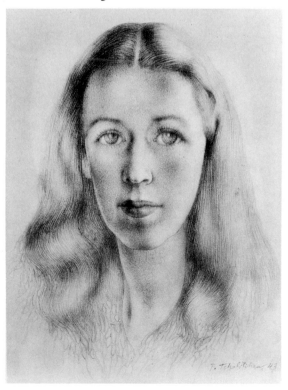

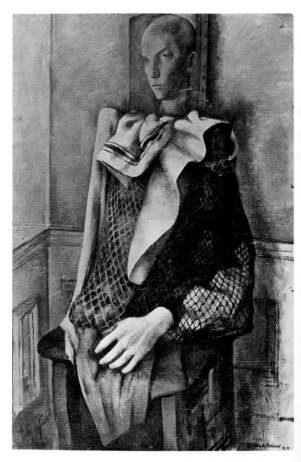

TCHELITCHEW: *Portrait of Constance Askew*, 1938,
oil on canvas. Collection Mr. and Mrs. R. Kirk
Askew, Jr.

TCHELITCHEW: *Portrait of Lincoln Kirstein*, 1937, oil on canvas. Collection Mr. and Mrs. Lincoln Kirstein.

TCHELITCHEW: *Portrait of Edith Sitwell*, 1937, oil on canvas. Collection Edward James.

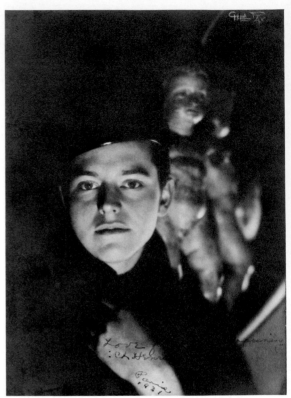

Above: TCHELITCHEW: *Portrait of Charles Henri Ford with Book,* 1937, oil on canvas. Collection C. H. Ford.

Above: Charles Henri Ford shortly after his arrival in Paris, 1931.

Below: Ford before his portrait by Tchelitchew with poppies and wheatfield, 1933, oil on canvas. Collection Charles Henri Ford. Inscribed to his father, C. L. Ford.

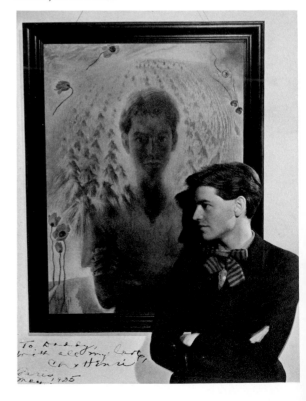

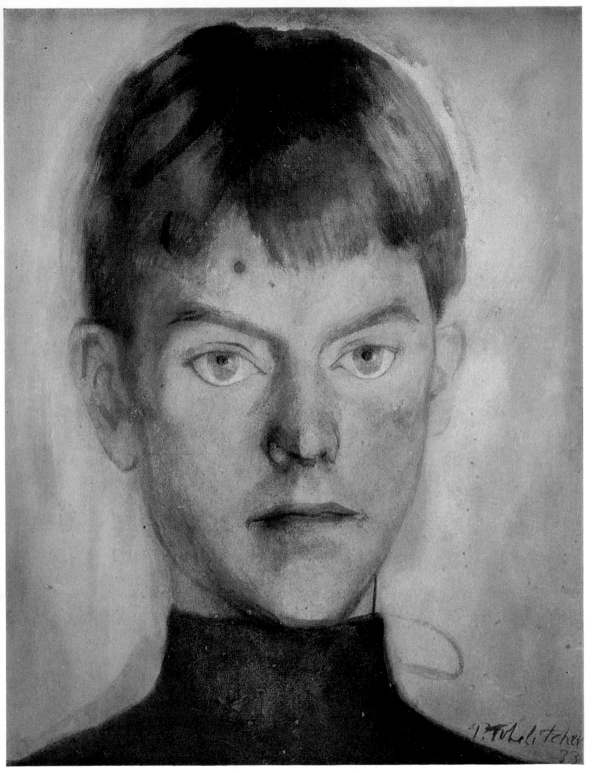

TCHELITCHEW: *Portrait of Charles Henri Ford in Blue,* 1933, oil on canvas, 21¼ by 16½ inches. Collection Charles Henri Ford. *Photo: O. E. Nelson, New York.*

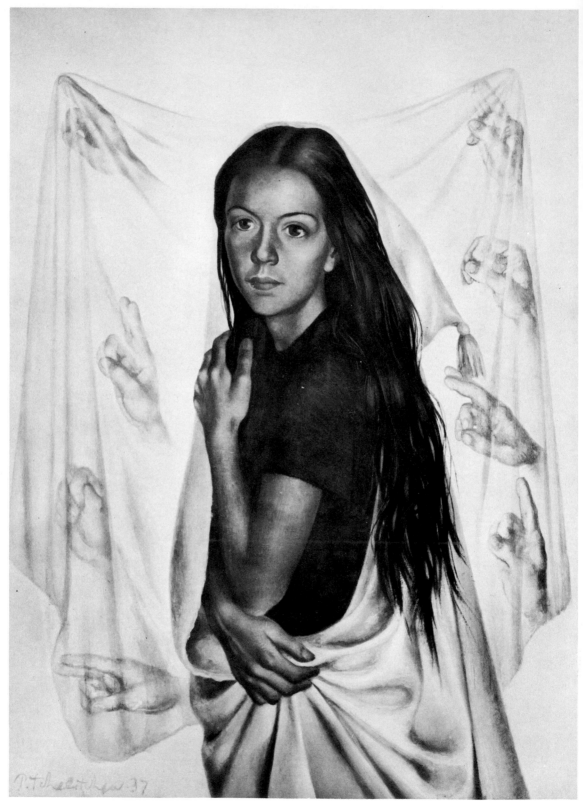

TCHELITCHEW: *Portrait of Ruth Ford*, 1937, oil on
canvas. Collection Edward James.

Painting Portraits

Miss Sitwell's London set is inclined to look down its nose at some of Tchelitchew's English friends but whenever Pavlik can form solid connections on the basis of personal regard and patronage, he behaves quite independently of social snobberies. Paris, of course, is a social milieu unto itself. There Mme. Kochansky plays "ideal sister" to our hero. Ever his staunch supporter and adviser, she introduces him to hostesses of the first cultural rank, whose salons are the apogee of fashion and invitations to which confer the all-powerful if ambiguous "status." One salon is that of the Princesse Edmond de Polignac, who holds performances of specially commissioned musical works. At her house, Tchelitchew first meets numbers of people (among them Arturo Lopez and Mrs. Dorothy Chadwick) who will become friends of his future.

Only now can he tell himself he has come in for his share of the true glamor. Society women and his relations with them are a lucid index to Blessed Status, which he might be wearing on his person like a fetich. Elegant, startling, distinguished ladies emerge and manifest on the near horizon. In the literary cliques, there is Djuna Barnes, made known to him by Jane Heap and Margaret Anderson; in the international set, Daisy Fellowes, Lady Iya Abdy, Misia Sert (wife of the painter Jose Maria Sert), Bernadine Szold and her daughter, Rosemary, Natalie Barney and Romaine Brooks. To Mrs. Szold's studio, Pavlik takes Glenway Wescott and Monroe Wheeler, to whom he introduces George Platt Lynes.

It has grown clear that, as strong a force as Gertrude Stein is, her peculiar traits leave her somewhat outside the main social stream. She does not jell with people like his friend Marie-Laure, who has married the Vicomte de Noailles and so is Anna de Noailles' cousin. The Vicomtesse is ambitious to carry on the family's established entente with high culture. At this time, Noailles finances the two famous avant-garde films, *L'Age d'Or* and *Le Sang d'un Poète*.

Pavlik considers that his natural nobility and personal attainments qualify him to move in exclusive high society. Retrospectively, we may allow Alice B. Toklas to underline the ambiguities of his case. As for legitimate talent, when Jane Heap tells Gertrude Stein that Pavlik is a painter, she replies, "Yes, he is." Yet, as Miss Toklas also states, "When Gertrude was not interested, she was done." Undebatable! Somewhat reflecting, perhaps, her old friend's views, Miss Toklas will elaborate: "Pavlik was not interested in life as he saw it, as it was. . . . He wanted to use it . . . Pavlik was a dreadful little arriviste. . . . As I see him beside other men of his generation, his attitude toward life wasn't clear. If you got into Pavlik deeply, you'd find a weakness."

At some historic point, Miss Stein herself thinks differently. Only a couple of years from now, she will dogmatically warn Charles Henri Ford against a connection with our hero. Why? "Americans are strong," she tells Ford, "Russians are stronger. You'll get the little end." This is the sort of pronouncement that makes up the Sibyl's profoundest, most insoluble enigmas. To Miss Stein's curiously positivist social creed, irony and nuance in human relations (not to mention passion) are of fluffy inconsequence. It is doubtful if Ford, to the end of his life, will ever understand just what her warning was meant to mean.

However, Miss Toklas has preserved the Stein positivism, which probably she helped to originate. "Edith Sitwell," she will declare, "had a greater experience of the world than Pavlik. He knew in advance just what he would do with anyone. There was for him no difference between the grande-dames and Edith." Perhaps there isn't, at first, but as we know, the artist's relations with Dame Edith will achieve a new level. The present key to the transformation in Tchelitchew's social-professional life is beyond doubt the mysterious, magically familiar Miss Sitwell, his established bosom friend, his declared champion, his patroness. To her, when she is away from Paris, Tanner writes candidly of the economic difficulties *chez lui* which the artist is too delicate to mention; invariably, though she is not a person of much means, a sympathetic response, even some material help, is forthcoming.

Tchelitchew has painted two portraits of her by the time, July 1928, he is introduced anew to the English public with a one-man show at the Claridge Gallery, London: one portrait is gouache and sand, the other gouache, sand and coffee; the better one is a model for the miraculous mask, in wire and wax, which I discussed previously. A magazine article may put a question mark after the heading, "Miss Edith Sitwell Presents a Genius." But the fat is already simmering savorily in the fire. Militantly loyal, the Sitwells (Edith, Osbert and Sacheverell) have marshalled all the social forces at their command to launch Edith's young Russian protegé. In fact, he usually fascinates those he meets in the Sitwells' drawing room, where his own name is sacred. Should anyone presume to raise his voice against Tchelitchew, Miss Sitwell does not mince etiquette; without ceremony, the poor brute is shown the door. Whether or not mainly because of the Sitwell prestige, artistic London is definitely more impressed by Tchelitchew than, up to now, artistic Paris has been.

The London show, while termed by Geoffrey Gorer "not very successful," is still an important step forward. Till a couple of years before, in Paris, Tchelitchew was haunted by the fact that he had no established gallery dealer, only an agent, who was conspicuously unsuccessful. For publicity he depends largely on feuilletons in the newspapers. In the Paris Herald, Elliott Paul anonymously writes that "one of the most discriminating and exclusive

galleries on the Left Bank" has some of Tchelitchew's works stored, awaiting an early exhibition. But an eager friend, says the piece, has called in advance to look at them. "Which period?" inquires the young man at the gallery. The anecdote delivers the gag line: "Tschelitsiew is 28 years old." Remarkably enough, the spelling of the artist's name receives here what I believe is a unique rendering—another inspiration of phonetics.

The gallery referred to by Paul is that of Pierre Loeb, the Galerie Pierre at 3 rue de Seine, handsome though not large. Tchelitchew is delighted at the prospect of a young dealer so knowing as Loeb. The gallery's original stable is Tchelitchew, Bérard and Berman. Loeb becomes very interested in Pavlik's work and will maintain, after the artist's death, that he dropped all three painters only because his interest turned to Surrealism. One reservation he has about the Tchelitchew of these days is strictly technical and empiric: he uses such heavy impasto that Loeb fears it will eventually break up. This proves true about *The Ship*, which will develop, over a decade later, the aforesaid "abscesses." Around this time Loeb observes that Tchelitchew's style is changing rather rapidly.

Truly, among the little group of Neo-Romantics, it is Tchelitchew who "changes his style" by making the boldest gestures. His personal feud with Bébé Bérard is real enough, though Pavlik is the aggressor; now, he constantly calls his rival "un voleur" (a thief). Léonid testifies that unquestionably the two feel a deep interpersonal rivalry and each one is arrogant in somehow always assuming that he, individually, stands above the rest of them. They all criticize each other, says Léonid, but in an informal spirit, never on the basis of "big theories." As for "stealing," none of them does that because each, in Léonid's opinion, has a totally different conception of painting.

Léonid will recall being much impressed by Tchelitchew's *Eggs* as "a true invention." Wittily, he will remark Bérard's "left-handed grace." One understands the desire of this Neo-Romantic artist to be impartial, but it strikes me that, like all groups bound together in empathetic feeling, they unconsciously take cues from each other. A 1930 work of Léonid's, *Fisherwoman*, must certainly stem from Tchelitchew's 1926 *Ship*. I feel sure, too, that Tchelitchew, at this point, is somewhat jealous of Bérard's lyric facility with the face and is impelled to surpass it. He despises Bébé's almost pathological infantilism yet cannot help perceiving that it is partly what makes him so effortlessly ingratiating; whereas for him, Tchelitchew, charming people creates a noticeable wear-and-tear.

Bérard, on his side, is jealously alert to Tchelitchew's inventions while feeling temperamentally powerless to do anything comparable; he takes his cues, rather, from minor emphases in the other painter, such as opalescence, shadow or some anatomic accent. In the view of Janet Flanner, writing many years later as Genêt of *The New Yorker*, Bérard is being influenced by

Tchelitchew's "metaphysical" style.* In any case, James Soby is warrant for the fact that all the Neo-Romantics owe some phase or aspect of their work to Chirico, who is the anti-Picasso of the period. Berman, with his picturesque melancholy, seems to have assimilated more of the source painter than the others although his style takes a quite personal form. Léonid is to concentrate on a lyric crystallinity of wide beach broken by far laconic figures, like the miniature finish of goldsmith's work, while Bérard is to cultivate and reculti-vate his precious area of wistful, translucent pathos. Though in a sense tangent to Surrealism, Neo-Romanticism crosses its territory wherever magi-cal or metaphysical effects are suggested—both schools coalesce in (or rather out of) Chirico.

As satisfying to the artist, strategically, as is the one-man Galerie Pierre show of 1929, it begins, according to Tchelitchew, with a disaster caused by the formerly sympathetic Cocteau. Tchelitchew, in a document written to guide Soby in the 1942 monograph, maintains that before the vernissage Cocteau rushed in and declared "gallicly" to Pierre Loeb that he, Pavlik, was "confusing the aim of painting with that of puzzlemaking. . . . As a result of this nonsensical verdict, I parted with my bewildered dealer although I had been with him four years." The time span is histrionic, not chronometric: surely "three years" is closer to the mark. It takes only this abandonment by a dealer to impress more deeply on our susceptible hero that his destiny lies across water, that fame somehow waits for him at the end of a journey.

The same year Tanner and Tchelitchew go to England to visit Edith Sitwell, who, while forming her solid alliance with the painter, has become affectionately intimate with his friend. The pair also wish to honor Igor Markevitch's debut with Diaghilev, who has made this young composer one of his "finds." As we know, this season will be Diaghilev's last. All his close friends are worried about his state of health. Tanner begs him on this occa-sion to see a woman doctor at the Pasteur Institute; her vaccines are said to be the only "cure" for diabetes. But the impresario crossly replies that he is taking the best possible care of himself. Meanwhile, in his hotel room, friends discover in a drawer the remnant of a box of chocolates that Sergei Pavlo-vitch has been nibbling.

Yet in London, now, there is cause for exultation. Tchelitchew's beloved Spessivtseva, one of his most admired ballerinas, is divine in Swan Lake. Osbert Sitwell holds a party at Anton Dolin's studio to which "all London comes." Probably Lord Gerald Berners, an addition to the Tchelitchevians, is present. But the gayety is shadowed by what Tchelitchew terms "omens." In particular, the second movement of Markevitch's concerto has been like a funeral march. And, to Tchelitchew's distress, huge heavy laurel wreaths were dragged on stage at the end of Swan Lake. Back in Paris, two months

* The New Yorker, April 15th, 1961.

later, Pavlik receives the telegram from Lifar and Kochno announcing Diaghilev's death.

Tchelitchew is tempted to think the impresario might have lived had he been wise enough to have his horoscope read. All the same, it cannot be proven that horoscopes have any role in winning the artist his English admirers—unless we assume, with the later Tchelitchew, that the stars always "pull the strings." Among those with whom Pavel Fyodorovitch completely carries the day across the channel are Edward James, a wealthy and whimsical young man of artistic bent, the late Peter Watson, also a cultivated youth (who has a fortune in the offing), and Cecil Beaton. All being, in different ways, men of cultural attainment, they have found the talented aristocratic Russian personally and otherwise congenial. As for Beaton, brought to Tchelitchew's studio by Edith Sitwell, he is awed by so much glamor which has yet to obtain its rightful place in the sun. Indeed, his awe keeps him from getting personally close to Tchelitchew. It is only when he hears Watson is on such intimate terms with him that he makes the necessary gestures toward Pavel Fyodorovitch.

The artist's first important London show cements the beginnings of the English-American coterie that will be chiefly responsible, so far as patronage goes, for Tchelitchew's future fame. Young Watson—lanky and languid, in love with the pleasures of life—eventually becomes the subject of a portrait "in blue armor." Tchelitchew has chosen the suit of armor from a museum; thus Watson poses without it. The artist spends hours, however, studying the metal torso, and insists on the bored subject being in place while he paints from the sketches he has made "on location."

Portrait commissions are the thing to follow a show containing portraits yet, at this relatively early period, Tchelitchew's portrait style is not calculated to appeal to the inevitably romantic standards of society's normal self-regard. Pavlik has already inaugurated those "histrionic" touches that subjects may find irrelevant or ambiguously flattering. Basically, the age is too prosaic for things like metaphysical fantasy. Edward James acquires some Tchelitchews but does not commission his portrait. Beaton is much touched when he is asked to pose later on, but the result does not get bought. Following Tchelitchew's death, the subject will feel a sentimental desire to possess it but, alas! it will have "disappeared."

In their correspondence, the artist and Miss Sitwell develop a set of satiric nicknames for everyone they know, forming (as happens in such tender intimate relationships) a sworn compact of two against the world. Impeccably mannered, destined to be so silvery-suave, Beaton like the others earns his undying nickname: no more than a routine matter of ever-alert *méchanceté*. Just the same, in 1960, Dame Edith will allude to Beaton as "always very chivalrous" to her. She finds him personally agreeable, she will say, but

like Tchelitchew, he gathers round him persons whom, for one reason or another, she considers "impossible."

During one of those "rows of unbelievable ferocity" with Tchelitchew (she will profess never to remember the causes), the artist threatens to kill her, her account asserts, while she is posing to him. Beaton appears like a knight in the great allegories though it be only to interrupt with his knock. The scene, one may be sure, is one of high camp, already a time-honored charade in which Tchelitchew, really vexed, wears the standard face of the domineering cavalier, taken straight from the school of operatic acting. Growling, "Yes, yes, I choose keel you, you know!" his tenor aria cautiously avoids breaking into falsetto. The gestures are grand but the threat is intimate, indeed cozily domestic. It is like a scene from an improbable modern comedy, with Beaton's theatrically timed knock and his beautifully tailored voice (dimmed of course) offstage: "Oh, what is happening? Let me in at once, Pavlik, do you hear?" Despite her studied effort at composure, Miss Sitwell, herself a redoubtable performer, trembles and gasps out, "Very well, old boy, if you must, you must, but kindly respect my amber." So she will allege. I am inclined to see her actually less debonair, alternating between muteness and a dignified stammer, but duly crying out in order to play up to Tchelitchew's extraordinary Method acting. The "rows" so freely acknowledged by Dame Edith, one may be sure, are not only superb displays of skill but hale emotional purges for both the participants.

Yet the subject cannot be dismissed thus lightly. I have reported merely the theatrical surface of the intimate relationship between Pavel Tchelitchew and Edith Sitwell. Of this, there is supporting testimony from the artist's side: his ambivalent nickname of "Sitvouka," his habit of complaining frankly to Allen and indulging, half-seriously, the sinister side of his character as magus. Beneath the literal falsity of charades, gay or grim, lies an unadorned truth of masks. All that Miss Sitwell has to seem to Pavlik is "pouty and *difficile*," as he once writes, for him to call her Sitvouka and give three spits. Officially he "kings" it *chez* Sitwell. Yet, to Allen, he maintains that close friends of Edith "land on me if I say this or that." Edith herself, after introducing him to Lady Diana Fitzherbert (a prospective sitter of course) "pecks" at him for reasons of petty jealousy. Dame Edith, to me, will shed a curious sidelight on her social function in Tchelitchew's behalf, saying in almost the same breath: "He is the greatest genius I have ever known . . . But I used to rail at his fashionable friends." Between two such titanic snobs as Dame Edith and Tchelitchew, the word "fashionable" necessarily earns a terrific beating.

When out of temper with his patroness, our hero instantly joins the league of those beyond the lady's immediate circle, especially if (like the Gorers) they happen to be Tchelitchevians. Mrs. Gorer, whose portrait he paints, is "goodness and intelligence itself"; he is, he betrays, pampered and spoiled by

gifts from her and her son; and importantly, as he says, "they protect me against Edith's forays." It may well be a portion of Tchelitchew's paranoia to fantasize that his intimate patrons demand more of his time than they actually do. But is Sitvouka *difficile?* "We [he and his fellow conspirators] only have to give her the absent treatment and she becomes like silk." He must inaugurate regular periods of coldness (say about "three days") because he doesn't want her to work herself up into, he claims hyperbolically, an amorous state. Her "entourage" he finds "stupid and pretentious," adding of the whole situation, "Je m'en moque royalement."—"I thumb my royal nose at them."

One may conceive the hero of such haughty secret defiance all too easily in Miss Toklas' terms, perhaps in worse, but in this Divine Comedy, one must read the surfaces through the depths and past them to the heights. Tchelitchew and Miss Sitwell are enacting a closet drama of enormous import just where their souls, as man and woman, are touched to the quick. She is more than the canonic Sibyl; she is also the Medieval figure of the Virgin to whom the troubadour, Pavel Fyodorovitch, swears eternal devotion. Pavlik's arias, in this respect, have more than a simple function. The outward drama is something of a parody on both sides but that is not the main point; the parody, despite all its baroque icing, is undergoing a real transformation of its essence. Like the troubadour, Tchelitchew commits himself to works of portraiture whose terms are set down permanently. The full-length "sibyl portrait" of Edith Sitwell will be more than a Court Painting in the genre sense because this "courting" is tinged with the old Court of Love. The portrait has the finesse of its deliberate scale, which is not just physically large but also spiritually ample. In a few years will also come the bird-genius portrait: very small because it is in *Phenomena* and a kind of wraith. Miss Sitwell's reclining figure there has the shape and the weight of a feather, cradled illusively next to Tchelitchew's shoulder as he stands at his easel . . . Consider that we are passing through the infernal dimension of Tchelitchew's life. As he himself is beginning to grasp, he is in Hell.

The Water Carrier

Hell is never so awful as the word sounds; perhaps it never was. That life can be conceived as only a game may be a sign of bad taste or it may be—the fact of it—beyond a question of taste. Conceiving life as a game, and playing it with or without respect for the rules, may be the only way of bearing the Hell of twentieth-century existence. A bricked-up hotel room, with an offbeat love triangle in it, may be quite a valid emblem of the times in which we live; still, it does not get us beyond boudoir drama. Like similar theatrical emblems, it tends to lack fresh air as well as the variety, the spice, of life. Pavel Fyodorovitch's life, conceivably a game, lacks none of those classic

quantities. His Dantesque biography is remarkably like what life used to be so widely reported as being: a universal human experience.

Tchelitchew has no particular signs of claustrophobia, or for that matter, agoraphobia: his relation to the world of publicity is honest. On the psycho-pathological chart, he begins and ends with insidious paranoia: a sublimated case. This affliction accounts for many things: many of his masks, many idiosyncrasies. It does not, by definition, account for the supernatural assumptions of his psychic life or the paintings to which, as fantasies, those assumptions lead. If we lacked the encyclopaedic masterworks of this artist, especially the Hell and the Purgatory, the case might be more speculative than it is. If the society portrait* becomes for Tchelitchew the image of a social paradox, art as vain worldly ambition, we have merely to follow patiently what is coming, to be led straight to the great initiation rite of *Phenomena*, where the society portrait is put in its place.

Somehow, while there is no clamor for them, portrait commissions come to Tchelitchew; he executes certain ones and, we may presume, is paid for them. His first multiple head portrait is of Ralph Church. Miss Sitwell's portraits are presented to her. Persons who are under social pressure from his patroness, however indirectly, come through. One of these is Harold Acton, who in his book, *Memoirs of an Aesthete*, adopts the tone of having somehow been manoeuvred into commissioning a portrait. Oddly enough, this painting is rather mannered, its striking feature being an immense gloomy deposit of augmented pigment situated on the subject's forehead. It may be a pixyish reference to Acton's intellectuality. Who knows? I do not, and I know of no records on the point except Acton's book, where the reader learns that the subject, rather bemused, relegates the portrait to his bathroom. At his house, Tchelitchew chances to note its location, whereupon Acton (putting it mildly) is struck off the artist's list. One entry more or less hardly matters; the list is leaping ahead by the page.

Lastly (or rather, firstly), everything is in the lap of destiny, where the stars are the only infallible signs. Nobody knows better than the artist himself that usually, from morning to night, he goes on behaving as if the heavenly signs do not exist. One can't be a successful artist and keep one's eyes pasted on the skies or on horoscopes. *Art is work*. It is his sole real occupation, and from it flows his welfare and the welfare of those who depend on him. The moment has come for something very practical: he sees that he must act to bring to its proper conclusion the leisurely romancing between his cousin Choura and Prince Pierre Galitzin. Pavel Fyodorovitch mentions marriage and offers to stage the wedding at the picturesque little Russian Orthodox Church, to which one must climb on a winding pathway. He hastens the affair

* The really unpleasant associations of this unavoidable term (usually denoting a commercial genre practised by academicians) have no validity in Tchelitchew's exploitation of portrait-painting.

by offering also to design the bridal costume and pay for it. One of those who hold the crowns over bride and groom during the long ceremony, Pavlik takes much satisfaction in the excellent "production" of this event. André Tchelitscheff, Igor Markevitch, Tanner and Roger Faure also take their turns as crown-holders.

Pavlik has a right to think himself a chivalric champion on more than one level. The demands of a rich social-professional life are by nature complicated. Like Leonardo, he must shift with the tide of the Sforzas; respond, at a psychological moment, to the patron of a "foreign" country. His own country, after all, is Genius. Of course, it is not on the map unless your name is on the map. Citizenship in it is acknowledged, anyway, only in the best society. Pavlik, moreover, has the calming recollection, which may come in any of his waking hours, that somewhere his astrological destiny, whatever he may or may not do, is being worked out for him. This force is to be known as Fate. Besides, everything that one does or does not do conceivably *does* matter: this force is called Fortune and may alter the future in one's favor.

Like his reverenced predecessor, he is painting his Mona Lisas and Ginevra di Bencis, and not without some of Leonardo's burning monomania in searching for an ideal type: Tchelitchew's type, too, is ultimately not so much to be realized in the flesh as isolated in a heaven of pigment. *La Dame Blanche*, as seen in *Inachevé*, has the same psychic reference and plastic memento in Tchelitchew's art as the remains of Christ's head in *The Last Supper* have in Leonardo's. But soon now, Pavlik's burning monomania will compass Helena Rubinstein's portrait aflame with the pale iridescence of sequins. It is an interesting venture, one of the first with the magnified eyes that will be a mannerism of future society portraits; the over-lifesized head is studded with sequins as if with star-streams. When first told the price Tchelitchew asks, Mme. Rubinstein smiles archly and responds: "And for *me?*" But an agreement is reached.

When the portrait is done, Mme. Rubinstein views it after Pavlik has left Paris on a trip to England. The mouth, she complains, is too large. Tanner reports her objection. "I truly believe," the artist answers his friend, "the head is very beautiful and one should not make it a lollypop . . . Am I a photographer à la mode who does pretty heads of women. . . . Voyons! . . . If you find that the mouth is too big, then stick three little sequins, one rose and two white, at the corner of the mouth, which will make it smaller." This modification is hieratically performed and the sitter, on due deliberation, accepts the work. It will appear in Tchelitchew's first one-man show in the United States.

In 1931, both the Balzac Gallery in New York and the Wadsworth Atheneum in Hartford include Tchelitchew in group exhibitions; the latter presents Bérard and Berman along with him. Already the transatlantic ma-

chinery for promoting him has been set in motion by his American admirers. At the same time, though as yet Tchelitchew is no more to him than one of the artists reproduced in *transition*, another young American is preparing to sail from these shores for his European adventure and is destined to meet Tchelitchew. This is Charles Henri Ford, a Mississippian, who not only will become intimate with Tchelitchew but will significantly alter the course of his life. Ford and I have been associated on his little magazine, *Blues*, which has had a life of two years. Ourselves poets, we have been drawn together by our interest in modern poetry and become acquainted (sometimes by correspondence) with a number of elder modernists: William Carlos Williams, Wallace Stevens, E. E. Cummings, Djuna Barnes, Ezra Pound and (last but not least) Gertrude Stein.

Out of his New York experiences, Ford has evoked a naughty novel on which he has persuaded me to collaborate, *The Young and Evil*, so plain-spoken that, for this still innocent era, the only possibility of publication seems to lie in Paris. The obvious course for Ford is to take the manuscript over himself and present it for Gertrude Stein's approval. Though Ford can barely finance his own trip, he gallantly offers to share his means with me if I also care to take the big step. But, in mortal fear of seasickness, I lack the drive to go to Paris at this moment. Ford thus, in April 1931, sails alone. We are faithful and profuse correspondents, however, so that soon he is writing me of Gertrude Stein's welcome of both him and our book; also, of having met a very remarkable Russian painter, Pavel Tchelitchew. Yet his letters are full of names; apparently he has dropped directly into the fleshpots of glamor. I am reassured, however, that he is not losing sight of his desire to publish our manuscript.

By no means do Ford and Tchelitchew get together right away although immediately the latter is aware of a strong, seemingly ungovernable attraction: the first perfectly serious one in his life. As in the true romantic tradition, various barriers stand in the way, contingent, accidental, material: everything that can create meaningless delay and nuisance. Having met the young poet at a party given by Djuna Barnes, Pavel Fyodorovitch invites him to dinner, tête-à-tête, and shows how extremely taken he is. They have several rendezvous. But Ford has social commitments and Tchelitchew domestic and other ties. The former is to spend the summer of 1932 in Italy with a woman friend of mine who bore an introduction to him and whom he met at the boat train in Paris. This young lady and he form an equivocal sort of liaison and have so quiet and isolated a summer in the country that they grow bored and decide to go to Tangiers. There the lady finds another to whom she loses her heart and who promptly spirits her away to Spain. Ford, alone and disliking it, wires Djuna Barnes in Paris asking her to join him. They have felt a positive attraction for each other. Ford, writing

me regularly, declares it a romance which has cropped up in his life very unexpectedly. Suddenly, I receive a short story which Miss Barnes has written about Ford. It is a very pretty piece and contains an impressive description of my friend, saying that his eyes go around the sides of his head like an animal's.

The heavens, which supposedly never sleep, may seem to have been idle and of contrary minds. Yet the truth is that, behind the veil of appearances, Ford bears a spiritual birthmark even more significant for Tchelitchew than Tanner's. Born on February 10th, he has Aquarius for his zodiacal house, considered a "fixed airy sign" despite its relation to water. Unlike Pisces, Aquarius means not bodies of water, precisely, but portable water; in any case, both Ford and Tanner represent (as Pavel Fyodorovitch comes to know) the airiness toward which he aspires by conquest and considers his by natural privilege. Ford has brought the Atlantic Ocean with him and will place it at Tchelitchew's feet like a carpet. In *Phenomena*, the young American has two symbolic presences, one an outright portrait. As the Spider Boy, he is recognizable as an illusion made by part immersion in water; he sits to his neck in a pool that has collected in the narrower part of the instep of the gigantic footprint in the painting's sandy ground. One may well wonder why this figure, all head and legs, is on the right or Plus side of *Phenomena*, which holds all sorts of monstrous redundancy.

The obvious answer is that the spider's multiple legs more than make up for its lack of body. Anatomically the scanted human part of this illusory zoörmorph is the torso; indeed, Ford's own torso is boyishly negligible though he has long slender arms and legs and a striking head. As always, the data of a visual occasion—here a snapshot of Ford in a bathing pool—merely reveal to the artist the saturative splendor of a complete and lucid truth. The Spider Boy is akin to the arachnoid center of *Hide and Seek*, where a little girl occupies the commanding position in the web of life: she is, as I have shown, pursuer and devourer first, and only second (like the mythical Arachne) a "sacrifice." In Tchelitchew's Hell, the arachnoid is on the Plus side not merely because of structural illusion and the spider's voracity but also because now it is male; another phallic coefficient in this infernal system is carefully, if obliquely, underlined. Since it is unlikely that Ford, who by 1936 will be supreme in Tchelitchew's life, should be relegated to so modest a position even in Hell, we may look elsewhere for him in this magic personnel. He *is* elsewhere but let his identification be postponed for the present.

In 1932, Ford is apparently about twelve years Tchelitchew's junior. To Parisians he is another wide-eyed, goodlooking American, intent of course, but with rather chimerical credentials. At once, he takes to wearing a cap of the type peculiar to porters and cab drivers, and adding to it a cape, has a studio photograph taken with a look known to the old South as one in which

"butter wouldn't melt in his mouth." All the natural innocence is a mask for a great deal of practical worldliness. But our hero, Tchelitchew, is someone to read faces for himself. As a modern painter, he cannot but register sensitively, if subconsciously, that by some miracle (he never, of course, ignores miracles) this young man bears a startling resemblance to Picasso's rose-crowned youth holding a pipe. Right now, the cheeks are a bit full, the features too rounded, for a precise resemblance. Yet the physiognomic affinity is unmistakable. It is apt, and airy, that the roses be lifted from the chest (where Vincent's rose tattoo triumphantly resides) to the brow.

When Ford appears, the face as a plastic riches, a fulcrum of the sensibility, is restored dramatically to Tchelitchew's consciousness. He is about to begin a portrait painter's career but till now has lacked the one vital inspiration that will bring the contact with human earth, his first Parisian ideal, to true and final fruition. Edith Sitwell's head, if not her body too, belongs to the world of spiritual things. So many heads which he has done belong to the world of aesthetic effects, plastic whims, to the dubious welter of fashions. Charles's head (at this time he does not use Henri, his middle name) seems to evoke a pure reality he has reached hitherto only by way of the body. Why else has he been willing to blur the faces of his nudes? The head of the great *Nude* (1926) is bald and even severed by the margin of the picture. It was when *Ode* came along, and the faces of dancers had to be suppressed by theatrical means, that he realized what the absence of the face portends for human relations. When it is not a specifically aesthetic omission, a suppression in anatomic studies or abstract style, it means a frightening gap in the continuum of existence. The human face will have its apotheosis in Tchelitchew's art for the ensuing years till it is anticlimaxed in his allegory of Hell.

Intrigues
Back in Paris with Djuna Barnes from Tangiers (where rats ate the poor lady's clothes), Ford continues living with Miss Barnes at her apartment, but starts interesting himself again in Tchelitchew of whom he feels, somehow, perfectly confident. Ford has met Tanner and they have mixed amiably. On the other hand, the artist has told Ford about his domestic situation and its problems. It is midsummer and a mutual friend, the late Allan Ross Mac-Dougall (Isadora Duncan's secretary and the author of a book about her) offers to be *entremetteur* since both parties seem to require encouragement. Charles and Pavel Fyodorovitch are gotten together tête-à-tête for a Fourth of July dinner. The American day of celebration as alternate to the French, so near at hand, is not without point. The Parisianized artist has already been Londonized, and the metamorphosis has been, so far as it went, beneficial.

Plainly, the prospect of now being Americanized boasts a very material inducement though it is still in the background. Ford's French, blended with

his Southern accent, is a poor instrument of communication but actual language is the least of Pavlik's difficulties in life; he has learned a great deal of colloquial English. While he pronounces it with a hybrid and amusing accent, distorts it at pleasure, it is quite practical. A few years before, an extraordinary incident has revealed his unconscious command of English. Almost simultaneously, he and Allen contract cases of appendicitis (they read in it their transcendental accord) and successively undergo operation at the hospital. While under anaesthetic, Pavlik is heard by the doctor and nurses to produce a fluent stream of faultless English; at least, so it seems in comparison with his usual English . . . Suddenly, as he sits opposite Ford at dinner, an image that Pavel Fyodorovitch has unconsciously been seeking, a charming identification, rises to the surface. His early education has introduced to him certain classic American authors, one of whom was Mark Twain. He has remembered the fascinating Huckleberry Finn and the adventures he had with Tom Sawyer and that big Negro. This stunning youth is an incarnation of Huck! For some time, Ford will be (as the artist addresses him in letters) "my darling huckleberries finn."

In the two years during which the destiny of their relationship is still in suspense, Pavel Fyodorovitch has time to assess and reassess his fundamental impulse toward the young American. It is a high-keyed time of crisis for he has achieved, with Miss Sitwell's aid, a nominal conquest of London; at least his field of operations is really wider, he has made new friends and collectors, and he has committed himself to portrait painting. Charles Ford is by all means airy, by all means a sign. His intent cloudless gaze seems to pierce the future and to ratify Tchelitchew's axiom on always looking ahead, never behind. He paints an over-lifesized head of Ford that remains one of the great portraits of his oeuvre: flawlessly frontal, direct, truly airy, a total communication of young dazzlement; the enlarged eyes are a figure for dawning consciousness steeped in skyblues; the line of the full placid lips is the horizon of a young male's self-affirmation. The picture is as gentle as a breeze, as artless as a field flower. Other portraits of him follow, mostly heads.

But Pavlik's anxiety about his sister Choura is at its apogee; he is plagued by things like taxes and other expenses; he is deeply convinced that the Allen-Choura combination at home is helping to keep Charles at a distance. Furthermore, he is indiscreet enough to say to Ford, "Choura's métier is illness." Shortly before first meeting him, the artist has to stay behind in Paris before joining Tanner in Guermantes because Choura has a lung crisis. She is running a temperature and the doctor says it is a new type of *grippe*. Pavlik is *distrait* because another cousin, Noura, is also in the house and enduring the last stages of consumption; she lives in the upstairs room belonging to the apartment and comes down only when she requires anything. Naturally Pavel Fyodorovitch lives in dread of "catching something" from one of the two,

even though a nurse friend of Choura's is actually tending his sister. He cannot work, he writes Allen, "with so much disorder, hubbub and strain."

Count Rzewouski, the music theoretician, his old friend who used to do van Dongenish paintings when he moved in society, has suddenly retired from the world to become a monk. It is so strange, in the midst of the present stress, to receive one of the periodic visits from him in his Capuchin habit. If only *he* could retire from the world, Pavlik tells him, and do nothing but paint. At last, Choura's fever drops and she is out of danger. One more crisis is surmounted! The Galerie Vignon has held a one-man show for him but at this point "gallery troubles about money" have arisen. "My god," he suddenly breaks out to Tanner in the letter just quoted, "tomorrow I am 33 years old, the half if not more of my life is already over. The smaller half remains for me—so much the better, all these 33 years, I haven't turned out much, sad to say."

At such moments he is always reminded of that strange hallucination he had in the empty Staatsoper, in Berlin, as if gazing into the theatre of Hell: arid, monstrous, a sort of jungle. If his life really be half over, time is thereby less "infinite," despite the devices of art, and the vanishing point something that no longer can be pushed on and on into the future; the recessiveness of the vanishing point used to disturb him; now— The words written Allen are a lugubrious note and sadly one of Tchelitchew's accurate prophecies: he *has* lived more than half his life. On this birthday of 1931, he thinks that Allousha's thoughts "are the most precious gift I could receive from anyone."

Yet now, having met Ford, he feels for the first time an active jealousy, a sensible pain, regarding possession of another human being. Social and professional duties have kept him in London in the early 'thirties. He is painting Cecil Beaton in a Tyrolean costume to which he has taken a fancy, but some are critical of the notion. He is never free, it seems, of officious mentors if only that domestic clique at Edith's—not Osbert or Sacheverell, of course, but "you know who." A philosophic talk with his painter friend, Jacques Stettiner, is soothing; so is seeing Edith after six months' absence, and walking with her in Hyde Park, where the sun shining through the mist seems "an unbelievable beauty." His patroness is now "thin," and on attending her lecture at Oxford, he notes how the overhead lights bring out ridges in her face. He is ensconced comfortably at The Elms, the Gorers' house, but as for "rest"—he writes Allousha, "Rest while you can in the absence of your demon brother [himself] who after all is very nice." During these hours he flees from an old critic friend and wonders if one of his great Russian ladies, by not writing him, is trying "to put me in my place." Vanity, vanity! Painting alone ravishes him; he emerges from a French exhibition in London, where he has seen "tragic" Gauguins, "as if from Paradise."

Ford's star on the horizon has been giving Allen's heart some soft perturba-

tion. Pavel Fyodorovitch assures him that he still loves him, but that from time to time people who love each other should take rests from one another. Ford has visited Guermantes; several nights, he has gone to Tanner's room for a cigarette and a bedside chat before retiring. The young American being initiated into Europe finds the other a knowing and sympathetic *confidant*. The following year, in one of the artist's letters to Ford, when the latter is staying with Gertrude Stein, he includes Allen's message that "he loves you very much." It is on returning to Paris in the summer of 1933 that Ford telegraphs Miss Stein, asking if he may pay a visit to Bilignin.

Her answer is YES IF YOU COME ALONE. She has already, by cultural wireless, been informed of Ford's connection with her ex-protegé. Moreover, she is put out to learn, on Ford's return visit to Bilignin, that he has again been seeing Tchelitchew. "If I had known that," she tells her guest with some spirit, "I wouldn't have invited you." Her miff doesn't particularly matter, for Charles already has her statement for our novel's jacket as well as commendations of the book by Djuna Barnes and Bernard Faÿ. Besides, this is the lady's famous "interference" tactic. When she warns him off Pavlik by saying that Russians are stronger than Americans, the Steinese simplification falls flat with the young poet. Ford is pleased to find himself the nexus of a glamorous little feud. His gaze is perfectly level and so is his social eyesight; he has grit, patience, tenacity, and he knows the full value of his personal assets. It is no more than natural that, like his artistic assets, these should make their impression. Tchelitchew is endeavoring to interest people like Jane Heap in his writings. With his practical vision, Charles is sure that he wants this greatly gifted painter only without his sister and his friend, Tanner. His campaign is therefore obvious: the domestic combination must be broken up—and soon.

Pavlik regularly sends his new friend outright love letters: "Oh my darling huckleberries finn where are you and what kind of a foul plan maed [made] the 'evil spirits' against you and me." He refers to Charles' revelations of the *can-can* at Bilignin and the fact that they seem to be missing each other's letters: Tchelitchew fears Gertrude may be "destroying" the incoming or outgoing mail. He also assails Miss Toklas: "I suppose A. is completely 'gaga'—M. told me that she begonn to be absolutely like an old horse misting [sic] everything together." And he reiterates feeling lonely. "Darling Charly, your presence is absolutely indispensable to me—your little figure and your two beautiful eyes are my stares [stars] and my ocean."

No presences in Paris, however important, can make up for Ford's absence. He rails against the society where it is also "indispensable" that he regularly appear. He writes Ford of who is "in vogue today at the jungle (Noailles crowd)." He himself goes faithfully to the Thursdays of the renowned salon-ière, Marie-Louise Bousquet, whom he regards warmly if only because she

has remarked of Ford, "Il me plaît!" ("He pleases me!") Ford writes that he cannot rid himself of the wet-dream habit he has had all his life. The information earns Pavlik's fervent sympathy but when he mentions it he spells it "wheat dream." He will literally do a wheat-dream portrait of Ford: the one with the Ukraine wheatfield spreading about his head like the illusive brim of a large straw hat.

Staying at the Gorers' summer place in Somerset, Tchelitchew one day brings out George Balanchine. A real friendship is being cemented between the artist and the brilliant choreographer. Gorer will insist long afterward that Pavel Fyodorovitch "invents fantastic libels" about people, but will add: "He never turned on me the way he did on some others. When he was a friend he was a very good friend." It is very possible that at times Gorer misconstrues Tchelitchew's hyperbolic forms of speech. At all events, one may observe impersonally, it is a great problem permanently to be friends with everyone.

Doubtless, Gorer thinks that Tchelitchew "turned on" Gertrude Stein, among others. In a way, the turning in this case is mutual. Moreover the artist (more judicious than often he is credited for being) assures Ford that when Gertrude's mind is above gossip, she is well worth listening to. His revolt against the exalted ladies of Paris and Bilignin is similar to the revolt of dozens of others who have had experiences parallel with his. "I have nothing against G. and A.," he writes Charles, "but couldn't stay in the 'continual last judgment'—too much and not amusing . . . I trust your stay [at Bilignin] is not like Dante's Hell." Subsequently the artist will associate the ladies "sitting in judgment" first with some circus pinheads he hallucinates on a beach, and only at last will remove them to their niche in Hell as burlesque Guardians of the Threshold.

Tchelitchew can look in the mirror (as often he does) and tell himself that he has any number of traits and moods, passionate or trivial, but he can never find in his own face an image of repose. His actual self-portraits, except for one bad one, virtually jump with his chained energy; at least one of them is exclusively symbolic. *The Mirror* (1932) is an exquisite summary of his quiet apprehension of circus mummery, being set in a dressing room and exuding allusiveness as a knight in armor stands with a clown and an acrobat. They are reflections in a mirror into which another clown is looking. The golden-dark tonality, suggesting both sunshine and earth, insinuates an atmosphere of dreaming revery. The persons are notably "inactive." Tchelitchew's grasp of the total human figure will never be more felicitous, poetic, more redolent of a fine solemnity. To the work's happy owners, Mr. and Mrs. James W. Fosburgh, Tchelitchew will reveal that it contains an allegory: the three grouped persons are a Poet, a Painter and a Philosopher. "I," the artist will say, "am the Philosopher." By this, one knows that the knight is meant to represent the Philosopher: Tchelitchew calls himself the Faithful Knight.

Not so much true repose envelops this scene, imagined of professionals off stage, as a sort of unnerved magical leisure. Pavel Fyodorovitch has begun by admiring in persons an earth-weight that is animal repose and, especially in the male nude, has found its true portrait. More frequently, he situates the "house of earth" in certain tours-de-force, like the huge rump of his hammock-hung Venus. The clothed body-mass of the full-length Sitwell portrait looks merely paradoxical in contrast with the pale nunlike face and the rapt, almost vacant gaze; the long hands, engaged with the paper and quill pen, seem arbitrarily thickened, almost masculine. Soon the elusive solidity jealous of its rights in the artist's work, the proud integral flesh, will assume a perspectival melodrama, when abruptly foreshortened anatomy implies proximity: a touching distance. He wishes to grasp the golden mantle of fame— and now a golden human being, Charles Henri Ford. Of the two, one is as exacting and elusive, as much an independent "personality," as the other. He now knows that Ford will capitulate only on one condition: the dissolution of the Choura-Allen-Pavlik menage.

Ford's novel and mine, *The Young and Evil*, has appeared, and so far as Tchelitchew's influential friends go, has harmed rather than improved Ford's general standing. Miss Sitwell is kept well-informed by Tanner of the hidden threat to the menage at the studio home of the artist in the rue Jacques Mawas, which he has occupied since late in 1929. To Ford's gift of the novel, Pavlik's patroness replies with lukewarm ironic courtesy; her compliments are formal and she ventures to scoff at the book's "pillow fights," her term for its crime-tinged amorous intrigues. Actually she is inclined to regard Ford as an upstart who happens to be endangering Tchelitchew's happiness, perhaps his reputation. As I have said, for the historic present, *The Young and Evil* is an obstreperously naughty book; it has made just enough of a splash to be looked at askance by a reviewer in the Paris Herald. Miss Stein's bravo is emphatic but it hardly reverberates beyond Paris.

Edward James is now a leading English Tchelitchevian. Desiring to present the dancer Tilly Losch, to whom he is married, in a ballet, he can think of nothing better than for Pavel Tchelitchew to design it. The artist and George Balanchine will invent an idea for it. James is disposed, in fact, to make it a grand occasion for ballet by forming a company under Balanchine and employing as many leading lights of the theatre as possible; he induces Boris Kochno to be artistic director. Thus is Les Ballets 1933 formed. James, it happens, views the "intrusion" of Ford into Tchelitchew's life with no more kindliness than does Miss Sitwell. They agree that *The Young and Evil* is abominable, and finding themselves one evening with a copy on their hands, they consign it to the flames of a grate fire.

They are doing no more than the immigration officials do to the publisher's consignment to English bookstores. At the time, the private purge by fire is kept from the knowledge of interested parties and is revealed only much

later. The scene may be West Dean, James's estate, or the Sitwells' estate, Renishaw, to which Edith has currently repaired for the summer. Meanwhile, the artist writes Ford that he intends showing a manuscript of his (presumably *The Life of a Child*) to Osbert and Sacheverell Sitwell. During 1933, the chief point of tension in Tchelitchew's life is the arachnoid Ford, gazing unperturbed, with unswerving blue glance, from dead-center in destiny's web.

The Wanderer

Seriously being courted by others, Ford stops to consider that no one is more magnetic than the handsome Russian painter. Tchelitchew's stock is very much up in the glamor market with the appearance of *L'Errante*, the ballet created for Tilly Losch. Balanchine and the artist have worked it out together, step by step. They have taken their theme from Schubert's *Wanderer Fantasy* (using Liszt's musical arrangement) and visualized an unconventional leading dancer to suit Miss Losch's special gifts; she is not a classically trained ballerina and the Errante is not danced *en pointe*.

The thematic point of departure is particularly a line from von Hofmannsthal's song cycle: "There where I am not is my home." The ballet is a beautiful one (I lament that it has been revived only once since its American debut) and while a great balletic spirit informs it, the Wanderer's role is mostly surging pantomime, constantly "forward," being interrupted by encounters with two lovers (naked to the waist and suggesting acrobats) who seem both pursued and pursuing. Balanchine's capacity for erotically enlacing his dancers, for carrying conventional *pas*, so to speak, to the "inside" of the erotic embrace, finds here an early inspiration.

Miss Losch's costume is conceived by Tchelitchew as a glittering green sheath with a very long train; its color is supposedly that of the salamander: magic dweller in fire and another symbol of resurrection. The lithe dancer, while suggesting a snake, is meant as a generic chthonic symbol since her train, as the artist states, signifies "the restraining forces of earth." In this light, she appears in allegorical nexus with the little female genius of *Hide and Seek:* somehow Eve, somehow Daphne of the enveloping tree, yet the earth force bent on capturing the illusive boys in its branches. The restraining forces of earth, allegorically speaking, certainly include the power of water that involves drowning. Not only will the artist assert that the little girl in *Hide and Seek* is "swimming" in the tree, since it also represents a lake, he will also, while painting that picture, have fantasies of drowning. As chthonic, the Wanderer, engaged in seeking "the ideal young man," is herself impeded by the forces that she symbolizes. She is Virgo, the House of Earth, as her two lovers are Gemini, the Twins.

Naturally, the long train poses for the dancer a personal as well as a general

choreographic problem: her strength must match her skill in order to control fifteen feet of material. Every problem of this kind is solved—with style if not complete success. Miss Losch's robe, thinks the designer, is after all, though very lovely, too heavy. Then difficulties, usual and unusual, inevitably turn up. Tchelitchew is at the height of his personal rivalry with Bérard, who seems to have won Paris with a strong artistic coterie, including Cocteau and the composer, Sauguet. In the view of Eugene Berman, Bérard began, in his rivalry with Tchelitchew, "a little ahead of the game," but Pavlik "made big, rapid strides and came abreast." In fact, Berman will recall the explosive, expansive Bérard as "platonically attached" to Tchelitchew, as always lovable in manner and always wanting to introduce his rival to everyone. Tchelitchew is the "antagonistic" one of the pair. And yet, Berman will reflect, he never knew a man more obsessed than Pavlik with making "conquests" of people.

Bérard also has designed something for James's ballets. Automatically, cliques form as if the two star stage designers from Montparnasse were vying for a prize. To make it more dramatic, Boris Kochno, the company's artistic director, has meanwhile defected to the camp of Bérard, thus compromising the long warm friendship with Pavlik that began with their collaboration on *Ode*. The designer's ideas, as usual, have been very spontaneous and everything is in readiness for rehearsals to begin at the Théâtre Champs-Elysées, where Kochno takes charge. Instantly, a sort of stolid contrariness is evident in his attitude so that there are several brushes with the artist. Tchelitchew, however, is a hard one to put down. Finally Kochno simply stalks out, shouting: "From now on the rehearsals will be directed by M. Tchelitchew!" Unsettled by the sudden burden of responsibility, Pavlik becomes very nervous; the prolonged hours of strain take their toll on him. It is impossible to get the silk curtain to fall as it should because the stage hands actually seem "primed," deliberately uncoöperative. Tanner, in the emergency, decides to appeal directly to Kochno's old regard for Pavlik; so doing, he effects a kind of truce and the ballet goes on under Kochno. But the fall of the silk curtain, its exquisite climax, remains "clumsy" in Tchelitchew's eyes.

First the program is presented in Paris, where Bébé's chi-chi décors for *Mozartiana* seem, to Tchelitchevians, to get more than their due owing to an energetic claque. *L'Errante*, however, "outshines" its rival. A young balletomane who has just met Tchelitchew, Lincoln Kirstein, unhesitatingly casts his vote for the Russian. According to Ford, *L'Errante* really bowls over Kirstein, makes him a Tchelitchevian and leads to his bringing Balanchine to America. At any rate, Kirstein certainly becomes the artist's admirer and when he brings Balanchine to the United States as leading choreographer for the American Ballet, *L'Errante* will be revived. Pavel Fyodorovitch is much fatigued by the preparation for the ballet in London, where he expects

to come out on top of Bérard. Leaving Paris in the company of Edward James, he finds him charming. "I like him," Pavlik writes his "little children," "when he is sweet and kind like a child."

But a terrible quarrel at once breaks out between James and Tilly Losch. Tchelitchew must play Guardian Angel and reconcile them. Miss Losch is full of temperament but so is her husband. There follow, reports Tchelitchew, "three days of scandals" among the star, James, Balanchine and the publicity director, Dimitriev, over matters of publicity. Pavel Fyodorovitch wants to die of boredom. Then all at once, as usual, everything is *arrangé*. The rehearsal, however, seems to Tchelitchew very bad: he must change the lights, which make the train of lacquered green silk look too bright. And then: *calamity!* Nine hours before the first performance, they learn that the material of the décors cannot be fireproofed; so the designer has to make a whole new décor. It is a terrible experience for him: Kochno is adamant and demands the ballet go on at all costs. Go on it does, with the décor more beautiful, thinks Pavlik, than before. The climax is a wonderful invention: the great curtain falls free from the proscenium and settles upon the stage like a dream grounding itself. Donald Windham's impression of the climax is given thus: "a writhing shadow of a man ascends the shadow of a rope ladder into the sky and a great, wet cloud of Chinese silk cascades from Heaven and obliterates the woman, leaving the mirror again crystal, white and empty."

The illusive transparency, of course, is an echo of *Ode*. Again Tchelitchew uses dry and wet motifs; the costumes, all white with touches of blue and red, are either of dull or glistening material. He is probably recalling the frost-laden windows of Doubrovka's schoolroom, from which he fantasized a ballet of Don Quixote when a boy. Echoes of the Aurora Borealis of *Ode* appear in the "sunset lights" which play on strips of white muslin forming the semicircle of the ballet's background. Another reminiscence of Russia is the great banners of "revolutionary red" which cross the stage, forming an "elegy" after the sudden intervention of a veil separates the Wanderer from her lover. Without much difficulty, an allegory of the artist's own exile may be read in this. A "double" is present in the two male dancers (the Twins) with whom the Wanderer becomes involved: they are dressed identically, except for the color of their sashes, in white tights. That the lover who "escapes" climbs a sky-ladder is of course, like the sashes, a reminiscence of the circus.

Despite the historic present, metaphoric reverberations go back and forth in Tchelitchew's life and work. The Hermaphroditic Angels that make an appearance in *L'Errante* directly refer to the tradition of the Hermetic Androgyne, pictured in old drawings as winged and having two heads. As if to conceal their bosoms, the female dancers impersonating the Angels wear their wings in front. Not only is the supposed unitary origin of sex implicit in

the Hermetic Androgyne but also, of course, night and day: one of the figure's two heads is dark, the other light. Another hermetic symbol in *L'Errante* is the ladder itself. In the Gnostic tradition, man climbs toward the immaculate word (Verbum) on rungs representing Sense, Imagination, Reason, Intellect and Intelligence. Reaching the supernal state, the Hermetic Ladder disappears into clouds beyond which a sunburst is shown.

The classic Hermaphroditus, we should recall, is the son of Hermes and Aphrodite. Tchelitchew's Wanderer is very close to a Venus-figure (Windham identifies them through the water symbol) and Venus-figures, whatever their fates, die only to be reborn. Aphrodite, according to the myth, is born from sperm scattered on the sea. Thus the cloud curtain that "cascades from Heaven" in *L'Errante* represents, in the hermetic dimension, sperm itself: here a sign of cyclic rebirth. A curious metamorphosis of the Errante symbols is destined for the artist's Hell. Far back and high, close to the City of Glass, on the Minus side of *Phenomena*, a female mannequin's torso is pedestalled on a tall ladder over which formal black drapes descend. And a very similar effect will constitute Eurydice's funerary image in the ballet, *Orphée*.

The "great climb" for Pavel Tchelitchew seems pretty close to the top of the "ladder." Of course, the ladder used for the climbing dancer at the ballet's end is of rope, as in the circus, and therefore to a degree flexible—and unpredictable. During the first American revival, the dancer climbing it will suffer in performance a bad sprain. . . . In London, during the nine hours in which Tchelitchew must make the new décor, he almost "dies of fright." But, so he writes his dear children in Paris, "the première went off very well." Despite the apathy of the English public, which somewhat chilled the ballerinas, he can further say that the "whole program was a great success"— with one notable exception: Bébé Bérard's *Mozartiana*. "Mathilde," he communicates, using his nickname for Bérard, "had a fiasco. Everybody makes fun of the costumes which are in the genre of the faggot balls at Magic City."

The speaker is prejudiced; so are his close supporters, who have formed an active clique in opposition to the equally active Bérardistes. Backstage intrigue logically develops and there are more than villainous glances and vitriolic *mots;* there are things as unsubtle (so legend will say) as tacks spread for the feet of dancers in the rival opus. Then something happens which leaves no doubt in Tchelitchew's mind that enemies are at work. A member of the corps, during an actual performance, steps squarely on Miss Losch's train, and amid universal horror, a ghastly tear is heard above the music. . . . Yes, an extra, unscheduled "restraining force of earth" has been applied to the ballet, and by one remove to Tchelitchew's career. There follows an unbelievable moment in the theatre, of which Miss Losch is the heroine. Taking up her severed train and signalling to the corps to proceed by ad-libbing, the

dancer whisks herself offstage, ascends the spiral staircase to her dressing
room and in about three and a half minutes (according to Tanner) is back on
stage in her duplicate practise costume.

It is with the philosophy of an old trouper that Pavel Fyodorovitch, on
July 19th, writes Allousha ("entre nous") that Les Ballets 1933 is a "fiasco."
At Monte Carlo, he mentions, the theatre was enormous and it was filled day
and night by Diaghilev's ballets; this company cannot even fill a small theatre.
L'Errante he terms "the success of the season" while he admits that the
company's appeal is altogether to a snob public. He is refusing all social
invitations and is scolded for it by Miss Losch. Apropos of his return, he
dolefully reiterates: "They hate me in Paris." Secretly, he longs for nothing
and nobody except his "darling Charly." There crosses his mind an impulse
to wonder if Choura's marriage to Pierre Galitzin is working out as he hoped
at first. It seemed "just right"! How large and luscious is the fruit of life
when in one's grasp—and, when not yet in one's grasp, it is even larger.
. . . He looks up. A large foot is quite close to his head: on the rung above.

> I lodge in fear;
> Though this a heavenly angel, hell is here.
> *Cymbeline:* Act II. Scene II.

Araby

The next year, for Tchelitchew the painter, will be one of continuous inner revelation that purveys itself regularly to paper and canvas. Each work is a fragment of his own horoscope, illustrates one of the laws governing his symbols. Orthodox horoscopes, ordered from professional soothsayers, will become a vice: a curse of the paranoia that functions in him as ceaselessly as his heartbeats. He, his personal fate, his art, his career, his human relations, now Charles Ford, all come in the one dense envelope of existence. His experience of the world is additive, modulative still; he acquires worldly knowledge and knowledge of his craft as other men acquire material property. It will be as if horoscopes were the magical law protecting the practical interest of this property, pointing out the wisest investments. His will be the inevitable paradox of holding magical attitudes in the modern world, where a personal art or philosophy, an absolute metaphysics, are the only forces foolproof against a morality constituted, activated by reason.

At heart, this deprived heir of old Russia feels that his greatest struggle is to rid himself utterly of the past; only so, will he be really free, perfectly fit, to fulfil with glory the Staretz's vision that he will live in foreign cities after crossing great oceans. Ford's manifestation is all that is needed to convince him that the domestic establishment in the rue Jacques Mawas is really outmoded in dynamic terms. All the cards are thus stacked in Ford's favor. The young poet, in the latter part of 1933, is persuaded by Tchelitchew's charm, and the image of his art, that this is the man of genius he has always wanted.

Obviously, Pavlik needs rescuing from all kinds of futile preoccupations: things distracting him, holding him down. At the Cafe Des Deux Magots, after *L'Errante* has been presented in London, Ford is introduced one day to a young portrait sitter with whom the painter has become infatuated. He notes a curious relish, as of triumph, in Tchelitchew's face, a whole story of amorous revenge in his voice. Afterward, Charles learns it is true; the other has treated Pavel Fyodorovitch with the casualness of a *grande cocotte*.

Now, at the cafe, Pavlik has presented him, Ford, as someone young, handsome, eligible *and* consenting. *L'affaire avec la cocotte est finie en grand style!* Everything, for Ford at this moment, crystallizes into apotheosis. It dawns on him that he must start a campaign to get Tchelitchew to America.

There his art will have an even greater success than in England, he is sure of it, and the move will separate him from his played-out domestic entanglement. Pavlik tells him much and he can read, back of his words, even more. He, Ford, has nothing against Tanner or the artist's sister; it is Tchelitchew who pretends to nurse all sorts of boredoms and grievances at home. As for Allousha, Pavel Fyodorovitch secretes the discontent that music has remained for him a graceful amateur's vocation; never, all this while, has he seriously sought a concert hall career; he has limited himself to private performances, to teaching. Has that been because of excessive devotion to him and thus a self-sacrifice? No matter. It would be better otherwise.

Pavlik has a permanent magic lantern in his head for the portraits of Guardian Angels, Sibyls, Second Mothers, and assorted patrons as well as lovers. Exchanging the lantern slide of the incumbent Guardian Angel for that of Ford, he seems to see a potent image that appropriates a whole sequence of slides. Is it possible? Does this young American poet symbolize the future—and a greater future? Ford speaks of New York, of its art-conscious public, its size, its cosmopolitanism. There, or near there, lives a host of his own American friends, new and old: Wescott, George Lynes, now Lincoln Kirstein, who wishes to rejuvenate ballet in America. Are they influential enough—? A fatal occurrence of the past April has begun to speak in an oracular voice. From Losovaya came his father's terrible message that his mother, Nadyezda Pavlovna, had died. The blow registered deeply as his soul shuddered for the past, for all that might have been and wasn't. The current moment tells him more clearly than ever that the door of the past is shut tight, that an unmistakable finger is pointing to the future. "God sent you to me," he tells Ford with a quiet throb, "because my mother was taken from me."

In 1930, in his *portrait nature morte* manner, Tchelitchew painted a Spanish dancer composed solely of the Guermantes hammock hung on the wall and plaster casts of hands and feet. This dancer will be echoed in *Phenomena* but meanwhile he makes a journey to the real Spain. It is an occasion to get away from Paris with Ford. However Edward James has invited him to stay on his lovely Sussex estate, West Dean, so he and Charles go there first. Despite an upset mood, an inner turmoil stronger than usual, he manages to act the grand seigneur and also to work. The tennis court reminds him of the games at Doubrovka and he does images of children as tennis players. A long-haired girl is foreshortened as if she were a figure from the past brought close by

spatial magic; the very stretch and reach of the body in tennis implies abrupt perspectives, strenuously propelled moves. *Hide and Seek* is plainly forecast: the girl's tennis racket momentarily screens with its wooden oval and crossed cords the whole figure of her opponent, a little boy, who thus seems caught by a net. And here he sketches the tree that will be the matrix of *Hide and Seek;* already it has a "manual" look but not till the following year (1935) will it acquire the children, the dandelion puff, the internal features of a magic anatomy.

At West Dean, Ford is a politely tolerated guest. Pavlik's English friends, with the exception of Beaton, regard the young American's influence over Tchelitchew as somehow threatening; undesirable, surely, insofar as it is pulling him away from Europe! On his side, Tchelitchew has become in Ford's case the "very good friend" that Gorer acknowledges he can be when he will; his efforts to have him sincerely accepted by his English circle, chiefly praises for his literary gift, are unremitting and partly account for his own inner perturbation. Before he and Charles have reached an understanding, Cecil Beaton has been the sympathetic recipient of the artist's lovelorn confidences. He has seen Pavlik in a state of hysterical despair, imagining Ford has given him up. Once he was asked to lunch just to listen to Tchelitchew's anguished laments and it was rather frightening. Beaton therefore understands the situation, and when the painter and the poet now notify him they are going to Spain, and why not come along, he flies down to join them on the train. If he vanishes from the expedition afterward, it is not because of Ford's or Tchelitchew's company but because (as he will recall) the primitive arrangements with which the others are content in Spain are a bit brutal for him.

Tchelitchew starts his bullfight pictures that will brighten his first New York one-man show of paintings with the violent pink and the *pointilliste* dance of light, which tactically he suppressed in his style during the twenties. Now, in the bodies of bullfighters, he emphatically reflects photographic foreshortening. As quoted by James Soby in his monograph, Tchelitchew says that Spain produced on him "an enormous impression. . . . The dry mother-of-pearl landscape of northern Spain, the characteristic proud faces of men and women dressed in dark clothes, the bullfights, the towns, the Arabian vestiges, all combined to induce me to take a wholly new direction." Just in what sense, or senses, new? In the palette, of course, and the growth of a master image of play and chance: the dangerous game of the bullfight that (as the artist is aware) is both a ritual and a dance. He is finding in the world a more solemn and complicated "circus," more profound in all its implications: the bullring is superlative theatre. . . . Those innumerable dry crystals that are sand, the pearly ornamentation of the matador's costume, sequins themselves . . . all things which absorb light and in turn emanate its

gleam: these begin to atomize and stabilize his plastic universe, to deck and praise and diversify the adorable matter of the everyday world.

Spain, like his planet Mercury, is hot and dry, yet joyous and "pneumatic" too, giving style and airiness, space and ritual drama, to death itself. How *open* is the arena where the bull dies—no tents, just the sky itself! And always, because of the beaches where one may have velvety visions—visions of flesh as it is—the reassuring intimation of *water*, a precious intimacy . . . all conjoined in Ford who loves to strip himself, to tan and swim and loaf, and have fantasies just as he, Pavlik, does: Charly is writing some sonnets. . . . There is an arctic glitter in the sequin, in the pearl a creaming ice. He works now through alternating stages of heat and cold in tokens of color and texture and consistency. Temperatures, he perceives, shed their reality through the spectrum, while in natural cycles they bring the condensation that makes opaque, the liquefaction that makes transparent.

As Ford's face opened a fresh world of humanity, Ford's body opens a fresh world of the senses: a world that has the faculty of reviving itself in any number of images and forms casually encountered; encountered, remembered and projected magically toward the future. Charles's ear, seen quite close from behind, the sunlight drenching it, rendering it luminously hotpink and veined, grows large under the touch of his mind, one of whose hands is memory. Amid this tangible glare of heat, those frigid blueblack nights at Doubrovka come back, when he and his brother Mischa, as boys, went out in the garden to chart the constellations—and he would return to the house with a huge frostbitten ear, to which Nanya had at once to apply that evil-smelling goose grease. He used to snitch some of Mama's cologne, swab himself with it, to prevent being obnoxious to those coming near him. Mama never knew why her cologne, Papa's special gift, disappeared so quickly. . . . He puts just enough of Ford's head in the bullfight scene to concentrate on one ear as precipitately present.

Now he is in sunlight and heat, not starlight and cold. But really, in the imagination, the senses live so close that they lose their spatial distinctness, as in the memory, in Proust's novel, they lose their temporal distinctness. Yes, in Hell, as he knows from Dante's poem, the extremes meet—meet just where Lucifer abides, cast down from Heaven by God, imprisoned in ice to his waist: the torrid gives way quickly to the arctic. The two poets in *The Divine Comedy* leave the Ninth Circle of Hell to approach Purgatory, and Dante is startled to behold the frightful demon, the King of Hell, now upside down . . . How marvelous of Dante to have visualized the spheric nature of the Earth in this way: Hell is inside our globe, underground, and if, from there, one steps again onto the surface, the great imprisoned demon, the Fallen Angel, would be seen of course from the other side, where (since he has been hurled head-first) his nether part sticks out . . . His legs are in Earth's air, where Dante now sees again, with joy, the stars . . .

Perhaps not altogether good, though, such visions of Hell. There were Vrubel's visions of Lucifer, which fascinated that artist so much, they say, that he went mad. Pavlik reassures himself by glancing at Charles Henry—he now calls himself Charles *Henri* as before but the artist pronounces it in the English way—with naked legs spread out beneath the sun of Spain. True, he seems so close, almost eye-level, somewhat like a mountain range in the distance: partly, no doubt, it's his own myopia. What a curse for an artist! That Polynesian model in 1932 had this very effect on him. "The picture," as Rosamund Frost will report his words*, "begins in the air in front of his eyes and air magnifies and distorts like water. Near at hand, he will focus on a texture, say the human skin, until it comes alive in what he terms a *termitière*—an antheap of crawling life."

Charly now: this Charles Henri: can he be as sure of his goodness, his loyalty, as he is of Allen's? Suppose there be something "demonic" in him, suppose what some people say is true? But these thoughts are very disagreeable, upsetting in themselves, probably just silly. No . . . Surely, Ford is Fate, its very person. "He must be Fate since I am Fortune." The inner terms are very clear. He must go forward with all this that has started . . . yes, all the way to America . . . But meanwhile things must be *arrangés*, somehow, with Allen . . . and then . . . then . . .

New York and Gloom

It is not at all easy: this tremendous step. Why is there always something in him that makes him afraid, so that inwardly he trembles, trembles terribly? Somehow the city across the sea is simply the future, and to turn his back on it, now when someone he loves is pulling him by the sleeve, would be like turning his back on the future, which he has sworn never to do. Let Bébé wallow in Paris and the present. *Le tout Paris!* Bérard wants to do for it, he has the pretentiousness to think, what Proust did. Let him go on trying to be a "serious" Kees van Dongen. That way, he will be swallowed up by his own fashion sketches.

Alice B. Toklas will insist that Tchelitchew was "amused" not by people with European habits, but with, as she put it, "foreigners and Americans." Léonid, in accord with her view, today considers Tchelitchew 100 per cent Russian and himself, for example, 100 per cent Parisian. Complex adaptation, doubtless, plays a great part in the characters of those artists who by nature are universally inclined. One should not forget that Parisian high society, all through the nineteenth century, developed (interpret it how one may) a cult of anglophilia. Ford thinks Tchelitchew was totally Parisianized when he met him. Yet it is Ford who reports the artist's saying, "Americans are like champagne." However personal the statement's implication as addressed to Ford, the speaker could hardly have meant American champagne.

* Rosamund Frost: "Tchelitchew: Method into Magic": *Art News*, XLI: 24–25, April 15, 1942.

The Parisianized American ladies (for Gertrude agreed with Alice) deliver a verdict on the basic Russianness of one who is "taken" mostly with Americans and Englishmen. It is all rather fluid and problematical; and academic, I would add, insofar as Tchelitchew represents an international or global attitude, retaining quite as many personal and historical (not to say also professional) traits as he does national, whether French or Russian. He may prefer Americans to Frenchmen for the simple reason that Americans prefer him (as Kirstein, for example, does) to Bérard. In Paris Tchelitchew always talks aesthetic philosophy. People listen to him and are impressed (so Eugene Berman will testify) but do not understand: maybe philosophy outside the classroom is still too "Germanic" for Parisian Paris. Pavlik's ill-fated friend, René Crevel, who spends some time at the same sanatarium as Choura, has been perceptive enough to explain why people "don't understand": "Pavlik paints like, and talks like, a prophet." The United States is still a country looking for self-conversions, for "prophets amid the wilderness." At least, somehow, Ford has communicated this probable truth to Tchelitchew.

Not at all ineptly, Soby discerns in Tchelitchew's temperament a decisive ambitiousness that makes him unFrench. "The metaphysical basis for his art," he will write in 1942, "is Northern, violent, passionate and deeply ambitious . . . he is primarily a Northern artist, even a Germanic artist in the good sense that Grünewald was one."* Despite the fleshy volumes of Tchelitchew's figures in the thirties, an almost gauguinesque languor of line, they retain a severity, a *brut* feeling, a chunkiness, that is the opposite of Parisian grace. In my opinion, the important thing is that the School of Paris saves Tchelitchew from being utterly Russo-German. The United States will have a great deal to say about this matter and has even begun to say it before the artist touches American earth. It has come to him, and taken root, by way of all the emissaries from America he has met. Such influences, finally, are profound sensory mysteries: a chemistry of the artist's very body that spreads through his brush and his palette. Tchelitchew is a maker of conquests, a preacher of doctrines. He is obeying an inner dictate, really, as much as he is heeding Ford's outer urgence.

Poor Fyodor Sergeyevitch, desolate in Russia, is bewildered, as he writes Tanner in his dignified manner, and thinks in his heart that Pavel Fyodorovitch has made his last gesture of revolt in repudiating his true nationality, his true home. Think! Panya his *own* revolution! It is perhaps the worst and the last calamity for the exiled scion of their family. Nevertheless, Pavel Fyodorovitch Tchelitchew sails for America in November, 1934, in the company of the still hopeful Tanner, whose devotion itself is immovable. Ford elects to "act the independent" and return by himself, economically, on a freighter. He is a better sailor than his great new friend. A storm harasses our hero's

* James Thrall Soby: "Return to the North": *View,* No. 2, May, 1942.

mental and physical equilibrium on his way to America. Then, seeing his mother's hand extended over the waves to calm them, and successfully, he imagines his confidence in Ford is perfectly ratified. Charly has been sent, obviously, to make up for his mother's loss and she, at least, approves.

The man sick and half-frantic in his stateroom, on the first of his trips to the city across the sea, has already established several links with the country to which he is bound. Monroe Wheeler has been publishing the As-Stable pamphlets with George Platt Lynes and Pavlik has illustrated Glenway Wescott's *Calendar of Saints for Unbelievers*. Moreover, the artist has a one-man show scheduled at an enterprising gallery run by Julien Levy, an ambitious young American of discernment who originally became interested in Tchelitchew through Lynes; in 1933, in fact, Levy held a show of Tchelitchew drawings. Both Levy and Pierre Coll have been acting as agents for the artist in the United States. Tchelitchew and Levy have only fleetingly seen each other in Europe but Coll is an old friend of the painter; at the same time, Coll also represents Bébé Bérard, a fact which, from Tchelitchew's angle, puts him under suspicion. If one room and one theatre find it hard to contain both himself and Bérard, why should one man find it easy? Invariably, a new dealer offers the artist a problem in strategy and the casting of his personal spell.

Eugene Berman, a former colleague now doubtfully reckonable as a Tchelitchevian, is already on the scene in New York. It was Genia, in 1928, who expressed to Geoffrey Gorer his opinion that *Ode* was a failure; Pavlik had just introduced the two and thereafter has thought of Berman's act as a betrayal. For his part, Berman will say, he always had more natural sympathy for Bébé than for Pavlik—when inclining toward Pavlik, he always yielded to the latter's "force." In Paris, Berman has consistently avoided both a certain sort of party and big social parties. But if he encountered Pavlik at one of the latter, his old colleague would turn his back on him, not even saying hello. At last, when in the United States, Pavlik suddenly greets him: "Why not stop this nonsense—?"

In New York, Tanner is delegated to negotiate affairs with Levy. To the latter, Tanner seems "fussy" and the two end by having a spat, as Levy will recall, although the artist's old friend remains quite vague on the point. Anyway, as soon as Levy can deal directly with Tchelitchew, who turns on the ritual charm, all goes smoothly. True, this artist perpetually talks his own painting but the dealer does not mind; he is quite won by the dynamic, glamorous Russian. To be sure, on arrival, Tchelitchew has been much preoccupied with his own tension; his relations with Tanner, with whom he has taken immediate residence at a hotel, are "in the air." His dear Charlie (finally he starts spelling it the more usual way) is in New York and it is in order, meeting his sister, Ruth, and his mother, that he be guest of honor at a

party in their apartment on Eighth Street; the two Southern ladies are now veteran New Yorkers. At the party, he finds the atmosphere rather trying—provincial-bohemian as he feared—and takes refuge in some broad impersonation of the stout American ladies he saw on shipboard. It is the parlor performance on which he universally relies. At my first sight of Tchelitchew, he seems an extremely uncomfortable, extremely nervous and offhand European who wishes to make the best of a delicate situation. Apparently he has a snuffling cold which very artfully he turns into a form of critical sniffing; then, of course, an outburst of his "chthonic" laughter drowns everything in good humor.

With him on this occasion—or perhaps a subsequent one—is Salvador Dali, then without the bristling grandiloquence of either his long mustaches or his future fame. Tchelitchew has brought only his personality; Dali has brought (so the painter Leslie Powell will recall) a prop: it is a small whippet who has the charming faculty of assuming, at his master's command, the shape of a slipper. Another sensation for newcomers at the party is the materialization of Carl Van Vechten, who arrives before anyone else, and somewhat to Miss Ford's consternation, her brother is not yet there to introduce him.

Tanner does not materialize at the party. While I have the advantage of being in Ford's personal confidence, he tells me (doubtless from mingled pride and discretion) nothing of the Ford-Tchelitchew-Tanner triangle. Ford and I take a saunter in nearby Washington Square, one afternoon, and he becomes confidential. "Pavlik taught me how to see," he says grandly, "how to look at nature!" Vaguely there comes to me the scene in Merejkowski's romance about Leonardo when he instructs his pupil, Giovanni, telling him that every leaf, though of the same kind, is unique, has an "individual countenance." Ford, though I do not know it, considers the business with Tanner quite settled: he is to be sloughed. Not till then will he consider he has accomplished his personal conquest of the man he has induced to come to America.

Pavlik has never actually asked Ford to "make him a great man." The great function, by this time, has been built into their relations. Tchelitchew is older and wiser: a very different man from the one who read Zossia Kochansky's letter while its entranced subject stood by him backstage at the Russian Romantic Theatre. Pavlik's good heart is fed by his baleful superstitiousness, his baleful superstitiousness is fed by his good heart. Such may be the imperishably paradoxical stuff of heroes. Yet without largeness of scale, the soul's magnanimity, there would be no virtue to it: the soul's magnanimity, and nothing else, finally measures a man. He is afraid to lose Allousha and he is going to cast Allousha off. He has a certain humility before all passionate devotion, and like a noble king (even in the posture he took in Berlin) he wishes to raise the one on his knees into a brotherly embrace.

Pavlik's whole impulse is to coalesce with others, to form a social organism that ideally would be termed the Total Tchelitchevian; it would be, this organism, merely an impregnable court of ranking favorites.

Tanner, the limb that must now be technically sacrificed, has been kept in the dark about the true situation. Not that the destined victim is not intelligent enough to fear the truth. But the trip to America has been discussed by them, formally, independently of Ford's role; in fact, they have agreed that they will return together to Paris in a year's time. Tanner knows that, as usual, his friend is full of apprehensions in general. Yet he is startled to find Tchelitchew with such an ungracious bearing toward him—something without precedent in their relations. The mood has begun immediately they bade farewell to the host of friends, led by Edith Sitwell, who have come to see them off: Lady Abdy, Sheila and Eileen Hennessy, Alice Halicka, René Crevel, Lifar, Markevitch, Kristians Tonny, others. And it does not, this irritable displeasure, cease throughout the voyage.

It cannot be attributed altogether to the fact, pronounced though it was, that they have sailed with grave fears. The boat they have taken is German-manned and flies the Swastika; the staff, the sailors, all look surly. Helena Rubinstein has deposited a small sum with the government as guaranty of Tchelitchew's solvency while in this country. Travelling with the party is Mrs. Beulah Livingstone, Mme. Rubinstein's secretary, who is managing the trip. She is Jewish and in consternation about the way she will be treated on board. Moreover their ship, docked beside the great ocean liners, seems minute. "It will turn over," Pavlik remorselessly exclaims, "in midocean!" Aside from the storm, nothing phenomenal develops yet the trip is thoroughly distressing for all three passengers.

For a while, at their New York hotel, Allen and Pavlik see a good deal of Charles Ford, his mother and his sister. Perhaps owing partly to their previously mentioned friction, Tanner becomes critical of Levy's general reception of Tchelitchew; it seems mysteriously cold, aloof, even strained and condescending, as if he held secret reservations about his new artist. Tanner's view may be colored, too, by the fact that the show, when it comes off, is not a success by almost any standard. Few pictures are sold—a result finally announced to Tchelitchew in what Tanner will recall in Levy as a blasé, undiscountenanced manner. Mrs. Joella Levy, the dealer's wife, is especially kind, it happens, yet one person's consideration does little to offset the starkly disagreeable facts. On his side, the artist is dismayed and bewildered quite apart from his dealer's attitude and is plunged into fresh dread. Only the quick courtesy and friendliness of Monroe Wheeler, Glenway Wescott and other Americans provide any reassurance for the unstable, superstitious Pavel Fyodorovitch.

Tchelitchew must hasten on to Chicago, Allen's home, where his pictures

are to have a show at the Arts Club through the offices of Mrs. Charles (Bobbsie) Goodspeed and Mrs. Alice Roullier, recent additions to his circle of admirers. Yet in this city, too, there is small tangible success for the glamorous Russian artist. The adamant and ungrateful fact under the surface is that Tanner is at the climax of being frozen out of Tchelitchew's life. It is a wan and bitter hour when, Pavlik's captious ill humor showing no sign of ceasing its barrage, Allen reflects on the twelve-year struggle of their past together—when he worked so hard for Tchelitchew's success, neglecting his own career, when they lived virtually as one organism, hoping, praying, scheming, all in Tchelitchew's interest, in the service of a career which, despite its brilliant moments, its social status, its dizzy summits in London and Paris, has no solidity, it seems, and invariably threatens failure. Is it his, Tanner's, fault? He did everything he could.

Only one New York critic, Henry McBride of the *Sun*, has given Tchelitchew any particular welcome; even he has had reservations, favored the portraits as if the artist were a new Society Painter. In Chicago, where only sales matter, Allousha feels quite worn out with strain, literally goes limp. His old friend, as vociferous as ever, resumes the tune that Allen is "through," has no ambition or energy left: the loyal helper and companion stands condemned as one grown useless to himself or anyone else. Allen's mother currently is in trying circumstances; she needs him. He divines that this is the moment to end his precious, magic, wonderful but now doomed, relationship with his friend.

Pavlik agrees with Allen that he ought to stay for a while and comfort and assist his mother. Of course, in a few months, he can join him in New York. Yet Tanner, by now, fully understands everything. In New York, Ford—younger, more dynamic, palpably a magnet to Tchelitchew in every respect —awaits the artist's return. Someone else will now fulfil that "protective companionship" which Pavlik professes always to need—someone else will be the Guardian Angel of his myth. Thus consciously, with only the tiniest shred of romantic hope, Tanner relinquishes our hero, and his, forever. At the railroad station, as Pavel Fyodorovitch departs, they defy convention and kiss. But the kiss is deliberately, on both sides, detached. They are not really estranged. Pavlik leaves with kindness and repining in his heart, realism and determination on his brow. The still small fact remains: a long romance has ended.

New York and Many Springs

It is odd to think that after so much living, life still has to open out for our hero, to pronounce in spirit and matter and form the full and final, the wider word of his destiny; indeed, the wilder word. The inward shock of exchanging one partner for another, the commitment of his career to another foreign country, the replacement of the whole social and professional set-up involv-

ing a new aggregate of intimate relations—this vital alteration in the scheme of things induces not only a new surge of paranoid emotions in Pavel Tchelitchew but also the kind of fright that animal prey feels in the jungle: he is secretly paralyzed for a while after returning to New York and this catapults him into more violent expressions of energy.

No longer is it a merely technical matter, a plastic relation on canvas, this "bridging" of a break, this moulding of a laconic image that he achieved with the help of sand . . . this has lost its primacy, its strict utility; it was altogether aesthetic. What—what—if the break is not an illusion, a manipulation of abstract space, but real, outside art—on *this* side of the canvas? Not a great while passes before George Balanchine soberly observes to a mutual friend, after seeing Tchelitchew for the first time in America, "Il est fou, il est fou!"—"He's mad, he's mad!" From a Russian, the adjective may be more casual than it seems; again, it may be less casual. . . .

From Charles Henri, privately, Pavlik draws all the personal reassurance he can. He is as confident of his new friend as he was of Allen on all basic points of loyalty and helpfulness, and besides, C. H. is more to be loved. Yet from the first he misses in him (and he takes occasion to admit this to himself) that meek form of hero-worship that creates selflessness in the worshipper; on the other hand, how could Charles Henri become a really distinguished man unless he had some ego, some kind of hard self-interest, indeed, akin to his own? So the artist finds his self-assurances must be reassured at every step while he moves forward, ever forward, like his own poor, desperate, rushing Wanderer. . . .

Thank Heaven (Pavlik reflects) he has already made friends with some important Americans. He can see that Charles Henri's friends—especially myself, the most intimate—have no position whatever and scant promise of any. In Ruth Ford, now a torch singer but ambitious to be an actress, he can divine possibilities. Perhaps he can do wonders for her; he can surely get her modelling jobs. And in Charles's mother, Gertrude, he discerns a native dignity and sensibleness; she has a profile like her son's. In his overwhelming way, Pavlik loads Charles Henri with roseate words about Ruth's future. He can easily manage his friend's family and without incurring them as burdens —no, he is not heir to a calamity like that. *Dieu!* That *would be* the end!

The most reassuring feature of his situation is the ever-smiling, gentle, solid friendliness of Monroe Wheeler, with whose seriousness, as head of the publishers, Harrison of Paris, he is already acquainted. It has been sweet of Monroe to arrange, virtually on his landing here, that he have studio space in the building where he has his own offices. As also a guest director at the Museum of Modern Art, this friend is a key personality at the moment. The steady-going Wheeler, who has a neat, conservatively modelled head, has always held Tchelitchew in unusual esteem. Yet from their first contact he has thought the artist's excitability of the reckless sort: he has seemed a young

man bent on *devouring* fame. But Wheeler has filed away this permanent impression. What of it?

Pavlik has only to be tempted to say something (Wheeler will recall thinking) in order to believe it is true. This sort of temperament can still be successful, provided friends are around to keep it in check when it threatens to burst out. When the water is merely rough, he and the artist's other friends will ride the breakers. Wheeler sits to Tchelitchew in informal fashion; that is, in the way a painter's friends consent to pose without committing themselves to a portrait. Several fine pencil sketches result. Then, with startling prescience, there appears a "skull portrait" of the sitter in gouache; it predicts the subcutaneous manner that will become the artist's style, and a genre, about ten years later.

To all who know Pavel Fyodorovitch, called Pavlik, it is natural that he act the part of a dynamo day in, day out, but there is no one, really, to measure the growth of the new heart of desperateness that begins in him. Behind the facile gayety that he can wear like a fresh boutonnière is the invisible wrinkled forehead of anxiety. Now he is a conscious internationalist, sails back and forth between Europe and America to spend his summers abroad. Actually it is not only to relax and to get away with Charles Henri (they have begun living together) but also to maintain that universal Tchelitchevian. Besides, there are definite barbarous aspects of the country which produces people who are "like champagne." Europe has a mellow flavor, especially its countrysides; sweet, and essential now, the artist believes, as an antidote to the incredible pace, the sweat and dirt, of New York—like nothing he ever experienced! On Lake Garda, Italy, starts the series of idyllic summers with Ford which one day—a grim one but far from 1935—Pavlik will nostalgically, lyrically describe to Charles Henri as "like diamonds all on one string." In London, this July, *L'Errante* is revived.

Certain sketches that break ground for *Phenomena* develop on his drawing pad under the fleshy, benevolent sun of Italy. On returning to New York, the past winter, he found Charles Henri fascinated with the Freak Museum on Fourteenth Street. There he has seen those professionalized types of physical malformation and excess that have produced a shocking inner revelation really new to him. He has before him, in organic form, a natural portrait of the purely formal devices of modern painting: nature's, not Picasso's, way of mocking man's perfectionism. Charlie's enthusiasms have a way of being contagious to him. The aesthetic heresy of contemplating the freaks in this light appeals to his radical desire to be defiant, to jolt the secure effeteness of modern taste. How utterly *bouche-bée* the art world would be by an elevation of this sordid aspect of humanity to the level of emblems. *Phenomena* is being germinated by a series of deep-lying intuitive associations.

Pavel Tchelitchew cannot rid himself of a visceral assertiveness that ren-

ders the formal triumphs of Cubism and all analytic form in painting a kind of assault on man as lord of the anthropomorphic universe. James Soby will touch upon this susceptibility when he writes, "Nervously, Tchelitchew is a man flayed alive . . ."* The artist's apostasy does not flow from a lack of his own skill. Has he not taught himself, with much pain, to be a subtle draughtsman? Now he has a versatile anatomic line, a sheer knowledge of the body that, if required, he might have declared at the Customs on entering the United States. It is not too common over here, no, indeed! Luckily there is no tax on the genius of a man's hand. But what has happened? He knew it would happen. It had to happen. The thing was: to show his portraits. His portraits, relatively, have created the most favorable public response. When all is said and done, the portrait is still the way into the heart of a client. At least, is there any surer way? The truth is that painting portraits has become a ritual for Pavel Fyodorovitch: the process by which that wonderful "individual," the zoörmorph of his worldly success, is inseminated, nourished, born, incubated and christened—with, he trusts, blessings.

A rich assured manner, bountiful of flesh and frontality, comes to being on his portrait canvas. The dimensions are typically enlarged now to suit the American scale. Already the future is haunting him, for the American portraits of Ruth Ford, Lincoln Kirstein and others do not introduce their renaissance till a couple of years from now, till after he has gathered a considerable troupe for the transcendental freak show he plans as a large chef-d'oeuvre—larger than at first he thought. How much moral freakishness there is behind the facade of polite, *his* polite, society! That is, of course, a platitude, but he has been thinking of the ingenious Grandville and his evocation of a dimension of truth that seems fantastic satire yet speaks, if one understands it, a language of demonic exactitude. *Bon Dieu!* What work the court painters of the world have put into their portraits and what impossible flattery! Pavel Fyodorovitch has an impulse to revolt against the traditional slavery of painters.

All that he abandoned in Russia when he cast off his White Army uniform, abandoned and forgot and replaced in Berlin and Paris, has a disturbing inner revival in New York. It is a prompting to sympathize with all the deprived and oppressed; especially those like himself: the disinherited who struggle for rehabilitation on a new economic level. He thought it was dead in him, this prompting, even if it had been alive. And yet: it is what Varya and her husband are doing now, and the rest of his family that remained in Russia—they struggle to regain, somehow, "their own." The world's moral air is full of Communism, of socialistic thought; even Charles Henri and some of the poets Ford knows are writing poems that take a "Marxist" line, or that, at least, see an exemplary romance in the Russian Revolution. That revolution pretended, after all, to enshrine certain moral emblems, freedom, democracy

* James Thrall Soby: "Return to the North": *View*, No. 2, May 1942.

and so on. In Paris, this year, he learned that Nazism is probably leading straight to another European war; in which case, Russia is sure to be the enemy. Even as a White Russian, he would side with his country against those German pigs. While one is painting, one has strange thoughts and memories that come back of themselves, spontaneously. He vividly remembers the "style" in which he *escaped* from Germany to France: no more dignified in essence than his flight from Odessa to Constantinople.

With a certain lush, malicious gleam he lets issue, on his canvas and paper, Pinheads, a Fat Girl, a Leopard Boy, a Negro: the last an emblem of an oppressed minority. His portrait of a Negro has shown him suffering, eyes turned up, elegant in a collar of viscous tears like rhinestones, but that was *mondain* frivolity, to be sure. Are not the frauds of a democracy a moral distortion, a freakishness, as shocking and evident as those created by the whims of Mrs. Nature in the human species? And accidents themselves—maimings or fatal falls: these are freaks of chance, as one says, but just as appalling, just as common, as deliberate killings and mutilations. He thinks of the portrait of C. H. with a bound head—one, two years ago, was it?—as if he had been wounded. He wanted to conceive him as thinner than he was, haggard, as if a poor boy, starving. . . . He is not thinking of his hallucination in the Staatsoper, of Hell, of the theatre . . . He is thinking of the world itself. That heroic head of the little boy he did in England, titanic, thick as a giant's thumb, a sort of partner for the girl tennis player, why—is he not a child Peter the Great? Pavlik smiles. He had George Antheil in mind as the model: an infantile grossness of feature that seems to signify adult stature. And the tennis court itself: delightful!

It becomes a pun. Russia as a sort of Gargantua, a miracle child of prodigious strength, playing the game of war, turning the Court of Emperors into the Playground of Revolutions. There he is in *Phenomena*, bald, bald with the infant's precociousness when it first plunges into the world! Just so, he played with Manya and Varya at Doubrovka, so young, so unaware, so happy: isolated in that innocent geometry of chalk lines and *savagely* desirous of winning . . . The boy, Mussolini-bald, batting with his hand: too poor to own a racket. Near them, in Hell, he will put the ruffled sand of the bullring and its bloody drama: the Dance of Death. And close by: the posturing matador, triumphant, at once dancer, priest, sacrificer.

He is on the beach now, leaning with both hands back of him, looking at Charles Henri sporting with a village boy in the water. It is summer and he is in Santa Margarita Ligure, Italy, enjoying the favor of a new friend, Romaine Brooks, who has lent him her villa. A year has gone by, an eventful year. He has held a one-man show the previous Fall at the Tooth Gallery, London, and one that December at Levy's gallery. They were not too badly received. Beyond doubt his career has gained some momentum. His confi-

dence in his American supporters is higher, has brought a certain needed assurance to his American demeanor; he is less jumpy, seems less "fou." Lincoln Kirstein in particular has shown him such marked attention. Linc (as he now affectionately calls him) adores his stage designs and has suggested he do a set of watercolor drawings for the revival of *L'Errante* in New York.

These are very happy works, exuding like the true theatre a just expectation, a prescient grace, of being admired as spectacle; of admiring, too, as if they praised nature with implicit moves, explicit lineaments. Seldom, anywhere, does Tchelitchew's draughtsman's line seem so flexibly free, disencumbered of formal intentness, and largely this is because of the whole angelic *ballon* of these figures, firm, integral with dance dignity itself, a full easy education of the dancer's body. They have that sweet succulent weight, enough, no more; a measured pride of production that needs, in actual dancers, much modesty, much humility, not to be arrogantly athletic, pedantically muscular. What a perfect mirror for a young dancer's deportment!

Kirstein has a ballet school and is setting up wonderful ideals, with Balanchine, for a new race of American dancers. George, thinks Pavlik, is a genius who will see what Americans are made to do. He is so full of etherealized energy himself: an almost overrefined virility. But that quality is dialectically valuable. He will create a new balletic style with his material; yes, both of them, these two Russians, admire American energy: something incisive, impersonal, tireless. It seems a more youthful energy that Europe's, a bit raw, but with more possibilities thereby. Oh, George will accomplish wonders—and he, Pavel Fyodorovitch, will help! Now he really does not think of himself in the Russian manner as Pavel Fyodorovitch, and he smiles ruefully at the "von Tschelistscheff" of his Berlin period. He even laughs at his foolish pretension. What a scandal to have *Germanized* his name! . . . Charlie has turned up a new friend whom he has recommended to George and Lincoln, and he will receive a scholarship to the ballet school: Nicholas Magallanes. He, Pavel Tchelitchew, is not yet forty, but almost; he, too, was studying to be a dancer when he was Nicky's age.

At the Wadsworth Atheneum, Hartford, under the sponsorship of a connoisseur admirer, A. Everett Austin, Jr., director of the Atheneum, Tchelitchew has done the Paper Ball. Outwardly a lark, an orgy for the rich, Pavlik as usual has flung into it all his ingenuity and capacity for hard work. Society people of the region *en masse* have a Gold Reserve entrance, with of course reams of gold paper. With a corps of assistants, the artist himself has painted and hung the all-newspaper decorations of the ballroom, a circus elegance, flowing from post-Depression *fausse modestie*. He is even filmed, while at work, in a record made of the ball for the Atheneum's archives. The Paper Ball is adjunct to a Music and Dance Festival. Virgil Thomson performs on the piano; Eugene Berman and Frederick Kiesler participate as

makers of décors; Tchelitchew does a short ballet, *Magic*, in which his old friend, Felia Doubrovska, dances. For Ruth Ford's beauteously slender face and figure, the artist devises an Indian Princess carried on a palanquin by naked young braves. This is "our" entrance, too, Ford's and mine. But we muff it, taking so long at the hotel to dress and make ourselves up as canonic Western cowboys, getting tight meanwhile on whisky, that we are late. Ruth and her entourage are half way around the floor before, cracking our pistols and snapping our whips with remarkable futility, we stride into an anticlimax that may look rehearsed. . . .

Pavlik suddenly sits up at attention. Charlie is shouting something from the water and he squints at him, shading his eyes. Is C. H. holding up something in his hand? Then he feels a sting in his own palm and glances back at the print his hand has made in the sand. There is nothing there: maybe a little insect bit him. But the depression made by his hand reminds him of his ink drawing for the catalog of his first American show of paintings. He could not help thinking of how his mother's hand appeared so vividly from the sky to calm the storm he had met coming across. And he has come to America to "make his mark." So he did a drawing of his own hand materializing from blown clouds and showing the whorl of lines on the projecting thumb. His "identification." The sure identification: surer than a voice, sure as the style of a master painter. At the edge of the distant sea below, a bull halts as if emerging from the water, and much larger, to the fore, greeting the apparition of his hand, the running figure of his blonde, long-haired girl, the tennis player and all the others, her near calf, and foot, huge as a bullfighter's. She *extends* over America. She is Europa and he the Jovian deliverer: his actual signature, on the scale of an enormous painting, banners across the open sky . . . Charlie is out of the water and drying himself with a white towel. Again, like the effect he put in a gouache of young bathers last summer, he sees Charles Henri's silhouette, and the middle break in anatomic continuity caused by the towel's being on a second plane in advance of his body. Illusion! Maya itself. No, it is not merely art, primarily painting, that is illusion. Any child discovers this. In fact, writing to me many years later, regarding his dead friend, Florine Stettheimer, Tchelitchew will make it explicit: "All art is illusion; world is too."

"Charlie! Hold out the towel in front of you. More! I want to see something. All the way out—do what I say! Lower now. *Merci!* But all the way. Yes, yes, your middle part is cut out, just as I thought. Mrs. Nature has many tricks up her sleeve."

Charles rushes at him and throws the towel over his head, clasping him in his arms and bearing him to the sand. Pavlik shrieks, violently repulses him, vaguely curses.

Charles laughs, lurches away and rolls over on his back.

"Demon! I don't say, like Djuna said, Parker is the angelic half of your

team, but anyway, you are the devilish half; enough to be Lucifer himself, I should say!

"Djuna," Ford retorts quietly, "changed her mind in Paris. In New York she thought *I* was the angel."

"I know!" says the artist. "She was wise to change her mind and now I change mine."

"SA-TAN!"

He pronounces the syllables pedantically, with mock wrath, in French.

The young man smiles broadly, sweetly, ironically, serenely. The smile dies a natural death, having lived a long, full life of half a minute. Now he stands and shakes the sand out of the towel.

"More away from me, Charles Henry, or I go home! Really, *quel* behavior!"

Ford moves off. Pavlik does not perceive his real image. He sees him holding up the towel before him, stage front, in a huge canvas, of which he proceeds to make a sketch. It will be the Phenomena of Mankind as *Ode* was the Phenomena of Nature. He puts himself in it, painting. It is only ink, the sketch. The tennis players are in a kind of box and the figures are unequally proportioned, he is merely doodling with them. But the architecture of the thing is there: a beach at bottom rushes up to a modern city tall with skyscrapers. Allegorical.

Phenomena (1936–38)

And *Orphée!* Glück's *Orfeo.* Divine funereal music making the heart swell. Again, as at the Staatsoper, he has been able to put over a *grand coup.* The Metropolitan Opera House. Those poor opera singers: relegated to the orchestra pit. Yet what a spectacle: all Linc's balletomanes loved it and some others did too. The press—the press accused them of "vandalism." *That* to the press. He recalls the little fête made for him after the première at fabulous Florine Stettheimer's big studio only a few blocks away on Bryant Park. Ruthie was there—she is probably going to marry Goetz Van Eyck—and Parker, inevitably. Charles Henri's literary chum, also a Southerner. Will he ever get over his intellectual affectation? Provincial . . . and so *passive:* he's always sitting at parties. But Florine. And Carrie! The Queen Mother herself. And Ettie, her other sister, looking like an intellectual gypsy fortune-teller. Florine however is the real seeress: an éphemère she calls herself. He dreamed about Florine before he met her, a dream in which she swore to be his friend always. And in the dream he saw a sunburst; then, there it was on the wall of Florine's apartment . . . she had painted it! She adores his art and her painting is exquisite: self-taught. Self-taught by *les fées!* By herself: that gauzy glistening thing that one can hardly see, much less touch. He would paint her but she would simply fly out the window . . . How old could she be? No matter. She is young like all sibyls. And thank God not fat or full of

pedantic talk. Or rather: sentences. But the ballet. It was simply beautiful. Such a dignity, George communicated it all, hypnotized the dancers. Where could it all come from but old Imperial Russia? Such a beauty Americans could hardly hope to see at home, yet here it was. Opalescence everywhere. Of course they do not know in the audience—how many could?—all the secrets, alchemic fire, the Aether, and so on. For them it is another fairy tale, some myth they hardly remember from schoolbooks. Otherwise they know only, as a rule, what they see at the Met. This is all spiritual, behind a veil like the old mysteries, each thing meaning something else: "More than what itself it is." Think: going down to the Underworld, to Hell, where it is all prison, in one great cage. "I made masks of horses' skulls for Furies, I guess, because I saw horse's skeleton in the Crimea." Like Dante searching for the soul of his beloved. In pagan times, of course, they did not have the Christian myth: only the gods lived up above. Except for the constellations—yes, everything is gathered together in the sky. Like he showed the Milky Way in the last scene: a star-stream, diagonal and geometric figures of the Zodiac all over, lines and dots, that is, jewels: sparkling.

Orpheus and Eurydice ascend to Heaven. I wanted wires holding then to show stark-white coming down from sky—but *hélas!* one can't have all. Really it's the same thing as in Dante. . . . The lyre that Orphée carries on his back, transparent against his dark cloak. The Elysian Fields. It looked sublime. Super-sublime. Yes, he insisted whole leafless trees he brought down from Connecticut to show all with their roots underground, yet visible, like X-ray. For all is continuous. It is all space . . . and light . . . and man moving through it, in it, of it. What a stage to do it in: almost *too* big. The trees are human, suffering, like in Dante, but freeing themselves like the souls in Purgatory, lifting off the veil. Ah, even the lightest veil is heavy when the time is a funeral. Eurydice is a bride and then she is dead. So he showed her as a bride. That *bouffante* at her hips, going in front full, *la femme!!*—that was brilliant—and all white, of course; so lovely, with Daphne Vane's long black hair streaming down her back . . . And the portrait of Eurydice painted on a veil, what an idea, Bébé would cry with envy: they *climb up* to put her face on a huge easel, and drape it . . . so . . . just so . . . The portrait is her soul, of course. Such a slowness, no retard or languor, but time, *dance* time, *stage time.* Rightness.

All portraits are of the soul or should be. And Amor. Bill Dollar danced him. Perhaps too cute but he *looked* just right. "And such wings: at least life-size. No one expected it—dancing *with those wings on.*" Such *things* George thought up. Eurydice running at Orphée from the back to make him look at her, jumping on him, hitting him with her knee. *Plonk!* like that. Sensational—but elegant. Only two performances. Still, they'll remember it. Laced buskins for Orphée: somewhat too short as made. But actual proportions,

those are different, remember, from a picture's proportions. Anatomy also. *Comme çela.* His long black gloves were of an elegance. "Swishy?" *Mais non!* "I wanted one hand missing; the hand-part, that is, missing from one glove. But I suppose it was somewhat too *raffiné*, perhaps tricky . . . spoiling line of arm. And so: just ends of fingers gone. *En tout cas, un grand succès, mon ami!*"

"*Comprends?*"

While the actual canvas of *Phenomena* is in progress, I am a constant visitor at the apartment Tchelitchew has taken with Ford on East 73rd St. I go there for lunch or dinner and stay during the painter's few hours of relaxation, sometimes going into Charles's room for a private talk. It never occurs to me that *Phenomena* is especially theatrical. Léonid will describe the theatre as a "disease" of Tchelitchew's. Perhaps it is somewhat better to say a vice: a compulsion to overindulge in display. This disease or vice is the core of the irony in *Phenomena*, where everything is on display and yet inverted in the glamor dimension; nothing here, even when it has elements of beauty, is authentically beautiful. But then beauty, in the extreme aesthetic sense, is an ambiguous quantity. Tchelitchew utilizes this ambiguity when it comes to defending the use of his friends for this masquerade. As he will tell his dealer, Levy, "My dear friends are freaks." And then, to pin down the paradox as foolproof, he adds: "And freaks are beautiful people."

The agents of high fashion magazines must be in the field on this occasion, for later on, the Beautiful People will be a sophisticated tag for a group not necessarily distinguished for conventional good looks. But the author of *Phenomena* is trading up, not down, in paradoxes with hints of perversity. Just now he starts calling his shocking palette "poison colors." Levy, among others, is warrant for Tchelitchew's assertion that here he conceives his friends as types and symbols of an esoteric nature. A number of factors, later on, will induce him to deny, in conversation, the work's deep layer of symbolism. On the other hand, as the years go by, he will find cause to insist on it.

Only in radical good faith is life viewed upside down in the Hell of *Phenomena*. Hell *is* upside down. Thus the image of the artist's hand and foot, overspreading this first part of his trilogy, is in inverse relief: not a clean print even, but approximations made by sand as an *un*binding, not a binding, element, and so the reverse of the mucile sand of the past. Freaks in themselves, even when they speak words, are the least articulate and enticing of theatrical performers. And yet, in conceiving society as a sideshow of Madison Square Garden dimension, an overcrowded mural, Pavlik knows he has peeled away the existential layer of repulsion over all that is really monstrous and given it the naked new pigment of a unique

pathos. . . . "Nothing really gracieux, *non, non, pas de tout*. Rather close, perhaps, but my Leopard Boy is an exception. Relaxed tension, poker face: no more."

Meanwhile, Tchelitchew has embarked on more portraits, some of which, really wanting to do, he paints as antidotes to those he doesn't want to do. He wants to pay a signal tribute to Edith Sitwell and now does the full length portrait, seated; on her breast one gigantic, magic and multiple jewel, like the "nest" he will put in *Hide and Seek*, a more ambiguous jewel on the floor beside her. The work has the space of a new country of the society portrait. In the artful drape behind her, in the horizontally striped wall, the implication of book and feather pen, there is a resonance of Renaissance court portraits. Just so is Kirstein's portrait rich and also sportive; the central waistdeep image is ideal, frontal, a transplanted, jacketed Ephebe. But the husky full length nude in boxing gloves has the character-truth of the best Renaissance works; it is more accurate than the main image: a Thinker's head topping an Athlete's body; while the third figure, sprawled on a striped floor reading, face averted, is the informally seen man of affairs, purely *mondain*, all Linc. Miss Sitwell's dress is monastically plain except for the brooch; even its folds are simplified, painted like small folds under a magnifying glass. Her thin hair is entirely uncoiffed, the broad forehead bare as a wild mountainside. She is seen in a poet's richness of outer poverty. As the Guardian Angel image of *Phenomena* (by the artist's shoulder) she is a pale feather, a desiccated wing, of herself.

These, and Ruth Ford's portrait, he wants to do; at least, it is the destiny of his art that he do them best. Ford's sister is shown in chastening simplicity, hair down, somewhat fuller in face, more rounded in feature than she is, but that is because youth's bland confidence and expectancy must be painted in; she, too, is emblematic. Again, Constance Askew's portrait is that of a lovely woman whose refined face is shown in the symbolic three ages of woman, the third (the reflection in the table) being a death mask. It must be called a Society Portrait because it cannot be called exactly a Court Portrait. It is gallantry of a high order in paint; like a cavalier compliment, it must be oversumptuous. But it is serious; that is, an emblem. Nothing of the personal fondness he feels for Mrs. Askew, or for Kirstein, appears in their portraits; they have not even the subtle affectiveness of images like Natalie Paley as Ophelia or Ford as Ford. The lushness of the new portraits is a trifle severe: less personally involved.

For Pavlik to accept portrait commissions is simply professional but still creates a "break," involves his hastening slavery to his craft. Histrionics in Tchelitchew's person has always been fairly close to hysteria. The professional stage, from the first, has been a self-aggrandizement, an extra-personalization of his deeply personal theatre. But likewise it is part of existence as

such. He grows genuinely hysterical when, because of the stage designers'
union, he has to take a formal examination in order to work in the New York
theatre. But he takes it—and "passes." That "art" is work, that he is a self-
confessed workhorse, are indiscriminately histrionic, hysterical facts. Never-
theless his work must be discriminating; otherwise it would be unnatural.
Individuals in society are the subjects, and individuals differ. The binding
factor is no longer sanded pigment but the survival of a plastic signature, to
be maintained on his canvases as a standard of living is maintained in his life:
with optimism.

The irony in the blurred hand-and-foot print by which his Hell is pat-
terned—forming huge depressions that correspond to the terraced ditches in
Dante's *Inferno*—is that no identities exist in this picture except those to be
established otherwise than by scientific devices such as the fingerprint. An
artist's true fingerprint is his style. Every portrait of another (as Tchelitchew
says) is also a self portrait. But more than that, in *Phenomena*, every portrait
is not precisely a portrait but an emblem. In Hell, the Society Portrait is the
Emblem turned inside out, yet no less positively emblematic. Recognizable
faces are here by courtesy of the unique pathos of which I speak. That the
pathos is far from pity is proved by the repulsion which many feel at first
sight of *Phenomena*. At this time no one exactly conceives it as Hell although
that is of course the key to its satire and its assertion of mystic faith.

One of the artist's most remarkable feats is to have purged such subjects as
the Half-Man Half-Woman, the Woman-breasted Boy and the Bearded
Lady of all suggestion of the fraud that produces hilarity: that gay recogni-
tion of incongruity that will publicly call itself, by 1965, camp. It is hard,
now in 1936–38, to anticipate that this term is destined to free itself from the
concentration camp lingo of homosexuals and begin wearing culture's store
clothes. In any case, Tchelitchew is not having in *Phenomena* any usual kind
of fun, whether the work be placed right now or in a period beyond the
historic present in which I write. Tchelitchew *accepts* every statutory or
natural irregularity in *Phenomena* as Dante accepts the sins of Hell. His
response is different from Dante's because the "sins" are different. *Phenom-
ena* is to be called an etiquette book of the basic improprieties: man-made,
man-suffered, and alas, nature-permitted, nature-committed. No judgment is
here; for nothing, strictly speaking, is inevitable. This is where Tchelitchew is
quite the contrary from Dante. The latter, we must assume, accepts the
Christian doctrine of Original Sin as man's unavoidable condition. As a true
Hermetic, Tchelitchew cannot do this. Therefore even what seems to be
nature's freakishness in his Hell is made of mere appearances; even when these
are literal images or organisms, they are appearances, for as the artist himself
(fortunately) will state long after the picture is painted, everything in
Phenomena is a symbol. The Veil of Illusion held by the Lion Man is the key

to this. Each physical irregularity means a false moral emphasis, an unnecessary extreme: some gratuitous disaster, however tangible. At the metaphysical center of *Phenomena*, therefore, is the classic maxim of Nothing Too Much. This is precisely why we are shown only Too Much and Too Little on opposite sides in the picture. This is why, though some connoisseurs think of Tchelitchew as essentially a Baroque painter of romantic temperament, he is really, often, a trompe-l'oeil classicist. Beauty is contained in this masterpiece the way the whole body is contained in corpses dissected and drawn by Leonardo. A wonderful sense of physical omnipresence saturates *Phenomena*.

The "disease" of the theatre has bred in Tchelitchew a morbid sense of penetration when the object examined is life itself. His moral eyesight has become preternaturally clear. Besides that, he is intensely and chauvinistically *human*. Regarding freaks that are only a few feet away, he is at drawing-room distance. He feels this dimension as keenly as when he is talking to a colleague or a client; indeed, is there any other purely social dimension? He beheld at the Freak Museum on Fourteenth Street a unique phenomenon that somehow is universal. By penetrating to the very souls of Pip and Flip, the Man with the Third Leg (who gives a spiel and hands out leaflets), the Half-Man Half-Woman from Australia; by grasping, and so being able to brush aside, all that is campy and sordid, part fraud part reality, he confronts the resident soul and perceives its true posture: *it is the Society Portrait in Hell*. Late or soon, the artist does not actually say this; more to the point, he paints it.

The result has the pathos of all committed social aspiration; not crowned now with success, but played a dirty trick by nature, an inside-out, bottom-side-up, lopsided and multifariously left-handed trick. Nature doesn't play favorites in social and economic classes; nor is her method always the same. On some of the great, she bestows little things; on some of the little, great; on someone who might be anything, she saddles a freakish doom. The inequity may not always be visible to the ordinarily inquiring eye. But to the moralist's eye, the painter's eye, the Hermetic eye, reality is different. These apprehend that all social presences are invariably, ritually theatricalized; they are panoplies, outsides. Their moral, perhaps their physical, embarrassments can be concealed, or else paraded; brilliantly clever people make the most of their physical as well as moral eccentricities, create a style for their peculiarities. Every professional actor, serious or comic, does so. Or one might put it like this: As there is a dimension in which freaks are Beautiful People, there is a dimension (to bring the moral full-circle) in which Beautiful People are freaks. The point, should one care to weigh it, is one of abundant finesse.

Tchelitchew's greatest wish in painting *Phenomena*, even before he can actually term it Hell, is to reduce histrionics as such to its minimum. The conditions of a professional freak's appearance often make gesture, expression, any effluence or token of "personality," quite redundant. This is why

(and Tchelitchew has caught it with superb accuracy) the freaks all sit like complete spectacles, with the remoteness of ritual objects. Even Serpentina's vulgar coquetry has less meaning than a little girl's playacting; so he gives her, rather, the look of a princess in bad humor. Charm, the most active social currency, disappears over the heads of Pip and Flip as with a wave of a wand. No, neither the strange Hell nor the strange Heaven of freakdom is socially negotiable; it is exclusiveness of caste and person turned inside out, eternally petrified in universal Untouchables. And *that* is its difficult charm that he has painted: the quivering immovable trauma of monstrously self-satisfied man.

It could not possibly be achieved by simply portraying a concourse of freaks. The artist has found a new use for his Simultaneity and Laconism. It is based now in organic nature, literally, it is not a matter of time's volumes, a plastic manipulation of art; it now has an abstract reference: the elusive quality of the untouchable. How can this reference be pinpointed? Finally by a social masquerade in which his own friends are induced to assume character-istics which certainly they do not literally have; the more familiar the surface look of an Untouchable, the more poignant his peculiar condition becomes; this is the function of personal recognition in *Phenomena*. Serpentina is a little woman who is carried around on a tray, like a baby, because her small body attenuates into nothingness: her legs are token legs. To have given her features which resemble Elsa Maxwell's is not to caricature Elsa Maxwell but to make that lady's highly peripatetic social function a pathetically hollow object of irony.

I know there will be, along with pursed lips, some outcries: "But you can't say there is no malice in the caricatures of Stein and Toklas as stubby character dolls of ambiguous charm, stationed at the threshold of a dumping ground! And you have to admit that giving a version of Bébé Bérard as the Bearded Lady, considering Tchelitchew's perennial feud with him, is the most transparent spite in the world!" One might think this, I grant, did one not have the painting itself to look at. It is the painting, not my prose, that decides the issue. But one must look with much care and remember the hermetic aura I have already indicated. We might perceive that the Guard-ians of the Threshold, Stein and Toklas, have an archaic terseness that in itself is not a burlesque. The apparition of the Opera Singer between them, Isolde, is a parody of vain ambition, but like all mysteries she wears a veil: therefore look behind appearance.

A seventeenth-century adept, Heinrich Khunrath, drew a Gateway (or Amphitheatre) of Eternal Wisdom showing a cavelike mound, with steps and a passageway at the end of which is a lighted door signifying the wise man's goal of enlightenment. Stein and Toklas are seated before a Shantytown structure that has the same arch and cavelike look as Khunrath's Amphitheatre, and not by chance, I think, at the very end of this structure is a lighted door-way with an illusion of a figure in it. It may be argued that this is the colossal

shoe it superficially embodies and another symbol of poverty, but that would be unfair, I think, to Tchelitchew's declared occultism.

The doorway, in the hermetic emblem I have just described, is broken by the figure of an initiate. Khunrath's drawing, like other allegories to which I shall refer, is constructed bisymmetrically with (as in *Phenomena*) day on one side, night on the other. A flight of birds is to the right of Khunrath's allegory; a flight of birds is also to the right of Tchelitchew's shantytown allegory. When brought to consider this most serious side of *Phenomena*, I am reminded of Lincoln Kirstein's unpublished dialogue about *Phenomena* in which the defending party repeatedly warns his opponent, the skeptic, that the painting is not a "background for cocktail parties and small talk." He implies the fact, perennial as it is, that discussing fashionable art in terms of arcane symbol and allegory is more than indiscreet, being apt to get one branded as a crashing bore.

Partly, one guesses, because of this irremediable handicap, Kirstein keeps the dialogue at a middle depth of interpretation by concentrating on the freaks as social and economic symbols and on the picture's complex use of formal ideas in this respect. Ingeniously he evokes Tchelitchew's time/space treatment of the objective world in ways stemming from orthodox Cubism, while compassing not a mere still life but a vast contemporary reality. Tchelitchew's private interest regarding the society portrait (the person-identification) is ignored and so are the essential underpinnings of the occult. The latter have a deceptively innocent look because, unlike so much in Bosch's Hell, these freaks are seldom zoömorphs but correspond rather to standard types of marred humanity—however much "doctored" or professionalized.

Phenomena's "difficulties," less complicated in symbolism, on the whole, are more disguised as such than the really difficult parts of *The Garden of Delights*. In Bosch's times, one might have expected an appeal to metaphysics and the refinements of theology. Just prior to World War II, one might have expected only the overt economic implications of Tchelitchew's "human monsters." Not that the targets in these two Hells are not sometimes virtually identical: at the same time, "sins" such as gluttony and greed must be read nowadays in the ambiguous terms of a different measure: modern psychology. Today we are ready to recognize that the gourmet and the gourmand belong to the same tribe as the glutton. The last, in giving way to appetite without taste or measure, desires to occupy in terms of sheer mass the space that he would like to take up in terms of other functions. In our century, this point illustrates a long-received idea: the vice of psychic compensation with its fatal physical consequences. The danger, with regard to this modern Hell, is to consider such an idea too casually and superficially. It is by looking at the total organization of *Phenomena*, its rhythms and composition, by appre-

hending its deep content and focussing on its true symbolism, that one avoids the unpardonable error of reading it shallowly.

The late Alfred Frankfurter, then editor of *Art News*, reacts with outright and violent disgust toward the sight of *Phenomena*. He is so blinded by emotion (already being prejudiced by publicity material boldly comparing Tchelitchew with great artists of the past) that he cannot see the skill of the painting, much less its unobvious contents. Similarly the press reaction everywhere is cold and scolding and viscerally oriented. The contemporary American school of painting the circus world (Kunyoshi, Reginald Marsh, Walt Kuhn) is picturesque, humorous, journalistic, not Dantesque or near it; Coney Island as a popular, merely funny saturnalia (as in Paul Cadmus for instance) is as articulate as American painting can be about social freak-ishness.

When Tchelitchew gets the chance, he treats the disapproval of eminent critics with old-campaigner tactics of his own personal variety. Nabbing Frankfurter outside the door of an exhibition, he buttonholes him and taking the balmy tone of "Seriously, I know just what you mean but—" he butters him up so beautifully that, when released, Frankfurter thinks that a charming, cultivated man of talent has somehow made a well-intentioned if rather odd blunder. Not that the artist himself is prepared to admit, at any given time, that *Phenomena* is a profound allegory. He knows how dangerous it is to ask anyone to think seriously. Encouraged by the helpfully optimistic Kirstein, he has hoped that *Phenomena* will look like a tour-de-force of popular liberalism, with just enough shock value to induce people to talk about it.

But . . . what about that "frank méchanceté" after all? One might take the view that part of the social vanity of being satirized in this work is the pleased vanity one has at being singled out for caricature. We have already seen that in our hero's world this is an "in" game on exclusive territory. Tchelitchew, perhaps rashly, takes this for granted while he tries to lift it a few levels. The serious claims of two hearthside witches entitle them to hermetic overtones. In the case of the arch rival who illustrates a tranvestite complex, the veil again imparts a hieratic dignity, while the contiguity of the Leopard Boy, lifting the tent flap with one gesture, hiding his nakedness with the other, lends a charming wistfulness to both figures.

On the most critical grounds of taste, it is possible to enter an objection in Bérard's case. So, too, one might protest the presence of Virgil Thomson's head on the infantile figure whose hands grow directly from its shoulders. Rather than personal attacks, however, the plastic style of these portrayals makes them cavalier pleasantries—an echo of the *plaisanterie de rigueur* of Tchelitchew's early Paris idiom. *Phenomena*'s "portraits" are the opposite of

caricatures (I refer momentarily only to the heads) in that they suppress, rather than bring into focus, resemblances to actual persons.

And suppose, regarding such "personalities," one insisted they are serious impertinences? That would be tantamount to invoking, I should say, the retired custom of basing a challenge to a duel on historically parallel grounds. It will be very witty of Mrs. Zachary Scott (Ruth Ford), on that future day when she is sniped at by Kenneth Tynan in a play review,* to tell people that she is challenging the critic to a duel. Theoretically, that recourse is still open to the insulted. Mrs. Joella Levy (the future Mrs. Herbert Bayer) has become one of the ladies really esteeming Tchelitchew as a charmer. In *Phenomena*, he has given her face to the multiple-breasted woman bearing in her lap an infant that is a male variation on the Siamese Twins. Whether or not "flattered," the lady is not offended. She is not offended because, perhaps, she is sophisticated; because she may intuit that Tchelitchew is satirizing the femininity that is frankly fulsome, frankly maternal. Moralists have long speculated that being a woman may be a vice, a sex-indulgence without limits, but that women may regard this "vice" as a pride and a privilege. Is Tchelitchew old-fashioned, therefore, or exploiting a vulgar sexual prejudice by insinuating such femininity is freakish? No, his mind is on things still higher, as I shall proceed to show.

Tchelitchew the painter is the only one in *Phenomena* conscious of the possibility of insult, of being open to flattery or ridicule, for his is the only intent look, the only one that pierces the space intervening between us and the spectacle. Standing in his corner (bottom left) and painting a dead Negro whom perspective betrays into looking like a pinhead, he directs an aggrieved, somewhat frightened look of scandal at the world reflected in the canvas before us. It is altogether his Hell as much as ours since he is a portrait painter in the mood of a slave in revolt. If one is already in revolt against the vagaries of man, one will not be personally revolted by the sight of *Phenomena*, but on the contrary almost anything but revolted; neither is Dante, in the Christian hell, revolted at sight of those committed to their painful condition, but is moved to compassion. *Phenomena* is our Hell, a mutual Hell, insofar as this inverted social compliment corresponds to realities which genuinely disturb us, make us empathetic with the sufferings of others.

The statistical reality of *Phenomena* affords us a ready-made escape from guilt feelings as such: *we* have not been cursed as nature has cursed professional freaks. Insofar as truths in us correspond to the stature of truths in the literal freaks in view, we are regarding so many pictorial figures-of-speech that serve us as the bestiaries served Medieval man: as moral hyperboles which are warnings and disciplines rather than accusations. As customary in Tchelitchew's case, an artistic fruition is the long-cultivated product of a

* Tynan's colleagues, reviewing the same play (*Requiem for a Nun*) when it is produced in London, will go into ecstasies over Ruth Ford's acting.

childish passion. When a boy he cherished (as he himself writes) a book of "prehistoric beasts." Surprisingly he says, "There I first fell in love with Eternity."

Eternal grotesques? Well, Mammon (the coin man), the Glutton, the images of economic waste (such as the rotten strawberry and potato, both "giants," and the dumped milk) are monsters sacred to custom, and so is the parody that fuses, below the Mammon portrait, the Confirmation ceremony with Ku Klux Klan ritual. Wittier still is the centenarian figure of Granny being upheld in a chair by the Strong Man: the cult of ancestor worship and the social care of the elderly and penniless are ellipsized into one curt ideogram, tender and tough. These are the "prehistoric beasts" of man's coming to social consciousness: his familiar grotesques. And the coddled centenarian is a thorn in the painter's own side.

And yet, Pavlik reflects, is not the will to live the most terrible, the most monstrous passion of all, persisting in spite of all that nature inflicts on the individual? He thinks of the disorderly army of loathesome cripples and diseased persons assailing Our Lady of Lourdes; he has heard and read fantastic stories about it. In his New York apartment, he is waiting for Charles Henri to call him to lunch and thinking of *Phenomena*. There is an odd rapport between the will to live and—and—the ambition to succeed! At Ford's call to lunch, the monster of careerism makes its monkey-face in his solar plexus but he gives no sign of noticing it. The professional freak, he thinks on sitting down, is calmly reconciled to the passion of the will to live; it forms whatever economic stability he has. At times the freak's air of being a sightly spectacle is qualified by an evident ill temper: he has put this touch in *Phenomena* by painting it on one partner of the Siamese Twins. But the same look is close to the smug composure, even the bored nonchalance of more than one hostess of his acquaintance, more than one bon-vivant. . . . Once Alice Pleydell-Bouverie* tells him of his yarn bracelet, "You have too many strings on your wrist." The remark sounds an alarm. Suppose she were right? Mrs. Pleydell-Bouverie, like himself, leans toward mystical things. Is she, beneath her charm, a "wise woman"? Anyway, he will paint her in the manner of a Madonna by suspending an egg above her head. When asked why the egg is there, he replies like an old Hermetic, snubbing the curiosity of the profane, "It's where she keeps her money."

Mysticism can be—fun. But the world is so clumsy! Suddenly he's aware of what he's eating. "Charley, again today the meat is not good. Can't we change the butcher?" C. H. is such a good cook, it's a pity—*Les dames, les dames!* Isa, the impossible sweet Isa, and Minnie, Alice's sister-in-law**: all

* Alice Astor by birth, the late Mrs. Pleydell-Bouverie was married successively to Prince Serge Obolensky, Raimund von Hofmannsthal, Philip Harding and David Pleydell-Bouverie; Ivan Obolensky, the publisher, is her son.

** The present Mrs. James W. Fosburgh, familiarly known as Minnie, was born Mary Benedict Cushing and was first married to Vincent Astor.

of them, in different ways, darlings. Only *ladies* suit him. He can always communicate with elegance. "And they like me!"

"Ah, why do they *like* me!!"

It is a sublime parody: the freak's professional exhibition. Furthermore, it holds the key to a mystique. Above all, nothing in this painting has been sentimental. Each victim of evil fortune is . . . intact, dry (in the *brut* way), inwardly secure, seemingly unaware of his own incongruity, "out of this world"; of course, *here* lies the mystique: the movement of adjustment that interiorizes the most outward monster and creates the equilibrium of my Serpentina on her little tray, *à l'odalisque*, the reposeful mass of my marvelous Potato Woman: the Fat Lady. . . . This "movement" governs the composition of *Phenomena*, regulates its pulse, balances by plastic weights the Plus side with the Minus. Even the worst society—and globally ours, democracy or socialist republic, is pretty bad—arrives somehow at its basic equilibrium—yes, as in Charles Henri's lines, in the strange metaphors of his poem, *The Garden of Disorder*. The poem gives the title to his first book, to be published in England and distributed here by James Laughlin's house. . . . Pavlik idly, in a good mood, finishes lunch.

Charles Henri is doing well. The distinguished elder poet, William Carlos Williams, has written a preface to his book. Now maybe Edith and Edward James, as Charlie says, will sit up and take notice. . . . He has to make that face a little less like Edward's. If first (he thinks as he folds his napkin) he made him two-headed, it was because he loves Dali, too, and plays him off against *him*. Now he finds a better reason for the two heads.

"James is a good boy, no?" he asks Ford, referring to Laughlin, the young American publisher of New Directions.

"He had better be," rejoins Charles Henri. "I'm hoping for the best!"

Tchelitchew thinks to himself: "Why do I like Laughlin? I have no reason to like him but I like him anyway."

Aloud: "You must dedicate the first copy of your book to Edith, inscribe it and send it or perhaps bring it. You have sonnets to Djuna and Parker—and to me—it is too bad there is none for her. If it weren't for those people around her, you would have gotten to know how wonderful she really is."

Phenomena is finished; that is, Tchelitchew, having spent two laborious years on it, will very soon (in his own term) "abandon" it. The great painting is full of small mementos, references to passing acquaintances; anything relevant falling under his eye, person or news photo. The Great Wall of China, animals from *Life* and *Look*, an aërial view of Sydney, Australia, contribute accents to it. Many documents are enlisted to form details of the broad diamond-faceted canvas with its double rainbow prism. Here all the heroic sweat and villainous swearing of his career, to date, is summed up in a testament. During this period, as a friend of Ford's and a regular visitor to the house, I am being thoroughly weighed as a true

Tchelitchevian. When it comes to common camaraderie, the artist has no snobbery (though he never lacks temper) and I have little to fear. He finds me amiable and bland, a good listener and one who praises without being sloppy. Yet on the score of poetry and artistic matters in general, I have some serious differences with Ford and thus am a "competitor." This is naturally reflected in my relations with his bosom friend. Realistically, too, I don't command the deference that would outwardly be given someone who could be regarded as a force in cultural affairs.

In effect, I am getting neurotic about the strong combination of Ford and Tchelitchew, bent on subduing and moulding me, absorbing me into the Total Tchelitchevian. It is something of a struggle: I feel I am fighting for my basic independence. Not unexpectedly, then, owing to unintentional offenses against protocol, I am ostracized by my friends for a brief, actually probational period. Finally, through Ford's stubborn personal loyalty to me, I am brought back gently into Tchelitchevian focus and Tchelitchevian grace without sacrificing my honor. It is a proper irony that a version of my head should surmount the figure in *Phenomena* called the Armless Wonder, shown typing with his feet. I don't pretend to be displeased (or pleased) at this definitive comment on my "rivalry" with Ford. It is symmetrical with the artist's frank *méchanceté* which I, too, have tasted—and decided to tolerate. All seems for the best. I shall remain faithful and find myself impelled to remove the last veil in *Phenomena*.

Behind the Veil
When, in future years, *Phenomena* will have become a complete dud with the public, universally misunderstood as *Hide and Seek's* ugly overpublicized sister, the project will arise of a book by Kirstein to elucidate its mysteries. By then, substantially, the Hell will have taken its rightful place by the Purgatory, and Edgar Wind's authority will have convinced the artist that he is naturally, instinctively, a painter of magic pictures. As different as the two works are, they are visibly by the same man and reveal transitions unmistakably connecting them. In accord with *Phenomena's* liberal metaphoric method, Kirstein perceptively observes that it is the "hand" which begs, the "foot" which crushes. Thus the imprint of the hand is on the left, the Minus or deprived side of the painting, that of the foot on the right, the Plus or overexploitive side. This is symmetrical Hell.

Rather, in the Purgatory (*Hide and Seek*), the foot and the hand—now highly charged symbols, not mock vestiges—are material, not illusory. Here the foot purchases a hold on earth in order for the hand to grasp an objective; the close dynamic pattern is from *L'Errante* by way of the circus: the aërial performer climbing aloft. In this respect, all the erotic features that *Hide and Seek* centralizes in the little girl hemmed in by *phalloi*, are transcended. Read hermetically, as finally we must read it, *Hide and Seek* is an image of man

climbing the Hermetic Ladder to the Empyrean; that is, to Paradise in the Dantean scheme. That we see the foot frontally, the hand from the back, may seem a detail: a matter of formal expressivity like the Egyptian treatment of the eye. The relative anatomic positions (as an individual's) would be unnatural, of course, to a climbing acrobat. Yet a precise symbolism lurks in what looks like abstract plastic arrangement. The explanation is that, in the step between *Phenomena* and *Hide and Seek*, a mystic *contrapposto* has taken place, a twist in the transitional figure of which we have internal evidence. In *Hide and Seek* it is at the middle where hand and foot join; an equivalent "twist" is in *Phenomena* itself, likewise and variously at another "middle." The locus is the Lion Man. The twist is in the break at his middle caused by the shadow on the towel he holds up: only his head and arms. In the transference of this much of his image to a plane in front of him, the step has "deprived" him of his genital region; for, on the plane behind the towel, we behold only his actual legs and an ambiguous tuft of hair. The oil painting which is a final sketch for *Phenomena* also contains the man with his towel, in central commanding position as in the work itself, but he is not yet a Lion Man and his testicles are visible.

It is far more probable that the artist's symbolic tactics, not his tactical timidity, causes the climactic illusion of sexual deprivation in the Lion Man. In any case, what looks like a theatrical effect (the reflection on the towel) is deeply saturated with the hermetic spirit. The centralized Lion Man is the predecessor of the Little Virgin in the subsequent painting and his meaning is just as highly complex. For one thing, like the tree hand and foot, he faces opposite ways; his lower half is away from us, his upper toward us. Now why, among all beasts, is the *lion* given stage-center in this extraordinary "bestiary"? Actual beasts are underemphasized in *Phenomena*. The charmingly demure Elephant-Skin Girl (for which the artist took his friend Léonor Fini as a model) is no more specially symbolic than the actual overbred sheep with its fulsome tail supported on a wheeled cart.

If some deeper iconographic meanings are subconscious in Tchelitchew while he paints his Hell, the evidence is all the more remarkable; that is, we have little to support the full hermetic reading of *Phenomena* more explicit than Tchelitchew's plea to Kirstein, in a letter written in 1948, that he should emulate Wind's type of criticism and clear up what he terms the painting's "hidden language of symbols." Since by such a phrase Tchelitchew could not possibly have meant the overt system of Too Much and Too Little symbols, inadequate to account for the work's exact form, he certainly means something more elusive. It should be remembered that in the occult tradition, knowledge is supposed to come hard: to exercise and provoke the seeker.

That the artist did mean something else by his phrase, in his intimidated but stubborn way, is fortunately documented owing to the vigilance of the

unswerving Kirstein. On the subject of his three perspectives, Tchelitchew informs his admirer that they "correspond to the three states of the human being: Body (from underneath), soul (neutral central point), spirit (perspective from above)." Body, soul and spirit are orthodox divisions of the personality in traditional hermetic doctrine and closely related to universal religion; the movement from body to spirit, of course, is ascendant. Yet Tchelitchew's words, without specific reference to that doctrine and its ritual, might seem mystical attitudinizing in a painter perhaps rationalizing at random to give his art more importance. Despite Tchelitchew's career mania, there is reason to doubt so frivolous a motive. There is always little hope that the modern art public will be impressed by what normally it could regard only as extraneous jargon.

The Pythagorean tradition (of which Pavlik's father, who loved Pythagoras, must have told him something) contains the description of three stages of mystic initiation recorded by that famous pagan teacher's followers and successors. These stages happen to have the perspectival implication in which Tchelitchew is interested and of course they are related to the trinities of universal religion. Their order, as follows, is consistent with the above-given order of the artist's interpretation of triple perspective: Epiphany (from below), Autopsy (neutral central point or head-on) and Theophany (from above). It is tacit that such perspectival viewpoints denote stages in a ritual passage—just such a ritual passage as Dante's in his *Divine Comedy*, where it is a matter of traversing mysterious terrain and encountering dangers, witnessing both terrors and wonders.

As we know, no authentic account exists of the old mystery rituals, whether those of Greece or some other nation's. But because of many profane quotations and approximations we know that they existed and that the "higher" ones were kept as secret as possible. We also know enough to guess with conviction what the theological language of Pythagoras means. Both in pagan and Christian usage, the term epiphany, meaning manifestation, denoted the materialization of a token of the god to mortal eyes; a theophany, on the other hand, expressly means the visible manifestation of a god in his own person. The refinement of Pythagoreanism certainly italicizes the distinction; with equal assurance, one can say that the distinction is meaningfully concrete in terms of some performed ritual. *Epiphany* would be a sign or condition of the God's presence, something experienced in the very first stage of ritual initiation or in mass ritual; the subsequent *Autopsy* stage is native to Pythagoreanism and implies special initiation; the word itself means "seeing with one's own eyes." In the case of a mystery ritual the god's presence is still implicit, and the word autopsy implies *further* revelation. *Theophany* as the climax and end-term would signify the complete (presumably personal) manifestation of the god; that is, total revelation.

It is hard to conceive this series of revelations spatially without imagining a progress of changing levels. Inevitably, to follow Dante's pattern as archetypal, the epiphany of "from below" means infernal revelation, a manifestation of divine punishment in the so-called Underworld, or Hell. One looks at things that are below and thus, psychologically, "from below." While, according to Tchelitchew's content in *Phenomena,* our viewpoint constantly veers and is involved with deliberate illusion (as when elephantiasis of the feet is illusively equivalent to their abrupt foreshortening) the general viewpoint is from a point looking down into a large, generally hollowed space; at the same time, the foreground (note the feet of the Siamese Twins) gives us the feeling of close contiguity, that is, of *descending* to the same level as the objects in view; toward the top of the painting, certain dominant figures (i.e., most of the City of Glass) are seen from below, a fact indicating that, as we become coincident with various spatial points, the objects in view appear above us; hence we are at the lowest point—namely, in the pit of Hell. The perspectival shifting in *Phenomena,* therefore, has a Pythagorean function in accord with the artist's formula given above.

As purely formal quantities, epiphany, autopsy and theophany are all expressed in *Phenomena;* this is natural, in that every stage of a ritual trial implies the other stages. At the same time, Tchelitchew does not lose his intuitive sight of the total pattern that becomes visible to him when Ford suggests that (*Hide and Seek* having been begun) he is executing a Divine Comedy. What is the mechanism of *Hide and Seek,* even in the derived and specifically medical sense, except an "autopsy" since we see head-on through a succession of superposed layers without losing the identity of any of them? As we know from Dante's poem, the initiate (the poet) when in Purgatory is aware of Hell, from which he has come, and yet has various intimations (as was promised him from the start) of the Paradise which he is to gain. Being at the middle of anything hence has the peculiar, if indeed familiar, advantage of seeing both what is past and what is to come. *Hide and Seek,* while in many ways referring back to *Phenomena,* very accurately prophesies the Celestial Physiognomies that make up Tchelitchew's Paradise.

In fact, Tchelitchew's master trilogy has an astonishing faculty of bringing back to life what necessarily must seem, at least to the present-day art and literary worlds, mere archaic data about lost rituals. My own interpretation of the Pythagorean sequence, Epiphany, Autopsy and Theophany, is that the first comprises the verbal instruction by a priest as to what the initiate is to experience and what is expected of his conduct (Epiphany); the second is the experience itself, when he sees everything "with his own eyes" (Autopsy); third, the personal manifestation of the god who by word and/or act climaxes the mystic revelation (Theophany). In terms of time and space, we have the initiate first descending underground, then meeting a new reality on even terms

(head-on), and lastly reaching a point where, in direct contact with divine be-
ing he himself is on the level toward which, at first, he literally had to look
up. He has merged, optically and spiritually, with godhead. He is viewing
life from "the above" of ultimate enlightenment.

In the hermetic structure of *Phenomena*, now assumed as authoritative and
authorized, the Lion Man participates even by way of Dante's quasi-Christian
scheme. Viewed in the perspective of *The Inferno*, the "sinfulness" of
Phenomena is concentrated mostly among the sufferers in the Second, Third
and Fourth Circles, where respectively the Carnal and the Gluttonous, the
Hoarders and the Wasters are being punished. These occupy all of the right
side of *Phenomena*. If we interpret the Half-Man, Half-Woman and Woman-
breasted Boy as "carnal," it also extends along the bottom to the left, and if
the Guardians of the Threshold (Sitting Bull and the Knitting Maniac) can
be said to hoard their possessions, it likewise includes some of the top left.
The general Dantean classification of the sins here is *rapacity*—the lion,
preying on all other animals, is especially rapacious.

Yet more, descending to Lower Hell (the last three Circles), we first
encounter those "violent and bestial" sins which are specifically, according to
Dante, the Sins of the Lion. Occupying the first round of the Sixth Circle are
the murderers and war-makers; *Phenomena* covers these with the gas-masked
soldier, the puppet dictator (just below the City of Glass) and a few other
figures. More significant, occupying the third round of this circle, are the
Perverts, the sinners against Nature. The Lion Man's head is turned to his
right and thus is directed across the sexual variants (the Half-Man, Half-
Woman and the Woman-breasted Boy) toward Tchelitchew himself. But
alas for all public piety, The *Divine Comedy* of Dante, as should be clear
from the previous discussion, is not the artist's chief symbolic source for
either his Hell or his Purgatory! Or rather, Dante's familiar Christian epic
simply forms the convenient handle by which properly we can enter the true
inner door of Tchelitchew's meanings, which as a whole are pan-hermetic,
drawing from Astrology, Alchemy, Orphism, Pythagoreanism and allied
sources, and approaching Dante's great poem only as that epic itself, in
reverse, is roughly related to the same sources.

In *Phenomena*, then, the main focus is on Hermetic, not Christian, alle-
gory. The painting's Lion Man is easily identifiable among the foremost
delineations of hermetic symbolism, not only by his animal hairs but also by
his towel. As often happens, by following a pagan pattern carefully, we may
come out finally at its Christian derivation; for our Lion Man, of course, is
Lucifer, the King of Hell. In purely architectural, non-pictorial structures of
the Universe, the mystic adepts place Satan at the station occupied by the
Lion Man in *Phenomena:* bottom center. Contrarily to the bestiaries, Medi-

eval times conceived man-beast elisions (zoömorphs) as strictly demonic; this is popular Christian myth and, so far, quite in the Dantean spirit. Touching black magic (a mongrel made from Hermeticism and Christianity), the Lion Man would be the animal demon of which I have spoken elsewhere in this book. However, I have also said that the Lion Man (as Ford) represents for the artist the Lyric Poet who is a "divine companion." Where is the transitional link between these opposites—between poet and demon?

It is hermetic of course and right in the center; that is, at the middle point of transition. One symbol is the towel as the Veil of Illusion, a very ancient emblem. Yet the towel is somewhat more, too. To ascertain just what the towel is, its symbolic environment must be explained. Hermetic icons (always allegories) often portray an Hermetic Circle or Cosmos in which the central human figure is explicitly or implicitly hermaphroditic; that is to say, the figure is equivalent to the two-sexed Eros of primitive Classic myth. The Alchemists conceived the god Mercury (properly winged) in this central position, uniting, as I have mentioned, the male and female characteristics in the Fixed Volatile (male = stable; female = unstable). The alchemic allegory of which I spoke on a previous page has exactly this scheme: Mercury is the hermaphroditic "angel" placed between, and peacefully joining, the belligerent opposites of male and female.

Note that all the principal figures occupying the foreground of *Phenomena* are in some sense doubles; going from left to right: the Woman-breasted Boy, the Half-Man, Half-Woman, the Lion Man, the Siamese Twins, the soldier and his horse, each in a gas mask as a version of the Centaur, and the Bearded Lady. It is also noteworthy that on the striped bath sheet with the first two figures in this set is a Scottie. The model for this dog was presented to Tchelitchew by Edith Sitwell; assumed to be a male, it was christened Ibraham; then, on the discovery that it was a female, the name was changed to Ibra. The chief personnel of the freak show, then, are identifiable as hybrid organisms whose function somehow is to unite opposites.

This peaceful dualism is carried out by the painting in the orthodox manner of hermetic icons: the sky on the right is Night (with a skull for the Moon), that on the left, Day. While the rainbow coloration of the whole scene suggests daytime rather than nighttime, we see that the shadows consistently fall on the left, that is, are cast nominally by the Moon rather than the Sun; the artist's use of shadow is his own modulation and may well refer to the nocturnal Aurora Borealis as well as to the fact that no true skies are visible in Hell. In essentials, the scheme of the painting follows the Hermetic layouts. In the old allegories, various symbols of the Sun and the Moon occupy opposite sides, Moon on the right, Sun on the left. Representations of the Moon as Diana and the Sun as Jupiter are canonical.

If we examine *Phenomena* in accord with these features of an Hermetic Cosmos, we may identify the artist at his easel as the lefthand Jupiter figure

(the Sun) and the Multiple-breasted Woman as the righthand Diana figure (the Moon); there is a specific Classic authority for Diana, of course, as multiple-breasted: the orientalized Diana of Ephesus. Is there perchance a reason (beyond that of capricious egoism) for Tchelitchew to identify himself with the Sun figure, Jupiter? In a minor sense, as situated on the Day side of the picture, he represents (and again this is orthodox hermeticism) what is hot and dry, rather than, as does Night, what is moist and cool. As we already know, this is consistent with the astrological status of his planet, Mercury; moreover, since Ford is involved with the Mercury-Lion Man amalgam in the center, he is deputized as Mercury (he would be that, let us say, on the side to which his face is turned: Tchelitchew's. Besides being kingly, Jupiter is canonically a "lucky" planet and the artist believes that he has brought luck to his friend.

As for Diana (moist and cool), Tchelitchew is obsessed with portraying the female's hair as a watery cascade, a device that he frequently adapts to his portraits. It is very conspicuous in the portrait of Constance Askew, where it is an opalescent torrent of nervously materialized moonlight, and in a pencil drawing of Mrs. James W. (Minnie) Fosburgh. Always, it is very handsome. Thus, incidentally, we can discern a quality of the impersonalizing method by which Tchelitchew arrives at the personnel of his freak show. At times, we see a collective *persona* rather than the *persona* of an individual (we *never* see the portrayed individual). One of the lesser figures in *Phenomena* used to be a stock item of sideshows: the woman with the hair longer than herself. Here the hair is a cascade parallel with the surplus milk being poured into the earth. Thus a classic trait of feminine allure (the figure is seated between the long toe and the ball of the footprint on the Plus, or Diana, side) is abstracted into preternatural excess to serve as another detail in the travesty of the Society Portrait. Vanity is its keynote since the long-haired woman is admiring herself in a hand-mirror. Ruth Ford actually posed for it.

In our time it is universally granted, I should say, that the depth psychology of the creative artist partakes of the unconscious. That Tchelitchew, at the age of 38 to 40, has seen prints of hermetic allegories goes without saying; that he saw precisely those of which I am speaking, while there is no proof that he did, seems at least plausible. In one representation of the Hermetic Circle, with signs of the Zodiac, the circle itself corresponds positionally to the towel held by the Lion Man; in its center, as in the shadow-catching towel, is a man's head; below, as below the Lion Man's towel, extend the straddling legs of a man. Canonically, the traditional figure thus partly revealed is the Hermetic Androgyne, uniting everything at the axis of existence. It seems not without meaning, furthermore, that the woman imprisoned at the center of *Phenomena* in a fishbowl (an aging matron bathed in milk coming through pipelines) is mostly face and echoes the isolation of the male face in the Hermetic Circle.

Traditionally Jupiter is associated with the lion; thus, in the design being discussed, the Jupiter figure (crowned, sceptred and with a shield) is seated close to a lion's head. Tchelitchew's brush corresponds to the sceptre, his palette to the shield. In another, much more elaborate design, the Hermetic Androgyne, placed centrally (as usual) with the Jupiter and Diana figures to either side, stands upright on a lion's head from which two lion-bodies extend in opposite directions; one presumably a male beast, the other a female. Thus the sexual combinations along the whole front of *Phenomena*, as well as the sexual differentiations, are hermetically inforced and reinforced. In this same design, canonically divided into Night and Day, a rearing lion shares the Sun sign on the left with the Jupiter figure. Between them, at their feet, is a strange bird expressly designated as the Phoenix. We recall that the Phoenix commits suicide from exposure to the sun's rays and arises then from its own ashes. Resurrection, naturally, is an essential part of the Hermetic creed as of many popular religions, the behavior of the actual sun probably being the model for the Phoenix myth.

At Tchelitchew's feet in *Phenomena*, I could not help noticing, is an anomalously prominent barnyard hen. Above I wrote of the incident at Philippeville, when Allen Tanner surprised the ritual of the sacrificial hen victimized by her own kind; his report of the incident greatly shocked Tchelitchew. That the artist remembered it, seems pretty conclusive from the painting of the titanic hen (1934) with lightning in her beak and standing over the naked prostrate body of a man. At Philippeville, the artist was laid up very sick for several days. The painting's image is dreamlike although (aside from the Philippeville incident) I know of no special evidence to suggest what symbolic meaning it may have. Its title is simply *The Hen and the Man*.

The hen's appearance in *Phenomena* therefore seems strikingly non-coincidental. It may partake of that synchronous principle of the laws of astrology to which I referred above as formulated by C. G. Jung. If we try to absorb the hen into *Phenomena's* symbolic scheme, as I think is sufficiently indicated, an obvious method is by way of the Phoenix's position in the hermetic allegory just described. Why, one may then legitimately ask, should this hen (which aside from a vaguely goblinesque expression looks quite commonplace) be in Hell, and why next to the artist's feet? In Allegories simple contiguity is never without significance. Thus the incident at Philippeville, according to the later painting of the hen, may well have suggested to Tchelitchew the Hen as a supernatural bird associated with the power of life and death.

This is no more than consistent with the psychology of all ritual sacrifice of life. The "sole Arabian bird" is really universal. Therefore this phenomenal hen might be a most appropriate stand-in for the Phoenix. Ostensibly she

fits *Phenomena's* scheme on the Minus side because, although she has wings, she cannot fly. To be resurrected is to fly heavenward; at least, to arise in some fashion. In religious doctrine, the soul may fly out of the corpse and enter another body in the cycle known as metempsychosis. The pathos on the Minus side of *Phenomena*, we should note, is regularly the paralysis or abuse of a normal faculty. Here also the hen would fit.

In the sexual instances, the meanings are obvious in this respect. But more than that, Serpentina cannot *walk*, the poor cannot *eat*, the typist cannot *type* (i.e., "write"), the opera singer (Isolde, between Sitting Bull and the Knitting Maniac) cannot *sing* (no matter how much she bellows), the Guardians of the Threshold are really keepers of trash, and the hen cannot *fly*. The oddly symmetrical upshot was, in popular opinion, that Tchelitchew could not *paint*. But considering that he, as author of the painting, could not mean this, we must ask: In what faculty is he fatally handicapped so as to find himself on the Minus side of Hell? Overtly, money-wise, he is as poor as some of those around him but he is certainly not sexually handicapped, technically, any more than Ford is. What else conceivably? For we must assume that he cannot be attitudinizing as "poverty-stricken." The answer is that, exactly because he can paint, *he cannot paint himself out of being obliged to paint*; he is condemned to manual slavery. At the same time, the hen at his feet, apparently a fellow prisoner, actually symbolizes the avenue of his escape. For, as the Phoenix, she can escape, achieve new life, even if it be at the expense of *this* life. As we know, Tchelitchew is destined to die under the precondition of consent to self-sacrifice.

This masterpiece is the statement of his *epiphany* in the ritual experience of life. As a magus, he is self-instructed and divines what is to come. He is the anointed victim of his own skill, of whatever success he has achieved, because he sees no immediate alternative to painting (among other things) more and more Society Portraits. New portraits are coming up! The catalogs of his two definitive exhibitions (1942 and 1964) will overflow with them. Even as he is painting *Phenomena*, he induces a woman acquaintance (whose piquant features he decides to use for the Siamese Twins) to pose in a plain dress for Edith Sitwell's body in the full length portrait, completed in 1937. Whenever possible, he uses drawings, photographs, memories, anything but the person himself, for all the *persona*-masks in *Phenomena*. Ford's face as the Spider Boy is fairly recognizable while it is, in the towel silhouette of the Lion Man, conventionalized.

We have come back to the bottom-most pit of the artist's journey: to the King of Hell and his missing middle. Regarding the aforesaid Hermetic Circle, with most of a human body shielded behind it (the Androgyne) we notice under it, between the visible feet, a plain geometric cube, seen from beneath and marked Corpus (Body). Here is a very precise documentation of

the first phase of Tchelitchew's triple perspective, self-designated as Body, Soul and Spirit. The Latin legend printed around the edge of the Circle is highly suggestive. It is: Visita . . . Interiora . . . Terrae . . . Rectificando . . . Invenies . . . Occultum . . . Lapidem. In English: "Investigate the interior of the earth. Rectifying, thou wilt find the hidden stone."* I have observed that Tchelitchew's art is a perpetual search for the Philosopher's Stone. Its illusive image is at the foot of the tree in *Hide and Seek:* the "nest" made by the reduced and inverted mirror image of the tree. The above legend undoubtedly has reference to this search as metaphysically undertaken by generations of adepts throughout recorded time. Seen more narrowly, it can be explained as a rough description of the stages of a mystery ritual, even being applicable to a journey such as Dante's. Of course, only the "rectifying" candidate for initiation understands, profits by, what happens to him.

But our particular interest, the cynosure of *Phenomena,* is still the Lucifer figure of the Lion Man, along with the symbol of the cube, Corpus, representing his purely physical aspect in the hermetic allegory. The supreme Archangel, defeated and hurled to his punishment by victorious Jehovah, was conceived by Dante in a way that reckons the exact position and condition of his body when he landed on our planet. He not only is three-faced (i.e., a parody of the Trinity) but has penetrated the crust of the earth, as Dante expressly says, so as to leave him visible and free from the waist up on the inside of Hell, only his legs emerging, visible and free, on the other side: in the earth's air. In this connection, the upside-down position of the Half-Man, Half-Woman (directly beside the Lion Man) is illustrative. But what does Dante, and indeed orthodox theology, imply but that, helplessly frozen in a polar band of ice, Satan's genitals (implicit in his degradation) are prevented from reproducing his kind? This is the hidden complex reason why the Lion Man's middle is theologically invisible: he is profane from the Christian standpoint, if sacred from the Hermetic standpoint. To be sure, he is an animal demon, a kind of zoömorph, but because of his place in hermetic symbolism, he also obeys the ascetic precept of Pythagoreanism that eliminates all lust, including the erotic. Tchelitchew has not left us to dangle in this storied speculation, however plausible. He is a painter and himself a symbolist, however intuitive rather than conceptual.

I have said that in the step between the sketch and the work itself, involving a transitional twist, the Lion Man's genitals (indeed, his whole visceral region) disappear, as if automatically, through illusion. But we have, in *Phenomena,* a sign for them, just as the cube in the design of the Hermetic Circle, the Corpus, is a sign for all that is animal about the Hermetic Androgyne, most of whose body is hidden. Between the Lion Man's legs, we find two objects; one a set of objects, a skull-and-bones, the other a live sea-

* Kurt Seligmann: *The History of Magic,* pp. 156–7.

lion apparently crossed with a polar bear. The skull-and-bones are wedged into the inverted V of the Lion Man's straddling stance. Sexual abstinence, sterility or taboo is symbolically plain enough. The general setting, we must note, is a desert, or at least tropical in that, at the very edge, it is a rocky or sandy beach and in the red, or "hot," belt of the lower rainbow spectrum. The sea-lion-polar-bear in such a context is a climatic contradiction, which is consistent, however, with the token meaning of a bleaching skull abandoned in the desert. Both skull-and-bones and zoömorph function in *Phenomena* as does the Corpus-cube of the Hermetics: they symbolize the ritually hidden, mystically eliminated, *animal middle*. Sex may be hot, but in Hell it is also "dry." The peculiar traits of presiding Mercury—his reading as the Androgyne may be extended to the left and right—are hermetically satisfied.

With *Phenomena* abandoned to the public, the *autopsy* stage of Tchelitchew's art is about to dawn in the purely plastic sense of X-ray, which in turn will lead to the dissection of the internal body opening upon the final stage: the Celestial Physiognomies. But in the orthodox epiphany sense, the future phases are implied by *Phenomena* in the external mechanics of seeing in the triple way: from below, head-on and from above. This whimsical visual rhythm in handling an aggregate of objects in *Phenomena* involves the desire to know matter in the round, to make available all its sides. Precipitate foreshortening has its emotional motive: the desire to touch, which sexually speaking is the desire to caress, penetrate, "possess." Such is the profane reading of the mystic perspective, and in Hell, logically, it finds its supreme location and its supreme paradox. For the creatures on display are, as I say, technically beyond reach: the Untouchables. Thus, by a simple shift from physical or real to mystic or abstract triple perspective, they coincide with their inherent hermetic function: hermetic secrets, to the profane, are "unknowable."

As only apt, there is a magic point of departure for the shift, and again this is centered upon the break of spatial plane made by the Lion Man's towel. It is a plane as illusive yet concrete as the picture plane that depicts depth and volume. At this nexus, our superstitious hero always fears the shift, the twist, the break, since he fears it not only as something utilized by his rivals to outstrip him, but actually in his viscera, where it registers not magically, so to speak, but medically. If the point were pursued according to Freudian doctrine, the break would be a displaced castration fear. Howsoever, it is fatal, and ideally so; which is to say, it "must take place," just as the mystic initiate, timelessly, must give up all mortal and material graces to gain immortal and impalpable grace. Hence there is some single, perhaps only "theoretic," spot at which it takes place: a purely transitional locus. This, for Tchelitchew, is the aërial suspension, the moment of terror in accident, all the alarming preludes to uncertain climax . . . the fall of the detached curtain in

L'Errante . . . the smile of a portrait sitter . . . the eyes of the French naval officer to whom he desperately applied in Odessa.

Phenomena is soberly saturated with this revolving and unfixed sensibility as no other painting in the world is or ever tried to be. According to his own account, the formal germ and the first theme of *Phenomena* arose from the sight of beggars in Italy and the idea, derived from the door of San Zeno Maggiore, Verona, of a story or epic in pictures. Something poor, awkward and inadequate in the flesh (something aesthetically more German than French) always had an obscure but poignant appeal, a vaguely religious vibration, for Tchelitchew. But this peculiar feeling, while essential, was only the platform for the total inspiration of *Phenomena*. Speaking for myself, I shall informally expand my interpretation of the Emotional Perspective, which I find in the painting, to a different sort of break or jump.

In a letter written to Tchelitchew while *Phenomena* is being shown abroad, I say, "In my estimation, you have intuited the freak of society as parallel to the broken-wave rhythm in physics and the leap in Marx's conception of history." What might be called a unity of dislocation prevails in *Phenomena*. Further (and despite all that has been said against the double rainbow spectrum of the work, I think this has not been said *for* it) a break lies even in the physical nature of the spectrum, which technically is a colored band of light produced by transmission through a diffractive object, that is, a prism. In *Phenomena*, light as well as objects and color are diffracted—local color is very incidental—and these live together in a dimension where all things are not true and absolute, but untrue and relative; namely, they are in Hell.

La Chute

An especially bootless routine it would be to describe the ineptitude with which *Phenomena* is successively received in the great capitals that Tchelitchew has always wished to take by storm: London, New York, Paris. Except where it seems polite just to Oh and Ah, the picture spreads hostility among the impartial, confusion and bewilderment, or at best amiable tolerance, among Tchelitchevians. Journalistic experts can do no better than relate it superficially to classic parallels. The nadir occurs when a London critic wonders why the artist has represented himself with "elephantiasis" of the feet.

Kirstein alone regards the work, at first, as a cause. Julien Levy hopes it will win through as a painting tour-de-force with modish politics, but this hope is instantly crushed by the New York reviews; even those critics who think Tchelitchew knows something about painting tend to regret the use to which he has put it in this muralish mirage. If I personally am not so enthusiastic about *Phenomena* as I might be (I tend to become fascinated and

analytic rather than ecstatic in its presence) it is largely because I have not guessed its underlying hermetic content. Kirstein and Tchelitchew make a tactical error: they should not compromise as they do on half and quarter measures but pursue the symbolic meanings to their uttermost. The artist is rather traumatized by his own daring, however, and as Levy notes, the general mood of the art public abashes both him and his loyal lieutenant. At this time, Edgar Wind is not on hand; when he is, the dazzling *Hide and Seek* will have the center of the stage and *Phenomena* be playing the role of ugly stepsister.

A time will come when I stand with Tchelitchew at the retrospective show in the Museum of Modern Art, in 1942, at a point where both the chefs-d'oeuvre, though in adjoining rooms, are in our line of vision. Referring as he always does to the works in the feminine gender, he says, "Do you know, I think *Phenomena* is a little jealous of her new sister, but really, when you come down to it, I don't think she ought to be—she can hold her head up without shame." Also there comes to mind a vision of Alexandra Danilova, a good friend of Tchelitchew's, standing mesmerized in front of *Phenomena* at Levy's gallery in 1938. She has arrived unaccompanied and has the picture momentarily to herself. Lingering to one side, I am dying to ask her what she thinks of the ballerina, a very minor figure poised on a high wire at the far top to the right. But I have not yet been introduced to Mlle. Danilova. She may have heard that Pavlik has put many of his friends there; perhaps she is disappointed that she can neither recognize nor fail to recognize herself in the miniature ballerina, who is without any identification. My impression is that she remains silent on the subject to Tchelitchew.

Nobody in the painter's less or more intimate coterie—such is the fact—cares to tackle what seems really difficult and problematical about *Phenomena*. From the inside, the work looks like a great error in public tactics; as such, it had better be buried as a topic of conversation as soon as possible. Julien Levy has acquired a partner, R. Kirk Askew, Jr., a connoisseur who quickly becomes a devout admirer of Tchelitchew and his painting. However Askew is as little disposed as anyone else to take up the cudgels for the artistic anomaly (somewhat larger than life) which the painter has seen fit to spawn. Tchelitchew can so well do other things that suit much better Askew's basically conservative ideals. Ford undertakes to save "dozens" of clippings on *Phenomena*, which he describes in a letter to me (enclosing some of the funniest) as follows: "Some are serious, some not, some good, some bad, some stupid, none worth the paper printed on."

Meanwhile Ford and Tchelitchew are organizing their social and professional lives entirely without regard to the casual embarrassments provided by *Phenomena*. Personally and artistically, Ford is an accepted quantity (at least for most intents and purposes) among Tchelitchew's English admirers. Miss

Sitwell has responded well to his first book and found there a lyric for which she has some superlative praise. The artist has met Alice De Lamar, who has a large estate in Weston, Connecticut, with an imposing guest house as well as a charmingly rustic residence called the Red Barn.

Tchelitchew strikes the wealthy Miss De Lamar as a lively and most amusing man, well worth helping, so she promises to make a studio of the Red Barn that he may spend the winter in Weston. He consents despite Djuna Barnes' warning, written to Ford from France: "Connecticut winters can be Hell." Invariably, snow agrees with Tchelitchew and he is already a chronic fugitive from New York City.

However Miss De Lamar herself tells me that Tchelitchew and Ford are facing "a long hard winter," so for Christmas I send them both lumberjack sportshirts. Most Christmases, during their intermittent stays in Connecticut, I am invited out. Since Weston is only an hour and fifteen minutes from New York, the pair grow fond of issuing invitations to drop in for tea (a household institution) and the respondents are numerous. Nicholas (Kolya) Kopeikine, whom Diaghilev introduced to the artist, has renewed his friendship with Tchelitchew and sees him frequently. Once there is a sort of reunion when he brings out to tea Natasha Nabokov, former wife of the composer of *Ode*.

I never find snow disagreeing with Tchelitchew even under the worst circumstances. It is a strange taste for a man devoted to the rich tropic leisure of sunbound beaches but doubtless it is Russia in his blood. A distant relative of the Tchelitchews, the late Dr. Vera Koshkin, will tell me following the artist's death about her visit, one Christmas, to Doubrovka when Pavlik was a baby: the snowy landscape seemed arctic and the manor house hemmed in by a black and white silence. Once, during a weekend I spend with Ford and the artist at the White House in Weston, a mild winter day and evening is concluded with a blizzard, like some monstrous beast that invades the country during the night and next morning is found sprawled over the world, panting and blotting everything out.

Yet Tchelitchew and I both have urgent business in New York. The only solution is to get to the station, normally less than ten minutes away, by a jeep of which the estate's superintendent is the proud driver. It is still snowing and so thickly that one can see only three or four feet ahead. The artist, tense but glowing, seems to exult with every triumphant manoeuvre of the fantastic little machine in which we set out. After some minutes the snow ceases its squalls and we perceive marooned automobiles, unable to move an inch; some have had minor accidents. We almost go off a little bridge ourselves, yet reach the station in perfect safety in about twenty minutes, laughing and heaping thanks on our driver. At another time, a freeze has made a crystal fairyland of the country around the White House. For some reason, Ford is

Above left: TCHELITCHEW: *Basket of Strawberries,* 1925, oil on canvas. Collection Mr. and Mrs. John Hay Whitney.

Above: TCHELITCHEW: *Pears in a Basket,* ca. 1928, oil on canvas. Collection Mr. and Mrs. Henry J. Heinz II.

Below left: TCHELITCHEW: *Head,* 1925, oil and sand on canvas. Private Collection.

Below: TCHELITCHEW: *Eggs,* 1925, oil on canvas. Private Collection.

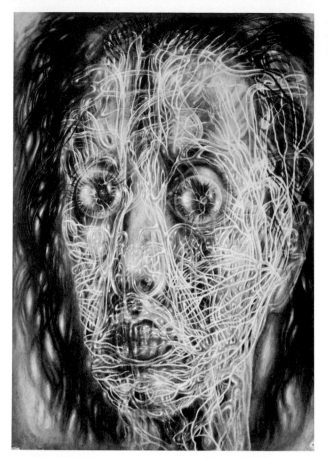

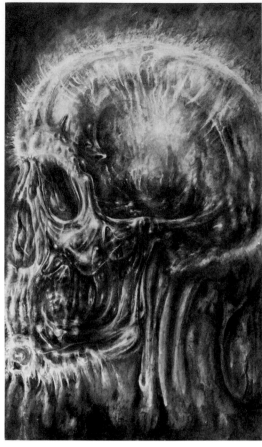

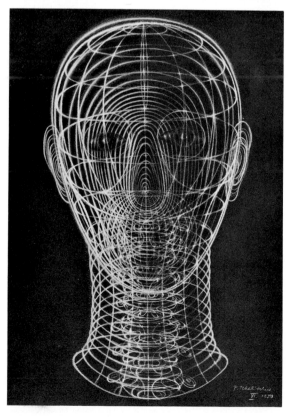

Above: TCHELITCHEW: *The Crystal Grotto,* 1943, gouache. Collection Edward James.

Above left: TCHELITCHEW: *The Lady of Shalott,* 1944, gouache. Collection Edward James.

Left: TCHELITCHEW: *Head VI,* 1950, colored pencil on black paper. Collection The Museum of Modern Art, New York. Gift of Edgar Kaufmann, Jr.

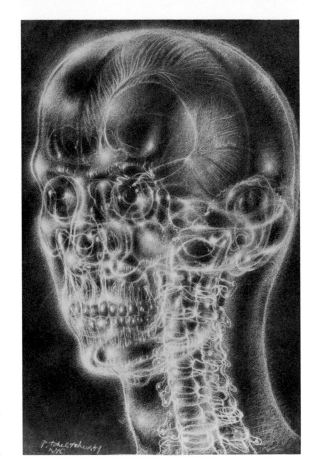

Right: TCHELITCHEW: Interior Landscape, 1949,
pastel. Collection Mr. and Mrs. Hugh Chisholm.
Below: The artist with early geometrical head,
ca. 1950. *Photo: J. J. v. d. Meyden, The Hague,
Holland.*

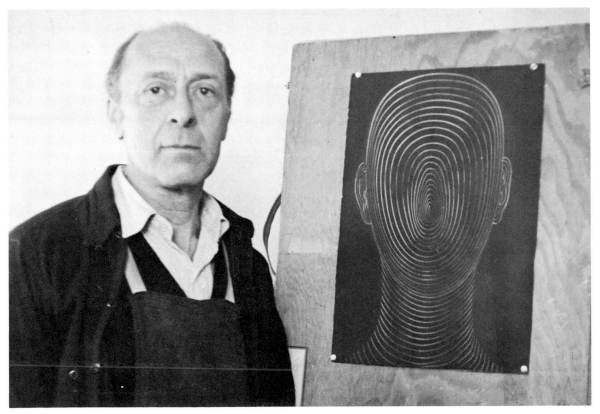

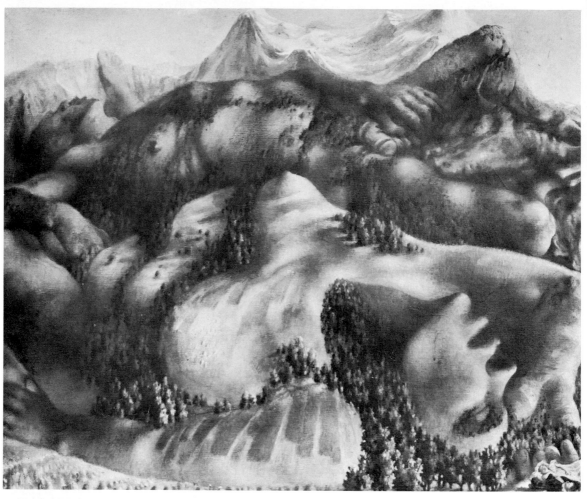

Above: TCHELITCHEW: *Fata Morgana*, 1940, oil on canvas. Collection Mrs. Zachary Scott.

Left: TCHELITCHEW: *Nude in Space*, 1926, oil, sand and coffee on canvas.

Below: TCHELITCHEW: *The Green Venus*, 1928, oil on canvas. Collection Mr. and Mrs. R. Kirk Askew, Jr.

The works on this page suggest the artist's chronic absorption with the figure caught and held in an increasingly complex network. He discerned a bull's head in his vision of the nasal labyrinth (*The Riddle of Daedalus*) and "concealed" a bull's head in the landscape of *Fata Morgana*, opposite page.

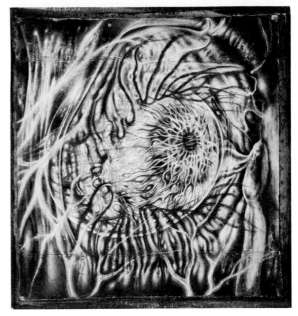

Above: TCHELITCHEW: *The Eye*, 1949, gouache. Collection Edward James.

Below left: TCHELITCHEW: *Portrait of Madame Bonjean*, 1931, oil on canvas. Collection Mr. and Mrs. James T. Soby.

Below: TCHELITCHEW: *The Riddle of Daedalus*, 1945, gouache. Collection Edward James.

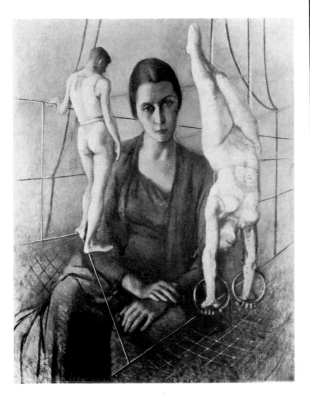

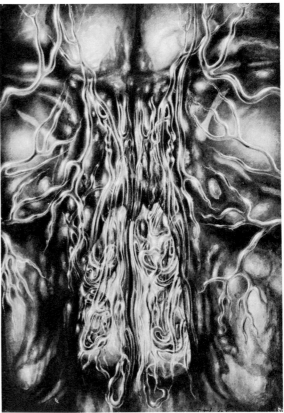

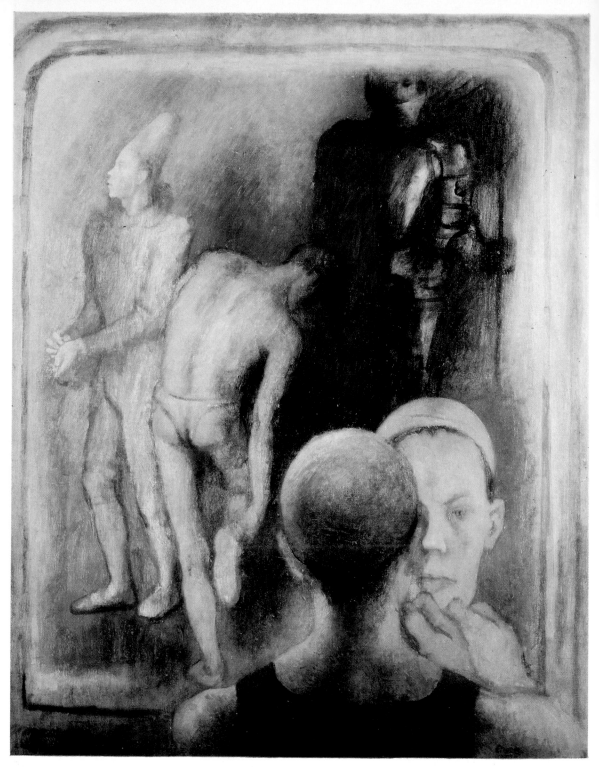

TCHELITCHEW: *The Mirror* (also known as *The
Dressing Room*), 1932, oil on canvas, 39¾ by 23
inches. Collection Mr. and Mrs. James W. Fos-
burgh. *Photo: Brenwasser, New York.*

TCHELITCHEW: *The Bullfight*, 1934, gouache, 40
by 28½ inches. Collection Charles Henri Ford.
Photo: O. E. Nelson, New York.

Left: TCHELITCHEW: *The Golden Leaf,* 1943, gouache. Collection Mr. and Mrs. J. Russell Lynes.
Below: Allegorical Figure of an Astrologer, engraving.
Below: TCHELITCHEW: *Study for Blue Clown,* 1929, ink wash. Collection The Museum of Modern Art, New York, Mrs. Simon Guggenheim Fund. The circle of the stomach became a corded drum in the subsequent oil painting.

indisposed, so that only Tchelitchew and myself, suitably outfitted, venture on a long walk to witness the wonder.

All but the little path we make with our feet is crusted snow and ice; every branch on every tree is a sculptured icicle and the sky itself seems a semi-transparent sheet letting in just enough light to make of the world the strangest of faint opalescences. Everywhere is an abysmally muted sparkle, grave and splendid, like a vast chorus of light far, far removed. We may be conversing about Spinoza or painting, poetry or Charles Henri. It doesn't particularly matter. Our own voices are a little distant, darkened by the thin steam coming from our mouths, but Tchelitchew's words, easy and for once perfectly contented and bland, themselves make a warmth, like an inner fireside: the heat of his heart is talking not with me, but with the genius of the cold.

Ford is now writing a prose work inspired by *Phenomena: Confessions of a Freak*. His sister Ruth has been doing some high fashion modelling and visits London with Tchelitchew and her brother to look into acting opportunities. Their mother, Gertrude Ford, has taken up self-taught painting and professionally adopts her maiden name, Cato. The magazine, *Horizon*, is being started in London under the patronage of the artist's friend, Peter Watson. On the surface, both Tchelitchew and the world around him are in high gear and going strong. There are threats of war but this does not deter Americans and others from going about their usual travels to Europe. Tchelitchew and Ford are now inveterate sojourners in Italy.

The artist's "housing" enjoys pretty steady patronage; in Santa Margarita Ligure, the villa comes with a cook, and even some food. During the pair's absences from New York, I am supplied with a stream of letters from Ford informing me of all matters of major and minor interest. They spend the summer of 1937 on Forio d'Ischia, where the Villa Belvedere is their residence. That name is somewhat deceptive because Tchelitchew will recall with a great pang, many years later, that despite the island's charm and a delightful summer, he always thought the houses on Ischia "are all setts [sic] for Minoan or Atridean tragedys." He will be galled at this time by the nemesis of great illness, but even in 1937, he experiences one of those revelations of omen that always perturb him. He and Ford go exploring the ruined castle on Ischia, which is reached by a stone mole. "I always," he will write, "had a terrible feeling of anguish in passing a certain long corridor before the entrance of the castle—I always felt as if I had been there before and something awful had happen to me then!" His feeling will be fully justified the following year.

At the beginning of 1938, the portrait of Constance Askew is added to that of Kirstein and Ruth Ford. These, with some of Charles Henri, are given a show at the Arts Club in Chicago. Actually, ever since London so much

broadened Tchelitchew's field of operations, both the Continent and the United States have seen shows of his in various leading institutions. In 1932, one took place in The Hague and another at Vassar College; the following year, the Salon d'Art Contemporain in Antwerp housed a group of works. Of course, Levy, his dealer, is giving him New York exposures whenever new work is ready. Arthur Tooth and Sons, London, started holding shows for him in 1933, and on June 16th, 1938, a three weeks' exhibition of *Phenomena* and related works begins at Tooth. It is hardly over before another lure from the theatre snares him and he is busy on designs for Massine's ballet about St. Francis, *Noblissima Visione,* using Hindemith's orchestral work of that name; the title of the ballet, in the United States, will be changed to *Saint Francis.*

The stone wall against which he paints in *Phenomena,* like an accumulation of the rocks on certain beaches of his experience, seems to haunt him. Rocks, of course, as burning and sharp, hurtful to the naked feet, make a valid appurtenance of Hell and are a universal symbol of poverty and hardship. A soldier's suit of mail, in the *Saint Francis,* becomes a trompe-l'oeil stone wall. Similar walls flank one of the sets for this ballet and compose a balustrade past which, far below, is a coastal landscape recalling certain of Leonardo's bird's-eye views. In *Phenomena,* the prison, top right, is of bricks; fortress-like, prison-like or conventual effects of this sort are due to appear over and over in subsequent works. In a sketch for *Hide and Seek,* a brick wall will appear amid the tree's branches but vanish in the work itself. Associating this plastic element with the visceral obsession of Tchelitchew seems unavoidable, especially since we are on the threshold of the summer he spends in Dubrovnik, Yugoslavia, where he contracts the fatal diarrhea that will plague him for the rest of his life.

At this time, despite an unusual degree of suffering from what may be a routine complaint of travellers, Tchelitchew does not suspect that anything "fatal" has befallen him. For years he has longed to see the Dalmatian coast. He, Ford and the poet's mother are united in their enthusiasm over the climate and its spectacles. Though inwardly smarting on the subject of *Phenomena,* whose New York showing is now a few months ahead, Pavlik has little reason to complain of his professional opportunities; in fact, he has had an overture from Orson Welles to do a play with him. The St. Francis ballet has been given a sumptuous production, Massine himself dancing the title role. The first night in London is a resounding success despite the banal reactions of the newspapers.

Ford writes me: "There were 21 curtain calls, screams for Tchelitchew who was dragged shyly onto the stage twice; then Alice von Hofmannsthal, Edward James and I went backstage to kiss him (there was one more ballet, the Bérard-Beethoven, to come) and the Russian-Jewish promoter yelled at

us to get off: I told him to shut up and he wanted to have us PUT OFF, called, 'Call Boy!' Alice said to Pavlik we've been insulted, whereupon Pavlik, already disgusted for many good reasons with said promoter, went into a barrage of Russian, mostly curses, beat the man's fat face with the ballet program, said he would never again set foot in the theatre and he didn't. We got a taxi and home to bed. Lights out: came a scratch on the hotel room door: Edward: rather bewildered to find Pavlik in bed before midnight with 'everybody' in London talking about his triumph, going backstage after the whole thing was over to congratulate him etc: Lady Cunard, Sir Kenneth Clark, Lady Juliet [Duff], Lord Berners, Baron de Gunsburg, and others . . . But I must say the balcony loved it too."

The very condition of humanity, poverty, which in *Phenomena* wears so hard, bleak and sinister a look, is sublimated in *St. Francis* by theatrical means and the nature of the theme. Poverty is Lady Poverty, a charming ballerina whose costume is a coarse dress full of gaping, perforce rather suggestive holes. But such a problem of taste, when close to the edge of aesthetic impropriety, has a morbid attraction for Tchelitchew, and he conquers all difficulties, as usual, by going straight to the point. The pas de deux between St. Francis and Lady Poverty, within its balletic convention, is tacitly, impeccably chaste. So are all aspects of the production's style.

It happens that on this visit to Europe, Miss Sitwell is in mourning for her old governess. With unflinching eye, when in London, the artist inspects the voluminous black gown being worn by his friend, thinks it badly cut and informs her of his opinion, adding as if for a clincher, "It makes you look like a giant orphan." The lady's gowns have become a permanent issue for Tchelitchew and will never cease concerning him so long as she is in sight. To some extent, his is the viewpoint of all artists: everything, and especially mourning perhaps, should be done well.

At moments of private self-inspection, Tchelitchew keeps telling himself that he should mark down *Phenomena* as having accomplished, after all, one essential purpose. It did shock a number of people and earned its bread, so to speak, in terms of publicity value. In New York, it is heralded and followed with double-page color reproductions in leading magazines; the fact that in one instance, on the reverse side of the page are some especially inane fashion drawings (also in color) by Bérard causes the artist to reflect on what seems the profound disparity of their respective artistic destinies. Tchelitchew is not at all the sort of celebrity who starts a feud with the press; he makes sure of being on his best behavior, whatever he may be feeling, when cast for a passing role in the public eye. Yet journalists and even high fashion editors can be awfully trying. Who would have dreamed that the notes of a *Life* reporter interviewing him could produce the epithet for him: "a nervous little man"? Nervous, one can allow. But "little"? Tchelitchew will never

look stout, and as he never looks shrinking, it is hard to imagine the circumstances (since he is slender and of average height) under which he would impress anyone as "little." Finally, Pavlik lays the epithet against the "hump" in his back; that is, the chronic stoop that tends to get worse despite his setting-up exercises and sessions with his chiropractor.

That Fall, he starts taking medicine for what generically is diagnosed as colitis and correspondingly begins his dieting regime. By him, at table, is a little bottle containing a clear fluid from which he counts drops into a glass of water. The illness depresses him and he starts thinking seriously of having a complete horoscope made by an extraordinary woman astrologist mentioned to him by a friend of Miss De Lamar's, Peggy O'Brien, one of the many women for whom, now, he is becoming paternal adviser and gossip.

It's odd! Could he be growing old? He is becoming a Byzantine Papa to everyone, to the ballet boys, to bevies of ladies who could be, as to age, his sisters. The "good wise old man." Why, it was only a few years ago that he was sitting at Anna Ivanovna's feet like a son, then at Gertrude Stein's, and after that, at Rachel Gorer's. Of course if one stops to count . . . His hair is much thinner than it used to be: he noticed it just the other night before retiring. Every evening now he administers a furious brushing to stimulate its health. Ah! look at Charles Henri: nobody can be young beside *him*. Who, in the whole world, is younger than C. H.? "Probably Charlie is eating me . . . What if——?"

Invariably, these days, he is torn between the conviction that he suffers from some mysterious microbe and the fear that secret or known enemies are directing magic against him. C. H. does not hate him but then even vampires can be said to *adore* their victims. Now seriously: Is it possible that *Phenomena* has really made him enemies from among his own circle? He is making a point of being extremely nice to his old colleagues from Paris. He has begun speaking again to Genia Berman, and when Léonid arrives in New York, he recommends him in the heartiest terms to Kirk Askew. Indeed, to Léonid, it seems nowadays that Tchelitchew is more overwhelming than of yore.

Pavlik plans another big chef-d'oeuvre and has determined it will have, beyond question, all those charms and graces that were mocked in *Phenomena*. This will be a tour-de-force that *cannot* miss. If he now paints a "tiger" portrait of his father, meshing the animal's head in a wintry landscape seen on his walks in Connecticut, it is partly to escape the persecuting single dimension of the Society Portrait. Few faces interest him so much that they are a study, and a beauty, in themselves. If the head of Esmè O'Brien, Peggy O'Brien's daughter, attracts him enough to do a fantastic silverpoint of her, her hair twined on twigs which are blossoming with jewels, it is because she seems to him a "young druidess of the spring woods." He realizes that

associating persons with animals and the forest itself has become an independent drive of his fingers. He wishes to make friends again with all the elements of the natural world which he showed out of whack in *Phenomena*.

Conceivably, Mrs. Nature in her role as the goddess, Isis, has been offended by his audacity, his wicked witticism at her expense: so dry, so detached, too "occult" maybe. After all, goddesses have a certain "divine simplicity," not to mention the common vanity of all women. Not yet is Tchelitchew a perfectly committed hermetic. He feels a fatalism in all the mystic influences in his work but the precise function of these influences is still unclear, insofar as it is in process. The apparent solution, he thinks, is to put himself in a mood of complete sympathy with the natural environment, to perceive all its most complex, its smallest, harmonies; never to be afraid to turn the search *inward* . . .

As in *L'Errante*, as in his career, he has gone forward, forward, forward! But this, he now sees, can perhaps be futile, even tragic. The "restraining forces of earth"—let them be shaken off! There was always something wrong with Tilly's long train. It was heavy and opaque, though shining. Once the greasiness of oil paint offended him; so he disciplined it with sand. But larded sand discourages the transmission of light. Suddenly he feels a new passion for all the transparency with which his art, his theatre art, has played in the past, with whatever seems to light up *from within*. All those multiple objects, multiple views: volumes modified by time . . . The solution may not lie in the multiple, no matter how much "simultaneity" or "laconism" is involved, may not lie in the dense impenetrable volume, but with—

His thought breaks off.

He feels scissors in his hand and sees the defenseless figure of the toy Harlequin he mutilated so many years ago: the one his poor dear Nanny so carefully stitched up, and so uselessly, for he threw away the Harlequin after a passion of sobbing over his ruined body. Yet life, he vaguely apprehends, has its own therapeutic method of assuaging such remembered pain, such traumatic young crises, which mix grief with a profound, viewless revelation that stuns momentarily; life has a way of secretly *resolving* them. Some kind white shadow passes before the inner eye, some thick white sheet, gently forcing us to look immediately ahead into the world, where the future grows like a branch with the apple of the eye large and larger on it . . . Blindness is part of the genius of seeing as forgetfulness is part of the genius of memory. . . . Of course!

Nobody knows better than this artist how necessarily blind we are, moving from point to point, hour to hour, of our lives; how this blindness is virtually a condition of our survival—this body-faith. It is like the very blood, that seldom sees the world but is an inner tremulous fantasy clasped to the tree of the body. And he sees the little girl of his past, the one who died, strong and

alive, blonde hair falling on her shoulders, pressing her face, her whole virgin body, against that actual tree . . . the one he discovered at West Dean and drew . . . It is now autumn and leaf-boys flow from his pen and brush, a flood of turning leaves, young and sere, crisp and flushed, sappy and crackling, afire . . .

The tree itself is shorn, utterly naked, naked as the newborn. It looks forward to rebirth, does it not? Leaves, the leaf-boys, actually grow from his hand; so quite naturally the hand, his own hand, is a tree, and his foot, that also leaves its passing print in sand, this too is essential, organic; the tree in his mind will not be *two hands*, one resting on the ground like an acrobat's—no, it seems better now to join the reaching hand to a planted foot. The tree-climbers, the children, will play hide and seek about this magic tree: the one at whose foot will be found the eternal life of a great hero, the blue fire of the Magic Fern. Its central form is an Easter Egg: token of resurrection; as a gem, it is the Philosopher's Stone. He thinks of Edith's brooch . . .

Has he not always said that he is the Faithful Knight who sets out in quest of the Fern? Well, he has found it! He is already at the spot. Now: now he must "dig." So Nyanya used to say and beyond question it is so . . . on a dark moonless night on the eve of the birthday of St. John the Baptist. That is as it should be. Why not? He must be ever so careful so as not to injure in any way something so preciously delicate as a fern . . . Ah! as if the whole world did not have a fernlike delicacy! And the fragility—yes, the fragility of an eggshell!

He is at the very edge of a tremendous precipice and has no conception where he is any more. Neither darkness nor light is around him: only a clustering endless nothingness. Dizziness assails him. For a few rigid moments he is intensely nauseated. Oh, it is the sickness, the perpetual sickness! Will he never be rid of this curse? *La chute, mon cher! Infiniment, la chute!* "I could scream and yell, Charles Henry, do you understand? I could scream and yell."

But he doesn't. Not yet. Not quite.

Then, early in 1939, his old friend, Louis Jouvet, telegraphs him from Paris that he wishes him to come over and design a production of *Ondine*, Jean Giraudoux's play. The voice of glamor has come all the way across the ocean to call him. Jouvet represents the best in the French theatre: the essence that is Parisianism: the high, high style. It is the acme of prestige to work with him. So he cannot dream of refusing and immediately wires back acceptance. Ah, now Bébé will be positively green, sick, *sick*, like a deflated balloon— with a beard! For some reason, he remembers that time at a cafe, years ago, with Genia and Léonid and Allen sitting there. A terrible spitting argument has started between Bébé and himself.

He has said something terribly mean and cutting—what could it have

been?—he only remembers Bébé's flushed cheeks, their fat almost concealed by the bushy beard, the infantile eyes protruding and tears of hurt starting; he has jumped up, furious, spluttering, trying to utter his retort—he cannot because in jumping up he has upset his glass of beer and inundated the whole front of himself; it drips down his beard, his lap is soaked. Nobody can do anything but laugh. They are literally convulsed. It's like all the times when weak pathetic things are befooled and bewildered, overcome with humiliation, petrified. Bébé's audience, for once, doesn't respond to his hysterical pose as the outraged victim. Everybody opens his mouth as wide as possible and lets his lungs thunder out his cruel, crushing amusement. All personalities are submerged, dissolved, rinsed out in the heroic purge . . . Such is life . . . That was one on Bébé!

And *Ondine* will be another. Bébé's fawning coterie (including that treacherous Cocteau) will be stammering and shaking and wild, attempting to console him, lying to him . . . Leaving the United States by ship (for he is not yet reconciled to flying), the artist poses for a news photograph at sailing time. He has made it. He has made it! Around his heart, a curious nagging little emotion wanders nevertheless. For he is taking over *Phenomena* to be shown in Paris. Frankly, he has not too much hope for it. It is insolently unstylish, and that is the first thing, of course, the French will notice.

Phenomena receives markedly little critical attention. *Ondine* is a smashing triumph. Thomas B. Hess, who is no Tchelitchevian, will tell me long afterward that nothing in the theatre ever seemed so visually beautiful to him. The costumes have sumptuousness urged into a fine, inwardly held fantasy. Nothing is elongated or inflated: the touch is authoritative, stylish and yet, as usual, bold. At least he has shown Paris that in the theatre he is supreme, acknowledges no superior. Jouvet has been a dream to work with. And he, with Madeleine Ozeray (the Ondine), have come around to Chez René Drouin, where *Phenomena* is being exposed, to be photographed with him in front of it. The long reviews of the play never fail to heed the extreme effectiveness of the setting in all respects, most bestowing praise, some expatiating, others claiming to be unable to find words. It is hard, of course, to compete directly with a Parisian combination like Jouvet and Giraudoux. But Tchelitchew's collaborators and an inner circle of Parisians are well aware of the great worth of his contribution. More than that, he has regained the friendship of Henri Sauguet, composer of *Ondine's* incidental music. A decade before, Sauguet brazenly deserted his personal cause to become—as he called him at the time—a follower of "Mathilde," his private nickname for Bérard.

According to Ford, *Ondine* has more variety and color than anything Tchelitchew has done to date. It denotes, remarks Donald Windham, the artist's "growing preoccupation not only with the sources of light but with

the beginnings of all life and the basic structures of nature."* Explicitly, with irrepressible wit, Tchelitchew has borne in mind "1914 pomp and circumstance," ospreys, trains, tassels: a pre-World War I paradise. This viewpoint helps liberate him into a truly fairy tale fantasy, where the very freedom to invent imposes a delicate impulse of restraint. Enormous bones, from which fishnets are draped, roof Ondine's hut by the sea. Male costumes in the court scene suggest animals, female costumes birds and fish. The casual wandering branches of coral for the backs of thrones echo the effect of transparency given by the roots of trees in *Orphée*. In the court scene, thick mother-of-pearl columns look luminous and at one point, lighted from within, become ominous swirling cascades of water; at another, they reveal mermaids who call to Ondine and then return to the opacity of stone. Tchelitchew is orchestrating his colors for the alchemic metamorphosis of *Hide and Seek*. Not only is there a shift in *Ondine* from rock to water and back, but also a seasonal transformation; in the background, "the hills [again to quote Windham] become heaps of dead animal bones, and the great rivers pale into frozen tree trunks." Exactly this last effect appears in the tiger's head portrait of the artist's father done this same year.

Charles Henri Ford collects an enormous scrapbook of clippings about *Ondine* and also describes for me how much the papers have raved. Now the play is breaking box office records for all the Paris theatres. Cocteau has attended, Ford says, and come away "rapt," vowing to write a fairy tale himself. "—but Pavlik," Ford continues, "spurns his love." The critic Leon Kochnitzky, another Russian friend of the artist, is the first to burst into applause (as audiences never fail to do) when the curtain for the Second Act rises, and happens to disturb a stout lady sitting in the row ahead. Silently she turns to cast a majestic look of reproach at him. Of course, she has already been spotted by Kochnitzky. It is the ex-Sibyl and former friend of our hero: Gertrude Stein. Tchelitchew's comment to Kochnitzky: "She's such a MEAN PERSON." Marie-Laure, the Vicomtesse de Noailles, who now sends ready smiles in Pavlik's direction, "goes," reports Ford, "every night" to *Ondine*. Literally thousands, he also tells me, swarmed in to view *Phenomena* at its unveiling, which took place a few nights after the play's première and lasted till two in the morning. His friend believes that Pavlik is prouder than on *Ondine's* first night. The painting is dramatically spotlighted at the end of the long, high gallery, and the only other light comes from one huge candelabra "—just like," the artist says, "the fête scene in *Don Juan*."

The summer is spent by Ford and Tchelitchew, with the former's mother, on Lac d'Annecy, St. Jorioz, where the artist continues coaching Mrs. Ford in her painting. They now have family discussions about Ruth Ford's stage

* Donald Windham: "The Stage and Ballet Designs of Pavel Tchelitchew," *Dance Index*, III: Nos. 1, 2, Jan.–Feb. 1944.

career or, as Pavlik interminably calls it, *carrière*. Ford has written me that Edward James (now divorced from Tilly Losch) has been attracted to his sister and may propose marriage. "They are," he has declared, "like that." Nations over the world, however, are decidedly not like that, while leaders of government, notably Hitler and Mussolini, are thinking just as exclusively and familially of their careers. Inevitably, between acts at *Ondine*, the conversation is partly devoted to the threat of German militarism, revived by Hitler in 1935 when Tchelitchew began his own conquest of New York.

In March, 1939, the Germans have occupied all Bohemia and Moravia, while Italy, that April, has seized Albania. The other great European powers, Great Britain and France, have been temporarily engaged in appeasing the aggressors. But on Sept. 1st, while Tchelitchew's party is still at Lac d'Annecy, Hitler invades Poland and two days later, England and France declare war on Germany. At the news, there is a profound vibration in Tchelitchew's organism. Not that he has waited two days to move. No, they are already in Paris, trying to get passage to America. The great plastic distinctions and the mystic laws of being alike melt and flee from Pavlik's presence, ignoring the boundaries of his flesh. There is only one reality: La Chute. And his bowels, as if made of clockwork, respond.

Europe at the moment is anathema and every passing divination which has seemed to confirm the prophecy of the Kiev Staretz arises and overwhelms his mind. Charles Henri was right. He was always right! The capitals of Europe have been just temporary refuges for the White Russian exile, cast out of a country whose hostile spirit had determined to persecute all true artists. Not so much revolution per se, but war—war is the artist's natural enemy! Getting from St. Jorioz to a seaport and on shipboard is one mad scramble for him as thousands of others are making the same attempt. He, Pavel Fyodorovitch, is not an American citizen (though he has resolved to be) but Charles Henri and his mother are. Still they could not have sailed so soon, probably, except for Giraudoux's prompt action in arranging their passage. They have crossed the ocean with almost magic rapidity, considering everything. Tchelitchew, a guest at the Shelton Hotel in New York, is able to write Edith Sitwell, whom he has had no chance of bidding goodbye, by September 8th.

This, the first letter of a correspondence that will last virtually ten years, is the only one in French. In his fright and excitement, he has forgotten that his friend prefers corresponding in English. It is as if he had never been in this city or this country before. "My dear Edith," he says, "Here I am in New York, a terrible shock to find again such a sea of insensitivity and mediocrity - the women above all - who are dreadful - and the men no better. The Gorers are here, 'very hurt' that I did not see them immediately, while I did not even know they were here! People ask too much of us without giving anything -

there is nothing more deadly boring than old friends - above all since one has nothing to say to them . . . I wonder which is best - the *war* - as Europe looks forward to it, with dread - as a thing terrible inexorable and destructive - or *peace* which is just as inexorable and hard as the former. My letter is lugubrious - like the state of my spirit - and I am desolate not to be able to say anything better, but I scarcely understand even what I say - or what I do. I know that this horrible city New York is killing me slowly - with its noise - its mad rush and the insensitivity of its people . . ." He closes briefly, with an embrace and love, after announcing that he is going at once to Weston.

The calamity of the war has wiped the slate of Europe clean in one fell swoop: it is no longer a field of operations, no longer a place where glamor offers room for him to flourish. He has rushed back to this country, where he has many friends, only to become, quite literally, the reigning prince of his own peculiar state of paranoia. Under the allusive, compulsive intimacy of the above-quoted letter lies, of course, the bugaboo of once more applying the whip to his dealer, Levy, whom he autocratically considers sluggish and irresponsible. He is particularly disturbed at the moment over a wrangle with one of his leading collectors about a painting with which he maintains he has absconded, since it had previously been promised to another.

It would be hard to deny an allegation that much of the above letter to Miss Sitwell, aside from its undoubted symptoms of persecution mania, shows simple bad faith. Like an ominous ghost, Gertrude Stein's charge returns that Tchelitchew always wishes before everything to "use" his influential friends. But insofar as there is truth in the charge, its quality and origin are plainly revealed by his direct, spontaneous words themselves. The emotion of insecurity has as heroic a stature in Tchelitchew as his most ambitious artistic projects; in fact, the latter correspond to it as if they were seen in a distorting mirror at Coney Island. And he is far too earnest about life to pretend, to the slightest degree, that the monstrous truth is otherwise. The "imagination of disaster," that human faculty to which Tchelitchew has a sovereign personal claim, is in high gear if only from the suggestibility of war's expected disasters. His being moves, like that of every artist, through a landscape of the mind; it is simply that in Tchelitchew's case, posted disconcertingly on every road, for all to see, is an official legend: *Caveat Emptor.*

From his next letter to Edith Sitwell, three weeks later, it appears that he feels he has left Europe in such haste that—while he can't expect people to comprehend it—he imagines he must still be there. His English grammar conspires to create the oscillating reality: "—it is very difficult to understand that one had left most of what his life was there and nearly $\frac{1}{3}$ of my work." He cannot deny the brute fact that he is cut off now as never before from his sister, his family and his friends, as well as from his own past and its feelings. For the moment, he quite forgets his supreme adage about looking ahead and

never behind. In a few sentences, however, he recovers his presence of mind:

"But here people still leave [live] in peace - amuse themselves - are gay and merry and one can hardly believe that on the other side of the ocean there is a terrible struggle for culture against new barbarism. What can we do - we have to think - to work as if nothing would happen - *we are the barometers of the epoch* [his italics] no one needs us but the [sic] history will probably read in us the level of the cultural state of the country." By a flourish of his wand he has converted both genuine and merely pious despair into the artist's call to arms. He is back in business. The fact is as gross and terrifying as the phrase expressing it . . . Macabre, too, for in his next letter to Miss Sitwell, he speaks of his room at the Red Barn as like "a witches' room" because it is full of the autumnal branches and leaves he is drawing. "They slowly die," he writes, "but I see them shrinking like a dead man's hand trying to protect the last warmth and life in them [selves]." This letter includes a moral postscript on *Phenomena*, which he protests has made Parisians more sensitive to his work as "the prophetic picture that everyone hates and everyone has be-spitted." In a few months he will be informing his friend that people tell him how much *Phenomena* has done for his reputation; it seems it earned, after all, some "good criticism."

Like the tirelessly resourceful craftsman he is, he goes forward with his next large work. Another "witch," nevertheless, haunts his rooms, the So-ciety Portrait, hale and hearty as life itself. It is as if he had not consigned it to Hell in *Phenomena*. With the resumption of his colitis and new agonizing sessions with doctors, he seems worse off than when he portrayed his mood in *Phenomena*. Yes: to be sure: his visit to Dubrovnik has intervened. As if things were not bad enough, he will speak to Kirstein of "brightening up" *Phenomena* to make it more appealing. Now that he has gone back to nature with anthropomorphic skies and palpitating autumns, there is no brake on the inspirations of his palette. Once more, bright saturated colors will be used to shock and overwhelm.

In 1940, two important moves take place, inspired career-wise largely by considerations of Ford's desires and the artist's own working interests. Both men are a bit bored with the Red Barn. It hasn't much guest space and the community out there is always the same ladies. Moreover, the ceilings are too low; Pavlik never gets quite enough light to work by indoors and conse-quently his eyes have been suffering. There is always an evil coefficient to the very virtues he is exploiting. His myopia, as he says, helps him to examine things so closely that they take on phantasmal changes of identity. Poor optical conditions, however, promote tired and listless eyes, which may cause one automatically to "see double." He experiments and finds the eyes have to collaborate to focus on the single image. Always Tchelitchew turns to an organic and subjective explanation of applied plastic devices; the optical

overlap and its shifting transparency have a mechanical explanation; it is not just an invention of drawing, a casual mannerism of sketching; nor is it, necessarily, a product of myth or symbolic thought.

Charles Henri's voice always interrupts his reveries and brings him back to crude, merciless reality. Well, they will move to New York City as C. H. wishes—but to a large airy apartment where he has perfect working conditions! It will cost something but this year, because of the war, they won't be tempted to spend the summer in Europe. Repeating Tanner's old function, Ford has discovered a beautiful penthouse studio on East 55th St. with very high ceilings and a pleasant room for himself at the other end of its hallway. The apartment boasts a wide terrace its entire length with Pavlik's big studio on the corner, getting northeast light. He is frightened by the rental although it is a great bargain by later standards. For his part, Ford is not merely eager for the amusements of city life. On the contrary he wishes to start a magazine, an international magazine that will exploit not only the best avant-garde talents in America but the many modern artists who have come here to escape the European war.

Besides Tchelitchew's old Neo-Romantic colleagues, there is a large Surrealist contingent here, both writers and painters, nearly all of them known to Ford and Tchelitchew. Matta (Echaurren) is already here; so is Dali. André Breton, Max Ernst and Yves Tanguy have soon appeared, and a young Greek, Nicolas Calas, a protegé of Breton. The late Kurt Seligmann, an independent Surrealist, begins a warm and lasting relationship with Tchelitchew. Seligmann knows enough about the background of magic to interpret Tchelitchew's big masterpiece, the Hell, but it is likely that professional policy, if nothing else, prevents his taking on the responsibility of being Tchelitchew's exponent. Marcel Duchamp is another modernist in the United States. He was long ago internationalized, spending much time in this country during the First World War and later.

Before leaving Europe, Ford has been drawn into Breton's politically radical FIARI group, planned as a world organization, and has written me enthusiastically of the new bloc of art and politics. This is when Paul Eluard and Louis Aragon split from the Surrealists on the issue of supporting the Soviet Union: Breton maintains a Trotskyist orientation. The locale of America somewhat alters the FIARI perspective, but to Ford's advantage. With high confidence, he starts *View* as a "newspaper for poets" and plays down the political angle. The "newspaper's" original tabloid format soon turns into a small coated-paper magazine that takes advantage of the presence of Tanguy and Ernst to issue special numbers on them; Tchelitchew shares an issue with the former. Ford interests some wealthy friends of the artist and *View* becomes a non-profit making corporation with shareholders' stock.

The young poet's practical vision grasps the strategy of making a cultural

popular front between fashionable transatlantic elements and neglected aspects of American talent. He has been disappointed, too, that Peter Watson, *Horizon's* sponsor, has placed editorial control in the hands of Cyril Connolly, whose taste fatally goes Auden-wards. Within *View's* range are all the native affiliates corresponding to the imaginative sources approved by Surrealism: self-taught, fantastic and naive poetry and art. I am enlisted as associate editor of the magazine, and one of our first issues is titled Americana Fantastica, with a collage cover by the still obscure Joseph Cornell. The given fact is that Tchelitchew, without wishing to do so, has allied himself in the mind of the American art public (all art publics being unhappy without neat categories) with Surrealism. Indeed critical distinctions over here, even of the expert kind, are short on delicate definitions and nuances of taste, if only because there is so strong an undercurrent toward a new expression of abstract tendencies. While connoisseurs everywhere prize painters such as Redon and Chirico, their influence on major American painters has been virtually nil. Abstract Expressionism is about to burst upon the world. Hence Ford adopts the tactic of exploiting, in Tchelitchew's behalf, the one school, aside from Abstractionism, which has made a dent in sophisticated American taste: Surrealism. Tchelitchew will never outlive being called a Surrealist. Moreover, his dealer, Julien Levy, has been showing Surrealists rather consistently at his gallery, having been the first to exhibit the boxes of Joseph Cornell and the paintings of Matta and Dali. If the latter is taboo'd by *View* it is not because of Tchelitchew's amiable feud with him but because he has run afoul of Breton's purist aesthetics.

In 1938, when Levy moved from his Madison Ave. gallery to smart quarters on 57th Street, I wrote a little preface for Cornell's first show. Two years later, Ford is convinced that my destiny is to be an art critic, and that in this capacity, as friend and admirer of Tchelitchew, I can be ideally, indeed indispensably useful. Besides, I have a talent of sorts for typography. At least, Ford delegates this function to me when *View* graduates into its large format in the spring of 1943; he is too busy organizing and editing the magazine, which of course cannot afford a professional layout man. Ford and I still have our minor literary differences and he is not interested in my poetry. But my lyric prose impressions of Tchelitchew's masterpieces are very welcome in *View*. The Tchelitchew issue has contributions on him by Kirstein, Soby, William Carlos Williams and myself.

In the vast history of the American little magazine, *View's* formula is destined never to be duplicated. We cover the arts, are lavishly illustrated and try to combine luxury with the avant-garde. The nearest equivalents are European: *Minotaure* and *Verve*. Tchelitchew has nothing to complain of—he is rather proud of Ford's initiative and gift for organization—until shortages in the magazine's funds make small raids on his own purse; however,

from 1943 to 1947, we make out mainly on our circulation, expensive ads (from Helena Rubinstein for instance) and shares occasionally bought by big-hearted patrons. Especially the advanced art galleries, regarding *View* as a legitimate publicity medium, collaborate with us by advertising; Sidney Janis and others are enthusiastic about it, Janis and his wife even contributing articles: one is about the Albright brothers. Ivan Albright's baroque naturalism is "*View* style"—anything stylish is *View* style except Abstract Expressionism. Harold Rosenberg and Lionel Abel, who as poets appeared in Ford's old magazine, *Blues*, become contributors of literary criticism; two Negro naïfs (one of them serving a term for manslaughter) join our roster of native exotics and primitives. We print Chirico's autobiographic prose and Mario Praz's criticism. We have a Belgian Surrealist issue, a Latin American issue, a Paris issue, a British issue, a post-war Italian issue. Our covers (in color except for a Man Ray photograph) are by leading exiled and American modernists: Brancusi, Calder, O'Keeffe, Léger, Duchamp (to whom an elaborate issue is devoted), Tchelitchew, Seligmann, Noguchi, Jean Hélion, Léonor Fini, Estéban Francès.

No modish school of painting or sculpture is unrepresented in *View* if only because of the full-page advertisements that usually have large reproductions. Even Jackson Pollock (whose work Tchelitchew abhors) gets a painting of the early 40's into *View* through an ad of Art of This Century, Peggy Guggenheim's gallery, where she houses her permanent collection and gives shows to promising young Americans. Besides, we are in her good graces through Tchelitchew, whose work she openly disavows but whom she likes personally, and also because one of our small format issues was devoted to her husband, Max Ernst.

Ernst and Tchelitchew also get along together. The latter's easy worldliness and personal charm make him agreeable to a number of Surrealists, who also appreciate the theoretic side of the "popular front." Particular friendships are cemented with the young Matta (whom Pavlik sets out to subjugate), André Masson and Yves Tanguy. Tchelitchew's artistic taste, in fact, is genuinely eclectic; he is very taken with Tanguy's chaste scrupulous style, which he thinks of as supremely French. Another friendship with a European painter, likewise an enduring one, has begun when Tchelitchew and Ford returned from Europe on shipboard in the summer of 1937. Léonor Fini, whom Ford has met previously, is another passenger, now making her first trip here.

Mutual chords of sympathy immediately sound between her and our hero; they both love high style in society and art and are unafraid of being considered snobbish or spiteful. In some obscure but potent way they also suit each other as man and woman. While not a Mister (as Tchelitchew loves to call all cats), she is exquisitely feline. Rather than the artist's Vittoria Colonna, she is by way of being his Heloïse minus the personal difficulties.

Mlle. Fini, French by adoption, Italian by birth, sibyl and odalisque by inclination, easily fits into the organism of the Total Tchelitchevian.

Others, however friendly, must function as fringe tentacles of this organism. Neither Tanguy nor Ernst flatter Tchelitchew, or vice versa. Our hero is not a type who exacts flattery on any extreme condition. Polite enthusiasm, the exchanged compliments of the salon, of course, are a different affair. Personally, I never get used to stupid conventionalities of that sort yet Tchelitchew rebels against them only when quite riled and bitter. My two friends regard my moral rebellion in this field as a provincial tic.

Tchelitchew's worldly attitude of amiable tolerance is no mere professional policy, though it takes some impetus from *View*'s policy of making a popular front in the arts. Adopting the really broad stand, he believes in the virtue of solidarity among artists. The anti-Stalinist orientation of the times really impresses him and he respects Breton for breaking with Aragon and other Communist leftists. When *View* begins and Tchelitchew really makes New York City his permanent home, it is in America where his relations with other artists and with culturally enlightened society reach their most pervasive, stable and happy state. It seems as if the very crisis of the war, with its implicit threat and uncertainty, emphasized, gave extra motive to his tremendous capacity for forming social liaisons with a professional tinge.

To term this occupation "arriviste," a la Stein-Toklas, is, to say the least, puritanical. Despite his nagging illnesses, chiefly the colitis, and a looming rupture with Ford, our hero's powers as man and artist are now at their peak. His most daring artistic act, the ostensibly Surrealist *Phenomena*, is behind him. In a way, he rests his artistic past on it; in another way, he must cancel it, redeem himself; it is not a dead-end, for he still has lots of creative sap; rather it is a precipice he has encountered in the progress of his Divine Comedy, faced squarely, inspected and recorded, only to avert himself and go off on a tangent.

The form taken by his "practice art," his sketching, is typical of him and peculiarly radical. While he preserves his drawing skill with beautiful silverpoints (mostly portraits), while he draws and paints trompe-l'oeil subjects with children, leaves and wheatspears, while the epic proportions of *Hide and Seek* germinate, he also engages himself to the fluid mysteries of a Rorschach-like art of picking out a miniature universe of disparate images (most of drawing-pad size) from spilled and coaxed ink and dripped watercolor. With the spellbound wonder of a Leonardo he is formulating his boyhood pastime of seeing figures in the clouds; a number of highly skilled and evocative drawings result. Without quite realizing it, he is also experimenting, more specifically and more freely, with the human earth he first posited as an ideal in Paris; it is now being prepared for its last serial metamorphosis.

There seems to be no intellectual movement in modern painting that Tchelitchew will fail to grasp, encompass in some manner of his own. It is

in the respect in which modernism is a synthesis of the past that Tchelitchew is pan-plastic. His casual metamorphoses are but the universal ground of all plastic discovery of equivalence of structure in nature. In the caval "tree," with its aortal "trunk," Vesalius automatically revealed the whole organic human figure down to the hands and feet; thus, with spontaneous accuracy, Goethe also recognized the tree's organic pattern in the single leaf. Both these images, so widely separated in the organic world, are venous in character and both are metaphors of organic growth; likewise: the spiderweb structure of *Hide and Seek*. Only by situating himself intellectually at the same viewpoint, that is, where a seemingly elementary structure in nature has a ready-made series of allied components (more complex than itself), could Tchelitchew have conceived the multiple plastic references he will build into the basic pattern of *Hide and Seek:* the prehensile tree with its fixed nuclear center.

It is by its program of total culture, precisely, that *Hide and Seek* will so significantly isolate and raise itself. Our metaphoric heritage was brought to its high literary point by the Symbolists, especially Mallarmé, Valéry and St.-John Perse, but more than that, it was given a major erotic inflection by Freud's dream analysis. Joris-Karl Huysmans, a Symbolist in the novel, wrote a fictional autobiographic trilogy (*Là Bas, En Route, La Cathédrale*) which follows the outline of a Divine Comedy. Huysmans, even as Tchelitchew, is an artist compounded especially of German and French influences. What will disgust Andrè Breton with Tchelitchew is exactly what Huysmans grapples with in the ordeal of sloughing the empire of the carnal. This ordeal means a direct confrontation of the ontological structure allying organic life with psychic experience. While not so "agonic" as Huysmans or Tchelitchew, Leonardo also had it: the will to face and recognize the depths and experience an ambivalent, rebellious love of them.

In *Là Bas* are two passages which are outstandingly Tchelitchevian in spirit. I am not sure if Tchelitchew ever read the book but that doubtful fact has nothing to do with the self-evident kinship. Huysmans' hero imagines the psychological fantasies of the notorious Gilles de Rais, the subject of a study he is writing: "It seems that nature perverts itself before him, that his very presence depraves it . . . He discovers priapi in the branches. / Here a tree appears to him as a living being, standing on its root-tressed head, its limbs waving in the air and spread wide apart, subdivided and re-subdivided into haunches, which again are divided and re-subdivided. Here between two limbs another branch is jammed, in a stationary fornication which is reproduced in diminished scale from bough to twig to the tip of the tree. There it seems the trunk is a phallus which mounts and disappears into a skirt of leaves or which, on the contrary, issues from a green clout and plunges into the glossy belly of the earth."* A learned diabolist argues with the hero: "The

* *Down There (Là Bas).* Translated by Keene Wallis. University Books. Pp. 175-76.

heart, which is supposed to be the noble part of man, has the same form as the penis, which is the so-called ignoble part of man. There's symbolism in that similarity, because every love which is of the heart soon extends to the organ resembling it."* Tchelitchew, like Pythagoras, is aware of the principle involved, both human and metaphoric, and takes a definite attitude toward it. So did the devisers of the Eleusinian Mysteries, which (as was noted on a previous page) absorbed it into their ritual, the popular myth displaying what is technically a euphemism—namely, instead of penis, heart.

For his next chef-d'oeuvre, Tchelitchew practises like a dancer or an athlete for some epoch-making performance. "Being social" while working is de rigueur. Quite aside from the forced ardors of portrait painting, party-going sets up internal conflicts in the artist both because it is nervously exhausting and because large doses of dinner table gossip tend to bore him. Entertaining his sitters while working at the easel is a tradition that is subject to odd hazards. Once, while he is painting Mrs. Millicent Rogers, the lady faints, dropping from her chair to the floor. He is alarmed to hear her say weakly as he rushes to her side, "Water! I must have water!" After bringing it to her, and when she has revived, he has an illumination: Why not paint Mrs. Rogers in a drop of water? He does so. If life is sad and tiresome, it must be made amusing.

Being one of the most uninebriate of persons, Tchelitchew is never "high." He allows himself only an occasional glass of wine with meals. Again, he can never be sure, no matter whose house he is in, of not encountering some of the impossible American vulgarians he has put at the bottom of his bad books: those who have the ingenious habit of combining specific ignorance of his painting with abysmal insensitivity to everything. He need only hear a fragment of praise for Dali or Picasso—who can be accounted more fashionable than he in America—for the evening to be totally spoiled. Willy-nilly he is forced to seem ill-tempered and jealous; however, hatred of those two painters, and Bérard, has become a compulsion. The younger two he regards as stealing outright from him.

Conversational incidents involving them seriously cramp his style since his great social forte is the aria, his command of which still subjects whole roomsful of people, and it is hard to shine out with an aria composed exclusively of malice. Exactly this special effort has earned him whatever bad name he has in London and Paris studios and drawing rooms. His attitude toward Dali persists despite the show of a camaraderie between them consisting of giddy commonplaces and trompe-l'oeil ironies. Once, when they have simultaneous openings at galleries across the hall from each other (Durlacher Brothers and Carstairs on 57th Street), each makes the point of paying a breezy courtesy call upon the other. After bestowing some slily impertinent

* *Down There (Là Bas)*. Translated by Keene Wallis. University Books. P. 198.

gallantries on his rival, Tchelitchew returns to a corner of his own exhibition to raise his hands and ejaculate to friends, more or less *sotto voce*, "You should go look at it, *mes enfants*, a chamber of horrors, painted and powdered, but most unsuccessfully disguised!"

When Dali, showing earlier at Levy's gallery, boasts of having incorporated the Golden Section in some multiple-image work, Tchelitchew scornfully declares that when you have to measure, as Dali does, you are snitching even the Golden Section. He claims that when the Golden Section appears in his work (which of course has already happened), it comes with silent step, voiceless, as divinely inconspicuous as the Duchesse de Guermantes arriving while a private musicale is in progress.

Fortunately, the conventions of good society save Pavlik from major disgraces, especially among painters, with whom he habitually tries to form solid personal liaisons. He gets along beautifully with the young Spaniard, Estéban Francès. To another young man with Spanish blood, the Chilean, Matta, he is also affable, the more so as he regards him as directly under his stylistic influence. Seeing each other often at Pavlik's studio, they form for a while a mutual admiration society. Yet Breton's appearance in this country, and his doctrinaire severity, start alienating Matta, who is a sworn Surrealist. One day, the elder painter seems rather autocratic, altogether too cavalier in assuming he is the master and the other his apprentice. The apprentice faces up to telling the master just how things really stand. *Tout est fini.* After that, Matta becomes the butt of some of Tchelitchew's unpleasantest wisecracks.

Before this incident takes place, Tchelitchew has been eager to honor a recent arrival, André Breton, whom *View* is welcoming. Kurt Seligmann undertakes to bring the Surrealist leader to Tchelitchew's studio and is impressed with the fuss our hero makes over one who has treated him coolly. Pavlik jokes and tries to be very urbane and pleasant. It is clear that neither he nor his work makes much headway with the distinguished visitor. Breton espouses the diabolic as a cult of beauty and is very particular indeed about the identity of the monsters he admires. To Seligmann and others, the Surrealist leader confides afterwards that everything about Tchelitchew has repelled him, his wit, the way he talks, his physical mannerisms, his painting. The last he considers "visceral": a damning quality with him.

All the same, *View* maintains its artistic policy of collaboration, Breton pays our office an official visit and a liaison of sorts is established. Mainly, of course, this is based on our proposal to publish his book of verse, *Young Cherry Trees Secured Against Hares (Jeunes Cérisiers Garantis contre les Lièvres)*. It is a bilingual edition with the English version by Edouard Roditi, whom we've known since the old *Blues* days. Marcel Duchamp supplies an ingenious jacket showing a color reproduction of the Statue of Liberty, whose cut-out face however permits Breton's face, printed on the front of the book, to show there instead. With his splendid, lucid bearing, his

quenchless look of intellect, this incarnation of Surrealism strikes me as strangely archaic, as if he were the sole survivor of a lost but very advanced civilization: a kind of modernism in eternal arrestment.

At any rate, Breton is not one to accept hospitality passively. Soon there appears a 100 per cent Surrealist, rival magazine, short-lived though it be, *VVV*, or Triple V as it is called. We conclude that obviously it is meant to be three times as good as *View*. *VVV* contains the work of a very young discovery of Breton's, only sixteen. This is amusing because we have already discovered (in plausibly improbable California) a young Surrealist poet of great talent, Philip Lamantia, who has been endorsed by Breton himself. In fact, when first published by us, Lamantia was only fifteen.

We have more than one cause to suspect an orthodox Surrealist intrigue although at the time we are unaware of the chief one. Ford invites to his house a number of intellectuals for a spontaneous conversation, which the leader will make into a formal dialogue for publication in *View*. After the participants have left, one of them (an undercover Alcibiades) suggests the thing will be too good for *View*—why not offer it then and there (with more drinks in prospect) to a certain New York painter who is dreaming up his own magazine? The *coup* is attempted that night. Somewhat hilariously, it promptly fizzes, even (as I recall being told) before drinks are served. Harold Rosenberg (one of the participants but not the traitor) writes the dialogue, which duly appears in *View*. To cap the camp of it, the title (in the Platonic tradition) is *Breton*.

More because he is tirelessly human than anything else, Tchelitchew accumulates those fetiches for knowing people that have always distinguished him. Knowing people in this sense is the bread and water of life, and only insolent philosophers, mad saints or lunatics have reduced such bread and water to the narcissistic dimension. In the worldly sense, one can never apply very accurate psychological analysis to such a habit. The sense of the worldly, indeed, is by nature allergic to analysis. So it is a moot point that Gypsy Rose Lee, who enters the artist's circle of friends in New York, is a prospective client, but a perfectly credible point that she and the artist really like, and are amused by, each other.

At this period, circa New York World Fair I, the former burlesque striptease artiste has become high fashion. Salvador Dali has an exhibit of his own at the Fair—if Dali can be thus defiant of good taste, he, Pavel Tchelitchew, can be just as defiant, and inevitably in better taste. What is rightly known as a "natural" comes to pass: Tchelitchew designs a number with which Miss Lee is to grace one of the Fair's entertainment functions. It will be her now luxurious routine of stripping, but done à la Tchelitchew; that is, with a chic and an ingenuity to out-Folies (demurely) the Folies-Bergères. Pavlik makes costume designs and invents the theatrical routine: Miss Lee will furnish her inimitable personal style.

It is an occasion for notice by the newspapers and one newspaper takes special and advance notice, sending its representative to interview the two artists in the midst of their conferences. The occasion is perfect for Tchelitchew to demonstrate his fantastic command of beautifully illiterate, extremely amusing English. On provocation, he explains the "number" he has imagined:

"First she take off the top. Slow. Then she keep take off down. Then she come to the pants. In the pants, pins is. The pins from the pants she takes out, and throw to the public. Whoooooooo! Then comes away the pants and she is left behind with only a night shirt. She yawn sleepy. Then she go away. The public he cry out for more. She come back, this time in night shirt, and she carry a candle. Ah! Aha! candle! The candle is light. She walk on the stage and she start the night shirt to take off. Comes almost off the night shirt, but not quite. She blow the candle. Poof! It is darkness, and nobody see."

"Marrrrrrrvelous!" Miss Lee exclaims. "The candle—that is wonnnnderful!"

"Yes," agrees the artist. "Also the pins from the pants is wonderful."

The fun is truly innocent. And innocent fun, at its best, is golden. I think that all the friends of Miss Lee's collaborator agree that he is one who scatters a golden kindness with the freedom of the Prodigal Son. Especially around the holidays, and especially to friends who are not collectors, he sends charming little drawings, sometimes in color, so that one must be very fond of mental reservations as such to criticize the ultimate sincerity of the spreader of greetings and compliments, both tangible and intangible. The truth is that as a Midas of sentiments, Pavlik is also their self-evident minter, converting at a touch ordinary feelings into extraordinary ones. His "flattery" is undoubtedly a kind of inflation of the social currency, but Tchelitchew is much too authentic an article to allow good judges to fuss about whether all that glitters about him is, truly, gold. When I say good judges, I think of his friends such as the Askews, Lincoln and Fidelma Kirstein, Oliver and Isa Jennings and Alice De Lamar. Fortunately, a certain courtliness in our century (Dame Edith Sitwell has termed it chivalrousness) has survived even if the institution which created it has, in effect, withered away. As for outright frauds, these never make headway in good society as anything but codified and forgiven rascals. But our hero, never warranting such codification, requires no such forgiveness. He is both the Prospero and the Ariel of the common compliment.

That, at this point, he should fail to develop the kind of dualism that breeds schizoid formations in the psyche, would be highly improbable. Being of two minds about the face values of society has never prevented an epicure from enjoying the most trivial of social treasures. Yet, in his depths, a man so complex as Tchelitchew is bound to suffer from the contemplation of his

own frivolity. It is just that, as so many pages of his wartime letters to Edith Sitwell make clear, there is nothing ambiguous about his frivolities and futilities; they arise like ogres to plague his nerves in the act and his conscience after the act. If rhetorically he exaggerates his conscience, his acts cannot be exaggerated. They are as plain as the black and white of the war headlines.

Ford is now the absolute intimate of his private life and perforce a measure of the moral contradictions in his personality and habits. Despite the young poet's temper (he can be as short and sharp over little things as his partner), the artist has grown very dependent on him. Ford helps manage the household and cooks whenever their regular maid is not on the premises; this has come to be for the evening meal since Pavlik feels he cannot afford a fulltime servant. To take care of the chore of dishwashing, either myself or another friend of Charles Henri's is invited to dinner. Of course, my presence is often in order simply, during these years, as an inside collaborator on *View*.

A headquarters of the elision between the artist's social and professional relations is naturally the high fashion magazines; thus Tchelitchew grows friendly with a number of their editors and publishers. Among these is Harry Bull, editor of *Town and Country*, who commissions several covers from the artist: seasonal fantasies, very colorful, that tune him up while painting *Hide and Seek*. For the fashion magazines, *Vogue* and *Harper's Bazaar*, he arranges a color photograph with Ruth Ford (to suggest the interior of a seashell) and draws fantasies of beautiful ladies: semi-theatrical figures elongated from the waist down so that they might, if they liked, claim lineage from Hellenic Greece or even Corot. Other works reproduced in these magazines are romantic silverpoint portraits of Esmè O'Brien and Mrs. Arturo Lopez-Wilshaw. Tchelitchew takes pleasure in dominating a medium (silverpoint) which cannot be corrected by erasure or obliteration.

A bizarre incident, regarding a fashionable lady's portrait, is connected with this same medium. Never willing to do things that might lack certain palpable signatures (such as his foreshortening), Tchelitchew has made his subject's nearer eye, in the three-quarter view, larger than life. The device has appeared in the Helena Rubinstein portrait and here it adds some distinction to a face that otherwise might seem only pretty. As early as 1932, the artist employed a parallel disproportion of eyes in the Ophelia portrait of Natalie Paley (later Mrs. John C. Wilson) except that on that occasion he made the further eye *less than* life size; there was, there, also a profound spiritual implication. Simply cover the mad Ophelia's more distant eye and note how the basic impact of the pathetic, haunted image completely evaporates.

The other portrait to which I refer, the unalterable silverpoint, naturally comes under inspection by the magazine's editor, whereupon what looks, alas,

like a physical eccentricity is registered with alarm. The subject, of course, has no such physical defect as an enlarged eye, so the editor imagines that Tchelitchew has drawn it negligently or perhaps with casual perversity. In any case, she feels bound to bring the matter to the artist's attention because some wrong impression might be created with someone. In unhappy ignorance, the silverpoint is sent to his studio with the request that nature's proportions be more humbly observed. I do not have on record the reply Tchelitchew makes, but it is enough to say that the silverpoint is returned to the editor's office in hardly more time than it has taken to write this passage. What he says has been sufficiently enlightening to have the portrait reproduced "as is."

The bald fact is that the creator of *Phenomena* worries far too much about money to eschew making even large oil portraits of friends rich enough to buy them. One such is the young Indian, Edalgy Dinsha, who is pictured as a sumptuously reclining faun with immense liquid dark eyes while a mountain crouches like a leopard in the background. The portrait has a private vernissage at Dinsha's hotel, where it is shown on the mantelpiece, a cynosure of special spotlights, amid an almost religious hush. Our hero may have averted himself from the spectacle of modern society as Hell and turned to a new, optimistically assumed mode of creativity. Yet the path through life and art is no smoother, no easier or more obvious.

This path must stay as it is till he has finished his next masterpiece and scored (in a parlance to which he is not alien) the knockout that he missed putting across with *Phenomena*. To this end, he is relying on his old friend, Monroe Wheeler (now Director of Exhibitions and Publications at the Museum of Modern Art), together with the in-group influence from the direction of prominent men such as Kirstein and Glenway Wescott, also friends on whose loyalty he can count. A strategically placed supporter, gained since his arrival in America, is James Thrall Soby, who is a Trustee at the Museum of Modern Art. It is Soby who, as director of the coming exhibition, will be elected to write the Museum monograph, Wescott's wistful desire to do so being passed over in favor of Soby's status as an art expert.

At one point, in reply to a candid hint from Tchelitchew that it is about time the Museum gave him a retrospective show, Wheeler airily replies (it happens to be in my presence), "We're working on it!" At the moment, the still unfinished *Hide and Seek* stands in the room with us. When the picture is finished, a committee from the Museum visits the artist's studio to see it, then and there avouching their desire to acquire it. Apparently the revelation of *Hide and Seek* is the clinching point in the suspended issue of the retrospective show. In any case, Wheeler and Soby will eventually confirm that in usual conclave the Museum's board of trustees, voicing no opposition, vote the Tchelitchew exhibition despite, one may add, Pavlik's mirage of scheming

enemies there. It takes place in October, 1942, and its undoubted popular hit, regardless of some strong adverse criticism, is the new chef d'oeuvre. As usual, however, Tchelitchew is stewing in an historic present of multifarious anxieties.

To an intellectual among the artist's American friends (actually introduced to him in the late twenties by Monroe Wheeler) the artist confides that *Hide and Seek* is a labyrinthine enigma from which he himself had to escape—he found a way out, as we know, with the birds in the upper lefthand corner. This friend is Agnes Rindge (later Mrs. Philip Claflin) who interests him particularly because she is both biologist and mathematician; hence a "bridge," a fusion symbol, which is always a good token. Sometimes his letters effusively begin: "Santa Agnessa . . ." It is she who will ask him to lecture on Gertrude Stein at Vassar, when he proves he knows his Dante by quoting him on the subject of the rose in connection with Miss Stein's rose monogram. We know the origin of *Hide and Seek* in Tchelitchew's Doubrovka childhood. As a labyrinth which one may escape by flying out, it connects itself with that of Daedalus at Cnossos, and with the Theseus legend when the Minotaur is killed. The equivalent of the Minotaur in the painting can only be the Little Virgin at the center, who, as Arachne, according to her legend, is punished with death by Athene.

In a letter to Edith Sitwell, the artist mentions about this time that he has a Minotaur to kill, and in another letter explains that, on reading an essay by Jack Lindsay, *The Gibbeted Goddesses* (about the ritual sacrifice of women), he has come to understand the link between *L'Errante* and *Hide and Seek*. Arachne's aggression is in rivalling Athene's weaving, the Minotaur's in demanding a tribute of youths and maidens. The Wanderer of the previous ballet is evidently, as a chthonic figure, more of a "devourer" than we thought. In one prime aspect, *Hide and Seek*, a celebration of Tchelitchew's early youth, is an assertion of the beauty of life in a positive sense quite the contrary of *Phenomena*. But no man so saturated with psychic nervosity as Tchelitchew could paint an unambivalent picture at a time when the nations of the world are joined in awful conflict. The note sounded by the creator of *Hide and Seek* has its dark gamut centered in woman as aggressor and victim; the Little Virgin (deriving from a dead little girl) is his own feminine *persona* and he cannot avoid the profound suspicion that she is destined for a wrack of suffering.

The artist's other important move in 1940 is his summer residence at Derby Hill, near Pawlet, Vermont, a glorious spot where he goes on painting *Hide and Seek*, where he exults in the landscape views by painting, in a succession of summers, several multiple-image works in oil and gouache. Derby Hill is a house dating from American Revolution times and perches on a great eminence looking down into the Green Mountains, which in the mauve-blue dis-

tance look like a cavalcade of beasts forever hurrying toward the vanishing point of the horizon. The house and grounds are described, purely as a setting, in my long poem, *The Granite Butterfly*. Everybody admires the isolated spot (Mary McCarthy and Bowden Broadwater will want to buy it); Tchelitchew and Ford grow to love it. It is so undisturbed that on sunny mornings it becomes a routine for the two men to strip and do their exercises on the lawn, ending with a lengthy trot in a wide circle. There I find that the artist's slenderness is deceptive, that he still has the articulated muscles of someone with balletic training; it is easy to tell, for the only garment he wears at such a time is a white handkerchief, knotted at the four corners, to protect his bald spot from the sun.

In one dimension Derby Hill *is Hide and Seek*, that is, an Eden. But one may expect an Eden to have its Serpent. Tchelitchew still has the exile's perpetual burden of creating a new life, of earning (in his case) what nature and fortune originally bestowed as a birthright, then took back. His panic during all these months of transition, the dark night of his transplanted soul, he communicates to Edith Sitwell on paper every few weeks. The Yankee Clipper, famous carrier of airmail between the continents, becomes a sort of incarnate Guardian Angel forging the bonds of a new rapport between the Russian painter and the English poet.

Once he is away from her and her milieu, Edith Sitwell assumes for Pavlik ideal features, a truly ideal substance. She is the anti-Arachne, the ungibbeted goddess; at least, for the present. Pure, unobstructed, there survives his profound inner need of a woman's consolation; he needs somehow to cry like a little boy at the knees of his Mamma or Nanny. To Edith he does not fail to mention his friend, Isa Jennings, "who is my mother now." In the Winter of 1939–40, in Weston, while complaining of his eye trouble and sinus infection, he hopes that he will not have to depend on Alice De Lamar's hospitality next year, even though his considerate hostess has promised to install a "skie light" in the White House. He agrees with his correspondent that only reading and working "can drag one away from this terrible horror [war]." And he adds, "I think human beings got back to their aboriginal state of beasts and now any culture or any effort won't help to change their attitude. My next picture about children [it is April, 1940] will be ferocious, as they are."

Perhaps he feels impotent as a "Theseus," even a little angrily indifferent, about depriving his Minotaur-Arachne of her quota of youths now being deliberately sacrificed on the field of Mars. Anyway, out of the thing of beauty he is creating, he plots the graph of Arachne's avidity signified by the the Little Virgin's clutching hand, the frenzy of the aërial boys' centripetal rush. Brooding on *Hide and Seek* gives one a strange sensation of the violence of basic human appetite. Every point of the boys' anatomy, in conformance with the tree's hidden sexual mechanism, has a phallic drive. Flesh is ambi-

sexual in childhood: the metaphoric gourmand. In one boy, to the right, it is a lusty foot, in another a fat tongue—the erotic thrust is eyeless, stabbing, indiscriminate, like the girl's greedy fingers. The artist now interprets his affection for cats in a phenomenal way: he would like a "pett tiger and a pett hyena [?] and a royal cobra. Imagine having a tiger purring when you scratch his enormous cheeks."

He is very worried about Choura, her welfare in Paris and her exact whereabouts: is she still at the old apartment? Now she is married, so in a sense he does not feel quite so much responsibility; at the same time, she is still sickly, so is her husband, and he seldom receives a letter from her. In view of his general complaints about not hearing from correspondents, one might think he really led the monastic life he constantly attributes to Ford and himself; on the contrary, they often have guests at Derby Hill; one summer, I spend a couple of months there. The artist's monkishness, on one hand, is simply his metaphor for concentration on work; on the other, an unwelcome condition that may be read as neglect of him by people who have it in their power to advance his career but fail to do so. Naturally, at the head of this list are the art dealers who represent him, and of whom, to close associates, he regularly complains. At this time, the culprit is still Julien Levy.

Ford has written *ABC's*, a scintillating suite of Surrealist quatrains for letters of the alphabet, and to Pavlik's delight, Miss Sitwell acknowledges her copy with praise. She has cabled him congratulations at *Phenomena's* vernissage but he admits that people think it "too horrible to look at." While he declares that, on the contrary, the new picture will be "lyric," he asserts it will be "painted like by lightning and violently bright full of vigor and terror." By remote control, the milieu of the war is being filtered to him through memories of the profane desires and insatiable brute sports of his childhood. News of the fierce bombings of London distress him for Edith's safety; he asks why she cannot move somewhere "nearer," that is, nearer him in America. As for war, however, "my dear," he writes her," I leave [live] in continuous war since 1919 - since the time I left Russia etc. I have no country, no home, no family . . . I leave [live] from day to day. I have no plans for tomorrow . . . I have no finished work at all - everything is begun and nothing is ended." Emotional hyperbole, and typical, but with its bitter little dram of truth.

Willingly he does not count the theatre any more as major artistic work. *Ondine* has been a sort of climax to end all climaxes. Yet, in December, 1940, he finds himself "forced by George Balanchine to accept a ballet on I. Stravinsky's music," and in the midst of work on it he becomes ill. The ballet is *Balustrade*, regarded by the composer as a happy collaboration. In the artist's collaboration with Balanchine and Stravinsky, three-quarters of Lincoln Kirstein's ideal team in the theatre has been realized, a team that will see

action once more. The fourth member, still prospective, is W. H. Auden, an admiration of Kirstein's he takes occasion, though without effect, to "talk up" to Tchelitchew. *Balustrade*, however, is not done for Kirstein's company, but for de Basil's organization, Original Ballet Russe, which according to Tchelitchew "exploits and vulgarizes Diaghilev's memory." Still this company has Tamara Toumanova, whom Pavlik has known since she was a baby ballerina at thirteen, more than seven years ago. He enthuses about her "great sleepwalking poetic beauty."

As for his indisposition, he writes that "the boring illness [contracted in 1938 in Yugoslavia] still has me in her clutches." Perhaps if it were not for Balanchine he would not, sick as he was, have agreed to do the ballet. *L'Errante*, the first ballet the two did together, remains in his memory as a "hypnotic collaboration." He has "very few friends," he declares, "masses of acquaintances." Yet for compatriots, such sympathetic spirits as Balanchine and Kolya Kopeikine, he reserves a special place in his affections; it is easy, and uplifting, to be tête-à-tête with them and "Russianize" in the old tongue, communing with their youthful exuberance. They remind him of himself when, lighter of heart, he could "wish" more fervently. Still, he is a magus! His self-cast spell is the ability to enter the sense of life like a pure dream and stay there, unharassed. It is a web whose threads seem to issue, like those of spinning creatures, from his own body, firmly entwining himself and perhaps a friend: a "nett" that traps but is also sublime.

He knows a way of verbalizing this state when, as it were, it operates in reverse, when the web that traps him is quite external, unhappy, onerous. He will reminisce of what I have already mentioned: his governess' ability to "saw his soul in two" by catching him in some linguistic pitfall. The man who can be so supernaturally cozy with another is fatally vulnerable. Ford is always on hand and at this period applies to him for pictures to reproduce in *View*. He wishes a special cover design at a moment when Tchelitchew feels he wants to do as many pictures "as fishes in the ocean" but instead, allegedly, can produce hardly any. At first he refers to Ford in the Sitwell letters as C. H. Ford. Now when the poet is more in esteem with his great friend, he becomes "C.H." So Pavlik writes: "C.H. was staying at my soul's hidden place - was like a cat to get his cover for 'View' . . ." Strange that Tchelitchew should spontaneously imagine himself a cat's victim, and a mouse at that! Is it subconsciously as a mouse that he adores cats? Perhaps, yes, "when you scratch his enormous cheeks." *Hide and Seek* is coming to be a maze of sizes, things, substances: a booby-trap of invisible transitions, glamorous changes of identity, unspeakable magics.

Tchelitchew says that now he will look directly into the sun. When he does, of course, he sees white, then black. But his sacred axiom already is the light that issues from black—the moral of the Aurora Borealis in *Ode*. He is

really penetrating, behind the blazing mirage of *Hide and Seek*, to the light whose locus is infinity and therefore in an inaccessible depth beyond even dreams. This is the background that he selected for *Balustrade*. The scene is all pearly, glittering iridescence over black, a plotless thing in which the airy, winged phenomena of nature form the "story." Balanchine's dancers flit like moths, flutter like insects, pulse and twitch like nervous night-things, surprised, surprising: "mate" like larvae insatiable for their wings.

The foreign artists are now all launching themselves toward America. He hears they have "no paint or pencils." Museum officials, he writes, are surprised to learn from Sir Kenneth Clark, now in the United States, that he (Tchelitchew) "has quite a good name in England." The poet beleaguered in London by deadly night-things wants to write a book about the night. During these years she will dedicate poems to him; meanwhile she is published in *View*. He assures her repeatedly that she is a great poet and that he and Ford are determined to make her name as great as it deserves to be in this country. "Yes, my dear Edith, a book on night, the sleepless sleeps on hell in dark and on hell in light - will be a book on [the] pres[en]t." He and she mean the bombings in London.

During the past two years his right eye has deteriorated and a doctor gives it a thorough test. The trouble, as the artist explains, "is the nerf [nerve] who controls this enlargement of the pupil - who is very stiff and doesn't loosen up. And nothing apparently can be done. I exercise it with a special stereoscope - but it doesnt help me much." The pupil can't open enough, it seems, yet something else opens too well and not well enough: the "pair" of his plastic myth. Is it one doubled or one halved? Himself *sawed in two*? He and his lover? The break—the hopeless "stereoscopic" split——? Still he blames Picasso and Matisse for propagating schizophrenic art.

Dali "has had the nerf to tell that he wanted a new clientele for his new work: the nouveaux riches." Tchelitchew one-ups him: "But there arent any, there are onely the nouveaux pauvres." He does not mean, of course, those who can be classed economically as poor. And now, as if reaching the limit of persecution by the theatre, Pavlik enters a "cave of sleep." It is a ballet Kirstein has requested and it derives technically from the medieval concepts of the body's "humors": melancholia, phlegma, sanguina, cholera. All color and light, now, are enclosed in a cosmic sort of paranoia. A woman "sleeping like dead" is found on stage. He is constantly dreaming of Edith and of Choura, imagining them in turn sad, veiled, frightened, in danger, even killed.

He declares this "will be a strange poet[ic] ballet with Farth [Fate] and Fortune with a naeked man with a red book and pale blue tarleton pages." *Ode's* original concept is being transmogrified. "It looks," writes Tchelitchew in words conveyed by the Yankee Clipper, "very placid and very terrific at the same time." Virtually this project, whose scene is the mind's

interior, is the sign that his "metamorphosis" period is over, the whole period represented by *Phenomena* and the still unfinished *Hide and Seek*. In terms of his strange unconscious ideogram, Fate/Earth ("Farth" ; see above), he will no longer find the human image in the planetary landscape, but hereafter the planetary landscape in the human image. All light is to be internally directed: the body will light up like buried jewels never before exposed to the eye. At the time, I speak of Tchelitchew's portraying for the eyes of his poet-protagonist "the structure of mankind, the brilliant twigs and branches of his body, the blaze of his bones, the lightning of his nerves, and the athletic tremors of his muscles."* This the artist calls the Interior Landscape. It is the true locus of the place of resurrection since the mystic initiate's goal is an interior living-space. As a ballet, *The Cave of Sleep*, while Tchelitchew does a suite of very lovely, Vesalius-like, vivisectional figures in color, presents too many difficulties and is abandoned.

The worse the environing world, given to the bloody terrors of war, the more Tchelitchew retreats inward: toward his own center. In terms of illness, day by day, he finds only vertigo and pain, an inordinate physical purge that weakens his defenses against the aggressions swarming from outside. But, alas, he writes, "I think war is an instinct and not a crime." To his future dealer, Kirk Askew, he will impart the statement with a more telling orientation: ". . . man is born with murder in his heart. Animals kill each other in order to satisfy their hunger, humans kill for pleasure apauling [sic] as it seems - it is apauling - and in spite of that we artists like crazy bees, give of our honey which nobody wants, no body cares too much, which is our blood and life!"

Nature is "still wild and unconquered." Why? He would dearly like to know. Still he plans to subject nature, within the boundaries of the human body, to an exhaustive plastic idiom as serene as a seam of unmined gems. It is the summer of 1941. The artist and Ford are madly packing to let the apartment in East 55th St. to a lady who, though she is with a high fashion magazine, "doesn't want my pictures left on the wall." At this moment, Germany invades Russia and the images of his surviving family are evoked in terror: his father, Barbe and Manya, his half sisters! He is relatively at rest about Choura since his friend, the painter Alice Halicka, is currently his intermediary in Paris. He starts for Vermont as if an army were at his heels.

Phenomena, we hear at this time, is already in the past of his childhood passion for prehistoric beasts: tattered, pathetic in its supposed Eternity. Regarding the fate of that painting, he writes his dear Edith: "I was too old, too 'dumb fool' to epater anyone except 1000 year old trees and elephants." The tree in *Hide and Seek* is at least that old. It will remind me, when I visit Cos, of the spectacularly venerable plane tree there, under which Hippocra-

* Quoted by Windham in *The Stage and Ballet Designs of Pavel Tchelitchew*.

tes is supposed to have lectured. Tchelitchew's tree is the beginning of his magic treatise on the cure of the body whose primary disease is matter.

View is booming and Auden's stock is much depressed with Tchelitchew because of Benjamin Britten's opera, *Peter Grimes*, on which Auden collaborated. "Poor W.H.," he writes, "has done a most dreadful libretto - stupid to a degree of a shame . . . unsittable and unbearable performance . . . It dislocated my jaws." A letter from Choura reports herself and husband well. Pavlik speaks of starving friends in Europe; one is "a refugee on foot." Breton and Ernst have arrived; so have Kay Boyle and Peggy Guggenheim. The exiled status of our hero is no longer so extraordinary. Virgil Thomson pays a visit to Derby Hill. "He is," remarks the host to his steady correspondent, "very amusing very brilliant but of common sence genre." Kirstein, in South America with his Ballet Caravan, writes him that the revival of *L'Errante* is a "colossal success." Jouvet is also there with the third act of *Ondine*.

Mrs. Nature, three days before his birthday, Sept. 21st, gives him a surprise party. At Derby Hill he witnesses a true Aurora Borealis and describes it in his aria style: "There were snow white enormous long ospreys floating lost from the giagantic headdress of the greatest of all prima donnas . . . no one knew in the papers that she will arrive. She came in [sic] in full gala dress with trembling snow white green curtains and fringes with magenta hat and pale green and white feathers . . . on Saturday she came again to say goodbye - but she wore onely her black stockings and endless volants [flounces] of white and green - like the vails [sic] of El Greco the divine Greek. I was most upset to miss her [apparently on this second appearance]. She came to warn that the winter will be frightfully cold and that she will make of the German hords [sic] in Russia an wonderful monument in ice and snow - shiny and beautiful as glass and dead as marble." He can do his metamorphoses in words like watercolor. Read it aloud: it has rhythm.

Papa Tchelitchew is now too old and ill to work: he is seventy-six. Barbe (Varya), his son hears, is in Moscow, Manya in Sevastopol. During these years he is keeping in touch with Allen Tanner; in fact, he will be trying to get him a job in New York. His former bosom companion has never ceased being interested in Tchelitchew and all his family. Tanner works for the Red Cross in Chicago and makes strenuous efforts, with success, to contact the various surviving Tchelitchews. Yet, on the film screen of his mind, Pavlik cowers before the pathetic image of his devastated family tree. *Hide and Seek*, therefore, is an arboreal monument to the Tchelitchews *en fleur*. "What a strange end of the story of that old branch on the old tree - whitch [sic] is my family - I am the last leaf on it - on the central great branch." To be sure: his double is Choura as the Little Virgin with her face against the tree. Now, he laments, his father will not die in peace. The horrors of war in nature's eyes are, he says, "like tearing up a masterpiece." *Phenomena* appears

to him "a very distant cloud." He tells Edith there are such strange things in *Hide and Seek* that he cannot put them in a letter but "will tell you and show to you all." He says it is "some sort of prophetic picture." Yet he hardly dreams just what it prophesies at the time when, years later, his great friend will stand before it, and react.

Zossia Kochansky has predicted that his dealer, Levy, will drop from him "like a dead leaf." He thinks Mme. Kochansky an "oriental" prophetess but the process of parting from Levy is not so simple as clairvoyantly imagined. With deceptive calm he conveys the news: "C.H. is probably going into the army." And he adds: "I don't think I will be taken into the army myself because of ill health, extreme nervousness, whitch they will probably call insanity etc." The war is encroaching, ruining everything. Plans for collaborating with Jouvet in South America "have collapsed like a castle of clouds." Yet Jouvet insists he will soon cable him money to come. He never does.

"I can't see rich people more. I get nosea [nausea] from single sight of their ears necks wrists . . . I think of that enormous map of misery [Russia] and the rest of Europe like a frozen lake." It is a direct reference to the symbolism of the picture he is painting. In the way he is conceiving objects, even paint, in *Hide and Seek*, his thoughts are being elided "alchemically." And he continues: "Oh how dreadful people are in peace and how awful they are in war. Excuse this language: A louse in peace is a louse in the war."

And the moment has come for him to count: "I have 23 very faithfull friends who know me since years - who can listen to my boring worrys and help me out of them sometimes." Probably he includes Mrs. Gorer and her son in this list. Gorer has a post in Washington and the artist constantly speaks of them, although the traditional protocol involved in this liaison gets into trouble when Ford declines to drive 200 miles (in all) to fetch Geoffrey and his mother to Derby Hill and take them back home. This is compromising because when Tchelitchew did not have a car, in London when he stayed with the Gorers, their car was at his disposal. As for his great correspondent of these years of trial: "No, my dear," he protests, "dont be childish, you are my greatest friend of heart and brain - others have eaten heart or brain or more - just like vegetables or trees growing in your garden they [i.e., the elements of their friendship] were planted when the garden was young. They will still grow until a storm will take them out of their place." And the aria soars: "Edith my dearest friend you are like an enormous heart who is also an ear and an eye to read through my madmans thoughts."

Like Miss Sitwell, who consistently writes him of how much she is publicly insulted, he is similarly humiliated and records that his inferior rivals have somehow climbed higher than he. He accuses Julien Levy of *dilettantisme* and has his usual trouble with old clients such as Edward James. James wanted him to design some stained glass windows for the church at West

Dean. The project never bore fruit and now his friend and collector is so literal as to want him to make good the $300.00 advance "for," he tells Edith, "the unfortunate stain glass." Thoughts of war never leave him: "Dante could never imagine the horrors of our physical inferno." Veritably, every morning, life pounces on him like a cat hungry for its breakfast. Both in reality and in his psyche, the animal metaphor, the unspeakable gestation, seem eternally wedded.

And he hears from Choura that her husband, Alex, is dying. Doggedly, he visualizes a "Paradiso" which will be the "triomphe de l'air" after the earth-symbol of *Phenomena* and the water-symbol of *Hide and Seek*. He is set on being a good Pythagorean but this code does not include Christian forgiveness. Even as he broods on how the "intrigues" of the Surrealists are poisoning his reputation, he is asked to pose for a publicity photograph of artists in exile, who are being given a show. The event is the idea of the art dealer, Pierre Matisse, with whom Tchelitchew is on good personal terms. The historic document contains Fernand Léger, André Masson, Ossip Zadkine, Yves Tanguy, Max Ernst, Matta, André Breton, Marc Chagall, Piet Mondrian, Jacques Lipchitz, Amedee Ozenfant, Eugene Berman, Kurt Seligmann and Tchelitchew. George Platt Lynes (whose oil portrait the artist has begun) takes the photograph, but it happens as if some malign fate, exquisitely logical, ordained that he, Tchelitchew, look like an outsider and a malcontent. Indeed, he seems to have manoeuvred, or have been manoeuvred, to a fringe position with the one artist besides Tanguy with whom he still has good and close relations, Seligmann. Because, it may be, he has not been urged to take a seat in the first row, an expression of stifled fury peers from his face that makes the dour mask he turns toward the spectator of *Phenomena* seem meek and mild. His arms are folded as in belligerent abstention.

He is, naturally, an exile among exiles.

He and Ford "expect a call to the army any day." But he now meets Edgar Wind and shows him *Hide and Seek*. "He [Wind] knows all," he informs the lady who every night defies the blitzkrieg, "he sees everything . . . He is become a wonderful friend, my soul's doctor." Pavlik decides he might not have been able to go on painting without Wind's emergence. Physically, too, our hero complains he is feeling very weak, while he used to have, as he writes, "sotch strength."

Wind, like other great scholars with sympathy for magic, can be eloquent when speaking of enigmas and in the act of unravelling them. But his basic reticence (to whatever morale it be owing) is clear from something he says to Tchelitchew. Lecturing at the Museum of Modern Art, Wind compares the artist to Pisanello and Dürer. Tchelitchew reports that Wind helped him "solve the enigma of the perfection of Raphael" by informing him that "the name I was giving to Raphael for the last five years (a term of geometry) was

exactly the secret of his perfection - and sudently [sic] Dr Wind looked at me and told me sadly [sadly] that a secret who remains enigma for 500 years ought to remains enigma forever." The artist then declares he will never explain the enigma to anyone. "I don't want you to think," he adds, "I am megalomaniac nut, but . . . "

For a ballet called *Concerto* (for Kirstein's company which is on a cultural mission in South America), he designs a "4th-dimensional ballroom," also "like a basilica of the 4th century (Byzantian) and like Crystal Palace too." In addition, it bears a resemblance to models of the Celestial Globe where he will find his Celestial Physiognomies. Balanchine, in ecstasy over his drawings, "was exclaiming like a chicken who had laid golden eggs." And Tchelitchew pays his great collaborator a tribute: "he is so gentil and so inspiring. He is the unique kind of his species in the whole world." But the artist has had to produce five décors and thirty-five costume designs in a very short time: "I could not say Papa or Mama for next two days. I was simply imbecilic."

He is friends with Peggy Guggenheim; indeed, their relationship will be a non-stop meaningless flirtation to the end, but he takes his revenge on her snubbing his art by designating her collection as " a sort of garbage can for world of art." He reports that he regularly insults all "silly mondain people," especially when they "pursue" him. One kind of dirge is classic: At the end of three years of dinner parties endured in a certain lady's house, she buys from him a drawing for $100.00. Nor can he quite, ever, give up the idea of being seen in public with prominent ladies, who have him on their lists as a distinguished escort at the theatre.

His cerebral devotion to his art is undiminished. Now he has it! The true meaning of *simultaneity* is surely reincarnation: eternal existence. Edith's apartment house in London is destroyed by the Germans and the news is like a bomb destroying his thoughts. Edgar Wind has just called him "the angel of Russia" so that, he admits, he is homesick for his native land. Then he has a trauma which hypocritically he relays to his correspondent with significantly unintended ambiguity: "I am not taken into the army in spite of [sic] being a very well known artist and aged 44. God knows anyhow I do hope I will be able to go to the country."

When called to the draft board for his physical examination, he has panicked and implored Isa Jennings to accompany him there in a taxi. All the way he cries like a baby, clinging to her and imagining the horrors which he is to be put through. Mrs. Jennings fears he will have a total collapse if he is accepted. He begs her, when there, to wait in the taxi for his return. Obediently, she does so—until hours later when he appears looking like a zombie, almost totally speechless. Somehow he has survived the profane initiation rite. Mrs. Jennings, who resides on the same penthouse floor, then

escorts him home to the tune of an aria fainter than she ever heard from his lips.

He speaks of the "hudge success" of his ballet, *Apollon Musagête*, his second collaboration with Stravinsky and Balanchine, and then writes that his father's house in Losovaya has been bombed; moreover, M. Tchelitchew has malarial flu, pleurisy and gastro-enteritis. The woe and the glamor flow on as if unaware of each other. Julien Levy *has* been accepted by the draft board. He feels sympathetic because Levy has told him, in front of *Hide and Seek*, that it is "the new painting, the new way, the door through which all the youth will go." This was said like a good dealer. Levy revises his opinion, apparently, when to others he deplores that Tchelitchew's new style is too much like Arthur Rackham's illustrations. The artist informs the great poet across the water that his terrace, where he grows his array of beloved plants, is 360 feet long. It is a beautiful guess, not literally true.

One cannot stop.

Tchelitchew cannot stop. I cannot stop—not yet. It is *la chute. La Chute en personne.*

The penultimate sublimity. The little girl in *Hide and Seek* swims in a sewer as well as in a lake. Still, she is shining, sedate, immaculate as the three Muses in *Apollon*.

The Tchelitchew exhibition opens its doors on Tuesday afternoon "and it seems to be a great sensation. It is rather ridiculous to say it about oneself but I simply repeat the words of Harry Bull, editor of Town & Country and dear friend of mine."

There are eight rooms, he tells Miss Sitwell, eighty pictures or so, two hundred drawings and gouaches, over a thousand people the first day, "300 more than Dali last year."

On the fourth day, he writes Tanner, almost two thousand persons jam the Museum and the police have to be called to close it.

Is it fame at last?

As if tardily celebrating, he takes out his final citizenship papers on Dec. 10th, 1943. The ceremony itself is a dull anticlimax which he cannot help deploring articulately. But the Russian exile is now an American.

Edith

James Soby's Museum monograph on Tchelitchew is scholarly, efficient, urbane, a most creditable piece of work. Pleased outwardly with it, inwardly Tchelitchew is dissatisfied. "It makes me seem dead painter," he confides to his intimates. Moreover, Soby can say things (such as that Matta must have influenced his color) that throw him into a great temper. Kirstein imparts to the artist his impression of the monograph: "He succeeds in making you sound completely dull." And, in a letter to Miss Sitwell, Tchelitchew adds: "Lincoln wants to write a book on me one day anyhow. It will probably be the most scandalous biography one could ever read."

The pictorial reproductions in the monograph are so mediocre as to remind one that it is wartime. To reproduce either of the big chefs-d'oeuvre in color, on a page so small, has been properly deemed impossible, hence these works appear in not very good black-and-white, with a boy's head from *Hide and Seek* as the color frontispiece. Tchelitchew holds a grievance, telling my friend Charles Boultenhouse that the whole reproduction of *Hide and Seek* looks like "a squashed beetle." Another form of the metaphor, the trope as endless as the Wanderer's train! Never forgotten are the convolutions of that train. The artist has suggested colors for the walls of the exhibition rooms; they "are like," he says, "a serpent in colors which unfolds itself." And yet: why not a squashed "spider"? Because, perhaps, the proper insect would make it sound profane. He is beginning to think of his Tree as the ancients thought of the Tree of Heaven, as bearing the fruit which are the Planets . . . Vaguely there blooms in the undergrowth of his memory the fact that Dante, in the *Purgatory*, speaks of three great symbolic trees. The second Tree of Life has laden boughs, with its fruit visible but beyond the reach of those who stretch their arms toward it, says Dante, "like spoilt and greedy children."

The third is the Tree of Knowledge, which has spiritual fruit. That will be his, Tchelitchew's, tree of the future. He has begun reading the mystics and the pagan teacher, Pythagoras. Surely, *Hide and Seek* is Dionysian! Yet there

is an Orphic tale about the eating of the child god Dionysius; one part of him is left uneaten: the heart. The *sacred* part. Ah, but . . . In the illustrations of Vesalius' dissections he has found strange, surprising analogies of anatomic form; in fact, he may have stumbled on the discovery (previously quoted) observed by a character in *Là Bas:* the heart resembles the head of the penis.

"Mrs. Nature, you witch, what can you not think of?—and not do?"

Though generally favorable, the critics have temporized about this and that aspect of Tchelitchew's total oeuvre, about this and that period. To his great annoyance, there survives the school of opinion that started years ago: "Tchelitchew draws rather than paints." A strikingly oblique confirmation of the show's success comes from an unexpected direction. The noted art expert, Lionello Venturi, writing a prospectus for a show of Louis Eilshemius at the Durand-Ruel Galleries in November, 1942, closes his piece: "Thus the message of Eilshemius is a precious one, a kind of antidote, in days when Tchelitchew triumphs." In the eyes of *View*, the two painters contrasted, different though they are, are not incompatible.

Numerous colleagues have been openly enthusiastic about the exhibition: Tanguy, Seligmann, Zadkine, Masson, Soudeikine, "even Berman." Of course, Monroe Wheeler, Soby and Glenway Wescott have been extremely articulate. But the artist especially prizes the glowing superlatives of his friend, Kirk Askew, Jr., who owns Durlacher Brothers.* Levy has been a sort of silent partner in this gallery but since he was inducted into the army Askew has been running both galleries.

Affairs with Levy (who is being divorced from his wife) are so mixed up that Tchelitchew is disheartened; anyway he has divined that privately his dealer considers *Hide and Seek* a stunt. For his part, Levy is aggrieved by the fact that, because neither himself nor Askew had a hand in negotiating the sale of *Hide and Seek* to the Museum, neither of them has received a commission on it. No contract, only a gentelman's agreement, has hitherto governed Tchelitchew's artist-dealer relationships. Pavlik has held it veritably as a grudge that recently Levy has been touring the country with a "boxcar gallery." Every three days, the dealer will assert, Tchelitchew sent him frantic letters in this period saying that he was deserted just when he needed him, that in any case his worst, not his best, pictures were being sold, and to his "worst enemies." If a picture went for as little as a thousand dollars, the artist invariably staged "a fit of dramatics." In the summer of 1941, Tchelitchew has changed his tune, explaining that he needs a great deal of money (probably to send his family) and would sign a contract. But with the prospect of getting out of the army, Levy wished to wait and settle things in New York. When he arrives here, however, the main events are in the past. *Hide and Seek* has been sold and the Museum show is a certainty.

* Later, Askew acquired a partner, George Dix.

Art dealers, Levy has gradually learned, are but candidates for total absorption in the Total Tchelitchevian. He has the feeling that Pavlik always wanted him to give up his own life and lead his artist's life. Therefore when Askew proposes to Levy that they change their standing arrangement of going 50-50 on Tchelitchew and Berman, by Askew's taking Tchelitchew and Levy's taking Berman, Levy agrees with an accent of relief. Naturally, Askew's suggestion has been prompted by Tchelitchew's willingness. The artist has already, to his devoted correspondent in England, termed Askew "my actual dealer, protector and dearest friend." Soon he writes her that he is "with him." Tchelitchew can hardly cease praising the gracious civility, the unusual culture, of both Askew and his wife, Constance. "They are," he writes Edith, "the only people I see regularly . . . absolutely wonderful and real people."

The Total Tchelitchevian is itself a family tree: one invented entirely by Pavel Tchelitchew and overspread with his monogram. The other, his family tree of ancient tradition, is being systematically wiped out. He himself will have no progeny; neither will Choura, nor most likely his surviving half sisters. With Paris occupied, he feels utterly cut off from his sister. This news for a moment freezes his blood. The Champs Elysées in the power of the Germans! The Field of the Blessed Souls are now the Fields of the Accursed. The tragedy of the death of Choura's husband makes the situation very dreadful . . . Stalingrad is saved and Pavlik is jubilant. But he hears from his father that the cruelty of the Germans was unbelievable.

His art shall abandon externality as such. "Now," he says, "I am haunted by transparency as a result of my children's landscapes - and as in the past the body is succeeding to the head and the bodys to the body etc. until it will be an enormous idea that will be Paradise. To find Paradise I will try to descend into the human being. I am like Diogenes now (with a lantern) looking for a leaving [living] man. I am looking in the insides of a leaving [living] man." The unconscious leaving/living pun has a weird effect. The world, as the world, is lost: sloughed like a skin.

On the cosmos: "that wonderful diamond clolk [clock] of relations dashing through emptiness into the precipice of nothing and never falling." Yes, his own ideal is never to "fall." Then comes one of those accidents that are such horrid omens. On the return of *Phenomena* from loan to the Wadsworth Atheneum a three-inch slash is found through the skull in the corner. The *tchelo!* Does he really think of the scar on his forehead and the ancestral arrow? It is likely although he may keep the inner event even from himself by his outward reflex: the cry that the Express company is responsible for the "vandalism."

One tie is fine and firm, infinitely consoling, the one maintained by the valiant Yankee Clipper. Yet he suspects even it may serve in vain at times,

that somewhere along the line . . . Again and again, he swears he has written on such and such a date and conjures Edith to tell him if she has not written before the date on the letter he at last receives. It is vital there be no interruption to their communication as if their rapport formed some "astral" physique important to life. Anatomy itself, its mystic function, is now an absorbing theme between the painter and the poet.

Pavlik is reading Jacob Boehme, Paracelsus and Swedenborg. Man is so clearly a physiognomy that spans time and space. Boehme even says, "Man is superior to the stars if he lives in the power of supreme wisdom. Such a person, being master over heaven and earth by means of his will, is a magus." Tchelitchew is surely given pause by the phrase, "by means of his will." He has willed to learn how to draw, he has willed to memorize anatomy, which he actually laments that he tends to forget—"like a child," he says, "who wants to forget." Deliberately he is replacing unconscious function with conscious function. He feels he has from Paracelsus his warrant for proceeding *into* man as a means of making a conquest of the stars. "The magus," says Paracelsus, a pioneer in medicine, "is neither from God nor from the Devil. He is of nature."

The colors sought by the artist are those of "jewels and the skie." Once his father warned him against "collecting precious stones" as something that eventually would make him a slave, "a miserable heartless slave." But the memory occurs to the son in order to flout this parental wisdom. "In the world of continuous death," remarks the artist, referring to the war, "isnt it a comfort to see something which remains since 75 million years or more?" To see, of course, is not to "collect." But the seeing, when transposed to the palette's colors, has itself become an obsession.

His real obsession is the secrets of the body in terms of a subliminal physique; the latter is still behind a veil but each new work removes part of the veil. Everything in nature is now transposed to man's anatomy. How long has the complex tree in *Hide and Seek* been the bursting apple of his eye! Long ago he painted twin apples on a branch, rather foreshortened and, as it were, halo'd so that they seemed to offer themselves. All that is *passé*. As he has studied books of anatomical drawings, the eye itself has become an object of special interest: it is globular, like the Earth and the Planets. "The eye," he notes, "is a marvelous transparent opalescent globe filled with aquatic substance lying under crystal cliff - transparent trees and veins and arteries growing under its surface."—"trees"? Another egress has been found from the maze of *Hide and Seek*. So the eye becomes a "flower of sight," denuded but with lashes like fern or tentacles, a sort of marvelous sea garden. The ear is a "snail of sound," then it is a clam. The nose is "a labyrinth of smell."

Charles Henri, it appears, is not going into the army, having gotten five months' grace "to improve his health." But many of the artist's young ad-

mirers, he says repiningly, are being grabbed away from their drawing boards. What of the male dancers? He worries over young Brooks Jackson for instance.* *View* continues to expand, rallying everyone available to the cause, even acquiring a loyal office staff: John Bernard Myers (later of the Tibor de Nagy Gallery) and Betty Cage (later of the business staff of the New York City Ballet). Some people of course have gotten the impression that the "cause" is just Tchelitchew and that *View* is a "Tchelitchew organ." This notion is a limitation of the truth in the direction of what, as we know, the true Tchelitchew organ is.

Ford and Miss Sitwell are now exchanging letters and compliments and signed copies of their books. Tchelitchew carefully supervises their relations and starts reminding the English poet that Charles Henri long ago suggested she ought to come to this country for a series of readings. Only the war, which now gives signs of being won by the Allies, stands in the way. These days Miss Sitwell needs special consolation for she is suffering the family injustice of being disinherited. Of course this particular blow is another cord binding the artist to his dear friend across the water. "Dear Sweetest Edith" is the refrain of a classic aria.

A ghost, Miss Sitwell writes, is haunting her house, Renishaw Hall, and Tchelitchew is startled into interest, advising her to have her brother Osbert find out "all about it" as that will "help." In a twinkling his mind has shifted to himself. "I am like a ghost too because I am so tired." He used to draw in the evening after painting all day but he cannot any more; no, but he does write letters then. He can hardly talk on the phone, so he protests, and even neglects his plants. Evidence of the truth of his fatigue is visible in his handwriting, which is getting more capricious and difficult to read, racing on and leaning forward, also making jagged hills, like a sprinkling of pins and needles on the page.

In May, 1944, he is plunged into agitated thoughts by the death of his friend, Florine Stettheimer. In fact Pavlik is obsessed with the deaths currently taking place, describing them all in detail. Some are violent accidents; one is a suicide. All are those of friends or acquaintances. He thinks Florine Stettheimer this country's best painter, opposing Duchamp's more patriarchal opinion that it is Eilshemius. He says that Florine foresaw her death. Then he notices with alarm that the lines on his hand have changed. "I dont know what it means," he sounds one of his regular laments, "but I know that I am changing completely without being able to runn back to a different being altogether." He may "will" a great deal but now he has no choice: he runs forward on terms of compulsion, on terms of a will beyond his own. He is sensing the *absoluteness* of his deliberate change of agenda in art. To identify man with the universe is at once to expand what is materially finite, the body, to what is infinite, and also in reverse, to reduce what is infinite, be-

* Jackson will become a partner in the Alexander Iolas Gallery.

yond the body, to the perfect intimacy of human anatomy. It is the climactic legacy of *reversibility, simultaneity, laconism*, those plastic seeds he cultivated in his art of the twenties. And relentlessly he forges ahead. *The Crystal Grotto* appears: a profile skull with the subtle shadows of a mammoth cave. *The Golden Leaf*: a diaphanous male nude whose visible skeleton seems an extra adornment. *The Pearl*: a skull so magically modulated that it seems one smooth surface.

One day, he feels a thousand years old—as old as the only things he thought himself fitted to "epater": trees and elephants. Charles Henri says to him he is "getting inhuman." But he proves there is little foundation to this by becoming friends with Edmund Wilson and Mary McCarthy during a summer in Wellfleet on Cape Cod. Prince Chavchavadze and his wife are also neighbors on the Cape, and the the artist, speaking humanly, terms them "very nice good simple unpretentious persons." As though art could be anything for Tchelitchew but an empiric idea, as though it were anything but an instrument to build the Total Tchelitchevian: that indefatigable and growing ghost—indeed, that ethereally expanding ghost!

He plans to send Lincoln Kirstein, who is going to England as part of his military duties, to see Edith. "He admires you very much" he rather cautiously informs her, "but he is overenthusiastic about everything he likes so be very careful, though [sic] he is a very great and dear friend of mine. He is in some way a most remarquable [sic] man - but don't get along with C.H." Ford and I are casually indifferent to the prestige of Kirstein's friend, Auden, and so are Tchelitchew and Miss Sitwell; indeed, their attitude transcends indifference. Kirstein cannot bring the anglicized American poet into the Balanchine-Stravinsky ambience that Tchelitchew fits; at least, he can't without shedding Tchelitchew.

Paracelsus, now daily reading, affords the artist genuine encouragement. Edgar Wind, too, a student of magic, has consolidated for him the distinction, emphasized by all the great adepts, between white magic and black. Celestial magic, the same as the Pythagorean magic of numbers, is, as he agrees with Wind, the true basis of great art. Paracelsus believes that great things can only be accomplished in proportionate lengths of time and recommends the greatest care and precision in all things undertaken. Before him Pavlik sees the prospect of an eternal happy weariness of work. Then suddenly, in the seer's pages, he finds something miraculous. Paracelsus refers to a "wonderful magic tincture" which is called Green Lion, an alchemic term.* A couple of years previously ("I didn't even know Paracelsus then") Pavlik has painted a picture to which he gave exactly that name. The nature of the picture is as interesting as the alchemic allegory of the faculty in nature of

* Like the Serpent and the Milk of the Virgin, the Green Lion is still another cognomen of the Mercury of the Philosophers, indeed the Philosopher's Stone itself.

turning green leaves red in autumn. Tchelitchew's picture is a double image. The somewhat quizzically benevolent lion's head (another "father portrait") envelops a scene of children fighting; or rather, one little boy, upright, seems to have vanquished another, who is prostrate, while in the foreground (its large head punning with the lion's nose) is a skirted figure betokening a little girl. One is reminded of the child's battles at Doubrovka with which Papa had to interfere but more particularly, of the contests between Pavlik and his brother Mischa as boys, when Pavlik was invariably the victor and his sisters and half sisters watched. The little girl present here seems an aroused spectator as do the "leaf faces" framing the group.

In *The Green Lion*, war and revolution are signified by Tchelitchew's own symbol of wheatspears. While cursing the Germans in his heart as "la race maudite" his eye is discovering the face of a bull in that part of the nasal structure medically termed the labyrinth. He is now a mature adept, proceeding fearlessly along the mystic path. In the occiput, the rear of the skull, he discerns the head of the Sphinx. His eyesight is now *mystically* educated, liberated. He has foresworn his genre of portrait painting, declined to set a production of *Othello*, abandoned one of *King Lear*, left somewhere or other one of *The Duchess of Malfi*. And now he simply "can't do The Tempest with Zorina," who will play Ariel. Vera Zorina, once married to George Balanchine, danced a revival of *L'Errante*. The artist is too busy being his own Ariel, his own Prospero. Yet the metaphor of cat and mouse persists, for superstitiously he reiterates, "C.H. stays at my soul." And the loved prehistoric beasts of his childhood haunt him. Of a snapshot of himself: "I look like a lizard which was folded in two like a paper and sat upon." Magically, on the theme of green, Miss Sitwell's book of poems, *Green Song*, is to be published by *View*. About its contents, besides his own accolades, he quotes his friend Mrs. Beartrice (Bébé) Guinlé as calling it "un vrai délice. Je les adore." Mrs. Guinlé plans reading from Miss Sitwell's poetry on the radio. Meanwhile, there is no relief from the sad sober nightmare of his fear that the true Sibyl of his life, or Sir Kenneth Clark, or another of his friends in London, will be the victim of a bomb.

It is now he does the above-mentioned Medusa head with the skin literally missing, about which he claims that friends tease him for having been "all my life in love with Medusa." Fidelma Kirstein has often posed for a portrait (he likes her looks because she is "not Vogue's eye view at all") and for this image he uses her head. It has an echo of the "telescope eyes" of his original marine Medusa, done when a boy. Oh, yes, the Medusa is haunting him! The traumatic head has a strange inarticulate pathos as if a deaf-mute were trying to convey everything with eyes which, being lidless, are like a raised voice uttering incomprehensible, perhaps terrible things.

The magic menagerie can never be driven from the gorgon-headed art of

Pavel Tchelitchew. At the heart of the Total Tchelitchevian is Tchelitchew himself as the Mercury of the Philosophers, the alchemic dragon (an image of the Master adept) with a man's legs and face, a bat's wings, a fish's body and an octopus' tentacles. This is a monster only to the profane, being a precept in metaphor and (unlike the freaks in *Phenomena*) without actual physical coefficients. Nevertheless, as the artist vaguely knows, it must be symbolically slain. This is the legend* attributed to the dragonish Mercury I have described:

"Raising myself from death, I kill death—which kills me. I raise up again the bodies that I have created. Living in death, I destroy myself—whereof you rejoice. You cannot rejoice without me and my life.

"If I carry the poison in my head, in my tail which I bite with rage, lies the remedy. Whoever thinks to amuse himself at my expense, I shall kill him with my gimlet eye.

"Whoever bites me must bite himself first; otherwise, if I bite him, death shall bite him first, in the head; for first he must bite me—biting being the medicine of biting."

To be sure: an occult riddle which it is not hard for good students of hermeticism to figure out. But here, in the mouth of a mystic surrogate of our hero, it becomes his symbolic autobiography. To a reader of this book, the clues are unmistakable.

And now, now, *now*: V-Day surely approaches. France is invaded by the Allies and he pities the peasants working through the bombardments. All at once, he feels helplessly alone and aware of a great silence, wondering if it will ever be filled with "the wonderful sounds of celestial universal harmony." It is so kind of Osbert Sitwell, he conveys to his sister, to write about him in his book; actually, the remarks constitute an afterthought and were, he thinks, written only for Edith's sake.** Now more than ever he needs a flood of reassurance. Yet he distrusts the way Lincoln Kirstein, his arch supporter, "races through time: 50 per cent faster than others. Is it really necessary to 'galop in such manners'?"

Edward James buys three recent pictures but the artist doubts he "understands" them. Does Kirk, dear Kirk still have his old confidence in him? A bit grimly, he wonders. Though denying the habits of a social life, he occasionally dines out: he must introduce Chavchavadze to Edmund Wilson, who wishes to meet him. He must also get Mary and Edmund to come to Gertrude Cato's vernissage. Ford's mother has made much progress under his tutelage and is having her first one-man show. Is life possible without struggle, without war, without socializing? How close the three words can

* Kurt Seligmann: *The History of Magic*, pp. 158–59.
** The book containing them was *Noble Essences;* a later book, *Pound Wise*, included a considerable tribute to the artist.

seem at times! Paracelsus predicted there would be an era of peace on earth as a result of his teachings. Alas, he, Pavel Tchelitchew, will probably not live to see even a glimmer of its dawn! But some kind of peace is coming: the American troops have occupied Paris. So runs time, back and forth, on the faces of the clocks.

He and Ford have escaped induction. Is the nightmare really over? There are somehow two nightmares just as there are, somehow, two worlds. Dear Edith, heaven be thanked, has escaped the German bombs; she is a heroine. She ought to write a tragedy—"in voices." Safe, yes, but her neuralgia is very bad, and his own colitis is uncured although he thinks his present physician, Dr. Garbat, very wise. He has told Edith her amber is lucky: a magic substance that is good for her health. Paracelsus says gold and gems are for health, not for "proud adornment," and that sulphur and liquid gold are to be taken internally. But perhaps the true secrets of such old remedies have perished. Man, man! He has thrown away his precious magic. It must be too late!

Askew insists on a January, 1945, show despite the fact that Pavlik is convinced his dealer is bewildered by his mystic anatomization. Tchelitchew defines his present work as "something never known or seen before and the grandeur of the vision has the dignity of a religious thought and the simplicity of a drop of water." *Kirk* should know. All, who behold it, should know. Yet he feels it indispensable to explain. And Bérard! He is painting all the fashionable ladies and gentlemen, including Marie-Laure de Noailles' daughters and the so-called F.F.I. boys "who are really the same bad boys of the rue de Lappe." Today he is even further away from Bérard, and from Paris, than he used to be.

"I am very tired - when one is tired a strange essence of one's life is evident - one becomes half a goast [ghost] all ready I had to walk in the street yesterday to send letters, deliver some of my book, *Yesterday's Children*, to friends and I saw hordes of people together drunk, screaming, walking in all directions - unsure hesitating steps - rough voices - all going to partys, to meet people also drunk, screaming and rough." An aria; however private and black: an aria.

Allen Tanner has a nervous breakdown and must get shock treatments. Poor Allen! Always so full of sentimental fantasy. An artist's place is at his workbench, nowhere else: that is why it happened to Allen. "To work!" And Pavlik seeks his easel. How capricious and ungeometrical are the walls of the nose's labyrinth—like a honeycomb—it looks like membranous butterfly's wings and the veins in Edith's lovely amber ring. Now that Paris is liberated, Choura may come over. A telegram from her was like a Christmas present. But she herself . . . She is so shy and proud. He remembers how, not long ago, she accused him of taking all her happiness from her, even her

luck! How would they get on together now? *Horreur . . .* Anyway, C.H. is against her coming. Why do people *persecute* Edith and himself? Linc, for instance, adores him "like children adore their dreams." Pavlik, just the same, finds this friend "disquieting." For one thing, C.H. does not get along with him; they are always nipping each other. Edward James, "heated up," he says, "by Kirk," threatens to sell his car to buy a picture. Can it be believed? People are so arbitrary! He yields to his mood to vie with Edith in pillorying the people they know. Of a former collaborator: "Like a dried up piece of good cake - very funny dressed. He thinks he is very elegant (but in French way dont you see?) He looks like a good size ratt fallen in a rose sugar and glazed."

His letters are getting pretty erratic in form and he apologizes to Edith: "I am simply gaga."

Yet the fact should not really surprise him. In one evening, for instance, he writes letters to his sister, Allen Tanner, Lincoln Kirstein, Capt. Philip Claflin, Natasha Glasko, to a soldier in the army, to a sailor in the Pacific, to two university professors (interested in the scientific aspects of his new style), and two "social ladys"—in order, he asserts of the last, "to make those stingy hard pockets drop few drops of money for needs of poor good people [not himself of course]."

He discusses the *Timaeus* with Edith. Plato brings us back, he says, to the sands of Chaldea, to the city of Ur, "that listens to the music [of] and watch[es] the Stars." Also Plato states that only the intellectual part of Bacchus (Dionysos), after being torn apart, was preserved with the help of Minerva, and that all the oracles—Chaldean, Orphic, Delphic, Egyptian—are "essential and the same." Pavlik comments: "This is what I love to do - bring back to one, which is not in our beginning but in our end."

He connects his correspondent with the Delphic Oracle who was a "bee priestess." Honey, he says, is liquid gold, and apropos of nature's endless chain, he finds the tiger now in the Monarch butterfly; he has already put this identification in the puffed sleeves of a Knight in *Ondine*. Miss Sitwell has had an honorary title conferred on her but she must feel that his congratulations lack body, for he hastens to write: "It is certainly a great compliment, if there is need of any addition to your unique name, Edith Sitwell . . ." On second thought, he realizes expressly how much she needs soothing after being "persecuted and misunderstood." On the other hand, he thinks all her trials and sorrows have made her bloom into a "great oak." Such is magic philosophy and he believes every word. And peace! Peace is expected in the world any minute.

"Mr. Kirstein," he writes her, "is back from Hell." Meaning the war. "It is such pity," he adds about this mysteriously tempered admirer, "that he didnt come to see you." With peace, Miss Sitwell can now make the fabled recital

tour. Pavlik mentions the subject to Kirstein, who tells him that the British government arranges such things through the embassies and consulates. Also, now that Kirstein is back, the old prospect of a book on both *Phenomena* and *Hide and Seek* is revived, but this comes in the midst of an new outbreak of illness. His sinus trouble is very bad and he has attacks of vertigo. The osteopath to whom he goes every week intervenes by thrusting his finger up the patient's nose and, ostensibly, decongesting the pharyngeal canal. Not only does the vertigo almost disappear but the pains in his head and neck are much relieved.

Has a new Minotaur been miraculously slain?

Now what incessantly preys on his mind, of course, is fear of the atom bomb that won the war. For by now the war has been won!

One day, just like that, the news spreads like a vast, trembling yet undiminishing echo. Is life so changed? Reading Tchaikovsky's diaries, he is reminded of himself. Tchaikovsky was not pretentious: he was "humble, nervous." Pavlik imagines if *he* kept a diary it would be much the same: "dining here, seeing so-and-so going to concert, seeing so-and-so, writing letters . . . coco, zizi, mimi, dodo etc. who are they lost shadows."

He dreams about having tea in a restaurant with Edith. She is wearing a black coat and a brown dress he never saw before. She tells him something has torn her soul away from her body and he is much upset. Then suddenly he realizes he is wearing no clothes. "I run in a tube station to hide myself from the police and awake trembling of fear and happy that it is a dream." But it is somewhat more than a dream. For once, he is not quite prescient. Perhaps because he has begun frequenting an eminent lady horoscopist, who requires, to aid her studies, an article of value belonging to the client. He and C.H. speculate if he will ever see it again.

Without his knowing it, his very acts are prophetic. "I live like a madman and walk on the terrace like a prisoned tiger - like a wild beast aller et retour [back and forth]." He is avoiding contact "with men downstairs . . . avec le sourire dentaire et la betise [with the dental smile and brute stupidity]." On the other hand, he says, the guards at the Museum make a fuss over him because *Hide and Seek* is the place's "favorite child," people standing (say the guards) two and three hours before it. To Edith he repeatedly promises a *Hide and Seek* sketch. He and she—*they* possess the voice of prophets. It is absolutely proper that they "have to accuse, to do something! to sitt silent when the earth herself screams - it is rather undignified." Is the earth still screaming of V-Day? Choura, whom he has neglected to bring across in spite of Kirstein's advice, "reaches her claws across the ocean." And he adds, "She disturbs me so much I am ready to runn away without leaving forwarding address."

C.H. too is driving him crazy with plans for the summer. "I feel like a

fountain of spending." He does not sell enough pictures, feels the past year has been altogether a crisis, one agony of self-doubt and insecurity. A "wonderful flower" is growing in him, yes, but it is "a burning wilde [sic] raging belief and I am killing myself in making mad absurd pictures to whom I cannot resist and burn in front of them as the candel in front of an icone [sic]." Coming in the midst of such moods: Bérard's arrival in this country. Instead of outrage: a *berceuse*. And the sweetest, the essential, Tchelitchew vocalizes: ". . . in spite of his not liking my Cache-Cache [*Hide and Seek*] and being against my work, my thought, but adoring my past work etc I was so touched and still am to see him (he came by plane in a terrible storm . . .) It is something touching, so sad, so tragic, so pathetic about him, he is like a child that was purposely crippled to become a monster, something more wonderful was in him that is gone and he is mourning the lost paradise like the ill animals, like the wild animals in the circus performing tricks - which always breaks my heart."

Bérard has come to lunch with him in his large picturesque studio on 55th Street.

"He can't work, can't paint," he reports of him. "How can he? He lives in a cloud of smoke."

"I really think Bebe was sent here in storm and torment for me [so] as not to doubt more - to see my youth, my past restored, and in spite of Bebe have being [sic] played the role of my enemy - I was glad to see him, as if he would [be] my best friend." These days he is inclined to experience certain ecstatic flashes—like the New Year's Eve in Constantinople when he was so happy: "drunk with happiness and wine."

He keeps calling Charles Henri "obcesst." And once he shifts to the "sex-obcesst": "Sex is not love, no it is contrary of love - it is a sort of madness like gloutonnerie [gluttony], like cleptomania [sic]." Before yielding to C.H.'s wish to go to Bermuda with his mother and himself, Pavlik asks Edith to be very kind to Kirk Askew, who is travelling to Europe and has a letter of introduction to her. *View*, it appears, is to issue the book on *Phenomena* as its second publication after *Green Song*. For a while a symposium is discussed for the form of the *Phenomena* study. However, Tchelitchew looks to Kirstein as his only hope though he despairs of explaining the work to him: "I am sure Phenomena is an amazing and pussling [sic] hermetic canevas . . . What people see is onely the surface. They never use their brains to think of what it really means." Yet, although he encourages both Kirstein and myself to "explain" *Phenomena* because basically we, like Wind, are "poets," he never supplies either of us with any diagrams or explicit formulae for reading it.

Bermuda? It is, he announces, Prospero's island. Yet while there he falls ill. Before he departs, Gertrude Stein's death is announced. He cannot tell what

emotions the news arouses and he flees back to New York as if to bury her ghost. In the society of poets and painters accumulated by *View*, he is doomed to have clashes with the young. A poet extends his hand to him while sitting. "You are too tall a man to behave like a lady," Tchelitchew says and ignores the hand, turning away. C.H. is pestering him so that he may even go to Paris, as awful as he anticipates it will be. One moment he is praising Marie-Laure de Noailles' salon as the epitome of high fashion in culture, the next he is shaking at the idea of all the Parisian snobs who will be lined up to judge him.

He has a nice evening with Edward James (who is a poet and can be very amusing) but Sir Kenneth Clark, over here now, is treating him with an odd lack of deference. Not all friends of former years can win him. When Peter Watson remarks of his current work, "You paint sweet ghosts," Tchelitchew replies, "I know some sour ones, too." Reporting the exchange to friends, he adds, "I think he understood." His highly placed female friends, even those closest to him, can ignore his existence, it seems, at a party. Once he finds Marlene Dietrich sitting quietly by herself in a roomful of chatterers. Being old acquaintance he approaches her and offers a penny for her thoughts. "Do you know what she said?" he tells me. "Her only reply was to quote a passage from Rilke's poetry. I told her he is my favorite poet."

"I have no friends besides you," he tells his Vittoria Colonna. "I have no real friends." He does have, however, terrible vertigos. The osteopath's manoeuvre seems not to have solved the problem. Doctors say it is an infection of the middle ear. For a few days, he is petrified.

A show of his work of 1930–33 is held at Durlacher's. Some pictures look very immodest, he considers, others very proud. Bérard's pictures, he says, "always begged for a smile or a compliment . . . Mine were non-flirting canevas." On Cartier-Bresson's current show of photographs: "[it] makes one happy like cats who as soon as they see snow run out to play around and live [leave] little footprints on the velvety surface of white."

A tragic note comes from across the ocean and back.

Choura: "I don't want to live."

Pavlik: "Keep it to yourself. I never said such a thing to you."

He sends her a fur coat by courtesy of Cecil Beaton, who delivers it to her at the station in Paris.

He is not in the least "amused" by doing the pictures that now obsess him. Nor has he any happiness or courage. Infallibly, the family motif unmans him: "I feel Choura hanging on my neck and my poor neck is so tired . . . She thinks she is a victim and I am a cranky stubborn selfish brother who cant even come to see her in Europe." Mme. Zaoussailoff's lung cavity is worse; she has been several times to Switzerland for treatment. As for himself, he has learned he has serious anemia. Again a doctor inserts a finger into the labyrinth of his nose, this time even farther up, in order to break the small

blood vessels there: the theory is they are swollen and have been giving him vertigo and head pains.

His past work is gradually reappearing to him "as a fog lifts from land-scape." He sees that the ninth landscape head about the tree in *Hide and Seek* is the newborn child at the bottom of the tree. This is the earliest spring landscape: the awakening. The veins in this head are suggestive and he studies the various parts of the brain as they govern the mental, nervous and instinc-tual functions of man according to hermetic interpretation. The creative part of the brain is in the back, "not the forehead [i.e., the *tchelo*]," and this is "evil" since man invents, he says, mostly to destroy "except in art where it comes from within." He is preserving the *tchelo* from profane contact. The "female end," which reminds him of *Hide and Seek*, " is the south bank of the river - the genitalia - therefore Eve had seduced Adam - not by her brain - therefore man's inventions are not welcomed by nature, just the contrary."

The *athanor*, the Alchemist's oven, is still burning in *Hide and Seek* but the process is further along the way. Not merely art is metamorphose; or rather, art's metamorphosis is only a reflection of life's. *Hide and Seek* is being abstracted into a total image of the brain and its spiderlike veins.

In *Life* he finds a photo of himself with Gertrude Stein, seated in Godiva; Allen Tanner took it twenty-one years ago. "*Quelle nostalgie!* How young I was!" At Flagstaff, Arizona, where he spends the summer, he and Ford chum around with Max Ernst and his wife, Dorothea Tanning; the Surrealist painter has long been divorced from Peggy Guggenheim. One day Tche-litchew is appalled to startle a huge kingsnake in his bedroom; it is just leaving by the window but unhurriedly, at a majestic pace, while he stands panting, transfixed, awed. There is a nerve tree, he thinks, that grows in us and blooms in our head. And he does the beautiful *Head of Nerves*, representing Quet-zalcoatl, the God of Rain.

Monroe Wheeler, Kirk Askew, James Laughlin are all undertaking to arrange for Edith Sitwell's American tour but she does not feel able to face the United States just yet. She is not strong and suffers from a bad arthritis. "I will take you to my chiropractor and give you a new life," he writes reassuringly. It is again Christmas, *alors!* A snowstorm with a record fourteen inches. If there must be Christmas, it is best if Kolya Kopeikine be a dancing Santa Claus: costume, beard and all.

"My dearest future Doctor! I can't tell you how happy I was to hear about your becoming a doctor because if there is anyone to be called one on account of one's wisdom, you are certainly *the one*. Cecil just said: 'She ought to be the Poet Laureate because she is it already.' "

He conveys that he is trying to pin down Alice Pleydell-Bouverie and Minnie Astor about guaranteeing the expenses of the Sitwells (Edith and Sir Osbert) if they visit the United States.

Then Pavlik smells out a cad in a certain "Mr. Suspenders" who never

presented Edith with a letter of introduction. Friends? There are friends, *en tout cas*, and there are acquaintances. Léonid is about to marry Sylvia Marlowe. "They are like children," Pavlik writes, "and I am terribly fond of Léonid if [as though] he would be my brother." It has been through Tchelitchew that Askew has become Léonid's dealer.

Considering the fatal truth that he is widely known only by *Hide and Seek*, he begins to find fault with Askew, his paragon of a dealer: he is narrow-minded, he concludes, after all, "and sees only a small part of me." His new exhibition is creating great admiration if also violent attacks. How can the critics call his pictures a "nostalgic world," he wants to know angrily, when it is a strange poetic world whose symbols are just becoming clear to himself? Yes, after years and years . . . Suddenly he thinks of his age. Soon he will be fifty: half a century. He looks, he thinks, ten years older than he is! The war did it. *And Charles Henri.* At times, in front of friends, he raises a symbolic fist against Ford, whose back is turned because he is retiring in bad humor to his own room. "He is eternal young," gasps Tchelitchew. "Can you beat it? What gave him that unnatural capacity? Will you tell me?" Going to dinner at Ettie Stettheimer's, he sits at table with Carl Van Vechten, his wife Fania Marinoff, and his hostile/friendly critic, Henry McBride. "Six at table," he notes gloomily, their combined ages equalling "436 years of life."

Memories of Gertrude Stein erupt in a letter to Edith and he recalls how Gertrude was his spiritual mother, but because she represented "rooling [ruling] matriarchal magic in the form of common sense," she "dragged him down." Yes, she incarnated those "restraining forces of earth." This is his current verdict on her ghost. To Edith: "When I paint your next portrait"— but he will never paint it—"it will be a 'Muse' not a 'Sybill,' an inspiration and not a destiny."

Recalling that Edith herself termed *Phenomena* a "prophetic" picture: "First of all I am a prophetic visionary painter who belongs to a family of artists thinking in symbols . . . I think even Lincoln, who listens to me like [as I] myself listened to my Nannie when she used to tell us fairy tales, he also is very little aware of the meaning of them all." Kirstein has made a choice of Tchelitchew's drawings for a handsome book being issued by H. Bittner and Co. Pavlik thinks the choice "uneven." However, on the subject of drawing, Kirstein makes an excellent listener and produces as preface to the book a first-rate essay full of patient sympathy and superlative understanding.

This summer Charles Henri is so ready to go anywhere that Pavlik accuses him of being a gypsy. "Painters," he remarks, "are not gypsies." Apropos of C.H.'s search for a summer paradise: "I do not believe in Paradise on Earth - here one can live, eat, sleep and take walks. People do not walk in Paradise. It

is their state!" Strange, on the other hand, the state of mere earthiness. The Tchelitchevians have been promoting a revised monograph by Soby with *Phenomena* as the central focus. At the Museum of Modern Art, Monroe Wheeler is all in favor of the idea; then, according to Tchelitchew, Wheeler and Glenway Wescott begin making difficulties.

A strange scene, told to me by Wescott himself, takes place when Wescott pays the artist a visit around this time. The writer is amazed to be met by the artist's rigid contorted face of anger and a finger shooting out at him. "I know you wish me dead," says Pavlik, "but watch out! My magic is stronger than yours and *you* will end up dead!" One fact is that Wescott will never relinquish his own desire to write a book on his phenomenal friend.

Nevertheless, it appears that "my dear Kirk" intervenes in the book situation and all seems arranged. But, evidently, only for the nonce. Time will somehow dissolve the project. In common with others, he soon declares himself "a prisoner of the clock." Just why? Because he forgets so many things he should "do, say and write." As cause or consequence, he is plagued with "hysterical fears." Several young painters who are his protegés, now back from the war, tend to upset rather than comfort him. On impulse, he reveals to Edith the identity of the faceless nude in the Bittner book of his drawings: "like a black puma. I call him 'my cat'." Every now and then, he and his correspondent have ventured to make fun of the world's "pretty young men." There are too many on the streets, says Tchelitchew, perhaps recalling that Dr. Sitwell, during the war, wrote him that she knew a number in London who "ought to be hanging out their lingerie on the Maginot Line." Another model, a dancer, is "like the Italian quattrocento portraits." And he adds perversely, "I hope so-and-so [naming one of his protegés] realizes I have invented him too." The "portrait" as such no longer exists in his creativity, only the "invention."

A casual retrospect on his portrait-painting: He meets a onetime subject, an Englishman, and declares to Edith: "I was right to paint him as the wall of the Gare St. Lazare. I bet the walls are looking the same as 20 years ago."

The artist says his work makes him feel "crucified." The Total Tchelitchevian is not in much better repair. Loyal friends like Monroe Wheeler (even though they may be at casual odds with him) send rich connoisseurs to Durlacher's to "look at the Tchelitchews." Somerset Maugham, for example, is one. But Maugham looks and looks, then buys one small drawing. Tchelitchew worries over the fact that his dealer, Askew, gives him no "security." Since he left Pierre Loeb in Paris, he cries out, he has never had a cent of guarantee. At times he does not spare the man he once thought his savior: "Kirk irritates me laetely [lately] to such a degree that I am holding my hands not to send him where he belongs."

Edith Sitwell's materialization in America is fast approaching life-scale. He

imagines great ladies of his acquaintance as her "ladies in waiting" and advises her how to choose. Later, doubtless in complete innocence, he makes a joke of kings and queens themselves. Seeing at Durlacher's the young Queen of Yugoslavia, Alexandra, lovely and elegant and an admirer of his, he comments to Edith: "All my royaltys are in the past - they are there with crowns and jewels - I am on a high mountain landscape now - kings and queens are in the valleys bellow [below]."

He is much annoyed with Askew because he also shows Queen Alexandra works by other painters of his. "A hunter who has hunted tygers cannot be pleased with hunting rabbits, even worse, ginney [guinea] pigs," he reports saying to Askew, and adds characteristically, "I think he got it." The pay-off: "I feel I am not in my place at Kirk's now. I am onely a prestige that's all." Yet good personal relations with Askew survive.

His last letter to his great correspondent before her arrival in the United States concludes: "Soon you will be here and we will be able to talk about many things - I would be so glad - I can't believe it. You'll find New York very childish and very exhilarating, also very trying - but you have to know how to protect yourself from people - they devour one if one lets them . . ." And he refers to the fact that their wartime correspondence will make quite a volume, that it must be kept intact, and go to some distinguished repository, probably Yale or Harvard.* "I wonder who is to be the custodian of this volume after all? You have to decide it. Ladys first."

Passage

The Sitwells' ship is about to dock and still Tchelitchew cannot decide whether to meet it or not, citing all the reasons for avoiding the confusion of conditions on the Pier at such times. Askew has urged him to go. Now, within an hour of the docking, Ford declares for the virtues of protocol: "It will be scandalous if you don't meet her. Kirk is right. Go dress!" What is bothering him—he both knows and doesn't know it—is the old implacable superstition that physical confrontation with his great friend produces an undesirable effect on her; besides, the human presence itself is something which plastically, in terms of pure vision, he holds today in such different focus than when he last saw Edith. Then he had not formulated his Interior Landscape and its supreme conversion of all anatomic identities.

It is rather grotesque, of course, but Edith Sitwell exists for him most truly as the great Sibyl he painted in 1937 and it has been to this image, a purely spiritual quantity, that he has addressed all his letters. But Kirk and Charlie are right. He is being an imbecile, perhaps! It would be more *grotesque* not to clasp as soon as possible, and kiss, his dear friend, delivered safe to him in America after surviving the physical dangers and mental terrors of the war.

* Several years later, at Tchelitchew's desire, it was committed to Yale University, where it reposes at the Beinecke Library, unavailable to the public till the year 2000.

He dresses and hastens to the Pier. The fever of the occasion, the personal consequence of the visitors, Osbert and his sister, honoring his new country, prevail. The heart's blood spills over, the head is vanquished. Everything on the Pier is delightfully dizzy—dizzy, of course, but truly delightful. He is glad he went; indeed, a histrionic occasion always provides a tension that tones him.

Moreover, an apocalyptic event lies immediately ahead: Edith will see *Hide and Seek,* and so will Osbert. His heart—the heart which goes "like a snail"—gives the slightest of flutters. There are a few hours to wait out.

The past September, he has arranged with Mrs. David Pleydell-Bouverie and Mrs. Vincent Astor (later Mrs. James W. Fosburgh) to provide tax-deductible funds for the Sitwells to occupy a suite at the St. Regis. Because Sir Osbert's lectures here are so successful, he will eventually make good a large sum to his guarantors. At once, the amiable hosts give a dinner in honor of the visitors. Among the guests are Lady Ribblesdale (Alice Pleydell-Bouverie's mother), Monroe Wheeler, Lincoln and Fidelma Kirstein, and of course Tchelitchew and Ford. Edith, the artist at once notices, is wearing a dress of striped gold and black material which he himself, having in mind Edith as the bee-priestess, has sent in advance to England. Explicitly he has directed his friend that her wardrobe have a Medieval style. Now, in irresistible reflex, he decides that the exquisite fabric has been deplorably tailored, and neither his face nor conversation can hide his irritation. Charles Henri, for his part, likewise has an inveterate reflex. This is his pain that his illustrious friend, as always, "hogs the conversation." Nothing seems too much amiss, however, since this is the ever-tuneful distinguished Russian, vivaciously full of himself. If he were otherwise, something evidently would be wrong. Rare is the instance when Tchelitchew is so perturbed he does not speak a word at a large dinner party. But it is possible.

Pavlik has written Edith thousands of words about *Hide and Seek.* The next morning, he learns that Dr. Sitwell has lumbago and cannot accompany her brother to see *Hide and Seek.* Again the artist registers a sort of clutch in his now tender vitals, a hot little storm at the top of his chest. Today he is expected to lunch with the Sitwells and wishes, on hearing of Edith's indisposition, to back out of it. He suggests tea, instead, but Sir Osbert says lunch has already been ordered, so he goes to lunch.

Edith appears wearing a red turban. Without ceremony he says of it, "It is too 'fixed'." The lady remarks that she herself has not made it. "Those you made," he replies, "were better." There is something both febrile and cold, and starchy, in Tchelitchew's manner, and the hypersensitive Edith, mystified, does not perceive it without a sinking heart. To Charles Henri, he has already scoffed at his friend's use of her doctorate to designate herself when leaving a phone message.

Then the great unique moment: she stands before *Hide and Seek!* To

Tchelitchew's amazement, regardless of any fugitive premonitions he may have had, his best friend, perhaps the most eminent of his admirers, is "silent." What can be the matter? Tchelitchew only knows that the burning leaves in the painting seem to have ignited his soul. His very eyes are full of their smoke: he is half blind. He dare not look directly at Edith lest he show her his seething annoyance.

In fact, *what can be the matter?* Does Edith Sitwell see too little in the painting after all—or too much? There is later indication that now she may be too full for utterance. Next morning, she will send him a letter overflowing with articulate praise. Charles Henri will reproach him about being extremely foolish to hold resentment over the moments at the Museum. But evidently, it is just those moments that make the difference for the artist.

In due course, I meet Edith Sitwell at Tchelitchew's apartment, but *Hide and Seek* is not mentioned and personally I hear nothing from her of her reactions to it. As I write, I cannot help imagining the two friends standing before the masterpiece and that their situation is a typical one. The physical presence of a painter when his work is unveiled to a close friend is a supreme challenge to that friend's objectivity and private conscience. On the other hand, I find it hard to imagine Edith Sitwell (so intimate with *this* painter) as capable, even on the strictest principle, of reserving her praise. Verbalized compliments of some sort, therefore, must be assumed on her lips. However robust in sense, they must be faintly vocalized. This alone would grieve Tchelitchew, to whom the theatrical note of ovation is the only proper response.

After the receipt of her letter about *Hide and Seek*, the two dine tête-à-tête and she confesses that she really is at a loss for the right words in society. In future weeks, he will berate her for lack of humility, but at this time something inherent in her professed shyness touches him and he assumes (as he tells Ford later) that Edith is, as a poet would be, perpetually in search of the right word. All the same, this very remark is a way of italicizing his friend's unfortunate difficulty. In short, he concludes his judgment of her with the old heretical sentiment, so damaging to the idealistic structure built up by their correspondence, that her behavior in the presence of *Hide and Seek* was caused by her overwhelming response to him as a man, a sex; that his person confuses and blinds her, robs her of her tongue . . .

If that were quite true, it would not be scandalous. It would hardly even be extraordinary except for the mutual image which is the myth so firmly uniting these two friends. What is regrettable is the violence of Tchelitchew's consciousness of it. We are in the deepest place of our hero when, in the dynamics of life, Edith Sitwell passes away as the Vittoria Colonna of a Michelangelo. The sphere of the great mutations that led to the ideal is now in retrospective phase. The time creation of the mandorla that will convert all

such images into La Dame Blanche has reached, in other words, its point of rest. Beyond lies the body of another sphere, Ford, which meanwhile has been moving into place from the opposite direction. As inevitable, the actual passage has not been achieved in Tchelitchew without physical nausea: an upset parallel with his colitis. This is all the graver because, simultaneously as it happens, he is experiencing the fatality of Ford's dominance in his life with a kind of revulsion, a true moral unwillingness. Only this precise feeling, ironically, is needed to acquaint him with the full impact of the Fate figure he always saw in Charles Henri.

His colitis, during Edith Sitwell's stay in America, is very bothersome. His friend is fêted, publicly and privately, but one might think he regretted not sharing her glory or at least not stealing her away from it. One very special event is the party at Frances Steloff's famous bookshop where she and Sir Osbert are photographed for *Life* in an ensemble of poets. Tchelitchew (perhaps not only because he cannot be classified technically as a poet) is absent. To Geoffrey Gorer, the artist complains that she doesn't pay enough attention to *les jeunes*. Perhaps this is because he wishes her to be more affable to Charles Henri and his sister. One thing persists: whatever his passing mood or private quarrel with Ford, he remains fiercely loyal to his general interests.

As the visiting dignitary is herself aware, naturally, she has come to be seen, not to see; to be heard, not to listen; to be adored, not to adore. Tchelitchew himself thinks her extraordinary sensitivity to being appreciated is the logical result of so often being attacked and ridiculed. She is welcomed in this country as a reigning celebrity; on this score she has nothing to complain of. Some greediness, even, can look out of the regal bearing: the avidity of a shy queen who secretly gorges on reverences. My friend, Charles Boultenhouse, cannot conceal in her presence a hint of awe behind his young smile and punctilious courtesy. "What a charming young man!" the eminent visitor candidly exclaims of him.

No, it is her bosom friend, Pavlik, who finds things to complain of. Forgotten is the homage due a great poet. He accuses her of basking with too gross and loitering an ease in the public eye. He accuses her of pride! The poor lady is physically not so well herself and wishes to enjoy her visit as serenely and fully as possible. With ugly incongruity, Tchelitchew alone threatens to spoil it for her. To Charles Henri, he identifies Miss Sitwell, because he happens to be reading a book on the Tarot, with Isis, known as the Great Mother or the Queen of Heaven, and representing the moral quality of temperance. Most of the mythic lore connected with the Isis of the Tarot is Egyptian and considers the initiate a surrogate of Osiris, whose dismembered body was, of old, reassembled by Isis. The supposed initiate experiences, in trance, the identical horrors historically suffered by Osiris (or, as in Tarot terminology, by the Master). Tchelitchew's reason for the Tarot

identification is plain: his great friend, his spiritual idol, possesses an aspect in which she supervises the reassembly of his own cut-up body; this role (as orthodox Tarot analysis agrees) is rich with ambivalent magic. Very probably, the artist notes that one symbol which the Tarot cards associate with Isis is the astrologic sign of Venus.

The Sitwells will return to England in a glow of public triumph. But Edith's mysteriously wounded friend, Tchelitchew, will not let her leave without a personal rebuke. Unhappily he elects to administer this during a large farewell dinner at Voisin's within earshot of all at table. It is impossible to specify just what is said, but undoubtedly it is a scene of intentional humiliation and virtually a monologue on the part of the chastiser. Though she will admit to someone that later she weeps, she shows, now, no signs of emotion. The mandorla's crystallization has carried with it a devastation. To Ford, Tchelitchew insists, "there are two people in Edith which I can't put together." The greatness of mentality in her work, he contends, is not in her life; in fact, he says that he and she have lost the secret of direct communication when together.

How so? "She is not feminine enough," her friend paradoxically asserts. What he means is "not passive enough." At this time, the late Dame Edith is in her prime maturity, inimitably grand despite her air of concealing, under the grandeur, a frightened young girl. To me, she seems the most majestic as well as the most feminine person I ever recall seeing. In one dimension remote as an idol, eternally composed, in another she seems the arch persecuted heroine of romance: defenceless against the brutal chance of insult. These, I mean, are the two extremes of her character. Her great friend, Tchelitchew, seems elected to disappoint neither the one nor the other extreme. She knows this from of old and now, as previously, she is ready to forgive him!

A less disciplined outburst from the artist (fortunately limited to Charles Henri's ears) takes place when the date of Edith's departure is announced:

"She's been ungraceful—ungracious and selfish; she has neither intelligence nor heart. I'd like to slap her face and have her kneel at my feet and crawl like a worm."

The words give us a little arabesque of at least one form taken by those traditional "rows." But the last *real row* with her has taken place . . .

Charles Henri

Edith Sitwell has not been the only recipient of Tchelitchew's confidences about the inner development of his art. Besides his sessions with Kirstein, he has held long conversations with Ford and some with me. Also, he continually rationalizes and justifies his new style (however gratuitously) to Askew, his dealer. For example, in a few years, he will write the latter: "I am not 'deliberately' and 'a priori decided' kind of man. I am an obsesst man - my

obsession - are the t[h]reads that attach me to the hands of Mrs. Nature which she pulls and I have to obey. Onely obsesst man can achieve the unachievable . . . I am not bragging, I am very humble in my humble position - now - but I am neither asleep nor bewildered nor in delusion - I am fully aware of what I am doing . . ."

To Charles Henri, of course, he can say more perhaps than to anyone. It is during this period of transition that he tells Ford he has finally recovered from the nausea he used to have when looking at his studies showing the internal organs of man because now he is imagining the same organs in an unrealistic, crystalline form. Incidentally he blames Kirstein for confusing him by insisting (while he is doing a series of things for silk-screen reproduction) that he keep "reality" before him. Kirstein has urged him to remain faithful to what he terms *le côté humain* (the human path). There is paradox in this crucial moment of transition and the artist finds it hard to convey the exact nature of the crisis even to intelligent sympathizers.

Truthfully, he has been terribly bored with studying what he decided was essential to his new style, the exact relative positions of nerves, muscles, veins and arteries, so as to visualize them simultaneously in depth. Since they overlap in a most involuted way, the problem of transparency quickly became acutely technical. When first he mentions his exasperated impatience to Ford, the poet earns his gratitude with the suggestion that he not try to put them all in *at once*. No! Art is selective. But more than that, it is transcendental. This means he will have to find a way of representing anatomic totality without being literal. And he *will* find a way. It is his fate—and, he fondly hopes, his *fortune*.

Regarding the things of earth, science and society (including fashionable philosophers) can detect no sensible lessening of color saturation or density: no alteration in the nature of volume. Yet for this artist, already "lost" in his search for Paradise, these elements have paled and altered; their normal seeming is discarded for the apprehension of their finer essence; the first steps of local celestialization take place on the face of Tchelitchew's easel. He will write Lincoln Kirstein that he was unhappy in the midst of the Interior Landscape "because I was feeling subservient and a slave of the literal world." Being a slave: an old complaint, a hellish complaint! Earth, the earth of man and the peace of the 1950's, seems hopelessly fragmented to him wherever he looks, whether into the street or into another painter's canvases. He does not really abandon the Total Tchelitchevian, the organism I have formulated for him; that would be to abandon life itself. As yet, he is not thinking of this or any impaitent, self-destroying fate.

But the depth and intensity of his concentration on refining objects and eliminating the dense full bloom of their literal being, replacing all that with an essence that still is visual, cause an unformulated change even in his con-

ception of the immediate world. He has virtually exhausted his hours of reading in mysticism. But coming across Gaston Bachelard's *L'Air et les Songes* (*Air and Dreams*), he exclaims over its metaphysical dreaming as "my portrait." He is waiting for new discoveries, one of which will be the Chinese Book of Changes, *I Ching*. More than anything, the primacy of mystic numbers obsesses him in the way number combinations fascinate a gambler. The true end of the Magnum Opus of the Alchemists must be in number. From the occult chemistry of the elements, carrying out a process that specializes nature, something must emerge approaching the abstractness of mathematics and music. This mystery he will work out for himself in his art—where else?—but the mystery of his life, his career, his relations with Charles Henri, these he has an impulse to refer to a professional sibyl: his female fortune teller who reads horoscopes for him in New York.

He does not presume to call her anything but a fortune teller now. "The fortune teller told me . . ." is a phrase always on his lips. Constantly, Ford hears such oddly ambiguous verdicts as, "The fortune teller told me that good comes of our talking to each other—there's no one else to talk to." The man Pavlik is still the boy with the passionate need of being mothered, of having someone (it used to be called his Guardian Angel) to guide and help him when he is in danger of faltering or despairing, and of course now he is always in such danger, or imagines he is. He even consults the daily horoscopes appearing in newspapers. "I read my horoscope," he informs Ford, "she asks me how I am spending my money."

Not that he relies fully on anyone or anything. Like primitive man, he needs soothsayers but himself works like a horse to ensure that their predictions come true (or untrue). When he tires and must put down even his pen that writes letters, he announces, "I'm an old horse. That's all what I am now." Every morning he wakes up early, comes to part the curtains of the windows in Ford's bedroom and raise the shades.

"I can hardly move," he says and regards the prostrate Ford. What has he accomplished, this lolling sybarite with the limbs of an eternal stripling? *View* has died, of course, two years ago. Printing costs became higher and higher; our circulation simply could not be pushed up or our advertising increased despite the frantic efforts of our advertising manager, John Myers, to boost the latter. For years Charles Henri has had a new and absorbing objective: writing commercial plays. He hopes to write a Broadway success, preferably starring his sister, who after an obscure career in Hollywood has made a distinguished appearance in New York in Sartre's *No Exit* (*Huis Clos*) directed by John Huston. But the play had a brief life. How much Pavlik has schemed to help Ruth in her career! He visualized her as Ophelia, predicted she would play it, and sure enough, the magus proved correct. Miss Ford was invited to act it in a company that presented *Hamlet* in English at

Elsinore.* Perhaps, if Ruth had married Edward James rather than van Eyck, he reflects, her career would not matter so much. Poor Edward, disappointed, had to console himself by going to Mexico.

Here, in the heart of existence, is Charles Henri, the abiding spirit in his House of Earth: the immutable factor: the last dense knot of the world's resistant matter . . . Ford has stirred but his eyes are still shut. Under his lids, Pavlik divines that axis that lives at the earth's center, that calm, insolent, tacit assurance—the secret, incredible breathing inside the innumerable envelopes of being. He understands why he identified Charlie with the Tarot card of the Sphinx. The Sphinx presides over the Wheel of Fortune. Why, it was just lately that he realized (and told C.H.) that the big round wheatfield in his red portrait of him represents the Wheel of Fortune!

No matter how many times, after midnight, Pavlik wakes to hear two pairs of footsteps in the foyer and going down the hall, no matter what scene he makes in the morning, their domestic arrangement and everything else go on as before. He allows himself freedom on his own side, but really, he leads a disciplined life, while Charlie—!! Yet not once, not even for a night, does he make good his plangent threat of going to stay at a hotel. Every threat is simply part of the tantrums that have become as frequent as his attacks of illness. During breakfast this morning, the artist tells his friend that he is Merlin, who lived in an enchanted forest from which there is no return.

But this "forest"—what is it? What does Merlin see beyond his tower? Well, anyway: Charles Henri! And a letter comes from Edith. He swore, while she was still here, to tell Osbert (who lauded *Hide and Seek*) that she was a *vielle idiote*. But he never did. Both brother and sister brought disturbance into the enchanted forest; the whole time they were here, he couldn't work, and he remembers how an iron rod, on the terrace, banged all night so that he couldn't sleep. What, now, does Dr. Sitwell have to say? Maybe she always wanted to enchant him; Merlin, he recalls, was enchanted by a woman. Is she persecuting him? Well, after reproaching him for being "cruel," she carried onto the boat, when she sailed, a conciliatory letter from him.

He reads: "Though you are for some reason angry with me, I really do not know the cause. You must know in your heart that I have been a devoted friend to you for over twenty years. It was a most terrible blow to me, coming to New York to find you were unhappy and then ill—really one of the most dreadful blows of my life. You gave me no opportunity of showing you what I felt but I really was shattered by it, as Osbert knew."

"*C'est possible!*" his heart says in French. He will wait a good while before replying.

C.H.: "Did you sleep well?"

* Production by Blevins Davis, Kronborg Castle, 1949.

Pavlik: "Je ne sais pas. I me reveille avec le dagger dans le heart." The mixture of languages is no effort at comedy.

C.H. (referring to the dagger): "Well it's of your own manufacture. You'll find the trademark to be Tchelitchew."

Or Tchelitsche! Or Tchelish!

And a *gold* dagger.

Gold? His illness expresses itself even as to color. "I loathe yellow yellow yellow. I have such a pain in my solar plexus, too much housekeeping." No servant is ever quite perfect: there are blow-ups and sudden leavetakings. Besides, they're always asking higher wages. An analysis of his blood and urine has showed bile. Dr. Garbat has advised getting away and resting; meanwhile he has taken some "shots" and daily imbibes a tonic.

Quarrels with Charles Henri are so frequent that he thinks of going to teach at some American university. To Ford, what is really "eating" his friend is simply his (C.H.'s) decision that what he primarily cares about now is himself, his own work. Allen Tanner's old role is simply not for *him*. Ford knows how much, during his occasional absences, Tchelitchew complains about him to his friends, and that some of these urge Pavlik to break with him. He decides he will be as considerate as possible of Pavlik in the future, intelligent, tactful, patient . . . He is really sick and getting old. The poet anticipates an inevitable series of exhausting crises which he will help his friend to weather. This is all he can do . . . "Pavlik," he tells the diary he has recently begun, "is a river without dams, unharnessed, flooding everything, wasting itself."

One evening Charles is lying on his couch drinking a glass of milk: it is about half full. Pavlik enters, stops over him, asks, "Why are you lying there?" He gets no answer. They plan to go to Europe this summer and the artist starts complaining hysterically of how much it will cost to take their Mercury car to Europe and back; Ford is the driver as Tchelitchew will not learn how to drive. And he asks his supine friend, "Why don't you get a job and make some money?"

Charles throws the remaining milk in his face.

"That's my answer. I'm sick of you! Sick! I have no more feeling for you!"

Pavlik stands motionless, dripping with the milk, making no gesture to remove it. In *Phenomena*, surplus milk is being poured into the ground. Why not also dashed into his face? *Why not?*

To Ford, still reclining, he looks very pathetic, terribly hurt, but seemingly unresentful. Without a word, Pavlik finally turns and leaves.

Ford thinks: "He's like a saint."

One morning, before Charles Henri is out of bed, Tchelitchew begins: "I'm in financial agony." Each separate agony of Pavlik's, Ford reflects, is taken in turn, relentlessly, like a merry-go-round.

But actually some succor is at hand. Askew, though the artist considers him "very tight," has at last guaranteed him a minimum of $500.00 monthly.

Sailing on the De Grasse, they realize they haven't seen Paris for ten years.

C.H.: "It's as if one were dreaming of the past. *On ne peut pas recommencer* . . . It's impossible to begin over."

Pavlik: "No. *Çela doit être autre chose* . . . There must be something else."

Of course they go stay with Choura in the Jacques Mawas apartment. Her lungs are still bad yet she continually smokes, coughs, chatters, ignores her brother's admonitions. It's the old Tchelitchew *esprit*.

Paris, Pavlik declares, has lost her pride. No longer is she the elegant queen of cities. The Champs-Elysées is like a whore. Everywhere he descries marks left by the Germans and the Americans.

Poor Natalie Glasko, white-haired, his friend for thirty years, now walking with a cane, pays him a visit. Pavlik thinks how old and unattractive he himself has become. Ford senses that the other's confidence can be restored only if he thinks himself loved and admired.

Now the artist has low blood pressure and is underweight. After a night of vomiting: "I could sleep for 10,000 years."

Yet, as usual, he goes into society with Charles Henri. Certain things are *de rigueur*. *Chez* Marie-Louise Bousquet. *Chez* Léonor Fini. Léonor has a ballet playing: *Le Rêve de Léonor*. It has some of her personal metaphors: bird costumes of the kind she wears at masquerade balls. Then there is an important soirée at which Henri Sauguet performs his new piece; Cecil Beaton, Dior, Arturo Lopez-Wilshaw are there. At one party, Ford hears that Edith Sitwell "went white" on hearing some horrible things Pavlik said about her.

The artist is seeing several new doctors. "The sand in my gall bladder," he tells Ford, "changes like the Arizona desert." The mucile sand, the binding sand, that used to be a remedy in painted images, has become part of his disease. One Paris doctor advises an operation, but instead they go to Molveno, Trento, in the Dolomites, to spend the summer.

Friends collect about him: Mlle. Fini, the painter Stanislaus Lepri, Edalgy Dinsha. And he works, on he works, visiting local doctors, contending with the noise of ball players outside the house, escaping crowds on the beach by the lake. Léonor comes down to the water in high heels: the eternal *précieuse*, but really distinguished, part of the Total Tchelitchevian. Such, anyway, is his hidden fantasy life, automatic rather than conscious. He suspects Léonor of having had her face lifted: her eyes seem to slant more than usual. He ventures to tell her how to fix her hair. *Les dames!* He was right to paint Léonor as an odalisque in *Phenomena*; he did her face there as she must have looked when she was fourteen. How far away both his Hell and his Purgatory seem . . . yet somehow they are still in his blood, in his entrails, just as *Phenomena* somehow circulates in *Hide and Seek* despite all the magic he

put into the latter. He has to paint Paradise in order to free himself, to cure himself. And on his way back to Paris, he stops at Peggy Guggenheim's *palazzo* in Venice. But he is too sick to go touring with Peggy and C.H., so he stays in bed all day, talking to Peggy's servant. His friends, when they return, learn he has had an enchanting time with the peasant woman.

Like some seismic convulsion, like the very convulsion of his bowels, the truth has come to him and will abide. He is, now, a machine as delicately responsive as the seismograph, which converts some distant profound dislocation of matter into a thin line on paper. The location of his seismograph is, of course, the brain: the front lobe, the *tchelo*, that must govern the creative part "on the south bank of the river"—where Eden is, and its mistress, Eve. There sex is, and the creation of children: the Lost Paradise. Lost, of course, because it represents the empire of the carnal: all the gyrations one sees in the distorting mirrors of Hell, the Fun House mirrors.

That is the trouble with Edith . . . there in the mass of her body, that truly feminine mass, which overwhelms and imprisons her brain, her spiritual self, whenever physical confrontation takes place between them. Ah! she hardly knows it herself and that is why she gets "confused." Gertrude Stein was different. She had taught her physical massiveness to be immune to overpowering sexuality; some subtle chemistry had converted flesh into brain. Maybe her magic was greater after all . . . Tchelitchew has told me, following Miss Sitwell's departure from New York, that perhaps he made a great mistake in allowing her to triumph in the "quarrel" over him between the two women. Miss Stein, he said, was more disinterested; she too said sibylline things but things that could be valued for themselves, were not mere personal compliments . . . He begins recalling all the wisdom she once poured out for his benefit.

As he was reminded when reading her disguised autobiography, she perceived that the line, in the work of Picabia and Marcel Duchamp, was meant to have the vibration of a musical sound "and that this vibration should be the result of conceiving the human form and the human face in so tenuous a fashion that it would induce such vibration in the line forming it."* He thoroughly agreed when she further said that the Surrealists took the manner for the matter "in the way of vulgarizers." That is not the way; no, nothing like the Futurists, either. He, Pavel Tchelitchew, has gotten lost in the labyrinth of the human body exactly through this mistake, through multiplying rather than simplifying, through imagining that totality is a quantitative thing, a perpetual passage of overlaps; there must be a choice among them and it must be simplifying. As he told Lincoln some time ago, the true form "quivers" under many layers of possibility—as Linc wrote, "wrapped in an halation of multiple choice." Halation, the light spreading too far in the photographer's plate, making (in the negative) "dark fog": that is why drawing goes wrong;

* *The Autobiography of Alice B. Toklas.*

rather, find that divine parhelion! the so-called "mock sun" that is brightest where two haloes cross, and prismatic!

Actually, as the masters of number, the true mystics, knew, it is always a question or rarefication, of reducing to essences . . . the sun's halo . . . not the sun: there true creation begins. He recalls seeing a Cézanne at an exhibit of Impressionist works last spring in Paris. Cézanne went directly toward an essence, and Pavlik, standing before the picture, exclaimed: "Untouchable and unbreakable!" Ah! the halo is but a vibration. . . .

When Gertrude said certain things, he could agree without reservation. For instance: "He who is going to be the creator of the vibrant line knows that it is not yet created, and if it were it would not exist by itself—it would be dependent upon the emotion of the object which compels the vibration."* It was about 1936 when she formulated that; he was just beginning *Phenomena*. Maybe she was prophetic and maybe *he* is the destined creator of the vibrant line!! The error of all the new abstractionist painters is that they have altogether forgotten about the emotion inspired by the object, the thing that "compels the vibration." Illusion! But illusion is nothing without reality. Modern painters get lost in the emotion itself, go crazy with it, then emotion becomes *motion* and they wallow in that, in paint for paint's sake, shoot it all over the place. That is vicarious and happens when one is a child. But he, even when a child, did not lose contact with objects.

He has gone down into men—ah, one must be careful of one's prepositions! Rare, and precise, exquisitely clenched, is the sweet terrible way of art: like walking on a tightrope. *Là bas!* The pit of Hell. There one is bound to meet strange things. It is the House of Earth. His own special "house," after all, so he has always been in particular danger. His researches in anatomy have proven that anywhere in man, one may encounter anything. In the brain itself, the central intelligence, everything is known and registered; without it, there would be chaos, even sensations be only an indistinct mass; no control, no specificity. *Pure horror.* This is one reason he has concentrated on the head. In the head, after all, is the birth of higher knowledge.

A Minotaur may hide in the nose's labyrinth; a Sphinx live in the occiput— a false Sphinx! False because buried in the body, locked there—*impure.* That is it. Impurity can be everywhere. If the better part of the brain does not triumph, the brain itself becomes diseased and allows the worst diseases in the rest of the body to rage at whim. Only the folk can be simple enough to adore the image of the monster; only ordinary people who are sincere animals understand the true symbolism of the monster: the transcendent union between man and the lower animals. To the people of India, all animals are sacred, therefore it is honorable for the monster to symbolize kinship between animal and human.

He will see how true this is on revisiting Ischia when he witnesses a festa

* Stein: *op. cit.*

and writes of it to Fred Melton*: ". . . lots of children, dwarfs, winged erect pricks, carried by horses and donkeys on their harnesses - the center is a huge prick that ends in a female organ kind of fig-shaped form surrounded by rabbit fur!! - on flat top of it there stays small erected winged prick ready to fly and shoot . . . whores, boys, shop boys, masquerading proposing you everybody and everything." This world is the hidden part of *Hide and Seek* which would never be understood if literally exposed to the art public. Even as it is: How many people who gather in front of *Hide and Seek* understand the symbolism—or even dare to believe their eyes? *Phenomena!* "What was *Phenomena* but a portrait of the very people whose eyes are so uneducated that, first, they dare not believe them, and second, if they do believe them, they don't know the true meanings of what they see!"

It is a matter between him and his own body, not just a matter between him and his art, his art and the world's art. In the *Head of Gold* and *The God of Rain* (or *Head of Nerves*, the Quetzalcoatl), which he did about three years ago, everything is becoming crystalline; yes, beautiful as jewels or lustrous impossible fabrics. But still they are labyrinths from which, if one were inside, one should have to find a way of escape. He has sought to show (as in *The Lady of Shalott*, his last Medusa) the whole eye behind its lids, the teeth behind their lips, the veins and nerves like trees and vines in air and water—as naked as if they were nudes. But still there is too much earth in them as if one were underground; they all look like the insides of caves while the hair of Quetzalcoatl (after all: the human hair of a young man) is like ocean waves rolling on veined bedrock.

Like a stage piled with too much scenery, beautiful, baroque, *too much,* rococo! Even as he regards Versailles: "too much." One cannot be the Bibiena of the human head. The head is not really a palace or a ballroom, however marvelous, as his décor for *Concerto* suggested. No: the human head is a model for the Celestial, not the Earthly, Globe. Through a process of evaporation, the liquescence of his anatomic heads—that look of jewels melted, running like blood and water unfreezing—steadily gave place, in his Interior Landscapes, to *the presence of air.* The concept of landscape then meant an exteriorization of the interior by exposure to air, as on the planet itself. Dante emerged from the infernal regions overjoyed to behold the stars again. He, Pavlik, emerged from his Hell overjoyed to gaze once more on the sun of his childhood with all its forest secrets. Now—well, as he once told Edith, he had to start over, just as everyone should be born again, the second time (as Pythagoras says) from a virgin. Yes, all of *Hide and Seek* has become for him the image of a brain—this is the work's essential concept as the heads surrounding the tree really prove. *Air:* air is the climactic element, the true womb of light celestialized! The brain, like the rest of the body,

* Melton started a silk-screen series of Tchelitchew works.

needs air, oxygen. Fire is absorbed by it, and water. The boys in *Hide and Seek* have all reached intermediate stages; they are caught, they remain there, because of the Tree, which symbolizes the cyclic processes on the planet: perpetual turn of earth, water, fire and air in the crib of the seasons.

Last year, he became more abstract; really, more *astronomic*. That is what they find it hard to understand. The Interior Landscape is really, when all its mirror images have evaporated, the landscape of the Cosmos—when irreducible, "untouchable and unbreakable," it is God's head: the Cosmic Intelligence. He has actually showed both the forms and the qualities of anatomy resolving themselves into pure lines and isolated, ghostly masses, volumes whose only "substance" is light, the pure parhelion, sun's *living* double. Once he made, on heads of plain rhythmic ovals, actual "halations" for mouth, nose and eyes simply by letting the black paper show through . . . The black cosmos on which he does everything now.

And now come the true formal heads: those I have named the Celestial Physiognomies. All suggestion of plastic realism, even "halational," is gone. The transcendent vivisectional plastique of the Medusa and the God of Rain has mutated into a geometrically formalized anatomy of the head. Human features are still present but defined by sequences of pure ovals as of expanding or contracting forces. Previously the abstract heads looked like the topographical notations of winds and tides, closed of course and as if following a simple surface, two-dimensional, either concave or convex: illusory. Now heads of solid geometry are altogether enclosed, have an austere classicality from which the human personality seems all pressed out; heretofore, some had an almost insouciant human expression, rather Far Eastern. Now, with these complex heads, there is an effect of serial movements forming independent, three-dimensional systems like coexistent but non-interfering universes; logically, Tchelitchew expands these into human figures. Spiral energy in the *Mercure*, for instance, knots itself at the joints—at all "pivotal" places—into perfect measured globes, so that such figures are like Vishnu, the god whose pores could emit whole universes. Eden's apple from *Hide and Seek:* it's the globe, the world: it's Newton's apple!

From the first, our hero's chosen problem in art was the dialectic act of creation, implying (as ultimately he learned) a second act: a "resurrection." But primitively, in plastic terms, the problem was that of interpenetrating volumes: double image, simultaneity, etc. Historically, it was man's problem when he wished to explain the mystery of birth, which at first he did not connect with copulation. Tchelitchew's art, as represented in his major trilogy, the Hell, Purgatory and Paradise, comprises three distinct versions of exactly the "interpenetration of volumes." The first (Hell) is on the biological plane, it is sexual: inseminative and parturitive; in brief, animal and physical: the Phenomena of Mankind. The human act is blind here, like

sexual desire itself, thus subject to infinite accidents and asymmetries, obliquities, real and illusive, that follow the most extravagant whims of desire. In *Phenomena*, we perceive as a whole the *social* climaxes for which the science of physics dutifully accounts in the natural world; hence the painting refers entirely to organisms. The magical status of these organisms (the "freaks") is purely symbolic, iconographic, as I have shown.

In *Hide and Seek* (to extend our reading according to the plastic interpenetration of volumes), we leave mere organic or statistical sex, and with the help of Alchemic postulates, approach the chemical dimension where forms refer not exclusively to organic bodies but also inorganic bodies: the forms of the elements—earth, water, fire, air. This is why, though erotic desire is more obviously, plastically present in *Hide and Seek* than in its predecessor, reality here is already transcending that very organic eroticism that it portrays. The dialectic act of creation is conceived as chemically saturative. Every "thrust," as I have said, every shape of energy in *Hide and Seek*, is *erotic* in that all its volumes (of varying densities) seem to have the impulse to merge, interpenetrate one another. This could have been shown plastically only by transparent overlap, even as different elements or different colors, decomposed by heat, dilution or chemical agent, may be seen in the process of dividing and uniting. All volumes are in the act of altering their boundaries—as I said previously, boundaries, strictly speaking, do not exist in *Hide and Seek*.

And now, on the third hand, after depicting the gradual immaterialization of natural volumes, both inner and outer, the artist has arrived at a supra-physical and supra-chemical phase; that is, at the purely geometrical. The interpenetration of volumes is now, though still present, divested of all but mathematical definition. Tchelitchew's plastic ideal, his cumulative ambition, is now strict transparency. The old problem of overlap in three dimensions has been solved by but one thing: the continuous surface (canonically instrumented in painting by the solid brush stroke) has been entirely sacrificed to the surface as defined by modulated, mathematically rhythmed lines. Notably these geometric sequences, however, are not *exact*; Tchelitchew, clinging to nature in the phenomenal sense, leaves room for tangible irregularity; for example, the two sides of a late frontal head are by no means strictly correspondent to each other; in the same way, the "dancing boxes" will have a trapezoidal look, so that parallel lines (with the exception of the containing rectangle that echoes the picture frame) will have a way of looking accidental, or at least casual.

The nineteenth century mathematician, Karl Friedrich Gauss, proposed surface as line. This is significant because my friend Jean van Heijenoort, a distinguished mathematician, believes that Tchelitchew's successive styles refer to the historic mutation of mathematics. This may be so yet it is certain that Tchelitchew's knowledge of mathematics has not equipped him to

consciously devise this parallel or correspondence. In fact, at this moment, he bewails to Ford his want of true mathematical knowledge. His instinctive belief is that mathematics can be reconciled with numerology as astronomy can be reconciled with astrology. He believes further that he can discover through plastic intuition the secret formulae that accomplish such reconcilements.

Success in this would signify the "state" of Paradise.

However arguable the premise, or its demonstration in Tchelitchew's art, we can follow, and to some extent evaluate, the artist's internal logic in terms of aesthetic and mystic philosophy. Essentially he now posits, as I began this book by asserting, the total object of the world as a yantra or mandala; a mystic diagram, that is, in the intent contemplation of which one can transmute and sublimate the human intelligence in an absolute sense: the visible world is "ecstasized." That the logic of this process rests deep in Tchelitchew, has its own special genealogy, can be revealed by comparing one of his geometric heads with the architecture of the theatre; especially the baroque theatre with its elaborate symmetries.

Taking a relatively simple frontal head (1950), a drawing in the Collection of the Museum of Modern Art, one sees in the cranium the "ballroom" of the *Concerto* décor, with its orthodox latitudinal and longitudinal lines of the measured Globe. One also sees simultaneously, in the twin ovals denoting the continuous structure of brow and cheekbones, the units of the wire-basket that so fascinated Tchelitchew about 1925 and the eggs which he painted that same year. These truly are "units" but if we conceive the whole head, and its neck, as an image of the theatre, we have a total architectural organism, one aspect of which is the ground-plan of a theatre with its seating capacity indicated by the spanning ovals of the neck. The point of the nose is the center of the composition and designates (as in Renaissance and Baroque theatres) the vanishing point. Around this are the "arches" which we find in many old theatre designs portraying heroic and recessive space; these widen (at the forehead) into the overall arch characteristic of the central dome in Romanesque and Byzantine churches. Of course the image of Santa Sophia in Constantinople has never faded from Tchelitchew's imagination, and undoubtedly has contributed to his present ideal of both transparency and geometric regularity, based solely on the closed curve. Heads in three-quarter view, of course, suggest more the oblique complication of the Baroque theatre. But, as yet, the Celestial Physiognomies have not acquired the straight line.

A creative artist consciously seeks that saturation of consistency which in other people would get them characterized as hopelessly accident-prone. Paranoid, a fugitive as much as a pursuer, Pavlik keeps a list of people he "blames." Heading it (as Charles Henri learns one day) are his sister Choura,

Ford himself, Edith Sitwell, Marx, the Germans and Picasso, essentially a list of six sources evenly divided, 3—3, into those nearest and dearest to him and those he most rejects and feels are furthest away—Marx, of course, because he fomented the revolution that deprived him of his patrimony. In the head which I described above as architectural, the vanishing point (infinity) is identical with the point of view from which it is seen, since for years the artist has been experimenting with *reversibility*, or that plastic form which is a transparent volume (on a plane surface) seeming at once to "come" and "go," to expose both back and front. In parallel, the psychic concept of moral ambivalence makes those nearest and dearest to him also blameworthy, classifiable with his worst enemies. With the death of his father in 1942— overwhelmed at last by old age, despair and illness—the last organic tie with his native land seemed magically to have snapped; now Russia, morally and geographically, is "nowhere."

Like his illness and his moods, all life seems to obey alarmingly automated modes of escalation. Now, as before the war, he is sailing back and forth across the ocean: across "waves." The Hanover Gallery, where he had a watercolor and drawing show the previous Fall, has become his English representative. The correspondence between him and its director, Erica Brausen, is fast growing formidable. Last August, a large retrospective show was held by the Institute of Modern Art, Buenos Aires, with an introduction by Lincoln Kirstein for the catalog. In Rome, where he goes the following summer (1950), a one-man show is given him at the Obelisco Gallery, Gaspero Del Corso, director. The artist lives in nearby Grottaferrata.

Far from abandoning his concept of time, *simultaneity*, he is deliberately using it to approach the fourth dimension through what he terms union-in-diversity and continuity-in-change; as we know, he connects the plastic effect with reincarnation. He also postulates an organic rhythm corresponding to the pulse and heart beats. It is strange that Stravinsky should compute this very rhythm of Tchelitchew and that Tchelitchew's impression of the composer's ballet, *Orpheus* (a collaboration from which Tchelitchew backed out in New York), should have been: "It's somewhat short-breathed." Tchelitchew will himself become short of breath when he has his heart attack: will breathe lightly, quickly.

He receives a moral blow, returning to the United States, on learning he has lost the tenancy of his apartment. Supposedly, several close associates have been watching over his interests; hence the list of those to "blame," even if momentarily, receives some fresh additions. However, his old friend, Alice De Lamar, comes to the rescue by offering him the big White House in Weston. Miss De Lamar is perhaps to be counted his only admirer concerned primarily with his physical welfare. The once promised "skie light" has been installed.

In Kirstein's monograph of 1964, he cites Leonardo's Archimedian treatise on polyhedrons and irregular bodies as referring to the kind of abstract object in which Tchelitchew is now interested; it is a thing of "divine proportions." Certainly, at this point, philosophic dreaming about purely ideal objects has a much more decisive influence on the approaching environment of the Celestial Physiognomies than does the Einsteinian ambience of science, which both Soby and Kirstein conclude has something to with the trend of Tchelitchew's time/space experiments. These experiments happen to be vividly reflected in Claude Bragdon's mystic concepts of space (circa 1928).

Bragdon was developing a theory of design which he terms Projected Ornaments; one of his descriptive terms for them is "webs" though actually they look more like complicated snowflakes than like spiderwebs. In a book called *Four-Dimensional Vistas*, Bragdon says something very much in the spirit of Tchelitchew's plastic researches: "The so-called dimensions of space are related to space itself as the steps which a climber cuts in the face of a cliff are to the cliff itself—they are not necessary to the cliff, they are only necessary to the climber. Dimensionality is the mind's method of mounting to the idea of the infinity of space." The last sentence seems inoculated with hermeticism; indeed, Bragdon's whole theory is obviously influenced by orthodox mystic thought for he deals with the concept of the Divine Androgyne or astrological Grand Man. What I have called Cosmic Man has been a figure in Tchelitchew's art ever since 1927, and in *Phenomena*, in 1938, it assumed a parody form of the Divine Androgyne: the Lion Man.

Ancient mythic geometry represents the earth as a square, heaven as a circle. In China, the active or masculine principle is denoted by a white circle (celestial), the passive or feminine principle by a black square (earthly). Astrologically, to his embarrassment, Tchelitchew is anchored in the latter precisely through the traditional physiology of Cosmic or Grand Man. In nature, however, the female spider spins from her belly straight lines that take circular paths; moreover, she tethers her web by the transverse lines stretching from the circumference of the whole web to its center; the tendency is to form pyramids joined at the center like the spokes of a wheel to its hub. *Hide and Seek* was formed like an independent spiral universe floating within a rectangular frame; it is a congeries without a definite outline: nestlike. *Phenomena*, on the other hand, less "webby" in look, has its internal divisions structured as if weblike lines (the frontiers of the diamond-faceting) anchored everything to the rectangular corners. Perhaps now Tchelitchew is influenced by the way Richard Lippold anchors his linear fantasies of the Sun and Moon, done in the "sculptural" medium known as metal construction. The general look of Lippold's works corresponds to Bragdon's Projected Ornaments and is dynamically related to Buckminster Fuller's tensegrity,

where architectural balance is achieved by forces that pull rather than push.

Tchelitchew sees that his geometric heads with their exclusive spirals rest on empty space, are in no way tethered within the picture frame. This bothers him and his solution is typically astrological in character. Progressively he sees sparkles of light at the intersections of his revolving ovals, luminescent frictions of parhelions that inevitably define themselves, finally, as stars. While seemingly motionless, they are, according to his plastique, really moving just as are the heavenly bodies, the curved lines forming their paths of motion. He has seen Cosmic (or Grand) Man in multiple, spanning earth and air, but still a planetary figuration. Now, since the object in view is Paradise, man must be *wholly* celestialized. Antiquity has already celestialized all nature, including man, by catching it up to the sky and patterning the Constellations. Movement which disguises itself by seeming still—this is only in relation to other, also moving, objects. It is relativity. Hence: what is the true totality? It must be *all space* and *all the objects* in it. This cannot be shown all at once but may be shown divisively if its principle of existence be understood.

Tchelitchew knows how, on the symbolic circle of the heavens, the astrologers plot the configurations that function in horoscopes. The moving planets form a continuous set of repeated relationships, a set of geometric figures created by drawing straight lines between them. This is the artist's plastic cue and results in what he christens "dancing boxes." So is converted the spiderweb tension of *Hide and Seek* that was converted previously from the flattened diamond of *Phenomena*. Therefore, this analysis is available:

<div align="center">

Hell = a Resting Prism

Purgatory = a Solid Glisten

Paradise = a Steady Shimmer

</div>

Signifying as such? *The progressive non-resistance of matter to light.* After piling and sanding his pigment in his Paris days, he became addicted to thin surfaces gradually. The paint is light in *Phenomena* and lighter in *Hide and Seek*, where he called it "thin as onion skin" and through it the canvas weave is often visible. It is a matter Tchelitchew has felt in his hands and his viscera as well as his eyes. It has been the decisive factor in saturation; for, using a rainbow palette and following the gleams of the spectrum, he wished not to thin with medium, not to blacken or whiten. This resulted in the raw "chemical" look of *Hide and Seek* that turned aside even some of the well-disposed.

The artist's solution of his color problem in his last phase finds a deeply based path that, not unexpectedly, refers to natural phenomena. He always had a fondness for opalescence and the Aurora Borealis excited him to the point of ecstasy. Thus the colors of the Celestial Physiognomies, purely linear, are basically that white which, like the opal, produces iridescence;

these works, whether in pastel, gouache or oil paint, are richly tinted with light. The philosopher Gaston Bachelard will admire the Celestial Physiognomies and remark in writing of them that "the great motor is color." Saying that "they are an elixir of youth for the retina," Bachelard isolates the motor quality as a living force.* Yet this beautiful and spiritual philosopher is speaking only of the images of light against the black picture plane.

Always seeking total visibility, and now climaxing the search, Tchelitchew treats the picture plane as the black base of his palette, otherwise we cannot imagine the continuous surface rendered by lines only: the lines articulate the black light of these works as the skeleton and its tributaries articulate the visible and real human body. Moreover (see the *Mercure*) the black abyss itself, the spaces inside the network, achieves a soft independent highlight as if in sympathy: it too has a residual "volume."

To have put everything in the circle of heaven (Paradise) would have been too conventional, dynamically too quiet, inert. The "dancing boxes," now providing an envelope, convey that variety of image that suggests life, the very essence of movement, dialectically contradicted by the self-enclosing system of ovals and spirals at the center. Indeed, Bachelard writes, "Tchelitchew has understood the inner life of relationships, how forces flow from one point to another, how centers of energy are born from their intersections." And the philosopher recognizes "their will to appear, their intimate struggles to seem each time different, always new."** Gradually these centers lose their human character to become canonic "eggs" composed only of a series of veering spirals, as in *Mandorla* (1954). Tchelitchew is an orthodox hermetic in assuming Man *is* God, basically, and has only to further, and climax, the individual's spiritualization. This would alter the Christian concept of the mandorla in which Jesus' image signifies, by the overlapped circles, the fusion of humanity and godhead. The hermetic problem is to involve the whole organism of nature, man and all animate and inanimate things, in the absolute spiritualizing function; thus Tchelitchew's mandorla is the primal egg destined historically to be the human head; this is evident in the transition from one work to another.

The passage in the Celestial Physiognomies, *from* or *to* the human, has been made a matter of rhythmic intervals between the lines as well as shapes of the dominant geometric ovals as they coëxist *in situ* and make an organic ensemble—the eyes two sets of ovals, the nose one, etc. As we know from perspectival law, regularly marked intervals, as they advance to the vanishing point, seem closer together; if indicated in an oval form, the intervals define (according to altering shape) the incidence of curvature, just as latitudinal and longitudinal lines do on representations of the earthly globe. Such

* Bachelard: Exhibition catalog, Hanover Gallery, London.
** Bachelard, op. cit.

intervals in perspective also imply speed according to the magnitude of the given interval; larger intervals seem to advance toward infinity at a greater rate than do smaller ones. Hence, surface as defined by line implies a kind of movement that would not be there if the surface were defined by solid brushstrokes, that is, a layer of paint.

Liveliness of surface, of course, has always been created in painting by the stroke and the dab, by splatter and lately by pouring, spouting and so on. Cubism and Futurism created it with transparent planes, a treatment of overlap, as well as by statistical movement. But these forces are, so to speak, at large in a space of which the picture frame forms only token boundaries. Painters, abstractionist or realist, tend to show the casual play of forces in whatever shape; Tchelitchew substitutes a peculiar architectonic tension in his last phase. The Celestial Physiognomies are not true architecture; one hesitates to imagine them in actual dimensions, such as those of metal construction, for there is in their suspension a quality of magic that seems to exclude literal architecture.

Their use of geometry, of course, is typical of architectural diagram. But we have to remember that Tchelitchew is now dealing with the spherical universe of astrology and that this "object" cannot exist except in the form of a diagram since, in nature, the universe is visible to man only from the inside, and only partially at any given moment. The globe form in the Celestial Physiognomies is repeated as if the epicyclic orbits of astronomy were being illustrated *en masse*, with the celestial equator, the ecliptic of the sun, and so on, within the band of the Zodiac. Yet, in capturing a complex object within this "network," Tchelitchew clings to the assumption that he confronts a totality of nature whose cyclic patterns are not *strictly* spherical but may also obey the forms of an infinite number of distinct and self-contained figures: man, pitcher-woman, vase, lemon, etc., etc. Thus we find that each central object within the dancing boxes seems to be *in situ* through some exquisitely docile agreement of forces. The only comparable tensile figure in the natural world seems the "alien" thing completely immobilized by the industrious spider's threads and "floated" in her nest, the web.

Tchelitchew has equilibrated this blundering captive by retaining its life and reconciling it to its "prison," the web. The Celestial Physiognomy is both *conquered* and *conquering* because all interpenetrating rhythms have been totally harmonized: the "music of the spheres." It is as if, in far space at least, peace were signed forever. Technically Tchelitchew has dispensed with all other methods to rely entirely on the intervaled line and the prismatic vibration, indeed a controlled sort of "halation." With these implements he attains a maximum of movement in a maximum of stillness in a space void of "protesting" forces. So he is the first plastic celestialist in modern painting and the creator of a new multi-dimensional surface in the flat. Human repose is no longer "archaic": it is modern.

This page, however, exists mainly to demonstrate that our hero exists apart from his Celestial Physiognomies; that, personally, he continues to exist in the way that his pictures continue to exist after the movements that created them, after he has finished with them. The man and his work both remain *in situ* in a consciousness that encloses and extends beyond them. Tchelitchew, the celestializer, begins to suffer a terrible pregnancy of earth. He is the unwilling host of an alien guest: the tape worm: the self-renewing tape worm, the very incarnation of the Worm Ouroboros whose integrity consists in its ability to hold tail in mouth and form the eternal circle of being. It is when the immaterial is translated back into the material that life becomes so terrible. The tape worm too is villainously, stubbornly *in situ* and resists eviction. But it must be evicted or it will kill its host. He who so often complains of being eaten from the outside is now being eaten from the inside. It is like a mirror reflection of those who supposedly eat him from without and whose leader, allegedly, is Ford. This is why, when the tapeworm is evicted, as we already know, nothing is changed. The artist is as weak as before, and as strong. He is strong enough, so to speak, to withstand Ford's presence, but too weak to dispense with it! There are a hundred threats and counter-threats between the two, fortunately expressed by both with an air of stage management. Twenty times Ford expressly offers to part from his great friend, to end the relationship. Twenty times the artist declines the gambit. Charles Henri, as he says, is Fate.

But he, Tchelitchew, is Fortune! There is a quenchless inner drive to seek fortune, to realize in terms of financial success the tremendous energy he has invested in Paradise. Thereby he contradicts himself and it is as if the hunger of the tape worm were the living contradiction. Every outburst of fatalistic pessimism (and they are numerous) is hypocritical. On he goes, painting in Grottaferrata and then in Frascati, one day all music with his Rome dealer, del Corso, the next condemning him to perdition. He is gambling with the dice of Heaven, staking his life's blood on every throw. He wishes to live within a greater glory of this world, in that aura which is denied him but which he thinks he can force the world to yield him before he dies. He will illuminate, he reasons, not merely the House of Earth above, transposed to the Zodiac, but also here below, where it joins the celestial scheme as Maya, Illusion.

He decides, in the summer of 1952, to move to Italy to reside. After all is said and done, he prefers Europe to the United States. But he is an adoptive and legal American. As if to honor the fact, Ford and Miss De Lamar arrange a Fourth of July fête in Weston for his friends to bid him farewell. It is a masquerade on an elaborate scale, with hundreds of guests, band music, dancing, prizes for costumes, fireworks: a very big sendoff whose glamor is faithfully superintended by Ford. It is the last time many friends and acquaintances will have a sight of him. Tchelitchew knows that, as a natural-

ized citizen, he must return in five years for a visit. He is very weary, ill, more desperate and paranoid than ever, but his physical and mental condition only makes his current project, a renewed conquest of the Old World, the more serious.

Consideration of Tchelitchew's state is part of my complicated reason for slighting an occasion in which of course my friends expect me to participate. I am resting far away in the country and the trip to Weston and back will be physically very irksome. Instead of attending the fête, I write Tchelitchew a letter of farewell. I know very well he and Ford will not regard this as tangible reparation but I write it anyway. Perhaps, in my embarrassment, I make light of their departure as a temporary absence, recall the past and salute the future. The past holds a similar experience I especially enjoyed. Once Miss De Lamar held a superb little fête in a barn which Tchelitchew decorated with an autumnal fantasy. It also was a masquerade. I came in a Spectre of the Rose costume lent me by Alexander Iolas (formerly a dancer but then an art dealer), a costume in which Lifar used to dance Nijinsky's part. Suddenly I encountered on the fringe of the dancers Miss De Lamar; we were both in half-mask but I fancy she recognized me as well as my masquerade. "Merciful Heavens!" she gasped and seemed to vanish.

In a day or so, Tchelitchew and Ford step on their boat. With the appearance of his last style, the fervor of his American admirers, while socially still organized, has somewhat abated. Loyal Tchelitchevians have had to fall back on their loyalty to keep up with their admiration. Men such as Lincoln Kirstein, Kirk Askew and A. Everett Austin Jr., highly committed and generally enlightened, hold fast; they still believe in the artist, or think they do, although as the years in Europe go by, Tchelitchew nurtures the feeling (well founded or not) that his American coterie is forgetting him.

Despite exhibitions at the Detroit Museum of Art and at Philadelphia's Museum of Art for its Diamond Jubilee, as well as regular shows at Dur-lacher Brothers in New York, his sales have not been good. Therefore in 1951 Kirstein has helped promote a circle of the artist's supporters to contribute each a thousand dollars yearly to his maintenance. Once settled abroad in 1952, he endures a kind of stage fright, concluding, straight off, that he has "no European name" and finding fault with "French arrogance." His wealthy friends are inclined, he decides, to "pay only their pet clowns." Nevertheless he duly acquires a Paris representative, the Galerie Rive Gauche, holding a show of drawings there in 1954 and one of paintings at the Obelisco in Rome the same year. And he can boast an addition to his roster of titled admirers such as the Rothschilds and the Noailles, considered necessary to his prestige; this is young Prince Henry of Hesse.

The only person to command the Total Tchelitchevian is the Master

Himself. Each dealer, each new or old supporter, is but a subsidiary, a *tentacle*. Usually it is hard to get this symbolic message across to those involved; hence his anxiety, the fulsomeness of his correspondence, the stance of the schoolmaster, all persist. The informally dubbed "Tchelitchew Syndicate" is really a fluid affair, the donors requiring reminders of the artist's existence, so it seems, because their checks are tardy. Sometimes Pavlik asks Kirstein or another close friend in New York to jog the lagging memory of a syndicate member; sometimes he performs the chore himself with his usual graces. If one can't send the nominal thousand, he hints, something like two hundred is acceptable.

The inwardly felt harshness of the economic situation, though by 1953 he is a toughened professional, can still make him send up a spontaneous cry: "I have no one to back me!" He always admired Miró, as he does Klee ("a bird of paradise" he calls Klee), yet when he hears of Miró's Chicago success, that people paid $12,000 or $15,000 for a canvas and "bow low before him," he reacts with bitter envy. He still counts on Kirstein to do a book on him and constantly sends him advice of all sorts upon the matter. Now he suggests he do a novel instead of a biographic monograph. As long before as January, 1952, Soby has sent Monroe Wheeler a letter giving up the job on the new monograph to Kirstein. Soby's personal warmth toward the artist has not declined but, he pled, he had too much else to do and had not followed Tchelitchew closely enough. Thus the artist's doubts about his American following are not wholly unbased.

As for his American dealer, he feels that Askew, while able and willing to admire privately, has been baffled by the practical problem of selling examples of his new style, and that the prospect over here is very dim. He looks around for another dealer, therefore, and starts writing Catherine Viviano in New York, expressing his desire to discuss terms, his need for a more enterprising and understanding representative in this country. Abroad, he starts a similar campaign with Parmenia Migel (Mrs. Arne H.) Ekstrom. There is never enough praise, never enough fame, never enough money, never enough love, never enough anything except the power to pursue his goal—a power that seems to have been given him at birth by Mercury the Fleet One. This being so, it is speed that will tell. Yet owing to ill health and the present fineness of his craft, its growing self-absorption, he must work with excruciating slowness.

An artist has every human need plus the need to create. A hypersensitive ailing organism, Pavlik feels all needs more than most and with a tireless hysteria: one eye on the world, one on work. No practice on a stereoscope will ever quite adjust this "pair" to normalcy of vision. Need is a far more accurate word here than desire, the need that is, first, a medical want or animal appetite; everything social, everything economic, has the quality of a

mechanism, a species of assimilation and elimination like the body's. Nothing like this complicates his relations with Charles Henri, who now is an object beyond any sort of appetite: a need in the form of a beyond-need—something like the teddy bear a child clutches at night else he is unable to sleep, or the supreme amulet a witch doctor wears else he would go mad with fear.

To soothe his watchful anxiety, Pavel Tchelitchew imagines society as phalanxes of wide-eyed admirers, cohorts of benevolent deed-doers, political cells of Tchelitchevians, clustering disciples, young, pliant, worshipful. This, he always thought, is natural to the life of a great man, a master; it is only the features of protocol. Like a lunatic, he knows that the world provides only poor testimony for his conception of it; this does not affect the conception; rather, it challenges, instigates it, makes it more inwardly integral, outwardly paramount. In such cases, it is hard to distinguish objective from subjective agency. He sees George Balanchine in Rome, when the New York City Ballet goes on a European tour, and comes home declaring to Ford that Balanchine is someone he can no longer talk to: "George is a different man." He admires his present wife, the dancer Tanaquil Le Clercq, thinks her a "sprite," but Balanchine, his old collaborator—well, Tchelitchew has seceded from all theatrical collaboration. Some time before, a telegram has come from Kirstein in London, urging him to costume and set a new production of *Petrouchka*, offering every sort of inducement. Several telegrams were exchanged. Pavlik has found every sort of reason, material and immaterial, to refuse. Kirstein is bewildered and hurt.

It would be hard, again, to maintain the artist is less tolerant of contradiction, but perhaps nowadays he is more inwardly distressed by it. In nearby Rome, he has several friendly colleagues who are inclined to look up to him, to show him the deference one gives a senior artist; he himself showed the same when he was young. A rapt audience and admirer is young Leonardo Cremonini, whose visits are always welcome. Also living near Rome is a young American, Carlyle Brown, who started out by admiring Tchelitchew's pre-war style and became his protegé. When displeased with Brown, the artist does not hesitate to give him a violent scolding and the younger man does not always take it lying down. Tchelitchew cannot get over the habit of telling another, to put it bluntly, just how to paint his pictures.

Besides optical weakness, Pavlik now suffers from deafness in one ear and is made nervous by the strain to hear. He always preferred talking to listening and Ford still endures deep annoyance when, at dinner parties, Pavlik mounts the rostrum and dominates the table. The artist himself contends that he talks continuously to prevent his being bored by what others have to say. When a formal reconciliation comes with Edith Sitwell, he and Ford spend a few days at Montegufoni, the Sitwells' castle in Italy. His great old friend, the English poet, herself covered with honors, seems to have arrived at a new, wiser

attitude. She hardly opens her mouth except for the most commonplace exchanges. Pavlik has the floor throughout their waking hours, at table and elsewhere. Ford, thoroughly bored, gazes at Dame Edith in astonishment, thinking that never before was she really "mute." Is it superior irony? Perhaps it is her way of being ideally feminine: a sweet, silent, perfect devotion. At last, *she may have guessed.*

However Tchelitchew's social performances lack the old zest; sometimes, he just doesn't have the energy. Ford testifies in his diary that Tchelitchew never stops talking except when asleep. He can talk when painting and even when reading, between sentences. On the other hand, fatigue overtakes him nowadays without notice and he collapses.

"How are you?" asks an old acquaintance of the artist in Rome. "Shadowy," he replies.

To Charles Henri, he has been fond of reminiscing of his youthful days, days bright with hope, but since he made his will in 1949, such recollections are scarce, and when they come, are not cheerful. On that intoxicating New Year's Eve in Constantinople, he was humble in his profession, and penniless. Yet the memory of that particular happiness is the only drunkenness he can find. The tone of memories now is moralistic.

"I came from Berlin gay, Paris made me sad."

He and Charles Henri never cease trading professional pecks. It is a new aspect of their domestic warfare.

PAVLIK: "After you write all the plays on others' plots, I hope you will find a play of your own."*

C.H.: "Well, did you know people are bored at seeing no other subject of yours but the human head—a drama with one character?"

Before long comes a hitherto unknown accusation, out of the blue, against his indispensable and eternally young companion.

PAVLIK: "You are too old."

He has his palm read by a professional astrologist: all good. A Gypsy woman reads Ford's palm, saying he has a friend "who wishes him well from his heart" but that, soon, an end will come to the friendship. A horoscope of Tchelitchew's has also predicted this terminal event. "I'll have no regrets," the painter says to his friend. "You are the one who will regret."

Tchelitchew insists on sleeping with his head to the North. "One sleeps better that way." When Charles Henri wishes to go see the tops of the Alps, he replies that one needn't "go places" in order to "see" them, the imagination can do the work. When Ford gets persistent about a change of scene, "Don't sit on my soul," he flings at him. At night, Ford massages his gall bladder.

PAVLIK: "You take all and give nothing. I have decided to live alone."

"Charles (to his diary): "His mood will change."

* Ford made a dramatic version of Dostoevsky's *The Idiot.*

Of course, it does.

For years, Ford has been struggling towards a career that will compare professionally with his friend's. He would like both the popular fame and the financial independence. Yet he suspects that his possible success would be the one thing to really end their relationship. It was jealousy of Dame Edith's success in New York, Ford firmly believes, that put the artist into such a towering ill humor with her.

Gertrude Ford, the poet's mother, has been conspiring with him to arrange the personal break that seems, now, both proper and destined. She will buy a ranch in Arizona and Charles will run it. Pros and cons on this project are long weighed and discussed. But the ranch is not bought. Ford cannot bring himself to the point; he is in just as neurotic a state as Tchelitchew. "I get no spending money at all," he complains to his diary, "yet he clings to me like an octopus."

One day Ford quotes to his friend a statement by Jung: "Everything pertaining to the psyche has a double face." They look at each other. Which one is Narcissus? which the image in the pool?

As if there were an answer!

The pair agree how much they like people—in New York, for example, Ollie Jennings and Peggy O'Brien—but since, then, they did most of their own housekeeping, entertaining them as overnight guests seemed too much. They sense that Askew and Kirstein, never asked to a weekend in Weston, have felt tacitly offended. I can testify to the difficulty of being a guest of Ford and Tchelitchew even though both were very good company. It took a decade for me to be absolved from the obligation to wash dishes: a service that could not be expected of Kirstein or Askew. My day of triumph came finally when Ford said, after we got up from table and Tchelitchew must have given a little sign, "Parker doesn't like washing dishes." In any case, no dishwashing guest, to my knowledge, ever fulfilled Tchelitchew's standard of efficiency. At one point, when I came for a weekend with my friend Boulten-house, the latter was commandeered for kitchen duty. As poor Boultenhouse finished with each dish, Tchelitchew, who was standing by him chatting amiably, took it up, washed it again and dried it. Of course, Italy has one prime attraction as a place of residence: servants are cheap and they are never without one.

Perennially Ford has nurtured a stifled yearning to marry and have a son. This has been part of the force of the Arizona ranch prospect and an openly discussed matter between painter and poet. The poet has dreamed of designing and building himself an Ideal House, all his own, where he could be a family man. He has designed and redesigned it. Finally, living in Italy, he decides to surrender the dream and become a painter instead. This means he also relinquishes his obsession with writing plays.

Eh bien! He has been stung by Pavlik on this subject so often. For instance:

PAVLIK: "You can't write a poor little old play when I have done sensation in theatre."

But the point is strangely ambiguous.

C.H.: "What do you want me to write?"

PAVLIK: "A play that no one would produce."

What widens the moral breach between them is an increasing "heavy solemnity" on Tchelitchew's part. Ford actually confesses to himself that his old friend's gift for the comic-grotesque was what chiefly made possible their relationship, now eighteen years old.

C.H.: "I am the only person in the world able to make you unhappy."

He often locks his door against Pavlik. But the voice and other sounds penetrate doors.

PAVLIK: "No, I will not have my gall bladder removed! It is my emotional organ and without it I could not paint."

C.H.: "You're a *déraciné* Russian and I can't bear your accent."

PAVLIK: "I won't make any more payments on the car. You can go where you want."

Maddened by Pavlik's garrulity, C.H. asks him at breakfast, one day, to take a vow of silence. Another day they discover they were both made sick on reading *Crime and Punishment* when they were young.

After all, in Weston, it was Tchelitchew, Ford contends, who felt "cut off from the milieu." Ford's comment: "There is no milieu anywhere."

Yet while still in America, Tchelitchew kept seeing New York friends, Kirstein, Stark Young, the Askews, and discussed being reconciled with an estranged Russian friend, George Volodine, a neighbor in Weston.

C.H. (to Tchelitchew prior to Mrs. Ford's death): "There is a corpse between us." Ford's father died some years before but that is probably not what he means. What does he mean? I do not plan asking.

In 1954, when I visit Rome, Allen Tate and his former wife, Caroline Gordon, are living at the American Academy and invite me to lunch with my old friends, Tchelitchew and Ford. The painter is his familiar chirping self in company and as full as ever of open *méchanceté* in the game of social politics. But when I visit my friends *chez eux*, I detect a new driness in the atmosphere, a certain hard, spare tension in both men, and in each so intent a preoccupation with his work that they actually don't make the usual effort to be cordial. I daresay our relations, even mine with Ford, are a tiny bit stale. As for Tchelitchew, he finds it hard to conceal his annoyance that, an American magazine having commissioned me to write on American painters in Rome, I have teamed him with Matta, someone I find it inspiriting to talk to and see much less frequently than I do Tchelitchew.

The two have made friends with Isak Dinesen and Ford writes her a poem. For some reason, Pavlik is much impressed with a particular quatrain in it:

> Happiness is a little boat
> That a little boy sets sail
> On a little lake of his very own tears.
> Need the lake dry up, must the boat disappear?*

Perhaps it is Pavlik's relative unfamiliarity with the Baroness Blixen (Isak Dinesen) that causes him to prefer her refinement to Edith Sitwell's. Dame Edith has written him that someone reported he called her a witch. He curses the tale-bearer: "*Svolotch!*"—"Dirty bastard!"

"Ha!" thinks Ford, pitilessly recording it in his diary. "Pavlik has no conscience whatever about stabbing people in the back to his intimates, but considers tale bearing of the same intimates as unspeakable gossip." Obviously, under current pressure, the feudal spirit is decaying in Ford.

PAVLIK (of a great friend): "The door is closed . . . *comme si elle n'a jamais existée* . . . as if she never existed."

The artist has an astrologist in Rome. Because she failed to comply with his request for a horoscope for 1952, he concludes that she has foreseen his death.

PAVLIK (matter-of-factly): "Fuck 'em all!"

Before deciding to live abroad, he has warned Charles Henri: "If we go, I'll be sent to a concentration camp and you'll be executed near Paris."

PAVLIK: "You drink my blood."

PAVLIK: "Because you really don't have your own life, you're living on somebody."

C.H. (to himself): "But he's the one who can't face living alone."

Young Ben Morris, an American aspiring to be an artist, is visiting Rome. He remarks of Uccello's geometrical chalice (drawn in straight lines and suggesting the Celestial Physiognomies), "It's science, not art, not expression." At which, Tchelitchew, replying kindly like master to pupil: "It's a principle of life, the shape of an Etruscan vase: What does that express? I know what it reminds me of but what does it remind you of?"

It reminds Tchelitchew of life and death, of La Dame Blanche.

PAVLIK (at the easel where he is enwebbing a member of his private Zodiac): "Arachne, Arachne, you are the queen of the world!"

He and Ford discuss the difference between the commercial and the professional. Of an object in his Zodiac: "A Christmas Tree ornament maybe?"

He has had the idea of making actual toys of his dancing boxes.

* *Isak Dinesen: A Memorial*, C. Svensen, ed., Random House.

His astrologist says he will be very nervous in May (exhibition time), that he would like to throw everything away but that he shouldn't. He now won't exhibit except on dates sanctioned by his horoscope.*

Pre-exhibition nerves: "I'm going to Paris alone, by train." Of course, he doesn't.

PAVLIK (apropros of nothing): "Choura will be relieved when I'm dead, I know."

C.H.: "Probably that's true."

PAVLIK: "Yeah? You think so?"

C.H. (blandly): "It's a well known psychological fact that one is relieved at the death of another."

PAVLIK: "There's something horrible in you."

C.H. (to his diary): "Pavlik is a bitch and a bastard about my expressed desire to start drawing, said he'd withdraw from my life."

PAVLIK: "You're jealous of Cremonini."

I am tempted to interrupt, to comment, to end. But the part I am writing is Hell; so no interruption, no comment. Only a formal end.

In Paris, they run into Peter (formerly Goetz) van Eyck, the ex-husband of Ford's sister, who has become Mrs. Zachary Scott.

VAN EYCK: " What does Charles do to stay so young?"

TCHELITCHEW: "Nothing. Like the Chinese, just nothing."

He is laconic and sarcastic in praising a drawing Ford has copied from a design on the back of a barber's chair; indeed, he is appalled at the persistence of his friend's desire to paint.

It has taken the artist nine weeks to find a gallery in Paris to show his pictures and he starts talking anti-French the way he once talked anti-American. But Ford now thinks it wise, in every respect, for them to live in Paris. The thought gives Pavlik his black hysteria: the *angoisses*. To make it worse, people tell him he should never have left the city. "Paris doesn't like it when she's deserted." But he has deserted every city he has lived in.

PAVLIK: "I can't even brush my hair."

When a woman with blondined grey hair offers him a seat in the Metro, he flips, bewailing the incident to Charles Henri.

Rarely does C.H. call his friend Pavlousha; oftener, just Pou. When feeling affectionate, that is.

The artist's legs bother him a great deal these days and he uses a "medical bicycle," for which (since the machine bores him) C.H. sometimes substitutes. Ford kneels on the floor and works Tchelitchew's legs while he sits.

* Letter to Erica Brausen, June 1953.

Once his knees hurt so badly that he raises his old pathetic appeal to Ford:

"I don't know what it is! Tell me what it is!"

But Ford's lusty efforts to replace the machine are not a success with the sufferer.

PAVLIK: "There's something wrong with you. You should buy yourself some holy water and sprinkle yourself day and night."

Then soberly, another time, to Charles Henri:

"You're ready to fuck the world."

They agree the animal nature must be pulled up by the roots in order to let one work.

PAVLIK (defiantly): "I was much more animal than you. I learned how to pull it up."

Apotheosis

The ambulance is speeding along the road to the penthouse. The inside is empty, waiting for him. Then it is not empty. Lying in the bed is La Dame Blanche, just like the sleeping woman in his *Cave of Sleep*.

Or is that she standing in the doorway?

He feels her inside him now, coiled like the tape worm, hatched from the egg laid by the female, growing again.

He does not know where he is but he is trying to place a suite of his dancing boxes on a huge Christmas Tree. He seems to have done this before; no, not just this but something like it. Ah! He used to decorate the arbor with paper lanterns on Mamma's birthday at Doubrovka! Again and again, he reaches for a set of his boxes, and with great difficulty, making himself breathless, succeeds in attaching it to the tree. Everything seems very big—and such distances . . .

Charles Henri is not here to help him.

Where is he?

Now he has to put one set, the last one, at the very top, where the Star always goes. But this one for some reason he cannot recognize, that is, he can hardly see it. His eyes! But also it is as if he did not hold it even in his mind's eye. In fact, it is not a toy at all. It is *himself*.

He reaches down to where he has had a pubic itch, where the salve took so long to heal it.

Surely, he does not mean to, but he grasps everything down there and starts pulling it up. Very slowly, with agonizing resistance, it moves up, like an exasperatingly tight garment one has to peel off with main force, so close it seems an extra skin, binding, chafing unbearably.

Painfully he passes it over his groin, on, on up to his navel . . .

Everything is coming with it . . . genitals, intestines . . . now his heart, too . . . all, all is coming.

And he dare not stop. He *will* not stop.

Gradually he succeeds in lifting it past his chest, then to his armpits. Panicked, he goes rigid. He will have to lift it past his protruding shoulders to get it over his head! It's being so hard because of his hump, too. *Dieu!* His fists seem caught in his armpits, tangled in their hair. He clenches his hands even more, sweating, ready to scream for the pain. He is one aching shudder.

Impossible! But he *must* do it. This is to be the Star at the top of the Tree.

Then suddenly he feels utterly helpless. He is cleansed, relieved, as when the tape worm left him. But quite weak, much too weak to go on. He looks down. His strength, his will, melt away together. There, where the tape worm coiled, a spiral, one of *his* spirals, so *simple* . . . He is shaking still, feels feverish. His arms relax. His fingers loosen.

Everything floats up.

Where is he? He still does not know. Is the Christmas Tree the world? Anyway, this rest is a divine moment of contemplation. It may be Paradise. And, when he dies, where will he go?

Probably into his *Mercure* because his figure is wrapped for burial, meaning resurrection. No, not into La Dame Blanche, who is the ghost of the Sun, its feminine part, but into Mercury, into his planet. Not that he insists. Any single one of his suite of boxes will do, his Zodiac, just so the passage is free, takes him whole into itself. Else what has he been spinning for all this time?—spinning like Arachne? He has been preparing to abandon this life, all this . . . his career, Charlie . . . everything . . .

Yet he does not abandon it . . . He cannot. He remembers. He is not abandoning it. He will remember. He has a show coming up. It will be a sell-out. They will see! So it's HELL. *Et pourquoi pas?*

Naturally. For a while longer.

"Charlie, call Salvator Mundi! Tell them that I want my old room."

This is composed of key monographs, articles, comments and poems shedding particular light on Tchelitchew and his work.

ACTON, HAROLD. *Memoirs of an Aesthete.* London: Methuen and Co.

BEATON, CECIL. *Cecil Beaton's New York.* J. B. Lippincott.

BELL, G. "Freak Show," *New Statesman and Nation,* XV: 1063–1064, June 25, 1938.

BUCKLE, RICHARD. *In Search of Diaghilev.* Thomas Nelson and Sons.

COTON, A. V. *A Prejudice for Ballet.* London. Methuen and Co. pp. 85–89.

CRAFT, ROBERT and STRAVINSKY, IGOR. *Conversations with Stravinsky.* Doubleday and Co.

DUKE, VERNON. *Passport to Paris.* Little, Brown and Co.

FORD, CHARLES HENRI. *The Garden of Disorder.* London: Europa Press. New York: New Directions.

———— *Poems for Painters.* View Editions.

FROST, ROSAMUND. "Tchelitchew: Method into Magic," *Art News,* XLI: 24–25, April 15, 1942.

GEORGE, WALDEMAR. "Art in Paris: Tchelitcheff," *Formes,* XVI: 107, June, 1931.

———— "Le Néo-humanisme," *L'Amour de l'Art.* XV: 359–362, April, 1934.

———— "1933 Ballets and the Spirit of Contemporary Art," *Formes,* XXXIII: 377–379, 1933.

———— "Paul Tchelitchew," *Apollo,* XVII: 40–42, February, 1933.

———— "Paul Tchelitchew—Towards a Humanist Art," *Formes,* IX: 6–7, November, 1930.

JELENSKI, K.–A. "Pavel Tchelitchew," *Preuves,* LXIX, November, 1956.

KIRSTEIN, LINCOLN. *The Book of the Dance.* Garden City Publishing Co.

———— "The Interior Landscapes of Pavel Tchelitchew," *Magazine of Art,* XLI: 2, February, 1948.

———— *Pavel Tchelitchew Drawings.* H. Bittner and Co.

————— "The Position of Pavel Tchelitchew," *View*, II: 2, May, 1942.

————— *Pavel Tchelitchew* (exhibition catalog), The Gallery of Modern Art, New York, March, 1964.

MCBRIDE, HENRY. "Russian Overwhelmingness," *New York Sun*, October 30th, 1942.

MANDIARGUES, ANDRE PIEYRE DE. "Tchelitchew: Le Peintre du Cache-Cache," *Art et Style*, No. 6, December, 1946.

RAYNAL, MAURICE. *Modern French Painters*. New York: Brentano's, 1928, pp. 152–153.

RODITI, EDOUARD. *Dialogues on Art*. London: Secker and Warburg.

SITWELL, EDITH. "Miss Edith Sitwell Presents a Genius?" *The Graphic*, July 28, 1928, p. 133.

————— *Pavel Tchelitchew*. Sitwell Sale Catalog. London: Sotheby and Co., 1961.

————— *Taken Care Of*, The Autobiography of Edith Sitwell, Atheneum.

SITWELL, OSBERT. *Noble Essences*. Little, Brown and Co.

————— *Pound Wise*, Little, Brown and Co.

SOBY, JAMES THRALL. *After Picasso*. Dodd, Mead and Co.

————— *Tchelitchew, Paintings, Drawings* (exhibition catalog), The Museum of Modern Art, New York, October, 1942.

————— "Return to the North," *View*, II: 2 May, 1942.

STEIN, GERTRUDE. *The Autobiography of Alice B. Toklas*. Harcourt, Brace and Co.

————— *Portraits and Prayers*. Random House.

TANNER, ALLEN. Exhibition of Paintings, Drawings, Caricatures, Autographs by Pavel Tchelitchew (catalog preface), Brentano's, April, 1964.

TYLER, PARKER. "The Amorphous and Fragmentary in Modern Art," *Art News*, XLI: 9–11, March 15, 1942.

————— "Human Anatomy as the Expanding Universe, Tchelitchew's New Phase," *View*, VIII: 2, Spring, 1947.

————— "Tchelitchew's World," *View*, II: 2, May, 1942.

————— "Two Americans in Rome, Tchelitchew and Matta," *Arts Digest*, 28: 12–13, July 1, 1954.

————— *Yesterday's Children*, drawings by Tchelitchew. Harper and Bros.

————— "Pavel Tchelitchew, 1898–1957," *Art News* LVI: 5, Sept. 1957.

————— *Florine Stettheimer, A Life in Art*. Farrar, Straus and Giroux.

WILENSKI, REGINALD HOWARD. *Modern French Painters*. Reynal and Hitch-cock.

WILLIAMS, WILLIAM CARLOS. "Cache-Cache," *View*, II: 2, May, 1942.

WINDHAM, DONALD. "The Stage and Ballet Designs of Pavel Tchelitchew," *Dance Index*, III: 1–2, January-February, 1944.

BOEHME, JACOB. *The Signature of All Things*. E. P. Dutton and Co.

BRAGDON, CLAUDE FAYETTE. *Four Dimensional Vistas*. Alfred A. Knopf.

CARON, M. and HUTIN, S. *The Alchemists*. Grove Press.

CIRLOT, J. E. *A Dictionary of Symbols*. Philosophical Library.

DANTE ALIGHIERI. *The Divine Comedy*. Translated by Lawrence Grant White. Engravings by Gustave Doré. Pantheon Books.

D'OLIVET, ANTOINE FABRE. *The Golden Verses of Pythagoras*. G. P. Putnam's Sons, 1917.

EISSLER, K. R. *Leonardo da Vinci: Psychoanalytic Notes on the Enigma*. International Universities Press.

FIERZ-DAVID, LINDA. *The Dream of Poliphilo* (Hypnerotomachia). Pantheon Books.

IAMBLICHUS OF CHALCIS. *Life of Pythagoras*. London 1818.

KERENYI, C. *The Gods of the Greeks*. Grove Press.

KRYLOV, IVAN A. *Krylov's Fables*, translated into English Verse by Bernard Pares. London: Jonathan Cape.

MACNEICE, LOUIS. *Astrology*. Doubleday and Co.

MARCADÉ, JEAN. *Eros Kalos* (in English). Geneva, Paris, Hamburg: Nagel.

PARACELSUS. *The Prophecies:* Magic Figures and Prognostications made by Theophrastus Paracelsus. London: W. Rider and Son, 1915.

PARACELSUS. *Selected Writings*. Edited with an introduction by Jolande Jacobi. Pantheon Books.

RAKOCZI, BASIL IVAN. *The Painted Caravan*. The Hague, Holland: L. J. C. Boucher.

SCHURÉ, EDOUARD. *The Great Initiates*. London: W. Rider and Son.

SELIGMANN, KURT. *The History of Magic* (*The Mirror of Magic*). Pantheon Books.

This book, designed by Bob Melson,
has been composed in linotype Janson by American Book–Stratford Press,
who printed the text and bound the book.
The color plates were printed letterpress by Clarke & Way, and
the black and white illustrations were printed by Graphic Offset Company.